MICHELANGELO

His Epic Life

MARTIN
GAYFORD

FIG TREE
an imprint of
PENGUIN BOOKS

FIG TREE

UK | USA | Canada | Ireland | Australia
India | New Zealand | South Africa

Fig Tree is part of the Penguin Random House group of companies
whose addresses can be found at global.penguinrandomhouse.com.

First published by Fig Tree 2013
Published in this edition 2017
001

Copyright © Martin Gayford, 2013

The acknowledgements on p. xxv constitute an extension of this copyright page

Every effort has been made to trace copyright holders and to obtain their permission
for the use of copyright material. The publisher apologizes for any errors or omissions and would be
grateful to be notified of any corrections that should be incorporated in future editions of this book

The moral right of the author has been asserted

Set in 11.6/14.5 pt Adobe Jenson Pro
Typeset by Jouve (UK), Milton Keynes
Printed in Germany by Mohn Media
Colour reproduction by TAG Publishing

A CIP catalogue record for this book is available from the British Library

ISBN: 978–0–241–29942–5

www.greenpenguin.co.uk

MICHELANGELO

Martin Gayford is art critic for the *Spectator*. Among his publications are: *A Bigger Message: Conversations with David Hockney*; *Man with a Blue Scarf*; *On Sitting for a Portrait by Lucian Freud*; *Constable in Love: Love, Landscape, Money and the Making of a Great Painter*; *The Yellow House: Van Gogh, Gauguin and Nine Turbulent Weeks in Arles*; *The Penguin Book of Art Writing*, of which he was the co-editor; and contributions to many catalogues. He lives in Cambridge with his wife and two children.

To my mother Doreen Gayford (1920–2013) and my father-in-law
Donald Morrison (1920–2013), in memoriam.

CONTENTS

vii

CONTENTS

THE BUONARROTI FAMILY IN THE LATE FIFTEENTH AND SIXTEENTH CENTURIES

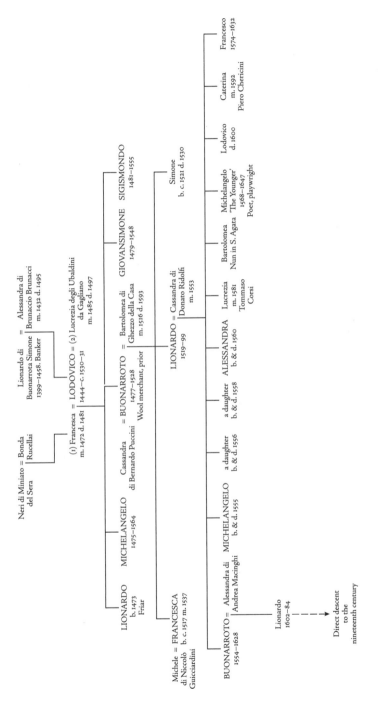

A SIMPLIFIED FAMILY TREE OF
THE MEDICI FAMILY IN THE FIFTEENTH
AND EARLY SIXTEENTH CENTURIES

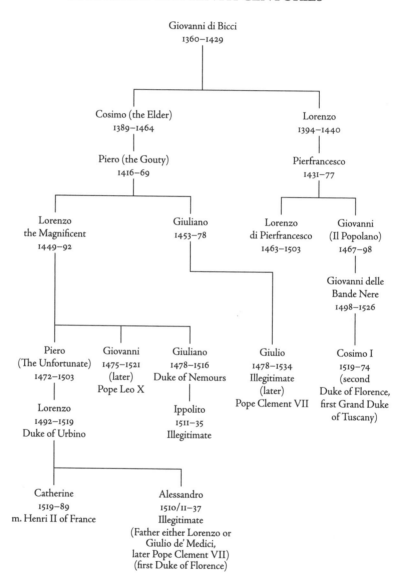

Giovanni di Bicci
1360–1429

Cosimo (the Elder)
1389–1464

Lorenzo
1394–1440

Piero (the Gouty)
1416–69

Pierfrancesco
1431–77

Lorenzo
the Magnificent
1449–92

Giuliano
1453–78

Lorenzo
di Pierfrancesco
1463–1503

Giovanni
(Il Popolano)
1467–98

Giovanni delle
Bande Nere
1498–1526

Piero
(The Unfortunate)
1472–1503

Giovanni
1475–1521
(later)
Pope Leo X

Giuliano
1478–1516
Duke of Nemours

Giulio
1478–1534
Illegitimate
(later)
Pope Clement VII

Cosimo I
1519–74
(second
Duke of Florence,
first Grand Duke
of Tuscany)

Lorenzo
1492–1519
Duke of Urbino

Ippolito
1511–35
Illegitimate

Catherine
1519–89
m. Henri II of France

Alessandro
1510/11–37
Illegitimate
(Father either Lorenzo or
Giulio de' Medici,
later Pope Clement VII)
(first Duke of Florence)

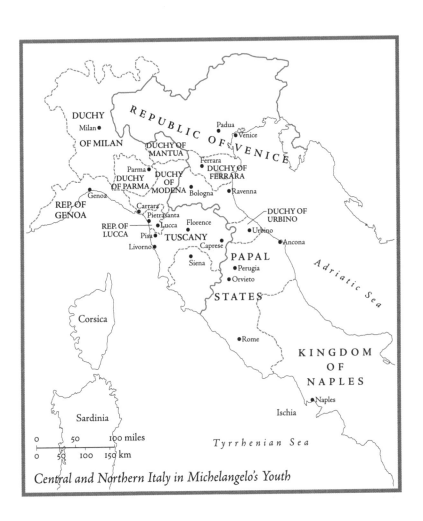

DUCHY
Milan ●

OF MILAN

REPUBLIC OF VENICE

Padua ●
● Venice

DUCHY OF
MANTUA

Parma ●
DUCHY
OF PARMA

DUCHY
OF
MODENA

Ferrara ●
DUCHY OF
FERRARA

Bologna ●
● Ravenna

REP. OF
GENOA

Genoa ●

Carrara ●
Pietrasanta ●

DUCHY OF
URBINO

REP. OF
LUCCA

● Lucca

Florence ●
Urbino ●

Pisa ●

TUSCANY

● Ancona

Livorno ●

● Caprese

PAPAL

Siena ●

● Perugia

Adriatic Sea

● Orvieto

STATES

Corsica

● Rome

KINGDOM
OF
NAPLES

Sardinia

● Naples

Ischia

0 50 100 miles

Tyrrhenian Sea

0 50 100 150 km

Central and Northern Italy in Michelangelo's Youth

LIST OF POPES IN MICHELANGELO'S LIFETIME

Sixtus IV (Francesco della Rovere):
9 August 1471–12 August 1484

Innocent VIII (Giovanni Battista Cybo):
29 August 1484–25 July 1492

Alexander VI (Rodrigo Borgia):
11 August 1492–18 August 1503

Pius III (Francesco Todeschini Piccolomini):
22 September 1503–18 October 1503

Julius II (Giuliano della Rovere):
31 October 1503–21 February 1513

Leo X (Giovanni di Lorenzo de' Medici):
9 March 1513–1 December 1521

Adrian VI (Adriaan Floriszoon Boeyens):
9 January 1522–14 September 1523

Clement VII (Giulio di Giuliano de' Medici):
18 November 1523–25 September 1534

Paul III (Alessandro Farnese):
13 October 1534–10 November 1549

Julius III (Giovanni Maria Ciocchi del Monte):
8 February 1550–23 March 1555

Marcellus II (Marcello Cervini):
9 April 1555–30 April or 1 May 1555

Paul IV (Giovanni Pietro Carafa):
23 May 1555–18 August 1559

Pius IV (Giovanni Angelo Medici):
26 December 1559–9 December 1565

LIST OF ILLUSTRATIONS

PICTURE AND TEXT CREDITS

Florence; p. 405 Photo Scala, Florence; p. 416 Photo Scala, Florence; Ch. 18 opener: Photo The Bridgeman Art Library; p. 423 The British Museum, London; p. 438 Photo The Bridgeman Art Library; p. 441 Photo The Bridgeman Art Library; p. 444 Photo The Bridgeman Art Library; p. 447 Photo The Bridgeman Art Library; Ch. 19 opener: Photo akg-images/IAM; p. 457 Photo The Bridgeman Art Library; p. 460 Photo Scala, Florence. Courtesy of the Ministero Beni e Att. Culturali; p. 471 Photo Scala, Florence. Courtesy of the Ministero Beni e Att. Culturali; p. 475 Photo akg-images/IAM; p. 477 Photo akg-images/IAM; p. 483 Photo akg-images/IAM; Ch. 20 opener: Photo The Bridgeman Art Library; p. 490 Photo Scala, Florence. Courtesy of the Ministero Beni e Att. Culturali; p. 495 The British Museum, London; p. 499 Photo Scala, Florence; p. 503 Photo Scala, Florence. Courtesy of the Ministero Beni e Att. Culturali; p. 506 The British Museum, London; p. 513 Photo The Bridgeman Art Library; Ch. 21 opener: Photo Scala, Florence; p. 523 Photo Scala, Florence; p. 525 Photo Scala, Florence; Ch. 22 opener: Photo Scala, Florence; p. 551 Photo Scala, Florence; p. 557 Photo Scala, Florence.

The publishers greatefully acknowledge permission to reprint extracts from:
Autobiography by Benvenuto Cellini, translated with an introduction by George Bull (Penguin Books, 1956). Copyright © George Bull, 1956.
The Lives of the Artist, Vols. I and II, by Giorgio Vasari, translated by George Bull (Penguin Classics, 1987). Copyright © George Bull, 1965.
The Letters of Michelangelo by Michelangelo Buonarroti, translated and edited by E. H. Ramsden by permission of Peter Owen Ltd, London.
Michelangelo: Life, Letters and Poetry, translated by George Bull (1999), pp. 9–12, 14–16, 21, 22, 28, 32, 37, 38, 45–8, 53, 67, 68, 70–72. By permission of Oxford University Press.
Forbidden Friendships: Homosexuality and Male Culture in Renaissance Florence, by Michael Rocke (1997), p. 349. By permission of Oxford University Press, USA.
Renaissance Rivals: Michelangelo, Leonardo, Raphael, Titian by Rona Goffen. By permission of Yale University Press.
The Poetry of Michelangelo: An Annotated Translation, by James M. Saslow. By permission of Yale University Press.

Michelangelo

HIS EPIC LIFE

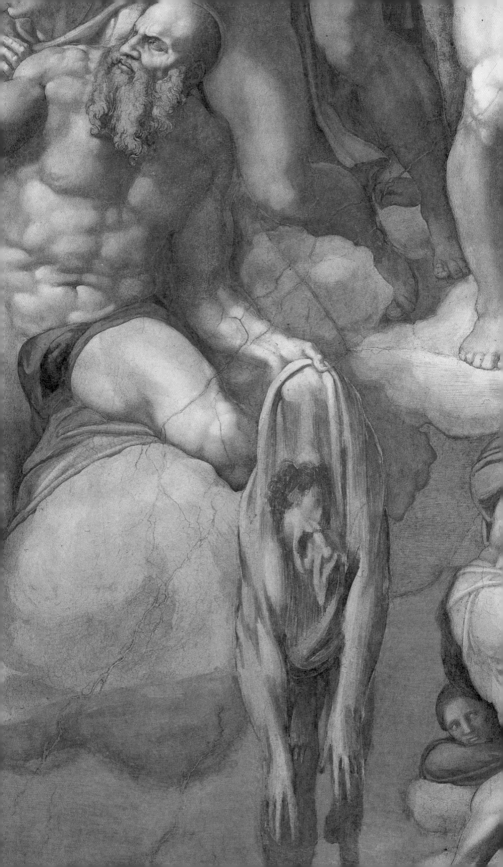

THE DEATH AND LIFE OF MICHELANGELO

'The Academy and confraternity of painters and sculptors have resolved, if it please your most illustrious Excellency, to do some honour to the memory of Michelangelo Buonarroti, because of the debt owed to the genius of perhaps the greatest artist that ever lived (one of their own countrymen and so especially dear to them as Florentines) . . .'

– Vincenzo Borghini, writing to Duke Cosimo I de' Medici on behalf of the Florentine Academy, 1564

O n 14 February 1564, while he was walking through Rome, a young Florentine living in Rome named Tiberio Calcagni heard rumours that Michelangelo Buonarroti was gravely ill. Immediately, he made his way to the great man's home in the street of Macel de' Corvi near Trajan's Column and the church of Santa Maria di Loreto. When he got there he found the artist outside, wandering around in the rain. Calcagni remonstrated with him. 'What do you want me to do?' Michelangelo answered. 'I am ill and can find no rest anywhere.'

Somehow Calcagni persuaded him to go indoors, but he was alarmed by what he saw. Later in the day, he wrote to Lionardo Buonarroti, Michelangelo's nephew, in Florence. 'The uncertainty of his speech together with his look and the colour of his face makes me concerned for his life. The end may not come just now, but I fear it cannot be far away.' On that damp Monday, Michelangelo was three weeks short of his eighty-ninth birthday, a great age in any era and a remarkable one for the mid-sixteenth century.

(facing page) Skin of St Bartholomew: detail showing the skin of St Bartholomew with *Self-Portrait of Michelangelo* from *The Last Judgement*, 1536–41.

Later on, Michelangelo sent for other friends. He asked one of these, an artist known as Daniele da Volterra, to write a letter to Lionardo. Without quite saying that Michelangelo was dying, Daniele said it would be desirable for him to come to Rome as soon as he could. This letter was signed by Daniele, and also underneath by Michelangelo himself: a weak, straggling signature, the last he ever wrote.

Despite his evident illness, Michelangelo's enormous energy had still not entirely ebbed away. He remained conscious and in possession of his faculties, but was tormented by lack of sleep. In the late afternoon, an hour or two before sunset, he tried to go out riding, as was his habit when the weather was fine – Michelangelo loved horses – but his legs were weak, he was dizzy, and the day was cold. He remained in a chair near the fire, a position he much preferred to being in bed.

All this was reported to Lionardo Buonarroti in a further letter sent that day, as a covering note to the earlier letter signed by Michelangelo himself. This was written in the evening by Diomede Leoni, a Sienese friend of the master's, who advised Lionardo to come to Rome, but to take no risks in riding at speed over the bad roads at that time of year.

After another day in the chair by the fire, Michelangelo was forced to take to his bed. At his home were some members of his inner circle: Diomede Leoni, Daniele da Volterra, his servant Antonio del Francese, and a Roman nobleman, Tommaso de' Cavalieri, some four decades his junior, who had been perhaps the love of Michelangelo's life. Michelangelo wrote no formal will but made a terse statement of his last wishes: 'I commit my soul into the hands of God, my body to the earth, and my possessions to my nearest relatives, enjoining them when their hour comes to meditate on the sufferings of Jesus.'

For a while, he followed the last of those recommendations himself, listening to his friends reading, from the Gospels, passages concerning the passion of Christ. He died on 18 February at about 4.45 p.m.

*

Thus ended the mortal existence of the most celebrated artist who had ever lived, indeed by many measures the most renowned to have existed until the present day. Few other human beings except the

founders of religions have been more intensively studied and discussed. Michelangelo's life, work and fame transformed for ever our idea of what an artist could be.

In 1506, when he was only thirty-one years old, the government of Florence described Michelangelo in a diplomatic communication with the Pope as 'an excellent young man, and in his profession unequalled in Italy, perhaps in the whole world'. At that point, he had almost six decades of his career still to come. From being the greatest artist 'perhaps' in the world, his prestige grew and grew.

There was an epic quality to Michelangelo's life. Like a hero of classical mythology – such as Hercules, whose statue he sculpted in his youth – he was subject to constant trials and labours. Many of his works were vast and involved formidable technical difficulties: the huge frescoes of the Sistine Chapel ceiling and *The Last Judgement*, the marble giant *David*, carved from an awkwardly shaped and previously used block of stone. Michelangelo's larger projects – the tomb of Julius II, the façade and the New Sacristy at San Lorenzo, the great Roman Basilica of St Peter's – were so ambitious in their scale that, for lack of time or resources, he was unable to complete any of them as he had originally intended. However, even his unfinished buildings and sculptures were revered as masterpieces and exerted enormous influence on other artists.

Michelangelo continued to work, for decade after decade, near the dynamic centre of events: the vortex in which European history was changing. When he was born, in 1475, Leonardo da Vinci and Botticelli were starting out on their artistic careers. The Italian peninsula was a patchwork of small independent states, dukedoms, republics and self-governing cities. By the time he died, the Reformation and Counter-Reformation had taken place. The political and spiritual map of Europe had altered completely; the European superpowers of France and Spain had invaded Italy and turned it into a traumatized war zone. The unity of Christendom had shattered: Protestants had split from the authority of the Pope in Rome and divided among themselves into a multitude of theological factions. Catholicism was resurgent in a more tightly orthodox and militant form. A century of religious strife had begun.

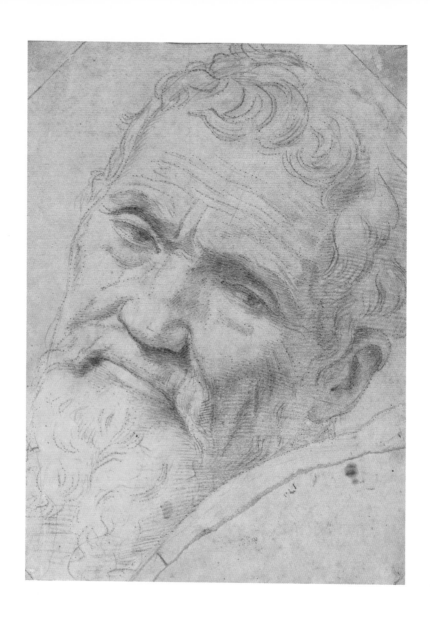

Daniele da Volterra, *Portrait of Michelangelo*, 1551–2.

While still in his mid-teens, Michelangelo became a member of the household of Lorenzo de' Medici, the Magnificent, one of the figures around whom our idea of the Renaissance has coalesced. He worked in turn for no fewer than eight popes, and with several his relations were close to the point of intimacy. He had grown up with the two Medici popes, Leo X (reigned 1513–21) and Clement VII (reigned 1523–34), at the court of Lorenzo the Magnificent. The former spoke of him 'almost with tears in his eyes' (but found him dauntingly difficult to deal with). With Clement VII, Michelangelo's connection was, if anything, even closer. He regarded Michelangelo 'as something sacred, and he conversed with him, on both light and serious matters, with as much intimacy as he would have done with an equal'.

Clement died in 1534, but Michelangelo still had thirty years to live and four more popes to serve. The huge church of St Peter's rose, very slowly, under his direction. Rome and Christianity metamorphosed around him. The Jesuit order and the Roman Inquisition were founded, and Europe froze into a religious divide between Catholic and Protestant quite as ferocious and lethal as any of the ideological struggles of the twentieth century. Still Michelangelo was there, acknowledged as the supreme artist in the world – and not just in his time, but of all time.

*

The day after Michelangelo died, an inventory was made of his goods. It listed the contents of a house that was sparsely furnished but rich in other ways. In the room where he slept there was an iron-framed bed with one straw mattress and three stuffed with wool, a couple of woollen covers and one of kid skin, and a linen canopy. The clothes in his wardrobe suggested a touch of luxury, including a selection of black silken caps – two in a luxurious shot-silk known as ermisino, and another of rascia (rash), the most expensive cloth made in Florence – two coats lined with fox fur, and a fine cape. In addition, Michelangelo owned a variety of sheets, towels and underwear, including nineteen used shirts and five new ones.

Apart from this, the house seemed bare. In the stable was the horse Michelangelo used to ride in the afternoons, described as 'a little chestnut-coloured nag, with saddle, bridle etc'. There was nothing in

the dining room except some empty wine barrels and bottles. The cellar contained some big flagons of water and a half-bottle of vinegar. Two large unfinished statues, one of 'St Peter' – perhaps in fact an effigy of Julius II once intended for his tomb – the other described as 'Christ with another figure above, attached together' remained in a workshop behind the house, with its own roof. There was also a little incomplete statuette of Christ carrying the cross.

Some drawings were found in Michelangelo's bedroom, though a very small number in relation to the quantity he had made over the years. Most of these concerned his current building projects, particularly the Basilica of St Peter's. Of the thousands of others he had made, some had been given away, some remained in Florence, where he had not set foot for almost thirty years, but a huge number had been deliberately destroyed by Michelangelo in a series of bonfires, one shortly before his death.

Also in the bedroom was a walnut chest, locked and bearing various seals. This was opened in the presence of the notaries carrying out the inventory. It turned out to contain, secreted in bags and small jugs of maiolica and copper, some 8,289 gold ducats and *scudi*,[1] plus silver coins.

Michelangelo remarked that 'however rich I may have been, I have always lived as a poor man.' Clearly, he was not joking, on either count. The inventory gives the impression of a decidedly Spartan style of life; the gold and silver in that chest represented a fortune. Stored in his bedroom was a sum just a few hundred ducats short of the amount which Eleonora di Toledo, wife of Cosimo de' Medici, the Duke of

1 Michelangelo's world was one with a confusing multitude of currencies – indeed, the bankers of his native city grew rich by taking advantage of the varying exchange rates between them. The mere list of their names makes the head spin. There were, to quote Hatfield, the expert on Michelangelo's financial affairs, 'florins, ducats, and *scudi*; *lire, grossi, giuli* and *paoli*; *soldi* and *carlini*; *denari* and *quattrini*, and *baiocchi* or *bolognini*'. Furthermore, there were differences even between different varieties of the same coin: broad or large florins, and the florin *di suggello*. There were significant differences between the values of all these, if – like Michelangelo – you were trying to extract the maximum from a deal. Fortunately, according to Hatfield, the main gold pieces – the florin, ducat and *scudo* – seldom differed in worth by more than 10 per cent. So we can accept with relief his conclusion that, from our point of view, they were effectively the same thing.

Tuscany, had paid fifteen years before for one of the grandest dwellings in Florence: the Palazzo Pitti.[2]

The gold in Michelangelo's strongbox represented only a fraction – considerably less than half – of his total assets, most of which were invested in property. He was not only the most famous painter or sculptor in history, he was probably richer than any artist who had ever been. This was just one of many contradictions in Michelangelo's nature: a wealthy man who lived frugally; a skinflint who could be extraordinarily, embarrassingly generous; a private, enigmatic individual who spent three quarters of a century near the heart of power.

By the time Michelangelo died, the praise of him as 'divine' – a description that had been given to other towering cultural figures before, such as the poet Dante – was taken almost literally. Some, at least, regarded Michelangelo as a new variety of saint. The strength of the veneration felt for him was similar to that in which famous mystics and martyrs were held. As a result, Michelangelo had two funerals and two burials in two different places.

The first was in Rome, in the church of Santi Apostoli not far from the house on Macel de' Corvi, where the artist and pioneer art historian Giorgio Vasari described how he was 'followed to the tomb by a great concourse of artists, friends, and Florentines'. There Michelangelo was laid to rest 'in the presence of all Rome'. Pope Pius IV expressed an intention of eventually erecting a monument to him in Michelangelo's own masterwork, the Basilica of St Peter's (at that point still a domeless building site).

This state of affairs was intolerable to Duke Cosimo de' Medici, ruler of Florence, who for many years had tried without success to lure the old man to return to his native city. He resolved that Rome should not retain the great artist's corpse, and so there followed a bizarre incident that echoed the theft of the body of St Mark from Alexandria by Venetian traders.

At the insistence of Michelangelo's nephew Lionardo – who had finally arrived in Rome but too late to stop the first funeral – the great

2 Admittedly, the Palazzo Pitti was greatly enlarged after this date, but in the mid-sixteenth century it was already one of the most substantial buildings in Florence.

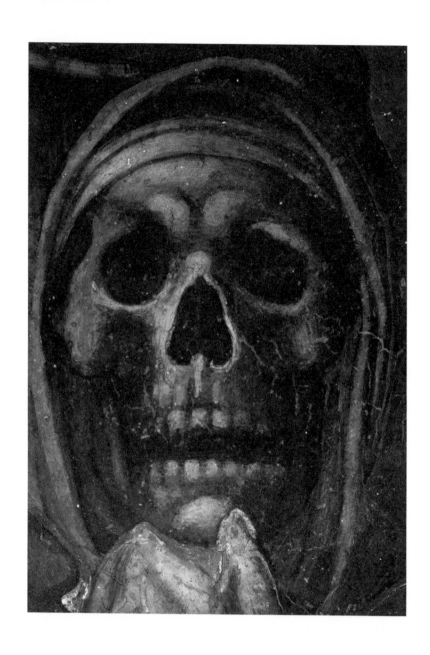

Skull; detail from the *The Last Judgement*, 1536–41.

man's body was smuggled out of the city by some merchants, 'concealed in a bale so that there should be no tumult to frustrate the duke's plan'. Arrangements for an elaborate state funeral and interment were made.

When the corpse arrived in Florence, on Saturday 11 March, it was taken to the vault of the Confraternity of the Assumption, a crypt behind the altar in the church of San Pier Maggiore. There, the next day, the artists of the city assembled at nightfall around the bier, on which Michelangelo was now placed in a coffin covered by a velvet pall richly embroidered with gold. Each of the most senior carried a torch, which would have created a scene of sombre magnificence, the flickering flames illuminating the casket draped in black.

Next Michelangelo was carried in procession to the huge Gothic Basilica of Santa Croce, the heart of the quarter to which his family had always belonged. The route would have taken his coffin close both to his childhood home and to the houses he owned – and lived in for some years – on Via Ghibellina. When word got around of whose body was being moved through the dark streets, a crowd began to assemble. Soon the procession was mobbed by Florentine citizens, distinguished and undistinguished, and 'only with the greatest difficulty was the corpse carried to the sacristy, there to be freed from its wrappings and laid to rest'. After the friars had said the office of the dead, the writer and courtier Vincenzo Borghini, representing the Duke, ordered the coffin to be opened, partly, according to Vasari – who was there – to satisfy his own curiosity, partly to please the crush of people present. Then, it seems, something extraordinary was discovered. Borghini 'and all of us who were present were expecting to find that the body was already decomposed and spoilt'. After all, Michelangelo had been dead at this point for the best part of a month. Yet Vasari claimed: 'On the contrary we found it [his corpse] still perfect in every part and so free from any evil odour that we were tempted to believe that he was merely sunk in a sweet and quiet sleep. Not only were his features exactly the same as when he was alive (although touched with the pallor of death) but his limbs were clean and intact and his face and cheeks felt as if he had died only a few hours before.' Of course, an incorrupt corpse was one of the traditional signs of sanctity.

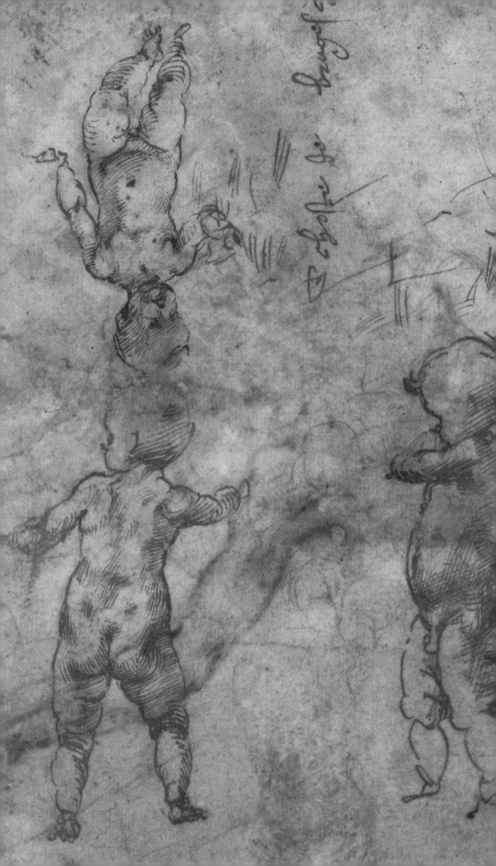

BUONARROTI

'I do not wish to expatiate further on the state of misery in which I found our family when I first began to help them, because a book would not suffice – and never have I found anything but ingratitude.'

– Michelangelo to his nephew Lionardo, 28 June 1551

The European world changed in many ways during Michelangelo's long, long life. In his youth, printed books and images were already circulating. By the time of his death, the best part of a century later, books and pamphlets were powerful enough to drive events; Michelangelo himself had become something approximating to a modern media celebrity. The reason why we know so much about his thoughts and feelings is, to a large degree, because of his fame while he was alive. His renown was so enormous that his correspondence was preserved, his creations admired and his life described in books in a fashion that previously would have been reserved for a saint or a king – but of course every existence, even the most famous, looks quite different when viewed from within.

Michelangelo may be the first individual ever to have had his biography written more than once during his lifetime. In his old age, both an authorized and an unauthorized account were published.

In 1550 there appeared an unprecedented book entitled *The Lives of the Most Eminent Painters, Sculptors, and Architects* by the Tuscan artist Giorgio Vasari (1511–74). This treated the careers and achievements of artists with the seriousness that before would be used in classical and medieval literature only for the biographies of kings, soldiers, politicians, saints and – occasionally – philosophers.

(facing page) Studies of Infants (detail), c. 1504–5.

Vasari set the template for the way Western culture has thought about art more or less from that day to this: in terms of talented individuals with personal styles, learning from, rivalling and outdoing one another. He set out, in other words, a star system. At its apex were great artists, heroes, geniuses: Giotto, Brunelleschi, Leonardo, Raphael (all, except the last, Florentine).

The initial sentence of Vasari's *Life of Michelangelo* has been hailed as a masterpiece in itself: a glorious example of Mannerist prose, looping and cascading through complex clause after complex clause, describing, in a fashion reminiscent of Michelangelo's own pictures on the Sistine Chapel ceiling of the Creation of the World, how God had sent a blessed spirit to Earth to provide, by its universal skill in all the arts and holy conduct, a model of perfection.

Despite its heady praise, Michelangelo was not entirely satisfied with Vasari's treatment of his life. It contained mistakes, missed out events and works which he felt were important and – conversely – emphasized points that Michelangelo himself thought better ignored.

These defects explain why, in 1553, only three years after the publication of Vasari's *Lives*, another biography appeared, the *Vita di Michelangnolo*[1] *Buonarroti*, ostensibly by an assistant of Michelangelo's named Ascanio Condivi but probably partially ghosted – since Condivi's writing abilities were rudimentary – by an altogether more accomplished literary man, Annibale Caro. At any rate, this new text showed every sign of what Vasari's had lacked: extensive access to the subject. Some passages read like verbatim transcriptions of Michelangelo's reminiscences, to the extent that the book has been claimed – with some exaggeration – to be, in effect, Michelangelo's autobiography.

Although the Condivi *Life* was unquestionably written with Michelangelo's help and approval, for various good reasons – he was unused to the process of publication and, approaching eighty, had other matters, such as the building of St Peter's, on his mind – he clearly did not get round to reading the finished text until after it was printed. When he did so, as he had when he read Vasari's book,

1 The artist's Christian name was spelled in a variety of ways by his contemporaries.

Michelangelo found that there were points that were inaccurate and others that required a word or two of amplification.

We know this because there is a copy of Condivi's *Life* with very faint contemporary annotations. These turned out to be in the hand-writing of none other than Tiberio Calcagni, the same loyal assistant who had hurried to Michelangelo's house when he heard the great artist was unwell. Before his death, on one or more occasions, Michelangelo seems to have gone through a copy of the book with Calcagni. Possibly, the idea was to help Vasari with the second edition of his work, which came out in 1568. If so, Michelangelo's comments were never passed on; perhaps because Calcagni himself died not long afterwards.

Calcagni often began a note with 'He told me' (*'Mi disse'*), but at one point he begins 'He says' (*'dice'*), indicating that Michelangelo was still alive at the time of writing. The last note was clearly made after Michelangelo had died. This annotation was beside a passage in which the elderly artist's health problems were described: 'For several years now he has found it painful to urinate.' This problem would have developed into kidney stones, the text goes on, if he had not been cured 'through the attention and diligence' of a friend, a famous surgeon and anatomist named Realdo Colombo (c. 1516–59). The annotation bleakly reads, '*Pietra Errore. Chiarito nella morte*' ('Stone Error. Made clear in death'). This is too clipped to make unambiguously plain whether it was a mistake that Michelangelo was cured of stones in the first place or whether it was the diagnosis of stones that was wrong. However, it does rather suggest that, having cut up many people's bodies over the years to examine their bones and muscles – sometimes in company with the same Realdo Colombo – Michelangelo was himself subjected to a post-mortem between his death and that first, Roman, burial.

*

There is little in the historical record to indicate that Michelangelo could have inherited much in the way of talent from his forebears, except perhaps a predisposition to eccentricity. The Buonarroti were a mediocre lot, for the most part. They did boast a surname, which in fifteenth- and sixteenth-century Italy was a sign of some status; many people were known simply by a patronymic such as Giovanni di Paolo,

which was in fact the name of a Sienese painter, meaning 'John, the son of Paul'. In documents, Michelangelo and his relations were referred to fairly haphazardly as 'Buonarroti', 'Simoni' or 'Buonarroti Simoni' (while on occasion the artist himself was simply 'Michelagniolo di Lodovico': Michelangelo, the son of Lodovico).[2]

This question of naming perplexed the artist, who took an interest in family history. In December 1547 he explained to his nephew Lionardo that he had been reading a chronicle of medieval Florentine history and found a reference to various possible ancestors who styled themselves 'Buonarroto Simoni', 'Simone Buonarroti' and 'Michele di Buonarroto Simoni'. 'So I think,' he concluded, 'that you should sign yourself as 'Lionardo di Buonarroto Buonarroti Simoni'.[3]

This preoccupation with the correct form of the family name was connected to a more general preoccupation with his social position. Eighteen months later, returning to the issue of naming, he ordered his nephew – not for the first time – to tell an old Florentine friend and ally, Gian Francesco Fattucci, to stop addressing letters to 'Michelangelo Sculptor', 'Because here I'm only known as Michelangelo Buonarroti.' He had always preferred to identify himself as a sculptor rather than a painter, but in old age he would rather have not been known for an occupation at all. By that time, Michelangelo, then in his early seventies, had convinced himself that he was more a gentleman than an artist: a gentleman who made works of art as gifts for his friends and – under protest – as service to certain great rulers: 'I was never a painter or a sculptor like those who set up shop for that purpose. I always refrained from doing so out of respect for my father and brothers; although I served three popes,[4] it has been under compulsion. I think that's all.'

2 A variant of Ludovico. In sixteenth-century Italian, as in English, names are apt to vary from modern forms. Thus Leonardo was generally Lionardo, and Michelangelo signed himself Michelangiolo. In this book the older forms are sometimes used for reasons of clarity. Thus the Buonarroti family members are Lionardo, but not Leonardo da Vinci.

3 Lionardo's father was Michelangelo's younger brother, Buonarroto Buonarroti. The naming question, to an outsider, can become quite confusing.

4 He still had three popes to go at this point, but nevertheless seems to have underestimated the number of his papal patrons at that date.

In his mid-forties Michelangelo became firmly convinced that the Buonarroti were descended from Countess Matilda of Tuscany (1046–1115). This was roughly equivalent to a Tudor Englishman beginning his family tree with William the Conqueror. To have *la grande Contessa*, as she was known, as an ancestor was to have the bluest blood in Tuscany.[5]

For almost his entire life Michelangelo strove to re-establish his family in – as he saw it – their rightful position. The paradox was that the actual, living Buonarroti were a sad disappointment to him. 'I have always striven to resuscitate our house,' he lamented to his nephew, 'but I have not had brothers worthy of this.'

Although, like a lot of people who take an interest in their genealogical roots, Michelangelo's relations had a notion that they had grand connections, the historical truth was more mundane. In his childhood the family was in decline and living in what, in English society, would be called genteel poverty. They had in the previous two centuries risen somewhat above the average social level of the Florentine population, and then, over the two generations prior to Michelangelo's, started to slip back.

They were, in origin, part of the *popolo*, the rising commercial middle class that began to grab power from the landed feudal aristocracy in the late thirteenth century. Like many successful Florentines, the early Buonarroti were mainly cloth merchants or money-changers. They figured as priors – the most powerful officials, in office for only two months at a time – in the Florentine Republic that was formed in 1282, and held various other honourable positions in civic government and major guilds throughout the fourteenth century. Occupying such offices was the main way in which Florentines established social status.

The apogee of the family – at least until the advent of Michelangelo – came with the career of Buonarrota di Simone (1355–1405), a wool merchant and money-changer. He held an impressive tally of

5 His faith was strengthened in 1520 when he sent another artist, as a sort of ambassador, to the then Count of Canossa, whose name was Alessandro. The Count searched the archives, turned up an ancestor who had indeed held a post in Florence and sent Michelangelo a very cordial letter addressing him as kinsman and offering hospitality. Later genealogical research, however, revealed that the Buonarroti and the counts of Canossa were not related after all.

honourable offices and lent the Florentine Republic a large amount of money for a military campaign against Milan in 1395. At this point, there was not a vast gap between the fortunes of the Buonarroti and of the Medici, another ascending clan.

In the next generation, however, the slide began. Buonarrota's eldest son, Simone (1374–1428), also held important posts in the government of Florence – but at the same time he featured in a decidedly odd episode. On 1 November 1420 one Antonio di Francesco Rustici was sitting with a friend on the bench outside the latter's house when Simone di Buonarrota di Buonarroti Simoni came along and threw a brick at his head. 'I did not know how to explain his attack on me,' Antonio confided in his *ricordi* (book of memoranda), but he was clearly unhappy about the matter. It seems that Simone had also been very rude. On 5 December Antonio went to the court of the *Podestà* (chief administrator) to complain about it. The judgement was in Antonio's favour.

This curious affair left an impression of wild anger, irrationality and perhaps deep frustration at some reverse. While it would be risky to suggest a genetic predisposition to this kind of bad behaviour, it is a fact that Michelangelo himself had a violent temper. He was recorded on various occasions as gratuitously insulting other artists, including Leonardo da Vinci.

Michelangelo's grandfather Lionardo had other problems. He was burdened by having four daughters, and thus four dowries to pay. The provision of dowries was a perennial Florentine difficulty. In combination with a lack of business acumen on Lionardo's part, it was probably enough to tip the Buonarroti finances into crisis.

Among the poor of Florence, there was a special category: the *poveri vergognosi*, or shameful poor. These were those who belonged to once grand families which had fallen on hard times. The Buonarroti were not quite in this group, but during Michelangelo's early years they were perilously close. His father and uncle Francesco recorded in their tax returns that they had lost a valuable piece of their rather small portfolio of property – a house – because of the need to provide a dowry for one of their sisters. There was a confraternity in Florence, the *Dodici Buonomini*, or Twelve Good Men, dedicated to assisting the *poveri vergognosi*. In their oratory of San Martino there is a cycle of

frescoes by the workshop of Michelangelo's own first master, Domenico Ghirlandaio (c. 1448–94). One of the paintings depicts the charitable act of providing dowries for the daughters of gentlemen too poor to afford them.

In his later life, the problems of distressed Florentine gentlefolk were close to Michelangelo's heart. At one point he mused that if his nephew were to marry a bride of good family, 'well brought up, in good health and well born, but penniless, you should consider that you do so as an act of charity'. At another, he asked Lionardo if he knew of 'any noble family in real need'; if so, Michelangelo said he would like to make a donation to them for the good of his soul.

The finances of the Buonarroti did not improve in the following generation. Francesco, Michelangelo's uncle, followed in the profession of money-changer, but in a small way and without much apparent success; Michelangelo's father, Lodovico, on the other hand, for much of the time did nothing remunerative at all. The only jobs he seems to have considered were the kind of honourable civic posts for which Florentine citizens of good family were eligible. The problem was that Florentines who were in arrears with their taxes[6] were ruled out.

Unfortunately, Lodovico owed the government money more or less continuously between 1482 and 1506, that is, from the time Michelangelo was seven to his thirty-first birthday, during which time Lodovico was unable to take up administrative jobs in Val d'Elsa, Volterra, Anghiari and, twice, in Cortona. During this time Lodovico lived off the revenues from small properties in Florence and a farm outside the city, perhaps eked out by the earnings of his elder brother, Francesco. The evidence suggests that Lodovico was extremely short of cash during Michelangelo's boyhood. Between 1477 and 1480 there are records of his pawning household utensils and some possessions of his wife, Francesca. Clearly, he had difficulty in paying his taxes, and as a result lost more money. It was a vicious circle: to increase his income Lodovico needed to have more of it to start with.

6 Citizens in this position were known as being a '*Specchio*', from the book known as the *Specchio*, or mirror, in which tax debtors were recorded quarter by quarter and district by district.

Early financial anxiety combined with an engrained family belief that the Buonarroti were really grander than their current circumstances would suggest goes some way to explaining Michelangelo's eccentricities. In later life he showed a strong, indeed neurotic, desire for money together with an equally powerful urge not to spend it. In fact, he possessed, as enemies were quick to point out, several of the classic traits of the miser. Michelangelo's demands for cash from his patrons verged on extortionate and – again in the view of hostile observers – sometimes amounted to sharp practice. However, he lived far more modestly than contemporaries and peers such as Leonardo, Raphael and Titian. Indeed, his parsimonious way of life was another target of criticism.

The very first account of Michelangelo's career, an extremely short one written by a doctor and man of letters named Paolo Giovio (1483–1552) in the 1520s, was acid on this very point: 'In contradiction to so great a genius [Michelangelo's] nature was so rough and uncouth that his domestic habits were incredibly squalid.'

Michelangelo ate little: according to Condivi, 'as a young man he would be so intent on his work that he used to make do with a little bread and wine.' He was not hospitable, Vasari noted in a slightly equivocal fashion, for one usually so full of praise: 'He rarely if ever invited his friends to eat at his table; nor would he ever accept gifts from anyone, because he feared that this would place him under some kind of permanent obligation.'

These patterns of behaviour are explicable – in part, at any rate – as the legacy of a proud, penny-pinching upbringing. The other outcome of this was an awkward relationship with his father, Lodovico. This, clearly reflected in numerous letters over a period of three decades and in the recollections transcribed by Condivi, emerges as a mixture of love, irritation, mutual suspicion and – on Michelangelo's part – occasionally contempt.

*

Michelangelo's birthplace was the more or less random result of one of Lodovico Buonarroti's few ventures into gainful employment. For half a year, beginning in October 1474, Lodovico was the *Podestà*, or

chief administrator, of the region of Caprese and the nearby town of Chiusi, located on the eastern margin of Tuscany, the Casentino. Lodovico's name had been pulled out of a bag as one of the citizens eligible for this post and, for once, he was able to take it up. He was paid around 70 florins for his six months' work, out of which he had to pay two notaries, three servants and a horseman. This was not a negligible sum of money, but not a fortune either – a little more than the amount his son would be paid for three small sculptures twenty years later. However, it was almost the best of positions Lodovico occupied as an official of the Florentine Republic.

As far as Michelangelo was concerned, his birth away from home was a piece of bad luck. Normally, for a Florentine, the selection of godparents was an opportunity to interweave still more closely the vital web of relations, friends and neighbours: *parenti, amici, vicini*. Alliances were made with as many wealthy and influential individuals as possible. It was common for Florentine officials whose wives gave birth when they were in a post outside the city, however, to choose local notables as godparents. In an important town, useful political connections could be made in this way. However, of necessity, Michelangelo's godfathers were a ragtag selection of local Caprese inhabitants, two clergymen, a notary, and various others. It is unlikely that he ever saw any of them again. Caprese, though a pretty little spot, could do nothing for Michelangelo, although in time his immense fame did something for it: the town is now officially known as 'Caprese Michelangelo'.

The birth took place in the small hours, as Lodovico Buonarroti noted in the *ricordi* in which, like many middle-class Florentines, he jotted down significant events. 'I record that today, the 6th of March 1474, a male child was born to whom I gave the name Michelangelo, he was born at the 4th or 5th hour before daybreak on Monday.' This seems clear enough, but actually created a muddle about Michelangelo's age that persisted for a long time.

The day on which Michelangelo was born was one that everyone in the twenty-first century, and many people in the sixteenth, would consider to be 6 March 1475 – not 1474. Florentines, however, thought differently from many of their Italian contemporaries about the calendar. They, and some other medieval societies, reasoned that the

world changed fundamentally at the moment of incarnation, when God became man: that the instant the embryo Christ began to grow in Mary's womb was the pivotal point in history rather than his delivery in the stable. Therefore, the Florentine New Year began on the Feast of the Annunciation, 25 March. The day that Michelangelo was born, as far as his countrymen were concerned, was still in the old year, 1474.

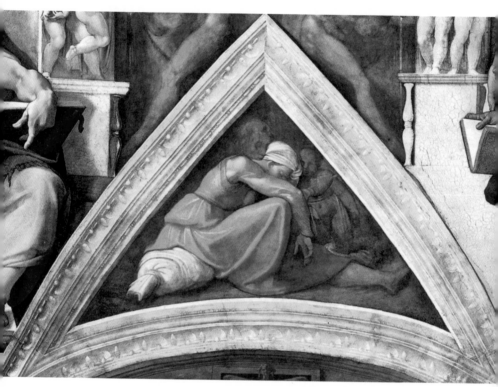

Detail of Spandrel with *Ancestors of Christ*, Sistine Chapel ceiling, 1508–12.

The consequence was that Condivi – who came from the Marche, where they reckoned the beginning of the year to be 1 January – and Vasari, among others following him, concluded that Michelangelo was a year older than he actually was.

Three weeks after his christening, on 29 March, Michelangelo's father's term as *Podestà* finished, and the little family – consisting of his mother, father and, probably, his older brother, Lionardo (though he

is not mentioned in the *ricordo*) – went home. We know almost nothing about Michelangelo's mother, Francesca di Neri di Miniato del Sera. When he was born she was still less than twenty years old, perhaps around eighteen, and his father, who was born in 1444, was thirty. A large gap in age between husband and wife was typical in middle-class Florentine families, where marriage was invariably a practical and financial agreement, though love might, in time, develop.

Francesca died in 1481, probably as a result of giving birth to a fifth child in eight years. Her dowry was relatively modest, but she had not been a bad match, being related through her mother to a large Florentine clan, the Rucellai, some branches of which were rich and powerful. The wealthiest had recently become allied by marriage to the Medici.

Losing his mother at the age of six must have had an effect on Michelangelo, but the fact is that we know nothing of how he reacted. In the extensive surviving correspondence of Michelangelo and his relations, she is mentioned just once. When, after endless deliberation, his nephew Lionardo finally got married, and a child was on the way, Michelangelo suggested that if it was a girl it should be named Francesca in memory of his mother.

Michelangelo's own views on marriage and procreation were conservative even for the sixteenth century. When Lionardo was searching for a wife, he advised, 'All you need to have an eye to is birth, good health and above all, a nice disposition. As regards beauty, not being, after all, the most handsome youth in Florence you need not bother overmuch, provided she is neither deformed nor ill-favoured. I think that's all on this point'.

So Michelangelo wasn't a romantic about marriage. When challenged about his own failure to wed, he implied that he felt lucky to have escaped from wife and family both, as Vasari related:'A priest, a friend of his, once told him:"It's a shame you haven't taken a wife and had many sons to whom you could leave all your fine works." Michelangelo retorted: "I've always had only too harassing a wife in this demanding art of mine, and the works I leave behind will be my sons. Even if they are nothing, they will live for a while. It would have been a disaster for Lorenzo Ghiberti if he hadn't made the doors of

San Giovanni,[7] seeing that they are still standing whereas his children and grandchildren sold and squandered all he left."'

These words were conventional enough. Many Florentine artists did not marry, and a wife was sometimes regarded as a professional impediment. Vasari himself drew that moral in his Life of the notoriously hen-pecked Andrea del Sarto. On the other hand, it is hard not to conclude that Michelangelo was avoiding the issue – and many in the sixteenth century would have thought so too.

During his lifetime it was well-known that Michelangelo had intense feelings for various young men, and he addressed passionate poems to more than one. These love affairs were even hinted at in print by the writer Pietro Aretino. It may have been true that these *amours* were chaste. Michelangelo claimed to Calcagni that he had lived a life of total sexual abstinence, recommending this rigour on health grounds ('if you want to prolong your life, do not indulge in it or at least as little as you can').

In the social world in which he lived, there was no such notion as 'homosexuality', or 'being gay' – though there were men who had sexual relationships exclusively with other men. For Michelangelo and his contemporaries there was instead a sin, and criminal offence, punishable in theory, though seldom in practice, by death – sodomy. This was any sexual activity, including that between a man and a woman, not directed to the procreation of children; but it was most frequently referred to in terms of intercourse between two men. If Michelangelo did not commit the act itself, he could claim to be guiltless.

However, what Michelangelo said as a pious and extremely famous man in his seventies and eighties may have been a different thing to his behaviour in his impulsive youth. There is almost no direct evidence about Michelangelo's sexual behaviour, as opposed to his emotional life (except, as we shall see, at one moment in his mid-forties), however it is reasonable to wonder whether his abstinence was really

7 That is, the doors of the Baptistery in Florence, the second, later, pair of which Michelangelo famously described, again according to Vasari, as 'so beautiful that they could stand at the entrance to Paradise'.

as total when he was twenty-five as he claimed it was when he was eighty-eight.

Michelangelo lived in an extremely masculine world. Of the five Buonarroti brothers, only Buonarroto Buonarroti, the third child, married and had offspring: Lionardo, Simone and their sister Francesca (also named after her grandmother). Apart from his mother, Francesca, dead when he was still a child, his immediate family consisted of his father, his uncle Francesco, who was married but childless, and his four brothers. The eldest, Lionardo, born in 1473, was two years older than Michelangelo. Three other sons followed: Buonarroto in 1477, Giovansimone in 1479 and, finally, Sigismondo – usually shortened to Gismondo – in 1481. Lodovico remarried in 1485, when Michelangelo was ten, to Lucrezia di Antonio Ubaldini da Gagliano (d. 1497), so, technically, he was only motherless for four years. Yet he never mentioned Lucrezia. Indeed, few women are referred to in his writings apart from his niece, Francesca, and an elderly female servant named Margherita, whose death in the late autumn of 1540 caused Michelangelo more apparent grief than that of his brother Giovansimone, whom he didn't like, eight years later.

Margherita he missed 'more so than if she had been my sister – for she was a good woman; and because she grew old in our service and because my father commended her to my care'. Shortly before she died, Michelangelo gruffly instructed his nephew Lionardo to 'treat her kindly in word and deed, and try to be a man of honour yourself – otherwise, I would have you understand that you'll inherit nothing of mine'.

With the Buonarroti, rows tended to be about money and property. The woman who made the most impact on them, then, was perhaps Cassandra, wife of Michelangelo's uncle Francesco, because after the latter died she had the temerity to ask for her dowry back (as was her right, if she elected to return to live with her blood relations).

Cassandra must have been a presence in Michelangelo's childhood, since she and her husband were then living hugger-mugger with Michelangelo's parents and their family. The family's declaration for the *catasto* (a Florentine property tax) for the year 1480/81 stated that they were living in a rented house on Via de' Bentaccordi, where nine

bocche (mouths) are listed: Francesco and Lodovico Buonarroti, plus their wives Cassandra and Francesca, their aged mother, Alessandra, and four little boys – Lionardo, seven; Michelangelo, five; Buonarroto, three; and Giovansimone, one and a half.

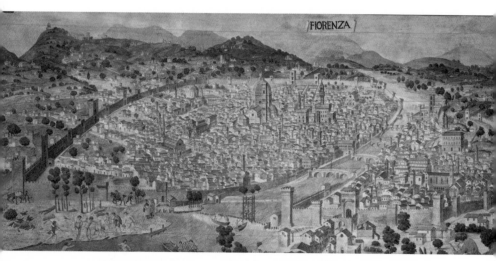

Nineteenth-century copy of the Pianta della Catena, or Chain Map, of Florence, c. 1470, attributed to Francesco di Lorenzo Rosselli (c. 1448; before 1513).

Fifteenth-century Florence was a small place, even by the standards of European cities at that time. We can get a sense of it from a late-fifteenth-century view known as the *Veduta della Catena*, or Chain Map. It shows a dense concentration of buildings clustering within protective walls on both sides of the river Arno. The Palazzo Vecchio, major churches and the swelling dome of the cathedral rise above a jumble of streets and houses. Beyond the gates, there are some scattered farms, villas and monasteries; in the distance, a ring of encircling hills. Just outside the walls, young men are seen bathing almost naked in the Arno.

At this time Florence contained some 60,000 inhabitants and could be walked across within half an hour. Nonetheless, it was divided into four large subdivisions – the *quartiere* – and sixteen smaller districts known as *gonfaloni*, or banners. There were four *gonfaloni* within each *quartiere*. Each of these was a little world of densely interconnected relations, friends and neighbours (again, the crucial trio of Florentine *parenti*, *amici*, *vicini*).

Via de' Bentaccordi is still there, a curving street that follows the outer wall of the vanished Roman amphitheatre, the miniature Coliseum of the classical city of Florentia. It is almost a fossil record of the classical building. The street is in the *quartiere* of Santa Croce and the *gonfalone* of *Lion Nero*, the Black Lion. Both of these localities and the people who lived in them continued to be of importance to Michelangelo throughout his life.

The Buonarroti brothers rented the house on Via de' Bentaccordi from a man named Filippo di Tommaso di Narduccio for 10 *fiorino di suggello* a year. They did not need any contract with him, the brothers Buonarroti pointed out on their tax return, since they knew him; he was their brother-in-law, married to their sister (and Michelangelo's aunt), Selvaggia.

In late-medieval Florence friends and family were also likely to be neighbours. A quarter of the house the Buonarroti family lived in was owned by Niccolò Baroncelli, a member of another branch of the same clan, the Baroncelli–Bandini family, who lived next door. Such alliances of blood and proximity were long-lasting. Francesco Bandini, a close friend and advisor of the elderly Michelangelo in Rome, was a member of this same family group. The wealth and prominence of the Baroncelli–Bandini in the *quartiere* can still be appreciated in the Baroncelli Chapel in the church of Santa Croce.

The identity of a Florentine was a matter of layers. He or she belonged to a family, a *gonfaloni*, and a *quartiere*, then of course to the city and, more generally, to Tuscany (over most of which Florence ruled). After all those loyalties had been taken into account, in contradistinction to a Frenchman or a Spaniard, Florentines might also consider themselves Italian in a general cultural sense, as opposed to non-Italian barbarians. The power base of the Medici, for example, and the greatest concentration of their supporters still lay in their locality of *Lion Bianco*, the White Lion, in which were found both their palace and the church where they were buried, San Lorenzo. The *quartiere* of Santa Croce, on the other hand, tended to be a hotbed of anti-Medicean sentiment and support for their enemies, such as the Pazzi family (whose chapel was built by Brunelleschi in the cloister of Santa Croce itself).

Even during the last thirty years of his life, which he spent continuously in Rome, Michelangelo's multiple identities as a Florentine remained important to him. In Rome, he mixed with a circle of Florentine expatriates, many hostile to the Medici. When he invested in property in Florence, he chose some adjoining houses on the Via Ghibellina, round the corner from the Via de' Bentaccordi (on this site, the Buonarroti's Florentine mansion was later built, now, since the family died out in the nineteenth century, the museum and library of the Casa Buonarroti).

There is little direct evidence about Michelangelo's early childhood. His father jotted down some expenses for baby clothes for him; at one point the family took refuge with his maternal grandmother's family in Fiesole during a visitation of the plague. It can be assumed, however, that the urban geography of the neighbourhood made an impression on Michelangelo when he was a boy. Just to the north, off Via Ghibellina, was the so-called *Isola delle Stinche*, the prison of Florence, a place where debtors and the mad might end up alongside genuine criminals, within blank walls 23 *braccia* high (approximately 44 feet), surmounted by watch towers. On at least one occasion, when Michelangelo was first in Rome in his early twenties, Lodovico Buonarroti was in danger of being sued for debt and sent to the *Stinche*.

A couple of minutes' walk to the east from Via de' Bentaccordi was the great church of Santa Croce itself, a Franciscan institution dedicated – among other purposes – to evangelical preaching to the laity. It seems likely that the pious Buonarroti, living so nearby, were from time to time members of the congregations that gathered around the new and beautiful pulpit carved by Benedetto da Maiano.

Indeed, in the 1480s, Santa Croce was already what it is today: not only a church but also a museum of Florentine art containing two cycles of frescoes by Giotto (parts copied by the teenage Michelangelo), a magnificent relief of the Annunciation by Donatello and two superb sculptural tombs, one by Desiderio da Settignano, the other by Bernardo Rossellino. Living conditions on the Via de' Bentaccordi might have been cramped, but there was great art on the doorstep.

The flavour of the sermons heard at Santa Croce is suggested by those given by a famous preacher, Bernardino of Siena, later canon-

ized, half a century before Michelangelo was born. St Bernardino preached repeatedly against the sin of sodomy, one to which Florentines were thought especially prone. On 9 April 1424 he had exhorted the congregation, 'Spit hard! Maybe the water of your spit will extinguish their fire. Like this, everyone spit hard!' And it was reported that the sound of spittle hitting the floor of the basilica was like thunder.

Three days later, he led the congregation out into the Piazza Santa Croce, where a huge bonfire of the vanities had been built, and the saint set it alight. This kind of preaching, and bonfire, was a recurrent feature of Florentine life. It was to return in the 1490s, its epicentre the convent of San Marco, where the fire-and-brimstone Dominican preacher Girolamo Savonarola (1452–98) held forth.

The *quartiere* of Santa Croce was home to a number of grand families and large mansions, particularly gathered around the Piazza Santa Croce, but it was, above all, the area of lower-middle-class dyers and their *tiratoi*, open sheds in which the dyed cloth was hung up to dry. Freshly coloured cloth – sometimes vivid in hue – would have filled these, and been visible to every passer-by. These *tiratoi* were roofed over to protect the cloth from the sun but open at the sides to aid the drying process, thus newly dyed fabric, and its colouring, was a characteristic sight in the district where Michelangelo grew up. A prominent silk merchant named Tommaso Spinelli (1398–1472) lived on Borgo Santa Croce, very close to the Buonarroti house. His records show that he employed local dyers to produce cloth in crimson (*cremisi*), vermilion (*vermiglio*), purple (*pronazzo*), green, yellow and chestnut (*tane*). These are the colours that would have festooned the Santa Croce *quartiere*. Perhaps they made a subliminal impression on a boy walking by.

*

Although he had a preference for the depiction of the human body naked, Michelangelo also had a highly individual sense of colour – and feeling for clothes. When the cleaning of the Sistine Chapel ceiling began in the early 1980s, in the lunettes and severies or groins, around the sides of the ceiling depicting the Ancestors of Christ – areas previously so dark as to have been almost indecipherable – rich reds, acid

greens and yellows, sky blues and oranges appeared. The dress of his figures – the prophets and sibyls as well as the Ancestors of Christ – is extraordinarily inventive, sometimes bizarre, and often apparently of his own design.

Detail of Lunette with *Ancestors of Christ*, Sistine Chapel Ceiling, 1508–12.

Thrifty though he was, Michelangelo had fastidious taste and an eye for fine textiles. The inventory of the clothes found in his bedroom hints at a sober dandyishness. The fact that he preferred almost always to wear black might suggest austerity, but it was also subtly ostentatious, since deep, rich black was the most difficult colour to produce and hence the most expensive.

Many of his memoranda, or *ricordi*, list expenses for items of dress. Evidently, he liked buying these not only for himself but also for other people. He supplied these necessities, as was customary, for his younger male assistants, but in such abundance as to cause even the raffish

Pietro Urbano, who ultimately turned out to be a bit of a crook, some embarrassment. In September 1519, when the latter was laid up with an illness and staying with relatives in Pistoia, Michelangelo dispatched a jerkin, a pair of hose and a riding cloak, leading Pietro to respond, 'There was no need for you to send so many things.'

Touchingly, Michelangelo's niece, Francesca, who became his ward when her father, Buonarroto, died in 1528, sent him a list of clothes when she was fourteen, beginning, 'This is a memorandum of all the things I need at the moment.' She added, 'The need is great as I am left with nothing.' First came a blue dress ('*saia azurra*') 'furnished according to custom and as you see fit'. So it seems she thought Michelangelo would be good at choosing a teenage girl's dress.

An expertise in textiles was to be expected in a member of the Buonarroti family, especially one with a truly extraordinary eye. The wool trade had been the business of Buonarroti ancestors for centuries – it was, indeed, the staple economic activity of Florence. Although Lodovico Buonarroti did not take part in the trade himself, in 1507 he became a member of the wool guild, the Arte della Lana, so as to pass the rights of membership to his sons. Belonging to this, one of the most powerful of Florentine guilds, made one part of the elite of the city. It was one of the seven Arti Maggiori (major guilds) that effectively ruled the city. There were in addition fourteen minor guilds. Labourers who belonged to none of these – the *popolo minuto* – were not eligible for government posts.[8]

Michelangelo spent a good deal of time and thought on the question of setting up two of his younger brothers, Buonarroto and Giovansimone, in a wool business of their own. He finally made this commitment, after years of discussion, but ultimately it was a failure and the lost investment became another bone of family contention.

In later life Michelangelo sometimes passed his leisure time, such as it was, in tailors' and textile shops. It was probably no accident that, in 1520, he was in a Florentine haberdasher's when he suffered a

8 Michelangelo never became a member of either the guild of the Doctors and Apothecaries to which painters belonged, or that of Masters of Stone and Wood, which included sculptors and stonemasons.

mortifying embarrassment. The Cardinal de' Medici's agent in Florence, Bernardo Niccolini, found him and read out a letter detailing a series of complaints from the executors of Julius II about the non-completion of the Pope's tomb, and from the Marquis of Massa, Lord of Carrara, about his activities at the quarries. This was done in front of the other customers, 'as if,' Michelangelo complained to the sender, the cardinal's secretary, Domenico Buoninsegni, 'it were a formal indictment, so that thereby everyone knew that I was condemned to death'. By the time he wrote his letter, Michelangelo had calmed down enough to be wry about the incident.

<div align="center">*</div>

No sooner had the Buonarroti returned to Florence from Caprese than the infant Michelangelo was handed over to a wet nurse in the countryside, a common practice.[9] Michelangelo was sent to the village of Settignano, three miles to the north-east of Florence, where the family had its second home and an important source of livelihood.

For the Buonarroti, as for many middle-class Florentines, life was not confined to the crowded streets of the city. They had had a farm and villa at Settignano since the fourteenth century; it had been bought at the height of the family's fortunes and was now their principal asset and claim to the status of gentry.

Their villa still exists, five minutes' walk downhill from the small town square just off a street now known as the Via de' Buonarroti Simoni. It is a substantial building, guarded behind grand eighteenth-century gates. The original structure was extended by later generations, but it must always have been sizable, with a fortified tower rising above the roof and a roomy porch. It nestles on a slope with a prospect of olive trees, an occasional cypress, sun-baked earth and, in the distance, the folds of wooded hills.

This was a base and a refuge for the Buonarroti. In later years, Lodovico Buonarroti spent much of his time at Settignano, as did his youngest

9 Wealthier Florentines frequently sent their babies to a wet nurse, who was often a peasant woman living on their property in the country. Even in the fifteenth century, however, there were those, such as the writer and artist Alberti, who denounced the practice as unhealthy and bad for family relationships.

son, Gismondo, of whom Michelangelo complained that it was 'to my great shame that I have a brother at Settignano who trudges after oxen'.

View of the Tuscan countryside from close to the Buonarroti
family villa at Settignano.

Michelangelo himself, however, had an unexpectedly bucolic side. As he grew richer, he became not so much a ploughman following oxen as a major landowner owning farms around Florence in various localities but investing especially in the Settignano area so that, eventually, he owned land stretching almost half a mile down the hill into the next village of Rovezzano. Wherever he was, Michelangelo added touches of rustic self-sufficiency to his surroundings. In the 1520s he planted vines next to his Florentine studio on Via Mozza. His Roman house and workshop on Macel de' Corvi had a garden behind it in which grew peas and beans, figs and Muscat grapes, with a cockerel and chickens scratching and clucking in the courtyard.

The ancestral Buonarroti farm was moderately substantial. According to the *catasto* tax statement of 1470, five years before Michelangelo

was born, two oxen were required to work the land, which produced, annually, grain, meat, eggs, figs, sixteen barrels of wine, and fifteen of oil. Also attached to the land, it appears from later records, was something not every farm would have, even in the environs of Florence: a quarry. It is easy to imagine the young Michelangelo playing there: certainly, he must have known it well from his earliest years.

Settignano was a village of masons. The whole area around, including adjoining settlements such as Fiesole, was as dependent on stone-working as other communities elsewhere might be on forestry or fishing. The place was full of quarrymen, stone-cutters and, at the top of the hierarchy of artisans, sculptors. The names of the Florentine sculptors who specialized in stone-carving are a list of these hillside communities: Mino da Fiesole, Desiderio da Settignano, Benedetto da Maiano – Maiano being a short distance away. The architect/sculptor brothers Bernardo and Antonio Rossellino were from a Settignano clan, and their uncle Jacopo di Domenico di Luca del Borra Gamberelli was a farmer and quarry owner: a typical local combination.

Michelangelo's wet nurse, Condivi wrote, 'was the daughter of a stonemason, and she had also married a stonemason. Because of this, Michelangelo used to say it was no wonder he took such pleasure in a mason's chisel'; this was a casual joke, but also doubtless meant in earnest. Vasari noted almost the same remark, more succinctly: 'With my mother's milk I sucked in the hammer and chisels I use for my statues.'

In this boast Michelangelo was also echoing a widespread Florentine anxiety that middle-class children would learn working-class habits as they suckled at the breasts of their surrogate mothers. This was St Bernardino's objection to wet nurses. He warned the parents in his congregation, 'Though he be your own child, and you be wise and pretty mannered and discreet, yet you give him to be nursed by a sow . . . And when he comes home and you say: "I know not whom you resemble! You are not like unto any of us!"' As we shall see, this was exactly what Lodovico Buonarroti must have felt had happened to his son.

Neither Condivi nor Vasari gives the name of Michelangelo's wet nurse, and Michelangelo probably didn't think it worth mentioning;

he was temperamentally inclined to leave out fussy details and concentrate on the essential. He preferred, for example, his angels without wings. There is, however, a possible candidate for this role, a significant one in Michelangelo's life: Mona Antonia Basso. Her husband, Piero Basso, worked the Buonarroti farm at Settignano. Their first surviving child, a son named Bernardino, was born in 1474/5.

Therefore, Bernardino Basso was about the same age, or slightly older, than Michelangelo: Antonia Basso might well have been lactating at the crucial time. A family servant or the wife of a labourer on a farm in family ownership would have been a typical Florentine choice of wet nurse. Piero worked the Buonarroti farm, but that wouldn't have precluded his being a stone-worker too. Most local men could probably turn their hands to both. Indeed, in 1505, he supervised the builders who were making some alterations to the house at Settignano.

Florentine children lived with their wet nurse until they were weaned, if not longer. Since his brother Buonarroto was born in 1477, only two years later, Michelangelo might have spent even longer with his rather than return to be looked after by his mother. In any case, he would have spent time in his childhood in and around the farm and the village a few hundred yards up the hill, mixing with masons and the children of masons.

The Settignano quarries yielded *macigno*, a fine-grained grey sandstone that was much prized in Florence. It is a gravely beautiful material in a range of dark-greenish and bluish greys, fine enough to carve in crisp detail and with a quality of simultaneously absorbing and reflecting the light, producing a paradoxical impression of dark luminosity. This is the material that Brunelleschi used for the columns and capitals of his buildings. Michelangelo would employ it in the same way in his projects at San Lorenzo in Florence.

The Florentines, being interested in this stone enough to make fine distinctions, gave names to the differing grades, the finest type being *pietra del fossato*, and the others including *pietra serena* and *pietra forte*. Michelangelo, who had immense sensitivity to stone, went further than these broad categories. He knew that each quarry, every stratum, would produce material of subtly differing character. The contract for

Two volutes in pietra serena, detail of the vestibule
of the Laurentian Library, c. 1526–34,
San Lorenzo, Florence.

the stairs and two doors of the library Michelangelo was building at San Lorenzo in the 1520s stipulated that the *pietra serena* supplied should be of the same 'colour and flavour' ('*colore et sapore*') as in the sample. 'Flavour' is a wonderful word to use of stone: bringing out its sensuous character as if it were actually edible.

When he designed buildings in Rome, Michelangelo was attentive to the qualities of the local material, travertine, a limestone noted for the pits and troughs in its surface – as different in its flavour and colour from Florentine sandstone as roast beef is from pâté de foie gras. His use of travertine for the walls of St Peter's and the palaces on the Capitoline Hill made the most of its rugged nature.

For sculpture he used only the finest type of pure white marble, known as *statuario*, found particularly in certain quarries above Carrara. Even this sculptor's marble, according to the sculptor and goldsmith Benvenuto Cellini, came in at least five or six grades, the first having a 'very coarse grain' and the softest, which he describes almost like flesh, 'the most cohesive, the most beautiful and the tenderest marble in the world to work from'. Michelangelo was renowned for his ability to discern the quality of a potential piece while it was still in the rockface.

When he was engaged from 1516 onwards on large construction projects at San Lorenzo in Florence which involved the quarrying, transport, dressing and carving of huge amounts of both marble and *macigno*, a majority of the masons he employed were from Settignano. The art historian William Wallace has established that many of this team 'lived within a radius of one kilometre – more than half of them within a few hundred metres – of his boyhood home'.

The dense network of neighbours and friends, in both Settignano and the quarter of Santa Croce, was the background to Michelangelo's childhood. Soon, however, he made two unexpected moves – both most unwelcome to his family – first into a painter's workshop, then to the court of Lorenzo de' Medici.

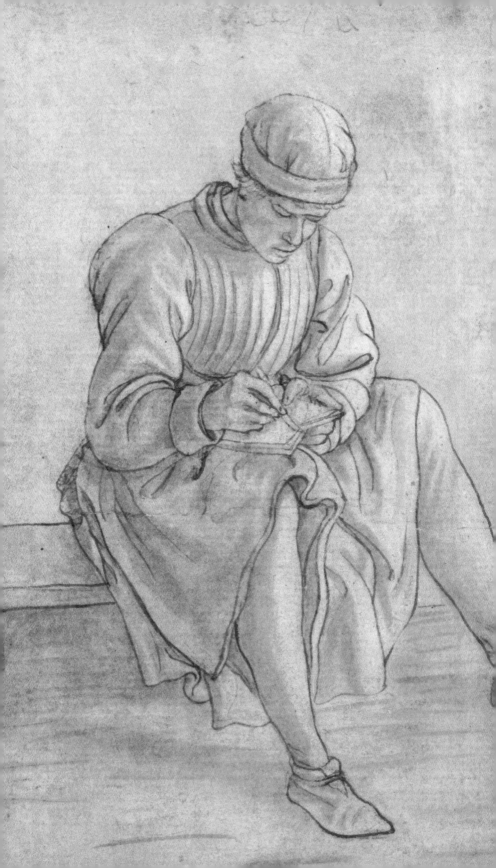

UNRULY APPRENTICESHIP

'What does the pupil look for in the master? I'll tell you.
The master draws from his mind an image which his hands
trace on paper and it carries the imprint of his idea.
The pupil studies the drawing and tries to imitate it.
Little by little, in this way he appropriates
the style of the master . . .'

– Girolamo Savonarola

'As a trustworthy model for my vocation,
At birth I was given the ideal of beauty
Which is the lamp and mirror of both my arts.'

– Michelangelo Buonarroti, Sonnet no. 164

Michelangelo, like many of his contemporaries, believed in astrology.[1] To mention the stars in love poetry – of which Michelangelo came to be one of the more celebrated authors of the sixteenth century – was customary, a cliché of the genre. Yet on several occasions in Michelangelo's poetry his allusions seem to go further. One poem was written in beautifully elegant script on a sheet of paper dyed blue – the only time he presented his verse in this way. It begins: 'Since through the influence of my bright star my eyes were so formed as to be able to distinguish clearly one beauty

1 Condivi emphasizes his 'splendid horoscope', indicating that a child born under such stars would have a 'noble and lofty talent as to triumph in all and every enterprise, but principally in those arts which delight the senses'. Unfortunately, since he had Michelangelo's birth date wrong by a year, none of this applied, astrologically speaking.

(facing page)
Maso Finiguerro, *Seated Boy Drawing,* c. 1460.

from another.' At the bottom, beneath the poem, Michelangelo added a note: '*Delle cose divine se ne parla in campo azzurro*' ('Of divine matters one speaks on a sky-blue field'). Blue was the colour of the heavens, of the Madonna's gown, of the most costly of pigments, lapis lazuli.

Astrology, unscientific though we may now find it, was a way of talking about a person's inherent abilities and tendencies: in that respect, it functioned like genetics or psychology (and, a cynic perhaps might say, just as well). So Michelangelo was saying that he had been endowed with the ability to discern and comprehend beauty – not just superficial prettiness, but the deep, spiritual quality that came, he believed, from God. If by this one understands that he had an immensely strong talent, apparently inexplicable in terms of background or heredity, it seems to have been true.

*

There are signs that Lodovico Buonarroti, though not ambitious for himself, had hopes for his sons, though they come down to us disguised as complaints. One of the first letters from him to survive was written in February 1500 to Michelangelo, who was then in Rome, probably in the final stages of polishing his first great masterpiece, the *Pietà*.

Although the preceding letter from Michelangelo is lost, he had evidently let fly, as he often did when strained to a pitch of anxiety and exhaustion by his work, with a series of accusations and claims of victimhood. Lodovico responded in kind. Indeed, one guesses that maybe he was the person from whom Michelangelo learned this kind of behaviour.

He wrote that at the advanced age of fifty-six he had five sons, yet 'no one to give me the slightest help or provide for me, not even with a glass of water' (his second wife, Lucrezia, had died three years before). 'I have to cook, sweep the floor, wash up the bowls, make the bread, take care of everything, physically and mentally, both in health and in sickness, and in every conceivable way.' He was still supporting four of his adult children. Michelangelo was probably already sending remittances home from Rome, but still Lodovico had to do work he considered demeaning.

Above all, Lodovico produced the morally blackmailing claim of parents down the centuries: he had sacrificed himself for his sons. 'In the past, some good opportunities came my way, which I didn't take for the love of my sons. I have loved others more than myself until now, and I always found myself last.'

One way in which Lodovico had probably tried to do his best for his sons was in education, though this had not turned out as he hoped in the case of the first two. Perhaps with a view to his joining his uncle Francesco, who worked as a money-changer, Lionardo was sent to one of the more distinguished abacus teachers in the city, Raffaello di Giovanni Canacci (1456–1504/5), the author of a treatise on algebra, a rarity in the late Middle Ages. The abacus syllabus, with an emphasis on mathematics and practical subjects, was considered a good preparation for boys going into business (as most middle-class Florentines did).

This well-intentioned educational enterprise, however, went horribly wrong. On 8 April 1483 Raffaello di Giovanni Canacci denounced himself for sodomizing five boys; such self-denunciation was a common procedure, because those who accused themselves could avoid serious punishment. On 10 April he was accused by Lodovico Buonarroti of having sodomized Lionardo in his school. Canacci then confessed he had committed the vice 'often and often from behind with Lionardo son of the said Lodovico'. He was sentenced to a fine of 20 florins and a year in prison, the latter part of the sentence being waived on the grounds that he had confessed. Given that, technically, the penalty for sodomy was being burnt alive, Canacci got off lightly. In practice only the most outrageously persistent offenders suffered the severest punishments.

The effects of this experience on the ten-year-old Lionardo can only be guessed. Thereafter, he almost disappears from the Buonarroti family records; in adulthood, he became a Dominican friar. In 1497 he turned up at Michelangelo's studio in Rome, having been thrown out of his friary in Viterbo, where there was a minor civil war at the time. He had lost his habit and had no money. Michelangelo gave his brother a ducat for his journey back to Florence, which seems a good deal less than lavish. His brief reference to 'Fra Lionardo' does not suggest much

affection, or even interest. On paper at least, none of the Buonarroti family mentioned him again.

Michelangelo must have been a bright, lively child. Perhaps for that reason Lodovico decided to send him to learn grammar, that is, Latin. Renaissance Florence had a highly educated population. Analysis of the *catasto* tax returns reveals that there was almost 70 per cent male literacy as early as 1427, which compares well with some twenty-first-century populations. Florentines, however, even more than their neighbours in Tuscany, opted to teach their children practical skills. Only a few, mainly from the elite, learned Latin, which might suit them for law, diplomacy or the Church. Of these, according to Condivi, Michelangelo was one.

He probably began to attend such classes in 1485 or so, at about ten years old, studying with a teacher named Francesco da Urbino, who was the author of a book of Latin grammar.[2] From the point of view of his father and uncle, this attempt to make Michelangelo a lettered gentleman went unaccountably wrong.

Condivi explained: 'both heaven and his own nature, which are difficult to contest, pulled him back to painting. In consequence, whenever he was able to steal some time, he could not resist running off to draw in one place or another, and seeking out the company of painters.' It is indeed exactly what one hears of other artists born to families with no previous tendency to the arts, such as the British painter John Constable, who spent his school days drawing. Similarly, Michelangelo's determination to become an artist, despite discouragement from his family, can be explained only by a powerful inherent talent forcing its way through.

Somewhere – in the street, or beneath a fresco he was copying – he met an older youth named Francesco Granacci, who was training to become an artist. Granacci lived around the corner from Via de'

2 Francesco da Urbino was also the chosen teacher of a family named Morelli, who were a much richer clan living in the same district, the Black Lion, as the Buonarroti. In 1483 Lorenzo di Matteo Morelli, who lived in the street of Borgo Santa Croce, a couple of minutes' walk from Via de' Bentaccordi, bought the book of Latin grammar written by Francesco da Urbino. It is quite likely he suggested the same teacher to Lodovico Buonarroti for Michelangelo.

Bentaccordi, on Via Ghibellina, and was the second son of a mattress-maker and dealer in second-hand goods who – like the Buonarroti – owned a farm outside Florence.

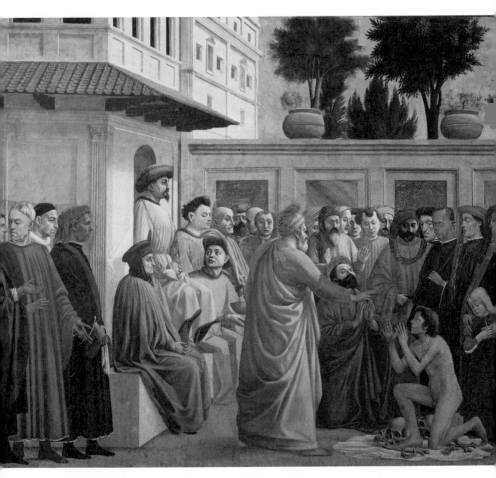

Filippino Lippi, *The Raising of the Son of Theophilus*, 1483–4. The nude youth was supposedly modelled by the young Francesco Granacci.

Born in 1469 or 1470, he was five or so years older than Michelangelo: just the right difference in age for hero worship. Francesco Granacci already had a couple of accomplishments a younger boy might admire. He had been associated with two of the best-known artistic workshops in Florence and, according to Vasari, had posed for a prominent figure in one of the most celebrated cycles of frescoes in

the city: *The Raising of the Son of Theophilus* in the Brancacci Chapel of the Carmine Church.[3]

This was one of the scenes begun by the greatest Florentine painter of the early Renaissance, Masaccio (1401–28), in the third decade of the fifteenth century, but completed much more recently by Filippino Lippi, Granacci's first master. By the mid-1480s Granacci had apparently moved on to a new workshop, run by the busiest painter in the city, Domenico Ghirlandaio. At around this time, when Michelangelo was about ten or eleven,'on seeing the boy's burning will and inclination, [Granacci] resolved to help him', gave him drawings to copy, and took him to Ghirlandaio's studio. The result of this entrée into an exciting new world – 'added to the constant stimulus of his own nature' – was that Michelangelo quickly lost whatever interest he had had in his Latin lessons and gave them up altogether. This caused consternation in the Buonarroti household.

To understand this reaction, it is necessary to grasp the significance of knowing scholarly, educated Latin at this time. Although most of the writing we value from the period – by Machiavelli, for example, Castiglione, Cellini and Michelangelo himself – is in the vernacular, that is, what we now call Italian, nonetheless, knowledge of Latin was crucial for entry into the educated elite. In later life, when he mixed frequently with men who belonged to those literary and learned circles, Michelangelo was rueful about his lack of Latin.

Writing to his great friend and fellow poet Luigi del Riccio in 1544, he confessed, 'I should be ashamed, being so much in your company, not sometimes to speak in Latin, albeit incorrectly.' In a dialogue written by another close friend, Donato Giannotti, the following year, in which Michelangelo (and Luigi del Riccio) feature as speakers, the subject of Latin grammar comes up. The character 'Michelangelo' wonders whether, since the Roman Cato the Elder had learned Greek at eighty, it was not too late for him to learn Latin thoroughly at seventy.

The contracts for Michelangelo's works are customarily in Latin but

3 The figure in question was a nude, an unusual feature in a religious painting: a pre-adolescent youth crouching, naked, his arms raised in wonder as he is raised from the dead by St Peter. It does indeed look as though it was based on a specific person.

sometimes summarized in the vernacular for his benefit. A document at Carrara concerning quarrying had a note by the clerk that he had written this in Italian because the excellent Master Michelangelo could not suffer that 'we Italians' should not write affairs down in the same language in which they discussed them. It sounds as if he was a bit prickly on the subject. That inhibition begins to account for the fact that, of a number of publishing projects he planned – a treatise on anatomy, for example – none was ever brought to fruition. At the age of eleven or twelve, naturally all Michelangelo knew was that he was born to live the life of an artist, and that was what he was determined to do.

This appalled his father and uncle. Lodovico and Francesco – the head of the family – 'hated the art of design', wrote Condivi, conveying a touch of the bitterness Michelangelo still felt sixty years later; consequently, 'very often he was outrageously beaten: as they were ignorant of the excellence and nobility of the art, it seemed shameful to them that it should be practised in their family'.

We read about the 'rise of the artist' in Renaissance Italy, but of course such social changes are not homogenous, any more than the causes of racial and gender equality have been in our own times. Contemporaries living side by side in the same community may have drastically differing attitudes. It is perfectly true that some individuals in late-fifteenth-century Florence had a very high opinion of the arts and artists. A pharmacist named Luca Landucci who kept a gossipy diary of late-fifteenth-century and early-sixteenth-century Florence mentioned painters among the important figures of the day and the inauguration of their works as significant events.

No doubt, the young Michelangelo and his friend Granacci picked up this current in the air: the fame and glory being accorded, by some at least, to great artists. But not everyone was so admiring of artists and the arts. The Buonarroti brothers, it seems, saw nothing but a painful social slippage. A clever boy who might have become a bishop was determined instead to become an artisan who worked with his hands. They probably felt it was their duty to try to beat it out of him.

They failed. Even in childhood, Michelangelo's will was much stronger. Though being thrashed 'was extremely disagreeable for him, nonetheless it was not enough to make him turn back'. His father

never took much apparent interest in his work: the comments that survive in letters are, if anything, undermining. In 1500 Lodovico wrote from Florence: 'I am very pleased that you are receiving so many honours, but I would be even happier if you were making some wealth – although I do hold honour in higher esteem than profit. But if the two come together, as they should, my happiness would be much greater still. I always thought that two opposites could not attract, and yet you have managed to bring them together as bedfellows.' The implication is: well done, but you could be doing so much better.

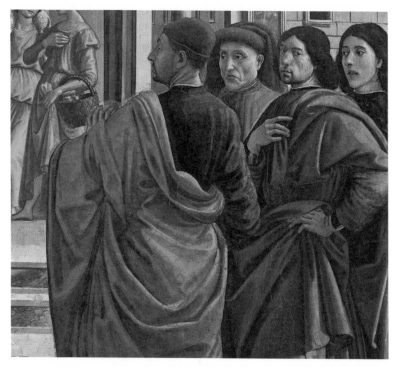

Domenico Ghirlandaio, *The Expulsion of Joachim from the Temple*, 1485–90. Detail of group on right showing Ghirlandaio and associates. The artist is indicating himself with a gesture to the chest.

In 1487, however, Michelangelo had his way and joined the workshop of Domenico Ghirlandaio. This is clear from one of the few documented facts about him in these years. Ghirlandaio was reaching the height of his success in the mid-1480s. One job – not the most important, but a major commission – was a large altarpiece of *The Adoration*

of the Kings for the Florentine Foundlings' Hospital (the *Spedale degli Innocenti*).[4] According to the contract, Ghirlandaio was to be paid for his work in regular instalments. One Thursday in the summer he sent along a new assistant. The records of the hospital note: 'Domenico di Tomaso del Ghirlandaio is debited on this day the 28th of June 1487 three large florins taken by Michelangelo di Lodovico.' This was the kind of errand that might be given to a responsible twelve-year-old.

In the past there has been confusion about Michelangelo's apprenticeship with Ghirlandaio, most of it caused by Michelangelo himself. Vasari, in the first edition of his *Lives of the Artists*, clearly stated that Michelangelo was a pupil of his; then, three years later, Condivi, relying on the artist's own testimony, went to almost comic lengths to avoid admitting that this had been the case. Then, four years after Michelangelo died, in his second edition of 1568 Vasari took a most unusual step. For the most part, he silently included all the new information he could glean from Condivi, occasionally garbling it a bit. Nonetheless, Vasari was obviously nettled by the other biographer's suggestion that he had made mistakes. Condivi, he complained, 'says that some people, because they did not know Michelangelo personally, have said things about him that were never true and have left out others that deserved to be mentioned'. Yet, about this point, Vasari had evidence that he had been correct in the first place. He printed the contract between Ghirlandaio and Michelangelo's father, which, though it has long since disappeared, Vasari seems to have examined in person. It was still to be seen, he noted, 'in the record book of Ghirlandaio, written in his own hand'. He quoted the text, in which Lodovico Buonarroti apprenticed his son to Ghirlandaio and his brother Davide for three years, and they in turn agreed to teach the boy 'the art of painting' and pay him 24 florins.

There are two puzzles remaining about this vexed business of the apprenticeship. The first is why, though Michelangelo was obviously working for Ghirlandaio in mid-1487, the contract is dated 1488. There are several possible solutions. Perhaps the rebellious pre-teenage Michelangelo started helping in the workshop without his father's

4 One of Ghirlandaio's most splendid paintings, it is still on view in the museum of the hospital.

permission and, eventually, after this had gone on for months, he gave in and decided he'd better put the apprenticeship on a proper basis. Possibly, at some point someone got muddled about the date (1 April is perilously close to that confusing Florentine New Year on 25 March).

More deeply intriguing is why Michelangelo wished to be so evasive – close to dishonest – about this small matter then over half a century in the past. He insisted in old age that he had 'never kept a shop'; that is, never been a trading, jobbing artist. Still less did he want to admit that he had been a humble helper in someone else's workshop.

There was another reluctance too. Michelangelo evidently did not want to admit that he'd ever been taught anything by anyone, certainly not by a fellow artist (certain matters had been revealed to him, as we shall see, by noblemen and poets, but that was a different matter). In Condivi there is no description of his having been instructed in sculpture, painting or drawing by anyone at all.

Furthermore, the passage in Condivi implies that Michelangelo was particularly resentful of the idea that he owed anything to Ghirlandaio: 'I have been told that the son of Domenico used to attribute the divine excellence of Michelangelo in great part to the teaching of his father, who in reality gave him no assistance at all.'

Even in the sixteenth century, it was hard to argue that Michelangelo learned nothing whatsoever from Ghirlandaio, as Vasari's reaction showed. This was the only point on which he directly contradicted the old man's statements (though putting the blame on Condivi). In the twenty-first century, quantities of technical evidence from the examination of his paintings and drawings prove that Michelangelo owed a great deal to his training in Ghirlandaio's workshop. It was there that he acquired his knowledge of fresco technique, how to paint a panel painting, the method of hatching to use when drawing in pen and ink. Michelangelo could still claim, however, that in truly important matters he had little debt to his master. The truth was that Ghirlandaio and Michelangelo were artists of types so different as to be diametrically contrary.

Condivi states – no doubt echoing Michelangelo himself – that Ghirlandaio was 'the most esteemed painter of that age', but he was strongest in just those areas in which Michelangelo disdained to take

any interest at all. In 1487 he had just completed one of his master-
pieces: the fresco cycle and altarpiece for the Sassetti Chapel in the
church of Santa Trinita (c. 1483–6), which illustrates exactly this point.
Its charm and beauty consist not in the sacred drama that was sup-

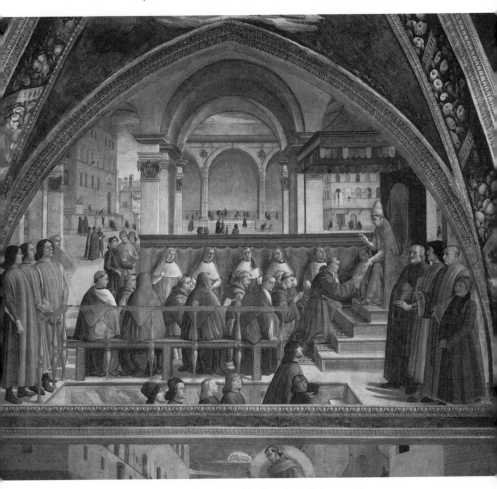

Domenico Ghirlandaio, *Confirmation of the Franciscan Rule*, 1479–85.

posed to be the point of the pictures but in the naturalistic description
of everyday life in late-fifteenth-century Florence. The large fresco at
the apex of the altar wall of the Sassetti Chapel, for example, ostensibly
depicts *Confirmation of the Franciscan Rule* (more fully, *The Confirma-
tion of the Rule of the Order of St Francis by Pope Honorius III*).

Your eye is caught, however, not by the Pope on his throne and the saint standing before him but by Lorenzo de' Medici and his entourage looking on at the right-hand side, his sons and their tutor emerging from a staircase at the bottom, and the townscape in the background showing in accurate topographical detail what the Piazza della Signoria looked like in the 1480s. It was not so much that Ghirlandaio neglected the religious subjects of his paintings. On the contrary, he studied the techniques which the great Florentine masters Masaccio and Giotto used to tell stories eloquently in visual form (reverence for those earlier painters, in fact, is one thing Michelangelo might well have picked up from Ghirlandaio).

High, serious drama, however, was just not Ghirlandaio's forte: his true talent was for portraiture, landscape and the details of everyday life. As a mature artist, on the other hand, Michelangelo produced almost no portraits – and those only of young men he considered beautiful – and reduced the landscape settings of his paintings to a bare minimum of treeless slopes and distant mountains, putting the emphasis as far as possible on the human figure, preferably nude.

Consciously or unconsciously, the adolescent Michelangelo was bound to resist the influence of this forceful but conflicting artistic personality. In the most crucial matters – his genius, the power and individuality of his art: the very qualities that made him so admired – Michelangelo actually did owe very little to his first master.

As an adult, Michelangelo considered himself above all a sculptor, and Ghirlandaio's workshop – unlike some comparable Florentine studios, such as those headed by Verrocchio and Antonio del Pollaiuolo, which made work in two and three dimensions – produced no sculpture at all. Michelangelo had found himself a master who was not only the wrong type of artist but specialized in the wrong medium.

*

In 1487 Ghirlandaio was a man in vigorous middle age, around thirty-eight or thirty-nine years old. Ghirlandaio's father, Tommaso Bigordi, was a leather-worker, a dealer in silk in a small way and also a maker of hair ornaments, or *grillandaio*. Later, he was believed to

have invented this fashionable type of garland, hence the nickname by which his son became famous: *Grillandaio*, or Ghirlandaio. The Bigordi family was comparable in wealth to the Buonarroti, but lower in social status. They had not been eligible for civic offices, as the Buonarroti were. That, however, shifted within a generation. Ghirlandaio's son was a member of the political class.

That Ghirlandaio's family rapidly rose in wealth, fame and social prominence was due to his abilities as a painter. In this respect, he certainly had a lesson for the young Michelangelo. We can still see Ghirlandaio – handsome, confident, pleased with his looks – gazing out from several of his paintings, including the altarpiece for the *Innocenti* for which Michelangelo collected one of the payments. In that year, he was embarking on an even more ambitious project than the Sassetti Chapel.

In September 1485 he and his brother Davide had signed a contract with a patrician financier named Giovanni Tornabuoni to paint the main chapel of Santa Maria Novella: the most prominent space in one of the most important churches in Florence. In October 1486 the scope of this scheme was extended when Tornabuoni and his family gained patronage rights over the entire chapel, including the altar. It was a huge job – the most ambitious fresco ensemble painted in late-fifteenth-century Florence. It is not hard to see why Ghirlandaio would have been interested in taking on extra assistants, such as the promising twelve-year-old Michelangelo Buonarroti.

It's very likely that in his mid-teens Michelangelo would have helped in the Tornabuoni Chapel, preparing the plaster surface, grinding the pigments, mixing them, holding colour ready for the moment the master required it, perhaps even painting some of the decorative framework and less important background areas. The prominent parts of the picture, particularly the faces and hands of figures, were reserved for Ghirlandaio himself and for his brother.

*

It is obvious from his own later drawings that Michelangelo spent time copying studies and sketches by Ghirlandaio. That was a staple part of an apprentice's training. However, Vasari described an

incident in which Michelangelo took the role of the master upon himself:

> It happened that one of the young men studying with Domenico copied in ink some draped figures of women from Domenico's own work. Michelangelo took what he had drawn and, using a thicker pen, he went over the contours of one of the figures and brought it to perfection; and it is marvellous to see the difference between the two styles and the superior skill and judgement of a young man so spirited and confident that he had the courage to correct what his teacher had done.

Vasari owned this very drawing, which he had been given by Granacci. Perhaps Granacci himself was the other apprentice, whose effort was corrected in this way; possibly, it was another youth in the workshop, such as the not particularly talented Giuliano Bugiardini. Either way, the story is a confirmation that Vasari was in direct contact with Granacci, which means in turn that he had an excellent source for Michelangelo's early days. In the case of this drawing, he diligently checked with the great man himself, showing it to him in Rome in 1550. Michelangelo recognized it, and was 'delighted' to see it again. 'He said modestly that as a boy he had known how to draw better than he did now as an old man.'

That modesty was, of course, double-edged. The elderly Michelangelo underlined the precocious brilliance of his youthful self. He must indeed have had an extraordinarily powerful talent at fourteen or fifteen; drawings survive from a few years later which show incisive forcefulness of line. However, while Vasari was retrospectively impressed by the young Michelangelo's 'spirit' and 'confidence', possibly Ghirlandaio – if he heard of the incident – wasn't so gratified.

*

From quite early on, Michelangelo began – in the phrase used by the Renaissance scholar Leonard Barkan – to lead his 'life on paper'. Drawing even took precedence over stone-carving; it was how he thought: playing around with ideas, brain-storming, searching for fresh solutions to a problem. This was a novel way of working, one that was followed by other artists in his generation but had originated only just before. The first artist thoroughly to exploit these new possibilities

Study after Giotto's *Ascension of St John the Evangelist*, after 1490.

was Leonardo da Vinci, born in 1452, but Domenico Ghirlandaio, three or four years older than Leonardo, was not far behind him.

A plentiful supply of paper – just as much as the study of ancient sculpture or single-point perspective – was among the factors that led to what we call the Renaissance. It allowed artists to think and work in different ways, a transformation as significant as the Internet and computer technology have been in the early twenty-first century. Not, of course, that paper itself was a new material in the fifteenth century. On the contrary, it had first been made in China a millennium and a half previously; but the recent availability of paper was a knock-on effect of another innovation: the invention of moveable type by Johann Gutenberg of Mainz.

By 1450 Gutenberg had set up a commercial printing press, and by the 1460s presses began to be established in Italy. As soon as that happened, there was a greater demand for paper, so more paper mills were built. The main alternative for drawing had been vellum – scraped and burnished calf-, sheep- or goat-skin – which was luxurious and labour intensive to prepare. The price list of a Florentine stationer's from the 1470s lists vellum as fourteen times more expensive than paper.

Paper, however, was still quite a costly material. That was why artists often used both sides of a sheet; it was too valuable to waste. So, after Ghirlandaio had used a piece of paper to work out the composition of *The Visitation*, one of the frescoes for the Tornabuoni Chapel, in a flurry of rapid pen strokes – establishing the positions of the figures, jotting down the background architecture – the paper was then turned over and used as a cartoon for a piece of classical moulding framing the scenes. A series of holes was then pricked through, following the lines of the egg and dart and palmette motifs, and charcoal or black chalk dust forced through them to transfer the lines to the wall.

Always acutely cost-conscious, Michelangelo was an especially assiduous recycler of used paper, sometimes searching through the litter in his studio for a useable scrap and coming up with a sheet he had drawn on years before but which still retained some blank space. As a result, Michelangelo's drawings, even more than those of, say, Leonardo, are palimpsests on which one may find jostling each other sketches and studies for various projects side by side with drafts of poems, stray remarks or quotations that seem to have drifted through

his mind, lists of expenses and other items that are apparently not by Michelangelo at all.

His correction of another apprentice's attempt to copy those draped figures by Ghirlandaio was the beginning of a lifelong habit. Michelangelo loved to teach young men to draw. This, to a Florentine, was the master skill from which all other visual arts flowed. To draw a thing properly was to comprehend its structure. If you could draw forms, above all those that made up the human body, you could also invent them. So if you could truly draw, you could not only paint but also, in principle at least, sculpt and design architecture.

A considerable amount of Michelangelo's domestic life in later years seems to have revolved around talking about drawing and teaching drawing. A sheet with studies of the *Madonna and Child* and a jotted memorandum of payment[5] to a marble contractor cutting the stone at San Lorenzo also bears an insistent injunction to his assistant Antonio Mini: '*Disegnia Antonio disegnia Antonio disegnia e non perdere tempo*' ('Draw Antonio draw Antonio draw and don't waste time'). A succession of letters to and from the dissolute Pietro Urbano, his assistant in the second half of the 1510s and the beginning of the 1520s (until things went badly wrong), circled around the same point: 'Work hard and don't on any account neglect your drawing,' Michelangelo wrote to Pietro when the latter was staying in Florence with the Buonarroti family, 'make the most of your opportunities . . .'. He also instructed his brother Buonarroto to keep on the case: 'Tell Pietro to try to apply himself.'

At times, Michelangelo set his juniors to copying – and not only those he employed, but also young men and adolescents he happened to like. One of the latter was a young man called Andrea Quaratesi, a member of a wealthy Florentine family whom Michelangelo befriended, apparently gave drawing lessons to and for whom, eventually – rarest of compliments – he made a portrait drawing of himself. A sheet of sketches in the Ashmolean, Oxford, has on it three profile heads, eleven hanks of hair and sixteen eyes, which suggest some sort of exercise carried out by – perhaps – Antonio Mini,

5 Dated 24 October 1524, although the other items on the same page might be later.

Quaratesi and other youths. Several of the efforts are more at GCSE art level than the products of transcendent genius, but this pedagogy shifted to doodling, cartoonish jokes and dreamy reverie.

On the other side of the sheet with the sixteen eyes are some more inept profile heads. Over these Michelangelo has superimposed a magnificent monster, with the hind legs and claws of a wolf and a neck so long that it has looped around itself in a knot, from which protrudes a snarling head. The practice profiles can still be seen through its slithering body.

Michelangelo and pupils, *Dragon* and other sketches, c. 1525.

Here is an example of Michelangelo's bizarre, extraordinary imagination – his *fantasia* – in free play, not harnessed to any task: flipping lines and images, one shape suggesting another. The result is a sinister, surreal masterpiece. Did he doodle this monster to entertain the youngsters around the table in his workshop, or just for himself?

*

Another development from Northern Europe, parallel with the appearance of books printed with moveable type, was the engraving. Engraving as a fine art was developed in the area around the river Rhine in the 1460s, by artists such as the anonymous Master ES, and Martin Schongauer (c. 1448–91) of Colmar. The innovation was quickly picked up by the more alert and adventurous artists in Italy.

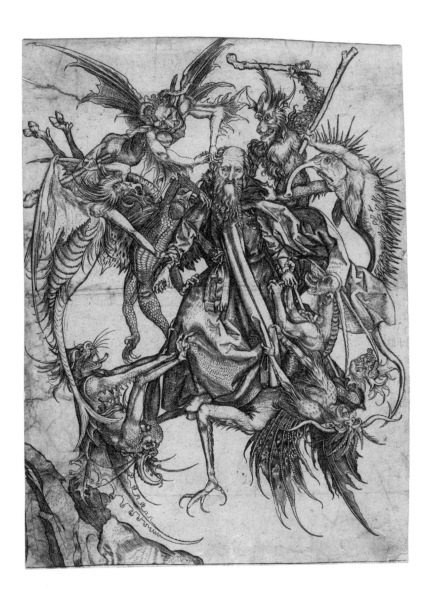

Martin Schongauer, *The Temptation
of St Anthony*, c. 1470.

Antonio del Pollaiuolo, one of the leading sculptors and painters in Florence, made a large and beautiful engraving, *The Battle of the Nudes*, which would be of great interest to the young Michelangelo. Francesco Rosselli, brother of the painter Cosimo and uncle of Michelangelo's friend Pietro Rosselli, travelled north to discover the art of engraving with a burin (a notched tool that allows for finesse in carving lines of different weight), and grew rich through having this unusual skill.

Domenico Ghirlandaio, though he made no engravings himself, evidently looked at them hard. His drawing technique depended on cross-hatching, which he borrowed from the engravings of Master ES and Martin Schongauer. It is an excellent way to give volume to an image made out of black lines and became the basis of Ghirlandaio's work in pen and ink (and, in turn, that of his pupils).

That, no doubt, was why, according to Vasari, Michelangelo did a 'perfect pen-and-ink copy' of one of Schongauer's masterpieces, *The Temptation of St Anthony*. Condivi says that it was Granacci who 'put this before him'. If so, it was presumably because Granacci was the senior apprentice and gave training tasks to more junior members of the workshop. Although Condivi glosses over the point, the print itself – a rare piece of cutting-edge, imported art – would have belonged to Ghirlandaio, not Granacci (or his mattress-making father). Copying such a work would have been a logical step in picking up the workshop drawing method.

What Michelangelo apparently did next was not. He decided, apparently off his own bat, to translate the engraving into another medium: a painting. This, Condivi says, he did as 'he now wished to try to make use of colour', suggesting this was an educational exercise. There is also about it a touch of what the Renaissance relished as the *paragone* – or comparison – an intellectual game in which the arts were pitted against one another. A frequent subject for debate, for example, was: 'Which could best and most fully convey a subject, sculpture or painting?'

Schongauer's *St Anthony* was a powerful example of a new medium which some people were probably already hanging on their walls as an affordable substitute for a picture. The thirteen- or fourteen-year-old

Michelangelo was therefore doing something shrewd and timely by transposing it into colour. It was also a bizarre phantasmagoria of an image which it is easy to imagine appealing to a teenager. In modern terms, as the art historian Keith Christiansen has put it, this is a *Star Wars* picture.

According to Condivi, whose only source could have been the artist himself, Michelangelo paid particular attention to precisely what would be most difficult to convey in black and line: naturalistic texture. He painted nothing without having first studied it again from nature. 'Thus he went along to a fish market, where he studied the shape and colour of the fishes' fins, the colour of their eyes and other parts, in order to reproduce them in his painting.'

Michelangelo's little painting was long presumed to have been lost, but within the last decade a panel of the correct subject has been claimed as the original and bought by the Kimbell Museum, Fort Worth, Texas (reproduced overleaf). A number of renowned Michelangelo experts do not accept the painting, and one can see their point. The schematic landscape, for example, looks nothing like any later Michelangelo painting. However, if one does accept that this is in fact the picture he made in his early teens, then it has an intriguing story to tell.

Technical examination at the Metropolitan Museum, New York, and later at the Kimbell has revealed that this painting is the product of intense and laborious effort. It is indeed true that the artist has added such touches as the shining fish scales on the body of the tube-nosed demon on the left and flames coming out of the mouth of the devil on the lower right to the original composition. But also, under close scrutiny, it can be seen how the lines have been adjusted and readjusted so as to give the image maximum clarity and impact.

An example is the tail of the fish-scaled monster, which waves downward in Schongauer's original. By introducing a mound of grass and rock, the painter gave himself a problem. The tail had to be moved, otherwise it would blend unsatisfactorily into the rock. So he gave it an extra twist, but also created a miniature arabesque between it and the spines on the heads of the two lower demons, all curving towards one another and almost but not quite touching, so this tiny corner of

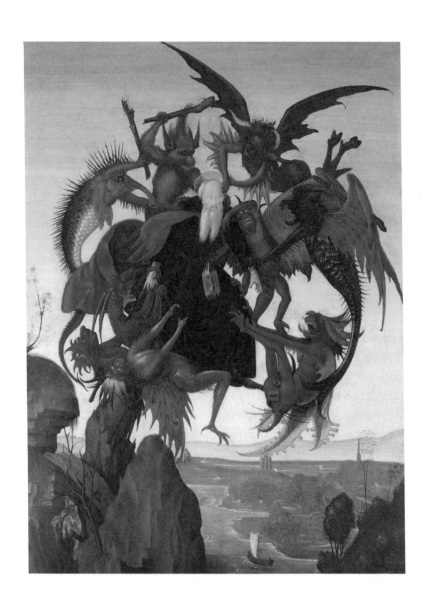

Michelangelo (?), *The Temptation of St Anthony*, c. 1487–8.

the picture crackles with visual energy. Whoever painted this has tried immensely hard not just to imitate Schongauer's engraving in paint but to outdo Schongauer, to make something better than the original.

If we believe that the painter was Michelangelo,[6] then we have a direct view of the set of gifts and qualities with which he began his life as an artist: a fastidious sense of line and form, a willingness to work ferociously hard to produce as sharply telling an image as possible and an overpowering urge to compete.

<p style="text-align:center">*</p>

Another story in Condivi reveals a pushy desire to rival, and fool, the master himself: 'He had been given a head, which was for him to draw, and he reproduced it so exactly that, when the owner was given the copy instead of the original, he did not recognize the deception until it was revealed to him after the boy had confronted one of his companions with it, and told him all about it.'

Who could have been the 'owner' in this case? The natural context in which an apprentice would be given a drawing to copy was in the workshop, and it would normally have been a sheet from the studio's image bank – probably drawn originally by the master himself, Domenico Ghirlandaio. The story is told in this roundabout way, presumably, to avoid admitting that Michelangelo had ever been in this humiliating position of apprenticeship – but it doesn't disguise a lingering sense of triumph, over sixty years later, at a successful trick.

The teenager not only copied the drawing perfectly, he did something you might call thoroughly adolescent, an action somewhere between a practical joke and forgery. 'Many people' wanted to compare the two drawings, and found no difference between them: 'This was because as well as the perfection of the drawing, Michelangelo had used smoke to make it appear the same age as the original. This brought him much reputation.' It may not, however, have endeared him to Ghirlandaio.

6 Technical examination shows it was made by someone close to the Ghirlandaio workshop. The only realistic alternative to Michelangelo would be another Ghirlandaio pupil, such as Granacci.

MEDICI

'No one, even among his adversaries and those who
maligned him, denies that there was in him
[Lorenzo] very great and extraordinary genius.'

– Francesco Guicciardini on Lorenzo de' Medici

'The beginning of love springs from the
eyes and from beauty.'

– Lorenzo de' Medici, *Comento*

On Sunday 26 April 1478, at the most solemn moment of High Mass in the Duomo, the conspirators struck. With the exclamation, 'Here, traitor!' a man named Bernardo Bandini Baroncelli suddenly thrust at Giuliano de' Medici, younger brother of Lorenzo, with a dagger. Another attacker, Francesco de' Pazzi, then closed in, striking him again and again. Giuliano's corpse was punctured by more than a dozen wounds. At the same moment, two priests made a move against Lorenzo himself, but he escaped first to the choir, then to the sacristy. Meanwhile, a seventeen-year-old cardinal, Raffaele Riario, cowered, praying desperately, near the altar.

This was the climax of the Pazzi conspiracy, an intrigue involving the Florentine clan of bankers and merchants of that name and also the King of Naples, Pope Sixtus IV and the Pope's nephew, Girolamo Riario (cousin of the cowering cardinal). It was the second attempted putsch in twelve years, and came within a whisker of succeeding in breaking the Medicis' stranglehold on the city.

Instead, it failed and the Pazzi and their co-conspirators paid a terrible price. Jacopo de' Pazzi, head of the family, was captured the

(facing page)
Domenico
Ghirlandaio,
Confirmation
of the Franciscan
Rule, 1479–85.
Detail of the
group to the
right of the
scene; Lorenzo
de' Medici is in
the centre.

Leonardo da Vinci, *Sketch of Hanged Man*, 1479;
Bernardo di Bandino Baroncelli
hanging from a window of the Bargello.

next day in a little hill village, beaten savagely and forced to sign a confession. At about seven o'clock on the evening of 28 April 1478 he and Renato de' Pazzi, another member of the family, were hanged from windows of the Palazzo della Signoria. Eighty-five years later Michelangelo remembered being carried on someone's shoulders, presumably those of his father Lodovico or uncle Francesco, to see this execution.

This was an apt introduction to the politics of his native city. Florentine society was endemically riven by rival factions, families and groupings. These were divided sometimes by principle but just as often and as bitterly by straightforward grudges. The 'chief cause that led the Pazzi to conspire', in the opinion of Niccolò Machiavelli, the Florentine politician and political thinker (1469–1527) was that they were deprived of a certain inheritance by order of the Medici. And Machiavelli, six years older than Michelangelo, was an acute observer of politics in the days of Lorenzo the Magnificent. The Pazzi conspiracy was a warning. Lorenzo survived as the effective ruler of the city by political skill, caution, constant vigilance and luck. But his position was never quite secure.

*

Lorenzo de' Medici (1449–92) has become emblematic of the period in which he lived. He appears in retrospect as the embodiment of the ideal Renaissance man. This seems true even in the loose modern sense of someone who does all manner of things and does them well. Not the smallest enigma about Lorenzo was how he fitted his enthusiasms and responsibilities into one existence: banker, dictator, poet, godfather of something approaching a mafia 'family', musician, diplomat, serial adulterer, avid book collector, philosopher, marriage-broker, patron of architecture, embezzler, arbiter of artistic taste for many of the courts of Italy, political fixer. Lorenzo must have been hard put to find enough hours in the day. His collected correspondence already runs to sixteen volumes, and the series is not yet complete.

It is no surprise that among the many pieces of advice he offered his middle son, Giovanni, on how to conduct himself as a senior ecclesiastic was to rise early in the morning: 'This will not only contribute

to your health, but will enable you to arrange and expedite the business of the day.' No doubt that was Lorenzo's own habit, and one adopted by another young man, nearly the same age as Giovanni de' Medici, who spent time in his household: Michelangelo Buonarroti, another frenetically driven pursuer of many occupations – poet, architect, sculptor, painter, military engineer – who slept little, and worked, we are told by Condivi, through the hours of the night.

Michelangelo probably first came face to face with Lorenzo de' Medici when he was around fifteen years old, most likely in the April of 1490.[1] The man Michelangelo saw was forty-one years old, with long dark hair and a look of coarse vigour about him. His appearance was fashionable in the aristocratic milieu of the 1480s and '90s: British monarchs who affected the same look included Richard III. Niccolò Valori, a friend of Lorenzo's who knew him well, described him as 'above the average height . . . broad in the shoulders and robustly built, muscular, remarkably agile and olive-complexioned'. He had a flat nose and a harsh voice. 'Yet his face, though nothing handsome, had great dignity.'

In the fresco by Ghirlandaio in the Sassetti Chapel of Santa Trinita Lorenzo is flanked by confederates and allies: Francesco Sassetti and his young son stand to one side, Sassetti's brother-in-law at the other. They are Medici men, honoured by Lorenzo's presence. Ghirlandaio subtly conveys Lorenzo's pre-eminence in the group, and in Florence itself, the main square and seat of government of which appear in the background.

What the fresco does not show are the armed bodyguards who ever since the Pazzi conspiracy of 1478 had accompanied Lorenzo as he moved around. The detail was made up of crossbow men with nicknames such as Garlic Saver (Salvalaglio), Black Martin (Martino Nero) and Crooked Andrea (Andrea Malfatto). Just like a modern

1 Early 1490 fits the chronology given by Condivi, but there was a narrow window of opportunity that spring, because of Lorenzo's limited mobility. In March of that year he had a particularly severe attack of the chronic arthritic complaint from which he suffered, causing one of his feet to swell hugely and making it impossible for him to walk. Presumably to recuperate, he left Florence to visit the thermal baths of San Filippo in southern Tuscany on 26 April. Thus, early to mid-April is the most likely point.

politician or boss of organized crime – both types to which he could be compared – Lorenzo needed constant security.

Like his father, Piero, and grandfather Cosimo before him, Lorenzo had no formal position as Duke or Prince. He was known by a rather imprecise honorific title given to many important individuals, but which stuck particularly to Lorenzo, no doubt because it fitted him so well: Il Magnifico, the Magnificent.

Legally, Florence remained what it had been for centuries: a republic governed by a complicated constitution whereby power revolved among members of the wealthier section of the male population. Officially, the most powerful posts in the administration were chosen by a carefully controlled process, designed specifically to prevent any one faction or family seizing control. Names of those eligible were placed in a bag and then pulled out at random.

However, rather as the Great Gatsby in F. Scott Fitzgerald's novel found a way to fix the baseball World Series, the Medici had developed strategies for fixing the Florentine constitution. Among others, they selected the officials – *accoppiatori* – who chose the names that went into those bags. Consequently, the levers of government were generally pulled by men who took their orders, privately, from the Medici. In 1490 the Medici regime had survived, despite intermittent attempted coups, for almost sixty years.

Whether Lorenzo was a towering figure in the annals of culture or merely flawed, venal and vicious is a difficult question to answer. He was, even for close contemporaries, a hard man to sum up or pin down. Niccolò Machiavelli made the most memorable of all remarks about him, namely that in observing Lorenzo you saw two different people, 'more or less made one by an impossible fusion'. This seems correct, except that more than two personalities, perhaps, were combined in Lorenzo.

Hero or villain, wise or rash, pious or libertine, intellectual giant or a bit of a fake, more a creation of image-making than of real substance – opinion remains divided. As the historian Lauro Martines put it, he was 'a vastly complex, slippery and contradictory man'. What few ever questioned was Lorenzo's great ability. The Florentine historian and politician Guicciardini (1483–1540) noted that 'No one,

even among his adversaries and those who maligned him, denies that there was in him a very great and extraordinary genius.'

In the opinion of those who hated Lorenzo, of whom there were plenty in Florence, even his talents were the source of tyranny. One of his most vehement, though prudently secret opponents, was Alamanno Rinuccini – a member of an ancient family who, like the Pazzi, greatly resented the assumption of power and privilege by the upstart Medici. He believed, 'Being inspired by the magnitude of his ability,' Lorenzo 'resolved to render to himself all public dignity, power and authority.' Guicciardini agreed that Lorenzo 'desired glory and excellence beyond that of anyone else, and in this he can be criticized for having had too much ambition even in minor things; he did not wish to be equalled or imitated by any other citizen even in verses or games or exercises, turning angrily against any who did so'.

His temper was probably affected by pain. In the spring of 1490 Lorenzo's energies – literary, political, musical and erotic – showed no signs of flagging, but his health did. He suffered from a chronic condition that his contemporaries vaguely named as 'gout'. It killed his grandfather Cosimo in his seventies; his father, Piero, in his early fifties. It may, medical researchers suggest, have been a form of rheumatoid arthritis called ankylosing spondylitis. Whatever it was, it was killing Lorenzo de' Medici.

*

The day that Michelangelo walked into Lorenzo's sculpture garden at San Marco changed his life, and hence the course of Western art. This was just one of several locations at which the extensive Medici collections of art were kept. Lorenzo owned over 40 classical sculptures, plus architectural fragments, 5,527 coins, 63 vases made from hardstones (such as rock crystal, lapis lazuli, agate, onyx, jasper, serpentine or carnelian; making inlays out of these was later a Florentine speciality), 127 gems, and in addition all manner of other works, including what we would now call contemporary art, that is, paintings by such artists as Pollaiuolo and Uccello, and sculptures by Donatello, Verrocchio and Lorenzo's own in-house sculptural expert, Bertoldo di Giovanni.

The finest of these were mainly on display in the Palazzo Medici

on Via Larga. An inventory made after Lorenzo's death has enabled scholars to work out a considerable amount about what went where. Two ancient sculptures of the flayed Marsyas flanked the door leading out of the garden into Via dei Ginori, a head of the Emperor Hadrian presided over the door from the courtyard into the garden, and other large pieces were disposed about the exterior spaces, with more delicate works indoors.

It was a fashion of the time to display classical antiquities in gardens and courtyards. At San Marco it seems likely that they were the less intact, more beaten up or less restored items: the equivalent of a study collection. This was the place where Michelangelo and Granacci fetched up one day. What seems to have happened is that Lorenzo asked Ghirlandaio if he could recommend any promising apprentices to be trained as sculptors, and Ghirlandaio had proposed Michelangelo and Granacci.

The reason why Lorenzo took an interest in the training of young artists was connected, like most things he did, with the maintenance of his own prestige. One of the ways he exercised influence – what in the twenty-first century is called 'soft power' – was through cultural eminence. Florentine artists, especially sculptors, were renowned throughout Italy. Rulers and the mighty – what contemporaries called 'gran' maestri' – sometimes turned to Lorenzo for advice when they were planning an important artistic project.

From Lorenzo's point of view, this was a useful service to offer. It emphasized the status of his city, Florence, as a cultural capital and stored up favours with important people. There is an example of his doing precisely this from May 1490, just after the teenage Michelangelo probably entered his orbit. Lorenzo had recommended a Florentine painter, Filippino Lippi, to Cardinal Carafa, a wealthy clergyman from a prominent southern Italian family. Lorenzo asked Nofri Tornabuoni, the agent running the Roman branch of the Medici bank, to check that Lippi was doing a satisfactory job on the cardinal's frescoes. Tornabuoni replied that he was confident Lippi 'will do what he promised me and work diligently and economically in such a way that I am sure the Cardinal will remain obliged to you and content with him'.

By this stage, Medici bank branch managers were expected to manage many things apart from money – to advise on the purchase of

classical statues, for one thing. In fact, the one task that was not being done efficiently was banking, for which Lorenzo had little time or talent. He was in the process of transferring the family's fortune, built up through wool-trading, money-lending and astute exploitation of exchange rates, into less tangible capital in the form, for example, of a cardinal's hat for his second son, Giovanni (who was a few months younger than Michelangelo).

There were still outstanding Florentine painters for Lorenzo to recommend, such as Lippi, but by the end of the 1480s he had run out of first-class sculptors. The greatest of the late fifteenth century, Andrea Verrocchio (c. 1435–88), had died in Venice, and Antonio del Pollaiuolo (1431/2–98) was in Rome executing the tomb of Pope Sixtus IV, probably at Lorenzo's suggestion. The consequence was that in 1489, when the Duke of Milan had asked him to propose someone to make a grand tomb, Lorenzo could not come up with a suitable artist. He had turned the project over in his mind, 'and the result is that I do not find a master who satisfies me'.

This background makes it perfectly plausible that he might have asked Ghirlandaio to send along some promising lads to be trained in this vital art. The request was probably not welcome to Ghirlandaio, who was working flat out on the frescoes in Santa Maria Novella (and was obliged, uncharacteristically, to postpone the completion date), but it was not one he could refuse. So Michelangelo and Granacci duly turned up at the sculpture garden.

That day, according to Vasari – perhaps depending on Granacci's recollections – they found a young sculptor named Pietro Torrigiano (1472–1528) at work 'on some clay figures in the round that Bertoldo had given him to do'. It is not explained whether this was a training exercise or a piece of sculpture Torrigiano had been allocated. Indeed, it is not clear whether the young artists were sent to the garden to learn from copying the ancient carvings there or to work on Medici commissions. The answer is probably a bit of both.

Bertoldo di Giovanni (d. 1491) was a long-standing member of Lorenzo's household and a pupil of the great sculptor Donatello. He was employed on various Medici schemes, such as a terracotta frieze over the portico of the villa at Poggio a Caiano. There is evidence that

Bertoldo had a small sculptural workshop, with at least one apprentice who is mentioned in a document, but, like his master, Bertoldo moved fluidly from one role to another. He also seems to have functioned as an informal custodian of the sculpture collection, an advisor on new purchases and a courtier-companion.

A strange letter survives from him to Lorenzo, made up largely of incomprehensible jokes about cooking, spicy stews and grilled song-birds, which may in reality have been all about sex. Whether or not this Rabelaisian rigmarole really consists, as one authority proposes, of the 'homoerotic double-talk so ubiquitous in Quattrocento Tuscany', it certainly shows that Bertoldo was on relaxed, joshing terms with the ruler of Florence. It also contains an erudite classical reference.

Almost archaeologically accurate classicism was the basis of Bertoldo's art, such as it was. The surviving examples suggest that he was not hugely gifted, but did have a better grasp of ancient Roman styles than most artists then working in sculpture. His forte was small bronze statuettes and reliefs: miniature things greatly appealed to Lorenzo, who was extremely short-sighted (a trait inherited by his son Giovanni).

Bertoldo would have been an excellent person to instruct young artists and encourage them in a more accurately classical style – which seems to have been one of Lorenzo's cultural ambitions. He wanted Florence rebuilt as a classical city. Indeed, his architectural ideas fore-shadow the High Renaissance classicism we associate with the Rome of Julius II and Leo X.

*

Whatever those 'clay figures in the round' were, they seem to have immediately fired Michelangelo's competitive spirit. Seeing Torrigiano at work on these, Vasari wrote, 'Michelangelo set out to rival him and made some himself; and Lorenzo took note of this high spirit and began to have high hopes for him.'

Pietro Torrigiano, as it transpired, was not so pleased by this display of youthful aspiration. He was three years older than Michelangelo, similarly ambitious, and also from a family that thought highly of itself. The Torrigiani were an old-established Florentine clan, not members of the true elite but ranking higher than the Buonarroti. And Pietro

Torrigiano was more than Michelangelo's equal in swaggering confidence. Benvenuto Cellini, who encountered him in middle age, described his as 'extraordinarily handsome', 'very hot-tempered' and altogether 'more like a great soldier than a sculptor, especially because of his powerful gestures and resounding voice and the habit he had of frowning in a way that would frighten the life out of even the bravest'.

Vasari, probably repeating Granacci's memories, described him as a fifteenth-century Florentine version of Flashman, the school bully. 'Not being able to endure that any one should surpass him, he would set himself to spoil with his hands such of the works of others as showed an excellence that he could not achieve with his brain; and if these others resented this, he often had recourse to something stronger than words.'

Michelangelo set out to rival the older youth, who bitterly resented this upstart, opinionated competitor. Eventually, there was violence one day in the Brancacci Chapel; Torrigiano struck Michelangelo a powerful blow in the face, knocking him unconscious. Not surprisingly, Michelangelo's opinion of Torrigiano was terse: 'an arrogant bestial man'. Benvenuto Cellini heard Torrigiano's side of the story one day in 1518, a quarter of a century or so after the fight had happened, during a period when Torrigiano had returned briefly to Florence from London, where he was working 'among those brutes of Englishmen':

> This Buonarroti and I used to go along together when we were boys to study in Masaccio's Chapel in the Church of the Carmine. Buonarroti had the habit of making fun of anybody else who was drawing there, and one day he provoked me so much that I lost my temper more than usual, and, clenching my fist, gave him such a punch on the nose that I felt the bone and cartilage crush like a biscuit. So that fellow will carry my signature until he dies.

It sounds as if the trigger for Torrigiano's assault was some mocking criticism that Michelangelo had made about his drawing. There are plenty of occasions in later life when Michelangelo was apparently stinging, sarcastic, dismissive and downright insulting to fellow artists. Torrigiano certainly comes across as dislikeable in Cellini's description, with his obvious satisfaction that he had signed young Michelangelo like a living sculpture. Yet it is possible to imagine that Torrigiano was

Study probably after Masaccio, after 1490.

provoked; that, indeed, if you were not a dedicated friend and admirer, Michelangelo could be thoroughly annoying.

This encounter disfigured him and, the evidence suggests, cemented his sense of dissatisfaction with his own looks. The lengthy description of his appearance in Condivi's Life, surely included with the artist's approval, is mainly a catalogue of faults. True, on the positive side, he is of medium height, slender and broad-shouldered, but his face is too small for his head, which, moreover, is of an odd shape, with his temples sticking out over his ears, his ears more than his cheekbones and those 'more than the rest'.

His eyes, the 'colour of horn, but changeable and flecked with tiny sparks of yellow and blue', were too small, his eyebrows sparse and his lips thin. There was nothing the matter with his chin, but his profile was ruined by the fact that his forehead protruded more than his nose, which was 'almost completely flattened save for a little bump in the middle'. Evidently, Torrigiano had given the *coup de grâce* to his appearance, at least in Michelangelo's own opinion. This supreme connoisseur of male beauty evidently believed that he himself was just off ugly.

*

For all we know, that day in the sculpture garden was the first time Michelangelo had made a work in three dimensions – though that is a little hard to believe since he seems to have started confidently to rival an older apprentice. At any rate, he managed to draw a veil over whatever training in sculpture he may have had before and after he entered the garden. Presumably, Bertoldo was able to instruct him in all sculptural techniques, though he himself was more of a specialist in clay-modelling than stone-carving. It is quite possible that, before or simultaneously, Michelangelo was taught by someone else. Benedetto da Maiano (1442–97), the best sculptor in stone then remaining in Florence, is one plausible master who has been proposed. As it happened, he was working on a project supported by Lorenzo at just this time – monuments to Giotto and the musician Antonio Squarcialupi for the Duomo. But Michelangelo did not want us to know how he learned to sculpt and, whatever the truth of the matter, he succeeded in suppressing it. The impression he wanted to pass down

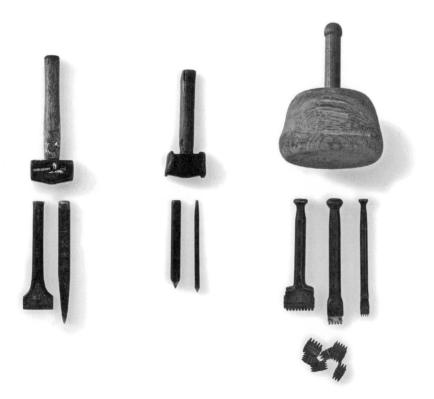

Sculptor's tools.

was that he just picked up the art of sculpture through sheer brilliance and inherent understanding of design; conceivably, that might even be correct.

The carving of stone is one of the most ancient of human artistic activities. Miniature sculptures of people and animals have been found from the time of the last Ice Age, tens of thousands of years ago. Beautiful small-scale objects and figures were being made from marble on the Cycladic Islands in the Aegean around 3000 BC, and in granite and other hard materials by the Egyptians from a similar date. Michelangelo was thus working in a tradition that came down from prehistory, via the Greek sculptors of the Archaic and Classical ages, over two thousand years before.

In many ways the process had scarcely changed. Most of the tools Michelangelo used were known to the ancient Greeks and Egyptians. It was basically a matter of taking away more and more stone until the finished work was finally revealed. This procedure was defined by Michelangelo himself in 1547 (when he was seventy-two) with a precision worthy itself of an inscription in marble: 'By sculpture I mean that which is done by subtracting [*per forza di levare*]: that which is done by adding [*per via di porre*] resembles painting.' This epigrammatic manifesto made clear that, for him, true sculpture was carving, not modelling in clay or wax (which was the preliminary to making work in bronze or terracotta).

The process of subtraction went in stages of progressive refinement, for which implements of diminishing coarseness were used. First a punch and coarse chisels, then a succession of finer ones, including claw-chisels with serrated edges, again in a variety of grades, to produce a smoother and smoother effect. There were also drills to make deep holes, such as those required for locks of hair, folds of cloth, eyes and ears.

In his later work, Michelangelo made great use of the claw-chisels, which, when a sculpture was not completely finished, gave an effect like the hatching of a pen, as if he had been drawing the form in three dimensions. The finer chisels went closer and closer on the figure's skin. The final stage, however, was of polishing, with pumice and emery, which when carried on for long enough produced a surface of

glassy smoothness which can be seen in some of Michelangelo's completed works.

The only eyewitness account of Michelangelo at work dates from late in his life, but it gives a sense of the headlong virtuosity that he must have achieved early on. The description is by Blaisede Vigenère, a French diplomat who was in Rome in 1549/50 and therefore saw Michelangelo working at the age of seventy-five.

Nonetheless, apparently he could 'knock off more chips of a very hard marble in a quarter of an hour than three young stone-carvers could have done in three or four, an almost incredible thing to one who has not seen it'. De Vigenère was amazed at the 'impetuosity and fury' with which Michelangelo attacked the stone, and feared that the whole block might fall to pieces. Sometimes he thought that if the sculptor had gone even fractionally too far, the whole work would have been ruined.

This account is fascinating, but contradicts what Vasari wrote on the subject, very probably reflecting Michelangelo's words. Those artists who are in too great a hurry and rashly hack away, he warned, leave themselves with no room for later adjustment. Many errors resulted from such impatience. Can these two statements be reconciled? Perhaps they can.

De Vigenère, evidently no expert on sculpture, probably watched the preliminary blocking out of one of Michelangelo's late *Pietàs*. If pieces of stone 'three or four fingers' wide were coming off, Michelangelo could scarcely have been using his more delicate chisels. With long experience, it may well have been possible for him to work with great speed at this point. The carving of stone is not a matter, as one might imagine before one has tried it, of bashing away with brute strength. It is a question of balance and rhythm, using the weight of the mallet to swing against the tool.

Just as an expert chef uses more than one sense when cooking – listening to the sizzle of the frying, smelling the odour coming off the food – so a skilled stone-worker would be alert to a change of note or resistance from the block suggesting a crack or flaw. Michelangelo would have known how far it was safe to go, and when it was necessary to slow down and change chisel.

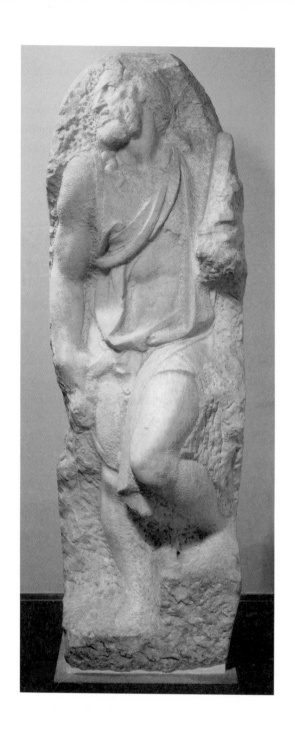

St Matthew, c. 1506.

As Vasari described it, watching the development of the sculpture was like seeing a figure lying in a basin of water gradually rising to the surface. This is what we can still see in an unfinished sculpture such as *St Matthew*, from around 1506. He seems to be struggling out of the marble slab; the parts of his body closest to us – his left leg and knee – are the most nearly finished. The deeper into the stone, the rougher and more inchoate Matthew appears, until he vanishes into the block.

There was a physical aspect to this, and an intellectual, almost mystical one. Michelangelo began one of his most celebrated sonnets by insisting that 'not even the best of artists has any conception/That a single marble block does not contain'. Of course, he knew what he was aiming at. Before he began carving, Michelangelo would have evolved a clear idea of the final work, from his imagination, then from studies on paper followed by small models in wax or clay, and maybe even a full-scale clay version. Still, however, he clearly had a sense of finding a figure that was already there, within the stone.

How much of this he already felt when he was fifteen or sixteen years old is impossible to know, but the evidence of his works suggests that his skill in working stone increased with great rapidity. And the Platonic notion that beautiful forms were somehow always in existence – on an elevated, spiritual plane or latent in a lump of rock – was in the intellectual air around him.

*

Some time after his arrival – whether days or months it is impossible to say – Michelangelo noticed an ancient head of an elderly faun, laughing and bearded, in the collection at the garden. This was worn and damaged, so the mouth was largely destroyed but, even so, Condivi wrote, 'it pleased him beyond measure.' Michelangelo then decided to do exactly what he had tried to do with Schongauer's *Temptation of St Anthony*: to imitate this work which fascinated him but at the same time try to improve on it.

There were some masons in the garden, dressing blocks of stone intended for a new building to house the Medici Library. This was one of many ambitious schemes under way that foundered because of Lorenzo's early death and the collapse of the Medici regime (the

library was eventually constructed to Michelangelo's own design decades later).

So the teenage Michelangelo begged a spare offcut of marble from the stone-cutters working on the library and also borrowed a set of tools from them. With these he set to work and copied the faun, Condivi claimed, 'with such attentiveness and zeal that within a few days he brought it to perfection, supplying from his imagination all that was lacking in the antique, namely the mouth open in the manner of a man laughing, so that one could see the inside with all the teeth'.

By and by, Lorenzo came along to inspect the building works. 'He found the boy who was busy polishing the faun's head; and drawing somewhat nearer to him, he first considered how excellent the work was, and having regard to the boy's age, he marvelled greatly.' But Lorenzo, a humorous man as well as an intellectual, couldn't resist teasing the boy. So he said, 'Oh, you have made this faun old yet left him all his teeth. Don't you know that in creatures of that age some are always missing?'

Lorenzo excelled at a style of poetic performance that required off-the-cuff witticisms to be exchanged with the audience on the spot – a genre of which Florentines were very fond. The little joke about the faun's teeth, though its humour has evaporated over the centuries, sounds authentic.

The teenage Michelangelo, however, did not find it funny. Condivi's narrative relayed a convincing memory of the agony of embarrassment suffered by this earnestly ambitious fifteen-year-old: 'It seemed an eternity to Michelangelo before the Magnifico went on his way, and he could correct his error.' Then, he got to work, taking a tooth out of the mouth of his sculpture, and making a hole in its gum to give the impression that it had come out by the root. Having performed this dentistry on the marble, the next day 'he waited for the Magnifico very eagerly.'

Lorenzo was amused by the lad's reaction but also on reflection impressed by the fact that he had attempted such a work at such a youthful age; so 'he determined to help and favour such genius, and to take him into his own house.' In other words, Michelangelo was to move from an artist's workshop to the unofficial court of Florence.

There is a slightly fairy-tale air to the episode of the faun's head, which does not mean it did not happen but might suggest it served as short-hand for a long process of talent-spotting. Lorenzo also seems to have seen some of Michelangelo's drawings; it is likely enough that, even before he arrived in the sculpture garden, Lorenzo had heard of this remarkably promising young talent.

Having decided to take Michelangelo into his household, Lorenzo asked him whose son he was. 'Go,' he said, 'and tell your father it would please me to talk with him.' When Michelangelo did so, Lodovico was filled with consternation, if not alarm, at being summoned by the powerful boss of the city. 'He lamented that his son was being taken away from him, all the time holding to this: that he would never suffer his son to be a stonemason.' It took a long time to talk Lodovico into going to see Lorenzo, with Granacci and others – perhaps Ghirlandaio – arguing with him. This audience at the Palazzo Medici was in fact a rare privilege; normally, Lorenzo was besieged by Florentine citizens wanting favours – a scrum of forty petitioners was described by one eyewitness – and often more than one visit was necessary to obtain a moment with the great man.

When Lodovico Buonarroti was finally dragged, protesting, to the interview, Lorenzo the Magnificent asked him what he did. Lodovico replied, with modest pride, that he was almost completely idle: 'I have never had any trade; but always till now I have lived on my tiny income, attending to those few possessions that have been left me by my ancestors.' Then the Magnifico offered to use his power of patronage to help Lodovico get any post he wanted: 'Make use of me, for I will do you the greatest possible favour that I can.' In the event, however, the job that Michelangelo's father requested was pitifully minor: a sinecure in the customs office, which paid a small salary. The Magnifico clapped him on the shoulder and said with a smile: "You'll always be poor," for he had expected to be asked for something more.'

The whole incident was evidently fresh in Michelangelo's mind six decades later: his anger at his father for trying to thwart him, and shame at the poverty of his father's ambitions.

ANTIQUITIES

*'When Lorenzo had shown him the collection, he, having
marvelled a long while at the rich materials and artistic skill
but much more at the unbelievable abundance of objects, is
reported to have said, "Ah! but what zeal and love can
accomplish! I see a truly royal collection, but such a one
that no King could assemble by wealth, by war,
or by [all his] authority."'*

– Niccolò Valori describing the Duke of Milan's reaction on
seeing the collections of Lorenzo de' Medici

L orenzo gave Michelangelo 'a good room in the house, allowing him all the conveniences that he desired'. It does not seem to have been in the main Palazzo Medici, where Bertoldo's room and furniture – including 'a feather bed and pillow filled with old feathers', 'an eating table', 'an old coffer with scenes of antiquity' and some artist's equipment – was mentioned in an inventory made after Lorenzo's death. Michelangelo might have had similar accommodation, but in one of the other Medici properties. It seems probable that he lived at the sculpture garden at San Lorenzo, where a tax declaration from the mid-1490s mentioned there was 'a loggia, rooms and a kitchen'.

Vasari added that Michelangelo was provided with a violet cloak – presumably to smarten up his appearance – and a salary of 5 ducats a month. This largesse handed out to a talented adolescent was in line with Lorenzo's general policy, as explained by Machiavelli: 'He loved exceedingly all who excelled in the arts, and he showered favours on the learned.'

Part of the secret of Lorenzo's extraordinary accomplishments in a relatively short life was that, in reality, he was the front-man of a team.

*(facing page)
The Battle of
the Centaurs,
c. 1492; detail of
left-hand side.*

The vastness of his correspondence was explained by the fact that much of it was drafted by secretaries. His collection was sifted and selected by numerous advisors, Bertoldo and Nofri Tornabuoni among them. Intellectually speaking, his household was a think tank crammed with many of the leading intellectuals in late-fifteenth-century Europe.

Domenico Ghirlandaio, *Confirmation of the Franciscan Rule*, 1479–85; detail of Angelo Poliziano and the sons of Lorenzo de' Medici.

Among these was Poliziano (1454–94). Born Angelo Ambrogini – the name Poliziano is a Latinized version of his hometown, Montepulciano – he was one of the finest Italian poets and scholars of the time; Condivi describes him, presumably echoing Michelangelo's view, as 'very learned and shrewd'. In 1490 Poliziano had been a close friend of Lorenzo's for two decades. He had served as tutor to Lorenzo's sons and can be seen – a swarthy man with a hooked nose and a stubble of beard – leading them up a staircase in Ghirlandaio's fresco at Santa Trinita.

Poliziano apparently took Michelangelo under his wing. The writer and scholar 'loved Michelangelo greatly', encouraged him to study and was constantly explaining subjects to the young artist and setting him tasks to do. As it happened, Poliziano lived almost next door to the

sculpture garden at San Marco, in another garden, which had been owned by Lorenzo's late wife, Clarice.

Whether there was more to his affection for the talented young artist than a desire to improve his education is impossible to say. However, Poliziano was undoubtedly a man with an active sexual interest in younger men, and Michelangelo at fifteen or sixteen would have been at precisely the most common age for the junior partner in such Florentine relationships.

One of the attractions of the Medici court was that it was not a true court, since – nominally, at least – the Medici were not princes but merely wealthy Florentine citizens. The result was that Lorenzo's household was more relaxed than was normal in aristocratic and princely circles. The son of Pope Innocent VIII, Franceschetto Cybo – who married Lorenzo's daughter Maria Maddelena – actually complained about the lack of ceremony with which he was received in the Palazzo Medici. It was explained to him that, with the Medici, the more a person was treated as a member of the family, the greater the honour.

A consequence of these more bourgeois manners was, apparently, that not much attention was paid to rank when seating guests for dinner. Looking back sixty years later, Michelangelo still felt pleasure at the way Lorenzo treated him during meals and elsewhere, no differently than he would a son. Naturally, a great many interesting people gathered around the Medici table. Quite often, Michelangelo remembered with pride, he would sit higher up than even Lorenzo's sons and other special guests. He was to have dealings with many other members of the Medici family over several generations, but the evidence is that he never respected – and perhaps loved – any of the others as much as he did Lorenzo.

Among the writers and thinkers present at any given meal might be intellectuals attached to Lorenzo's retinue, such as Marsilio Ficino (1433–99) and Count Giovanni Pico della Mirandola (1463–94). For a teenager who had not completed his education in Latin grammar, this must have been heady company: in modern terms, equivalent to a move in one step from a workshop bench to an Oxbridge high table. One wonders how much Michelangelo could have understood of conversations about ancient literature and abstruse philosophy.

However, he was an exceptionally gifted adolescent and might well have been able intuitively to pick up the ideas circulating around him.

Certainly the theories held by the intellectual stars of Lorenzo's court crop up again and again in Michelangelo's poetry of decades later. Ficino, who had been Lorenzo's tutor, was the leader in a revival of Neoplatonism, an esoteric and mystical doctrine of late antiquity. He was also the first to translate the corpus of Plato's works – which were barely known in the West earlier in the Middle Ages – into Latin. He introduced the term 'Platonic love' to modern European thought. It is an idea first discussed in Plato's *Symposium*, which proposed that love might be a route to the divine: to God. For Ficino – and, indeed, for Plato – the love in question was frequently between two men (which has given a second meaning to 'Platonic love').

'The appearance of a man, which because of an interior goodness given him by God, is beautiful to see,' he wrote in his *Commentary on Plato's Symposium*, 'frequently shoots a ray of his splendour, through the eyes of those looking at him, into their souls.' This was a way of thinking and feeling Michelangelo came to share, and an experience he knew well.

Pico della Mirandola's celebrated *Oration on the Dignity of Man* of 1486 proposed that men could rise to higher and higher states of being through the exercise of their free will. When he was creating the world, he wrote, God 'filled the excrementary and filthy parts of the lower world with a multitude of animals of all kinds'. When the rest was completed, as both Plato and the Bible testify (a characteristic double authority), he longed 'for someone to reflect on the plan of so great a creation, to love its beauty and admire its magnitude'. So he created man, a creature who can relapse into the state of a beast or even a plant but can also rise to become like an angel and a son of God.

Michelangelo could not have read Pico della Mirandola's *Oration*, which was in Latin. The thoughts in it, however, would be expressed with majestic force in visual form on the Sistine Chapel ceiling two decades later. This does not mean, of course, that Michelangelo had already absorbed them as a teenager, but it is intriguing to know that he must have sat at the same table with their originator, perhaps side by side.

*

86

Apart from the fact that he was treated with great respect, mingling with Lorenzo's sons and guests, Michelangelo related few details about what he did at Lorenzo's court. He described one important work made at this time, but little else. When reading through Condivi's Life with Tiberio Calcagni, he wanted to clarify one point, and that was a negative one: 'He never left his studies for the lyre or for improvising songs.' That is, he did not take part in the quintessential court pastime of musical performance.

This was characteristic and revealing. Lorenzo himself loved music and was famed as a singer of a kind of Florentine song that involved quick-fire exchanges with the audience. His eldest son, Piero, was also a skilled exponent, and other, more courtly, artists played musical instruments and sang. Leonardo da Vinci was a celebrated musician and designed a remarkable silver lyre or *Lira da Braccio* for himself, shaped like a horse's head.

Michelangelo, however, stood apart from these musical parties. It sounds as though, even as an adolescent, he was already antisocial, reclusive and driven: constantly drawing and carving. Only such dedication could explain the rapidity of the progress he made. Within two years, he had become as skilful a sculptor in marble as any alive.

What else, if anything, he did at Lorenzo's court was not recorded. For the great Florentine civic festival of St John's Day, 1491, Lorenzo – who had only one year more to live – devised a pageant in the classical style, a re-creation of the triumph in Rome of the consul Aemilius Paulus. This display was thought up by Lorenzo, organized and supervised by Lorenzo, all in praise of himself: the point being that Florence owed its wealth to him, as Rome had to Aemilius Paulus. However, the implementation was, in part, delegated to the 22-year-old Francesco Granacci. It is quite possible that Michelangelo lent a hand; if so, he did not think it worth mentioning. He concentrated, as always, on the essential.

*

There was a profound sense of artistic style in Lorenzo de' Medici's Florence. In 1490 the Duke of Milan's agent there sent his master a memorandum about the leading painters in case the Duke wanted

to summon any of them to work at the Certosa di Pavia. He noted that Filippino Lippi's works had a sweeter air than those of his master, Botticelli, but less skill, in the agent's opinion. Perugino's had an angelic air and were (also) very sweet; when it came to Ghirlandaio the agent ran short of adjectives and merely said he had a good air (adding the practical point that Ghirlandaio got things done quickly). The understanding of differing artistic qualities would have been more sophisticated among the courtiers who surrounded Lorenzo. Most would have read Cristoforo Landino's *Commentary on Dante's 'Divine Comedy'*, which contains a summary and brief character sketches of the great Florentine artists of the fourteenth century and earlier fifteenth centuries – Giotto, Masaccio, Fra Angelico.

The teenage Michelangelo, however, was still an artist without a style. He was hopping from idiom to idiom, and medium to medium – from imitating a print by a leading artist from the Upper Rhine, to copying the frescoes of Masaccio and Giotto, to imitating the manner of the greatest Florentine sculptor who had ever lived: Donatello. In 1490 or early 1491 Michelangelo began the marble relief known as the *Madonna of the Stairs*. It revealed him mimicking the manner of Bertoldo and, through him, Bertoldo's master, Donatello, but not following this model completely fluently or thoroughly.

Michelangelo's *Madonna* was carved in the manner of Donatello's reliefs. Using the very shallow cutting that Vasari called *rilievo schiacciato* – 'squashed relief' – Donatello had been able to make sculptures with much of the atmospheric and spatial effect of paintings. Michelangelo was borrowing from a relief by Donatello of this kind in the Medici collection – *Herod's Banquet* (now in the Lille Museum) – but the teenage artist didn't seem interested in making sculpture imitate the possibilities of painting.[1] It's the space he squashed: instead of making the staircase recede, he brings it forward so it rises like a wall behind the figure of the Madonna.

1 Also in the Medici collection was a relief sculpture of the Madonna and child known as the *Dudley Madonna*, probably by Donatello and now in the Victoria and Albert Museum, which has several resemblances to Michelangelo's Madonna – except that in it the mother and child are engaged in charming, playfully intimate interchange.

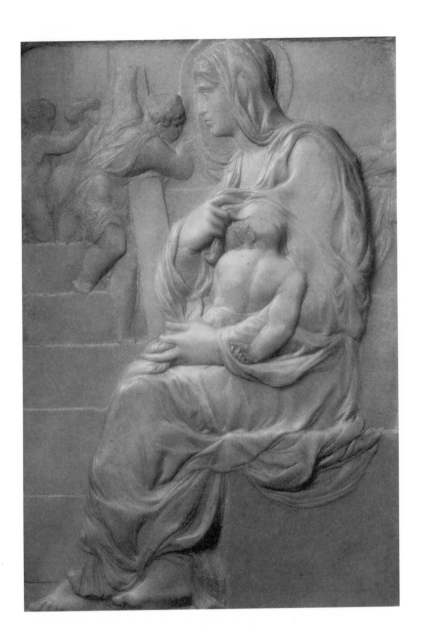

Madonna of the Stairs, c. 1492.

Perhaps this is partly beginner's incompetence, like the Madonna's stevedore hands and chimpanzee's legs, but it was also instinct. Michelangelo never devoted much attention to representing atmosphere or deep space. Seventy or so years later, he was reading through Condivi with Tiberio Calcagni when they came to a passage describing his efforts to train himself as an artist: 'He devoted himself to perspective and to architecture, and his works demonstrate how much he profited thereby.' The aged Michelangelo commented pithily to correct that passage: 'Perspective, no, because it seemed to me to be a waste of too much time.'

What makes the *Madonna* impressive, despite the oddities, is a feeling of grandeur. If the *Madonna of the Stairs* were to stand, she would be a giantess as well as a goddess. She has the ample sense of form that appealed to the sixteenth century, a taste that Michelangelo himself did much to create. That was why, no doubt, Vasari felt she had 'more grace and design' than even a Donatello. That was perhaps derived from a different source: classical antiquity.

The Italian Renaissance is always associated with Brunelleschi's championing of single-point, linear perspective (in which, as we have just seen, Michelangelo was surprisingly uninterested), but the period was characterized, perhaps more deeply, by another sense of perspective, not in space but in time. It was an age that had rediscovered a predecessor in the past. Of course, ancient Greece and Rome had never been forgotten. The High Middle Ages, for example, were deeply affected by the writings of Aristotle.

Fifteenth-century Italy, however, had a new sense of the past, clearer and better focused, of predecessors who were distinctly different and in some respects more accomplished than they were themselves. In other words, they had a kind of cultural double vision: they saw their own age in comparison with another – a model to aim at.

It is hard to understand the culture of the fifteenth and early sixteenth centuries without grasping that this was an era that experienced constant archaeological excitement. Literary detectives such as the Florentine Poggio Bracciolini (1380–1459) ferreted out forgotten and long unread manuscripts by classical authors, such as Lucretius's *On the Nature of Things*, and humanist critics looked at ancient texts

with the eyes of scholars, cleansing them of the mistakes and muddles caused by centuries of copying and re-copying. Even writing itself became elegantly classical instead of gothic. Meanwhile, the works of ancient artists were emerging from the earth, creating a similar sense of revelation to later excavations in Egypt, Assyria, China, Mexico and elsewhere.

Like Howard Carter peering into the tomb of Tutankhamen, fifteenth-century connoisseurs felt that they were seeing wonders, hidden for millennia. In common with ancient literature, the art of the classical civilizations had never entirely disappeared. Certain works had always been above ground and on view, such as the equestrian sculpture of the Emperor Marcus Aurelius which stood beside the church of St John Lateran through the centuries that followed the fall of the Roman Empire (mainly because it was believed to represent Constantine, who had converted the empire to Christianity). From time to time, no doubt, ancient marbles and bronzes had accidentally been dug up in the course of building or farming. The difference was that now there were customers willing to pay for them, so those chance discoveries were not – as before – habitually melted down or burnt to make lime. Some were now cherished, exhibited and looked at as models of how art should be.

While Michelangelo was living in Lorenzo de' Medici's household he had access to one of the finest collections of ancient Roman art then in existence. He told Condivi that 'many times a day [Lorenzo] had him summoned, and showed him jewels, cornelians, medals and similar things of great value, in the manner of one who knew him for a person of intelligence and of judgement.'

The strength of Lorenzo's collection lay in small and exquisite objects such as cameos and small-scale relief sculpture. Lorenzo's close-focus vision would have allowed him to linger over the detail and nuance of these miniature objects. Above all, he prized hardstone vases: 'rare and lordly things', as one Renaissance collector wrote to another, adding that Lorenzo had 'held them most dear'.[2] Indeed, he had many of them inscribed with a monogram: 'LAV. R. MED'. There

2 Francesco Malatesta was writing to the obsessive art accumulator Isabella d'Este.

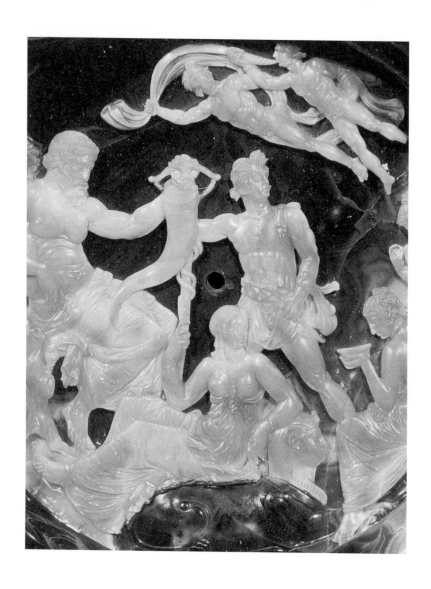

Tazza Farnese, cameo cup, 2nd century BC.

have been numerous attempted explanations of that enigmatic 'R'. One possible meaning – the most obvious, but in a Florentine political context an outrageous one – was 'Rex': King.

Lorenzo had some notable ancient marble statues, but the very best eluded him and his agents, partly because the main source of them was Rome – a place beyond his territory where other collectors, such as the great princes of the church, had first pick of whatever was discovered. In February 1489 Nofri Tornabuoni reported a thrilling find. Recently, the nuns at the convent of San Lorenzo in Panisperna had 'found a large complete figure, who appears as if he were shooting an arrow, which is thought to be an exceptional object'. But, he added pessimistically, it was likely to come to the attention of Cardinal Giuliano della Rovere, 'who will want it, and nobody would now dare to haul it away from him and flee with it, out of respect for him'. This was the *Apollo Belvedere*, the greatest classical sculpture to be discovered in the fifteenth century. It was soon installed in the cardinal's sculpture garden beside his palace near the church of Santi Apostoli.

The collection was part of what Lorenzo's brother-in-law Bernardo Rucellai called 'his royal splendour', but that did not stop it being a genuine obsession. The intensity of Lorenzo's enthusiasm was demonstrated by the sheer amount of time and energy he and his staff spent evaluating potential and actual purchases. The pieces were shown off proudly to special guests, such as the Duke of Milan or the great Venetian humanist scholar Ermolao Barbaro – though Piero de' Medici doubted that the latter understood much about the antiquities he was shown. This was a court at which even a highly educated outsider might come across, in comparison with the inner circle, as a little ignorant.

Although Michelangelo did not leave a record of what Lorenzo said to him as he pulled one precious item after another from the cabinets and chests in his study, we can come close to eavesdropping by reading Lorenzo's correspondence. For example, a Roman carved gem representing *Phaeton Driving the Chariot of Helios* was much praised. It was a cornelian cut with incised intaglio relief – that is, cut into the surface, the opposite of a cameo – so the image was contained within the translucent stone, like amber or honey. The lighting of such a thing

was important, as it is for any sculpture. Nofri Tornabuoni wrote, 'It seems to me it has this subtlety, so that one can enjoy it by night as well as by day, because it is no less beautiful to see it by candlelight than in daylight.' This was a subject to which Michelangelo returned forty years later, when he made a drawing of Phaeton as a gift at the height of his love for Tommaso de' Cavalieri.[3]

Michelangelo's second surviving sculpture is known as *The Battle of the Centaurs*. It dates from around 1491/2, when he was sixteen years old. This is another small-scale piece: a collectors' item, carved on a slab of marble less than 3 feet wide but filled with numerous struggling, fighting, dying figures. Some of these have the hindquarters of horses and, on close examination, it can be seen that a few of them are intended to be female. Essentially, though, the relief is a densely interwoven mass of naked warriors, fighting to the death.

The first time this little work was mentioned in writing was three and a half decades later, in 1527, when Michelangelo showed it to an agent of the Duke of Mantua (who was then desperate to get hold of something from his hand). *The Battle of the Centaurs* was then described as 'a most beautiful thing', containing more than twenty-five heads and twenty bodies in various attitudes. Michelangelo had begun it for a great lord, but never finished. The great lord, evidently, was Lorenzo de' Medici.

This little relief has struck more than one observer as a compressed summary of everything Michelangelo was to create in the seventy-odd years to come. The critic and historian Kenneth Clark wrote that, when contemplating it, 'We seem to be looking into the boiling cauldron of his mind, and fancy we can find there, forming and vanishing, the principal motives of his later work.' There, on this smallish slab of stone, it's not hard to make out in embryo the composition of *The Battle of Cascina* or *The Last Judgement*.

Michelangelo seems to have thought something similar, because – according to Condivi – when he saw it again, he lamented that he had

3 He also must have long remembered Lorenzo's Roman chalcedony intaglio of *Diomedes and the Palladium*, in which the lithe, tensely poised naked hero was a brother to the athletic male nudes of *The Battle of Cascina* and the Sistine Chapel ceiling.

not spent his entire life on sculpture. Carving stone, he felt, was what he was born to do. It showed, he told Calcagni, 'that the labours of the art, for one who falls in love with it, are very light'.

The subject of nude men engaged in murderous combat might seem odd to the twenty-first-century mind, not to say impractical, but for an aspiring sculptor in the late fifteenth century, it was what Sigmund Freud called 'over-determined'.

The combination in this strange subject of homoeroticism and ferocious antagonism seems to reflect something deep in Florence itself: a city notorious both for the sin of sodomy and for ferocious factional strife. Around two decades before, Antonio del Pollaiuolo had made his large and splendid engraving of sinewy naked warriors engaged in hacking at each other with swords, daggers, arrows and axes. Another predecessor was already installed in Lorenzo's private suite: a bronze relief of an ancient battle by Bertoldo. This was placed over a fireplace in a small room off the *sala grande*: in other words, in an intimate space where it could be examined at eye level. Bertoldo's bronze was closely based on a badly damaged battle scene on a Roman sarcophagus in the Campo Santo at Pisa. This was a suitable field of battle on which Michelangelo himself could take on older artists.

According to Condivi, Michelangelo's subject of the Centaurs was originally suggested by Lorenzo's close friend, the poet and philosopher Poliziano: 'One day he suggested to him the rape of Deianira and the battle of the centaurs, and he expounded the whole story to him stage by stage.' This sounds very likely, the only problem being that there is no classical text that describes such an event.

There is, however, a long description in book XII of Ovid's *Metamorphoses* of a gory conflict involving centaurs.[4] It is likely that this is the one Poliziano told the young artist about, but Michelangelo didn't

4 There is also a shorter account of a rather squalid myth by another Roman author, Hyginus. In his *Fabulae*, Hyginus relates how Hercules himself had violated Deianira, and promised to marry her, but she is subsequently betrothed to a centaur, who is murdered by Hercules. It seems that the story Poliziano must have told Michelangelo was the one from Ovid, presumably not in Latin, which his pupil hadn't mastered, but in Tuscan. However, excusably, Condivi or Michelangelo muddled up the two Greek maidens Deianira and Hippodameia.

follow the poem very closely, sensibly enough, since much of the detail in Ovid's narrative would be impossible to render in a medium such as marble, which tends to fracture if cut into fine, thin forms. Most of the fighting is with swords and bows, for example, neither of which is suitable for cutting in stone; nor is the hero Theseus's weapon: 'an ancient mixing-bowl'.

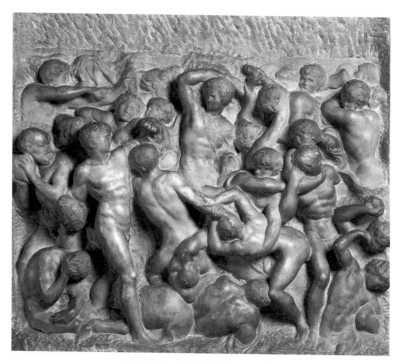

The Battle of the Centaurs, c. 1492.

Michelangelo had a temperamental aversion to spelling out the fussy who, where and what of the subjects he was depicting. Through-out his career he tended to omit such dispensable accessories as the attributes of saints (a habit which has caused a good deal of confusion to scholars). As far as possible, he liked to leave his figures as just that: bodies, charged with the significance that comes from movement and muscles.

There are beginner's mistakes here, as in all Michelangelo's early works. The foreshortening of the kneeling centaur is extremely odd, for example, leaving him with vestigial mini-thighs, but *The Battle of*

the Centaurs was a giant step forward from the *Madonna of the Stairs*, the first indisputable sign of Michelangelo's huge talent. Already, he had slain one of his predecessors, metaphorically, with this work. In comparison, Bertoldo's *Battle* seems awkward and bitty.[5]

Michelangelo's warriors in the *Battle* relief are humanity re-imagined and perfected in his mind. There is an ease about them, a flowing movement that runs throughout their bodies, an amplitude quite different from the tense jerkiness of Pollaiuolo's men. This is humanity derived from the art of ancient Greece and Rome, but freshly poised and energized.

Here was one of the lessons that Michelangelo learned in the household of Lorenzo de' Medici. The second was spiritual and philosophical. Condivi recalled that when Michelangelo spoke of love, which was frequently, he always followed the ideas of Plato. His mind, like his taste, was formed in the Medici court.

5 Michelangelo did, however, seem to have borrowed a figure, and a feeling for anatomy, from one of Bertoldo's finest works, a small bronze statuette of the Greek hero Bellerophon taming Pegasus.

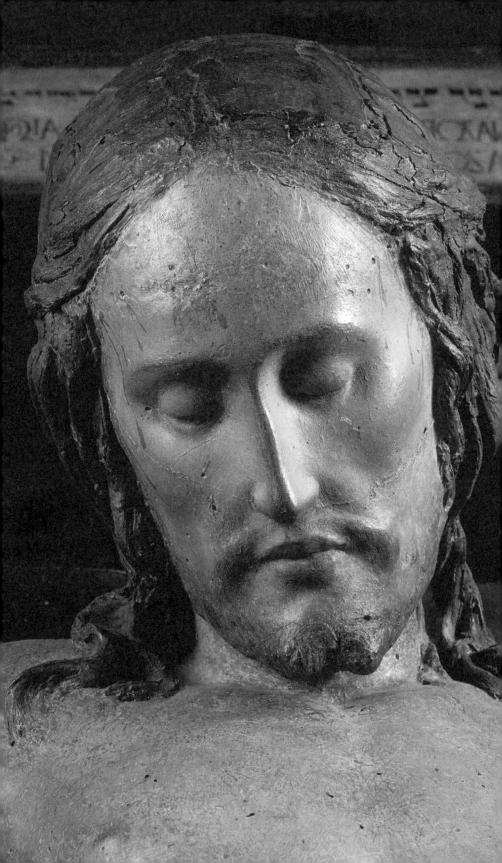

PIERO DE' MEDICI AND FLIGHT TO BOLOGNA

'Michelangelo has similarly with great diligence and attention read the holy scriptures, both the Old Testament and the New, as well as the writings of those who have busied themselves with their study, such as Savonarola for whom he has always had a strong affection, and the memory of whose living voice he still carries in his mind. He has loved, too, the beauty of the human body, as one who knows it thoroughly and well.'

– Ascanio Condivi, 1553

Eighteen months after Michelangelo entered Medici service, at the end of 1491, Bertoldo died at the villa of Poggio, at Caiano outside Florence. A contemporary letter noted that Lorenzo was 'much affected' by this loss. The day after Bertoldo's death, 29 December, Lorenzo himself had an attack of his chronic illness. On 19 January it was reported that he had not been out of the Palazzo Medici for twenty-two days. In the third week of February, he rallied a little and began to work and potter about, but on 28 February he relapsed.

As a result, Lorenzo was unable to take part in the public celebration of the greatest achievement of his life: the official consecration of his middle son, Giovanni, as a cardinal. This was, of all Lorenzo's triumphs, the one that had the most far-reaching consequences. Because Giovanni became a cardinal, and eventually Pope, the Medici were transformed into one of the ruling dynasties of Europe.

In 1489 Lorenzo had persuaded Pope Innocent VIII to make the thirteen-year-old Giovanni a cardinal deacon, largely because the Pope

(facing page)
Detail of
Crucifix,
c. 1492–4.

owed the Medici bank a great deal of money. It was, even by fifteenth-century standards, a scandalous appointment, and one the Pope made on the understanding it was to be kept secret (an agreement the jubilant Lorenzo quickly broke). Now the time had come for Giovanni's official consecration. The youth, now sixteen, received the hat on 10 March. The next day he heard Mass at the Duomo, and the Signoria presented him with '30 loads of gifts carried by porters'. Lorenzo managed to make an appearance at a celebratory feast in the hall of the Palazzo Medici, where Giovanni was entertaining leading Florentine citizens and foreign dignitaries. Michelangelo must have witnessed these events, which affected his life as profoundly as they did the future of Florence.

On 18 March Lorenzo went to his villa at Careggi with Poliziano and other close companions and, for a while, he seemed to improve a little. He told Poliziano that if he did not die he would devote his life to poetry and study, and the poet replied that his fellow Florentines would scarcely allow that. However, in the early hours of 9 April Lorenzo did die, aged forty-three. His body was carried to the convent of San Marco; the following day he was buried at San Lorenzo. According to Condivi, 'Michelangelo returned to his father's house; and he was so grief-stricken by Lorenzo's death that for many days he could do simply nothing.'

He was to be involved with the Medici for much of the rest of his life, but – judging from the account in Condivi – Michelangelo did not feel anything like the same love and admiration for any other member of the family. As we have seen, he did not want posterity to know that he had been apprenticed to Ghirlandaio, but he wanted to advertise the fact that he had learned from Lorenzo. Il Magnifico was a more satisfactory father figure, in many ways, than the father he actually had.

*

A letter written on 7 April 1492 – that is, just over a day before Lorenzo's death – by a 25-year-old man named Niccolò di Braccio Guicciardini to his cousin Piero Guicciardini (father of the historian Francesco Guicciardini) – revealed a degree of panic about the crackdown on the vice of sodomy.

Niccolò described how Savonarola and other preachers had prophesied apocalyptic doom for the city if sodomy were allowed to continue.

He had been unnerved by the fall of part of the structure of the Duomo two days before, after a lightning strike. Lorenzo had apparently seen this as a portent of his own death; Niccolò understood it as a sign of impending fire and brimstone. 'God sent this scourge so that we would repent of our sins, especially sodomy, which he wants to be done away with, and that if between now and August we don't correct ourselves these streets will run with blood . . . such that all of us are frightened, especially me. May God help us.'

Obviously, some among the rulers of the state had felt the same. On 3 April twenty young men had been pulled in by the Otto di Guardia, a senior magistracy responsible for public order, 'all of good families', according to Niccolò. One of them, a youth nicknamed Mancino, listed among other men who had sodomized him one 'Messer Agnolo da Montepulciano', that is, Poliziano. Next came a sweep of the taverns, with anyone in the company of a boy arrested.

Sodomy was astonishingly common in Florence. The historian Michael Rocke, who has researched the subject extensively, established that 'In the late fifteenth century, by the time they reached the age of thirty, at least one of every two youths in the city of Florence had been formally implicated in sodomy to this court alone; by age forty, at least two of every three men had been incriminated.'

The Florentines were extremely concerned about the issue, as Niccolò Guicciardini's letter suggests. Preachers regularly denounced sodomy; it was believed that it might bring down the wrath of God on the city. Civic anxiety about it culminated in the foundation in 1432 of a unique institution: the Office of the Night, a team of magistrates dedicated to rooting out sodomy. It was to the Officers of the Night that fifteenth-century Florentine sodomites were denounced, or to whom they denounced themselves to avoid severe penalties.

Like most human beings at all times, Florentines had little difficulty in living with drastic discrepancies between their beliefs and their behaviour. Sodomy was abhorrent; but it was at the same time a widespread aspect of everyday life. Medieval and Renaissance Florentines seem indeed to have followed two codes simultaneously. On the one hand, they were devout Christians and believed same-sex intercourse to be sinful. On the other, for much of the time they adhered

to something much more like the moral code of ancient Rome, whereby such activities carried no stigma at all, or, rather, the disgraceful thing was to be the passive partner in all sexual acts, irrespective of the gender of the participants. The result was an equivocal attitude to the subject. Officially, sodomy was denounced and subject to draconian penalties. In practice, except in periods of unusual tension – such as immediately after Lorenzo's death – it was punished lightly, if at all.

There is no certain information about Michelangelo's sexual life at this or any other time, but it is clear that same-sex activity was going on all around him. In 1492, '94 and '96, a youth named Andrea who worked in the Ghirlandaio *bottega* was denounced to the Officers of the Night. He was said to have been sodomized frequently by a painter named Giglio, with the connivance of his mother and of his father, a weaver named Fioravante. In 1502 the painter Botticelli, an older colleague and acquaintance of Michelangelo's, was also denounced to the Officers of the Night, for keeping a young male lover. There were rumours even about Lorenzo – though he was famed for his heterosexual affairs.

*

If Michelangelo grieved sincerely over Lorenzo, his feeling about the rest of the Medici family was more ambiguous, and that was especially the case with Lorenzo's son and heir Piero (1472–1503). In Condivi, the assessment of Piero is harsh. He 'inherited his father's position, but not his gifts'; he was 'insolent and overbearing'; his vices led to his being chased out of Florence after a mere two and a half years of rule.

This was one of the points at which Tiberio Calcagni notes a comment in the margin: 'He told me he had never said such a thing.' However, that view of Piero was more or less received wisdom in Florence. His denial was a sign of the anxiety his relationship with the Medici was still causing him, seventy years later.

Other indications suggest that, to begin with, Michelangelo was a prominent member of the youthful Piero de' Medici's entourage. Vasari stated that Piero treated Michelangelo 'most affectionately': it sounds as if he was valued for his understanding of classical sculpture – he would have been a suitable replacement for Bertoldo as advisor on the Medici collection – and for his evident and astonishing

gifts. Piero was in the habit of saying that he had two remarkable men in his employ: Michelangelo and a Spanish groom.

It sounds, from what Michelangelo told Condivi, as if Piero was not the only one to be impressed by this groom, the beauty of whose body was 'marvellous'. He was 'so agile and hardy and possessed such vigour that when Piero rode his horse flat out he did not outdistance him by an inch'. Such footmen, who were expected to run beside their masters on long journeys, would have been among the few individuals with the extraordinarily athletic muscular development displayed in Michelangelo's sculptures and paintings of naked men. He would have been a living David or Adam. His body lingered in Michelangelo's memory half a century after he had seen it.

Almost certainly there was a much longer connection between Michelangelo and Piero than the 'several months' Condivi mentions. In reality, Michelangelo probably returned to the Medici court soon after the transition of power was complete. And clearly he gained in status under the new regime. For the first time Lodovico Buonarroti took full note of his son's prominence at court, going so far as to spend money to make sure he looked sufficiently well turned out.

After he recovered from his grief at the death of Lorenzo, Condivi wrote, Michelangelo bought a 'large piece of marble, which for many years had been lying in the wind and rain, and from this he carved a Hercules'. This clearly implies that he made this sculpture of his own accord, but the idea of Michelangelo making a monumental sculpture such as this on spec, for his own satisfaction, is improbable. The work was 4 *braccia* – 7 feet 7 inches – high. It would, however, make sense as a public statement by a new Florentine ruler. Hercules was a civic symbol of courage and fortitude, a suitable successor to previous Medici commissions from Donatello for the sculptures *David* and *Judith*, whose meanings were similar. Those stood in the courtyard of the Palazzo Medici, and it's likely that the intended position of Michelangelo's *Hercules* was the same.

With this in mind, the wording of Condivi's text is revealing. It explains where the marble came from – such a large piece would be difficult to find and time-consuming to have quarried especially, so this was probably sourced from some place that stockpiled materials, such as the courtyard of the Opera del Duomo (where the block that was to become

David was already lying). The commission, in other words, must have come from someone rich and powerful, such as the new ruler of Florence, Piero de' Medici, but Michelangelo did not want to say this – perhaps because, after Piero fled, rather disloyally he arranged for his uncle to repossess the statue and never returned it to the Medici family.[1]

While Michelangelo was making the marble *Hercules*, 'there was a heavy snowfall in Florence and Piero de' Medici . . . wanting, in his youthfulness, to have a statue made of snow in the middle of his courtyard, remembered and sent for Michelangelo and had him make the statue.' This looks like conclusive evidence of Piero de' Medici's silliness: asking a great artist to make a snowman.[2]

However, perhaps this was not as frivolous a use of Michelangelo's talents as it might seem. These snow sculptures were a Florentine institution, at least when there was a heavy enough fall. Landucci, the Florentine apothecary who kept a dairy, reports that, after another exceptional blizzard in January 1511, the city was filled with an outdoor exhibition of frozen sculpture, including 'many snow-lions' and 'many nude figures' made by 'good masters'.

Sadly, Michelangelo's marble *Hercules* also seems to have melted away, eroded by the rain in the garden of Fontainebleau. Consequently, a crucial piece of evidence about his development as an artist – his first full-scale figure carved in stone – is irretrievably missing. It is impossible even to guess with much certainty what it might have looked like, but grand and classical it must have been.

At court, according to Vasari, Michelangelo took the place of his

1 On 11 August 1495 Francesco Buonarroti presented himself to the *sindaci* – the trustees appointed to oversee the sale of Medici property. He swore that the marble statue of *Hercules* was his nephew's own property and it was handed over to him. The document states that Michelangelo – whose name is missing – was Francesco's son, an understandable mistake, as Francesco Buonarroti was the head of the family and on the spot at Orsanmichele where the sale took place, as that was also where he conducted his small money-changing business.

2 That heavy snowfall actually happened. Landucci describes it in his entry for 20 January 1494, the day of St Sebastian: 'There was the severest snowstorm in Florence that the oldest people living could remember.' The storm lasted for twenty-four hours, and Landucci noted that 'There was such a quantity that it took a long time to melt away, as sometimes when boys make a snow-lion. In fact, these mountains lasted a week.'

dead teacher Bertoldo as advisor on antiquities and their purchase: 'It is said that Piero de' Medici, who had been left heir to his father, Lorenzo, often used to send for Michelangelo, with whom he had been intimate for many years, when he wanted to buy antiques such as cameos and other engraved stones.'

One has the impression that Michelangelo had moved from being a protégé to the position of a courtier-companion. This chimes with what is known about Piero's behaviour at this time. There was unhappiness among the mercantile magnates of Florence, caused by Piero's tendency to rely on his servants and familiars. Talented, youthful and poor, Michelangelo was perfectly cut out for Piero's circle. So, for another two years, Michelangelo was at Piero's court, but there is reason to believe that he was listening to dissident whispers against this new Medici 'boss of the shop'.

*

Hercules was one kind of male nude – heroic and muscular. Michelangelo's next sculpture was of a very different type of naked body: Christ on the cross. Condivi implied that this work came about almost as a favour, 'a crucifixion made to oblige the prior of Santo Spirito in Florence'. Actually, it was probably yet another consequence of Michelangelo's position at the Medici court.

For the church of Santo Spirito, south of the Arro, Lorenzo had supervised the building of a sacristy. This is in fact the surviving building that gives the best idea of the grave classicism of Lorenzo's architectural taste. The sacristy was part of a project to remake Florence – piecemeal and mainly by pulling hidden levers of power – in the Medici style.

Piero de' Medici followed in his father's footsteps to become a member of the committee supervising building works at Santo Spirito in March 1493. It's likely that the commission for the crucifix came after that, and that it was Piero's suggestion that Michelangelo should carve it.

Such lifesize crucifixes were a Florentine tradition. Brunelleschi and Donatello had both carved examples, in competition with each other, and more recently Giuliano da Sangallo – architect of the Santo Spirito sacristy – and his brother Antonio had made a series of them for various churches. Michelangelo was again competing with his elders, and this time it was not clear he came off best.

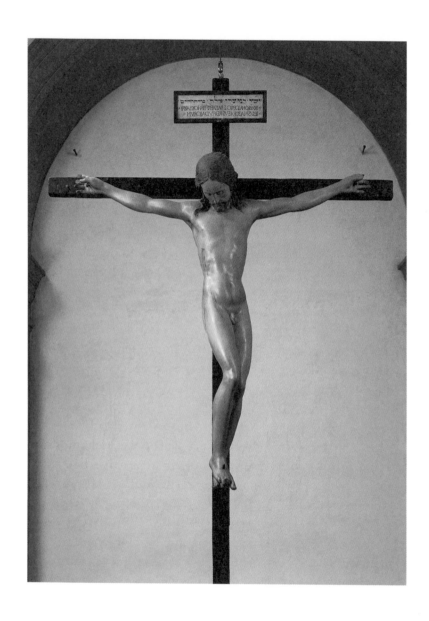

Crucifix, c. 1492–4.

Michelangelo's Santo Spirito *Crucifix* is an ungainly and not entirely successful work. That is no doubt the reason why it was overlooked as a work by Michelangelo for centuries, and only re-identified in the 1960s.[3]

The first impression is that there is something disturbingly wrong with its proportions: the waist area is strangely elongated, the head too big. Perhaps these distortions were an attempt to adjust for the sculpture being seen from below. Vasari, who would have known it well, described the *Crucifix* as being 'placed above the lunette of the high altar'.[4] But the *Crucifix* improves on closer acquaintance. The qualities that make it worthy of Michelangelo are the carving of the ribcage and the subtlety of the muscles of the abdomen and legs. The young artist, perhaps, had miscalculated the effect of his carving: instead of a sculpture that makes an impact at a distance, he created something that needed to be appreciated from close up.

Michelangelo's wooden figure corresponds well to the description by Girolamo Savonarola in a work written a year or two before the *Crucifix* was carved. The Dominican friar's *Treatise on the Love of Jesus Christ* (1492) painted a picture in words of Christ's 'noble and delicate sense of touch', and his being so sensitive to pain – like Savonarola – that 'every little prick was very painful to him'. Savonarola advocated the burning of vanities such as paintings and sculptures of nudes; however, he seems to have been a sensitive, admiring observer of religious art.

Such detailed visualization of holy bodies and sacred scenes was part of late-medieval piety. The English mystic Margery Kempe of King's Lynn (c. 1373–post 1438) was vouchsafed a 'showing' of Christ's suffering during a pilgrimage; she seemed to see 'his precious body all rent and torn with scourges, fuller of wounds than ever was a dove house full of holes . . . his beautiful hands, his tender feet nailed to the hard tree'. In a more classical way, with less emphasis on blood and more on the reality of anatomy, the Santo Spirito Crucifix is a similar

3 Perhaps the advent of modernism made it possible to conceive that Michelangelo might have made a work as anatomically strange as this. Some scholars are still doubtful about this attribution, but the balance of opinion is in his favour.
4 Its current position in the sacristy is also high, but the impression it makes is still uncomfortable.

attempt to imagine what it was truly like to be there looking at Christ's crucifixion on Calvary. It was a method of dramatically focusing the viewer's attention and thoughts.

Savonarola's sermons used similar devices, some of which, half a millennium later, sound distinctly hammy. His outline notes for his Lenten sermons of 1491, a series delivered in the Duomo before enormous congregations, give some hint of his oratorical devices: 'Take the crucifix [at this point] and lifting it high, cry out, *Misericordia!* Mercy!'; 'Take out a nail from the Crucifix, letting his [Christ's] right hand fall, and cry out, O Lord!'

Many star preachers of fifteenth-century Italy used dramatic devices such as those, but Savonarola was unusual in the closeness of the relationship he claimed with Christ. In his sermon of Sunday 20 March 1491, delivered in the Duomo before a vast congregation, he declared, 'I believe Christ speaks through my mouth.' Three and a half years later, after the flight of Piero de' Medici and the establishment of a more rigorously republican constitution, Savonarola conducted a public dialogue with Christ in his sermon on Sunday 21 December 1494. Savonarola asked the Lord why he, a friar born in Ferrara, had come to hold an extraordinary sway over the Florentines. 'What business is it of mine to be preaching about the government of Florence?' Christ's reply was that Savonarola had been picked as a humble instrument through whom Florence was to become a spiritual city, and he reminded the friar of his own crucifixion: 'Thus will it be with you and not otherwise.' And indeed, four years later, Savonarola was not crucified, but arrested, tortured, hanged and then his body burnt outside the Palazzo della Signoria.

Earlier on, however, there was every reason for Michelangelo to pay close attention to what Savonarola said. Condivi related that Michelangelo had 'always had a strong affection' for the writings of Savonarola and that, over half a century afterwards, the artist still heard the 'living voice' of the friar echoing in his memory. Savonarola stood for an intense, reformed Christianity centring on a personal relationship with Christ. This, whether or not he ever became one of the *piagnoni* – wailers or snivellers, as the friar's devoted followers

were called – was Michelangelo's style of faith, and perhaps became more strongly so as he grew older.

<p style="text-align:center">*</p>

In the early 1490s, the brilliant young sculptor and the learned, charismatic Dominican preacher were – strange though it might seem – both members of the Medici circle, both talent-spotted because of their extraordinary abilities. Savonarola was preaching in the Convent of San Marco from the summer of 1490, shortly after Michelangelo probably arrived.

The leading intellectuals of the Medici court became enthusiastic admirers of the preacher, among them Michelangelo's literary mentor Poliziano, and Pico della Mirandola, who had prompted Lorenzo to ask Savonarola's superiors to transfer him to Florence. Pico felt the hair on his head rising when he heard one of Savonarola's apocalyptic prophecies of doom.

The closeness of the Medici to Savonarola seems ironic in retrospect because Lorenzo soon became a personal target of Savonarola's diatribes. When denouncing tyrants in general, Savonarola seemed particularly infuriated by the very qualities of all-round, versatile accomplishment that have so impressed posterity. He took aim at Lorenzo's urge to excel: whatever he took up – poetry, jousting, philosophy and horse racing – he had to be the best.

At first, however, Savonarola was simply an inspired preacher who was an ornament to Florentine life. He apparently kept his distance from the Medici household – Lorenzo allegedly complained that 'a foreign monk has come to live in my house and he hasn't even come to visit me' – but he attended Lorenzo on his deathbed and had good relations with his son Piero.

Nor is it as odd or surprising as it might seem that Savonarola was at first a Medici protégé: after all, Lorenzo and his court philosophers were believing Christians, as indeed was everybody in fifteenth-century Florence (bar the small population of Jews, who were tolerated by the Medici but disapproved of by the more devout). Preaching was both a form of entertainment – Savonarola's sermons could last two to three hours – and an enthralling experience. Philosophy and theology

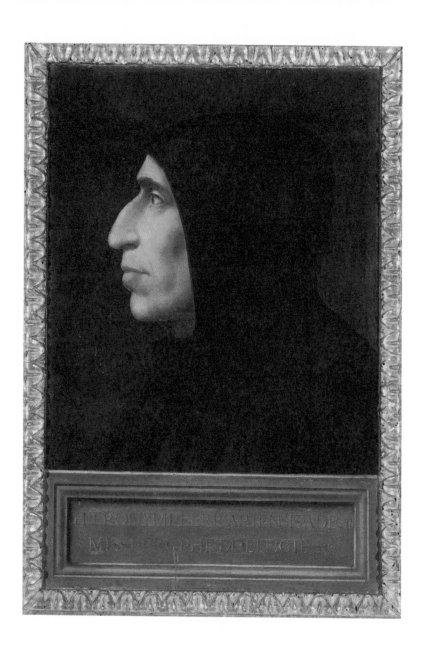

Fra Bartolomeo, *Portrait of Savonarola*, after 1498.

were hot topics because they dealt with what mattered most: the nature of human life and man's relation with God.

Individuals such as Pico della Mirandola and Ficino were interested in esoteric currents of ancient philosophy such as Neoplatonism (partly because it seemed to be a way of reconciling classical philosophy and Christianity). For the same reason – because they were excited by ideas – they were susceptible to the intellectual drama of Savonarola's millenarian mysticism. But the modern thing about them was not so much what they thought, as that they were conscious of a range of possibilities: a market of ideas.

On 23 June 1489, the day before the celebrations of the Feast of St John the Baptist, a debate was held in the Florentine Duomo. The main antagonists were a Dominican and a Franciscan, both intellectual stars of their orders. The point at issue was sin – more precisely, who bore the responsibility for its existence? Was it Adam, who had sinned through disobedience in the Garden of Eden? Or was it God, who was, after all, omnipotent and had created the world and everything in it, sin included?

The debate so engaged Lorenzo that he had it restaged at the Palazzo Medici a week later, on 30 June. In attendance were two more academic thinkers, and the intellectuals of the Medici household: Poliziano, Ficino and Pico della Mirandola. It was essentially a round-table discussion in which all the shades of theological and philosophical opinion were represented.

Lurking behind the debate in Lorenzo's palace was a question that eventually caused the deepest divisions of the age. At issue was what sort of being man was: a fallen creature dependent on God's grace for any hope of salvation, or, as Pico argued, perfectible, able to rise towards heaven through his own efforts to be virtuous, made in the image of God? These were matters of paramount importance to Michelangelo and his contemporaries – and crucial to an artist who made images both of man and of God.

*

In the last analysis, the power of the Medici relied on consent not so much by the people in general as by the heads of the powerful Florentine clans: the oligarchs among whom they were accepted as leaders. From

early on many of these men were doubtful about Piero de' Medici. Some supported him, while others were tempted to switch their loyalties to the older and more experienced men of the junior branch of the Medici family: Lorenzo and Giovanni di Pierfrancesco de' Medici, descendants of Cosimo de' Medici's younger brother, Lorenzo, great-uncle to the Magnificent.

A few years later we find Michelangelo in a tight relationship of business and patronage with Lorenzo di Pierfrancesco. It is likely, then, that he was already associating with him in 1493 and 1494. Any confidence he had in the regime drained away when, two years after he came to power, the youthful, arrogant Piero was faced by the worst political crisis to have struck Italy in a century.

In 1494 the fragile balance of Italian politics was fatally and permanently disturbed, with the result that later generations looked back to the era of Lorenzo the Magnificent as a golden age of peace. In reality, it was nothing of the sort: as experienced at the time it was a period of plots, tension and threats of war. The art of self-preservation, skilfully exercised by Lorenzo, lay in manipulating the balance between the five major Italian powers: Naples, Milan, the Papacy, Venice and Florence.

After Lorenzo's death the larger European states – France and Spain in particular – which had been disrupted by internal wars and divisions, began to come under stronger central control. At the same time, technological change transformed the nature of war: gunpowder and hence artillery became crucial weapons.

The trigger for cataclysm was the decision of the young French king, Charles VIII (1470–98) to enforce an ancient claim to the throne of Naples. He had been encouraged, unwisely, by Italian politicians, including Pope Innocent VIII and Ludovico Sforza, Duke of Milan, who hoped a French invasion would give them a short-term advantage against their enemies.

Charles VIII was short, ugly, not particularly bright and only two years older than Piero. The call to fight in Italy was an opportunity for glory and excitement. On 2 September 1494 he crossed the Alps with an army of 25,000 – enormous by Italian standards – including Swiss mercenaries and, an alarming innovation, cannon. By 9 September he had reached the town of Asti, north of Genoa.

On that very day the little city of Rapallo, further south on the Ligurian coast, was taken from a Neapolitan garrison by French advance troops under the Duke of Orleans, who had been in Italy since July. Two days later the news of this defeat had reached Florence. Landucci noted grimly in his diary, 'They fled towards the mountains, and were all killed or taken prisoner; the fleet of the King of Naples being disarmed and destroyed.' Rapallo was sacked by the Swiss mercenaries.

Whether even a brilliant political tactician such as Lorenzo would have been able to withstand such an earthquake is doubtful. His inexperienced son Piero responded in the worst possible way. Encouraged by the Roman clan of the Orsini, to which both his wife and his mother belonged, he had made an alliance with Naples; and he clung to it despite all warnings. This put him on the opposite side of the most formidable army to be seen in Italy in living memory.

The French continued southwards in the direction of Florence, and before they arrived – quite when is unclear – Michelangelo decided to get out. He told Condivi a strange story about how he came to flee. This concerned a virtuoso lyre player, a great favourite of Lorenzo and his son, whom he calls Cardiere (in fact, that is an Italianization of the name; he was Johannes Cordier, one of the many Flemish composers and performers whose talents were prized in Italy).

This Cardiere had a disturbing dream in which the ghost of Lorenzo de' Medici appeared before him, almost naked in a tattered black cloak, and instructed the musician to tell Piero 'that shortly he would be chased from his home and he would never go back'. The lyre player confided in Michelangelo, who urged him to do as the phantom Lorenzo had said – but Cardiere was too frightened. Michelangelo met Cardiere one morning some time later in the courtyard of the Palazzo Medici. The musician was visibly upset. Lorenzo had again appeared to him during the night and boxed him on the ear for not having carried out his orders. This time Michelangelo cajoled him into doing what the ghost wanted. Cardiere set off for the Medici villa outside the city at Careggi where the court was staying. En route he encountered Piero and his entourage riding in the opposite direction and told them about his vision, but they just made fun of him.

Piero called his grooms over, and 'encouraged them to keep jeering'

at Cardiere. Then 'his chancellor, who later became Cardinal Bibbiena, said to Cardiere: "You're a madman. Do you think Lorenzo prefers his son or you?" Two days later, fearing that Lorenzo's ghost's warning would come true, Michelangelo fled the city with two companions.

Some things about this story are plausible. The frivolous flight from reality of Piero de' Medici and his entourage was mirrored in a series of letters from precisely the man Michelangelo mentioned, Bernardo Dovizi (1470–1520), later Cardinal Bibbiena. These jokey, gossipy reports were written from the camp of Florence's allies, the Papal–Neapolitan army, between 2 September and 25 October 1494. They suggest that Piero and his advisors were in denial about the seriousness of the crisis they faced. These letters also help to date Michelangelo's flight.

If the detail about Dovizi being present and joining in the ridicule is correct – and it would have been an odd thing to get wrong, since Michelangelo knew this man for decades – then it means that the incident happened before Dovizi left Florence at the beginning of September (since the artist was gone by the time he returned). Therefore, rather than wait until the French army was approaching the city, Michelangelo withdrew early. It may be that, having seen Piero de' Medici at close quarters for years, he had no confidence at all in his political ability. This would not be the last time that Michelangelo foresaw an approaching disaster and got out fast. He also had a tendency eventually to return.

In Tiberio Calcagni's copy of Condivi there is an annotation after the story of Cardiere and his dream: 'He told me he had heard this from others, confirming the dream, however, anticipating the flight of the Medici from the words of various citizens, he left.' The phrasing of this is confused; probably the meaning is that Michelangelo confirmed the tale of the dream, but added that many people he talked to were predicting the fall of the Medici, and that was really why he fled.

This also seems convincing. Michelangelo did not leave his post at court, his income and hometown simply because of a Flemish musician's dream. Florence was buzzing with grim prognostications. It did not need supernatural intervention to see that the prospects were terrifying. There was a strong chance that the city, one of the richest in Europe, would be savagely sacked – as Rapallo had been – by an army made up of northerners regarded by fifteenth-century Italians as barbaric.

By mid-October at the latest, Michelangelo had gone. On 14 October a Florentine sculptor named Adriano who had moved to Naples was sent a letter by his brother, Amedeo, in Florence. Amedeo reported that Michelangelo had left his position at the sculpture garden and gone to Venice without warning, adding that Piero de' Medici had taken this desertion very badly.

The next month Piero de' Medici's regime fell. Badly miscalculating negotiations with Charles VIII, he handed over the strategic fortresses and strongholds of the city. This in turn so infuriated the Florentines that on 8 November Piero had to flee the city, riding past the garden at San Marco and out of the Gate of San Gallo. Henceforward, like his father, he had a nickname: Lorenzo went down in history as the Magnificent; Piero as *Il Fatuo*, the Unfortunate.

*

Michelangelo fled to Venice with his two companions. However, they stayed for only a few days, because money began to run out – Michelangelo was footing the bills, suggesting that at nineteen he was already the senior member of the party, a fledgling master. He decided to return to Florence, but only got as far as Bologna, where chance intervened.

Bologna was, from the contemporary Florentine point of view, like Venice, in a foreign country: on the other side of the Apennines, speaking a somewhat different language, with its own history, food and government. The most notable feature of Bologna was that it was the location of a great university, the oldest in Europe (where, Michelangelo would have noted with interest, medical dissections had taken place in public for centuries). Strictly speaking part of the area of Italy ruled by the Pope – the Papal States – in practice, the city and its territory had been ruled by the Bentivoglio family for most of the century. At the time, Bologna enforced a sort of archaic visa system. When foreigners first arrived in the city, they had to present themselves at the Ufficio delle Bullette to receive a red wax seal, which they had to carry on the middle finger of their hand. This, Michelangelo and his companions had failed to do, and they were found out and taken to the office, close to the Piazza del Comune. They had to pay 50 small coins called *bolognini* as a fine, and Michelangelo did not have the money.

At this point, in an awkward predicament, Michelangelo encountered a saviour in the form of a Bolognese nobleman named Gian Francesco Aldrovandi. He was one of the Sixteen – that is, the *Sedici Riformatori*, a hereditary council of patricians who had authority in the city, and therefore over the petty bureaucrats administering foreigners' seals.

Aldrovandi, seeing Michelangelo, had him set free, 'especially having recognized that he was a sculptor'. This last remark suggests that Aldrovandi – who was an admirer of Tuscan culture and knew Florence well – already knew Michelangelo at least by sight and reputation (and hence this meeting was perhaps not so chance after all). He invited the young artist to stay in his nearby palazzo, at which Michelangelo remarked that he 'unfortunately had two companions with him whom he could not abandon, though he did not want to bother Aldrovandi with them'. The nobleman replied: 'I'd come and travel the world with you too, if you'd pay all my bills!' Persuaded by this, Michelangelo decided to leave his two fellow-travellers in the lurch after all. So, having turned out his pockets and handed over what money he still had to them, he went off with Aldrovandi.

The whole episode seems like an adventure – almost a lark, except perhaps for those companions, left to cope as best they could with Michelangelo's small change as a budget. You feel that Michelangelo was exhilarated at being, for the first time in his life, out on his own, having got away from Florence, his family – and the Medici. Even when the exiled Piero and his court turned up in Bologna, it seems his ex-household sculptor and advisor on antiquities did not join them. He remained, according to Condivi, with his new patron in his house on Via Galliera, a grand street in the centre of Bologna. Aldrovandi 'did him great honour, being delighted by his intelligence'. Every evening the Bolognese patrician would have Michelangelo read to him, something 'from Dante or from Petrarch and now and then from Boccaccio, until he fell asleep'.

It sounds like an idyll, even a romance – although no more information is available about Michelangelo's relationship with Gian Francesco Aldrovandi – but there is also a clue suggesting that Michelangelo had learned more from Poliziano than just the subject of *The Battle of the Centaurs*. To read verse aloud requires understanding. Evidently, at twenty, he was already well acquainted with the great classics of the

Tuscan vernacular: Boccaccio, Petrarch and Dante. He was therefore already on his way to becoming what he later was: an artist-poet.

*

The first works Michelangelo made in Bologna after he fled Florence were three small religious statues. The account in Condivi suggests this commission came about quite casually. One afternoon, while his host, Gian Francesco Aldrovandi, was showing Michelangelo around Bologna, they went into the church of St Dominic, where the elaborate sculptural decoration of St Dominic's monument was still unfinished. Several small marble figures were missing from this complicated stone confection, known as the Arca di San Domenico.

Finishing the shrine of their founder was an important matter for the Dominican order. The saint himself, who died in 1221, had asked to be buried in a plain, brick-lined vault. This had been replaced by a more ornately carved monument after his canonization in 1234, but in 1469 it was decided that even this was not sufficiently impressive.

A sculptor named Niccolò was commissioned to make an intricate cover for the sarcophagus, consisting of a two-tier roof-like structure flanked by festoons of fruit, dotted with figures of saints and topped off with a figure of God the Father standing on a pinnacle like a candle-stick. Eventually, it came to be some 20 feet high. For some unknown reason, Niccolò (known as Niccolò dell' Arca from his labours on this sculptural fantasia) never quite finished it off. He died on 2 March 1494, seven or eight months before Michelangelo arrived.

One can't help wondering whether Michelangelo already knew that this handy sculptural commission was waiting in Bologna, and that was why he headed there when he left Florence. Someone who would have known all about the Arca of St Dominic and its distressing state of incompletion was Girolamo Savonarola, who had been a senior academic tutor at the Convent of San Domenico for three years before his return to Florence. He would have wanted the work to be done by a sculptor of great talent. There is no direct evidence that the two men communicated, but it is quite possible they did.

Aldrovandi asked Michelangelo if he 'dared' make the little statues for the Arca, and he simply answered 'Yes'. It wasn't a prominent

Angel, 1494–5, Arco di San Domenico.

commission, but it was in some respects a tricky one. The most conspicuous of the missing figures was an angel for a position low down, at the front. It must have been painfully obvious that the angel was missing, because Niccolò had already made its companion on the left-hand side. Michelangelo was thus faced with a delicate problem: how to make a counterpart to a work by an artist of an older generation in a style that must have seemed outmoded. His angel had to fit into the ensemble while quietly proclaiming his own talent.

The result stands out, but does so discreetly. The candelabrum-bearing figure Michelangelo carved echoes the pose of Niccolò's on the other side, but it is different in body type. Angels are traditionally held to be sexless, and it is indeed hard to allocate a gender to Niccolò's slender, elegant creature with long corkscrew curls of hair. Michelangelo's angel, in contrast, despite two small breast-like bulges on its chest, looks unequivocally male: chunkier, more four-square, with powerful-looking biceps and shoulders beneath its robes.

Condivi mentions only two figures Michelangelo carved for the Arca: the angel and *St Petronius*, for which – typically – he remembered the prices: 18 ducats for the former, 12 for the saint. The text doesn't mention the third, *St Proculus*, which might mean either that Michelangelo was not pleased with it, or that either he or Condivi had become muddled by having to list two obscure Bolognese saints whose names began with 'P'.

The little statuettes Michelangelo made in Bologna were small, highly finished objects, less than 2 feet high: not the kind of pieces that were likely to make his reputation. The angel is reasonably visible, but the other two figures are high up. We look at them hard now, because we know that they are by Michelangelo and, consequently, see hints of his future work. For example, *David*'s frown is detectable in the knotted brows of *St Proculus*, whose little figure's air of heroic determination makes him seem to stride from the fifteenth century into the sixteenth. Yet the truth is, no one seems to have noticed these miniature figures at the time.

Pleasant though life in Bologna was, the opportunities for a sculptor there were not very great: apart from the Arca, there were few other prospects of work. After a year, Michelangelo decided it was time to go home, as things there had quietened down.

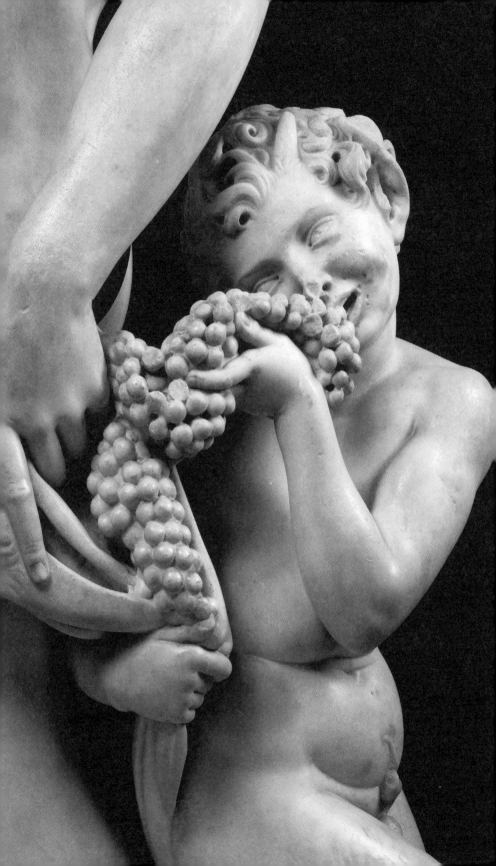

ROME: *CUPID, BACCHUS* AND THE *PIETÀ*

'The church itself is like the most expensive junk shop in the world, with that horrible smell of incense. But in the middle of all that there was this beautiful thing, full of feeling.'

– Lucian Freud, on seeing the *Pietà* in St Peter's, 2004

'The countenance of this figure is the most revolting mistake of the spirit and meaning of Bacchus. It looks drunken, brutal, and narrow-minded, and has an expression of dissoluteness the most revolting. It wants unity as a work of art – as a representation of Bacchus it wants everything.'

– Percy Bysshe Shelley on Michelangelo's *Bacchus*, 1820

M ichelangelo returned to a city transformed. In the fraught days of November 1494 Savonarola, from being a greatly admired preacher, became, in a strange way, the successor of the Medici: the guiding voice of the city. After the flight of Piero de' Medici, the French had briefly occupied the city then, rather than sacking it, as had been feared, unexpectedly withdrew, apparently unwilling to risk hand-to-hand fighting in the streets – but the Florentine political landscape had been changed for ever. For the first time in sixty years there were no Medici surreptitiously pulling the levers of power behind the scenes. Without taking any post himself, Savonarola, who had acquired great prestige as a prophet, argued for a solution that was radically republican by contemporary standards. Power would rest in a new enlarged legislature, the Great Council, extended to include the *popolo*, by which was then meant the not particularly wealthy middle

(facing page)
Bacchus,
1496–7;
detail of satyr.

classes: people, in fact, like the Buonarroti. Including the poor would have been too much even for Savonarola.

Florence, in Savonarola's vision, was a city for which God had a special destiny. It was to be a beacon of holy living, from which reform of a corrupt Church and rotten social order would spread. Its ruler would not be a Medici, or any other tyrant, but Christ the King.

However, prospects for an ambitious young artist in the city were not dazzling. The new government, a loose coalition of powerful factions and individuals, was under this sway of this puritanical preacher. Even sacred art was not being commissioned as it had been before, owing to political disturbance and a new war with Pisa, 43 miles distant, and naked statuary was a regular component in the bonfires of vanities which had replaced the irreligious antics of carnival. Michelangelo clearly needed a new patron, and attached himself to Lorenzo di Pierfrancesco de' Medici.

This was a sensible choice. Lorenzo di Pierfrancesco had been brought up at the court of Lorenzo the Magnificent; a patron of Botticelli, he clearly had discerning taste in the visual arts. Politically, he was now an influential man. He and his brother had enthusiastically joined the anti-Medici revolt with a new, revolutionary, surname: Popolano. For Lorenzo, Michelangelo made 'an infant St John'.

Next, Michelangelo 'applied himself to making a god of Love'. This *Cupid* – which vanished centuries ago – represented the ancient god as a chubby toddler: a putto or amorino. Michelangelo called it a *bambino* – a baby. It was closely modelled on an antique sculpture of a sleeping cupid that was in the collection of Lorenzo the Magnificent and hence well-known to Michelangelo. Indeed, it seems to have so closely followed this model that it brings his copy of Schongauer's print to mind. It sounds like another case in which Michelangelo tried to emulate a work he admired while at the same time striving to outdo it.

This time, however, the affair went a lot further than simply rivalling and copying an earlier work. Michelangelo's *Sleeping Cupid* was sold as a genuine antiquity to a wealthy Roman cardinal, Raffaele Riario. Before that happened, though, it had been deliberately aged by similar methods to those a modern forger might use: it was buried to give the marble an artificial patina of venerability. This is clear from the sources,

but a fog descends over the crucial matter of who exactly was responsible for the faking.

Condivi, presumably following Michelangelo himself, gave credit for the skilful ageing of the marble to the artist but attributes the idea of doing it to Lorenzo di Pierfrancesco. It is at least as likely, however, that the scheme was cooked up by the young artist, desperate for money, all on his own.

The *Sleeping Cupid* was sent to Rome, where a business contact of Lorenzo's named Baldassare del Milano sold it to Cardinal Riario for a good sum, 200 ducats. At that point, however, the scam unravelled. Baldassare, in the manner of dealers, felt that he had done the truly important work – the selling – and suggested that 30 ducats was a reasonable amount for the artist's share. Michelangelo was infuriated by this.

Next, somehow the cardinal heard that his new Roman sculpture had in fact been carved recently in Florence. He was 'indignant at being tricked', and the fact that his bank account was credited with 200 ducats on 5 May 1496 suggests that he insisted on a refund – and got one. Then Riario dispatched a Roman financier named Jacopo Galli (or Gallo), who looked after his business affairs, to discover who had made this marvellous thing.

This might seem to be contradictory – rejecting the fake while simultaneously trying to discover and recruit the artist who had made it – but the Renaissance attitude to forgery was not the same as the modern one. The contemporary view – or at any rate, Riario's – seems to have been that making this new work seem old was a brilliant feat but that then selling it as an antiquity was sharp practice. The agent for Isabella d'Este, Marchioness of Mantua and avid collector, who finally ended up with the *Sleeping Cupid*, also thought it was worth less as a modern work than as an antique.

After he arrived in Florence, Galli visited various artists' studios and came eventually to Michelangelo's house. When he saw the young Michelangelo, 'being wary of revealing what he wanted', Galli asked to see some work. As it happened, Michelangelo had nothing on hand to show him, so he took a quill pen and drew a hand 'with such grace and lightness' that Galli 'stood there stupefied'.

This story is suspiciously reminiscent of other anecdotes of great artists impressing with a demonstration of drawing, such as the legendary circle by the young Giotto. On the other hand, witnessing Michelangelo produce a sketch in front of one's eyes – and one with which the artist was pleased, since the description of its 'grace and lightness' is presumably his too – might well have been a stupendous experience. In any case, Galli then asked Michelangelo whether he had ever made a work of sculpture, and when Michelangelo replied that, yes, he had, a *Sleeping Cupid*, giving the correct dimensions, he was convinced he had the right man.

The lost *Sleeping Cupid* seems to have beguiled the connoisseurs of the late fifteenth century because it fulfilled a collector's fantasy of the day. It looked exactly like a Roman sculpture but, unlike genuine antiquities, it was in perfect, pristine condition. If it ever turned up, it would probably disappoint us for the same reasons. In retrospect, the most important thing about it was that it propelled Michelangelo to Rome.

*

The first letter in Michelangelo's huge correspondence was written there on 2 July 1496. It is to Lorenzo di Pierfrancesco, but addressed to Sandro Botticelli – perhaps so the painter could forward it to Lorenzo, wherever he was. It began by telling Lorenzo that 'we' – presumably Michelangelo, Jacopo Galli and his servants – had arrived safely the previous Saturday, 25 June.

Rome was, as far as fifteenth-century Florentines were concerned, like Bologna, another country. The Romans were an alien people with a somewhat dissimilar language, history and habits. In 1496, Florence was a tightly packed late-medieval town in which, in retrospect, we can see such features of modern life as capitalism, high finance and democratic politics beginning to emerge. In contrast, Rome was a city whose development had gone into reverse. For hundreds of years it had been the centre of Western civilization, one of the most advanced places on the globe. Then came conquests and sacking: decline and contraction had followed, with the result that in the late fifteenth century the population of Rome was much smaller than it had been in the fourth.

The city Michelangelo entered was a settlement nestling among the

remnants of the ancient metropolis. Medieval Romans colonized the vestiges of the ancient city as sea creatures might a sunken ship. Amphitheatres and temples were turned into fortified strongholds; the monuments of the imperial capital were used as quarries for building materials. An entire neighbourhood was devoted to burning classical marbles, sculptures included, to turn them into lime: steadily reducing the glories of antiquity to powder.

When Michelangelo first saw it, the urban centre was crammed into the bend of the Tiber, around the Campo de' Fiori and the Piazza Navona, with other bustling districts across the river around the Vatican, Castel Sant' Angelo and Trastevere. Much of the remaining area within the classical walls was semi-rural, with only scattered dwellings: a zone known as the *disabitato*.

Whereas Florence made money from banking and trade, Rome was dominated by feudal aristocratic clans such as the Orsini and the Colonna. These, like the rest of the citizens, who included a large contingent of courtesans, were parasitic on the fundamental business of the place, which was religion.

Rome was the greatest place of pilgrimage, bar Jerusalem, in the Christian world. It was also, for most of the time at least, the seat of the popes, who in turn claimed spiritual and – in a more shadowy, much contested way – also political authority over Christian Europe. Thus there was a lingering sense, especially among intellectuals connected with the papal government, that Rome, ruinous and depopulated though it was, remained the *caput mundi*, the head of the world.

When the papal court was absent – as it had been from 1309 to 1378, while seven popes reigned from Avignon – Rome was a poor and provincial place. Chaotic conditions had continued for some time after the return from Avignon, which had been followed by a schism during which at one point there were three rival popes contending for the throne of St Peter. By the 1490s, however, the city was visibly reviving. New buildings were appearing, Pope Sixtus IV had laid out roads and built a bridge across the Tiber, the Ponte Sisto, the first for centuries. There was a growing appreciation of the ancient city, including its classical art – and a desire to re-create papal Rome in the style of the Caesars.

Michelangelo's first act on arriving was to call on his powerful new potential patron, Cardinal Riario, and present his letter of introduction from Lorenzo di Pierfrancesco. And Riario's immediate reaction on meeting this young man who had produced a superb carving over which he, personally, had been cheated was to tell him to go and inspect his collection of antiquities. Or, as Michelangelo put it, he 'immediately desired me to go and look at certain figures'.

By the 1490s the cardinal had one of the great arrays of antiquities in late-fifteenth-century Rome – so one of the best in existence. Two of the works that are known to have been in his possession at that time – and so very probably among the main items Michelangelo was looking at – were grand over-lifesize statues of Divine women. One, a colossal figure of the *Muse Melpomene*, is now on display in the Louvre; the other, an equally majestic *Juno*, is in the Sala Rotonda of the Vatican Museums. This was Michelangelo's first encounter with the full majesty of classical art in his own medium of choice: marble sculpture. The perusal proved so absorbing that it took Michelangelo all day.

The next day, Sunday 26 June, the cardinal sent for him again, this time summoning him to his 'new house', the huge palace that Riario was having built near the Campo de' Fiori – known from a later occupant who was Papal Chancellor as the Cancelleria. This, one of the grandest buildings of fifteenth-century Rome, was rapidly approaching completion.[1]

First, the cardinal asked Michelangelo's opinion of his collection. Perhaps Riario really wanted to hear what an intimate of Lorenzo the Magnificent thought of it, but – as immediately became apparent – he also wanted Michelangelo to add to it: 'Then the Cardinal asked me whether I had courage enough to attempt some work of art of my own. I replied that I could not do anything as fine, but that he should see what I could do.'

Briskly, a commission was arranged. Michelangelo concluded his letter with a terse announcement: 'We have bought a piece of marble for a life-sized figure and on Monday I shall begin work.' It is not stated exactly

1 In the meantime, the cardinal was staying in the Palazzo Riario, built by his uncle Girolamo, and then owned by Girolamo's widow, Caterina. It was there, in what is now the Palazzo Altemps – part of the National Museum of Rome – that Michelangelo had first met him.

who that 'we' comprises, but it must be not the artist and the cardinal but the same 'we' as arrived in Rome together: Michelangelo and Jacopo Galli. As it turned out, Galli was to prove a much more stalwart and discerning patron and friend to Michelangelo than Cardinal Riario.

Jacopo Galli (c. 1460–1505) was not wealthy in the manner of Riario – whose position was comparable to an oligarch or hedge-fund billionaire today – but he had an extremely solid position in late-fifteenth-century Rome. The family fortune had been made by his father, Giuliano (1436–88), a merchant and banker, like the Medici.

Galli was the young artist's advisor – almost his dealer – for the next few years. He also offered him his hospitality. For the next couple of years, Michelangelo took up residence in Galli's mansion. The Gallis lived in the area of Rome known as the Rione Parione, near the market-place of the Campo de' Fiori. Just beside the rising mass of Cardinal Riario's vast new palace there was an *isola*, or 'island' – that is, in Roman parlance, a city block that was a dynastic centre of power: given their name, Isola Galli.

This was more a warren than a single building, an 'agglomeration' of at least two big old houses into one substantial mansion with inner courtyards, surrounded by shops and businesses nestling in crevices of the rambling structure. Somewhere inside this complex, Michelangelo set up his workshop. Here he carved the commission he had been given by the cardinal, which was for a Bacchus, and also – according to Vasari – another sculpture, 'a marble lifesize statue of Cupid'. This last – a Cupid holding a quiver, or according to other sources, a young Apollo – might be identical with a battered statue of a naked boy discovered by the art historian Kathleen Weil-Garris in a mansion on Fifth Avenue in New York, and now on display in the Metropolitan Museum of Art. Many scholars, however, remain dubious about this appealing but ungainly work.

In the long run, Michelangelo's apparently promising relationship with Cardinal Riario turned out badly. According to Condivi, in the years that Michelangelo was in his service he gave him no commissions at all. That statement, however, is flatly untrue. The cardinal's rejection of the *Cupid* seems to have been followed by a more wounding rebuff, one that stung Michelangelo so badly he did not even mention it.

The cardinal had offered the young sculptor the reasonable fee of 150 ducats for making the marble *Bacchus*. It can even be deduced where the cardinal probably wanted to put the statue: the grand courtyard, the *cortile*, of his new palace. His finest antiquities, such as the *Muse Melpomene*, were later put just there. The *Bacchus*, unlike many of Michelangelo's statues, is a work that positively demands to be seen from all around. It is, in fact, not only a sculpture of Bacchus; the god is accompanied by a beguiling satyr who is hiding behind one of his legs nibbling grapes, so that from some angles you can't see the little fellow at all. Perhaps like the *Muse* it would have been positioned under one of the arches, where its splendid back view (and playful satyr) would have been enjoyed by those walking under the arcade, the front admired from the courtyard itself. Yet, wherever Riario was thinking of putting the *Bacchus*, it didn't end up there. Something went wrong. It is next heard of in the collection of Jacopo Galli.

What could have been the problem? Cardinal Riario was a patron of cautious, antiquarian taste. His new palace, the Cancelleria, is magnificent in its proportions, but a little dull in design. Not only did Cardinal Riario collect classical sculpture, he was also the patron of revivals of classical literature and of the humanist Accademia Romana. In 1486 the first edition of *De architectura* by the Latin author Vitruvius printed in Rome was dedicated to him. Probably, the cardinal's idea was to get Michelangelo to make a brand-new antiquity to fill a gap in his collection.

The *Sleeping Cupid* had been a copy, or at least a variation, on a well-known type of classical sculpture. The *Bacchus* is quite different, in that Michelangelo attempted to use his own imagination to make something radically new. He carved an ancient god who is very clearly drunk, reeling, unsteady on his feet. Or, as Condivi puts it, he has the 'merry face, and the squinting, lascivious eyes, such as are usual in those who have fallen excessively in love with wine'. It is, like the realism of the fruit, a spectacular sculptural effect: a standing figure who seems to stagger, who appears on the point of falling down.

Moreover, *Bacchus*'s body has been carefully configured to suggest self-indulgence. A layer of soft fat covers his ribs and pectoral muscles,

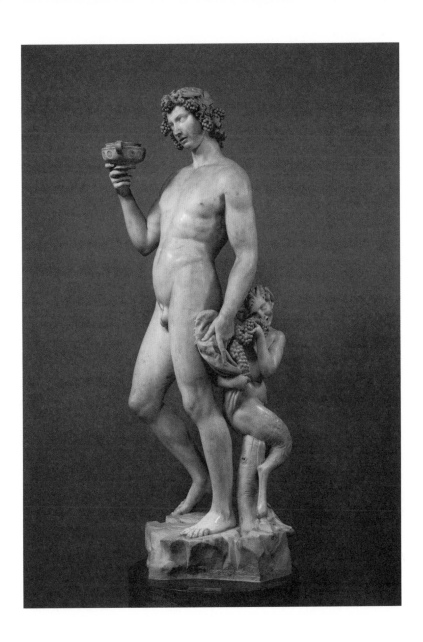

Bacchus, 1496–7.

forming breast-like pads, and his stomach protrudes. Vasari wrote about *Bacchus*'s androgyny with enthusiasm: 'the slenderness of a youth combined with the fullness and roundness of the female form'. At some point, presumably to increase the antique effect, *Bacchus*'s penis was chiselled off.

One can see why, on reflection, Cardinal Riario didn't think this was quite the right sculpture to place in his courtyard. He was not the only person to be displeased by *Bacchus*. He has proved a great favourite with art historians, who are fascinated by the possible meanings of this antique-looking yet strangely unclassical work but, otherwise, not many have had a positive word to say for it. Today, only a few visitors pause to admire it in the Bargello, in contrast to the milling crowds that perpetually file past *David*, a few streets away in the Academia.

How did Michelangelo manage to go so wrong? There was a passage in Pliny the Elder's *Natural History* describing a sculpture of Bacchus by the Greek sculptor Praxiteles that appeared to be drunk. And Pliny the Elder was an interest of none other than Angelo Poliziano, Michelangelo's literary mentor.

Bacchus, to Poliziano, was not such a respectable figure as he was to Roman antiquarians such as Cardinal Riario and his entourage. At the end of Poliziano's *Fabula di Orfeo*, a short play which was one of his best-known works, there is a wild drinking song sung by the maenads who have just dismembered Orpheus: '*Ciasun segue, o Bacco, tè/ Bacco, Bacco, oè, oè.*' ('Bacchus, all must follow you/Bacchus! Bacchus! Hey! Ohey!') This is the mood of Michelangelo's strangely unclassical sculpture – an unexpected figure to be carved in marble: louche, tipsy and out of control.

*

Michelangelo's day of excited exploration of Cardinal Riario's collection was just the beginning of a lifetime's engagement with the ancient sculptures and ruins of Rome. Already in the 1490s the first vestigial beginnings of museum collections had begun to coalesce. In the Palazzo dei Conservatori on the Capitol were the bronzes that Sixtus IV had presented, including a Hellenistic sculpture of a boy pulling

a thorn from his foot known as the *Spinario*. In 1492 Innocent VIII added the huge head and hand of a colossus which had been discovered in the Basilica of Maxentius. It was a first glimpse, for Michelangelo and his contemporaries, of a genuine classical giant. Its round, staring eyes and curly locks were repeated a few years later in his own giant, *David*.

Galli himself had a collection (among which Michelangelo's *Bacchus* was eventually displayed), as did many Roman nobles and senior ecclesiastics. Sculpture gardens were a new fashion. Antiquities were assembled in the courtyards of palaces, or surrounded the villas out of the centre of the town in which wealthy Romans liked to relax. Lorenzo's gardens in Florence were probably an imitation of this Roman fad.

Another visit we can be certain Michelangelo made was to the garden of Cardinal Giuliano della Rovere, next to the church of the Santi Apostoli, where he could see the *Apollo Belvedere*: a naked body stepping forward in graceful movement, his weight – just like *David*'s – on one leg.

*

In mid-1497, Michelangelo had just completed his *Bacchus* for Cardinal Riario and was trying to extract the final payment from him, as per contract. 'I've not yet been able to settle up my affairs with the Cardinal,' he told his father on 1 July, 'and I do not want to leave without first receiving satisfaction and being remunerated for my pains. With these grand masters one has to go slowly, because they cannot be coerced.' (Intriguingly, he used the same term, '*gran' maestri*', for Riario that Savonarola habitually employed in his attacks on the rich and powerful.)

Six weeks later Michelangelo was still in Rome, from where he wrote another letter to Lodovico. It is only possible to guess at his reasons for not leaving; there were, however, plenty of arguments for staying put.

Florence was in an increasingly serious political, economic and medical crisis. On 18 June a proclamation from the Pope excommunicating Savonarola had been read in the major churches of the city, thus giving another twist to an increasingly tense stand-off between the papacy and the new republican government. Heavy rains the

previous summer brought rocketing prices and famine among the poor (in the countryside, a contemporary diarist noted, 'Christians ate grass like beasts'), and for a month epidemic disease had gripped the population. On 2 July, the day after Michelangelo had first written, the apothecary Landucci noted that many were dying of fever and plague; on one day alone there were twenty-five deaths at the hospital of Santa Maria Nuova.

The news grew steadily worse, and many thought of fleeing the city. A week later, on 9 July, plague had broken out at the convent of San Marco, and most of the friars left for greater safety in the country. Only a few remained there, with Savonarola himself. That day, Lodovico Buonarroti's second wife – and Michelangelo's stepmother – Lucrezia degli Ubaldini da Gagliano, died. They had been married for twelve years.

This family bereavement might have seemed an additional motive for Michelangelo to return. In reality, the reverse was true. Not only was Florence a dangerous place to be, but the Buonarroti finances were in crisis. The funeral expenses for Lucrezia may have pushed Lodovico's always precarious financial position over the edge. By August he was being pursued for a debt of 90 florins by his brother-in-law Consiglio d'Antonio Cisti, the husband of Michelangelo's paternal aunt Brigida. Michelangelo had already sent his father 9 florins in March, as his bank records show, and obviously Lodovico had been frantically begging for more, and Michelangelo – who was anxious himself about his failure to please Cardinal Riario with the *Bacchus* – had answered angrily.

At long last, his younger brother Buonarroto was sent as an emissary, arriving on Friday 18 August. Buonarroto settled into an inn, as there was no room for him in the Galli house, as Michelangelo explained: 'He's got a room where he's comfortable and will lack for nothing as long as he likes to stay. I have nowhere convenient to have him with me, as I lodge with others, but it suffices that I'll not let him lack for anything.'

The day after Buonarroto's arrival – and, one gathers, a long parley about family affairs, in which Buonarroto explained that Consiglio was trying to have Lodovico arrested and generally giving Lodovico 'a

lot of trouble' – Michelangelo wrote home to his father in a more kindly spirit: 'Don't be surprised that I have at times written to you so tetchily, for at times I'm very troubled by reason of the many things that befall those who live away from home.'

Clearly, he was at an awkward point professionally. Having just failed to satisfy a hugely rich and influential patron, he was now casting around for other sources of income. One he had tried was Piero de' Medici, now in Rome, with whom he had obviously re-established relations after his flight in 1494. He had been commissioned to make 'a figure' for Piero but hadn't started it 'because he hasn't done as he promised me'. That probably meant that the first instalment of the fee hadn't been forthcoming.

Michelangelo had purchased a piece of marble for 5 ducats, presumably for the promised commission from Piero de' Medici, but it turned out to be flawed, so that was money thrown away, as he bitterly noted to his father. He'd had to spend another 5 ducats on a second piece, and, on that, he added, 'I'm working for my own pleasure.' There's no more information on what that sculpture was to be.

Piero de' Medici, though obviously still an admirer of Michelangelo's work – and, as Michelangelo's biographies do not reveal, in touch with the artist – was now an exile leading an expensive life and consequently strapped for cash. He had plotted his return to power in Florence and appeared outside the city with a small army in April 1497. The attempted coup was a fiasco, however, and his plans were further crushed on 5 August, when a group of secret Medici supporters were condemned to death, their request to appeal denied. Among these was the young, handsome, charming Lorenzo, son of Giovanni Tornabuoni, the patron of Ghirlandaio's frescoes in Santa Maria Novella. The execution of this popular young man and four other conspirators caused a sensation in Florence. Landucci, though a supporter of Savonarola's, could not prevent himself from weeping when he saw the young man's corpse carried past at dawn. Under torture, one conspirator revealed that Piero de' Medici's finances were under strain, all his valuables pawned, and his relationship with his brother, Cardinal Giovanni, disintegrating. All this might well have dampened Piero's appetite for luxuries such as sculpture. Michelangelo, living in

Rome and knowing all this, could not have had many hopes for Piero as a patron. On the other hand, there was a chance that one day a conspiracy would succeed, and Piero would return to rule Florence.

*

At some point in the 1490s – perhaps in Florence, perhaps in Bologna, most probably in Rome – Michelangelo began a small picture of the Madonna and child, with the infant St John and four angels. It is not even completely certain that Michelangelo was the painter of this unfinished picture, known from its appearance there at a celebrated exhibition in the nineteenth century as the *Manchester Madonna*.[2] Quite when or where it was painted is a matter of guesswork. Since the picture was in a Roman collection before it came to Britain, however, there is a distinct possibility – an unfinished altarpiece being an awkward object to move around Renaissance Italy on mule back – that it was also painted in Rome.

Like its date, the patron of the *Manchester Madonna* is unknown. Its relatively small size and subject makes it more suitable for a palace or a house, not a church, but it is larger than most such religious pictures used for private contemplation. The client, then, was wealthy. Michelangelo's Roman patrons were few: so far, excluding the disappointing Cardinal Riario, there was Jacopo Galli. Perhaps Galli, who was assiduously drumming up work for Michelangelo at this time, might have found another Roman commission for him. Yet one other possibility remains: Piero de' Medici, rapidly running out of money and options but still interested in commissioning work from Michelangelo.

The sculpture for him had fallen through, but he went on to order another unspecified work from Michelangelo, and this time it looks as though it was the artist who didn't fulfil what he had promised to do. On 26 March the following year, 1498, he drew 30 ducats from his bank account to repay Piero de' Medici, presumably for a work

2 This picture was doubted by many scholars at one point, and attributed to an anonymous 'Master of the *Manchester Madonna*'. There are still a few sceptics, but the consensus has swung in its favour in recent decades.

The Manchester Madonna, c. 1496.

undelivered. It's a fairly modest amount, a fifth of the fee for the *Bacchus*, but perhaps about right as payment or prepayment for a medium-sized painting.

Though unfinished, it is obvious from the more completed areas of the *Manchester Madonna* that this was intended as a connoisseur's piece, to be appreciated at close quarters. The folds of red cloth, for example, covering the Virgin's feet are painted with delicate exactitude by someone with an eye for cloth. Technically, it is a picture done by a painter who had studied the methods of Ghirlandaio. But there is a difference. This *Madonna* is the work of an artist who is – as Picasso was famously dubbed – a sculptor/painter. That is, when painting, the artist thinks in terms of carving.

The *Manchester Madonna* consists almost entirely of figures, posed – like the *Bacchus* – on a little stony platform. The composition is cropped tightly, and always was – since the panel has not been cut – so that the bodies of the outer angels are sliced off. The artist's focus is resolutely on a tightly packed, intricately interconnected mass of bodies and textiles. This is a picture by a well-trained painter whose imagination is essentially sculptural, indeed who is completely – almost perversely – lacking in interest in many of the effects that painting can produce.

There is no atmosphere, no deep space produced by perspective, no landscape (or almost none), none of the incidental charm that Florentine paintings of the Madonna and child, Ghirlandaio's included, usually provided: blue, distant mountains, paths, flowery meadows, the towers and walls of nearby cities. The neat, parallel brush-strokes of the underpainting of the Virgin's mantle and of the rocky plinth irresistibly suggest the marks left by a claw-chisel in marble.

Instead of landscape and atmosphere, there is an almost fierce concentration on form, so sharply defined as to seem almost polished and hard in the most nearly completed sections, such as the figure of the infant Jesus. The beauty of the picture and the expression of its religious message come from bodies, and as was always to be the case with Michelangelo, close attention to the fine detail of anatomical forms. Much of the story of the picture is told, for example, in the language of hands and fingers: the Christ child reaching out to point

at the prophecy of his passion, the other hand clutching, toddler-like, at the fabric of his mother's mantle, her hand holding the book. Only the infant Baptist fixes us with a look, underlining the significance of the moment.

Apart from a glimpse of green at the sides, of sky above, it is an image that could be carved. One block of marble might even suffice; at most, three – one for the central group, two more for the angels on either side – would be enough. The angels themselves are adolescents, and distinctly male – the one whose finished face is turned towards us looks like *Bacchus, David* and *St Proculus.*

Beautiful young male angels were a feature of Florentine Madonnas by artists such as Botticelli. However, the angels of the *Manchester Madonna* are graver. A detail, perhaps accidental, brings Savonarola's youthful moral enforcers to mind. The preacher frequently exhorted his young followers to have their hair cut about their ears – long, flowing locks being associated with loose morals and wild living. Michelangelo's angels have abundant, curly manes, but their ears are carefully left exposed.

If Michelangelo was indeed painting the *Madonna* in the early autumn of 1497, he abandoned it because he had something much better to do. Not a private, devotional picture which would be hidden away in his patron's apartments but a monumental marble sculpture to be installed in the most important church in Western Christendom. Nothing could have been more calculated to establish his reputation, or more to his taste, since marble was his medium of choice. It was a recurring pattern in Michelangelo's career for him first to accept a commission, then neglect it or give it up entirely when something better came along. On occasion, though, more rarely and – one suspects – most reluctantly, he returned the money he had been paid for the abandoned work.

By the late autumn of 1497 Michelangelo had been given a commission by one of the most important French clergymen in Rome, Cardinal Jean de Bilhères-Lagraulas. The cardinal succinctly explained what he had in mind in a letter written on 18 November to the Elders of Lucca: Michelangelo was to 'make a *Pietà* of marble, that is, a clothed Virgin Mary with the dead Christ, nude in her arms, to be installed

in a certain chapel we intend to establish in St Peter's in Rome, in the chapel of Santa Petronilla'. The arrangement was then quite recent; the cardinal says he has 'newly' agreed on the project.

This had come about through the eloquent advocacy of Jacopo Galli, who vouched for Michelangelo in the final contract, boldly promising that his protégé would finish the work in a year and that 'it will be the most beautiful work of marble that exists in Rome today, and that no master today could do the work better.' Michelangelo – as Jacopo Galli would surely have pointed out – was a brilliant young artist who could carve with exceptional, unprecedented levels of naturalism. The living textures of the classical, dissolute *Bacchus* – which surely the cardinal would have been shown – could be used to give the sacred beings of the *Pietà* an almost hallucinatory presence.

De Bilhères was an eminent Gascon clergyman and experienced diplomat. Abbot of St-Denis since 1474, he had also been, successively, ambassador to Spain and sent on a diplomatic mission to Germany, and had risen through the French Church until – probably around the age of sixty – he was appointed ambassador to the Holy See by the youthful King Charles VIII. He was well-known to Cardinal Riario, and hence to Jacopo Galli. His ideas about art, architecture and other matters, therefore, had been set in late-fifteenth-century France, where there were numerous examples of lifesize sculptural groups of *The Entombment of Christ*. The *Pietà* was *The Entombment* reduced to its emotional essence: mother and dead son. It was a type of monument common in France and Northern Europe, but not in Rome: a way of making a patriotic point. One of the greatest of late-fifteenth-century French *Entombment*s is at the Abbey of Solesmes in the Loire Valley, dated 1496 and bearing the arms of Charles VIII, de Bilhères's royal master. It is also lifesize and placed low so that the figures are on a level with the spectators. This was how de Bilhères *Pietà* was to be positioned in Rome.

The fee was three times as much as Michelangelo received for the *Bacchus*, and the work was prominent enough to make his reputation. It needed his whole attention. By the third week in November he had set off for Carrara to oversee the quarrying of the block of marble for

this carving in person, presumably guided by local quarrymen, but making the final choice himself. A piece was selected, but in a high and inaccessible zone. Over a quarter of a century later, one of Michelangelo's right-hand men, Domenico di Giovanni da Settignano, known as Topolino, or Little Mouse, wrote, telling him that he had tracked down some good bits of marble 'right under' the point on the rock wall where the piece for the *Pietà* was located,'on the slopes of Polvaccio, that difficult spot where you know they are of good quality'.

*

By 13 January 1498 Michelangelo's friends in Rome were beginning to worry, as he had not bothered to get in touch. We know this from a letter sent to Florence, to Buonarroto, by a new figure in Michelangelo's life: an assistant. Nothing is known about the origins of this young man, except his name – Piero d'Argenta, or Peter from Argenta – and that his father's name was Gianotto, or Giovanni. It seems, from a couple of shreds of evidence, that he had been Cardinal Riario's hairdresser, so living across the street from Michelangelo in the Cancelleria. Vasari mentions that Michelangelo became friendly with 'the cardinal's barber, who had been a painter and worked very studiously in tempera, though he had no draughtsmanship'.

Apparently, Michelangelo drew a cartoon for this artist-cum-barber, to help him paint a little altarpiece of St Francis receiving the stigmata. This painting, which vanished centuries ago, was in the church of San Pietro in Montorio. Another sixteenth-century text mentions that the painter was Piero d'Argenta, so the circle seems to be complete. Piero was evidently part of Michelangelo's circle by the summer of 1497, when Buonarroto Buonarroti came to visit for the family financial-crisis conference, because later he wrote to Buonarroto in the most friendly terms. Nothing more is known about Michelangelo's feelings for Piero, but Piero remained loyal and affectionate for decades. At the time of the siege of Florence in 1529/30, and subsequently, he sent touching letters enquiring after Michelangelo's welfare and offering him a refuge – if he needed one – in his own house. It is fair to say that their relationship seems unusually close for that of master and apprentice. Over the following decades Michelangelo frequently

showed extremely strong feelings for younger men in his household, nursing them anxiously when they fell ill and – when one died – expressing a degree of grief verging on despair.

For his part, Piero seems to have thought of himself as virtually a member of the Buonarroti family. His gossipy letter to Buonarroto in January 1498 was motivated by anxiety about the sculptor, who was absorbed in selecting his block of marble: 'Master Jacopo Galli and all of us wonder that he hasn't sent a word.' Had Buonarrato heard any news? Piero ended on a light note, although admittedly his fifteenth-century sense of humour now seems appallingly heartless. The only news, he wrote, was that there'd been a blizzard at Rome, and they'd all been up to their arses in snow. There wasn't any fire to warm them, so a couple of malefactors had to be burnt alive in Campo de' Fiori 'for their good works'.

Piero asked Buonarroto to give his regards to Fra Girolamo (Savonarola), a standard tease of the time by an outsider in address to a Florentine, since the fact that the city had fallen under the influence of a mere preacher was widely regarded as ridiculous, particularly in Rome, where the onslaught on Savonarola was about to enter its final stages.

The winter was very severe that year in central Italy. On 17 February Landucci noted that the cold was 'intense' and that there had been frost for two months. It must have been freezing fiercely up in the mountains above Carrara, hampering the process – difficult and dangerous at any time – of extracting the block from the cliff face using chisels and wedges, then manoeuvring it down precipitous slopes on a sledge-like platform known as a *lizza*.

It was 9 February before Michelangelo was paid some expenses for a bridle and harness for the horse to pull the cart for the marble – suggesting the load had finally reached the bottom of the market and could be transported on wheels instead of a sledge. After that, he returned, evidently via Florence, because he carried back with him a reply from Buonarroto to Piero. He must have passed through the city around the time of the last and biggest of the bonfires of vanities organized by Savonarola's brigades of puritanical youths. On 27 February in the Piazza de' Signori, a pile of 'nude statues and

playing-boards, heretical books . . . and many other vain things, of great value, estimated at thousands of florins' was set alight. It was attended by processions of boys carrying crosses.

On 10 March Piero d'Argenta wrote again to Buonarroto. Michelangelo had returned, but the marble had not yet arrived. There was no news from Rome, according to Piero, except that nine people had been put in the pillory the day before, and five hanged.

The tragedy of Savonarola was coming to a climax. Pope Alexander VI was determined to destroy him; in Florence, relentless pressure from Rome was tilting the balance against him. According to Piero d'Argenta, 'the Seraphic Brother Girolamo . . . is making the whole of Rome talk about him – and what is said is that he is a rotten heretic.'

Piero suggested he should come to Rome, where he would be 'canonized'. That would have meant, in all probability, being burnt alive in the Campo de' Fiori, an extremely short walk from the Isola Galli, where Michelangelo lived and worked. Savage executions took place there regularly. On 7 April 1498, for example, there was a spectacularly horrible death, of the Moorish – presumably black – servant of a courtesan named Cursetta. He had been in the habit of going around wearing women's clothes under the name of 'Spanish Barbara' and committing acts of ignominy that Johann Burchard, the Papal Master of Ceremonies who narrated these events, could only guess at. 'Spanish Barbara' was taken to the Campo de' Fiori with his dress raised so that all could see his testicles and burnt at the pillory (though there was trouble getting the fire to light, owing to the wood being wet after heavy rain).

Piero d'Argenta regarded such spectacles as a diverting part of daily life, which was probably the general contemporary response. What Michelangelo thought is not recorded, but there are hints that this harsh treatment powerfully affected his imagination. The images he created in stone and on paper, and also the imagery of his poetry, are often connected with punishment and imprisonment. Binding, torture, captivity come naturally to his mind as metaphors for his own fate as a hapless lover, or simply for the human condition. A madrigal by Michelangelo of around 1544/5 begins: 'One who's led from a court

of justice to the place/Where the soul leaves the heart/Walks no less unwillingly/Than I do towards death.'

It is hard to avoid the sense that his emotions were caught in a trap. His strongest feelings of physical desire were denounced as sinful by the Church in which he believed; and if the law were strictly applied – as it generally was not – such desires were punishable by death. This position seems to have bothered some of his contemporaries little enough – senior clergymen among them – but it probably troubled the serious-minded, pious Michelangelo very much indeed.

For his part, Girolama Savonarola was very soon to be walking towards death. In March his support collapsed after an awkward failure. The Franciscans of Santa Croce challenged Savonarola's Dominicans to an ordeal by fire, to discover which was truly favoured by God. It ended on 6 April in a stand-off. An elaborate raised structure, packed with brushwood and soaked in pitch, oil and gunpowder, was set up in front of the Palazzo della Signoria. An assistant of Savonarola, Fra Domenico da Pescia, had volunteered to pass through this fiery passage, but the Franciscans made a series of objections to the arrangements and, eventually, it began raining.

The result was that nobody walked through the flames, but Savonarola was the loser. The Florentines had expected a miracle, and no miracle was forthcoming. The next day, the convent of San Marco was besieged;[3] Savonarola and his lieutenants were taken prisoner. He was tortured, forced to confess to being a liar and a fraud, recanted, was tortured again and finally hanged with two of his companions on 23 May. Their bodies were then burnt and Savonarola's ashes scattered to prevent his relics becoming the focus of a cult. That stratagem did not work. The friar's death was the end of an epoch in Florentine history, but the cult of Savonarola was just beginning.

*

On 7 April, the same day that Spanish Barbara burnt, Cardinal de Bilhères wrote to the Signori of Florence (who were busy subjecting

3 Among its defenders were members of the family that specialized in glazed terracotta sculpture, the della Robbia.

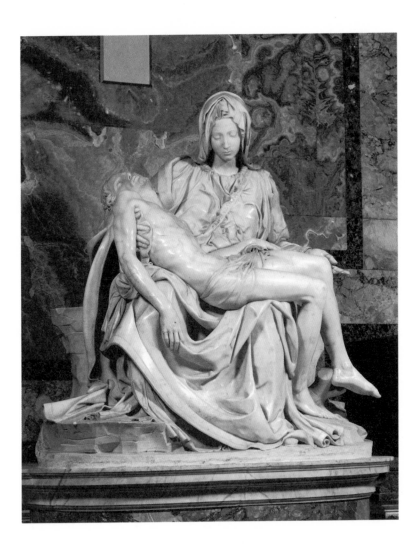

Pietà, 1498–1500, Basilica di San Pietro, Vatican.

Savonarola to agonizing interrogations). De Bilhères asked the Signori to assist with the transportation of the stone for his *Pietà*. He complained that '*uno nostro*' (one of his servants) was being impeded in the quarrying and transport of marble. The problem may have been to do with the tax on exports of marble from his lands that Count Alberico, Marquis of Massa and Carrara, was sharply increasing at this time. With one delay after another, for over two months Michelangelo continued to pay for moving the stone as it progressed to the mouth of the Tiber and was finally unloaded at the port of Ripa in June. While he was waiting for the stone to appear, it is likely that he was refining his ideas for his sculpture.

In the finished sculpture, the apparent age of the Virgin is one of its strangest aspects. She looks to be a teenager or, at most, in her early twenties. By the time Condivi came to write, in the mid-sixteenth century, this odd feature of the *Pietà* was clearly causing comment, and it is one of the points at which Michelangelo himself seems to step out from behind the respectful narrator and address the reader directly.

Condivi explains that he put this question to the great man, who explained that a woman of the Madonna's chastity, uncorrupted by 'a single lascivious desire', would preserve her youthful appearance for much longer than normal. This virginal freshness, in his opinion, would have been miraculously maintained by God as a way of emphasizing her purity.

This reason, though ingenious, is distinctly implausible. Yet, whatever his motive, Michelangelo carved a Madonna of a kind that would have been suitable for a sculpture of the Virgin and Child. This lends poignancy to the sculpture: a young woman of child-bearing age holds, instead of a baby, the corpse of her adult son on her knees.

This sense that this is a parent and child is accentuated by the huge scale of the Madonna: if she stood up, she would be a giantess. Her shoulders are broad, her knees like the two towering sides of a high mountain valley (not unlike the high peaks above Carrara, indeed). The oddity, once you notice it, is extreme, but, as so often with Michelangelo, the strangeness is inseparable from the power of the work.

The true explanation perhaps was his sense of artistic decorum. The goddesses of ancient Greece and Rome were not middle-aged; a divinity such as the Madonna should appear ideally youthful – or at least she should to a mind as absorbed in classical antiquity as Michelangelo's was in 1498. The theological explanation would have been worked out long afterwards.

*

Today, Michelangelo's *Pietà* is a prime case of a work of art too famous for its own good. In the twenty-first century you see it – or try to see it – at a distance, behind bullet-proof glass. The visitor stands among a jostling scrum of other tourists, straining to appreciate the work far away but brightly lit. This is exactly contrary to the way in which Michelangelo expected his sculpture to be experienced.

Its original destination, the chapel of Santa Petronilla – demolished when Bramante began to rebuild St Peter's a decade later – was a fourth-century Roman mausoleum. The evidence – not least the evidence of the sculpture itself – suggests that it was positioned to glitter in light filtering down from the windows in the rotunda above. It is a work of extraordinary surface detail and refinement. Vasari described the almost naked body of Christ with ecstatic enthusiasm: 'It would be impossible to find a body showing greater mastery of art and possessing more beautiful members, or a nude with more detail in the muscles, veins, and nerves.' Yet, as William Wallace has pointed out, the body and head of Christ become visible only when seen from the vantage-point of someone standing approximately on the same level as the sculpture itself. The *Pietà* was made to be seen close up, and in half-light, its pure white surfaces shining in the gloom.

If Lorenzo de' Medici, in Machiavelli's view, was two people held together by an impossible fusion, the same could be said of Michelangelo's artistic personality. In the *Pietà* he yoked together the most intensely emotional image in Northern European pious contemplation with the serene features and flawless, anatomically accurate nudity of classical art. The most classical touch was his own signature. On a band crossing the Virgin's breast Michelangelo inscribed the words

'MICHAEL.A[N]GELUS.BONAROTUS.FLORENT.
FACIEBA[T]' ('Michelangelo the Florentine was making'). Vasari
has a vivid story about why he did this:

> One day he went along to where the statue was and found a crowd of
> strangers from Lombardy singing its praises; then one of them asked
> another who had made it, only to be told: 'Our Gobbo from Milan.'
> Michelangelo stood there not saying a word, but thinking it very odd
> to have all his efforts attributed to someone else. Then one night, taking
> his chisels, he shut himself in with a light and carved his name on
> the statue.

That can't be true, as told, because the band on which Michelangelo
inscribed his signature is an integral part of the design, and it has no
purpose except to bear those words. Therefore, he must have intended
the sculpture from the start to be an advertisement for himself.
It seems likely, however, that he was keen to point out that it was
indeed his work, and not that of a competitor such as Cristoforo Solari
(1468–1524, and known as Il Gobbo, or 'the hunchback').[4]

Michelangelo's signature was in the imperfect tense: *faciebat*. This
was an elegantly scholarly reference to a passage from the preface to
Pliny's *Natural History*. The Latin author had described the modesty
of great Greek artists such as Apelles and Polyclitus, who had signed
their works in just this way, 'as though art was always a thing in pro-
gress and not completed'. Michelangelo had probably heard about this
passage in Pliny long before; it had been noted and emphasized
by his old mentor Poliziano (who had found a version of it on a
marble fragment in Rome in 1488, close, as it happened, to Jacopo
Galli's house).

This form of signature proclaimed that perfection in art was
an ideal, never likely to be attained – which appealed to Michelan-
gelo's temperament. He added a witty touch of his own. The word
faciebat is itself unfinished, the final 'T' disappearing behind a fold
of cloth.

4 Another bitter rival, Pietro Torrigiano – the bully of the sculpture garden who had
smashed Michelangelo's nose – was recorded in Rome in 1498.

This, the most elaborately finished of all his sculptures, is the only one which Michelangelo prominently points out could still be further perfected. He never signed anything ever again, because he didn't need to. From this point onwards, it was always obvious whose work this was. It was installed by July 1500 – if not before. The *Pietà* made his name: he was twenty-five years old.

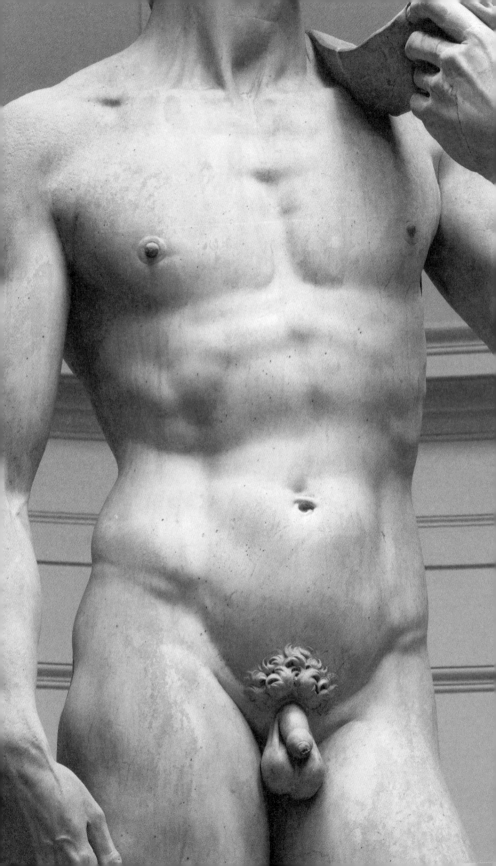

DAVID AND OTHER BODIES

'[Michelangelo's] plastic problem was neither the mediaeval
one, to make a cathedral, nor the Greek one, to make a man
like a god, but to make a cathedral out of man.'

– Barnett Newman, *The Sublime is Now*, 1948

'With Michelangelo anatomical science is transformed into
music. With him the human body is architectonic matter for
the construction of dreams.'

– Umberto Boccioni, *Futurist Painting*, 1911

On 2 September 1500 Michelangelo was credited with 60 ducats for a painting for the church of Sant' Agostino in Rome. Once again, it seems Jacopo Galli had found him a job. The picture was to be the altarpiece of a chapel endowed by Giovanni Ebu, the deceased bishop of Crotone. The bishop had died in 1496, and the winding up of his affairs was in the hands of Cardinal Riario. However, the cardinal himself was now in exile, having decided it would be safer to leave when the political climate in Borgia Rome became menacing.[1] Two of his men of business were left in charge of setting up the bishop's chapel, one of whom was Galli.

The late bishop of Crotone's chapel was dedicated to the *Pietà*, and so in all probability what Michelangelo was asked to paint was another, quite different, depiction of Christ's dead body. Many, but not all, scholars believe that he began but did not finish the picture, and that

1 The Pope's son, Cesare Borgia, attacked the della Rovere family's old possessions of Forlì and Imola.

(facing page)
David, 1501–4;
detail of
upper body.

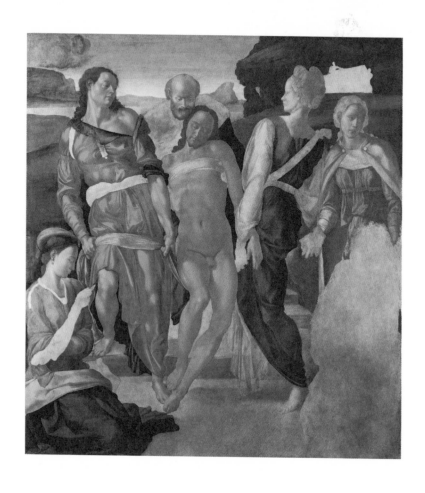

The Entombment, c. 1500–1501.

it is the panel now in the National Gallery, London, known as *The Entombment.*

The colours have faded unevenly, so that the orangey red of St John's robe zings out, but this was not the artist's intention. According to the original chromatic scheme, that red would have been balanced by a strong olive-green robe on the Mary who is holding up Christ on the other side, while Mary Magdalene was to have had an outfit in sky blue and strong pink, and the Virgin presumably the deep blue of lapis lazuli. The body of Christ would have been encircled by an aureole of richly dyed fabric.

He is totally nude and is being held in such a way that he seems to float, almost upright, in front of us. As the art historian and Michelangelo scholar Michael Hirst has pointed out, the first description of the work in the 1649 inventory of the Roman collection it was then in (the Farnese) is more accurate: *Christ Carried to the Tomb.* The focus of the picture is a beautiful male corpse, virtually unmarked by the ordeals of the flagellation and crucifixion. Ostensibly, the three people around Christ are carrying his body up a flight of steps to the rock-cut tomb in the background. Actually, they are displaying it to us, and displaying it with unusual comprehensiveness.

The painting has several areas that were left entirely unpainted, including the mourning figure of the Virgin at the lower right and the open mouth of the cave tomb above. The strangest of these bare patches is the one in the area of Christ's penis. It is very hard to believe that Michelangelo should have left just this item incomplete. Possibly, someone later decided to erase it. Michelangelo's determined use of full nudity for sacred figures in public places was always controversial, and became fiercely so later in his life and after his death.

The Entombment is the first of Michelangelo's works – at least for the scholars who agree it is indeed by Michelangelo – for which a study survives: a drawing for the figure of Mary Magdalene, who kneels on the left. The figure was clearly posed by a live, female model. If you accept this drawing – and, naturally, those scholars who don't favour the painting also reject the drawing – then it is the only case in which Michelangelo is documented as looking at a live, naked woman. In the *Pietà*, *The Entombment* and over the years to come, his

theme of themes was the nude, muscular, almost supernaturally beautiful male body.

*

Michelangelo investigated the body not only by looking at nude bodies of living people but also by cutting up corpses, peeling off their skin, scrutinizing the muscles and bones beneath. He began to do this in his late teens. While he was working on the *Crucifix* at Santo Spirito, Michelangelo began the study of human anatomy that he continued for most of the rest of his life. Condivi described how he was on very good terms with the prior of the convent, who provided him with bodies to cut up and a room in which to carry this out. This grisly business – squalid, insanitary and horrifying, under pre-modern, unrefrigerated conditions and so best done in Italy when it was cold – gave him 'the greatest possible pleasure'. From that moment, Michelangelo told Calcagni, he carried out dissections whenever he had the chance. And this macabre pastime was understandable, because the bones and the muscles of the human body were the basic elements of his art.

Santo Spirito was not a major hospital, where medical dissections might have been expected to take place, but an Augustinian convent with an infirmary attached where, from time to time, patients died. Nor was it easy for artists to pursue anatomical studies – although knowledge of the subject was recommended for painters and sculptors. Lorenzo Ghiberti, creator of the 'Gates of Paradise' of the Florentine Baptistery, wrote in 1450 that a sculptor aiming to make a statue of a man should attend some dissections, so as to discover 'how many bones are in the human body, and the muscles and all the tendons and their connections'.

The analysis of the interior of the human body by dissection was one of the most extraordinary steps forward in knowledge taken in that supposedly backward era, the Middle Ages. The historian of medieval science James Hannam has described it as 'one of the most surprising events in the history of natural science'. There had been a powerful taboo against the cutting up and examination of dead bodies in almost every previous culture. Classical knowledge of anatomy, as

laid out in the writings of the ancient medical authority Galen, was largely based on the examination of dead animals, particularly pigs and apes. Neither Roman nor Islamic regulations allowed the dissection of human corpses.

Like several of the innovations that shaped modern life, this began in medieval Italy. (The invention of spectacles is another example.) The first recorded dissections took place in the medical faculty of the great University at Bologna in the early fourteenth century. The teacher would expound from a lectern while assistants sliced up the cadaver of an executed criminal and the audience looked on from benches around. This was probably the kind of dissection that Ghiberti advised artists to attend.

The dissections that Michelangelo told Condivi about were clearly private, ad hoc affairs in which the artist was not just an observer but an active investigator. Michelangelo was one of the first artists to do this, but there was a precedent. According to Vasari, Antonio del Pollaiuolo 'understood about painting nudes in a way more modern than that of previous masters, and he dissected many bodies to view their anatomy'.

However, getting the necessary specimens – dead bodies that no one minded being cut up – was far from easy. Even a celebrated anatomist such as Andreas Vesalius (1514–64), half a century later, admitted to resorting to grave-robbing, quickly flaying the skin off a dead woman so her relatives wouldn't be able to recognize her, and – in a particularly macabre scientific mission – at dusk secretly retrieving the singed limbs of a criminal who had been burnt at the stake.

Leonardo da Vinci (1452–1519) was another artist who was definitely studying anatomy in the late 1480s and early '90s. In Milan, however, where he was based, his opportunities to study human specimens were apparently limited by the fact that he was 'merely' a painter. The prior of Santo Spirito might well have been accommodating about this matter to a favourite artist of the Medici court such as Michelangelo. Santo Spirito itself was closely linked with Lorenzo and Piero de' Medici, and in a strongly Medici-supporting quarter of Florence. The young artist would still, though, have needed some instruction about how to carry out the operation. Artists, in practice, often seem to have collaborated with a doctor.

One way or another, Michelangelo evidently did find opportunities to carry out dissections over the years. Bologna would have offered chances to observe and maybe carry out dissection, and in Rome there were public dissections in the sixteenth century – though under licence from the papal authorities – and with the support of powerful cardinals, Michelangelo might have got permission to dissect privately. That he did is suggested by the quickly developing mastery of his work. He was about to create one of the most celebrated sculptures of the nude in the history of art.

<p style="text-align:center">*</p>

In the spring of 1501, apparently leaving *The Entombment* unfinished in his Roman studio and putting Piero d'Argenta in charge of the premises, Michelangelo departed for Florence. Probably the overriding reason for his journey was given by Vasari: 'some of his friends wrote to him from Florence urging him to return there as it seemed very probable that he would be able to obtain the block of marble that was standing in the Office of Works.' This, he added, was a piece of stone that Michelangelo had long coveted.

That was doubtless true. The block had been quarried at Carrara almost forty years previously, shipped to Florence, and then abandoned. Michelangelo told Tiberio Calcagni that, when he was carving the *David*, some of the masons who had transported the original stone were still living. According to a document, one of them was named Bacellino da Settignano. So it is likely that Michelangelo had heard about that mighty, challenging piece of stone from boyhood in that same village, Settignano.

It is not hard to guess who the 'friends' of Michelangelo's might have been who could have sent him the news that this block was likely to become available. Several of the circle of artists and architects around Lorenzo the Magnificent were then in Florence, including the architect Giuliano da Sangallo and his colleague Simone del Pollaiuolo, known as Cronaca (c. 1457–1508), who was *capomaestro* – architect in chief – of works at the Duomo and thus extremely well placed to know what discussions were afoot. Simone had earned his name in an interesting way. As Vasari told the tale, he was a younger relation of the great

sculptor Antonio del Pollaiuolo, who fled from Florence 'because of some brawl'. He joined Antonio in Rome, where the latter was working, and while he was there began first to observe the ancient buildings, then came to delight in them so much that he spent his time measuring them, 'with the greatest diligence'. When he returned to Florence he described the Roman ruins with such accuracy that he was dubbed *Il Cronaca* – the Chronicle – or, as we might say: the walking architectural encyclopaedia. As we have seen, this almost scholarly taste for classical remains was one that Michelangelo fully shared.

Clearly, it was advisable for Michelangelo to be on the spot if he wanted to get a chance to carve this block of stone. The competition to sculpt the unfinished giant was not as much of a foregone conclusion as it might seem. With hindsight, it is impossible to imagine anyone else sculpting *David*, but in the spring of 1501 Michelangelo had been out of Florence for half a decade, and his ground-breaking masterpiece – the *Pietà* – had only recently been unveiled, and in a distant place. There were other sculptors who might reasonably hope to win this commission. Condivi pointed to one in particular: Andrea Sansovino asked the committee who supervised the building works and decoration of the Duomo – the Operai – to 'make him a present of' the marble, 'promising that, by adding certain pieces, he would be able to carve a figure from it'.

Andrea Sansovino (c. 1467–1529) was a somewhat older artist than Michelangelo who had also – according to Vasari – worked in Lorenzo the Magnificent's sculpture garden. He, too, specialized in marble carving and around this time he was receiving substantial sculptural commissions: two statues for Genoa Cathedral, probably in 1501, and a prominent group of the Baptism of Christ for the Florentine Baptistery, agreed in a contract from April 1502. Had Michelangelo not returned from Rome, Sansovino might well have ended up with the giant block for *David*. It seems probable that, as was to happen time and again, Michelangelo determinedly deprived a rival of a job that he passionately wanted himself – but how did he convince the Operai that he should be given this piece of marble?

Sansovino apparently proposed to make his sculpture by patching on additional pieces of marble, so possibly Michelangelo's clinching

argument was an explanation of how he could make a figure from the block just as it was, without additions. This was a nobler and better way of sculpting – from one stone, '*ex uno lapide*' – praised by Pliny the Elder. Michelangelo had realized that there was enough material within the already partially carved block for a different figure, and he could make one – this was perhaps the crucial step – by taking off his *David*'s clothes.

To understand this, we need to look briefly at the history of that piece of stone. In the early fifteenth century, there had been a series of attempts to make figures of prophets to stand on the buttresses of the three tribunes, or apses, of the Duomo. This scheme was long-standing: in 1408/9 Donatello and another sculptor of that period, Nanni di Banco, had made a couple of lifesize marble figures for this position, but they were never put in place, presumably because it was realized they would seem ridiculously tiny when seen from the ground. What was required for this position was *giant* sculpture. Donatello went on to make one colossus, a *Joshua* of terracotta, painted white. However, easily eroded terracotta was evidently not an ideal medium.

So, in 1464, a further sculptor named Agostino di Duccio was commissioned to carve a David in marble. He went to Carrara to have a suitable piece of marble quarried, and to lighten the heavy load on the journey back to Florence Agostino did some preliminary carving on his sculpture. The figure was described as 'badly blocked-out' ('*male abozatum*') by the Operai in 1501.

Agostino had 'hacked a hole' between its legs, according to Vasari, and apparently also roughed out the torso, because, according to the minutes of the Operai, on the chest of the block there was a *nodum*, or knot. This in turn implies that the original Agostino *David* was to have been *clothed*, not naked, which is in fact much what one might have expected.

Donatello's *David* of 1408 was dressed in cloak and tunic and had indeed a knot on its chest where the cloak is tied together. Verrocchio's bronze *David* is also clothed. It is true that Donatello's later bronze *David* was naked, but that was originally not meant as a public sculpture but for a semi-private space in the courtyard of the Palazzo Medici.

If the original blocked-out sculpture was intended to resemble Donatello's early marble *David* – legs apart, cloak fastened in front – that would explain how Michelangelo was able to find a slimmer, naked figure within that drapery. In other words, *David*'s nakedness was a practical necessity as well as artistically desirable. And of course that full-frontal, detailed, individualized nudity – combined with his heroic scale – has continued to be the statue's single most arresting feature from the sixteenth century to the twenty-first.

David's is not a realistic anatomy, but it is full of the closest observation of real bodies, living and dead. It is the work of someone who has looked very closely at, for example, the structure of the nipples, the navel recessing into the muscle wall of the abdomen with delicate dimpling of the skin around, the soft architecture of the skin, the muscles and ribs of the chest – not sharply outlined as in the nudes of older artists such as Pollaiuolo or Signorelli, but soft and living – the way that veins stand out over the ligaments and bones of the hand.

Vasari claimed that Leonardo da Vinci was also considered as a candidate to carve the gigantic block. If so, it cannot have been a very serious proposal, since Leonardo – despite his training by the great sculptor Andrea Verrocchio – had no track record of working in stone. He was, however, a looming presence on the Florentine art scene: the most celebrated painter alive. For almost two decades Leonardo had been based in Milan, so Michelangelo would not have met him face to face, though he would certainly have heard about his achievements, including the great mural of *The Last Supper* and the hugely ambitious project for a gigantic equestrian monument, cast in bronze.

Now, Leonardo was back in Florence, having fled Milan after the French army captured the city in 1499. He marked his return with a spectacular, if characteristically delayed, *coup de théâtre*. After he had got back to Florence in 1500, the Servite friars commissioned from Leonardo a large painting of the Madonna and child with St Anne for their church of Santissima Annunziata. For some time, he did nothing about it, then in late March and April 1501, just as Michelangelo was arriving to set about winning the great block of marble for

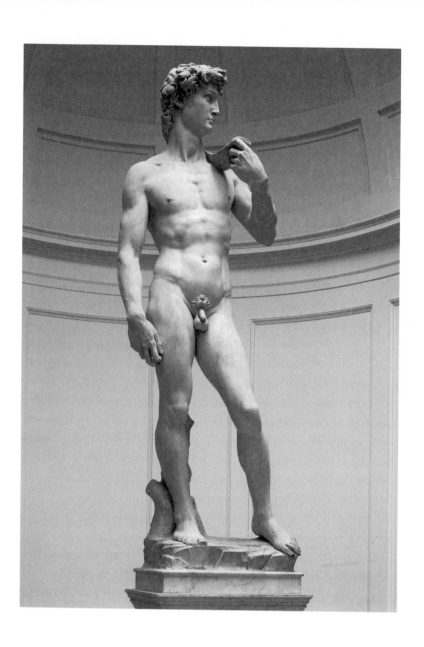

David, 1501–4.

David, Leonardo made a cartoon, a full-scale working drawing, for this picture.

When it was finished, he did something unusual (and unprecedented): he staged an exhibition of this cartoon in his workshop at Santissima Annunziata. Naturally, the artists of Florence all came to see it; Vasari wrote that, for the two days it was on show, the room was filled with 'a crowd of men and women, young and old, who flocked there as if they were attending a great festival, to gaze in amazement'.

This is an extraordinary moment. For the first time since, perhaps, classical antiquity, an audience assembled to admire a work of art not because of what it represented but for its own sake, as a 'marvel'. The whole affair sounds curiously modern – like the private viewing of new work by a celebrity artist. As we shall see, Michelangelo took note, both of the cartoon and of the way it was displayed.

We know tantalizingly little about the interaction of these two supreme artists. There are no surviving letters from Michelangelo, back at home with his family, and Leonardo's voluminous notes contain little that is personal. Yet for half a decade they were both based largely in Florence, at one point working in explicit, almost formal, competition. Michelangelo could have picked up a great deal from the older man, though as we have seen from his attempt to hide his apprenticeship with Ghirlandaio, he was extremely loath ever to admit learning anything from another artist. Leonardo was from the same generation as Michelangelo's father, Lodovico. In 1501 he was forty-nine; Michelangelo twenty-six. Still, there were also aspects of Michelangelo's work which, even if Leonardo did not exactly copy them, at least spurred him on in new directions.

One of these, perhaps, was anatomy. As we have seen, Leonardo had been briefly fascinated by this subject a decade before, but had set it aside. The reason may have been that Milan had no university at that time, hence no medical school, and no tradition of dissection. Perhaps he simply became sidetracked on to other interests: the expression of human emotions by gesture and facial expression in *The Last Supper*, the anatomy of horses, new techniques of portraiture. Yet at the point at which Leonardo let his interest in human anatomy drop, the young Michelangelo took it up and – on the evidence of the

Pietà and *David* – pursued it passionately. It was only at the time that *David* was nearing completion, around 1504, that Leonardo's drawings show a renewed investigation of the muscular male body. A few years later, that was to become a ruling obsession.

*

Four days after knocking the *nodum* from David's chest, on 13 September 1501, according to the minutes of the Operai, Michelangelo started to carve the marble in earnest: 'On the morning of the said day, he began to work with determination and strength.' He did not, however, long continue to do so in public. A month later, on 14 October, a payment was made for building a wall around the 'Giant', '*Il Gigante*', as the sculpture was known, even to the accountants of the Operai. Another ten weeks later, on 20 December, a roof was put over it.

Vasari attributed the building of this little hut – 'a partition of planks and trestles around the marble' – to Michelangelo's secretiveness about his work (of which he had personal experience). Behind this barrier, 'working on it continuously he brought it to perfect completion, without letting anyone see it.' Michelangelo probably did not want to work in front of an audience of curious passers-by, and who can blame him? Equally understandably, he also wanted some protection from the winter weather. Certain visitors must have been invited inside to get a sense of how spectacular this *David* was going to be, because there is evidence that the terms of the original contract were being renegotiated. It had been stipulated that Michelangelo would receive the not particularly generous salary of 6 florins a month while he was working on the sculpture; it was anticipated to take two years, so 144 florins in all. When it was finished it would be up to the Operai then in office to decide whether it deserved 'a better price'. However, on 25 February 1502, only five and a half months after he had begun work, the Consuls of the Wool Guild announced that Michelangelo could expect 400 florins in all. Presumably they saw something that impressed them. It must have been enough to give a sense of the final effect: they called the statue '*semifactum*', 'half-finished'.

Simultaneously, the actual purpose of the statue, its intended position, seems to have begun to shift. The original intention in the

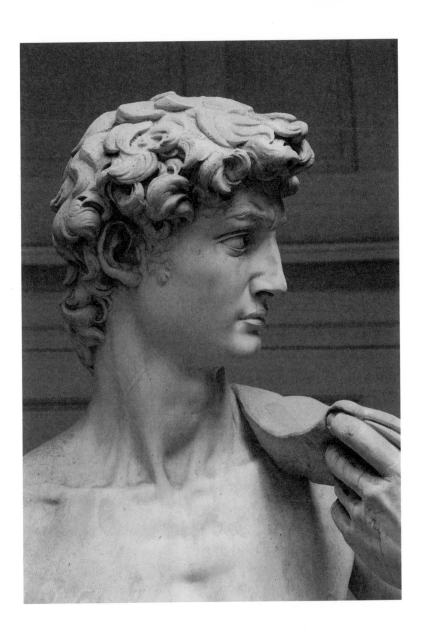

David, 1501–4; detail of head.

fifteenth century was for the *David* to be displayed high up on a buttress above the wall of the Duomo; in July 1501 it was still the idea that the sculpture should stand on the cathedral skyline, 'put up on high', as the minutes of the meeting have it. Yet the sculpture itself shows that, at some point, that intention changed.

Clearly, *David* was carved to be seen from behind as well as in front, and from close quarters. For example, he has a sling hung across his back. This is his attribute, the object that makes the figure identifiable as David, yet it would be hidden from view if he were facing out from a buttress over 70 feet in the air. Equally obviously, the fine detail of his anatomy – his veins, toenails, navel and nipples – would have been virtually invisible in that position. Someone – perhaps Michelangelo himself, perhaps some influential politician – was preparing *David* for a completely different role than sentinel on the Duomo roof.

In the autumn of 1502, a year after Michelangelo began to carve *David*, there was a crucial change in the Florentine political world. For the first time in the history of the city, on 22 September a *Gonfaloniere* was elected for life. The man chosen for this post, which Lorenzo de' Medici had been suspected of wanting but had never dared to take, was Piero Soderini (1450–1522). He was to live in the Palazzo Vecchio with his wife, which, for the first time in Florentine history, would be not only the seat of government but the official residence of a permanent ruler. It would be, in fact, the exact equivalent of the Doge's Palace in Venice, and as such ought to be further embellished with imposing works of art.

For the next few years, Soderini was to be Michelangelo's most important patron and supporter; he was to be an affectionate friend for the rest of his life. Perhaps those bonds had been formed long before, since Soderini was a member of an influential family who had been close to Savonarola and, before him, to Lorenzo de' Medici.[2] No doubt Soderini took a close interest in this extraordinary new work. It could be that it was at this point, before the final surface was carved

2 In March to April 1501 Soderini had been *Gonfaloniere di Giustizia*, before becoming *Gonfaloniere* for life the following year. This was precisely the time that 'friends' had advised Michelangelo to come to Florence and make a bid to carve *David*. Perhaps Soderini was one of those 'friends'.

and polished, that Michelangelo began to think of *David* as a statue for a much more prominent place than the roof of the cathedral.

*

Michelangelo told Condivi that he carried the statue out 'in 18 months' – which might seem like a boastful exaggeration. However, it seems that *David* was at any rate ready to be displayed to the Florentine public just twenty-one months after Michelangelo began work. On 16 June 1503 the Operai of the Duomo decided that on the eve of the city's great festival day, St John's Day, 23 June, the wall around the marble *David* would be removed so that anyone who wanted would be able to see it for the entire day.

This sounds like an imitation of Leonardo's sensational exhibition of his cartoon at Santissima Annunziata two years previously: Michelangelo's own attempt at self-promotion. However, there was another reason for showing the statue. Although, it seems, it had been decided not to put it high on the Duomo, there was apparently no consensus as to where it should be installed instead.

Though not extraordinary from a twenty-first-century point of view, this was an almost unprecedented situation. In the fifteenth century, it went without saying that large works of art, such as monumental sculptures or altarpieces, were made for a specific place, but after the fall of the Medici in 1494, the republican government had seized several sculptures from the Palazzo Medici, including Donatello's bronze *David* and *Judith and Holofernes*. These, like *Hercules*, were long-standing emblems of Florentine courage and fortitude in confronting the enemies of the city.

This earlier game of musical statues may have planted the idea of giving *David* a more prominent, politically loaded position, but, clearly, no final decision had yet been taken because, six months later, on 25 January 1504, the Operai of the Duomo brought together twenty-eight artists and architects to advise on where to put the statue. Among those present were Botticelli, Giuliano da Sangallo, Perugino, Filippino Lippi, Cosimo Rosselli, Piero di Cosimo and Leonardo da Vinci. In other words, this was probably by some distance the most star-studded arts committee ever assembled.

They met in bitter cold. Ten days later the Arno froze. After first inspecting once more the great, almost finished sculpture in the court-yard outside, huddled in cloaks and furs in an indoor chamber, they came together to deliberate. One oddity about this meeting was that, for reasons that can only be guessed at, Michelangelo himself wasn't present. Perhaps his views were well enough known; possibly he was thought too closely involved, since the question of the statue's location touched his own fame and prestige. However, several of the participants in the discussion mentioned his absence and clearly thought it strange.

Domenico Ghirlandaio, *Confirmation of the Franciscan Rule*, 1479–85. Detail of back-ground showing Loggia dei Lanzi and Piazza della Signoria before the installation of Michelangelo's *David*. Two of the proposed sites for the sculpture are visible: under the central arch of the loggia and in front of the entrance to the palace, at left.

Another puzzling point is the delay. *David* was fit to be exhibited in June 1503, but at the end of January 1504 it was still described as 'almost finished'. Michelangelo had a logjam of other commissions, and possibly these diverted him from putting the final touches on *David*.

As the minutes of the meeting show, the question of *David*'s loca-tion was still completely open. Various proposals were made. Some

speakers suggested that the statue should be placed outside the main portal of the Duomo; others favoured various spots inside the Loggia dei Lanzi – the grand fourteenth-century ceremonial space at right angles to the Palazzo della Signoria; a third group argued that it should be situated inside or outside the palazzo itself.

These positions held political implications. Outside the Duomo, *David* would retain more of its original, religious significance. It would be connected with the church for which it was originally commissioned, simply placed lower down so that it could be seen better. If it were to move closer to the palazzo, the seat of government and residence of the new *Gonfaloniere*, naturally, *David* would take on a more political meaning.

That Florentines could think about such matters in a highly superstitious, almost primitive, way was demonstrated by the First Herald of the Republic, spokesman for the regime, who was the first to speak. He declared that Donatello's *Judith and Holofernes*, which stood in front of the palace, was ill-omened, 'an emblem of death' – especially since it showed a woman killing a man. Since it had been set up, he went on, as if this were cause and effect, Florence had lost Pisa. The republic was embattled in various directions: embroiled in an interminable struggle to retake Pisa, it also faced an intermittent threat that the Medici and their followers would seize power again. The seesaw of warfare in the Italian peninsula posed a constant danger of strategic upset.

In January 1504, as it happened, the Florentines had just seen one menace recede while another, simultaneously, increased. The news had arrived that Piero de' Medici – unfortunate to the last – had been drowned while trying to cross a river north of Naples. This, from the government's point of view, was good news. Less welcome was the fact that Piero had drowned while retreating with a French army that had suffered a catastrophic defeat. This was a blow because the French – who had re-invaded Italy in 1499 under a new king, Louis XII (Charles VIII had died as the result of hitting his head on a door) – were now the main allies of Florence. In this turbulent and shifting environment, *David* – heroic, triumphant, courageous – was an ideal national emblem.

There were several other considerations voiced at the meeting. Some thought that the sculpture should be protected from attack

(whether by political enemies or casual vandalism was not clear); others felt it should be sheltered from the elements. Giuliano da San-gallo, Michelangelo's friend and mentor, was one of the latter. He favoured a position in the loggia, because of 'the weakness of the marble, which is delicate and fragile'. Until recently, this argument has been discounted, for the good reason that *David* stood in the weather for four hundred years and did not deteriorate. However, technical analysis carried out in 2003 revealed that the marble in fact was not – like the stone for the *Pietà* – from the Polvaccio quarry, where the very finest *statuario* was obtained, but of inferior quality. Sangallo may well have been expressing Michelangelo's own worry about his creation.

Leonardo da Vinci, for his part, was discreetly negative. Without being overtly hostile, he advocated an obscure site for the statue, tucked away at the back of the Loggia dei Lanzi. He also slipped in the pro-position that *David* should be displayed 'with decent ornaments', suggesting that he thought the figure's nakedness required a fig leaf or similar covering. He had, indeed, a number of reservations about the statue, as he revealed in a drawing of a revised, and – in Leonardo's mind, no doubt – improved version of Michelangelo's sculpture. The head is smaller, his pose more harmonious and better balanced, the heroic energy drained from the figure, whose private parts are discreetly hidden. Clearly, this is what Leonardo truly thought about Michelangelo's mas-terpiece: that it was an interesting piece of work, but badly proportioned, overbearing and indecorous. He, Leonardo, could do better.

This meeting – like those of so many committees in all ages – failed to reach a clear conclusion. Another couple of months went by, then, finally, it was decided to move *David* to the Piazza della Signoria, which meant that at least the position in front of the Duomo was ruled out. This decision was taken on Michelangelo's advice, according to a Florentine diarist named Piero Parenti. On 1 April Cronaca and Michelangelo were instructed to move *David* there.

To do so was in itself a feat of engineering: this was an object nearly 18 feet high, weighing tons, and with a delicate, easily damaged surface. The solution was to suspend it from a wooden framework and then slowly pull it over a temporary surface of greased wooden beams. More than forty men tugged and turned winches to drag it along. The marble

Leonardo da Vinci, *Neptune*, c. 1504
(?), after Michelangelo's *David*.
This seems to record Leonardo's view
of how *David* could be improved.

was not rigidly fixed but suspended from ropes in a way that allowed it to sway gently in response to jolts. It hung, its feet not touching the ground, held by 'a slip-knot which tightened as the weight increased: a beautiful and ingenious arrangement'. Whether that was Cronaca's idea or Michelangelo's was not recorded.

On 14 May at around eight in the evening, *David* emerged from the courtyard of the Opera del Duomo; part of the wall above the entrance had to be demolished so that he could get through. Like the effigy of an ancient god being carried in a procession, *David* passed through the streets of Florence. The few hundred yards from the Opera del Duomo to the Piazza took four days, *David* finally arriving at eight in the morning on 18 May. By that time, he and his 29-year-old creator were Florentine celebrities.[3]

Considering his subsequent fame, *David* received a surprisingly mixed response when he trundled out of the Opera del Duomo yard. No sooner was he seen in public on the first evening of his progress than some youths threw stones at him. This incident has received several explanations, from pro-Medici protest to an attack on sodomy provoked by the statue's nakedness. It is true that the four young men involved came from families that were more likely to support the Medici than not, and that the authorities took a dim view of the matter (three were locked up in the *Stinche* until they paid a fine). But perhaps it was merely a case of the loutish behaviour to which Florentine yobs were prone, especially at times such as carnival and the Feast of St John. The fact that *David* was dubbed 'the Giant' gives a clue to how Florentines felt about him. 'Giganti' – stilt-walkers wearing clothes and costumes to make them look like giants – were part of the fun on St John's Day. The popular reaction to *David* seems to have been wonder at his size rather than at the artistry of his carving. He was a spectacle, a freakish oddity.

According to Parenti, *David* was not universally praised by 'discerning judges', who, however, excused the work's deficiencies, saying that they resulted from the difficulties of carving such an awkward

3 Landucci noted in his diary, 'said giant had been made by Michelangelo Buonarroti'.

block of marble. It is not hard to guess the name of one such critic. The kindly but condescending tone sounds just what one would expect from Leonardo da Vinci; if Michelangelo heard what was being said – as he surely did – it would have rankled.

On one point alone Leonardo's view was victorious. The Florentine authorities agreed that *David*'s nakedness was too shocking for public display. Ten days after he had arrived in the piazza, the decision was finally made to install him beside the entrance to the palace. It wasn't until September, though, that he was completely unveiled. By that time, *David* had been placed on a plinth designed by Cronaca and his tree stump and sling had been gilded – but his private parts had also been covered by a garland of gilded leaves, and that was how they remained for centuries. The other criticisms have been dismissed by posterity.

It has to be said that the critics had a point. *David* is – and isn't – naturalistic. In specific areas it is sensuously, delicately truthful. In his overall proportions, however, it is anything but accurate. On the contrary, *David* is a monster whose parts do not add up to any real human frame: the body and muscular development of a fully grown adult but the proportions, in several respects, of a boy.

In post-twentieth-century art, *David* might be termed a three-dimensional collage. In previous Florentine art the figure of David had been represented either as a pre-adolescent – as in the bronzes of Donatello and Verrocchio – or as an older male, post-puberty. Michelangelo's *David* has the body, huge hands and body hair of a man, but the large head of a child.

The fact that we overlook – or just don't see – this disproportion is a tribute to the power of Michelangelo's art. He had, in effect, redesigned a body so powerfully convincing that we are oblivious to the fact that it does not look much like a real human being. And oblivious we have been, for over five centuries.

Already in 1550 Vasari was unable to put his praise any higher. Far from deploring the statue's proportions, he singled out the harmony of head, hands and feet: 'Anyone who has seen Michelangelo's *David* has no need to see anything else by any other sculptor, living or dead.' This was a little over the top, but few would disagree that *David* is among the greatest sculptures ever made.

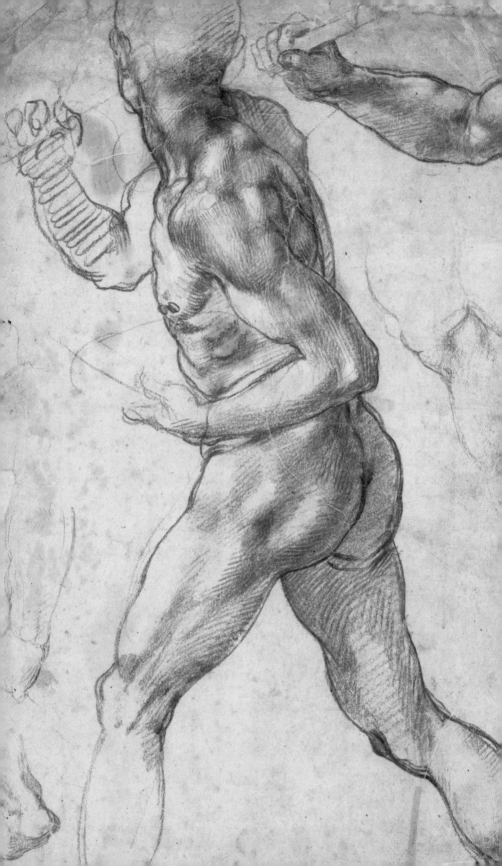

MICHELANGELO VERSUS LEONARDO

*'On another occasion Michel Agnolo wanting to hurt
Leonardo asked him, "So those thick-headed
Milanese actually believed in you?"'*

– Anecdote recorded by the *Anonimo
Magliabechiano*

In order to carve *David*, a work he deeply and passionately wanted to make, Michelangelo postponed, cancelled or ignored a string of other commissions. Throughout his career, the works he gave his full attention to tended to be those that would bring him the most honour. First, at the time he was beginning *David*, in November 1501, Michelangelo decided to write off the *Entombment* altarpiece for San Agostino in Rome. He then began to make a series of payments to the convent and to a certain Master Andrea, who had agreed to paint the picture instead. The involvement of his friend and mentor Jacopo Galli in the original deal explains why Michelangelo made this refund, which must have pained him. To do so would save Galli embarrassment (and perhaps Michelangelo made him a gift of the three-quarters-finished painting at the same time).

Six months earlier, in mid-1501, before Galli had found yet another lucrative commission for him, which, it turned out in the long run, he did not really want. It came from an influential Cardinal, Francesco Todeschini Piccolomini, nephew of Aeneas Sylvius Piccolomini, or Pope Pius II (reigned 1458–64). The Piccolomini family was Sienese;

*(facing page)
Study of Man
Running and
Looking into
the Background
(for The Battle
of Cascina),
c. 1504–5.*

in 1481 the cardinal had ordered a marble altar to be constructed as a memorial to his uncle in Siena Cathedral.[1]

On 22 May 1501 Michelangelo drafted and dated a letter of acceptance to Cardinal Piccolomini, quibbling only about a couple of clauses. It was signed by the cardinal on 5 June, by Michelangelo on 19 June and by Jacopo Galli on 25 June. According to the contract, he was to produce fifteen statues within three years, and 'not to take or accept any other work in marble or other work that might impede him'. In August, he bagged the commission for *David* and did nothing about the Piccolomini Altar for the next two years.

Michelangelo must have got a shock in the late summer of 1503. The patron, Cardinal Piccolomini, had already made a will, noting that the first statues had not yet been delivered, as per contract. Then, on 18 August Pope Alexander VI Borgia died, and on 22 September the aged and ailing Francesco Piccolomini was elected Pope in his place.

As it turned out, he ruled – as Pius III – for only twenty-six days. That, however, might have been enough to jolt Michelangelo into action. By 11 October 1504, when Michelangelo signed a revised contract with the cardinal's heirs, four of the sculptures had been delivered. Then he was diverted by a series of other, more pressing, projects.[2]

It was still on Michelangelo's conscience over half a century later. On 20 September 1561 he wrote to his nephew Lionardo, asking him to search in his late father Lodovico's papers to find a copy of the contract, 'Because the said work has been suspended, owing to certain differences, for about fifty years now and because I am an old man, I should like to settle up the said matter.'[3] There was some more

1 The architecture of this Piccolomini Altar was constructed by the Roman artist Andrea Bregno and his workshop, but for some reason he failed to carve any of the fifteen sculptures that were to stand in its niches and on its pedestals. The job was then transferred to none other than Pietro Torrigiano, so once more the bully of the sculpture garden crossed trails with Michelangelo. However, Torrigiano had only managed to make one, not quite finished, statue of St Francis.
2 Jacopo Galli died in 1505 and therefore could not urge his friend and protégé to keep his word about this commission.
3 Characteristically, he remembered the name of the notary who had drawn up the contract but muddled the name of the Pope (he called him Pius II, not III).

correspondence, but the matter was not settled until after Michelangelo's death, when Lionardo Buonarroti handed back 100 ducats to the heirs of Pius III, almost exactly sixty years after the original contract had called for the fifteen statues to be completed.

The four sculptures for the Piccolomini Altar are extremely interesting works, not because they are among Michelangelo's best but because they are among his worst. They are not shockingly bad, just routine. If his name were not connected with them, few would notice them today (and, indeed, not many people pause in front of the altar in Siena Cathedral, where there are much more exciting things to see). The lesson is clear: if Michelangelo was not deeply interested in what he was doing, he could be mediocre – and that is a useful correction to the kind of romantic scholar who believes Michelangelo to have been a superman who could produce nothing that was less than superlative.

Probably, if by some miracle the only bronze sculpture by Michelangelo that might conceivably still exist were discovered beneath some field in northern France, it would be equally disappointing. His bronze *David* was last recorded on 25 November 1794 in an inventory of sculptures at the Château de Villeroy, near Mennecy, south of Paris.[4] Certainly, it would be fascinating to know what it looked like, but the signs are that – like the Sienese altar – this was a commission he did not really want.

On the other hand, it was particularly hard for him to refuse. It was for a man the Florentine government wanted very much to please: their friend at the court of the King of France, whose decisions might determine the fate of the city. Pierre de Rohan (1451–1513), known as the Maréchal de Gié, was a prominent French nobleman and soldier. He had accompanied both Charles VIII and his successor Louis XII on their expeditions to Italy. While passing through Florence, the Maréchal's eye had been caught by Donatello's bronze statue of a naked, boyish *David* (just why this startlingly sensuous work attracted him so strongly, one can only guess). The Maréchal told the

4 Subsequently, it might well have been melted down to make a cannon, as happened to Michelangelo's other bronze, a seated statue of Julius II. A drawing (see p. 178) gives some idea of what it might have looked like.

Florentine diplomats in France, with, as they put it, 'great insistence', that he would like such a sculpture himself.

On 12 August 1502 Michelangelo was commissioned to make this piece; it was to be done in six months. This can't have been a very welcome task: a replica of a work already nearly seventy years old would not add much to his reputation. Furthermore, it was for a work to be cast in bronze, a tricky procedure which so far he had not attempted. However, the contract was with Piero Soderini, who was about to be elected *Gonfaloniere* and was already a force in Florentine politics.

For the next two years there was a flow of messages from the Florentine ambassadors in France enquiring about the progress of the Maréchal de Gié's statue, noting how much the Frenchman wanted his bronze and how much favour he displayed towards Florence.

The Florentine government replied that, with paintings and sculptures, it was difficult to predict exactly when they would be completed. On 30 April 1503 the reply came back, wearily, that if Michelangelo kept to his current promise – which was by no means certain, given the mentality of artists – it would be ready by the feast of St John on 24 June.

Astonishingly, given that he already had more commissions than he could handle, on 24 April, a week before this slightly discouraging news was dispatched to France, Michelangelo took on another enormous job. He agreed to make twelve over-lifesize statues of the Apostles for the Duomo, at a rate of one per year. In other words, this was twelve years' work. The lure in this case was not so much the fee – which was low – as a reward in kind. In exchange for the sculptures, the Opera del Duomo and the Arte della Lana (wool guild) would build Michelangelo a house.

Nor would it be just any house but one built according to a model made by Cronaca, Simone del Pollaiuolo, the *capomaestro* of the Duomo, old colleague of Giuliano da Sangallo and in all probability a friend of Michelangelo's for a decade at least. Here was a chance to set up his family in an imposing house, the dream of all Florentine clans. He took it, but, for the time being, did nothing much about the Apostles.

In July 1503, after Michelangelo had missed his target for delivering the bronze *David*, the Florentine civil servants who were handling the affair wrote once more to the ambassadors, saying that they had pressed Michelangelo about the statue again and again, 'but because of the nature of the man' and the character of the work, it just could not be hurried. Here, for the first time, the difficulty of working with Michelangelo was mentioned on record.

So, there are reasons for Michelangelo to be unenthusiastic. The bronze *David* was not a work he longed to make as he had yearned to carve the giant marble statue and, in addition to being forced on him, this project in bronze would have awoken anxieties. The Maréchal de Gié's whim forced Michelangelo into direct competition with Donatello, the greatest sculptor of the Florentine school, in a field in which Michelangelo had no experience (and which he was later to describe, in what was a favourite phrase, as 'not my profession').

As described by Benvenuto Cellini, casting in bronze involved first making a rough model thinner than the intended figure by a 'spare finger's breadth' and formed from clay mixed with horse dung, iron flakes, burnt ram's horn, urine and other such ingredients intended to help it dry without cracking. Next a layer of wax the thickness of the final bronze, modelled with the full richness of detail the finished work was intended to have, was added. After that, other layers of fine clay were carefully brushed over the wax surface and the whole left to dry. Vents were provided for hot gas to escape and the whole was lowered into a pit in front of a firing oven and molten metal poured in.

The idea was that the wax would vaporize and the bronze replace it, taking the shape of the sculpture. This was the most alarming moment (as Cellini's heart-stopping account of casting his *Perseus* makes clear). The metal might not liquefy properly, the inside mould might shift or crack, the sculpture might be only partially cast or emerge full of holes caused by the gases ... a dozen things could go wrong, especially if the artist was inexperienced. There were plenty of reasons for Michelangelo to hesitate, however much the officials cajoled him.

Who were the unfortunate bureaucrats who were dealing with Michelangelo? The secretary of the Ten of War (or *Dieci di Balìa*, the

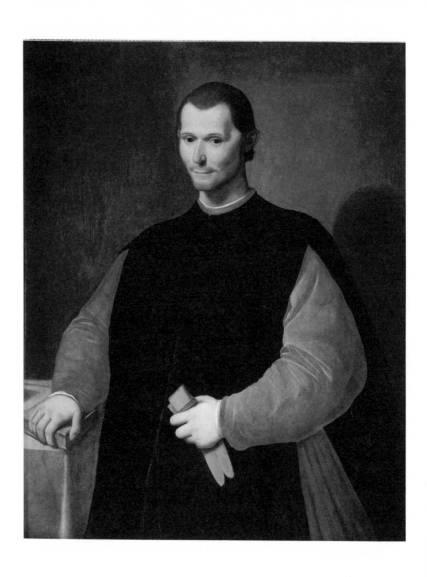

Santi di Tito, *Portrait of Niccolò Machiavelli*, c. 1513.

powerful government committee supervising the war effort), who was sending these exasperated replies, was none other than Niccolò Machiavelli. Machiavelli would certainly have taken an interest, since, because of its diplomatic importance, the costs of the statue were being charged to the budget for the war against Pisa.

Michelangelo seems finally to have cast the bronze *David* in October 1503, when he was given an additional fee, then he apparently did nothing more, as five years later Soderini described the statue as still rough and not in a condition to please anyone.

By April 1504 the Maréchal – or 'friend of *David*', as the diplomats called him – was furious, complaining that he had been deceived. Fortunately for Michelangelo, at this point the Maréchal fell out of favour, was accused of embezzlement and banished from the French court. His bronze *David* no longer mattered. However, then, Michelangelo having got so far with the figure, the Florentine authorities eventually decided to offer it to their next contact, Louis VII's advisor and finance minister, Florimond Robertet. He, too, was an enthusiast for Italian art; he owned a Leonardo, the *Madonna of the Yarnwinder*. However, the earlier failure of the Florentines to send the bronze *David* to the Maréchal had been noted in the French court. Robertet told the ambassador, Francesco Pandolfini, that it showed that they were fair-weather friends – when the Maréchal lost influence, they forgot about their promise – and they were incompetent, to boot. It was not surprising, he added woundingly, that in a decade they had not succeeded in retaking Pisa.

Michelangelo's procrastination had thus caused Florence real loss of diplomatic credit. It is an early demonstration of just how much his patrons were prepared to put up with from him. On 22 August 1508 *Gonfaloniere* Soderini decided that the *David* was to be completed urgently and sent to France. Michelangelo – who was in Rome painting the Sistine Chapel ceiling by this time – received a letter asking him to come back and finish it as soon as possible, or, if he was unable to do so, to recommend another artist who could do the job. In the end, the bronze *David* was completed by Benedetto da Rovezzano.[5]

5 Probably what he did was chase, polish and, if necessary, fill any holes there might have been in the figure that Michelangelo had cast.

That Michelangelo was thinking about the bronze *David* around 1503 is shown by a drawing that must date from sometime between 1502 and early 1504. It contains a detailed working sketch of the marble *David*'s right arm and – done with the paper the other way up – a

Studies for the bronze figure of *David*, and arm of marble, *David*, with verse fragments, c. 1502–3.

sketch for the bronze figure. This suggested that Michelangelo might have been considering something more individual than a straightforward copy of the Donatello. The little figure is subtly Michelangelo-ized: the pose more dynamically swaggering, the young body more firmly muscular. That, and the working study for the marble *David*, would be enough to make this an important sheet of paper, but even more significant are the words carefully penned on the right-hand side. The higher lines read:

> *Davicte cholla fromba*
> *e io chollarcho –*
> *Michelagniolo*
> (David with the Sling,
> and I with the bow –
> Michelangelo)

Further down the page there is a fragment from a poem by the fourteenth-century writer Petrarch: '*Rotta l'alta colonna e'l verde lauro*' ('Broken are the high Column and the green Laurel').

Looking at this sheet of studies, we seem to be able to eavesdrop on Michelangelo's thoughts. It is unwise to assume that the palimpsest of drawn images and jotted words on any given sheet of paper are necessarily related. Sometimes the sheets were reused after an interval of years. Here, however, everything he drew and wrote seems to be connected.

The words 'David with the Sling, and I with the bow – Michelangelo' made an extraordinary comparison between himself and a great Biblical warrior. Michelangelo apparently saw himself – at least for a daydreaming moment – not as an artist, however brilliant, but as the hero in an epic narrative.

But why should the hero Michelangelo have a bow as his weapon? This mystery was solved convincingly by the art historian Charles Seymour, who proposed that the artist had been thinking of the sculptor's hand drill, a device which was turned by means of a bow (*archo*) and bow-string. This common carver's tool was one Michelangelo used a good deal when sculpting *David*, to excavate the crannies in his curling locks, the pupils of his eyes and his nostrils.

The line quoted from Petrarch ('Broken are the high Column and the green Laurel') seems to point in a different direction. 'Laurel' was a reference to Laura, Petrarch's muse and love. The poem was one of mourning: for Laura, and also for the poet's patron, Cardinal Giovanni Colonna (*L'alta colonna*).

Michelangelo's brief quotation – hardly more than a nod, as one might say 'Where are the snows of yesteryear?' or 'Half a league onward' – was elegiac. In Florence at the beginning of the sixteenth century, however, it is hard to believe that 'Laurel' would not have immediately brought someone else to mind: Lorenzo de' Medici. 'Lauro' was related to the Latin version of his name, 'Laurentius', and was also a Medici emblem. The line is written beside a drawing after Donatello's *David*: a sculpture Michelangelo would have seen frequently when he was in the Medici household. The fragment of

Petrarch was aligned with the head of the fallen giant, Goliath. He must have been thinking of his dead patron and teacher, Lorenzo, and the fallen house of Medici. Taken as a whole, though, the message of Michelangelo's jottings is not mournful but triumphant. The Medici had fallen, Michelangelo's first great patron was dead, but he, with his bow, mallet and chisels, was all-conquering.

<div align="center">*</div>

During these years, Michelangelo had a formidable older rival. Just as David was confronted by Goliath, he was in competition with Leonardo da Vinci. Eventually, this contest was given official status in a pair of commissions devised so that the two artists could struggle to outdo one another. Yet their relationship may well have begun in admiration rather than rivalry.

Nothing would have been more natural than for Michelangelo to have looked up to an artist of astonishing brilliance and originality, over twenty years his senior, a fellow Florentine who had also been a protégé of Lorenzo de' Medici.[6] No sooner had Michelangelo returned to Florence than he would have seen Leonardo's cartoon of the *Madonna and Child with St Anne* exhibited in Santissima Annunziata in the late spring of 1501. As we have seen, Michelangelo may well have imitated this unprecedented exhibition when he showed his unfinished *David* two years later. His whole career suggests he took to heart a piece of advice from the older artist. The gifted painter, Leonardo noted, 'will compose few works, but they will be of a kind to make men stop and contemplate their perfection with admiration'. That is exactly what Michelangelo set out to do himself.

Michelangelo's fascination with Leonardo's *Madonna and Child with St Anne* is made clear in a sketchbook dating from 1501–3. On one page, he drew a version of Leonardo's work, but it seems he had rotated Leonardo's group in his head. On the other side of the paper, he outlined the Madonna's head. Michelangelo's pen-strokes provide a further intriguing clue, spotted long ago by the great scholar Johannes

6 According to Vasari, Leonardo also studied in the sculpture garden.

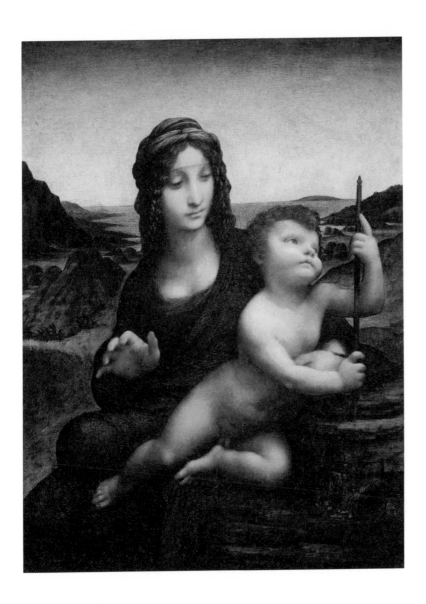

Leonardo da Vinci, *Madonna of the Yarnwinder*, c. 1501.

Wilde. Michelangelo drew the group with 'short firm parallel strokes partly following the curve of the form': a technique that he had not used before but was characteristic of Leonardo's pen-and-ink studies of that time. In turn, this implies that Michelangelo had been inside Leonardo's studio and had been shown the older artist's private image bank of observations and ideas.[7]

In April 1501 Leonardo was visited by Fra Pietro da Novellara, an emissary of the avid collector Isabella d'Este, who yearned – unavailingly – for a work by the great painter. Fra Pietro spotted a picture being done for a favourite of the King of France, 'a Madonna who is seated as if she intended to spin yarn, and the child has placed his foot in the basket of yarns, and has grasped the yarnwinder, and stares attentively at the four spokes, which are in the form of a cross, as if he were longing for the cross'.

Michelangelo must also have seen this painting, the *Madonna of the Yarnwinder* (which survives in several versions, all without the basket Fra Pietro saw), because he borrowed and adapted the athletic posture of Leonardo's child in a round marble relief, a *tondo*. It ended up in the hands of a Florentine patron collector of avant-garde art named Taddeo Taddei, who may have commissioned it. He was a man of Michelangelo's generation – five years older – and subsequently a patron of Raphael.

The *Taddei Tondo* was a response to Leonardo, and a challenge. This is the work in which Michelangelo comes closest to Leonardo's charm. In his mind, Michelangelo has swivelled Leonardo's group, so it is as if we are looking at the *Madonna of the Yarnwinder* from the side. She is in profile, and the child is lunging across her body. However, instead of reaching for a symbol of the cross, the infant Christ is leaning away from another emblem of the Passion – probably a

7 A hint of close contact between the two men comes in a list of his books Leonardo jotted down in 1503/4; along with various Latin primers – suggesting that Leonardo was trying to improve his knowledge of the language – there is 'Libro di regole latine di Francesco da Urbino', that is, a book by the Latin teacher whose classes Michelangelo had attended. That two great Florentine artists should both be connected to this obscure schoolmaster seems too much of a coincidence: it implies a recommendation, even a gift.

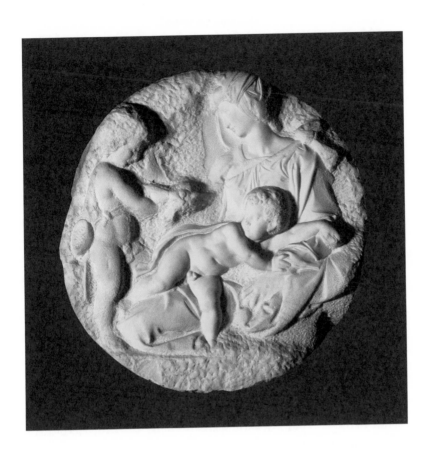

Taddei Tondo, c. 1503–5.

goldfinch – which is being held out by the infant St John. It is an adaptation of Leonardo's ideas to a material that Leonardo himself thought horrible to work with: marble.

Leonardo, though he never managed to produce a final text of his *Treatise on Painting*, left voluminous records of what he thought about the subject. To Leonardo, painting was the supreme art and the fount of what came to be called the sciences: 'Whatever exists in the universe, in essence, in appearance, in the imagination, the painter has first in his mind then in his hand.'

That is at the heart of Leonardo's high conception of painting: the painter, through rigorous observation of everything, comes to understand everything. And Leonardo was not wrong about that. The future course of scientific understanding would be largely based on observation, often through instruments not yet invented, such as the telescope and the microscope. Therefore, in Leonardo's cool, rational understanding of religion, painting was 'related to God'. Some of his conclusions, however, were calculated to make Michelangelo bridle.

As an artist who practised both painting and sculpture 'in the same degree',[8] Leonardo felt he could venture an opinion as to which art was 'of greater difficulty and perfection'. And he had no doubt which it was: 'Painting is more beautiful, and richer in resource. Sculpture is more enduring but excels in nothing else.'

Among the different varieties of sculpture, Leonardo believed stone-carving to be the lowest form: messy, unpleasantly physical, plebeian (a snobbish view that echoes Lodovico Buonarroti's):

> The sculptor in creating his work [he wrote] does so by the strength of his arm and the strokes of his hammer by which he cuts away the marble or other stone in which his subject is enclosed – a most mechanical exercise often accompanied by much perspiration which mingling with grit turns into mud. His face is smeared all over with marble powder so that he looks like a baker, and he is covered with a snow-storm of chips, and his house is dirty and filled with flakes and dust of stone. How different is the painter's lot.

8 Itself an assertion that Michelangelo might have disputed.

'The painter' – for whom, read Leonardo himself – 'sits in front of his work at perfect ease. He is well dressed and moves a very light brush dipped in delicate colour.'[9] It is easy to imagine him discoursing with complete confidence on such matters while Michelangelo, wearing sober black, stood – in a phrase from one of his earliest poems – 'burning in the shadows' with irritation.

Although there is no contemporary record of what Michelangelo thought about these matters, we do know his views at the age of seventy-two, in 1547. Michelangelo was responding to a request from Benedetto Varchi (1502–65), a leading Florentine intellectual and luminary of the new Accademia Fiorentina. Varchi had paid Michelangelo the high compliment of expounding one of his sonnets in a lecture, and he wanted to devote a second to the famous dispute about the rival merits of painting and sculpture, the *paragone*. He asked Michelangelo to write down his views, and the great man did, although he professed he had had little time to spare for such things – which 'take up more time than the execution of the figures themselves' – 'because I am not only an old man, but almost numbered among the dead.' (He had seventeen years to live.)

Perhaps his opinions had not changed much over the years, since they read like a point-for-point rebuttal of Leonardo. Far from being the supreme art, according to Michelangelo, painting was an inferior form of sculpture, 'and that between the two the difference was as that between the sun and the moon'. Or rather, he went on, in a characteristically serpentine mental gyration, he used to think that. Now, having read a draft of Varchi's lecture, which argued diplomatically that, since painting and sculpture had the same aim – representing the world – 'philosophically', they were the same thing, he had changed his mind.

Michelangelo claimed to be happy to accept Varchi's contention, then went on with slightly menacing irony. In comparison with painting, sculpture involved 'greater difficulties, impediments and labours',

9 Leonardo was a man to whom clothes were extremely important. An inventory he made of his wardrobe in 1504 gives a vivid sense of how he presented himself in the streets and piazzas of Florence, a peacock dandy. The list includes 'one gown of dusty rose, one pink Catalan gown, one dark purple cape, with a big collar and hood of velvet . . . one purple satin overcoat, one overcoat of crimson satin, à la française'.

and required 'greater judgement'. If one did not think that those differences made carving more noble than painting, then indeed they were just the same (he looked down on modelling as not much more than a three-dimensional form of painting). Clearly, Michelangelo gloried in the hard, sweaty work of sculpture which Leonardo despised.

Relief sculpture was the middle ground, where painting and sculpture blended. Leonardo thought the only good thing about it was that, like painting, relief used perspective. Predictably, Michelangelo took the opposite point of view: 'painting may be held to be good in the degree in which it approximates to relief, and relief to be bad in the degree in which it approximates to painting.' In other words, the more like a sculpture it becomes, the better it is, and vice versa.

Looked at in the context of this dispute, the *Taddei Tondo* could be a form of manifesto of Michelangelo's views. It is in the highest of high relief. Its figures bulge out of the block: fully half the Madonna's head is protruding, and it looks as though, if it had been finished, almost the whole of the infant St John would have been in the round.

However, the relief was never completed, perhaps because – and it was not the only time – Michelangelo's stone betrayed him. Its marble contained a nasty crack, which when discovered might well have caused Michelangelo to stop. As a result, the *Taddei Tondo* was left as a demonstration of the different phases in the carving of a piece of marble. It displays surfaces at all levels of finish from almost inchoate parts, such as the bird in St John's hand – a mass of roughly chiselled stone which somehow gives a sense of fluttering – to the flank and tummy of the Christ Child, which have been polished to baby-soft smoothness. In between, there is a series of surfaces, such as the Madonna's face and the underside of the baby, that are defined in coarser or finer claw-chisel strokes.

*

Many of Leonardo's own activities during these years in Florence were inconclusive, or – like his attempts to fly and to square the circle – led nowhere. However, he began one masterpiece that was already renowned when it was in his studio. This was the picture known as the *Mona Lisa*, a shortened version of 'Madonna' or 'Mistress Lisa'.

The painting remained in the artist's studio – and was never to be delivered to Lisa's husband, Francesco del Giocondo, who had, presumably, commissioned it. In October 1503 a Florentine humanist civil servant named Agostino Vespucci, who worked for Machiavelli, among others, put a note in the margin of his copy of a work by the Roman author Cicero. The text referred to the Greek painter Apelles, and how he 'perfected the head and bust of his Venus with the most elaborate art, but left the rest of her body inchoate [or unfinished]'.

Beside this, Vespucci noted, 'That is the way Leonardo da Vinci does it with all of his paintings, like, for example, with the countenance of Lisa del Giocondo and that of the holy Anne, the mother of the Virgin.' On 11 November a friend of Machiavelli's, Luca Ugolino, sent him good wishes on the birth of a son, Bernardino: 'Congratulations! Now we know for certain that your Marietta did not deceive you, for your new son is the spitting image of you. Leonardo da Vinci himself could not have painted a better likeness.'[10]

The *Mona Lisa* was, when finally completed, a supreme demonstration of what, in Leonardo's view, painting could do: create misty distances, delicate colours, soft naturalism, convey the mysteries of human emotion through facial expression and, in the vast landscape behind Lisa, provide a mirror of the cosmos: 'sea and land, plants and animals, grasses and flowers, all enveloped in light and shade'.

Michelangelo's art moved in the opposite direction. The *Taddei Tondo* had a touch of Leonardo's delicacy and playfulness, but these qualities rapidly disappeared. Around this time Michelangelo was engaged on three more works depicting the Madonna and child. First, after the *Taddei Tondo*, came another round relief sculpture, done for a man named Bartolomeo Pitti, who joined the Opera del Duomo committee on 1 July 1503.

Pitti was one of the men in a position to be useful to Michelangelo over the question of where to site *David*, and also in another commission he had taken on in April 1503, after the almost finished *David*

10 However, Machiavelli had some reason to suspect she had deceived him, as he had her; the child must have been conceived as soon as he returned to Florence the previous January, or just before.

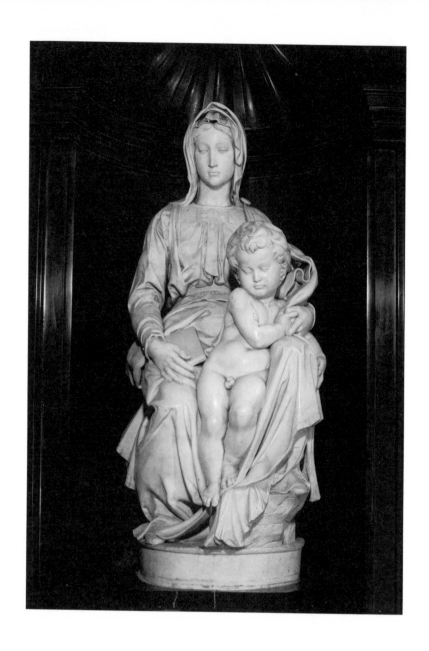

Bruges Madonna, c. 1504–5.

must have been seen and admired: that for the twelve Apostles for the Duomo. In the end, this tondo was not quite finished either, although the marble was not flawed. Perhaps, after a while, Pitti's assistance was no longer so necessary and Michelangelo set it aside. In its nearly completed form, it is a more defiantly sculptural relief. Crouched on her block of stone, the Madonna seems cramped, in need of more space. Her head is almost bursting out of the block into full three-dimensionality. The whole work suggests impatience with relief sculpture: the flatter the worse, in Michelangelo's opinion. It was, indeed, probably the last relief he actually carved.

The *Pitti Tondo* is a portent of the way Michelangelo's work was to develop in another way. The Madonna of the *Taddei Tondo* is feminine in a slender, stately fashion, though not in the almost flirtatiously pretty manner of some fifteenth-century Florentine virgins.[11] In the *Pitti Tondo*, the Madonna is strongly masculine, as if Michelangelo could not be bothered to disguise the fact that the model he used was male.

The third Madonna and child of these years was fully sculptural, a gracious group carved in marble for two Flemish clients of the Balducci bank in Rome. It was the last commission found for Michelangelo by Jacopo Galli, who was soon to die. The two clients were cloth merchants named Jean and Alexandre Mouscheron, and they ordered the statue for a family chapel in the church of Our Lady, Onze Lieve Vrouwekerk, in Bruges. This was, like the *Pietà*, a work for a Northern European patron who wanted a familiar religious image but made in the most up-to-date Italian manner. This was what Michelangelo eventually delivered.

The most striking aspect of the sculpture, the one that was picked up by younger artists such as Raphael, was the Christ Child. He is an almost alarmingly powerful-looking toddler, his head an enormous, rounded mass topped with swirling tufts of hair that seem to give off energy in waves. This unsettlingly robust infant revealed the true focus of Michelangelo's interest at that time: the representation of heroic strength.

11 Leonardo recorded that someone had once fallen in love with a 'divine image' he had painted, probably a Madonna.

The last of Michelangelo's early Madonnas was a painting, but one that strove as far as possible to have the qualities of a sculpture. It belonged to Agnolo (or Angelo) Doni (1476–1539), a successful merchant who lived in a fine house on the Via dei Tintori, and the most likely trigger for the commission of a painting from Michelangelo was Doni's marriage to Maddalena Strozzi on 31 January 1504 (she was only fifteen; he was twenty-seven). The painting, however, probably took some time to complete.

As it turned out, it was almost a rebuttal in paint of Leonardo's ideas. In place of an encyclopedia of the natural world there is an almost derisive gesture at landscape background: a few blue, distant hills on one margin. Virtually the entire space is taken up with figures, including a strange row of naked young men, the religious significance of whom has never been conclusively explained (despite numerous attempts).

The Madonna has the brawny, knobbly arms of the muscular young man Michelangelo was drawing at the time: he probably posed for her figure, too, and Michelangelo again made no attempt to hide the fact. This strangely athletic Holy Family was painted in clear, bright colours with sharp outlines. It was a painting in a style the opposite of the softly mysterious *sfumato*, or smoky, technique that Leonardo had developed – and which Michelangelo detested.

<p style="text-align:center">*</p>

There was, Vasari wrote, 'the greatest disdain' between Leonardo da Vinci and Michelangelo. He did not say, and probably did not know, how this first arose, but it is not hard to understand the antipathy between these two men. They were a generation apart, equally balanced in abilities but opposite in temperament, mental attitudes, appearance, manner and (one would guess) such details as body language and tone of voice. Vasari described Leonardo's powers of conversation to have been 'such as to draw to himself the souls of listeners'.

In contrast to Leonardo's suavity, Michelangelo was driven, irascible, solitary and had a reputation for living in frugal squalor. The doctor and man of letters Paolo Giovio, who knew both men, greatly approved

of Leonardo, 'by nature affable, sparkling, generous, with an extraordinarily beautiful face', while he bluntly described Michelangelo as 'rough and uncouth' (as we have seen).

Urbane and elegantly dressed, Leonardo was a natural courtier. He excelled in the courtly arts of music and intellectual debate. The tendency of his mind was empirical, objective and observational. It is no accident that Leonardo's surviving writings are almost entirely theoretical and scientific notes; Michelangelo's are letters and poems. With Leonardo, everything was impersonal; with Michelangelo, as the art historian Rudolf Wittkower wrote, everything that concerned him in poetry and correspondence tended to be about '*his* state of mind, *his* emotions, *his* thoughts'.

There was, however, a paradox in all this. The equable Leonardo was, it seems, not nearly so deeply engaged with other people. He had ups and downs with his assistant and – apparently – lover, Salai, but the evidence of Leonardo's writings is that his deepest engagement was with the mysteries of the natural world. The antisocial and bad-mannered Michelangelo, on the other hand, contained an inner emotional volcano. Those thoughts and feelings, which might seem so selfish, were filled with love (or, alternatively, hate and anger) towards the people in his life.

At the age of seventy Michelangelo was made to make an extraordinary confession in the Dialogues written around 1545 by a close friend, Donato Giannotti.[12] Words spoken in Renaissance dialogues need to be treated with care, since in this case the author was Giannotti, not Michelangelo. However, this particular literary conversation was not only written by someone who knew the artist intimately, the other characters, too, were members of Michelangelo's Roman circle. It featured, and was going to be read by, individuals who met Michelangelo virtually every day (and almost certainly the artist himself). The words he said therefore had to ring true.

In this dialogue, the character 'Michelangelo' makes an astonishing declaration. He is, he said, 'of all men, the most inclined to love persons'.

12 *Dialoghi de' Giorni che Dante Consumò nel Cercare l'Inferno e'l Purgatorio*, or *Dialogues on the Days that Dante Spent Looking through the Inferno and Purgatory*.

And this is a weakness that he guards against: 'Whenever I see some-one who may have talent, who may show some liveliness of mind, who may know how to do or say something better presented than by the others, I am bound to fall in love with him, and I fall prey to him in such a manner that I am no longer my own: I am all his.' This was not intended as an erotic admission, but nonetheless seems to take us into the centre of Michelangelo's emotional world, a place where he was always the victim overcome by the powerful attractions of others.

Rather than sparkling in company and being affable and charming in the manner of Leonardo, Michelangelo felt actively threatened by it. This man, with such an intimidatingly powerful personality that popes were nervous of him, privately felt a fear that his sense of self would be overwhelmed by the physical and mental attraction of others. Even the morning spent in the dialogue discoursing with a trio of old friends as they strolled through the fields and ruins of Rome had destabilized him. When invited to accompany them to dinner, he reacted with alarm: 'If I were to have dinner with you, as you are all so well endowed with talent and kindness, beyond that each one of you three has already robbed me of something, each one of those din-ing with me would take a part of me.'

In Giannotti's dialogue, Michelangelo has to be coaxed into debate, first producing a string of excuses, among them the highly character-istic one – frequently repeated in his letters – that the subject suggested, 'is not my profession'. Curiously, just such a discussion of Dante, approximately forty years before Giannotti wrote his *Dialogues*, would prove the flashpoint for the public row between Leonardo and Michelangelo.

*

One day, according to a sixteenth-century chronicler, the *Anonimo Magliabechiano*, Leonardo da Vinci was passing through the Piazza Santa Trinita. Some gentlemen were debating a point in Dante in front of the Spini family palace. They called Leonardo over and asked him to explain the passage they were puzzling over, but just at that moment Michelangelo happened to come along and Leonardo instead

suggested that the sculptor should elucidate it. For some reason, this proposal touched Michelangelo on the raw. Instead of discoursing on Dante, addressing Leonardo in the disrespectful '*tu*' form he snapped back, 'You explain it yourself, you who made the design of a horse to be cast in bronze, but who was unable to cast it.' With that, he whipped around and strode away, leaving Leonardo standing there, 'made red in the face by his words'.

This sounds like an insult from which their friendship, assuming any had existed, was unlikely to recover.[13] In mentioning the horse he touched on an extremely sensitive point. In the early 1490s Leonardo had devised and come close to completing a vast equestrian monument in Milan: the horse was to have been over-lifesize. The model was made but never cast in metal because, due to the French invasion in 1494, the metal collected for it was needed for weapons. However, Michelangelo's mentor, Giuliano da Sangallo, had debated whether the project was possible. This was the nub of Michelangelo's attack: he was accusing Leonardo of being over-ambitious, incompetent and of failing to deliver work he had promised (all areas about which he himself must have had inner anxieties).

The reason that Michelangelo reacted so badly was perhaps partly his ingrained reluctance to take part in such discussions, unless carefully ensnared by dear friends such as Giannotti (or, in another mid-sixteenth-century dialogue, the poet Vittoria Colonna, who was even closer to his heart). Leonardo clearly did not come into that category, and his remark, 'Michelangelo will explain it to you,' perhaps contained a hint of that condescending assumption of superiority that

13 The evidence we have is just a glimpse, a vignette embedded in a manuscript on anecdotes and information about Florentine artists written many years later. However, it seems, as Charles Nicholl has pointed out, to be an eyewitness account from someone called Giovanni da Gavine, a friend of Leonardo's who furnished a few other tidbits of anecdote. And it is consistent with everything else we know about these two great artists. According to the same source, 'wanting to needle Leonardo' – *mordere*, to bite him – Michelangelo fixed on the same sensitive point, Leonardo's failure to cast the giant horse in Milan: 'So did those Milanese thick heads actually believe in you?'

can also be sensed in his reaction to *David*: not a bad effort, but capable of correction and improvement.[14]

*

Condivi claimed that, at just this time, after completing *David*, Michelangelo neglected sculpture and painting and turned instead to literature: 'for some time doing almost nothing at all in these arts, but devoting himself to reading Italian poets and orators, and writing sonnets for his own amusement.' The first part of that statement was not true. On the contrary, Michelangelo was dangerously over-committed, with a daunting pile-up of commissions for painting and sculpture – but the second part was correct. On the evidence of his surviving drawings, it was at precisely this time that Michelangelo began to become a poet.

It is not surprising to discover that poetry was another art, like stone-carving, of which Leonardo had a low opinion. It was, in his view, inferior to painting. Leonardo also argued that poetry was more limited than the other art at which he himself excelled: music. The painter can depict many things at the same time, he argued – and the musician can play a number of notes, but the poet is confined to one word followed by another. Therefore, 'The poet ranks far below the painter in the representation of visible things, and far below the musician in invisible things.'

Here, perhaps, was another undercurrent adding tension to that electric moment in Piazza Santa Trinita. Possibly, Leonardo – kindly, but with insulting condescension – was saying: 'A question about poetry? Here's Michelangelo, he bothers his head with that kind of thing, he'll answer it for you.'

14 Which passage was the debate about? It's tempting to guess the subject was Canto X of *Purgatorio*. At this point, Dante and Virgil, who are climbing the spiral terraces of Mount Purgatory, encounter huge reliefs carved in white marble illustrating the virtue of humility. This subject would explain why an artist was asked to elucidate the poetry. If the subject of the passage in Dante was pride, that would have given extra sting to Michelangelo's retort. Perhaps he was saying, 'You, Leonardo, are the one who is an expert on overweening, you who tried to cast a gigantic bronze horse and were not able to do it.'

We may know where the row between Leonardo and Michelangelo took place – in the Piazza Santa Trinita, near the river Arno – but it is much harder to pinpoint the incident in time. Leonardo and Michelangelo were both in Florence intermittently for several years during the first decade of the sixteenth century, firstly, from Michelangelo's arrival to bid for the commission to carve *David* in April 1501 until the summer of 1502, when Leonardo departed to serve as military advisor to the Pope's son, the ruthless Cesare Borgia. At that time, Borgia was engaged in hacking a territory for himself from the patchwork of states, nominally the possessions of the Church, lying across the Apennines from Tuscany: the Romagna.

In March 1503 Leonardo was back in Florence, having witnessed some of the reality of warfare, which he described in a manuscript as 'the most bestial madness (*pazzia bestialissima*). Nonetheless, he was a satisfactory servant to Borgia, who gave him the 'cape à la française', noted in an inventory he made of his wardrobe in 1504; this cape Leonardo in turn passed on to his assistant Salai.

In the autumn of 1503 Leonardo was given a daunting but by no means intrinsically unfeasible artistic commission by the republican government, which probably meant, in this case, *Gonfaloniere* Soderini. Leonardo was to paint a huge picture on one half of a long wall in the Hall of the Great Council in the Palazzo Vecchio. This continued the comparison, and implicit decorative competition, between the Florentine seat of government and the Doge's Palace in Venice.

Florence had its own equivalent of the Doge in Soderini. In Venice, the senators met in the Great Council Chamber adorned with paintings by the Bellini brothers, Giovanni and Gentile, among others. So the Florentine council chamber would have paintings, too, but bigger and better. The subject Leonardo was given was a fourteenth-century Florentine victory over the forces of Milan at a place in eastern Tuscany called Anghiari. According to the building contracts, the painting would have been approximately 12 *braccia* in height and 30 in width: that is, 23 feet by 57. This was perhaps a larger area than had been covered by a single painting since Guariento had frescoed Paradise on the wall of the council chamber of the Doge's Palace in the mid-fourteenth century.

Leonardo moved into a new workshop in the monastery of Santa Maria Novella, where there was a room large enough for him to draw the full-scale cartoon he intended to make before beginning the actual painting. It was characteristic of Leonardo to make elaborate preparations for every project, sometimes so much so that he never actually began. Vasari related that Pope Leo X, observing Leonardo distilling varnish for a picture before painting it, exclaimed in exasperation, 'This man will never accomplish anything. Here he is thinking about finishing the work before he evens starts it!'

Extensive adaptations were being made to Leonardo's new workspace and accommodation at Santa Maria Novella in January 1504, at the time of the committee meeting about the siting of *David*. At the end of the summer, Michelangelo was commissioned to paint an equally massive mural on the other half of the same wall in the Great Council Chamber. *Gonfaloniere* Soderini did this, according to Benedetto Varchi, when he gave Michelangelo's funeral address, 'to stage a competition' between the two artists.

So it is tempting to place the quarrel between the two in that same year, between Leonardo's disparagement of *David* at the beginning of the year and Michelangelo taking up the challenge with furious vigour towards the end. Perhaps, as Leonardo's biographer Charles Nicholl mused, it might have been in the spring of 1504, when the weather was warm enough for 'men to lounge in a loggia discussing Dante' and Michelangelo was full of tension, devising the cradle to transport his giant statue, considering its position, too busy for idle discussions.

*

Leonardo had written about battles and how to paint them in his notes years before he was asked to do so. He wanted to depict the smoke of artillery combined with the dust thrown up by cavalry and foot soldiers, the confusion, the furious anger in the countenances of men and horse. As the central scene in his vast painting, Leonardo proposed to show a whirlpool mêlée of horses and warriors desperately struggling for control of a bridge over the Tiber. His studies for the ferocious features of the leading warriors are investigations of real emotions on human faces; in comparison, the trademark scowl of Michelangelo's *David*

looks like a formula borrowed from classical art. And that was, no doubt, exactly the contrast that Leonardo, the great naturalist, intended. The two great battle paintings were to be a contest not just between two artists but between two competing conceptions of art.

Soderini must have known that this extraordinary younger artist held views about art that were in some ways directly contrary to Leonardo's. Had the two paintings been completed, they would not have added up to an artistic unity, but Florence would have had one of the great examples of compare and contrast in the history of art. We do not know if Michelangelo angled for the commission, or who chose the specific subject. There is an intriguing indication that Niccolò Machiavelli might have been involved. Machiavelli's pet project was the institution of a Florentine militia – that is, an army made up of the inhabitants of the state, rather than of mercenaries. Cascina was a victory won some 150 years earlier by an army which partly consisted of Florentine volunteers over Pisa: the enemy of the current moment. The need for a militia is one of the major themes of *The Prince*, the treatise on government Machiavelli was to write a decade later, but he first mentioned the subject on 24 May 1504. That is, at just the time that the final decision about the placing of *David* was being taken. (It had been moved to the Piazza in mid-May, but it was not until 28 May that it was decreed that it should stand before the palace, rather than in the Loggia.) Intriguingly, in *The Prince* Machiavelli used the story of David in the Old Testament as an allegory for depending on one's own military resources.

Whoever chose the subject played brilliantly to Michelangelo's strengths. As the art critic and historian Jonathan Jones drily noted, there are not many opportunities in the history of warfare 'to portray an army with its clothes off'. But the Battle of Cascina was one of them. This combat had taken place near the small town of Cascina near Pisa in the hot summer of 1364. The Florentine troops had taken off their armour and were cooling in the river Arno when warning came of an attack by the Pisans under the English mercenary John Hawkwood. The men scrambled out of the river and won a notable victory.

The central group in Michelangelo's mural – very different from Leonardo's – was to be a mass of nude and half-nude men frantically clambering from the river and putting on their armour at high speed,

for which reason the mural's alternative title became *The Bathers*. In other words, it was a virtuoso display of male nudes in the widest imaginable variety of postures.

Little survives of this magnificent conception. The cartoon itself was cut into pieces, and most of those fragments were lost before even Vasari had a chance to see it whole; all of them subsequently disappeared. One person who did see and describe it was Benvenuto Cellini, and he – perhaps with the nostalgia that is naturally felt for all lovely, vanished things – thought *The Battle of Cascina* the most beautiful of all Michelangelo's paintings. Even the Sistine Chapel ceiling, in Cellini's opinion, did not reach 'half the same perfection'.

It is clear from the surviving studies – which are indeed among his most beautiful drawings – that Michelangelo was working at his highest intensity and *con amore*. A couple of black chalk studies in the Teyler Museum, Haarlem, and another in the British Museum in pen and wash, with white highlights, give an impression of the impact that cartoon must have had. They help explain why, according to Vasari, it became 'a school for craftsmen', the instruction manual for the next generation of Florentine artists.

Paradoxically, this was why it did not survive. It was admired so much that it was carried off by painters and sculptors. Michelangelo may have mourned its loss, but the effect seemed to be to increase his fear of having his ideas stolen and imitated. Subsequently, he began to destroy his own cartoons and drawings.

The figure studies for the *Battle* place chunky, muscular bodies in postures that are at once complex and graceful. They are freeze-frames – instants of twisting, rushing, clambering and turning in sudden panic at the alarm that had been sounded: ideograms of energy, in which each muscle and joint stands out on its own yet is part of a rippling, flowing movement. To an extent, they are life studies. The Teyler and British Museum drawings are based on the same model, identifiable by the cap he wears over his hair, but they cannot be only representations of what Michelangelo saw in front of him.

The British Museum drawing shows a young man sitting on the rocky bank of the river with his knees pointing forward but his body turning so that he is looking back in diametrically the opposite direction.

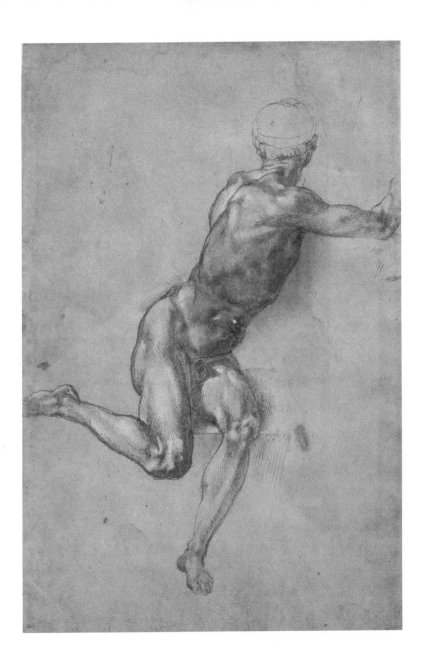

A Seated Male Nude Twisting Around, c. 1504–5.

This degree of flexibility is impossible for a human spine and torso. At minimum, it must have required two poses. The Teyler drawings both show postures that would be hard to maintain for more than a few minutes, not long enough for Michelangelo to complete drawings of such finesse and – in the areas in which he was interested: particularly, thighs, buttocks, shoulders, throat and chest – delicately high finish. He must have been looking at the model and at the same time using his imagination and knowledge to amplify, idealize and adapt what he saw.

Michelangelo's anatomical investigations must have intensified in the years in which he was creating *David*, the *Battle of Cascina* cartoon and the nudes of the Sistine Chapel ceiling. These works involved nothing less than what the art critic and historian James Hall has called 'the reinvention of the human body'. In those works a new human being appears, a fresh conception of masculine humanity, which was one of Michelangelo's greatest achievements.

Michelangelo, though he would certainly never have admitted it, was still learning from Leonardo. The older artist set about making an enormous cartoon for his mural. This was part of his leisurely progress towards a picture whose perfection would 'make men stop and contemplate' with admiration. In this way, he could calculate the effects of the finished work with precision at full scale. So Michelangelo also constructed a cartoon of his main scene – the naked men scrambling from the river. He drew it on multiple sheets of paper glued together, using exactly the method Leonardo was following. Typically, however, Michelangelo found ways to save money on both paper and labour.

Perhaps he derived another procedure from the older artist. Leonardo recommended a 'new device for study' to fellow artists: it was a method for stimulating the imagination. If 'you have to invent a scene', look, he advised, at 'walls splashed with a number of stains, or stones of various mixed colours', or, alternatively, at the 'ashes of a fire, or clouds, or mud'. We have, then, a good idea of how Leonardo went about finding inspiration for *The Battle of Anghiari*: by peering at damp walls, dying fires, mottled rocks and cloudy skies and letting his mind drift from one phantom vision to another. Similarly, he developed a

method of brainstorming ideas, on one sheet jotting down so many variants of a Madonna and child that they blur together like a multiple photographic exposure.

Michelangelo adopted this freewheeling way of incubating ideas. On one sheet, for example, he sketched first in lead-point pencil then

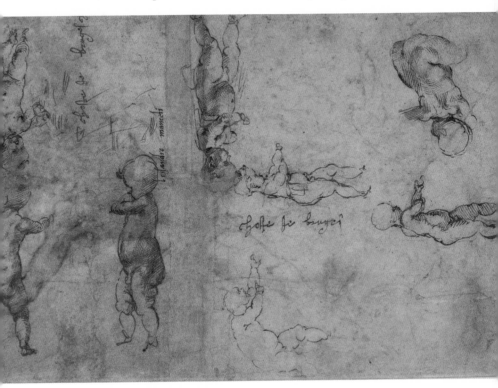

Studies of Infants, c. 1504–5.

in pen and ink an assortment of chubby children of eighteen months or so, candidates to be infant Christs or St Johns – in profile, from behind, seated, standing. From these he selected a figure with arms outstretched to be the little John the Baptist in the *Taddei Tondo*. But Michelangelo also took the brainstorming process in a new and different direction. He applied it not only to images but also to words. Leonardo wrote on his drawings, sometimes cryptically, but always notes, observations, reflections. On Michelangelo's pages, stray phrases start to appear like fragments of a stream of consciousness,

words, lines of poetry quoted from Petrarch, gnomic remarks of his own.

A sheet from around 1503/4, for example, contains a jumbled palimpsest of words and images, including three views of an Apostle, no doubt one intended for his set of sculptures commissioned by the Opera del Duomo, and a vivaciously drawn cavalry battle. Sprinkled among these disparate sketches is the first verse of Psalm 53 – 'God in your name save me!' – in Latin; what also seems like a scrap of a prayer, 'God devotedly'; and a Dantesque image that implies a dread that he might not be saved after all: 'dolore stanza nel inferno' ('pain resides in Hell'). On the other side of the sheet there are six lines of a sonnet, his earliest poem – or unfinished bit of poetry. It is characteristically gloomy, concluding, 'Nothing mutable exists under the sun which death does not conquer and fortune change.'

By this stage, however, Leonardo was – if not exactly learning from Michelangelo in his turn – at least destabilized by the force of the other man's conception. A note he made at approximately this time seems aimed directly at Michelangelo: 'You should not make all the muscles of the body be too conspicuous, unless the limbs to which they belong are engaged in great force or labour . . . if you do otherwise you will produce a sack of walnuts rather than a human figure.' Another note begins, as if addressing his adversary, 'Oh anatomical painter!', and continues: 'beware lest the too strong indication of the bones, sinews and muscles, be the cause of your becoming wooden in your painting.'

While he was sniping, in private, at Michelangelo's muscular nudes, Leonardo was also trying to work out his own way of producing the same effect. A drawing from 1504–6 contains a tiny, vivid sketch of a skirmish with a galloping horseman and fighting infantrymen. Around this is arranged a sequence of drawings of a naked man, his arm cut off at the biceps to show what the artist was displaying with greater clarity. The text, in Leonardo's mirror-writing, methodically notates what he has drawn, beginning, 'The principle muscles of the shoulder are three, that is $b\ c\ d \ldots$'

Through his contest with Michelangelo, Leonardo was once more becoming absorbed by anatomy. Over the next few years, this was to

become a ruling obsession and led to one of his greatest achievements. *The Battle of Anghiari*, however, came to nothing. Leonardo began to paint it but, in his determination to create a masterpiece, one that he could meditate on and revise as he worked on it, he used an unconventional medium which – apparently – caused problems.[15] He slowly painted the middle section, then asked permission to go to Milan in May 1506. This was grudgingly given, for three months only.

Leonardo ignored the time limit and, on 9 October, *Gonfaloniere* Soderini wrote to the French governor of the city, Charles d'Amboise, complaining that Leonardo 'has not behaved as he should have towards the republic, because he has taken a large sum of money and only made a small beginning on the great work he was commissioned to do'. Michelangelo had done even less. In a rush of energy and inspiration, he had completed the cartoon and – like Leonardo – departed from Florence having not even begun to paint his picture. However, as far as Florentine artists and connoisseurs were concerned, in the contest of the two *Battles*, Michelangelo had decisively won.

15 Leonardo seems to have used an oil medium instead of true fresco and, according to a sixteenth-century chronicler, it 'did not stick'.

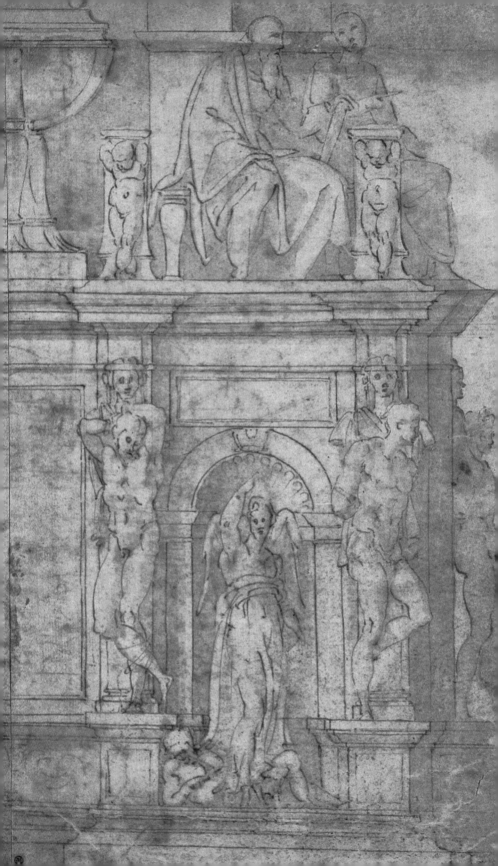

CHAPTER TEN
GIANTS AND SLAVES

*'Françoise . . . knowing she would have to compose, by
methods known to her alone, a dish of boeuf à la gelée, had
been living in the effervescence of creation; since she attached
the utmost importance to the intrinsic quality of the
materials which were to enter into the fabric of her work,
she had gone herself to the Halles to procure the best cuts
of rump-steak, shin of beef, calves' feet, just as Michelangelo
spent eight months in the mountains of Carrara
choosing the perfect blocks of marble for the
monument of Julius II.'*

– Marcel Proust, *Remembrance of Things Past*,
Volume II, Within a Budding Grove

In February 1505 Julius II called Michelangelo to Rome. Julius, previously Cardinal Giuliano della Rovere, had been elected Pope on 31 October 1503 in the shortest conclave ever held. A nephew of Sixtus IV, he had long been a powerful force in the politics of the Church. In a fresco by Melozzo da Forli painted in 1477, almost thirty years before, the young Giuliano – a heavily handsome young man with a massive jaw – looked, as Kenneth Clark put it, like a lion among 'the donkeys of the papal secretariat'. He was *consigliere* to Innocent VIII (reigned 1484–92), then a contender for the papacy himself at the conclave of 1492. On that occasion he was outmanoeuvred by his rival and enemy, Rodrigo Borgia, who became Pope Alexander VI. For much of the next decade Giuliano was in exile in France, but he returned to Rome on Alexander's death in 1503. Approaching

(*facing page*)
After
Michelangelo
(?), Design for
the Tomb of Pope
Julius II (detail),
c. 1505 (?).

sixty,[1] he remained an imposingly – even alarmingly – forceful man, and one whose time at last had come.

According to his enemies, he took the name Julius because he intended to emulate Julius Caesar. Certainly, he set about seizing control with a ruthless panache reminiscent of his classical namesake. First he tricked Cesare Borgia, the son of Alexander VI, into supporting him, then within a month had him arrested and stripped of all power. Cesare (another man with an imperially Roman name) was a menacing opponent; one of the main models for Machiavelli's *The Prince*, he had carved out a principality in central Italy over the previous few years and had ambitions to control the papacy in perpetuity (or even become Pope himself).

Rapidly, Julius neutralized and destroyed this fearsome strategist.[2] Next he set about subduing the local Roman aristocratic warlords, the Colonna and Orsini, before turning his attention to his true ambition: the reassertion of the power of the popes as not only representatives of Christ on earth but also successors of the emperors of ancient Rome.

Julius was also a connoisseur of sculpture who had beaten Lorenzo de' Medici's agents and got possession of the *Apollo Belvedere*. In addition, he had long been a patron of Michelangelo's friend the architect Giuliano da Sangallo. Thus Julius had abundant reasons to take an interest in this brilliant sculptor: recommendations from Giuliano, reports of the triumphant beauty of *David*, and the sight of the *Pietà* next door to the Vatican in old St Peter's. Imperiously, he summoned the artist to Rome.

Michelangelo seems to have finished his cartoon for the mural of *The Battle of Cascina*, for which he was paid in full on 28 February 1505. Three days before this he received a generous 100 ducats for his travel expenses on his journey to Rome and opened a bank account at the Hospital of Santa Maria Nuova, depositing 900 gold florins – a very large sum that represented his savings up to that date (including

1 Julius's date of birth is not known, although evidence suggests December 1445 as the most likely time.
2 Machiavelli, observing events on behalf of the Florentine government, was impressed.

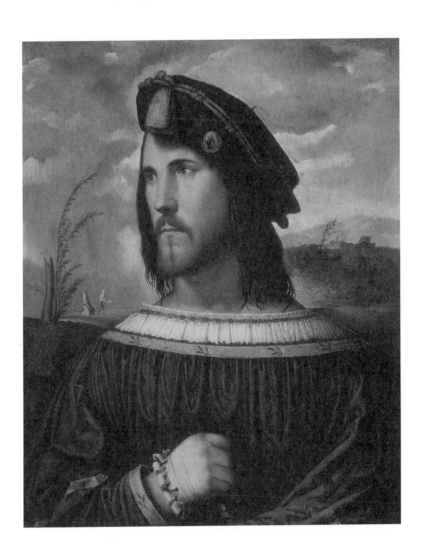

Altobello Melone, *Portrait of Cesare Borgia* (?), c. 1513.
This picture, though painted after Borgia's death,
has long been held to represent him.

payments for several works uncompleted or even not yet started). For comparison, Leonardo da Vinci left an estate of 289 florins. By 27 March Michelangelo was in Rome, depositing money with his bankers.

It seems the Pope already had a commission in mind: for his own tomb. The tomb of his uncle Sixtus IV by Antonio del Pollaiuolo, effectively Julius's commission, was the richest papal monument of the fifteenth century, a lavish affair housed in its own chapel in old St Peter's. His own would be yet bigger and more beautiful. Whatever Julius's virtues, modesty was not one of them.

The precise design agreed on at this stage is unclear, but Condivi described it, undoubtedly quoting from Michelangelo's words: it was to be a free-standing structure, 24 feet by 36; all around the lower storey on the outside there were to be niches containing statues and, between these, bound, naked figures whom Michelangelo called 'prisoners' (also described often as slaves or captives). These represented the liberal arts, 'as well as painting, sculpture and architecture', and symbolized the fact that, with Julius dead, the arts themselves were imprisoned, since no other patron would ever rival him.

Above this level there would have been a cornice with four big statues at the corners, representing, according to Vasari, Moses, St Paul and the Active and Contemplative Life. Higher still there would have been 'two angels supporting a bier: one of them would have been smiling, as if to rejoice that the soul of the Pope had been received among the blessed spirits; the other weeping, as if to lament that the world had been deprived of such a man'.

The tomb would have been in effect an independent structure within the basilica, with an inner chamber containing the actual marble coffin of the Pope. Condivi stated that there would have been more than forty statues in all, plus bronze reliefs representing the great deeds of the Pope (most of these not yet accomplished, but no doubt planned). Here was a simply astonishing glorification of a man who had been in power for sixteen months and, so far, with the exception of outwitting Cesare Borgia, had achieved very little. However, right from the beginning, this was not only to be Julius's monument but also Michelangelo's. If the tomb were carried out, he later wrote to

Giuliano da Sangallo, 'I am certain . . . there will be nothing to equal it the world over.'[3]

The scheme was all agreed by the end of April, with – apparently – the artist and his patron egging each other on in grandiosity. There is no contemporary account in letters of the process of design and

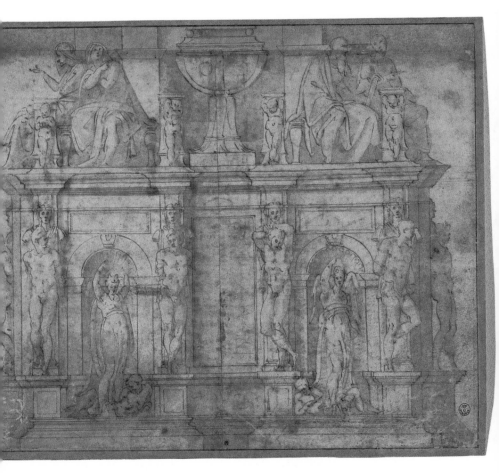

After Michelangelo (?), **Design for the Tomb of Pope Julius II, c. 1505 (?).**

3 Michelangelo must have been aware of the description in Pliny the Elder's *Natural History* of the Mausoleum of Halicarnassus. It was, according to Pliny, the sculpture above all that made this one of the Seven Wonders of the Ancient World, which was completed by the artists who made it even though their patron, the widow of Mausolus, had died, 'since they believed it would be a monument to their own glory and their art'.

commissioning, but there are signs that – not for the last time – Michelangelo was successful in selling a megalomaniacally extravagant scheme to a patron. His drawings for the project, few[4] of which survive, would have been seductively beautiful. The image conjured up of a monument – which would have been one of the wonders of the world had it been realized – must have been immensely beguiling to a man such as Julius II, a lover of ancient sculpture and a man of formidable ego.

Naturally, the question arose of where such an enormous monument could be placed; it would require more space perhaps than was currently available in any Roman church. According to the version in Condivi, Michelangelo's solution was that the new chancel of St Peter's – begun half a century before by Pope Nicholas V and never built far above foundation level – should be completed: 'The Pope asked him: "What would this cost?" To which Michelangelo replied, "A hundred thousand crowns." "Let it be two hundred thousand," said Julius.' This story was probably not much exaggerated because on 28 April Francesco Alidosi, the papal treasurer, wrote to a Florentine banker and politician named Alamanno Salviati[5] saying that he was sending him a letter of credit in Michelangelo's name for a thousand ducats. This was in respect of an agreement between the Pope and Michelangelo, one about which His Holiness was 'happy and relaxed'.

With this pledge that the vast resources of the papal treasury were behind him and his soaring ideas, Michelangelo departed to quarry marble.

<div align="center">*</div>

4 Scholars are divided about the authorship of most studies of the whole tomb design, and also about the dates at which they were made. This first project is the least well documented of the succession of schemes Michelangelo produced for Julius's tomb over the years, since no contemporary contract for it survives and the attribution and dating of surviving drawings is disputed. The main sources of information about its appearance are the descriptions by Condivi and Vasari, both written decades later.
5 The role of Alamanno Salviati in this is intriguing. The Salviati were a rich and powerful family who had played a part in installing Piero Soderini as *Gonfaloniere*, but lost confidence in his populist policies shortly afterwards and joined the pro-Medicean opposition. Alamanno's cousin was married to Lucrezia, eldest daughter of Lorenzo the Magnificent. He was thus brother-in-law to Cardinal Giovanni de' Medici, soon to be right-hand man of the Pope. There is a hint here that Salviati was involved.

The previous five years had brought one success after another – the *Pietà*, *David*, the cartoon for *The Battle of Cascina*, and now this heady commission for the Pope's tomb, the greatest sculptural project since the fall of the Roman Empire. It was at this moment that the most ambitious conception of his entire career came to Michelangelo.

One day when he was high up in the mountains above the town of Carrara, looking down at the peaks and valleys below and the Mediterranean in the distance beyond, 'he formed the wish to make a colossus, that would be visible to mariners from afar'. In other words, Michelangelo wanted to carve a chunk of mountain into a human figure. One guesses, though the subject is not described, that he had in mind a naked male body.

He was inspired to this reverie by 'the available mass of rock, which could be carved most conveniently', and by the desire to emulate – not to say outdo – the ancient Greeks and Romans, who, he would have known from reading Pliny, had created several gigantic statues. Obviously, however, this project was impossible. No patron would pay for it, no one was likely to want it – even the sailors who would gain at fantastic expense a possibly useful landmark. With the available workforce and technology, it was wildly impractical. Even with modern power tools, such mountain carving is a difficult and lengthy process. A memorial to the Native American warrior Crazy Horse begun in the Black Hills of Dakota in 1948 has still not been completed.

However, Michelangelo was strangely reluctant to give this dream up. 'He certainly would have done it if he had had enough time,' the Condivi Life insisted, apparently directly quoting the words of Michelangelo. Then, slipping into the first person, Condivi added, 'Once I heard him complain sadly about this.' Another decade later, now verging on ninety, Michelangelo repeated much the same regret to Calcagni: 'This was, he said, a madness that came over me, but if I could have been sure of living four times longer than I have lived, I would have taken it on.' That casual estimate puts the period necessary for the completion of the figure carved from the mountain at over three hundred years.

It is tempting to speculate on why he found this wild idea so hard to abandon, so that the thought of it still filled him with sadness half a century later. The reason must have been that the unexecuted man-mountain was emblematic of two things. It stood for all the ambitious schemes, among them the tomb of Julius itself, that were never completed or only in a much reduced manner. And, perhaps even more, the colossus at Carrara represented a project that was his idea alone, not something done at the instigation of a powerful patron, some swaggering *gran' maestro*. Michelangelo's urge to take control of every aspect of the creative process is one of the traits that make him seem modern. Eventually, he was to make important works just because he wanted to, for people he loved. However, they were on pieces of paper, not carved out of Apuan Alps.

Michelangelo's duel of ego and will with his patrons dominated much of his life and, with Pope Julius, it was just about to begin. Michelangelo stayed a long time in the mountains – eight months, with trips back to Florence included; indeed, he was away too long because, in his absence, Julius's attention was diverted on to another costly project, proposed by a man as ambitious and imaginative as Michelangelo himself: the architect Donato Bramante.

On the whole, the popes of the Renaissance have received a critical assessment from posterity. Vanity, worldliness, nepotism, corruption, greed and lust are among the charges frequently brought against them. It is true that the character of Julius II was less than saintly. He put the papacy on a war footing and determined to recover the territory of the Papal States[6] in central Italy, causing astonishment by leading his armies in person when approaching the age of seventy. Julius was notorious for

6 The Papal States were an area of central Italy at one time controlled by the Emperors of Byzantium then presented to the popes by Pepin, father of Charlemagne, in the eighth century. They comprised much of the modern-day Italian regions of Lazio, Emilia-Romagna and the Marche. It was seldom easy in practice to control this disparate area, straddling the Apennine mountains, nor was it clear whether the popes ruled on behalf of the Emperor or in their own right. Normally, actual government was maintained by an ever-shifting patchwork of city states and local aristocrats. From the late fifteenth century, however, under Alexander VI and Julius II, a determined effort was made to transform this territory into a true state.

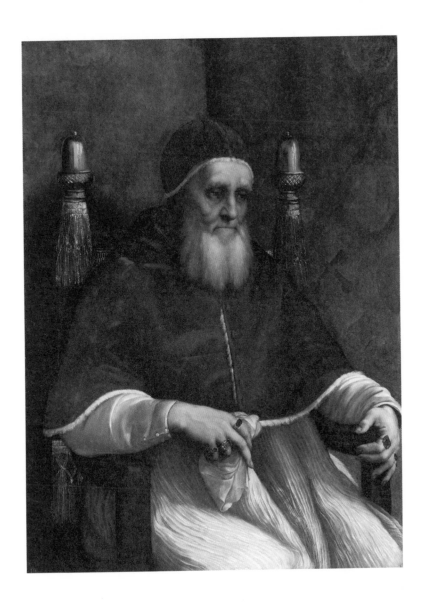

Raphael, *Pope Julius II*, mid-1511.

his impulsive irascibility. Servants who displeased him would be driven from the room with blows; ambassadors who made unwelcome remarks might be treated to a stream of alarming insult and invective. This was a side of the Pope Michelangelo was soon to discover.

To be fair to Julius, however, he was not motivated entirely by egotism and gusts of violent emotion. In some respects, he was a more conscientious pontiff than most of his immediate predecessors or successors. For example, he was much less inclined to give lucrative positions in the Church to his relations than either Alexander VI or his own uncle Sixtus IV (who had originally made Julius himself a cardinal in an act of shameless nepotism).

When he changed his mind about the commission for his tomb, sidelining or at least postponing the scheme, he might well have been acting from reasons of conscience. There were more pressing uses for the available money than a hugely expensive monument to himself. Rather than tinker with the fabric of St Peter's in order to fit it in, it was obviously more desirable – and responsible – to devote the funds and energy to the basilica itself.

St Peter's was nearly 1,200 years old and in danger of falling down. It had originally been built in the reign of the Emperor Constantine on an awkward, sloping site, the location of a Roman cemetery where it was believed St Peter himself had been buried. For a long time, the state of the structure had been worrying: the walls were leaning out of true. Various plans for repair and reconstruction had been proposed over the years, of which one was the unfinished choir in which Michelangelo's tomb for Julius was supposed to go.

Boldly, Julius took the decision that earlier popes had hesitated to take. St Peter's, the most venerable church in Christendom, would be rebuilt. Condivi audaciously attempted to make Michelangelo the first cause of this grandest of all grand Renaissance architectural dreams. That might have been so, but the result was to frustrate Michelangelo's ambitions and – as the consequences played out – to derail his career for years on end.

What happened, allegedly, was that the Pope sent his architects Giuliano da Sangallo and Bramante along to take a look at the unfinished choir which was to house the tomb. One idea led to a bigger

one, as it often does in architecture, so, eventually, 'the Pope formed the wish to build the whole church afresh.' Proposals were drawn up, and 'Bramante's was accepted, as being more elegant and better thought out than others.' St Peter's, in Bramante's design, would rise anew as an immensely spacious, grand, domed classical building.

This was the position when Michelangelo returned to Rome about eight months after he had set off for the marble mountains. He was back by the end of the year, anxiously waiting for his stone to start arriving at Ripa, the river port of Rome on the Tiber, after a long and tricky journey from the quarries. However, before it arrived, one of the most exciting archaeological discoveries of the age – indeed of any age – took place in front of Michelangelo's eyes. On 14 January 1506, on a vineyard owned by one Felici de' Freddi near the church of Santa Maria Maggiore – that is, in *disabitato*, the part of ancient Rome given over to agriculture – some beautiful sculptures were discovered beneath the ground. Immediately, the Pope was informed, and he in turn sent a messenger to tell Giuliano da Sangallo to go and take a look.

What followed was described many years later by Giuliano's son Francesco, who had been eleven at the time: 'Since Michelangelo Buonarroti was always to be found at our house, my father having summoned him and having assigned him the commission of the pope's tomb', Sangallo suggested he should come along too, and the three of them went to examine the new discovery. Young Francesco climbed down into the hole, whereupon Sangallo announced that it plainly was the *Laocoön*, a great masterpiece of classical sculpture representing a Trojan priest and his sons being strangled by serpents sent as a divine punishment.

As Sangallo instantly realized, this was a work described and praised by Pliny in his *Natural History*, the primary source of information about ancient art for the Renaissance. The reappearance of these mighty, naked, pinioned figures must have seemed astonishingly timely, just as Michelangelo was preparing to sculpt his own naked *Prisoners* for the tomb. That day, according to Francesco da Sangallo, his father and Michelangelo rode home talking constantly about antiquities, and carried on over dinner and into the evening.

On 31 January 1506 Michelangelo wrote to his father in Florence, complaining about the problems he was experiencing with the shipment

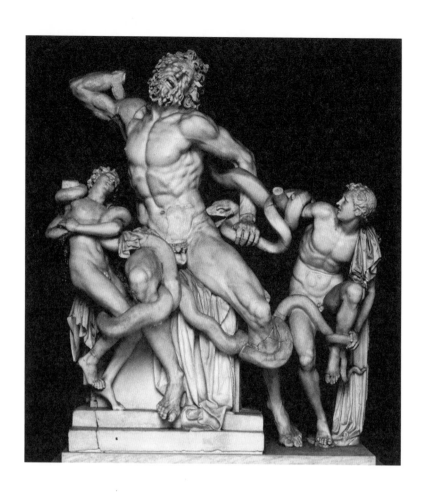

Laocoön and His Sons, c. 25 BC.

of his marble from Carrara. One boatload had arrived, he had unloaded the stone, then the level of the river had immediately risen, submerging it all. Meanwhile, he added optimistically, 'I'm making promises to the Pope and keeping him in a state of agreeable expectation so that he may not be angry with me.'

The project was ready to speed ahead. Michelangelo began to arrange a house and sculpture workshop on the other side of the piazza from St Peter's itself, behind the church of Santa Caterina, buying 'beds and furniture' and recruiting masons – *scarpellini* – to work on the architectural structure of the tomb, which, as we have seen, amounted to a small building. This was the first time Michelangelo had been in charge, financially and practically, of such a large operation.

Perhaps it made him anxious. At first, all seemed to be well. Frequently, Julius went to Michelangelo's house, 'discussing with him the tomb and other matters just as if they were brothers'. To make access to the workshop easier, according to Condivi the Pope arranged for a gangplank to be slung from the raised corridor between the Vatican and the Castel Sant' Angelo to Michelangelo's room, 'by which he could go there privately'. This might be true: there is a record of a payment that could refer to such a raised walkway.

Within a couple of months, however, there were signs that the tomb was no longer the Pope's most urgent concern. After all, even with the most hopeful estimates of progress, it would be many years before the church would even be ready for the tomb to be installed.[7] It could wait. It was suggested that Michelangelo might undertake a different task which needed doing: the repainting of the ceiling of the Pope's formal place of worship, built by Julius's uncle Sixtus IV and consequently called the Sistine Chapel. As it became clear what was happening, Michelangelo became agitated.

His reaction was to badger the Pope for more funds for the tomb. These were, in reality, not needed at this point. He had been paid an additional 500 ducats in January, making his total fees for the tomb so far 1,600 ducats and 60 Florentine florins. The fact that he had

7 As it turned out, it was around a century and a half before the exterior and interior of the new basilica were entirely completed.

banked 600 ducats in his own account in Florence was scarcely the Pope's fault. Nor was this a good moment to demand more cash. In addition to launching a huge new building operation at St Peter's, there was also the prospect of a major military campaign: before long, Julius was to march north and recapture erstwhile papal territories in Central Italy – an enterprise much more expensive even than his tomb. Predictably, faced with yet more demands from Michelangelo for money, Julius lost his temper.

On 11 April, Holy Saturday, Michelangelo heard Julius talking at dinner with a jeweller – one of the artists and artisans clamouring for papal patronage. In dismissing this man, Julius remarked that he did not want to spend another penny on little stones – or big ones either. Michelangelo, overhearing this (as perhaps Julius intended), was dismayed, but nonetheless asked the Pope for yet more money for the tomb. He was told to come back on Monday. This he did, but got no audience – although the Pope knew he was waiting – nor on Tuesday, Wednesday or Thursday. On Friday he was turned away by a servant; the Bishop of Lucca, who saw the incident, said to the groom who had done it, 'Do you know who this is?' And the groom replied, 'Pardon me, but those are my orders'. At this, the artist was 'overwhelmed with despair'.

He went home and wrote to the Pope: 'Most Blessed Father, I was turned out of the Palace today by order of Your Holiness. I must therefore inform You that from now onwards, if You want me, You must seek me elsewhere than in Rome.' He withdrew his money from his Roman bank, returned to his workshop and told his assistants to 'find a Jew and sell the contents of the house', then follow him to Florence. Then, not for the first time, or the last, when faced with a crisis, Michelangelo fled.

Probably on Saturday 18 April – the very day the foundation stone of the new St Peter's was laid – he took a post horse and rode to Poggibonsi, inside Florentine territory and beyond the Papal States. According to Condivi, there, 'feeling he was in a safe place, he rested'. Tiberio Calcagni noted down a further detail that the aged Michelangelo told him: 'I left before day-break and rode for twenty hours.'

Condivi described what happened next: Julius dispatched five horsemen with orders to bring the artist back. However, by the time they caught up with him, he was out of papal territory and

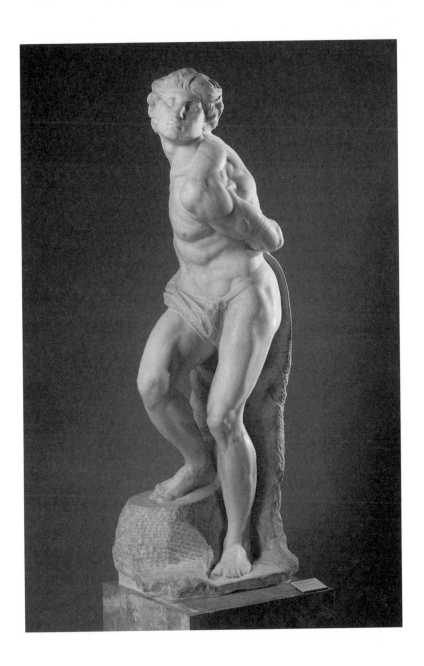

Rebellious Slave, c. 1513–16.

threatened – presumably banking on his friendship with the *Gonfalo-niere* Soderini – that 'if they tried anything he would have them murdered,' so, instead of using force, they tried entreating him to return.

That didn't work either, so then the men pleaded that he should at least write a message to the Pope, explaining that the men had been unable to force him to go back. They then asked him to read a letter from the Pope himself, which said that 'he should at once return to Rome, under pain of his disfavour.' Michelangelo replied that he would never return, and that after working so hard for the Pope he did not deserve 'to be chased from his presence like a rogue'. If His Holiness did not want to carry on with the tomb, he was finished with that commission and did not want another one from the Pope.

Michelangelo was clearly sulking and defiant. He was in fact being astonishingly high-handed in defying the wishes of a great prince in this way. True, there were precedents for an artist to act in this fashion, such as Leonardo's neglect of his commission from the Florentine government – but there was an implication in Michelangelo's words and actions of something more. He was behaving as if he had been slighted by someone close, a friend who had treated him 'like a brother'. Brotherhood was, for a Florentine, among the deepest of relationships, membership in the same male clan. This in turn suggested that he and the Pope were equals; the trigger for Michelangelo's flight was his being turned away, like an underling or a servant. Yet, to anyone in the medieval or Renaissance world, an artist, no matter how gifted, was just a servant. Michelangelo's defiance of Julius II was highly unwise, but revolutionary.

No sooner had Michelangelo left Rome than he began to get calls from his allies in Rome, urging him to come back. The Pope, Sangallo told him, was willing to forget and forgive – angry though he was at Michelangelo's abrupt and disrespectful departure. He would make more money available and do everything that had been agreed. But the artist would only half submit. He would agree to carve the tomb in Florence, but – either because he was frightened or because his pride was hurt – Michelangelo still adamantly refused to go back to Rome.

More messages were sent, including one from Michelangelo's

Roman banker Giovanni Balducci,[8] an old friend and advisor, urging him to be prudent. Another, extraordinary, account arrived from a master mason named Pietro Rosselli, a loyal friend and humble admirer of Michelangelo's artistry. This Rosselli had been doing some drawings for the Pope and presented them to him while Julius was eating supper. Afterwards, the Pope had sent for Donato Bramante and remarked to him, 'Sangallo goes tomorrow to Florence and will bring back with him Michelangelo.' The reply Bramante made to this was highly revealing: 'Holy Father, for sure he will not come, for I am intimate with Michelangelo, and he told me that he would not undertake the chapel, although you insisted upon giving him this task, but that he would only attend to the tomb and not to painting.'

Bramante then added his own interpretation of Michelangelo's reluctance to take on the painting: 'I believe that he lacks the heart to do it, for he has not done all that many figures, especially where the figures are high up and foreshortened, which is quite another thing from painting on the ground.' The Pope, quite affably, affirmed his confidence that Michelangelo would come back to Rome.

Perhaps Michelangelo was indeed frightened at the prospect of tackling what was to be the greatest and most celebrated of all his works. In sculpture, he felt sure of his ground. He had already carved magnificent marble sculptures. In painting, he had done much less, finishing little since his apprenticeship. His still-pending *Battle of Cascina* mural looked like being a triumph but, as Bramante shrewdly pointed out, painting a ceiling was a very different matter, involving complex problems of foreshortening. No one in living memory had attempted to fresco a vault on anything like this scale: it was a project that bristled with all manner of challenges – practical, technical and compositional. Michelangelo might well have been made nervous at being pressured to attempt something he was far from sure he could do.[9]

8 He had been the partner of Jacopo Galli, who had died the year before (and who, had he been alive, might have prevented this disastrous quarrel).

9 He added a dark postscript to his message to Giuliano da Sangallo. Being insultingly barred from the Pope's presence was not the only reason for his departure. 'There was something else besides, which I do not want to write about – it is enough

There the matter rested throughout the summer and early autumn of 1506. Bizarrely, and for perhaps the first time in history, an attack of artistic temperament caused a diplomatic incident. Michelangelo in Florence steadfastly refused to go back into the Pope's service in Rome; Julius put pressure on the Florentine government to make him return. In his desperation, Michelangelo thought seriously of fleeing to Constantinople to work for the Ottoman Sultan Bayezid II, who wanted an Italian engineer to design a bridge across the Golden Horn. A few years previously, Leonardo had produced working drawings for a sweeping single-span structure. Characteristically, Michelangelo thought he could rival this conception and undertake a civil-engineering scheme of a scale as daunting in its way as the colossal sculpture at Carrara. A Florentine merchant named Tommaso da Tolfo talked Michelangelo out of moving to the Ottoman Empire. He explained that the Sultan had sternly Islamic views about the depiction of figures, which he loathed, thus making any work for him apart from architecture out of the question. Tiberio Calcagni noted next to the passage in Condivi the words, 'It was true, and he told me he had already made a model.'

There is a hint that Michelangelo was in a highly wrought state in an anecdote that occurs in the manuscript of the *Anonimo Magliabechiano*, which recorded the vicious verbal clashes with Leonardo. Apparently, Michelangelo got hold of and dissected the corpse of a member of the influential Corsini family. Understandably, the Corsini were angry about this, and complained to the *Gonfaloniere*, who laughed it off, 'seeing that it was done to add to his art'. There were few Corsini deaths while Soderini was *Gonfaloniere* but two who qualify were Giovanfrancesco Corsini, who died on 6 June 1506, and Sebastiano, who died on 5 August. Almost casually, the *Anonimo* noted that this happened while Michelangelo was 'interdicted for shedding the blood

that I had cause to think that if I remained in Rome, my own tomb would be sooner made than the Pope's.' What this mysterious further threat was, he never said; indeed he never mentioned the matter again. It is possible, for example, that with his ability to wound with words he had made a dangerous enemy of some rival artist in Rome. However, it is more likely this was a melodramatic way of saying that, if he had to paint the ceiling, he thought it would kill him.

of one of the Lippi'. In other words, he had been involved in a violent quarrel and was banned from the neighbourhood of the victim.

Months went by, with the head of the Florentine Republic – *Gonfaloniere* Soderini – trying to coax, implore and browbeat Michelangelo into returning to Rome. 'You've tried and tested the Pope as not even the King of France would dare, so he will no longer wait to be asked. We don't want to wage war with him over you and put our State at risk; so prepare to go back.'[10]

Even Julius II, a notoriously irascible man, was surprisingly understanding about the whole matter. Eventually, in September, Michelangelo gave in and agreed to go back into the Pope's service. By this time, however, Julius was no longer in Rome. Towards the end of August, the chessboard of Italian politics was transformed by a sudden move, a sweeping diagonal attack north from Rome led by no mere bishop but by the Pope himself. The intention was to bring Bologna, long effectively ruled by the Bentivoglio family, back under the control of the papacy, to which – in the eyes of Rome at least – it belonged.

The first time Michelangelo set out to meet the Pope as he advanced, he went only part of the way then returned to Florence, either because of the chaos caused by the war or because he simply lost his nerve. It was not until the end of the year that he finally made his peace with Julius, by which time Julius had conquered Bologna and was holding court there.

On 11 November Julius was carried in triumph through Bologna like his namesake Julius Caesar, to the church of San Petronio to give thanks for this victory. Ten days afterwards Cardinal Alidosi, Julius's main man of business, sent the Florentine government a crisp request to send Michelangelo immediately, as the Pope needed him urgently to do important work. Quite amazingly, the Florentines replied with a recommendation of how to treat this difficult, brilliant young man: 'His disposition is such that, if spoken to kindly, he will do everything. It is necessary to show him love and to favour him.' In other words,

10 In the interim, Michelangelo probably got on with various works, including the *Doni Tondo* and the never to be finished sculpture of St Matthew, the only one of the twelve apostles for the Duomo that was even started.

the lesson that Soderini (and also Machiavelli) had learned was that it was crucial to treat this artist like an equal, as a gentleman – not as a servant.

Then, finally, Michelangelo showed up, a humiliation he still felt bitterly almost two decades later, as he complained in a letter of 1523: 'I was forced to go there with a rope round my neck, to ask his pardon.' According to the account he gave Condivi, Michelangelo still seems to have fallen short of outright penitence. No sooner had he arrived in the central square of Bologna, on his way to hear Mass at San Petronio, than he ran into some papal grooms who took him to Julius, who was in a nearby palace.

When he saw Michelangelo, 'the Pope turned to him with a look of rage and said: "You were supposed to come to find us, yet you've waited for us to come to find you."' However, apart from the angry expression, this sounds like a joke more than a threat: he, the Pope, had had to travel north before encountering Michelangelo, rather than the sculptor coming back south to Rome as he had been asked. Michelangelo's answer was less than a full apology. He knelt, asking for pardon, but explained that he had acted as he did from rage at being ignominiously chased away.

This still seemed to place the blame on Julius, but the pontiff took out his ire on a 'certain monsignore' who had been sent by the Florentine Cardinal Soderini, brother of the *Gonfaloniere*, to oil the wheels of this meeting. The courtier tried to explain that painters were ignorant about matters outside their own art, at which Julius exploded: 'You are abusing him, and we are not. It is you who are ignorant and you're a miserable wretch, not him. Get out of my sight, and bad luck to you.' Or so, at least, Michelangelo chose to remember this awkward moment: as a humiliation for someone else and a backhanded compliment to him, the artist.

Now the artist was given yet another unwelcome task: making a monumental bronze statue of Julius to mark the Pope's conquest of Bologna. He wanted to get this done quickly; and at the best of times Michelangelo was chronically inclined to underestimate the time a commission would take up. This was illustrated in comically voluminous detail in the letters he sent back from Bologna while he was engaged

on this second bronze: a 9-foot effigy of the seated Julius II intended to put the fear of God's representative on earth into the citizens of the town.

In the very first letter, sent on 19 December to his brother Buonarroto at the Strozzi wool company, Michelangelo predicted that making this colossal sculpture of Julius would require only another couple of months: 'If God helps me, as he has always done, I hope by Lent to have done what I have to do here. After that, Michelangelo will return to Florence.' As letter succeeds letter, this schedule is slowly extended, month by month.

At the end of April 1507 he had finished his clay model and began to make an outer mould from it. This he expected to take three weeks or so, then he would cast the sculpture and would soon be home in Florence. At the end of June it was finally cast, with the help of Bernardo d'Antonio da Ponte, Master of Ordnance to the Florentine Republic (summoned by Michelangelo to give technical assistance with the tricky business of casting such a large statue).

Unfortunately, only the bottom half of the figure came out properly, and the top had to be recast. The figure needed considerable cleaning up, as well as the chasing and finishing always required with a bronze. This, too, took far longer than he had anticipated. On 10 November he was still labouring flat out, and filled with mixed sensations of stress, exhaustion and triumph:

> I'm living here [he wrote to his brother Buonarroto] in the greatest discomfort and in a state of extreme fatigue; I do nothing but work day and night and have endured and am enduring such fatigue that if I had to do the work over again I do not believe I should survive, because it has been a tremendous undertaking and had it been in any- one else's hands it would have been a disaster! But I think someone's prayers must have helped me and kept me well, because the whole of Bologna was of the opinion that I should never finish it.

The whole process of modelling, casting and chasing the sculpture ultimately took him exactly a year longer than he had hoped; the statue was not installed over the main door of San Petronio until February 1508. Understandably, his irritation spilled over when – after this

colossal effort – a Bolognese painter of the older generation named Francesco Francia (1450–1517/8) praised it in infuriatingly faint terms: for being a fine casting in beautiful material. Vasari related with relish that Michelangelo retorted, 'Well, I owe as much to Pope Julius who gave me the bronze as you owe to the chemists who give you your colours for painting.' Then, losing his temper, in the presence of all the gentlemen standing around, he called Francia 'a fool'.

We know a great deal about the progress of this work: all that is lacking is the slightest trace of the sculpture itself. Its subject, the Pope, was an exponent of Machiavelli's dictum that it is better for a ruler to be feared than loved. Machiavelli did not write *The Prince* until 1513/4, but the observations on which it was based were made at exactly this period, and Julius is one of the contemporary rulers, in common with Cesare Borgia, whose actions Machiavelli most intensively analysed.

Evidently, the bronze statue, like its subject and its maker, had the quality of *terribilità*. A contemporary poem asks of an imaginary traveller why he flees from it, since it is only an image of Julius, not Julius in person. Clearly, the pontiff was a formidable presence. Michelangelo was evidently nervous.

At two o'clock on the afternoon of Friday 30 January 1507, the Pope had paid a visit to the studio in which Michelangelo was making the clay model of the sculpture. He told Buonarroto how the Pope had come and 'stayed to watch me at work for about half an hour; then he gave me his blessing and went away'. Michelangelo expressed relief that the Pope was pleased with what he saw: 'For this I think we must thank God above all,' he told Buonarroto, 'and this I beg you to do and to pray for me.'

This was probably the occasion when, as Michelangelo told Condivi, he asked the Pope what he should put in his left hand (the right hand being raised in blessing). He asked if it would please Julius to be holding a book. 'The Pope replied: "Why a book? Do a sword; for I'm not a man of letters."' And, making a joke of the right hand, which was boldly outstretched, he said to Michelangelo smilingly: 'This statue of yours, is it giving a benediction or a malediction?' Michelangelo said: 'It is warning the people here, Holy Father, to be prudent.'

Unfortunately, Julius did not carry out another of Machiavelli's

recommendations: that, though it was better to be feared than loved, it was good for a ruler to avoid the hatred and contempt of his subjects. Shortly after the Bolognese got rid of their papal garrison, on 30 December 1511 they pulled the bronze Julius from its plinth and melted it down, less than four years after it was finished. Part of the metal was made into a cannon by the Duke of Ferrara and given the insulting name La Giulia. Not even a drawing or – apart from that poem – an eyewitness description survives. The tantalizing suspicion is that it must have been a masterpiece.

*

The correspondence from Bologna gives some revealing information about the squalor of Michelangelo's living conditions. He was earning large sums of money, was highly regarded by the most powerful men in his world, *Gonfaloniere* Soderini and Pope Julius, but preferred to live like a hermit in a cell.

This self-punishing tendency had first revealed itself in Rome. When the marble for the *Pietà* finally arrived in the summer of 1498, Michelangelo – presumably to carve this large sculpture more conveniently – for the first time took a house and workshop of his own. When his brother Buonarroti came to visit during the Holy Year of 1500, he took back a very critical report of Michelangelo's living conditions. The result was a marvellously Polonius-like letter of advice from Lodovico Buonarroti, in which we can hear the voice of Michelangelo's father clearly: fussily irritating but, irritatingly, sometimes right:

> Buonarroto tells me that you live at Rome with great economy, or rather penuriousness.[11] Now economy is good, but penuriousness is evil, seeing that it is a vice displeasing to God and men, and moreover injurious both to soul and body. So long as you are young, you will be able for a time to endure these hardships; but when the vigour of youth fails, then diseases and infirmities make their appearance . . . above all

11 The word Lodovico used, '*miseria*', was explained by Machiavelli. He used '*misero*', or miserly, for 'a man who is mean with what he possesses', while the Florentines used '*avaro*', or avaricious, for 'a man who wants to plunder others'. According to his enemies, at least, Michelangelo was both.

things, shun stinginess. Live discreetly well, and see you have what is needful. Whatever happens, do not expose yourself to physical hardships; for in your profession, if you were once to fall ill (which God forbid), you would be a ruined man. Above all things, take care of your head, and keep it moderately warm, and see that you never wash: have yourself rubbed down, but do not wash.

Michelangelo may have taken to heart this alarming advice about personal hygiene. Condivi reported some thoroughly insanitary habits: 'When he was more robust he often slept in his clothes and in the boots which he has always worn for reason of cramp, from which he has continually suffered, as much as for anything else. And sometimes he has been so long in taking them off that subsequently along with his boots he sloughed off his skin, like a snake's.' Vasari added a little more information on that last, revolting, point. The buskins were of dog-skin, worn next to the skin, with which they bonded.

From 1501 to 1506 Michelangelo would have spent much of his time in the Buonarroti family dwellings in Florence (a drawing on the wall of the kitchen at Settignano assigned to those years suggests he spent time up there, perhaps during the summer heat, working out ideas). However, as soon as he arrived in Bologna, Michelangelo set up temporary accommodation of a fiercely economical kind. He wrote on 19 December 1506, 'I'm living in a mean room for which I bought only one bed and there are four of us sleeping in it,' the other three occupants being Michelangelo's faithful assistant, Piero d'Argenta,[12] and two older Florentine sculptors whom Michelangelo had recruited to help him, Lapo d'Antonio di Lapo (1465–1526) and Lodovico di Guglielmo Lotti (b. 1458), an expert in bronze-casting who had worked with Antonio del Pollaiuolo.

However, perhaps Michelangelo emphasized the discomfort of his lodgings as a reason why Giovansimone, the fourth of the Buonarroti brothers, should not come to visit him. By February he had found another reason for Giovansimone to stay in Florence: the Pope was

12 We hear nothing of Piero from 1501 to this moment, almost six years later, but the assumption is that he must have been close to Michelangelo throughout the intervening years.

departing during carnival, and was not leaving 'a settled state of affairs' in Bologna; that is, there might be fighting. Then, in March, the plague broke out, announced with splendid understatement by Michelangelo. It was 'of a deadly kind, because no-one who gets it recovers, although so far there are not many houses affected – perhaps forty, according to what I'm told'. Giovansimone apparently commented on this report, and received a sample of Michelangelo's sarcasm in return: 'You write me that a friend of yours, who is a doctor, has told you that the plague is a dangerous disease and that one may die of it. I'm glad to hear it, because there is a lot of it about here, and still these Bolognese don't realize that one may die of it.'

Michelangelo's four-in-a-bed sleeping arrangements with Piero d'Argenta and the two seasoned Florentine sculptors did not last long. On Friday 30 January he parted company with both of the latter, dismissing Lapo 'because he is a deceitful good-for-nothing'. Lodovico – who was 'not so bad' – had sided with Lapo and departed too. Michelangelo was a little worried that these two disgruntled ex-helpers would complain about their treatment to his father, which – naturally – was exactly what they did.

A week later, having received a reprimand from Lodovico Buonarroti, Michelangelo replied, his teeth almost audibly grinding with exasperation:

> I have to-day received a letter of yours, from which I learn that you have been told a long story by Lapo and Lodovico. I value your reproof, since I deserve to be reproved as a miserable sinner, no less than others, and perhaps more so. But I would have you know that I have done no wrong in this matter, about which you reprove me, either to them, or to anyone else, unless it be that I did more for them than I need have done.

He added a detailed account of how Lapo had tried to cheat him over the purchase of 720 lbs of wax (required to make the mould for the bronze casting of the statue of Julius II).

It was the spring of 1508 before, the bronze at last installed, Michelangelo was ready to begin work on both the tomb and the other job he had so fiercely resisted: the ceiling.

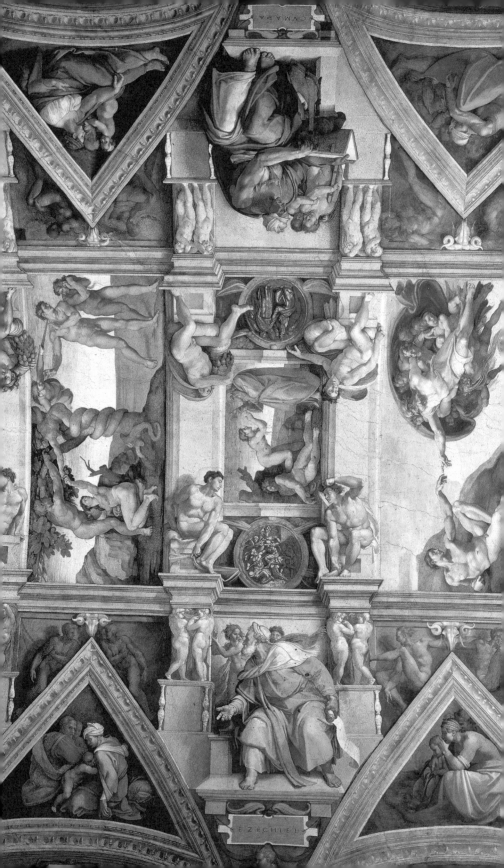

CHAPTER ELEVEN
VAULT

*'On 28 November we visited the Sistine Chapel again and
got them to open the gallery for us, because from there the
ceiling can be seen at closer range. The gallery is rather
narrow and we squeezed into it with some difficulty and
feeling of danger – people who suffer from vertigo would be
advised to stay below – but this was more than made up for
by the masterpiece that met our eyes. At present I am so
enthusiastic about Michelangelo that I have lost all my taste for
nature, since I cannot see her with the eye of genius as he did.'*

– Goethe, Rome, 2 December 1786

*'When I went to the Sistine Chapel I expected it to
be overwhelming. In fact I found the most beautiful
decoration I had ever seen above my head.'*

– Lucian Freud, 2004

It looked as though Michelangelo did not intend to return to Rome
at all. Once back in Florence, in March 1508, he rented a house
on the street of the Borgo Pinti, the fine residence originally
designed for him by the architect Cronaca. It had been intended as
part payment for carving the series of twelve Apostles for the Duomo,
an offer now withdrawn because of Michelangelo's failure to get on
with the commission. Even so, he wanted to move in and was presum-
ably planning to get down to the long list of outstanding commissions
that had been piling up since before Julius had initially sent for him.
Then another urgent summons arrived from Rome, and very quickly
he was back negotiating face to face with a domineering Pope.

(facing page)
**Sistine Chapel
ceiling, 1508–12,
central section.**

Understandably, the painting of the Sistine Chapel ceiling struck Julius and his advisors as an urgent matter. It was in an extremely unsightly state. In the spring of 1504 the fabric of the chapel, not yet thirty years old, developed serious structural problems, so bad that the service of vespers had to be transferred to St Peter's in May, and in August the building was described as 'under construction'.

The walls had shifted because of the instability of the soil beneath and, as a result, the vault cracked. Johann Burchard, one of the Papal Masters of Ceremonies, described it as 'split down the middle'. Chains had to be inserted to hold the upper section together, and these emergency works had wrecked the existing decoration of the ceiling, which was a traditional design of blue, patterned with stars – a symbolic vault of heaven.

The ceiling could scarcely be left in that condition, because this was the 'capella magna', or Great Chapel, of the Vatican Palace. This was the place where – with the exception of the Basilica of St Peter's, which was at present partially demolished – the pontiff appeared at certain Masses with the maximum majesty and richest symbolic significance, in the presence of the entire College of Cardinals, the generals of monastic and mendicant orders, other senior clergymen who were visiting Rome, the chamberlains, theologians, secretaries and other officials of the papal household, and – behind the screen that divided the floor – members of the laity, such as the senators and conservators of the city of Rome, ambassadors, diplomats and princes.

Obviously, something had to be done about the decoration of the damaged vault. The original proposal – presumably coming from the Pope or his entourage – was straightforward. As Michelangelo later recollected, it called for 'twelve Apostles in the lunettes'. This was an echo of the project Michelangelo had made a start on for the Florentine Duomo. The rest of it, which he described with a smidgeon of contempt as 'ornament as is usual to fill the remaining area', could have been done, and probably would have been expected to be done, by a team of assistants under Michelangelo's direction.

Therefore, all Michelangelo had to do was paint twelve large figures, variations on a theme about which he had already thought, and devise

a conventional decorative surround (probably including some smaller scenes of the Apostles' acts, which again could have been painted by assistants to Michelangelo's designs). This would have satisfied Julius.

That was apparently the understanding on which the whole affair got under way. On 10 May Michelangelo wrote a memorandum in his book of *ricordi*: 'I, Michelangelo, sculptor, have received on account from our Holy Lord Pope Julius II five-hundred papal ducats toward the painting of the ceiling of the papal Sistine Chapel, on which I am beginning to work today.' It was not until later, 'After the work was begun', that Michelangelo had second thoughts: 'I told the Pope that if the Apostles alone were put there it seemed to me that it would turn out a poor affair. He asked me why. I said, "Because they themselves were poor." Then he gave me a new commission to do what I liked.'

There are a couple of preliminary sketches for the vault with Apostles, proving that Michelangelo did begin thinking about this scheme. He changed his mind, it seems likely, while the vault was being prepared. On 11 May, the day after the contract was signed, he paid Piero Rosselli 10 ducats for hacking the old plaster off the ceiling and putting down a new layer of *arriccio* (the rougher layer of lime and sand that preceded the final fine coat of plaster).

'*Buon fresco*' – good, or true, fresco – was, in Vasari's opinion, 'the most masterly and beautiful' of all the techniques employed by artists. This was because it required the most unerring skill and judgement. In other methods, such as the Venetian way of working with oils, it was possible to retouch and alter what had been painted.

In fresco, after the final, thinner layer of plaster (known as the *intonaco*) was applied, it was essential to work rapidly and decisively, as, when the *intonaco* dried, the paint bonded chemically with it. This normally took a day, so each session of painting – detectable by a fine line in the final work, was known as a *giornata*, a day's work. To Florentines, fresco was a manly technique – in which Vasari felt it was necessary to work 'boldly'. It revealed hesitations and mistakes but showed off fearless brilliance – or, at least, that was the theory; in

practice, frequently corrections as well as ornaments and additions were added afterwards on top of the dry fresco, so *a secco*.[1]

Rosselli was also required to do whatever else was necessary in the chapel. That last item included making the scaffolding, which presumably came first – as Rosselli and his workmen would need it to do the other jobs. By Saturday 10 June the senior Papal Master of Ceremonies, Paris de Grassis, complained that the office of vespers on the eve of the Pentecost had been disrupted by the construction that was 'proceeding on the topmost cornices, with a great deal of dust, and the workmen would not stop even when told'. The cardinals who were present complained, de Grassis remonstrated with the workmen several times and finally sent to the Pope, who despatched two aides to tell them to stop, 'and they very nearly did not stop even so'. We get a sense from that fractious incident of the furious pace with which the works were being driven on, impelled by an implacable force: Michelangelo's will.

The workmen were probably making a lot of dust because they were banging holes in the chapel walls – cavities that were discovered by the restorers cleaning the ceiling in the 1980s. These were to provide footings for an ingenious system, apparently of Michelangelo's own invention, which in effect consisted of an arched bridge across the top of the chapel. (One wonders whether the designs for the bridge over the Golden Horn gave him the idea.) The vault could be painted from the top and stepped sides of this, while services could continue undisturbed below. The last payment to Rosselli was on 27 July. At that point, the vault was ready to be frescoed.

One factor that might have affected Michelangelo's conception of the design was having a close look at the vault itself from the scaffolding. The sketches for the Apostle scheme suggest that, when he did them, he had not yet grasped the awkward geometry of the ceiling itself. Basically, this is a shallow vault over the chapel – but it is interrupted at intervals by windows with semicircular lunettes above them.

1 Much of the controversy over the cleaning of the ceiling frescoes in the 1980s turned on how many *a secco* additions Michelangelo had made and whether the conservators had accidentally removed some.

These lunettes cut into the vault, creating a sequence of curved, triangular groins, or severies.

In response, Michelangelo devised an unprecedented system that partly follows this architecture and partly contradicts it. The lunettes he conceived as shallow spaces in which ancestors of Christ perch on the arched windows as if on chairs. But the severies are imagined as dark spaces within the vault in which more ancestors nestle, with larger illusionistic spaces in the bigger groins at the four corners of the room. Between each window an elaborate throne is apparently rising into space above the real vault, with a giant prophet or sibyl seated on it. Above the thrones, painted arches span the ceiling, framing rectangular spaces in which more scenes – including the creation of the world, the birth of Adam and the story of Noah – are depicted. Around all of this is a population of putti in painted stone, nudes in painted bronze, and more, larger male nudes of painted flesh and blood whose job it is to support round medallions of fictional bronze with yet more stories on them, from the Book of Maccabees and other parts of the Old Testament.

In other words, Michelangelo hugely complicated the commission, creating level after level of illusion. In the process, of course, he laid out the template for a supreme masterpiece. It turned out to be a work with 'nothing to equal it the world over', just as he had predicted the Pope's tomb would be. However, by elaborating the ceiling he also enormously impeded his attempts to get on with work on the Pope's tomb, which still seems to have been his intention in the early stages of the painting of the ceiling. He paid for more marble on 6 July, in addition to the masses still standing around outside his workshop. It might just have been possible to carry on with the tomb and the original, Apostle scheme, granted plenty of help from assistants. This new plan, however, ruled out carving marble on the side. And, by his own account, it was all Michelangelo's doing.

*

Generations of scholars have thrown doubt, quite understandably, on Michelangelo's claim that Julius allowed him to do 'what I liked'. After all, it scarcely seems probable that Michelangelo would have been given carte blanche to devise the iconographical scheme for one of

the most important sacred spaces in Christendom. Surely one of the expert theologians in the papal Curia would have taken responsibility for that? What is plausible is that, given that there were two possible themes for the ceiling, Michelangelo might have concluded that he needed the one that offered the most potential for his invention to soar, and the greatest potential richness. On this point – essentially an artistic one – it is believable that Michelangelo's advice might have been accepted (especially if the subject of the Apostles had originally been selected to make it less troublesome for him to carry out).

There were in fact two potential themes which would continue the cycles of frescoes that already existed: the creation of the world and the Apostles. In 1481 a team of painters from Florence – including Michelangelo's master, Ghirlandaio, his friend Botticelli, Perugino and Cosimo Rosselli, relation of his helpful correspondent Piero Ros-selli – had signed a contract to decorate the new building with murals. Around all four walls of the chapel, above the lowest section, this team painted sixteen pictures in a sequence. Apart from the frescoed altar-piece, *The Assumption of the Virgin* painted by Perugino,[2] these frescoes consisted of two cycles. One told the story of the life of Christ and the other the life of Moses. Above the lower frescoes, a further cycle presented portraits of the first thirty popes from the first three centuries A D: that is, the immediate successors of St Peter (around a third of these are by Ghirlandaio and his studio).

The decoration of the chapel was therefore a condensed history of the world, from the papal point of view. It contained the entire epic narrative by which supreme spiritual and temporal power had descended step by step to Julius II, the current occupant of the throne of St Peter – with the exception of two gaps. Missing was the early part of the Old Testament account, from the creation of the world to the life of Moses, and the interval between Christ's earthly life and resurrection and the era of the early popes. This was the period of the Acts of the Apostles.[3]

2 This was destroyed in the 1530s to make way for Michelangelo's *Last Judgement*.
3 There have been many erudite and arcane interpretations of the imagery of the Sistine Chapel ceiling, some of which are more credible than others. However, it is worth noting that Michelangelo's contemporaries did not imply that the subject matter was obscure at all. The writer Pietro Aretino simply alluded to the ceiling as

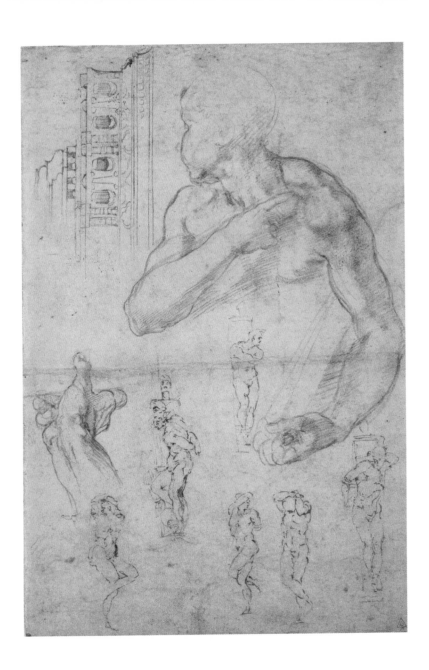

Study for *Figure beside Libyan Sibyl*, sketch of
an entablature, and studies for the *Slaves for
the Tomb of Julius II*, c. 1512.

After toying with the Apostles as a theme, Michelangelo might well have gone to Julius and explained that he could produce a more glorious, elaborate result by tackling the earlier sections of the Old Testament, with larger figures representing not Apostles but the prophets and sibyls who had foretold the birth of Christ. As he so often did, Michelangelo sold an extravagant, ambitious scheme to his patron. Julius agreed, though naturally he and other theologians and ecclesiastics at the papal court would have a say in exactly which scenes and figures would be included.

Michelangelo's dilemmas over the ceiling can be imagined. To begin with, his impulse was apparently to get it done as quickly as possible. The obvious way to do this was to employ a team of experienced masters who could carry out the work at speed, more or less to Michelangelo's designs. However, there were drawbacks to this method. The more assistants he employed, the more he would have to pay them, particularly if they were painters of standing who could execute important passages on their own. So, employing assistants directly conflicted with Michelangelo's stinginess. There was another problem, one that did him much more credit: as his ideas expanded, the more his honour and ambition as an artist were involved. Therefore, the more he wanted to control its execution – and quality – himself.

Michelangelo's resistance to delegating was a cause of many of the difficulties he suffered over the coming decades. It made the grand sculptural projects he longed to carry out almost impossible to accomplish and it put an enormous physical and mental strain on him personally. Much of the cantankerousness and irascibility we read about is easily understandable as the behaviour of someone suffering from exhaustion and stress. However, his inability to cede control and allow his ideas to be interpreted by platoons of skilled assistants was one of the reasons for the supreme quality of much that he did manage to accomplish. Ultimately, this would prove to be the case with the Sistine Chapel ceiling.

a painting of 'the creation of the world'. Pope Paul III, appointing a cleaner to dust the frescoes in 1543, simply distinguished between 'events fulfilled' – the scenes on the ceiling, sacred history that had already occurred – and 'events prophesied': the later *Last Judgement* on the altar wall.

The question of Michelangelo's assistants on the Sistine Chapel ceiling has been much debated. The various pieces of evidence from the paintings, from Michelangelo's financial records and the frescoes themselves, are complicated and contradictory. One point, however, is clear. He began to paint in the second half of 1508 with at least one assistant, an experienced master from Florence named Jacopo, and the result was disastrous. This huge work, which was to be the greatest of all Michelangelo's triumphs, began in humiliating and catastrophic failure.

As Michelangelo told Condivi: 'after he had started the work, and had finished the picture of the Flood, it began to grow a mould in such a manner that the figures were scarcely discernible.' Vasari told much the same story, which he claimed to have heard from Michelangelo himself. He believed the problem was the plaster mixture used in Rome, which consisted of a lime made from the local stone, travertine, combined with *pozzolana* (sand derived from volcanic ash).[4] This held a lot of moisture and was slow to dry, sometimes causing an efflorescence on the surface as it did so.

This sequence of events is apparently mirrored in Michelangelo's letters home. At the beginning of October, there were signs of strain. Michelangelo wrote to his father that his assistant, Jacopo, had deceived him, though quite how is not clear: it might have been over money – the source of the row with the two Florentine sculptors in Bologna – or Michelangelo might have been complaining about bad advice about the plaster.

By the end of January 1509 Michelangelo was utterly despondent. He dared not ask the Pope for more money; he told his father, 'my work does not seem to me to go ahead in a way to merit it. This is due to the difficulty of the work and also because it is not my profession. In consequence, I lose my time fruitlessly. May God help me.' He had sacked Jacopo, who had been badmouthing him all over Rome and would probably do the same in Florence: 'Turn a deaf ear and leave it

4 Raphael also had difficulty with his plaster when painting his first fresco in the Stanze, suggesting it posed problems even to experienced painters who were unfamiliar with its properties.

at that, for he was in the wrong a thousand times over and I have every cause to complain about him.'

'Thinking that this excuse [of the mould] should be enough to let him escape being burdened with this task', Michelangelo went to Julius and told him that he wasn't a painter, and had been right all along in trying to avoid doing the ceiling: 'I have indeed told your Holiness that this is not my art: what I have done is spoilt: and if you won't believe it, send to see.' Julius then sent for Giuliano da Sangallo, who, having built extensively in Rome, knew all about the behaviour of local materials. He diagnosed that Michelangelo's plaster was too damp; after that, 'the Pope made him proceed and no excuse helped.' There was no escape from the ceiling.

The restorers in 1980–89 discovered that most of the fresco of *The Flood* had in fact been removed and redone; only the section showing fugitives from the waters sheltering on an island survives from the first version. Examination at close quarters revealed something else: that this section was painted by various distinct hands. Their conclusion was that Michelangelo himself had executed the moving group of the naked father climbing to safety on a rock, carrying his drowned son in his arms. Many of the surrounding figures they attributed to other artists, perhaps Granacci and Bugiardini.

This fits well with the story Vasari related: 'Some of his friends, who were painters, came to Rome from Florence in order to assist him and let him see their technique. Several of them were skilled painters in fresco.' He listed Granacci, Bugiardini, Jacopo di Sandro, Jacopo d'Indaco, Angelo di Donnino and Aristotile (also known as Bastiano) da Sangallo. One of the two Jacopos, probably di Sandro, was the one who deceived Michelangelo and was sacked by the end of January 1509.

Technical evidence from *The Flood* demonstrates that it was executed quite rapidly, by several artists working together following Michelangelo's designs. When he saw the result, evidently Michelangelo was not satisfied. Vasari passed on an anecdote which he might well have heard from Granacci or Bugiardini themselves:

Having started the work, Michelangelo asked them to produce some examples of what they could do. But when he saw that these were

nothing like what he wanted he grew dissatisfied, and then one morning he made up his mind to scrap everything they had done. He shut himself up in the chapel, refused to let them in again, and would never let them see him even when he was at home.

Except for the fact that Michelangelo did not, as Vasari thought, scrap everything that the others had done, this seems basically correct. The only problem – as Rab Hatfield, expert on Michelangelo's finances, has pointed out – is that there did not seem to be any room left in his extremely tight budget for paying a team of expensive collaborators. The explanation might be that they were paid via Michelangelo's father in Florence. Even so, there would not have been enough to cover more than travelling expenses and a short spell of work in Rome, after which Michelangelo must have told them to 'Go with God', or, in other words, clear off.

By June or July 1509 Michelangelo's mood had brightened. Even though he had an illness – perhaps one of the malarial fevers endemic in Rome during the hot months – he made one of his darkly sardonic jokes about it: 'I learn from your last that it is said in Florence that I am dead. It is a matter of little importance, because I am still alive.' He followed that reassurance with a touch of paranoia: 'Let them say what they like, and do not mention me to anyone, because there are some malicious people about.' (Did he suspect the rumour of his death was being spread by the collaborators he had sent packing?) He was evidently still ill at the time he was writing as in his next letter he says that, although he had assured his father he was not dead, 'I did not feel too well,' but suddenly he was more confident about his painting.

At this time Lodovico Buonarroti was in a state of panic. His sister-in-law, Cassandra, widow of his brother, Francesco (who had died in 1508), was threatening to sue him for the return of her dowry – as was her right under Florentine law. Lodovico feared this would wipe out his savings. From Rome, Michelangelo had reassured him, 'For if she were to take away everything you have in the world, you would not lack the means to live and to be comfortable, if there were no-one else but me.' He added a reflection that sounds very much like his current, more optimistic thinking about the Sistine Chapel ceiling.

He urged his father to defend himself boldly, 'for there is no under-taking, however great, which, if undertaken without trepidation, does not appear small. Michelangelo had had no more money from the Pope for over a year, he noted, 'but I expect to have some at all events within six weeks, as I made very good use of what I had'. He was determined to work as hard as he could. Perhaps it was significant that he wrote 'I', not 'we'. By that time, Granacci and Co. had returned to Florence.

Michelangelo was left with a much smaller entourage. In July 1508 he had recruited one junior assistant, named Giovanni Michi, from Florence. As always, the faithful Piero d'Argenta was available to help. In addition, two more apprentices were added to the little workshop behind the church of Santa Caterina which was Michelangelo's Roman base. These would have been enough to mix the plaster, transfer the cartoons and carry out less crucial areas of painting, such as the architectural framework. However, the burden of painting the main scenes and figures would fall entirely on Michelangelo himself.

A glimpse of the household was given in a letter sent by Michi while Michelangelo was away, trying to get more money out of the Pope in Bologna. With a pious, Biblical metaphor, Michi declared he had been left pining like the turtledove, because he had lost his lord, but every-thing was carrying on according to Michelangelo's orders, and that the two junior assistants, Bernardino Zacchetti and Giovanni Trignoli, 'are engaged in drawing and are doing you honour by this fidelity'. Perhaps they were working on cartoons for the ceiling, or possibly simply practising their draughtsmanship, as Michelangelo frequently pressed the younger members of his studio to do over the years.

The amount left in Michelangelo's Roman bank account – after most of the money he was paid by the Pope had been transferred to Florence and invested – was slim. This in turn suggests that the life led in the studio behind Santa Caterina was spartan, and that is exactly the impression given by Michelangelo's reaction to the idea that an important guest might stay with him. His brother Buonarroto wrote, mentioning that Lorenzo Strozzi, a wealthy Florentine wool merchant who had employed Buonarroto, was coming to Rome. Perhaps Michelangelo could put him up? The response was exasperation: 'I don't think

you realize how I am living here!' Nor could Michelangelo give much help to his youngest brother, Gismondo, who would also be in Rome: 'I cannot supply my own necessities. I am living here in a state of great anxiety and of the greatest physical fatigue; I have no friends of any sort and want none.'

<p style="text-align: center;">*</p>

While he was engaged on that amazing marathon, painting huge areas of ceiling with ever increasing speed and artistic power, Michelangelo wrote a caudate sonnet – a standard fourteen-line sonnet with an added 'tail' – of wryly humorous self-deprecation. It is a farcical, but also embittered, portrait of the artist at work on his supreme masterpiece.

> I've got a goitre from this job I'm in –
> Bad water does it up in Lombardy
> To peasants, there or in some other country –
> Because my belly's shoved up against my chin.
> Beard skywards, nape of neck pressed back upon
> My hump, I'm hollow-chested like a harpy . . .
> Somehow my loins have climbed into my gut,
> And as a counterweight I use my arse.

Beside the verses, which were in a beautiful hand, he rapidly sketched himself standing on the steps to the side of the scaffolding, stretching up to paint a figure – a prophet, sibyl or heroic nude, from its position – represented in the universal visual language of graffiti, with Halloween pumpkin-mask eyes and hair sticking straight up like a fright-wig.

Even more extraordinary is the sting in the tail – the coda – of the sonnet. It begins '*Pero fallace e strano/ Surge il iudizio che la mente porta, che mal si trá per cerbottana torta.*' ('However, the thoughts that arise in my mind are false and strange, as one doesn't aim straight through a crooked peashooter.')

Did he mean his ideas in the forms he was painting on the ceiling were 'false and strange'? It seems he did. In the final lines Michelangelo

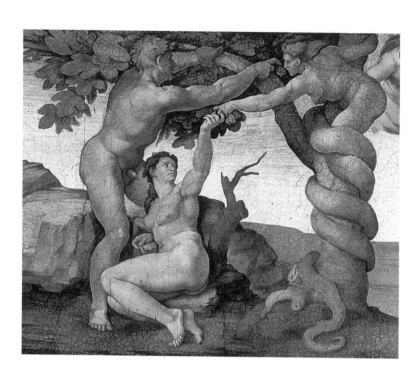

Sistine Chapel ceiling. Detail: *The Fall of Man*; Michelan-
gelo's earthy indication that sexual sin followed the
temptation in the Garden of Eden.

directly addresses the recipient of the poem: 'Giovanni,[5] now you know my state, defend my dead painting, since I'm not in a good position, nor a painter.' The painting of the Sistine Chapel ceiling was an almost superhuman feat of inspiration and endurance. It is easy to believe that, while he was painting it, Michelangelo was plagued by self-doubt.

*

The scholar John Pope-Hennessy once wrote that Michelangelo's letters were 'disappointing'. So they are, in comparison with, for example, the correspondence of Vincent van Gogh, in that there is little in them about what we would most like to know: in particular, about art. While he was working on the Sistine Chapel ceiling, Michelangelo wrote not a word – at least that survives – about the astonishing images he was making: the prophets, sibyls, nudes, the *Creation of Adam*, the beginning of the world. What we hear about is weariness, desperation and money; often all three together.

The most extraordinary missive from these years was addressed to his second youngest brother, Giovansimone. It was undated, but was sent perhaps around the late summer of 1509, as Michelangelo was setting out, without Granacci and Co., on his long solo effort.

Of the Buonarroti brothers, Giovansimone was perhaps the most like Michelangelo, in that he was – evidently – wilful and also creative. Alone among the other Buonarroti, Giovansimone dabbled in the arts: he wrote a little poetry. Now, aged thirty, it seemed he had wanted to withdraw money from family funds in order to set up an enterprise on his own. There had been a nasty argument; apparently Giovansimone had threatened Lodovico in some way.

The letter gives an idea of what a close encounter with Michelangelo in a bad temper might have been like. He tore into Giovansimone, becoming angrier the more he wrote: 'I could give you a long lecture

5 From the inscription on the verso of the sheet, the poem was addressed to 'Giovanni, *a quell propio [sic] da Pistoia*'. However, this cannot have been the Giovanni di Benedetto da Pistoia, who was later a member of the Florentine Academy: that Giovanni was not born until 1509. In any case, he was clearly a fellow Tuscan from Pistoia with whom Michelangelo exchanged poems at this time. Who saw Michelangelo's poetry at this time is unknown; later, he sent his works to friends, fellow poets and lovers.

on your behaviour, but it would be mere words to you, like the others I've given you. To be brief, I can tell you one thing for certain – that you possess nothing in this world; both your expenses and the roof over your head I provide for you.' Michelangelo had done this believing that Giovansimone was his brother, but in that it seemed he was mistaken: 'On the contrary, you are a brute, and as a brute I shall treat you.' If Michelangelo heard the slightest complaint about Giovansimone in the future, he would ride post to Florence and teach him how to behave better. Were he forced to do so, Giovansimone would bitterly regret it: 'I will give you cause to weep scalding tears.'

Michelangelo then signed the letter, but he did not end there. Instead he carried on with an extraordinary, incandescent postscript:

> I cannot help but write you another couple of lines to this effect – for twelve years now I have gone about all over Italy, leading a miserable life; I have borne every kind of humiliation, suffered every kind of hardship, worn myself to the bone with every kind of labour, risked my very life in a thousand dangers, solely to help my family; and now, when I begin to raise it up a little, you alone must be the one to confound and destroy in one hour what I have accomplished during so many years.

Many of Michelangelo's anxieties were financial, as were – at least, ostensibly – virtually all the quarrels in the Buonarroti family. There was a further explosion during these years, brought about by Cassandra's threats. On 28 September 1509 Lodovico settled his dispute with her out of court. He had legal expenses on top of this so, in the end, out of 350 ducats Michelangelo had sent from Rome to be banked safely, he deposited only 113. When, as was inevitable, Michelangelo paid a visit to Florence and discovered this misappropriation of his cash, there was a memorable detonation of rage.

Lodovico, fortunately for him, was out of town at the time, doing one of his rare stints of salaried work as *Podestà* of the little community of San Cassiano, south-west of Florence. Buonarroto wrote to tell him what had happened, news that caused Lodovico such distress he feared it might kill him before his time. In a second letter he lamented 'our' error – though perhaps it was really his – and observed that 'knowing who Michelangelo is', he should have realized how angry he would be.

Michelangelo clearly both loved and distrusted his father and brothers. A Florentine family was bound together by the tightest of filial and paternal bonds; it was ruled by the father, the senior male, and was, essentially, a male affair. Fathers and sons – in theory, at least – were almost extensions the one of the other. According to a proverb, 'the pear eaten by the father sets the sons' teeth on edge': that is, father and son were considered to be almost the same person, the younger male a continuation of the older. As the Florentine philosopher Marsilio Ficino put it, 'the son is a mirror and image, in which the father after his death almost remains alive for a long time.' The Buonarroti, however, did not live up to the ideal. Their hierarchy had been inverted; Michelangelo was, and probably had been since his late teens, the principal earner and, effectively, the head of the family.

In the spring of 1508, in the brief interval he spent in Florence between the installation of the bronze statue of Julius in Bologna in February and the Pope summoning him to Rome to paint the Sistine Chapel ceiling in late March, Michelangelo had been emancipated. That meant that, a week after his thirty-third birthday, he ceased to be a minor. Otherwise, under Florentine law derived from Roman practice, a son remained the legal dependant of his father until the father's death. Emancipation, which involved a ritual carried out before a judge, was usually undertaken to clarify ownership of property or to ensure that fathers and sons were not liable for each other's debts. In the case of Michelangelo's emancipation it is not known what the motivation was. Perhaps Lodovico, prone to nervousness about finance, was concerned that his son had received large sums of money for the Pope's tomb, the bronze *David* and the Piccolomini Altar, none of which had been completed. If Michelangelo had succumbed to a fever, Lodovico would have been responsible for the lot.

On the other hand, it is possible Michelangelo himself wanted to sort out questions of ownership. A few days before his emancipation he withdrew 750 florins from his savings account and put it towards paying for a row of three houses in the Via Ghibellina, in the ancestral quarter of Santa Croce. This was a step towards providing the Buonarroti with what all Florentine families of standing required: a suitably grand dwelling in the city. For Florentines, the notion of the

family and that of the house were inseparable. Ideally, according to treatises such as Alberti's *Della Famiglia*, the entire clan should live under one roof under the benign rule of the paterfamilias.

The Buonarroti attempted to comply with this custom, in that the rest of them seem to have moved into these new houses. However, in the end, the property on Via Ghibellina became just another source of dissent. The truth was, the Buonarroti were an ill-assorted combination. According to what Michelangelo wrote in moments of recrimination, his main motivation in creating transcendent masterpieces such as the Sistine Chapel ceiling was to raise the Buonarroti back to the status he (wrongly) believed they had once had. He became highly anxious if any of the family fell ill. Yet he showed signs of actively disliking Giovansimone and had little time for his youngest brother, Gismondo. The other Buonarroti were impressed by his achievements; Buonarroto, particularly, tried to help him as much as he could. But they were all a little frightened of his temper, and seem to have thought him eccentric, if not slightly deranged.

There were strains, too, in the relationship between Julius II and Michelangelo. As we have seen, in the case of the bronze *David* and the Piccolomini Altar, Michelangelo was not always enthusiastic about executing other people's ideas. But Julius II's ideas of what he could do were marvellous: perhaps better than his own. By forcing Michelangelo to paint the Sistine Chapel ceiling, the Pope did a huge service both to the artist and to posterity. Without it, Michelangelo's life's work would lack its climax.

The Pope apparently took a close interest in the work: visiting Michelangelo while he was painting, climbing up by a step-ladder and being given a helping hand by the artist on to the platform. But there was friction between them too.

Julius and Michelangelo had another characteristic in common apart from having very short fuses. They were both impatient. Julius, who was by nature eager and intolerant of delays, once half the ceiling was done – namely from the door to the middle of the vault – wished it to be revealed. Unfortunately, when Michelangelo was finally ready to reveal a finished section, Julius was no longer there. His departure was abrupt. He made up his mind on 1 September 1510 and left the same day. The possibility,

however, had been rumoured for some time. While Michelangelo had been up on the scaffolding, the great wheels of politics had been turning.

In his efforts to make the papacy a stable and dominant power in Italy, Julius had first formed an alliance with France, the Holy Roman Emperor Maximilian I and Spain – in other words, the leading European powers – against Venice. Then, worried by the growing power of France in Italian affairs, he went into reverse and allied the papacy with Venice against the French. His anti-French campaign was under way by the summer of 1510, and Julius was obsessed by it. 'Those French have taken away my appetite and I don't sleep,' he complained to the Venetian ambassador.

As he often did, Julius had gone on a peregrination around the Papal States during the baking month of August, so he had been absent from the eighteenth. This must have wrong-footed Michelangelo. When he put the last touch to the segment of the ceiling around *The Creation of Eve*, Julius was out of town but could have been expected to return before long – at which point Michelangelo intended to ask for the 500 ducats he was owed for the previous year's labour, and another 500 he believed he was due in advance to cover – among other things – the cost of putting up the final section of scaffolding. However, the next thing he heard, the Pope had marched north without returning to the capital and all the cardinals had been summoned from Rome to follow him.

Now, Michelangelo received a letter from home reporting that Buonarroto was ill. He was stricken with anxiety, and also in a dilemma. If his brother was seriously unwell, he would leave everything and ride straight to Florence. Yet if he did so, it might infuriate Julius. (Michelangelo evidently retained a lively memory of the last time he had left Rome without permission.)

The Pope, he wrote to his father, 'has gone away and has left me no instructions, so that I find myself without any money and do not know what I ought to do. I do not want him to be angry if I were to leave, and to lose my due, but to remain is hard.' He implored Lodovico to make sure Buonarroto had proper medical attention, and to take money out of the savings account to pay for it if necessary. Eventually, Michelangelo decided to ride north and demand more funds from his patron. It was not a propitious moment.

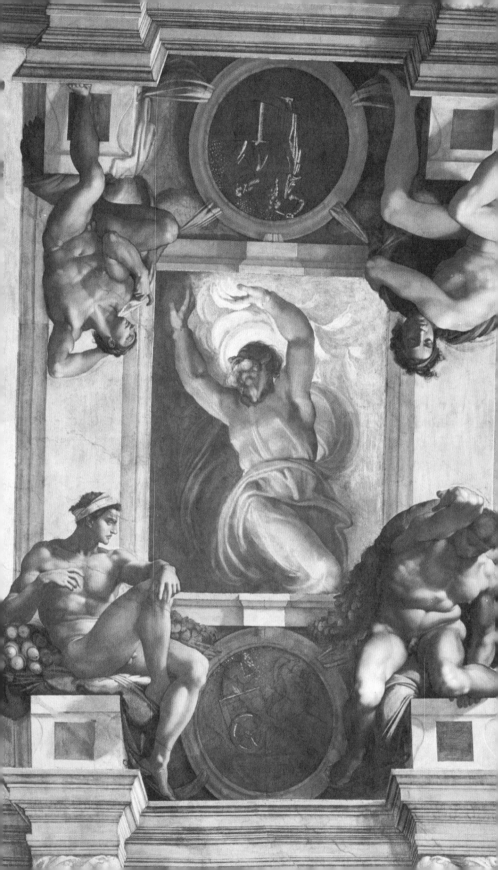

CHAPTER TWELVE
INCARNATION

*'Of course, as most of my figures are taken from the male
nude, I'm sure that I've been influenced by the fact
that Michelangelo made the most voluptuous
male nudes in the plastic arts.'*

– Francis Bacon

B y the time Michelangelo caught up with Julius the latter had
made another triumphal entry into Bologna, on 22 September
1510, then set about raising an army for a major war. It was
evidence of the strength of his relationship with the Pope that Michel-
angelo managed to get a promise of 500 ducats out of him at this time
of financial crisis.

On 25 October it was paid to him in Rome. However, before he
carried on with the ceiling, he was adamant that he must have more,
paid in advance. As he saw it, what he had received was simply pay-
ment for the work already done. That money was his, sent straight to
Florence to be invested. He must have a second tranche of his fee
before, as he put it to Buonarroto, he could 'continue the work', which
involved rearranging the scaffolding in the chapel. But the additional
ducats did not arrive and, towards the end of the year, Michelangelo
went back to Bologna again.

Fresco painting, however, must have been the last thing on the
Pope's mind. He had taken to his bed with fever. At one point, when
the French forces were outside the walls, it looked as though Julius
might have to negotiate a peace. He could neither eat nor sleep from
fury and frustration and said that he would rather die than surrender.
He was ill for most of November and December, refusing to eat what

(facing page)
Sistine Chapel
ceiling; detail:
*The Separation
of Light from
Darkness.*

he was told to and threatening to have his servants hanged if they informed his doctors.

On 2 January 1511, barely recovered, Julius departed from Bologna in the snow to take personal charge of the siege of the little town of Mirandola, an outpost of his main target, Ferrara, with the words, 'Let's see if I've got as much balls as the King of France.'[1]

The behaviour of this elderly Pope astonished contemporaries. The Florentine historian and statesman Francesco Guicciardini was amazed that 'the supreme pontiff, the vicar of Christ on earth, old and ill and nurtured in comfort and pleasures, should have come in person to a war waged by him against Christians, encamped by an unimportant town, where, subjecting himself like the captain of an army to fatigue and dangers, he retained nothing of the pope about him but the robes and the name'. On one occasion a cannon ball went right through the room in which Julius was sleeping, injuring his servants but leaving him unharmed.

It must have affected Michelangelo's imagination to work for a patron of such masterful, even alarming, force of will, especially when considering how to portray that most masterful of all beings, God the Father. Still, under the circumstances, it must have seemed more likely than not that Julius would soon die. If so, the ceiling might be assigned to another artist, or the contract might be altered. This was another reason to make sure he got his fee up front. The papal datary, the official in the papal administration who controlled the Pope's personal expenditure, Lorenzo Pucci, had promised he would arrange for it to be disbursed as soon as he returned to Bologna.

However, by February, over a month after Pucci had set off, it had

1 Ferrara was typical of the cat's cradle of loyalties and claims that made Italian politics so complex. Traditionally, this area was part of the Papal States, but its ruling family, the d'Este, came from a little further north and were thus hereditary subjects of the Holy Roman Emperor. In addition, Ferrara was situated between the area controlled by the Pope and the territories of Venice and Milan – claimed by both the French and the Empire. At this point, Julius's objective was to get hold of Ferrara before the French could. The (successful) game plan of the Duke of Ferrara was to remain independent by playing all these other parties off against each other. The Duke consequently drove the Pope to fury.

not yet arrived, and Michelangelo was contemplating making a third journey north. Writing a decade later, he considered these months as lost. In February 1511 it was already six months since he had completed the first part of the ceiling; Julius did not return to Rome until late June.

By that time, his campaign had gone horribly wrong. Julius had declared, 'It's God's will that the Duke of Ferrara should be punished and Italy freed from the hands of the French.' But papal and Venetian forces were defeated by the Pope's greatest bête noire, the Duke of Ferrara, on 28 February. Then, on 23 May, Bologna was lost to the French, quickly followed by Mirandola; afterwards, in a dispute over who was responsible for this disaster, Julius's nephew Francesco Maria della Rovere had murdered his right-hand man, Cardinal Alidosi. The King of France and the Emperor were proposing a General Council of the Church, aimed at perhaps deposing Julius. In mourning for Bologna, and in defiance of canon law, Julius grew a beard.

Understandably, the Sistine Chapel ceiling was a low priority. It was not until high summer that the first half was finally uncovered, the scaffolding being taken down almost a year behind schedule. In his diary for 14 August, the vigil of the Feast of the Assumption, Paris de Grassis described Julius's excited interest in 'the new paintings recently exposed' (unless, he added drily, the pontiff had come early to the chapel for the sake of his devotions). Four days later, the Pope fell ill again with fever, headaches and vomiting. Soon he was so weak he was barely breathing. His death was expected at any moment; he himself whispered to Cardinal Riario that he wanted to die. Allegedly, he was revived by a cardinal announcing in a stage whisper that, since he was about to die anyway, they might as well murder him now and loot his possessions. The resulting rush of wrath brought the Pope back to life; he threatened to have the cardinal thrown out of the window and his doctors hanged unless they allowed him to drink wine, and he eventually returned to full vigour. But it was over a month before Michelangelo finally began painting again.

During this time, Michelangelo later wrote, he had begun 'to do the cartoons for the said work, that is for the ends and the sides round the said chapel of Sixtus, in the expectation of having the money to

finish the work'. This was far from inactivity: it would have involved conceiving the compositions and studying the figures for the greatest images he ever painted, including *The Creation of Adam* and *The Separation of Light from Darkness*. Almost a year spent on making cartoons, however, interrupted only by a couple of journeys north, suggests a less intensely busy period than he had known for years: since, in fact, he had begun to carve *David*. There was time to do things not directly connected with the ceiling.

Several of Michelangelo's earliest completed poems date from around this time. One is an attack on the martial policies of his patron. It begins: 'Here they make helmets and swords from chalices/And by the handful sell the blood of Christ;/His cross and thorns are made into lances and shields.' This was precisely what was happening in 1511, as Julius put his papacy on a war footing and directed all his resources towards troops and armaments (consequently making the financing of frescoes and sculptures more difficult).

In this poem Michelangelo sounds like a zealous reformer. Christ no longer has any place in Rome, since 'his flesh is being sold, and every road to virtue here is closed.' He signed the sonnet, which was probably another verse letter to his correspondent, Giovanni da Pistoia, *'vostro michelagniolo in turchia'* ('your Michelangelo in Turkey'), suggesting that Rome was the capital not of faith, but of the infidels.

Martin Luther, who had paid a visit to Rome in 1510, could have put it no more strongly; nor could Savonarola. But then, almost everybody agreed that there was a need for reform, including those who abused the system. Even Lorenzo de' Medici, who by corruption and diplomatic pressure had succeeded in getting his sixteen-year-old son Giovanni made a cardinal, took it for granted that Rome was 'the sink of iniquity'.

He wrote as much in his letter of advice to that same son, Giovanni, now an important lieutenant of Julius II's. Among the powerful Italian families who gained the papacy, or, like the della Rovere, became powerful through the luck of one member becoming Pope, a version of the prisoner's dilemma operated. While the system remained corrupt, it would be folly not to use it to the advantage of oneself and

one's family. Similarly, Alexander VI and Julius II would have claimed – as Machiavelli argued on their behalf in *The Prince* – that only by becoming strong, politically and militarily, could the papacy avoid becoming a puppet of either the great European powers, France and Spain, or even – as had happened at times during the Middle Ages – coming ignominiously under the control of the Roman aristocratic clans, the Colonna and the Orsini, and thus merely a puppet of local lords. His behaviour at Mirandola, and throughout his campaigns, Julius no doubt believed, was not a betrayal of Christ but the only way to establish a golden age of papal rule in Italy and throughout Christendom.

Another poem by Michelangelo struck a more personal note, addressing Julius directly (though it's doubtful he dared send it to the Pope). He had, he insisted, long been the Pope's faithful servant, but the harder he worked, the less he was favoured. Heaven, he lamented, cruelly made him try to 'pluck fruit from a tree that's dry' – the dead tree in question presumably being the della Rovere oak, abundant garlands of which he had been painting on the ceiling, together with ample bundles of giant acorns, fruit of the oak. In the poem, Michelangelo had another accusation: that Julius was listening to the siren voices of rival artists: 'You have believed fantastic stories and talk / And rewarded one who is truth's enemy.'

Who could that have been? The most dangerous competitor Michelangelo had in 1511 – indeed, the only one – was a younger painter of extraordinary gifts, Raffaello Santi: to the English-speaking world, simply Raphael. In October 1511 Julius appointed him to a lucrative sinecure as *Scriptor brevium*, or one of the writers of papal missives or briefs (naturally, the painter would not actually have to do this work). The document describes him as 'our dear son Raphael' and added that he was being given this additional income 'in order that he may be maintained more fitly'. The wording suggests that Raphael had a less abrasive relationship with Julius than did Michelangelo. It is hard to imagine him having the exchange Michelangelo recalled for Condivi: 'One day the Pope asked when he would finish that chapel, and was told: "When I'm able to." In a temper the Pope continued: "You want me to have you thrown off that scaffolding, don't

you now?"' (Julius was fond of threatening to throw people from heights, though never actually did so.)

Perhaps Raphael was 'truth's enemy' in Michelangelo's poem, and this was the reward for which he had been cajoling. His reputation was certainly shooting ever higher. On 16 August 1511, just after the first part of the Sistine Chapel ceiling was unveiled, Grossino, the Mantuan ambassador, wrote to Isabella d'Este with some items of art news. One was that the Pope had arranged a new display of classical sculpture in the Belvedere of the Vatican, including the *Laocoön*. The other news was that many were praising the painting in the chapel as a beautiful thing. The painter, according to Grossino, was Raphael of Urbino. If that misunderstanding got to Michelangelo's ears, it would have made him simmer with fury.

Born in Urbino in 1483, Raphael was eight years younger than Michelangelo, but had been snapping at his heels for some time. They were in some ways quite similar – hugely gifted and precocious, fiercely ambitious and keen to get the maximum price for their works. Raphael, too, was a poet; though, unlike Michelangelo, a bad one. In other ways, they were opposites. Where Michelangelo was averse to society and almost a recluse, Raphael had the gift of charm and popularity. He was a lover of the good life, 'a very amorous person, delighting in women and ever ready to serve them', according to Vasari. Whereas Michelangelo was condemned for the squalor in which he lived, Raphael at length moved to a palatial house in Rome in the very latest style.

Raphael quickly accumulated many admirers and supporters in Rome, among them the older architect Bramante, who was also a native of Urbino. In sixteenth-century Italy, such things mattered. Their cultural identity meant that Italians felt themselves distinct from the French barbarians, or, in Benvenuto Cellini's phrase, 'those beasts of Englishmen'. However, in a concrete, everyday sense, to a Florentine, someone from Urbino was a foreigner, not of their nation, and vice versa.

Urbino was the home of Italian courtly civilization. *Il Cortegiano* (*The Courtier*), the elegant primer on how to lead that life to urbane perfection, was set in the city in 1506. Its author, Baldassare Castiglione

(1478–1529), was a friend of Raphael's, and the subject of one of his finest portraits, at once polished and intimate. Though Raphael himself did not feature in this book of dialogues, several of his sitters did, Giuliano de' Medici and Cardinal Bibbiena among them: the world of the courtier was Raphael's world. The thrust of Castiglione's book was that the perfect courtier should be able to dance, sing, play musical instruments, talk in an amusing fashion, ride, fence, even paint, but all with an impression of effortlessness; with no plebeian sense of strain. In short, Castiglione formulated the notion of the gentleman (his treatise was read throughout Europe, including England, where a translation by Sir Thomas Hoby was printed in 1561).

Raphael's art projected just this sense of mastery with ease, whereas Michelangelo expressed heroic effort and passionate vehemence. A sixteenth-century critic observed that Raphael painted gentlemen but Michelangelo's figures looked like porters. Clearly, Raphael had the manners of a courtier himself. It was rumoured that Leo X intended to make him a cardinal, but was prevented by Raphael's early death. This, too, emphasizes the contrast: it is impossible to imagine Michelangelo as a prince of the Church – a hermit or a mystic, perhaps, but not a cardinal.

Probably before they were rivals and enemies, Raphael and Michelangelo had been friends. It is true that, in Florence, Michelangelo clashed badly with Raphael's master.[2] According to Vasari, he told Perugino in public that he was 'an oaf in art' ('*goffo nell' arte*') – but Perugino had probably asked for it. Vasari noted he was 'always trying to wound his fellow-workers with biting words'; he was so affronted by Michelangelo's insult that he complained about it to the police committee, the Otto di Guardia, but emerged 'with little honour'.

On the other hand, Michelangelo could be generously helpful to young men who wanted to learn to draw, and Raphael was not only charming but good-looking. The young artists in and out of Florence

2 This dispute is hard to date, but it was presumably between 1504 and 1507, while Perugino was in Florence completing an altarpiece begun by Filippino Lippi for Santissima Annunziata (and, by that date, looking distinctly old-fashioned).

in the middle years of the decade were learning from the revolutionary new works of Leonardo, in particular, but also from those of Michelangelo. His patrons – Agnolo Doni, Taddeo Taddei – were also Raphael's patrons (Taddei liked always to have Raphael 'in his house or at his table', according to Vasari, 'being a great admirer of talented men').

Raphael was a participant in 'the most beautiful conversations and discussions of importance' that took place in the studio of the architect and wood-carver Baccio d'Agnolo, 'particularly in winter'. Vasari heard that Michelangelo – driven, busy and allergic to social gatherings because they seemed a threat to his inner thoughts and feelings, attended 'sometimes but not often'.

If there were good relations between Michelangelo and Raphael, however, they did not last long. When he was in Rome early in 1506, Michelangelo wrote home to his father, instructing him to make sure that Michelangelo's chest – probably full of drawings – was put in a safe place and to have 'that marble of Our Lady' (presumably the *Bruges Madonna*), moved inside the house, 'and not to let anyone see it'. That 'anyone' may have been specifically aimed at Raphael.[3]

A few years later, Michelangelo had more grounds for paranoia. In one of the most extraordinary confrontations in the entire history of painting, Raphael had begun to work in the Vatican, at almost the same time that Michelangelo started painting only yards away in the chapel. While they produced their own masterpieces, naturally, each was conscious of the other.

*

On 21 April 1508, just as Michelangelo was arriving in Rome to begin negotiating the contract for the Sistine Chapel ceiling, Raphael had written to his uncle, asking him to arrange a letter of recommendation

3 Raphael certainly used the Christ Child in the *Bruges Madonna* as a source for his own work, and drew a study of the sculpture, as he also did of Michelangelo's unfinished *St Matthew*, suggesting that at some point he had access to Michelangelo's workshop. In addition, Raphael's survey of the older artist's achievements included an elegant back-view of *David* (like Leonardo's, less overpowering and more harmonious than the original), and studies of the *Battle of Cascina* cartoon. He used the *Taddei Tondo* as a source for his *Bridgewater Madonna*.

from the Pope's nephew, Francesco Maria della Rovere, to *Gonfaloniere* Soderini. He was interested in painting 'a certain room', and seemed to want these two influential men to help him obtain the commission. This was probably the middle chamber of Julius's suite of accommodation in the Vatican. He had moved a floor up from the rooms his hated rival, Alexander VI Borgia, had occupied. In 1508, after renovation, a team of experienced artists was assembled to decorate these rooms, the 'Stanze'. Within months, Raphael had elbowed the others aside and was in charge of the project.

The first frescoes he finished, *The Disputation of the Holy Sacrament, or Disputa, Parnassus* and *The School of Athens*, had made almost as sensational an impact as Michelangelo's own *David* and *Pietà*. They were done simultaneously with the first part of the Sistine Chapel ceiling, in the papal apartments, beginning with the Stanza della Segnatura, which was, at the time, Julius II's library. *The School of Athens* and *The Disputa* depicted a compendium of the intellectual worlds that Renaissance Rome wanted to blend together. Respectively, they assembled the major thinkers and philosophers of the ancient world, centring on Plato and Aristotle and the great saints and theologians of the Christian Church. Artistically, they represented a synthesis of everything Raphael had learned from earlier masters, together with the quality of civilized elegance that was his own. With these pictures, Vasari felt that Raphael had thrown down a challenge to all other painters – but the most obvious rival, working close by in the papal chapel, was Michelangelo.

For his part, understandably, Julius II was hugely impressed. Michelangelo not only suspected that Raphael and Bramante were intriguing against him, he believed that Raphael was stealing his ideas. In a desperate, angry moment over three decades later, Michelangelo made these two accusations: 'All the discords that arose between Pope Julius and me were owing to the envy of Bramante and Raphael of Urbino.' What was more, 'Raphael had good reason to be envious, since what he knew of art he learnt from me.' This had a grain of truth. Part of Raphael's talent was that he was an amazingly fluent assimilator of other artists' styles and innovations. His art drew on a number of sources, including Leonardo and Perugino, but one of them was indeed Michelangelo.

According to Condivi, when Raphael saw the 'new and marvellous style' of the ceiling, he, 'being a brilliant imitator, sought through Bramante to paint the remainder himself'. This, while not certainly true, is possible. Although it now seems unthinkable that Michelangelo should not have been given the commission to complete the Sistine Chapel ceiling, perhaps it did not appear so incredible in 1511.

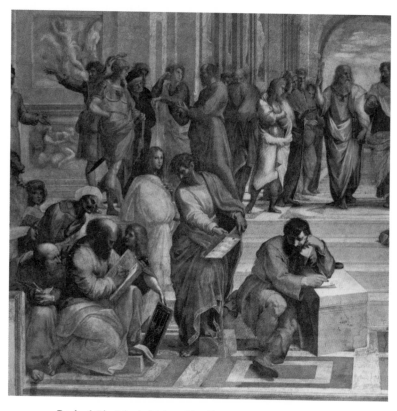

Raphael, *The School of Athens* (detail), 1509–10, fresco, *Stanza della Segnatura*, Vatican. Heraclitus, or 'The Thinker', is on the lower right, seated on the steps, his head resting on one hand, a pen in the other. This is perhaps a portrait of Michelangelo and certainly an imitation of his newly painted prophets on the Sistine Chapel ceiling.

After all, Raphael had eased several senior artists out of painting the Vatican *Stanze* – why not Michelangelo too? He showed himself willing and able to produce his own versions of Michelangelo's prophets and sibyls. His fresco of Isaiah in Sant' Agostino was obviously derived

from the figures on the ceiling, but with less *terribilità* and more of Raphael's signature quality: grace.

That was done after the first part of the Sistine Chapel ceiling was unveiled in the summer of 1511. It is possible that Raphael was given a sneak preview. While Michelangelo was absent from Rome, Vasari related, 'Bramante, who had the keys of the chapel, being a friend of Raphael brought him to see Michelangelo's work and study his technique.'[4]

One figure in Raphael's fresco of *The School of Athens*, datable to 1509–11, is on different plaster. The philosopher Heraclitus, seated brooding in the foreground, is obviously derived from Michelangelo's Sistine prophets, but this philosopher is in contemporary dress, with boots and bare knees. This is often presumed to be a portrait of Michelangelo, which is possible – although it lacks some of his distinguishing marks, such as a badly broken nose. In any case, it was definitely a declaration from Raphael: anything Michelangelo could do, he could do too.

*

Another occupation which Michelangelo might have found time for during the break in work on the ceiling was dissection. His intense preoccupation with the male nude at this time and his steadily increasing mastery in representing it suggest that if he 'had the opportunity' he would have taken it, perhaps in January or February of 1511. A suitable place to carry out his anatomical studies would have been the great hospital of Santo Spirito in Sassia, splendidly endowed by Julius II's uncle Sixtus IV and a short walk from Michelangelo's workshop.

The scholar James Elkins has established that there is virtually no anatomical feature represented in any of Michelangelo's works that could not be discovered by looking at a naked model. This in turn suggests his motive in dissecting bodies: he wanted to understand better what he could see. The muscles and bones of the body were the basic vocabulary of his art. Everything he did (including, later in his career, architecture) was based on that. By going beneath the skin he

4 The first time Michelangelo was away after beginning work on the ceiling, as far as we know, was in September 1510, when he went to Bologna. If this actually happened it would have been in the coming months, during which Michelangelo was intermittently absent from Rome.

could comprehend and internalize these complex biological features, so that he could then analyse, simplify, emphasize and memorize them, and then invent new and beautiful bodies at will.

This must have been why the horrible process of dissection, according to Condivi, gave Michelangelo 'the greatest possible pleasure'. It was providing the most vital source material for his art and imagination. You could say that Leonardo was attempting a science of the body, while Michelangelo wanted to make visual poetry out of it. The paradox was that the drawings Leonardo made of anatomy belied the gruesome and putrefying reality of what he was looking at – they are immensely beautiful – whereas Michelangelo's anatomical drawings are among his least attractive and most mundane factual works.[5] For him, anatomy was simply a utilitarian stage towards the creation of the final result, which was the carving or painting of transcendentally beautiful figures. That in turn helps to explain the almost cruelly destructive attitude he took towards his drawings.

There are perhaps five hundred drawings by Michelangelo surviving – the exact tally is the subject of intractable scholarly disputes – but it is clear that these are the remnants of thousands which originally existed, and that the reason why many disappeared is that Michelangelo himself destroyed them. Vasari wrote that he knew 'for a fact that shortly before he died he burned a large number of his own drawings, sketches, and cartoons so that no one should see the labours he endured and the ways he tested his genius, and lest he should appear less than perfect'.

Long before that, in 1518, Michelangelo had ordered his most trusted assistant to burn a pile of *chartoni* in his Roman studio. These were probably the cartoons, and also perhaps most of the preparatory studies and sketches for the Sistine Ceiling chapel. At any rate, few studies and no cartoons for the ceiling still exist. The loss of what must have been among the most wonderful drawings ever made is certainly sad, but the conclusion is unavoidable: Michelangelo did not much care about the steps by which he reached a finished work. Only the perfected result mattered.

In the early autumn of 1511 Julius was ready to begin pushing his

5 There is a scholarly dispute as to whether many of these are originals or copies after Michelangelo. However, even if they are imitations, the originals must have been similarly dry.

Anatomical Study of a Torso in Three-Quarter View, uncertain date.

favourite projects forward with the urgency of a man who had several times been close to death in the previous twelve months. On 1 October he paid Michelangelo 400 ducats, which probably signalled that the new campaign of painting was underway, or soon would be.

It was in the final year, from autumn 1511 to late 1512, after a long period of preparation and with the benefit of renewed energy, that the ceiling reached its full, sublime power. The figures were now a step up

Sistine Chapel ceiling, 1508–12; detail: *The Creation of the Sun, Moon and Plants*.

in scale and grandeur, the composition of the panels clearer and simpler, the work more and more daring. The enforced year's pause in painting had given Michelangelo time to meditate on what he had done and plan how he was going to continue. It also allowed him to do what had presumably been impossible with the scaffolding in place: to look at the finished section as viewers would always see it, from the floor of the chapel almost 70 feet below.

When he started work again, what he painted was larger and more forceful. The prophets and sibyls grew a size, from under 12 feet high to well over. The central panels are composed of a few, heroically powerful figures; a couple depict only God, blessing the earth, creating the Sun and Moon, and separating light from darkness. The whole surface has a rhythmic movement, as the earliest sections had not, in which the prophets, sibyls, nude young men and God himself interact like dancers in a sacred ballet, responding to and countering each other's movements.

One of the most extraordinary features of the entire ceiling is its emphasis on male nudity, which Michelangelo valued so highly that he made nonsense of the story of *The Drunkenness of Noah*. The point of this story is that the patriarch, being the first to plant a vineyard and make wine, sampled his brew and was discovered lying in his tent, his nakedness uncovered. His sons, averting their eyes from the shameful sight, covered him with a garment. Michelangelo depicted this faithfully, but undermined the point by depicting Shem, Ham and Japheth stark naked too.

The greatest of the nudes, however, come in the last parts of the painting. Adam in the panel showing the creation is one of Michelangelo's most celebrated inventions, dividing that honour with the marble of *David*. And, like *David*, Adam is a completely unreal confection, but in a quite different way. Whereas *David* had a huge head, Adam had a tiny one, and an enormously expanded chest. As he grew older, Michelangelo was more and more inclined to widen the upper bodies of his nudes. The reason was, perhaps, that it gave him more scope to turn the muscles and bones of the shoulders and ribcage into a pattern of energy and movement.[6]

6 Michelangelo had strong feelings about human beauty and proportion. Towards the end of his life, Condivi tells us, he contemplated writing a treatise on 'different kinds of human movement and appearance and on the bone structure'. Sadly, this seems to have foundered because of Michelangelo's lack of confidence in his powers as an author. That was characteristic, but so, too, was his scathing judgement of the ideas of the German artist Albrecht Dürer (1471–1528), who wrote *Four Books on Human Proportion* (published 1528). Michelangelo found Dürer's ideas, which were based on mathematical harmonies, again according to Condivi, 'very weak' and

The nudes surrounding the panel of *The Separation of Land and Water* demonstrate how he did this, just as much as Adam, who looks like their brother. They are all quite different, in face, body, posture and mood. One crouches on his seat, over the head of the prophet Daniel, staring down at the spectator, his hair a mass of tight curls resembling an Afro; his partner raises his arms and one leg in a gesture like a ballet dancer's.

Detail of nude flanking
The Separation of Land and Water, 1508–12.

One of the two opposite (see p. 269) is tranquil, lost in thought, his hulking chest hidden in shadow, clutching a bundle of giant acorns. Opposite is a young man swivelling in agitation, glancing nervously to the side, his hair blowing in a wind that leaves his companion

realized how much more 'beautiful and useful' his own ideas would have been for posterity to read. It is impossible not to agree.

unaffected. His whole body forms a diagonal, which lines up with the commanding arm of God in the next panel, calling the sun into being. His mighty thorax is a composition in itself, the bones, joints and bunches of muscle forming a knot of coiled strength. Like *David*, if he came to life he would be a monster, his shoulders grotesquely wide.

This figure shows what Michelangelo had learned from his dissections and observation of living models: how to make the human body expressive in ways never imagined before. The twenty *ignudi* are like a series of musical variations on a theme. What they are doing on the ceiling is an interesting question, and one to which numerous answers have been suggested. The art historian Christiane Joost-Gaugier listed some of the meanings that have been suggested: 'captives of ancient ignorance, symbols of the beauty of the human body, genii, slaves, Atlantean strong men, angels, adolescent heroes, symbols of eternal life, acolytes of Christ, athletes of God, supporters of medallions, celestial victory images'. It is noticeable that contemporaries did not identify them as any of those.[7]

The reality of nine years of intermittent warfare, plus the capture and loss of Bologna, did not add up to an idyllic period. In the minds of Julius and those around him, however, the purpose of his assertion of papal power on the battlefield was precisely to bring about a golden era. It would be a return to rule by Rome, as in the days of the Caesars, so much admired by the intellectuals of Renaissance Rome, but it would be an empire greatly superior to the ancient one, because the new Emperor was the Pope, vicar of Christ on earth. This helps to explain why it seemed appropriate to fill the Pope's chapel with paintings of naked men which looked to contemporaries like the statues of antiquity renewed.

There was another, theological reason for nudes to be painted, which neatly dovetailed with the cult of ancient art. In these decades, from

7 Vasari simply suggested that, 'to show the vast scope of his art he made them of all ages, some slim and some full-bodied, with varied expression and attitudes, sitting, turning'. The acorns and oak leaves the young men are holding, Vasari thought, were to represent 'the emblem of Pope Julius and the fact that his reign marked the golden age of Italy'.

the 1490s to the 1520s, preachers in Rome laid great stress on the doctrine of the incarnation, that is, the fact that Christ was God made man. And this meant that the human body – which, in turn, because of the automatic misogyny of the times, meant the male body – was not the shameful, sinful thing it had been considered to be through much of the Middle Ages, but glorious, beautiful and holy. According to some startling preaching on the theme of the circumcision, this applied even to the private parts. Here was a theological reason to decorate the chapel with buttocks, penises, biceps and pectorals. As the mood of the times darkened, this optimistic theological mood vanished, and the nudes of the Sistine Chapel ceiling seemed strange and scandalous.[8]

While he was conceiving them, Michelangelo felt he was acting like God, or so a little four-line verse suggests: 'He who made everything, first made each part and/Then from all chose the most beautiful/To demonstrate here his sublime creations,/As he has now done with his divine art.' That was what he himself was doing: constructing divinely beautiful bodies from observations of corpses and young men without their clothes.

We know nothing about Michelangelo's private life at this time, but it is impossible to believe he conceived these naked young men without feeling desire and longing. Some, at any rate, of the audience for the ceiling no doubt felt the same, in a city in which the male population was much larger than the female, and which was as notorious for sodomy as for the enormous numbers of prostitutes and courtesans working there.

To understand Michelangelo and his art, it is necessary to accept both these truths. He believed that the sight of beautiful individuals was a path to the divine beauty and goodness of God. Simultaneously, it was a source of hopeless erotic yearning. On the same sheet of paper as the little poem about God's creation and the complaint to Julius there are two love poems. That the lover burnt with painful, unending, frustrated desire was essential to the conventions of love poetry in

8 Only a decade later, the Dutch pope, Adrian VI (reigned 1522–3), was apparently shocked by what he saw painted on the ceiling of the papal chapel.

imitation of Petrarch. It was a literary fashion that took hold in sixteenth-century Italy, as rock and roll did in 1950s Europe, and perhaps for a similar reason: that it expresses widespread feelings. This was a society in which marriages were arranged and often loveless, all other sexual relations sinful if not actually illegal. Yet quite early on an anguished, personal note sounded in Michelangelo's poems.

Detail: Two *ignudi* flanking
The Separation of Land and Water, 1508–12.

These two madrigals are more frantic than polished. One uses the favourite metaphor of the prisoner of love: 'Who's this who leads me to you against my will, /Alas, alas, alas, /Bound and confined, though I'm still free and loose?' (The answer must be Cupid.) The other reads more like a cry of desperation than a literary exercise: 'How can it be that I'm no longer mine?/O God, O God, O God!/Who's snatched

me from myself/So that he might be closer to me/Or have more power over me than I have?/O God, O God, O God!'⁹

The nudes are the most sensational, and unexpected, figures on the ceiling – but even more prominent and charged with power are the mighty sibyls and prophets. At the end of the chapel, in one of the last sections to be painted, comes the figure of Jonah, who seems to loll back on his seat, although the vault at this point is actually bending forward. Nowhere is it made more impressively obvious that Michelangelo was able to remodel the space of the chapel into a new one of his own imagination, through an almost incredible feat of foreshortening on a complex, curving surface. Jonah, Vasari felt, felled everyone who saw him with 'admiration and amazement'.

Most awe-inspiring of Michelangelo's creations, however, was his visualization of the creator: God the Father. Here was a subject that required all his *terribilità*. In the first of these scenes to be painted, admittedly, God looks much as he did in fifteenth-century art. *The Creation of Eve* was an updated version of the relief sculpture of the same scene by Jacopo della Quercia on the main portal of the church of San Petronio in Bologna (carved c. 1425–38).¹⁰

By his second manifestation, however, in *The Creation of Adam*, God is not standing in the Garden of Eden as in the Jacopo della Quercia relief, but flying, enveloped in a billowing cocoon of drapery containing angels and one female figure: the soul – according to a persuasive interpretation – of the still uncreated Eve. In the next two panels God floats, summoning up sun, moon and plant life and dividing land from water. He is conceived in completely physical terms, Michelangelo visualizing such divine anatomy as God's feet and even his buttocks, thinly covered by his violet robe as he whisks over the

9 The translator of this poem, James Saslow, notes that the line 'So that he might be closer to me' is gender neutral in the Italian. Later in his life, however, Michelangelo openly addressed love poems to other men.

10 It is not surprising that this composition fixed itself in Michelangelo's memory, since he had been brought very close to Jacopo della Quercia's sculpture in February 1508 – just before he began the ceiling. In that month he and Cardinal Alidosi had installed the bronze statue of Julius just above the same door (which doubtless involved many trips up and down the scaffolding, past the mighty early-fifteenth-century carvings).

newly created fronds of vegetation. Above all there is God's frown of commanding will as with a gesture of each arm he brings sun and moon into existence, and at the beginning of everything the vortex of his body is in primordial chaos, dividing light from darkness. It is in

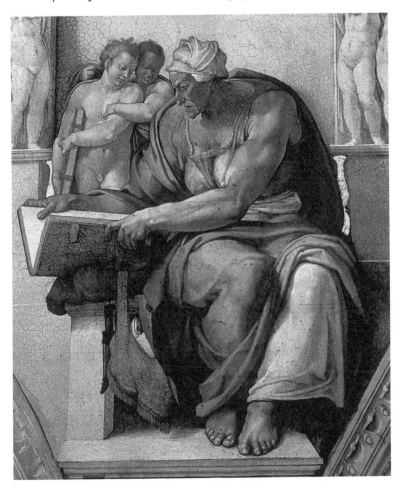

Sistine Chapel ceiling, 1508–12. The Cumaean Sibyl is the most heroically muscular of all Michelangelo's female figures.

these images that Michelangelo's art is at its most profound: he never had a deeper subject.

The closer to completion of the ceiling Michelangelo came, the more he accelerated. There is evidence of the speed of his brush – and the

confidence he had gained – in the frescoes themselves. By this stage he was painting with amazing fluency and dash. In *The Creation of Adam*, God's hair swirls like smoke, each individual brushstroke clearly visible; the same is true of the green drapery fluttering in the wind below the lower angel in the group around God. It consists of a few dozen strokes, put down with a velocity that in turn energizes the image. The leaves and fronds in *God Creating the Sun, Moon and Plants* were themselves painted with a short-hand freedom – just a flick of the wrist, a touch of the brush – reminiscent, to a contemporary eye, of the work of Matisse.[11] The panel of *The Separation of Light from Darkness* was a single *giornata*, one day's painting. The whirlwind of God's creation and Michelangelo's own merge into one.

*

While Michelangelo was furiously at work on the ceiling, the wheel of political fortune turned. In April 1512 the army of the French King laid siege to the papal city of Ravenna. On the eleventh, Easter Sunday, a terrible battle was fought outside its walls between the French and the armies of the Pope and his new ally, Spain. Three of the commanders of the Holy League – Spain and the Pope, plus Venice and Naples – were captured, including the papal legate Cardinal Giovanni de' Medici.

At first it seemed that the French might march on Rome; Julius had a fleet of galleys prepared for his escape. However, there were also many dead among the French, including their brilliant commander, Gaston de Foix. The victory left them weakened, demoralized and badly led. At the end of May the arrival of 18,000 Swiss mercenaries to fight for the papal side gave Julius the upper hand yet again. The French retreated from northern Italy, and the city of Bologna sent envoys to pledge eternal loyalty to the Pope. He replied by haranguing them about their misdeeds, mentioning, among others, the destruction of the bronze statue of him by Michelangelo.[12]

11 An observation made to the author by the critic Waldemar Januszczak, who saw the frescoes from the scaffolding while they were being restored.
12 Not long afterwards, in mid-July, Alfonso d'Este, the Duke of Ferrara – and the very man who had melted down the bronze statue of Julius and cast the metal into a

The balance of power in Italy had tilted unexpectedly. The Spanish and the Pope were in control and those previously allied with the French were vulnerable, among them the Republic of Florence, which had not only remained in the French camp but also allowed the anti-Julius Council of the Church to be held on its territory at Pisa (which Florence had eventually managed to regain in 1509). Early in August the Holy League met at Mantua and decided that Medici rule should be reinstated in Florence (not surprisingly, since the papal delegation consisted of Giuliano de' Medici and his secretary, the Medici ultra-loyalist, Bernardo Dovizi da Bibbiena).

The Spanish army was then sent to enforce this order. During August it marched into Tuscany, menacing Florence and the nearby town of Prato. Hearing this news, Michelangelo wrote urgently to his family in Florence. His advice was to get away as quickly as possible: 'Don't get yourselves involved in any way, either by word or deed; act as in case of plague – be the first to flee. That's all. Let me have news as soon as you can, because I'm very concerned.'

By the time he wrote this on 5 September, however, it was all over. The Spanish commander Raimondo da Cardona offered to withdraw, provided the Medici were allowed to return as private citizens and his troops, who were starving, given food. Soderini hesitated, perhaps unwilling to supply the enemy.[13] On 29 August Cardona attacked the city of Prato, which was full of food and rich citizens. The result was an atrocity. Prato fell after twenty-four hours; there followed weeks of massacre, torture, rape and extortion as the Spanish tried to extract the maximum benefit from this good fortune. Within a day, Soderini had fled Florence.

cannon – paid a visit to Michelangelo on the scaffolding. Alfonso lingered there longer than his courtiers, for 'he could not see enough of those figures.' This may have been the most enjoyable part of an otherwise fraught visit to Rome, in an unsuccessful attempt to negotiate with Julius. An ambassador suggested Alfonso should then inspect Raphael's paintings in the *Stanze*, 'but he did not want to do it' – a reaction that must have given Michelangelo satisfaction.

13 His assistant, Machiavelli, could have had him in mind two years later when he noted in *The Prince* that 'the circumspect man, when circumstances demand impetuous behaviour, is unequal to the task.'

Horrifying stories circulated of wells choked with bodies, hundreds or thousands of victims. There was an outpouring of outrage and revulsion.[14] Prato was an extremely close neighbour of Florence, a mere ten miles away, so close that Michelangelo had toyed a few months before with buying a farm just outside it. On 1 September Giuliano de' Medici entered the city to shouts of 'Palle, palle!', the rallying cry of the Medici faction, referring to the family coat of arms, with its red balls on a golden ground; a fortnight later his brother Cardinal Giovanni made a formal entry. After eighteen years, the Florentine Republic had fallen and the Medici were back.

As soon as he heard, Michelangelo wrote to Buonarroto, taking back the permission he had given to his family to raid his savings account in extremis, which, he explained, only counted if their lives were in danger. Complaining that he himself was suffering 'the utmost discomfort and weariness', the Buonarroti were to keep their heads down: 'Do not speak either good or evil of anyone, because no-one knows what the outcome will be.'

Lodovico Buonarroto wrote later with chilling news. It was whispered in Florence that Michelangelo had been speaking out against the Medici. Michelangelo replied by half admitting that it was true. However, by his own account, he had never said a word against them except what was said by everybody else, and even the stones would have protested about the sack of Prato. Many things were said, which Michelangelo had repeated, but he claimed to have rebuked one acquaintance who 'spoke very ill' of the Medici. Finally, he asked if Buonarroto could try to find out where the rumour had come from so that he could be on his guard.

At intervals through the summer Michelangelo had been writing home, announcing that he saw the end of the ceiling painting in sight: 'I work harder than anyone who has ever lived. I'm not well and worn out with this stupendous labour and yet I'm patient in order to achieve the

14 Estimates of the casualties varied, according to their author's hostility to the Medici, from 500 to over 5,000. One poem, 'Il miserando sacco di Prato cantata in terza rima' by Stefano Guizzalotti began by remarking that not even the infidel Turks treated Christians with such cruelty (an echo of Michelangelo's implication that papal Rome was equivalent to Turkey).

desired end.' On 21 August he thought – as usual, optimistically – that there was another month's work to do. But, he admitted, 'The truth is it's so great a labour that I cannot estimate the time within a fortnight.' Then he added an unexpected reason for the inspired brilliance of the brushwork in the final sections of the ceiling: 'I'm being as quick as I can, because I long to be home.' In mid-September he announced that 'I shall soon be home. There is no doubt at all that I shall celebrate All Saints' with you in Florence,' then went on, more uncertainly: 'If God wills.'

To judge from his letters, Michelangelo was not jubilant at completing a phenomenal masterpiece but prostrate with anxiety and exhaustion. Typically, he was inclined to blame all his worries on his father: 'I lead a miserable existence and do not care of life nor honour – that is, of this world; I live wearied by stupendous labours and beset by a thousand anxieties. And thus have I lived for some fifteen years now and never an hour's happiness have I had, and all this have I done in order to help you, though you have never either recognized or believed it.'

In early October he told Lodovico the chapel was almost finished, and the Pope 'very well satisfied', but he would not be able to get home for All Saints' Day, as he could not afford to. He then made a remark that, coming from the greatest artist of the High Renaissance at the very moment of the completion of his supreme masterpiece, is simply stunning in its Eeyore-ishness. Apart from Julius being pleased, 'other things have not turned out for me as I'd hoped. For this I blame the times, which are very unfavourable to our art.' By that he perhaps meant that he had not yet been paid the balance of his fee of 3,000 ducats; for that he had to wait until just before Christmas.[15]

On 31 October, the vigil of All Saints' Day, Paris de Grassis noted that 'Today is the first day our Chapel was opened, the painting being finished.' Julius lived just long enough to see the completed ceiling. His health failed for the last time early in the New Year. He was bed-bound and feeble by mid-January, and died on the night of 20–21 February 1513. Now his tomb was more urgently required.

15 In a sense, though, Michelangelo was right: the times were unpropitious. He was trying to create hugely ambitious works for patrons with unstable finances in conditions of near-constant warfare.

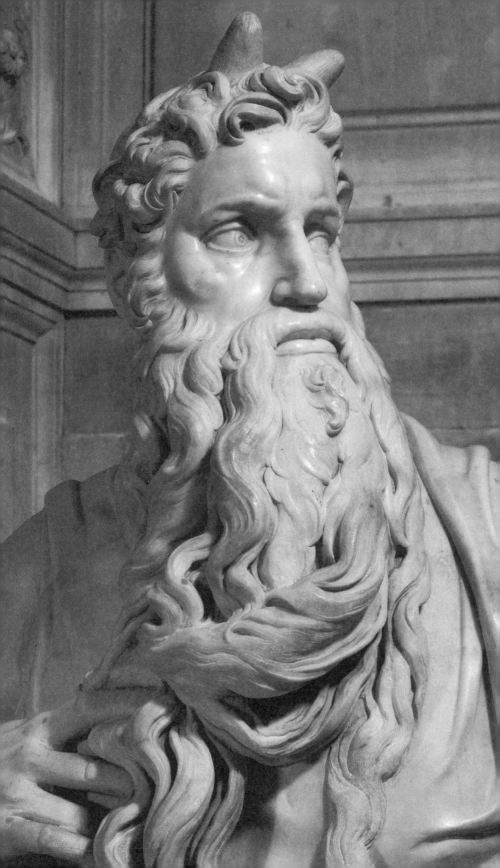

CHAPTER THIRTEEN
ROMAN RIVALRY

*'No piece of statuary has ever made a deeper impression on
me than this. How often have I mounted the steep steps from
the unlovely Corso Cavour to the lonely piazza where
the church stands, and have essayed to support the
angry scorn of the heroic glance.'*

– Sigmund Freud on his encounters with the statue of
Moses on the Tomb of Julius II in the church of
San Pietro in Vincoli, 1914

From his sickbed, on 4 February 1513 Julius had instructed the
Papal Master of Ceremonies, Paris de Grassis, that his body
should lie in the chapel of his uncle Sixtus IV – whose grand
monument by Antonio del Pollaiuolo Julius himself had commis-
sioned – until his own tomb was completed. He had already ordered
work on this to be started. Over two weeks before, on 18 January, the
balance of 2,000 ducats – an enormous sum, equivalent to two thirds
of the entire fee Michelangelo had received for the Sistine Chapel
ceiling – was transferred into the artist's account by the papal bankers,
the Fuggers of Augsburg. Thus, in a few months, Michelangelo had
amassed a medium-sized fortune.

Eight years after Julius had first summoned him to Rome,
Michelangelo was free to embark, full time, on the most ambitious
sculptural commission of his life. However, it seems likely that the (*facing page*)
Pope's ideas about his tomb had changed. Michelangelo's first design, *Moses* (detail),
in 1505, had been extremely unorthodox. According to Vasari's account, the Tomb of
a monumental figure of St Paul would have been the only specifically Julius II.

New Testament ingredient. The other sculptures would have represented Moses, and the Active and Contemplative Life, with the seven liberal arts and the captive provinces subdued by Julius below in the manner of Roman triumphal monuments. The overall impression would have been overwhelmingly classical and almost secular. As he lay close to death, Julius perhaps had misgivings. After all, he had recently been subject to an attempt by the abortive Council of Pisa to depose him for unfit behaviour. He may have been sensitive to the charge that he had acted like a warrior prince, rather than the vicar of Christ. Or he may simply have been concerned about his soul.

Whatever the reason, the design finally agreed by Michelangelo and the Pope's heirs at the beginning of May had all the signs of a compromise. It was still, essentially, the monument proposed by Michelangelo in 1505, but was now awkwardly attached to a wall along one of its sides and had a 'chapel' containing a group of the Madonna and child slapped on the top of it, making the new scheme more orthodoxly Christian than Michelangelo's original, near-pagan, proposal.

There was also now to be an effigy of Julius surrounded by four angels, with six monumental seated figures around that group. The new project would, however – had it ever been built – probably have looked like an unsatisfactory fudge. According to the contract, this whole immense construction, still comprising around forty sculptures, some very much more than lifesize, was to be completed in seven years from signing – which was evidently impossible.

Michelangelo moved to larger premises, from his old workshop off the piazza opposite St Peter's to a house apparently owned by Cardinal Leonardo Grosso della Rovere, a nephew of Pope Julius and one of the executors of his will (known as Cardinal Aginensis because he was Bishop of Agen in France). This was on Macel de' Corvi, near Trajan's Column and the Campidoglio, close to the border where the heavily populated area of Renaissance Rome gave way to the *disabitato* – the semi-rural area outside the medieval and Renaissance city centre, dotted with ruins.

Michelangelo's new dwelling was spacious, described a few years

later as 'a house of several storeys with reception rooms, bedrooms, grounds, a vegetable garden, wells, and other buildings'. On the premises he had two workshops, one of which was large enough to contain the front section of the tomb – which, he noted, was II *braccia*, or almost 21 feet, wide. Here he could get on with doing exactly what he always protested he wanted to do: carve marble. He was rich, and going to get richer. The contract he signed with the late Pope's executors priced the entire tomb project at 16,500 ducats, a colossal sum for an artist.

Of this he had already received quite a large advance, but apparently there was unseemly haggling about exactly how much. While drafting an aggrieved letter – one of a number he wrote about the tomb and its interminable contracts and terms over the years – a decade later, Michelangelo noted that at one point Cardinal della Rovere had called him a 'swindler'.

There was one other stipulation: he was not to take on any other tasks which would distract him from the great tomb. Michelangelo, as usual, ignored this. Within three weeks of signing the contract for the tomb on 22 May he had already agreed to carve another sculpture – a nude *Risen Christ* – for a memorial chapel in the church of Santa Maria sopra Minerva dedicated to the memory of a Roman noblewoman named Maria Porcari. In practical terms, he really did not need this additional job – the forty-first large-scale sculpture he was obliged to make. The fee of 200 ducats was trifling in comparison with his other earnings. The reason he took it on was probably that he knew the patron. Metello Vari, a relative of the deceased Maria, was a client of the Balducci bank, no doubt through Jacopo Galli.

Vari himself wrote that he thought Michelangelo had taken it on 'more from love than money'.[1] For the first time Michelangelo showed signs of a trait at odds with his passion for wealth: a desire

1 If so, Michelangelo was acting in the same spirit in which Machiavelli dedicated his masterpiece, *The Discourses on the First Ten Books of Titus Livius*, not to rulers, but to two Florentine gentlemen, Cosimo Rucellai and Zanobi Buondelmonti, who, as he put it, 'on account of their innumerable good qualities', deserved to be princes.

to work not as a slave to the rich and powerful, but freely for those he liked.

This should have been a moment of happy liberation for Michelangelo, after years of being forced to do fresco painting and bronze-casting against his will. However, his letters at the end of 1512 suggest he had completed the Sistine Chapel ceiling in a state – a common one for him – of exhaustion, mixed with what can only be called furiously active depression. Perhaps the marathon effort of painting had left him drained, and this mood persisted. Possibly, he was unhappy about the changes to his tomb design; or perhaps it was the rapid political transformations around him.

Conditions in Florence remained tense at the beginning of the year. On 18 February, just before Julius died, a slip of paper with a list of names on it fell from the pocket of a young Florentine gentleman named Pietro Paolo Boscoli. It was shown to the agents of the new Medici regime, and a plot was suspected. Immediately, Boscoli and his closest friend, Agostino di Luca Capponi, were arrested on suspicion of conspiring to assassinate Giuliano de' Medici, and tortured. They confessed that they were opponents of the Medici, but that their list was not of conspirators, only of people who might be favourable to their cause.

One name on the paper was Niccolò Machiavelli's. The previous autumn, when the Medici had returned to power, Machiavelli had been thrown out of his post as a civil servant. No sooner was his name discovered on 19 February than a warrant was issued for his arrest and proclaimed throughout Florence. He was rounded up and subjected to six agonizing jerks of the *strappado*, his arms tied behind his back, hoisted then dropped so the whole weight of his body tore at the muscles of his shoulders.

Poor Machiavelli had nothing to confess and was cast into the prison of the *Stinche*, where he wrote sonnets to Giuliano de' Medici pleading for release. Boscoli and Capponi were beheaded on 22 February. The night before their execution they were consoled by another friend, Luca della Robbia, descendant of the sculptor, who subsequently wrote an account of their exemplary courage. Boscoli and

Capponi died thinking of Christ and Brutus, heroic assassin of the tyrant Caesar.

Just over two weeks later the political hierarchy of Italy was transformed yet again by the election of a new Pope. Cardinal Giovanni de' Medici was late in reaching the conclave. He arrived from Florence on a litter, suffering from a painful anal abscess. According to the Roman bookmakers, there was no obvious favourite. For the first time, the conclave met under Michelangelo's frescoes in the Sistine Chapel.

The leader in the first ballot on 5 March was a Spanish cardinal; it seems that Michelangelo's old and unsatisfactory patron Cardinal Riario – cousin of Julius – was also a strong candidate. The winner, however, was Giovanni de' Medici, still only thirty-seven but already a cardinal for twenty years. Although he was rich enough to buy the papacy, it was not necessary to do so: he was selected because, as the effective ruler of an important Italian state – Florence – it was hoped he would have the political weight and wisdom to steer between the menacing powers of France and Spain. His coronation had to be delayed, as he had not yet been consecrated as a priest. After this was done, on 9 March he was crowned with the triple tiara on the steps of St Peter's. He took the name Leo X.

When the news of Leo's election was heard in Florence, there were wild celebrations with bonfires that spilled over into arson attacks on the houses and shops of steadfast *piagnoni* (followers of Savonarola), but even many of the latter were filled with patriotic triumph at the arrival of a Florentine Pope. In two moves, within less than a year, the Medici had come to dominate the chessboard of Italian politics. The feeling of jubilation was widespread, and not only in Florence.

On 11 April Leo X processed through Rome to St John Lateran under a series of temporary triumphal arches through streets decorated with tapestries and strewn with flowers. The date was chosen to underline the transformation in Leo's own circumstances. On 11 April 1512 he had been a prisoner of the French after the Battle of Ravenna. In under twelve months, he had become one of the most powerful rulers in Italy, controlling the Papal States – thanks to the efforts of Julius – plus Florence and Tuscany. He may never have said, as the

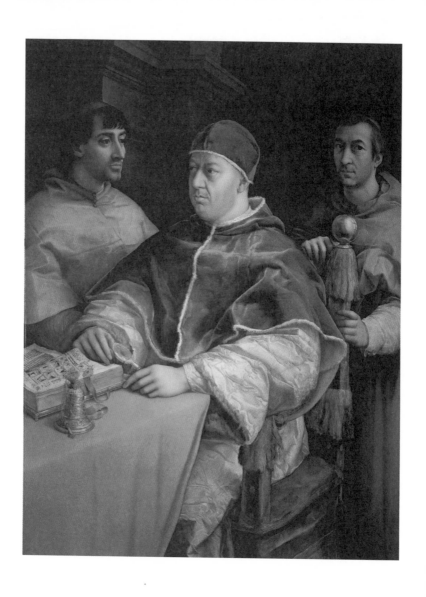

Raphael, *Portrait of Leo X with Two Cardinals*, 1518.

Venetian ambassador reported, 'God has given us the papacy, let us now enjoy it,' but the sense of triumph was genuine.

The Medici had achieved what the Borgias had struggled for: a powerful, unified political unit in the centre of Italy. To many, Leo's election looked like a promise of peace after two decades of foreign invasion and war. Machiavelli, hoping in vain to be forgiven and returned to office, dedicated *The Prince* to the Medici rulers of Florence:

> See how Italy beseeches God to send someone to save her from these barbarous cruelties and outrages; see how willing the country is to follow a banner, if only someone will raise it. And at the present time it is impossible to see in what she can place more hope than in your illustrious House, which, with its fortune and prowess, favoured by God and the Church, of which it is now the head, can lead Italy to her salvation.

The Medici never gave Machiavelli a job, but he was at least released from the *Stinche* in the amnesty that followed Leo's coronation.

Michelangelo's own feelings were probably complicated. The most powerful individual in his world was now a man of almost his own age, with whom he had grown up and whom he knew intimately. Although Leo was overweight and suffered from the unfortunate abscess, a Pope of under forty years of age might be expected to reign for a long time, perhaps the remainder of Michelangelo's own life. However, the artist was committed to a commission for a dead Pope and a family that was losing power. And Leo – although son of his old mentor, Lorenzo the Magnificent – seemed in no hurry to employ him.

The new Pope's favourite arts were music and architecture. As a lieutenant of Julius's, he may have observed how difficult Michelangelo could be to deal with. Almost certainly, if it was said in Florence that Michelangelo had spoken out against the Medici at the time of the sack of Prato, Leo knew about that too. For whatever reason, the sculptor was left in his new workshop to get on with the tomb.

It cannot have improved his mood that his old bête noire, Leonardo

da Vinci, installed himself in Rome in the autumn of that year, living in the Belvedere under the protection of Giuliano de' Medici. It is true that Leonardo accomplished little in the next three years, which he spent in Rome, but he was more in favour at the new Medici court than Michelangelo.

For obvious reasons, Michelangelo's thoughts about the Medici restoration were carefully guarded. One incident, however, suggests he had some sympathy for the diehard republicans and adherents of Savonarola. In the summer of 1513, it was reported, he was standing in the garden at Macel de' Corvi, on 'one clear evening':

> While praying he raised his eyes to heaven and beheld a remarkable triangular star totally unlike any known comet. It was an enormous star with three rays or tails. One of these rays extended towards the east and was of a certain splendid and glittering silver like that of a burnished sword and its end twisted like a hook. The second ray or tail was extended in the direction of Rome, and was the colour of blood. The third ray pointed in the direction of Florence between north and west and was the colour of fire and bifurcated.
>
> When Michelangelo had contemplated this marvel, he had the impulse to make a coloured drawing of it; he gathered his materials, went outside and made the drawing and when it was finished, the great spectacle faded from his sight.

This sounds very much like a vision, communicated by Michelangelo in graphic form. Exactly what it portended is hard to say, but neither the tail the colour of blood pointing towards Rome nor the ray the colour of fire pointing towards Florence seemed to bode well for the Medici government of those two cities.

Apocalyptical prophecies and visions were frequently deployed by opponents of the Medici. This account comes from a book, *Vulnera diligentis*, by a fanatical adherent of Savonarola's, Fra Benedetto Luschino, who was imprisoned from 1509 in the convent of San Marco because of a murder he had committed, probably in a struggle against the opponents of the *piagnoni*. Fra Benedetto was, obviously, not the best of sources. The rest of *Vulnera diligentis* is packed with weird

and recondite symbolism. On the other hand, he seemed confident about this story. 'Go and find the said sculptor,' he advised his readers. 'He will very kindly show you this thing and tell you the whole truth of the incident, and you will be assured that I have not spoken an untruth.' Two years later, Michelangelo complained that his brother Buonarroto had accused him of 'running after friars and fictions and you made a mock of me'. That in turn implies that Michelangelo was more sympathetic to predictions of doom for the Medici than the other members of his family. Perhaps he hoped they would come true.

Such prophesying was finally banned in 1515 on pain of imprisonment for life, and/or excommunication as a heretic. All such writings were to be turned over to the court of the Archbishop of Florence, Giulio de' Medici, cousin of the Pope. From September 1513 Giulio was also a cardinal, after Leo had asked a Papal Commission to investigate the question of his illegitimacy, since in canon law cardinals were supposed to be legitimate. It was declared (most implausibly) that his parents had secretly been betrothed, and therefore that Giulio was no bastard after all. If the new Cardinal de' Medici knew about Michelangelo's vision, as he probably did, he chose to overlook it, as – in the future – he was to forgive even worse offences by the artist.

*

We get a snapshot of Michelangelo's daily life in April or May of 1513 in a letter he wrote four years later. It described a meeting with Luca Signorelli, an older painter who was in Rome at this time. They bumped into each other at Monte Giordano, a small district near the Tiber and more or less directly on the route between the Vatican and Macel de' Corvi.

'He told me that he had come to request something of the Pope, I don't remember what, and that he had once nearly had his head cut off in the Medici cause and that this seemed to him, so to speak, not to have received recognition.' Possibly Signorelli wanted help in a dispute he was having with some nuns; possibly – now over sixty and out of fashion – he was hoping for a commission. Michelangelo was

not very interested in Signorelli's affairs: 'He told me other things in the same vein, which I don't recall. And to crown these arguments, he asked me for forty *giuli* and indicated to me where I should send them, that is, to the shop of a shoemaker, where I believe he was lodging.'

Michelangelo went home and dispatched his assistant Silvio with this smallish sum – 40 *giuli* equalled about 4 ducats. 'Then a few days later the said Maestro Luca, who had perhaps not succeeded with his project, came to my house in the Macel de' Corvi, the house which I still have to-day.' Signorelli asked for another loan, for the same amount as he had had before, and Michelangelo went upstairs and fetched it from his room, where it seems he was already keeping his cash. Evidently, Signorelli needed the money to get back to his home-town, Cortona.

Michelangelo's reason for recounting all this detail was that in 1518 Signorelli still had not repaid the 8 ducats. Michelangelo, who as usual had an enormous amount of things to do, went to the trouble of writing to the administrator of Cortona to try to get back this small debt from an older artist, now down on his luck, who was obviously a friend and to whom he owed an artistic obligation. The male nudes in the frescoes of *The Apocalypse* and *The Last Judgement* Signorelli had painted in Orvieto were among the clearest precedents for Michelangelo's own work. It is evident that Michelangelo must have seen them as he travelled between Florence and Rome.[2]

One remark of Signorelli's had stayed in his mind, perhaps because it was beautiful and offered hope. Michelangelo had complained he was ill and could not work. Signorelli replied, 'Doubt not but that Angels will come from heaven and take you by the hand and aid you.' With that, he took the money, 'went with God', and Michelangelo had not seen him since.

The phrase Michelangelo used for the indisposition that stopped

2 Michelangelo related all these details, he explained, 'because if the said things were repeated to the said Maestro Luca, he would remember and not say he had repaid me'. Tom Henry dates Signorelli's visit to April or May 1513.

him from carving, '*mal sano*', could suggest mental ill health as well as physical. The fact he was well enough to be wandering around Rome – where he had met Signorelli in the street – implies that he was not gravely sick. Could it be that his problem was depression or a creative block? If so, the angel did descend, because energy and inspiration returned.

In his letter Michelangelo described the sculpture standing in his workshop the day that Signorelli called for his second loan. It was a 'marble figure – upright, 4 *braccia* in height, which has the arms behind'. This was clearly the so-called *Rebellious Slave*, which is now in the Louvre, together with its companion, *The Dying Slave*. If he was at work on it in April or May 1513, *The Rebellious Slave* must have been the first figure from the tomb he tackled. This was one of the bound, naked figures whom Michelangelo always called prisoners, who apparently represented the arts – fettered by the demise of their great patron, Julius. These nude young men, like the *ignudi* of the Sistine Chapel ceiling, were an unexpected, and surprisingly prominent, ingredient in the scheme. One guesses they were there not so much because the tomb of the Pope demanded them as because the artist deeply wanted to carve them. Of course, he had to begin somewhere; but it is psychologically intriguing that, of the forty or so sculptures that the design called for, he elected to start on one that was nude, fettered and defiant.

Over the next three years, work proceeded quietly and steadily in the workshop on Macel de' Corvi. Michelangelo set about organizing a team to work on the huge project of the tomb. He started to push forward and apparently brought many master-craftsmen from Florence. In July he subcontracted the architectural elements of the front, including the tabernacles 'with pilasters, architrave, frieze and cornice', to a man named Antonio da Pontassieve. Another he sent for from Florence was a mason from Settignano named Michele di Piero di Pippo (1464–1552?), who had joined him in Rome by July. This man had worked with Michelangelo years before – he had assisted him when he was quarrying for the *Pietà* in 1498 – and was to collaborate closely for years in the future. He was an old friend and neighbour of

the Buonarroti. When he addressed Michelangelo in a letter it was as 'my dearest friend'. Nonetheless, there was a sharp disagreement about money soon after he arrived in Rome.

In November 1513 Michelangelo asked his father to look out for a youth who would act as a servant in exchange for a little instruction in drawing: 'some lad in Florence, the son of poor but honest people, who is used to roughing it and would be prepared to come here to serve me and to do all the things connected with the house, such as the shopping and running errands when necessary, and who in his spare time would be able to learn'. He wanted someone from home, since in Rome there were only rascals.

This proposal turned out badly. Lodovico eventually found such a teenager, who arrived in the autumn of 1514, but there was a misunderstanding. The boy arrived on a mule and the mule owner demanded payment of 2 ducats from Michelangelo himself, who was infuriated: 'I should not have been more annoyed if I had lost twenty-five ducats, because I see that it is the fault of the father, who wanted to send him grandly mounted upon a mule.'

Then it turned out the boy expected to spend most of his time studying rather than looking after Michelangelo: 'Besides all the other worries I have, I've now got this dry shit [*merda secha*] of a boy, who says that he does not want to waste time, that he wants to learn.' Far from approving of this enthusiasm, Michelangelo wanted him sent back to Florence: 'Say that he is a good lad, but that he is too refined and not suited to my service.' It sounds as if living conditions in Michelangelo's household remained spartan.

The artist's attention, and perhaps affection, was focused on his other assistant – presumably Silvio, who had been sent to give the money to Signorelli. This youth had been ill: 'his life was in the balance and despaired of by the doctors for about a month, so that I never went to bed.' In contrast to the irritable, penny-pinching figure who often appears in the letters, this presents a picture – also true to his character – of Michelangelo sitting up anxiously, night after night, by his apprentice's bedside.

At the beginning of the next year, 1515, Michelangelo sent for

Bernardo Basso, son of Piero and – perhaps – the baby of his own wet nurse. However, Bernardo Basso's tenure as assistant did not last long.

'That scoundrel Bernardino,' Michelangelo fulminated to Buonarroto on 28 July 1515, 'cost me a hundred ducats during the time he was here, besides going about tittle-tattling and complaining about me all over Rome.' He instructed Buonarroto to 'shun him like the devil' and not let him in the house. There was no one he could send to Carrara to select marble for him, because all his subordinates were useless: 'If they are not fools, they are knaves and rascals.' Running a team or delegating did not come easily to him.

It was perhaps around this time that Michelangelo broke with Jacopo Torni, known as L'Indaco (1472–1526), who had been one of the painters he called to Rome to assist him in painting the Sistine Chapel ceiling and also a fellow apprentice in Ghirlandaio's workshop. After Michelangelo dispensed with the services of the team of master fresco painters, rather than returning to Florence like the rest, Jacopo Torni had hung on in Rome. According to Vasari, 'Jacopo worked for many years in Rome, or, to be more precise, he lived many years in Rome, working very little.'

Apparently, for a long while Michelangelo found him good company: taking 'pleasure in this man's chattering and in the jokes that he was ever making, he kept him almost always at his table'. Michelangelo found him relaxing when he wanted diversion from 'his ceaseless exertions of mind and body'.

By and by, however, Michelangelo got tired of his friend because of his incessant babbling, so he sent him to buy figs, then bolted the door behind him. Jacopo knocked in vain for a long time when he got back, then finally, 'flying into a rage, he took the figs and the leaves and spread them all over the threshold of the door.' For many months, the two men did not speak, then were reconciled.

As the art historian Fabrizio Mancinelli has pointed out, the door is closed at some point in almost all Michelangelo's relationships, literally or metaphorically. Sometimes, there was a subsequent reconciliation, sometimes not. Sooner or later, Michelangelo always

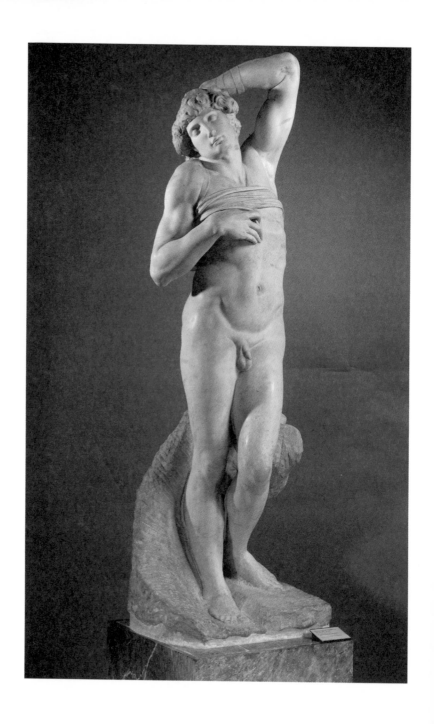

Dying Slave, 1513–16.

seems to have felt an impulse to shut out the people who were close to him.

*

The years from 1513 to 1516 were scarcely ones of artistic failure. During that time Michelangelo created three of the greatest sculptures of his life: the *Rebellious* and *Dying Slaves*, and *Moses*. As an example of what Michelangelo 'would have achieved' if he had managed to finish the tomb with some forty figures of this quality, Condivi gave the two 'prisoners' (otherwise known as 'slaves' or 'captives') this assessment: 'All those who have seen them consider that nothing better has ever been made' – which was and remains not far from the truth.

The two *Slaves* are brothers of the *ignudi* on the Sistine Chapel ceiling but carry a greater emotional charge. *The Dying Slave* is the most sensuously beautiful of all Michelangelo's representations of the supreme subject of his early career: the young, nude and athletic male body. The monkey lurking roughly carved behind his legs implies that he is an incarnation of the arts that ape nature: Michelangelo's own disciplines of painting and sculpture.

The tremendous *Moses* was the culmination of the sequence that began with the vanished bronze of Julius and the mighty prophets of the Sistine Chapel. Michelangelo never produced a more overpowering visual embodiment of that quality he shared with the late Pope: *terribilità*. Michelangelo's *Moses* resembles his paintings of God the Father on the Sistine Chapel ceiling but is if anything even more charged with power, his muscular arms revealed, his right leg and knee – often a crucial joint in Michelangelo's artistic anatomy – tensed as if he were ready to bound up from his throne, his long beard rippling with electric energy.

In the fifteenth and early sixteenth centuries Moses – prophet, law-giver and ruler – was frequently seen as a precursor of the popes, which is why his life was painted in the fifteenth-century frescoes on the walls of the Sistine Chapel (and why Michelangelo did not paint him higher up: Moses was already there). *Moses* was not a portrait of

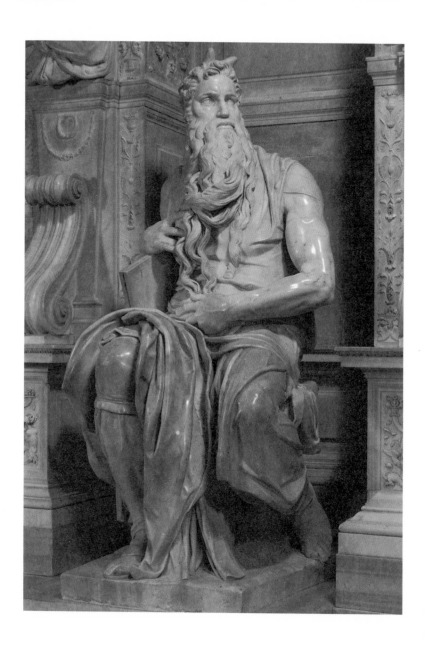

Moses, 1513–16, from the Tomb of Julius II.

Julius, but he was an image of what he stood for: the power of God's representative on earth.

While he was creating these mighty works, however, there were many indications that Michelangelo's nerves were taut. Around the time that he sent for the apprentice from Florence who arrived on a mule and turned out such a disappointment, he was 'only working very little', apparently because of a dispute he was having with Cardinal della Rovere about his house. The essence of this was probably that, though the cardinal thought he was simply letting Michelangelo have the use of the house on Macel de' Corvi while he was engaged on the tomb, Michelangelo was now insisting on being given it permanently. In other words, he was upping the generous payment in his contract to include a large building on the outskirts of Rome. He continued with this demand for two decades until, out of sheer weariness, the executors gave in.

Perhaps Michelangelo was trying to get as much as possible from the tomb, because it was all he had and, at the current rate of progress, it looked like taking the rest of his life. There was no sign of support from his old teenage companion, now the Pope and ruler of wide areas of Italy. Meanwhile – he must have been intensely aware – he had rapidly been overtaken by his younger rival. Raffaello Santi was fast becoming the artistic monarch of Rome.

On 11 March 1514 Donato Bramante died, aged seventy. His successor as the superintendent of the building of St Peter's was not another architect but the painter Raphael. In a letter to his uncle in Urbino dated 1 July 1514 Raphael described how Leo X called on him 'every day', together with his elderly architectural mentor and colleague Fra Giocondo, 'and engages in discussion with us about the construction'. Thus, at thirty, Raphael was in joint charge of the greatest architectural project in Europe, despite having virtually no relevant experience.

The same letter from Raphael to his uncle mentions that Cardinal Bibbiena, one of Leo's closest and most loyal associates, wanted to betroth the artist to his niece. In addition, the cardinal had his portrait painted by him, and Raphael and his team also decorated a *stufetta*,

or steam bath, for his use in the Vatican in the classical manner, with startling and explicitly erotic images.

Raphael seemed able to move smoothly into the role of courtier. The contrast with Michelangelo was obvious. But, of course, Raphael had far more qualities than just suavity. In addition to his own brilliance as a painter, he had another crucial ability. Michelangelo had great difficulty in working with other artists of anything like equal status, largely because he wanted to keep control over every aspect of the final result. In contrast, Raphael was an inspired collaborator. Like an actor-manager of a theatrical company, he had a flair for casting other artists in roles that used their talents to the best advantage.

Giovanni da Udine, for example, was a specialist in the re-creation of ancient stucco reliefs and also in painting flowers and fruit. Raphael showcased these talents to maximum advantage: when he and his workshop painted frescoes in the loggia of a luxurious villa beside the Tiber owned by the wealthy banker Agostino Chigi (later dubbed the Farnesina), Giovanni added an astonishing festoon of fruits, flowers and vegetables that combined botanical accuracy with almost pornographic suggestiveness of shape.

By skilful use of gifted assistants such as Giovanni da Udine, Giulio Romano, Gianfrancesco Penni, Polidoro da Caravaggio and Perino del Vaga, Raphael was able – in modern terms – to enrich his brand without diluting it. The finished product looked like a Raphael, but with added ingredients – and came at a speed of delivery that derived from many hands. From the customer's point of view, the result was that if you ordered something from Raphael it was done: quickly, efficiently and reliably. For ambitious artists, his workshop was the place to be.

In 1519, at the height of Raphael's power, Pandolfo Pico della Mirandola, the Mantuan envoy, wrote to Isabella d'Este on behalf of an artist of twenty, a follower of Michelangelo whom he thought very accomplished. Raphael did not think much of his talent, however, so he was looking for work away from Rome. The message was clear: if Raphael did not approve, you might as well get out of town.

*

Michelangelo in March 1515 turned forty, a point at which Renaissance people began to feel they were old (Erasmus wrote his poem 'On the Discomforts of Old Age' when he was this age). He had spent the previous twenty years in unremitting labour, often under intense nervous strain. However, the artist's life was not quite as bleakly hard-working as his letters to his family sometimes suggested. His friends were not as exalted as Raphael's, but he had some, among them a fellow Tuscan named Giovanni Gellesi. When Michelangelo went back to Florence for a visit in April 1515 Gellesi touchingly declared that, deprived of Michelangelo's company, he felt like an orphan in the Babylon of Rome.

He added that in the artist's absence he and Michelangelo's other friends had recruited a replacement to their social circle. This man, Domenico Buoninsegni, was secretary to Cardinal Giulio de' Medici and was destined to take an important part in Michelangelo's life over the coming years. Another firm supporter was a man known as Leonardo Sellaio, or Leonardo the Saddler, a Florentine who seems to have worked at the bank run by Florentine banker friend of Michelangelo's, a discerning patron of art named Pierfrancesco Borgherini.

Sellaio acted as a sort of major-domo for Michelangelo: he looked after Michelangelo's house and affairs during the years the artist was away from Rome and was an indefatigable correspondent, sending Michelangelo a stream of news about what was happening in the Roman art world, mixed occasionally with wise advice. Sellaio's unwavering friendship was proof of the fact that, despite his awkward temperament, Michelangelo was able to arouse almost feudal loyalty in his close associates.

A new friendship from these years was with a fellow artist, a Venetian painter named Sebastiano Luciani.[3] Sebastiano, born in 1485, was a decade younger than Michelangelo, and openly hero-worshipped him, as is clear from many garrulous letters from him that survive: 'I

3 Later known as Sebastiano del Piombo, or Bearer of the Lead Seal, after a papal sinecure he was given.

wish to see you emperor of the world,' he wrote to Michelangelo on one occasion, 'because to me it seems that you deserve this.'

Sebastiano had arrived in Rome on 21 August 1511, six days after the first part of the Sistine Chapel ceiling had been revealed: the perfect moment to be bowled over by the force of Michelangelo's genius. His intense admiration might have been one of the reasons for their comradeship. This was the only close and lasting bond Michelangelo formed with another artist of anything approaching his talent (although, decades later, Sebastiano, too, was shut out of Michelangelo's life). There was another reason for the alliance: they combined in bitter rivalry with Raphael.

Sebastiano had been invited to come to Rome by Agostino Chigi, the Sienese banker who had become vastly wealthy on the profits from the papal alum mines at Tolfa (a monopoly concession which he had obtained, probably by bribery, from Alexander VI and Julius II). Chigi was a hugely desirable patron for a painter, but – like Leo – he had abandoned Sebastiano and become an enthusiastic admirer of Raphael. At some point between 1513 and 1516 – precise dating is impossible – Michelangelo and Sebastiano decided to combine their talents and collaborate on a picture. It was a *Pietà* ordered by a cleric named Giovanni Botonti for his family chapel in the church of San Francesco, Viterbo. He was not powerful or hugely wealthy but he was a rising man, working in the papal finance department, the Apostolic Camera. Ostensibly, the painting was by Sebastiano, executed in his rich Venetian oil technique, but Michelangelo supplied drawings for the main figures.

Vasari succinctly described its rationale. Italian painting was in the process of exhilarating transformation. The developments of the fifteenth century in perspective, anatomy and the assimilation of classical art were being mingled with other advances from Northern Europe. The artists of the Netherlands, particularly, had achieved magical effects of naturalism. They could depict, as Florentines could not, the lustre of metal and glass, the true softness of skin, or the nuances of atmosphere at dawn and dusk. The Italian city where the artistic currents met and mixed was Sebastiano's hometown of Venice, an

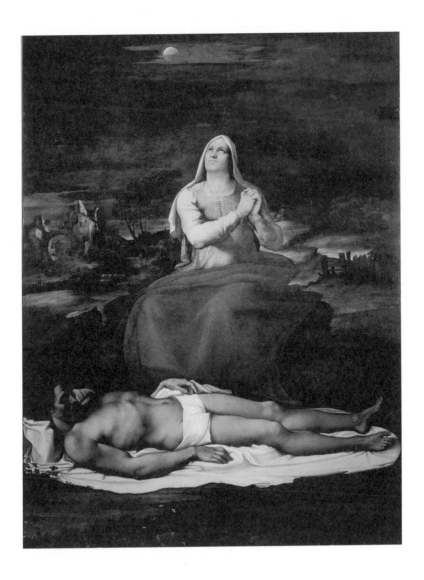

Sebastiano del Piombo, *Pietà*, c. 1513–16.

international trading centre close to the Alps – and Sebastiano himself excelled in the depiction of landscape, texture and naturalistic portraiture.

From the point of view of an intelligent Italian connoisseur of the second decade of the sixteenth century, the greatest painter was the one who could best combine these varied aspects of his art. And, according to Vasari, plenty of people thought Raphael was that artist. Michelangelo's response was astute but strangely lacking in confidence. He took Sebastiano 'under his protection, thinking that, if he were to assist Sebastiano in design', Vasari explained, he could confound those who thought Raphael the greatest painter, and do so by proxy, 'without working himself'. Together, Michelangelo and Sebastiano possessed every talent a painter could possibly require.

The *Pietà* that resulted is a strange but powerful hybrid. Sebastiano's nocturnal landscape in the background is wonderfully eerie; Christ's body is anatomically precise and poignantly expressive in the way that only Michelangelo could make bodies emotionally eloquent, but the corpse was painted with the fleshy softness of Venetian oil painting. A preliminary study survives, revealing what is, anyway, obvious: that the model for the Madonna was an athletic young man, whose chest and torso Michelangelo drew and also, repeatedly, his hands clasped in prayer, the fingers of the right hand gripping the left.

According to Vasari, this painting won Sebastiano golden opinions. Nonetheless, it was a limited success. It looked like what it was: two dissimilar ways of making art forcibly yoked together, lacking the sense of a unifying mind controlling the whole which Raphael gave the products of his studio.[4]

In those years, Raphael's rise was inexorable. Leo decided to make his own, characteristic contribution to the decoration of the Sistine

4 A Venetian dialogue, written many years later, contains an unreliable – but, on the other hand, rather plausible – recollection, attributed to Aretino, of Raphael's response: 'Oh, how delighted I am, Messer Pietro, that Michelangelo helps this new rival, making drawings for him with his own hand; because from the repute that his pictures do not stand up to the *paragone* [comparison] with mine Michelangelo will see quite clearly that I do not conquer Sebastiano (because there would be little praise to me to defeat one who cannot draw) but Michelangelo himself.'

Chapel: a cycle depicting the acts of the apostles Peter and Paul in the luxurious, and enormously costly, medium of tapestry. This was a commission that might have been expected to go to Michelangelo, who had so triumphantly painted the ceiling. Instead, the Pope decided it should go to Raphael. On 15 June 1515 he received the first payment.

The evidence of the tapestry cartoons themselves is that Raphael gave this task the closest personal attention. It was another *paragone* – a contest – with Michelangelo. When the tapestries were hung in the chapel for a few hours in August 2010,[5] it was obvious how hard Raphael had striven to rival and excel the frescoes on the vault above. This was despite the ever increasing busyness of Raphael's professional life, which now included the supervision of St Peter's and a plethora of painting commissions. However, Raphael did not quite succeed: splendid as the tapestries look *in situ*, they are overpowered by the grandeur and energy of the ceiling above.

Nonetheless, during this time Michelangelo began to hope that Leo would employ him after all. On 16 June 1515 he wrote to Buonarroto, saying that he must 'make a great effort here this summer to finish the work as soon as possible' – that is, the tomb of Julius II. The reason was that 'afterwards I anticipate having to enter the pope's service.' He added, ambiguously, that, for this purpose, he had 'bought some twenty thousand weight of copper, in order to cast certain figures'.[6]

It isn't clear what this was for; perhaps the bronze reliefs on the tomb, though these were never actually cast. However, the letter does imply that he was tiring of work on the tomb and anxious to get it over with. This sounds like a reversal of his previous attitude. *Moses* and the two never quite finished *Slaves* were carved lovingly, with his total attention. Now, he told Buonarroto, in the three months since his visit to Florence he had carved nothing; instead, he had devoted his 'attention solely to making the models and to preparing the work'.

5 This was done to test a theory of the order in which they were originally placed in the chapel, in advance of an exhibition at the V&A in London. Normally they are shown in the Pinacoteca of the Vatican Museums.
6 On 11 August he wrote to Buonarroto that he intended to 'make one great effort with a host of workmen to finish the work in two or three years'.

The idea, clearly, was that an army of assistants – much like Raphael's – could then take over and mass-produce sculpture following Michelangelo's models at speed. The resulting tomb would not be quite the great masterpiece he had planned, but at least it would be finished. To this end, Michelangelo was even prepared to spend money: as he ruefully explained, he had 'incurred heavy expenses'. The main problem now was that, despite the enormous amount he had had quarried and delivered to Rome a decade before, he had run out of marble. For that reason, though he had prepared the models, there wasn't anything for an army of assistant sculptors to do.

At some point in this period, quite possibly in 1515, Michelangelo did have a small papal commission, the façade for a private chapel that was being built in the Castel Sant' Angelo. It is a neat, elegant little structure, suavely classical except for the bulging volutes on the central window frame. The question is, why did Michelangelo take on the design of an inconspicuous little structure, tiny in comparison with the vast edifice of St Peter's which Raphael controlled? The answer, presumably, was that the one person who could not fail to see it was Leo. It was a way of demonstrating that Michelangelo, too, could create architecture.

It is only possible to guess at the reasons for the change of direction in Michelangelo's ambitions, but it is tempting to connect it with the appearance of that new individual in Michelangelo's circle of friends: Domenico Buoninsegni. He was secretary and treasurer to Cardinal Giulio de' Medici, who was in turn the chief advisor to his cousin the Pope. Cardinal de' Medici can indeed be seen in exactly that position in Raphael's beautiful portrait of *Leo X with Two Cardinals* from 1518.

Giulio, though only three years younger than Leo, seems much more youthful, dark-haired, with a handsome, intelligent face. Leo, in contrast, looks chubby and jowly, seated at a desk with an opulent illuminated manuscript open in front of him. The latter is evidence of Leo's tastes, luxurious but pious and learned, while the magnifying glass in his hand testifies to the myopia he had inherited from his father, Lorenzo the Magnificent. (One wonders how well he could see the Sistine Chapel ceiling, 70 feet above his head.)

The painting, with its depiction of sumptuous ecclesiastic vestments, is emblematic of Leo's wealth; his pose, seated and flanked by lieutenant cardinals, represents his power. In the middle of 1515 Leo was pondering a dramatic demonstration of the latter. Julius II had arranged for his nephew, Francesco Maria della Rovere, to be adopted by the childless and sickly Duke of Urbino, Guidobaldo da Montefeltro. On Guidobaldo's death in 1508, Francesco Maria had duly succeeded.

What one Pope had given, another could take away. Urbino was, technically, part of the Papal States. Located on the other side of the Apennines from Tuscany, it would be a suitable addition to the Medici family territory. In Rome, there were rumours that Leo was contemplating depriving the della Rovere family of the dukedom and, in the summer of 1515, these rumours were strengthened. Francesco Maria had been Captain General of the Papal Army. But this year his contract was not renewed: on 29 June in St Peter's, Leo presented the general's baton instead to his brother, Giuliano. Michelangelo must have known the gossip, as he was now regularly meeting a man plugged directly into the inner circles of Roman power, and he must have known what it meant. The power and wealth of the della Rovere, patrons of Julius's tomb, were ebbing away, and the Medici were continuing their spectacular ascent.

On 30 November Leo X made a triumphant entry into Florence: essentially – though not formally – he was a ruler taking possession of his state. To celebrate and orchestrate the arrival of the city's greatest citizen, extraordinary preparations were made, created by teams of artists and artisans. A series of temporary triumphal arches was set up along Leo's route, at each of which the Pope and his procession of cardinals and dignitaries paused and listened to songs. The entire affair lasted seven hours.[7] At other crucial points there were suitably classical monuments: an obelisk, a column like those of Trajan and Marcus

7 Michelangelo was sent a long account of the entry by his brother Buonarroto, who was most struck by the crowds, the shouts of 'Palle!', the splendid costumes of the Pope's attendants and the pageantry of it all.

Aurelius, a theatre in the Roman style, rapidly run up out of wood, canvas, plaster and clay. The decorations for the *entrata* were a blueprint for what might be commissioned in the future, the monuments of a city to Leo's taste.

The artistic *équipe* that carried out this spectacular transformation was a mixture of old friends and associates of Michelangelo's – including Granacci and Bugiardini – and the rising generation of young men born in the 1480s and '90s. Prominent among the sculptors were a young man named Baccio Bandinelli and Jacopo de' Tatti, who had taken on the name of his master, Andrea Sansovino. This Jacopo Sansovino, the most talented of the younger sculptors, collaborated with the painter Andrea del Sarto on a gigantic equestrian sculpture placed outside the church of Santa Maria Novella. Sarto and Jacopo Sansovino also collaborated on the centrepiece of the whole scheme: a grand classical façade for the Duomo.

The façade of the cathedral had been left unfinished in the fourteenth century. In front of this Gothic structure Sarto and Sansovino erected a composition of triumphal arches, Corinthian columns, entablature and cornices, with statues, paintings of figures and reliefs. According to Vasari, when Leo saw the temporary façade of the Duomo, he said that 'it was a shame that a real façade of that temple was not built.' And he was so impressed by the 'spirit and force' of the equestrian monument Sansovino had made in collaboration with Andrea del Sarto that Sansovino was taken to kiss the feet of the Pope, who showed him 'many signs of affection'. In Leo's entourage were two of Michelangelo's deadliest rivals: Leonardo da Vinci, and – according to Vasari – Raphael too.

Leo was en route to an appointment in Bologna. The new King of France, Francis I, had invaded Italy and on 14 September won a tremendous victory against the Swiss at Marignano, near Milan. At Bologna, some high-political horse-trading took place. The Pope offered to hand over the territories of Parma and Piacenza; in return, Francis I agreed to protect Florence and the Papal States, while Giuliano de' Medici was given the rank of a French prince and made Duke of Nemours. This sealed the fate of Francesco Maria della

Rovere; his dukedom of Urbino would have to be given to the 23-year-old Lorenzo de' Medici, son of Piero. On 13 October Cardinal Giulio de' Medici had written, 'As for Urbino, the pope's mind is made up. He does not wish to hear the matter discussed, but it will be done without more words.'

There was a great deal here for Michelangelo to ponder. The della Rovere were due for a great fall. There was the prospect of glittering commissions in Florence. And another generation of rivals had arisen.

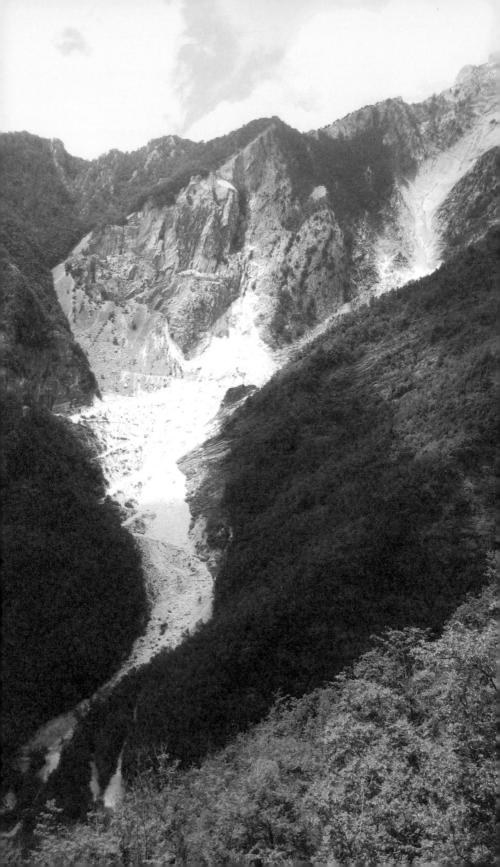

MARBLE MOUNTAINS

'I shit blood in my works!' ('Nelle opere mie caco sangue!')

– Michelangelo to Bartolomeo Ammannati, as reported
by Gianlorenzo Bernini

At the time of Leo's triumphant entry into Florence and meeting with Francis I in Bologna, his only surviving brother, Giuliano de' Medici, fell desperately ill with consumption. By February 1516 he was near death. This left Lorenzo de' Medici, Duke of Urbino, as the only legitimate male in the family who was not a clergyman.

As the power of the Medici increased, their numbers were dwindling. The greatest enemy of this brilliant clan was, as always, ill health. Nonetheless, Leo began proceedings against Francesco Maria della Rovere, with a view to ejecting him from the dukedom of Urbino. Francesco Maria was accused of the murder of Cardinal Alidosi, treachery and disobedience. In March the Dowager Duchess of Urbino, Elisabetta Gonzaga, arrived in Rome to plead the cause of Francesco Maria, her adopted son, and of the della Rovere family, who would forfeit home and lands if he lost the title. She is the coolly witty woman who presides over the conversations in Castiglione's *The Courtier* (which he was drafting at the time).

Castiglione's book was set in 1506. Now, ten years later, poor Elisabetta was reduced to begging not to be ejected from her palace. In an audience with Leo she pleaded for mercy: 'Surely, Holy Father, you who know what it means, will not drive us out of house and home, and force us to wander in exile and poverty.' This was a reminder that she and her late husband had offered shelter and hospitality to Leo's

(facing page)
View of the
Apuan Alps
near Seravezza.

305

brother Giuliano and his secretary, Cardinal Bibbiena, during their years of exile from Florence. Leo's response was merely to shrug. This was a matter of brutal power politics: the world of *The Prince*, not *The Courtier*. Bibbiena, who discourses urbanely on the subject of humour in the book, was probably among the cardinals who sat in silence as Elisabetta left the audience chamber.

Events moved on quickly. On 18 March the news of Giuliano's death reached Rome; on the same day, Francesco Maria della Rovere was excommunicated. Lorenzo de' Medici immediately departed for Rome, and when he arrived his uncle granted him the duchy of Urbino. Before she left Rome, defeated and dispossessed, Elisabetta wanted to see the sculptures Michelangelo had made for the tomb of Julius II. Cardinal della Rovere wrote a letter to the sculptor saying that this would give her the greatest pleasure. It is written in the most courteous terms, phrased as a request not a command and addressed to Michelangelo as 'dearest friend'.

However, perhaps it was no accident that, just when the authority of the della Rovere was waning, Michelangelo decided to renegotiate the contract for the tomb. The result was a change to his advantage. According to the new contract, signed on 8 July, the tomb would be much smaller, and more conventional: it was now to be a wall monument, with the number of sculpted figures almost halved, to twenty-one, and only one bronze relief. The price remained the same, despite the political problems of the della Rovere. Michelangelo was allowed nine years to complete it, of which three had already elapsed, and could do so where he wished. All in all, the scheme, though still enormous, was more achievable, especially with the mass of assistants Michelangelo planned to employ.

No sooner had he signed the new contract than Michelangelo was arranging to leave Rome. A week later, on 15 July, Argentina, the wife of Piero Soderini, wrote a letter asking her brother Lorenzo Malaspina to put in a good word for Michelangelo with Alberico Malaspina, the Marquis of Massa and ruler of the little state containing the marble quarries of Carrara.

Argentina Soderini describes Michelangelo in terms very similar to the ones in which her husband had recommended him to Julius II: as a person without equal 'in Europe today' and – more surprisingly –

as mannerly and courteous. Piero Soderini sent it on with a covering note, couched in the warmest terms, offering to do any other favour 'for love of your *virtù* [prowess] and goodness'. Soderini was now living quietly in retirement, his brother Cardinal Soderini having done a deal with Leo to allow him to return from exile in Dubrovnik. Soderini's power had withered but, clearly, he still retained affection for Michelangelo, and admiration for his genius.

Ostensibly, there was a perfectly sound reason for leaving Rome. Argentina Soderini's letter makes it clear that he intended to look for more suitable blocks of marble in Carrara. It seems, however, there was more to his decision. In early August he was sent two worried letters by friends in Rome. The first, dated 9 August, was from Leonardo Sellaio, whom Michelangelo had left to look after his house and studio at Macel de' Corvi. Evidently, Michelangelo's abrupt departure had caused comment. Sellaio obviously had doubts himself, but he encouraged Michelangelo to prove that those who were saying he was never going to finish the tomb were liars.

Michelangelo's friend Giovanni Gellesi then wrote that he was pleased Michelangelo was now in a good state of mind and intended to 'regain his honour'. It seemed Michelangelo had left Rome in bad condition – either physically or mentally.

One explanation for this nervous crisis was that he had suffered a disaster with the statue of the naked *Risen Christ* he was making for Metello Vari. At quite a late stage while he was carving this an ugly black flaw appeared in the marble, showing up as a scar right across Christ's cheek, from his nose to his beard. A mark in a less conspicuous place might have been ignored, but not this. After an enormous amount of work, Michelangelo would have to abandon this sculpture he did not really have the time to undertake anyway. This discovery would have been enough to agitate him.

In addition, there had been some sort of jangling row in Michelangelo's workshop. His assistant Silvio Falcone, beside whose sickbed he had sat for night after night a few years before, had walked – or been thrown – out. He wrote, chastened and apologetic, a couple of years later, to say he was not doing very well on his own. He wanted to apologize to Pietro Urbano, another of Michelangelo's assistants,

who appears now for the first time: a hint that jealousy might have lain behind this row.

However, there was also a bigger problem to be confronted: a decision that was one of the major turning points of Michelangelo's life.

*

After excommunicating him, Leo and his nephew Lorenzo waged a brief war to eject Francesco Maria della Rovere from Urbino. This was a costly and chancy expedition partly paid for by the Papal Treasury. Urbino surrendered on 30 May 1516 and the territory was under Medici control by the end of June. In July Lorenzo was formally made Duke. This was a moment at which Leo could think seriously about less practical expenditure. One such project was a costly, and not strictly necessary, façade for the family's ancestral church in Florence: San Lorenzo.

Like quite a few major Florentine churches, San Lorenzo had been left without a grand frontage. It was the burial place of Cosimo the Elder and Piero the Gouty, and adjacent to the Medici Palace. Nowhere could be more suitable to make a grand architectural statement declaring that the Medici had returned and were back in charge of the city. The scheme had probably been under consideration for a while, certainly since Leo's triumphal entry into Florence the previous autumn.

Perhaps this was the reason why the year before, in June 1515, Michelangelo had anticipated 'having to enter the pope's service'. He would have had information from Leo's innermost circle via Domenico Buoninsegni, secretary to Cardinal Giulio de' Medici. If anyone was pushing for Michelangelo to take part in this new scheme, it was likely to be the cardinal, who later on became one of the artist's greatest and most discerning patrons. There were hints that Leo was tempted to give the commission to his favourite artist, Raphael of Urbino, who was already running several other large projects with smooth efficiency.

For Michelangelo, this magnificent venture in Florence constituted a dilemma. On the one hand, he was committed financially, creatively and morally to Julius's tomb. Also, this was to be a monument to the Medici, a family about whom his feelings were ambivalent. On the

other, here was a splendid opportunity to create a glorious work in his native city, to see off a generation of younger artists and thwart his deadliest rival.

However, the façade was fundamentally an architectural work, and architecture was an art of which he had very little experience. At this stage, the Medici – and perhaps Michelangelo himself – were thinking only in terms of him taking charge of the sculpture for the façade. He needed to collaborate with an experienced architect. However, the doyen of Florentine architects, Giuliano da Sangallo, died a couple of months later and was probably already ill. There were not many obvious alternatives.

Michelangelo spent a month or more in Florence in August and early September. During those weeks he seems to have agreed, perhaps with some misgivings, to work up a proposal for the façade of San Lorenzo in collaboration with the architect Baccio d'Agnolo (1462–1543). They were an oddly assorted team.

Baccio d'Agnolo was a man of an older generation who had graduated from woodworking to architecture. Vasari took him as an example of how 'one sees someone rising from the lowest depth to the greatest height, and especially in architecture.' He had won much praise for the woodwork in the Great Council Chamber of the Palazzo della Signoria (deliberately wrecked when the Medici returned). However, although now in his mid-fifties, he had built little apart from an elegant classical tower for the church of Santo Spirito and a section of the *ballatoio*, or gallery, beneath Brunelleschi's dome on the Duomo. After a long gestation, the first section of the latter had been unveiled on St John's Day, 24 June, 1515, to general disappointment.

This was not a good augury. Michelangelo's own view of Baccio's *ballatoio* was that it looked like a 'cage for crickets', but it is likely he kept that to himself for the time being. He must, however, have had misgivings about working with Baccio, because over the following months a tense comedy was played out. On 7 October Domenico Buoninsegni wrote to Baccio that he had spoken to his master Cardinal Giulio de' Medici about this idea and the Pope had agreed to let Michelangelo and Baccio have the commission. Buoninsegni summoned Baccio and Michelangelo to a secret meeting at Montefiascone on Lake Bolsena, in the papal territory

north of Rome, not mentioning that their journey had anything to do with the San Lorenzo project, so as not to alert 'the friend you know, or other friends of his'. That was, presumably, Raphael. This, however, didn't happen, probably because Michelangelo refused to come.

The autumn wore on, and Michelangelo remained in the fastness of the marble mountains, living in Carrara, scouting for marble. It seems Buoninsegni had been made responsible – presumably by his master, Cardinal de' Medici, for delivering the great sculptor as a participant in the San Lorenzo project. In his own opinion, Buoninsegni explained confidentially, it did not matter who Michelangelo chose to work with, or indeed if he took on the whole thing himself.

Michelangelo, however, was being awkward. Buoninsegni wrote repeatedly, pressing both Baccio and Michelangelo, but particularly Michelangelo, to come to Rome to talk to the cardinal and settle the commission with the Pope. By 21 November Buoninsegni was furious with frustration. If not yet driven mad by Michelangelo's behaviour, he was not far short of it: 'And now from your last letter I see you have again decided not to come, and I am equally determined not to be bothered ever again by these matters, since I only end up ashamed and rather embarrassed.' It would be Baccio and Michelangelo's fault if this great commission was given to foreigners – that is, non-Florentines. The only one of those in the frame was Raphael.

There are glimpses of complicated intrigues behind the scenes. Naturally, many artists wanted some of the glory and profit that would come from such a commission. Jacopo Sansovino was also angling for some of the work, as was a Florentine architect, Baccio Bigio. Leonardo Sellaio sent a warning that Raphael was teaming up with Antonio da Sangallo the Younger as a colleague, presumably on the design of St Peter's, but Antonio da Sangallo would also have been a good partner for Raphael on a bid for the San Lorenzo façade.

Finally, in mid-December, Michelangelo rode to Rome, where he met the Pope and agreed with him on a design for the façade. En route back to Carrara, he stopped off in Florence, where he arranged for Baccio d'Agnolo to make a model of the scheme that had been decided on. However, poor Baccio, though famed as a woodworker, did not please Michelangelo even in this humble role.

Over the coming months, Baccio made two attempts at the model of the façade, both of which Michelangelo rejected. On 20 March 1517 he wrote to Buoninsegni, 'I came to Florence to see the model which Baccio has finished and have found the same thing again, that is to say that it is a mere toy.' It was a criticism that echoed his remark that Baccio's gallery for the Duomo looked like 'a cage for crickets'. Baccio's work seems to have struck him as feeble and finicky.

Instead, Michelangelo decided he would have a model made of clay under his own supervision by one of his masons: Francesco di Giovanni Nanni della Grassa, known as La Grassa. Like a large number of the stone-workers Michelangelo employed over the next decade and more, La Grassa was from Settignano. Michelangelo seemed more at ease when working with a team that owed him personal allegiance: men from his own village, from families known to him since childhood. He chafed at collaboration with anyone approaching equal status. This did not bode well for Baccio, nor for Jacopo Sansovino, who believed that someone – Leo perhaps – had promised him part of the work.

While Michelangelo was in Rome in December he must have talked not only with the Pope but also with his cousin, the cardinal. There is no record of what was said, but a hint of one topic: it seems likely that Michelangelo suggested another competition with Raphael.

Michelangelo was already engaged in a second collaborative project with Sebastiano: a chapel in the church of San Pietro in Montorio. This may have been a substitute for a painting Michelangelo had promised to do for the patron, the Florentine banker Pierfrancesco Borgherini, but had not got round to before he left Rome. In the summer of 1516 Borgherini commissioned Sebastiano to paint this chapel, on the understanding that Michelangelo would provide the design. Michelangelo had indeed sent a drawing and, presumably, Sebastiano had started work.

Suddenly, early in 1517, the Borgherini paintings were put on the back burner because something more urgent had come up. Sebastiano was given an extraordinary opportunity. Cardinal de' Medici wanted an altarpiece for the cathedral of Narbonne in France (of which, in addition to many other ecclesiastical positions, he was archbishop). Uniquely, however, he decided to commission not one but two

paintings – one from Raphael, one from Sebastiano assisted by Michelangelo – then select the better one.

The exact sequence is not documented, but it looks as though Raphael was commissioned first, and this *paragone* was an afterthought. Whether Michelangelo suggested it to Cardinal de' Medici, or the other way round, is not clear. But by 19 January 1517 Sebastiano had been advanced money to buy the wood for the picture. Two days later, Leonardo Sellaio wrote to tell Michelangelo that Raphael was 'turning the world upside down' to prevent Sebastiano having this rival commission. Sebastiano was watching him suspiciously.

From this point, Cardinal de' Medici worked ever more closely with Michelangelo. He sent a letter himself about a matter that was dear to his heart and the Pope's. They very much wanted Michelangelo, as far as possible, to get the marble for the San Lorenzo project not from the usual quarries at Carrara but from alternative ones some miles to the south near Pietrasanta. These were in Florentine territory, therefore it would not be necessary to pay taxes on the stone. Works were already under way to open these new quarries, and to do so completely would be a public good: an asset to the Medici state. Michelangelo continued to be chivvied about this but, for the time being, did not react.

Cardinal de' Medici also sent a list of the saints to be carved on the façade, this time via Buoninsegni, suggesting he was in executive charge of the project.[1] In answer to a query from Michelangelo as to how the figures were to be dressed, the cardinal replied that it was up to the artist, as he did not intend to take up the trade of tailor.

The little joke was a sign of the intimacy between the two men. Giulio de' Medici was three years younger than the artist; he would have been about twelve when Michelangelo entered the household of his uncle, Lorenzo the Magnificent. Illegitimate and orphaned, he would have been perhaps more wary and less confident than his cousins, Lorenzo the Magnificent's sons. As a man, he showed a subtle mind and remarkably original taste in art and architecture, but also crippling caution.

1 At the top there were to be saints Cosmas and Damian, a pair of early Christian martyrs who were also physicians. Michelangelo was to carve them in the dress of doctors or *medici*: this play on their name was presumably the reason why the Medici had taken Cosmas and Damian as patron saints.

He was obsessively interested in detail, including other people's business. When Leo's beloved pet elephant, Hanno – a present from the King of Portugal – died in the summer of 1516 there were extraordinary funeral rites. The Pope himself composed a Latin epitaph and Raphael painted the beast's portrait above his tomb. Afterwards, some wag, probably the witty and outrageous young writer Pietro Aretino (1492–1556), composed a satirical will and testament for Hanno. He bequeathed the cardinal the elephant's huge ears, 'so he would be equipped to hear the affairs of the whole world'.

Whatever the cardinal learned about Michelangelo, he forgave it. His attitude towards the artist was tolerant and affectionate; Michelangelo, in return, treated him with – for the time – a startling lack of formality. Later, Giulio remarked, 'whenever Buonarroti comes to see me, I am always seated and I always ask him to sit down, because he certainly will, without leave or licence.'

While all this was going on in the months following his departure from Rome, there is evidence that Michelangelo was giving himself what one scholar, Christof Thoenes, has called 'a crash-course in classical architecture'. The San Lorenzo façade was to be the most important structure built in Florence in a generation. It would be a manifesto of the learned, elegant classicism so admired by Leo.

Six sheets of drawings dated by scholars to approximately this time – 1516/17 – reveal what he believed he needed to learn. They are incisive analyses in Michelangelo's hand of studies by a Florentine architect and woodworker named called Bernardo della Volpaia (1475–1521/2). The original drawings were detailed and precise observations of ancient and contemporary buildings in Rome.[2] However, the drawings by Michelangelo show him zeroing in on certain elements, particularly entablatures and columns. Rather than simply copy the images in front of him, Michelangelo used his powerful visual imagination to shift the forms in space, reducing a detailed three-quarter study of an entablature from the Arch of Constantine

2 The della Volpaia family produced cartographers, surveyors and clockmakers as well as architects; other members knew Michelangelo; Bernardo had worked in Rome with Giuliano da Sangallo. In other words, Michelangelo and Bernardo were connected in several ways by artistic and social links.

Drawing of Marble Blocks for the Façade of San Lorenzo, 1516–20.

to its practical essence: a single line, the profile of the stonework. He must have done this after leaving Rome: otherwise, why not study the ruins themselves directly?

Whatever self-doubt and indecision Michelangelo may have felt about the San Lorenzo project, it was gone by late spring 1517. On 2 May he wrote to Buoninsegni with buoyant assurance, 'I feel myself able to execute this project of the façade of San Lorenzo in such a manner that it will be, both architecturally and sculpturally, the mirror of all Italy.' There was no longer any question of his collaborating with anyone else. He wanted – indeed demanded – complete control. The Pope and the cardinal would have 'to make up their minds quickly as to whether they wish me to do it or not'.

His letter was written with arrogant assurance, combined with a bitter undercurrent. Michelangelo suggested an overall budget of 35,000 ducats, a huge amount – reflecting the architectural scale of the project – and estimated it could be completed in six years. He was only willing to deal in round sums: 'I cannot keep account and shall not be able ultimately to show proof of my expenditure, except for the actual amount of marble I shall deliver.' Nor could he be concerned with small economies: 'As I'm an old man it doesn't seem to me worthwhile wasting so much time in order to save the Pope two or three hundred ducats.' Michelangelo had just turned forty-two.

These terms, high-handed as they were, were accepted by the cardinal and the Pope, with the wry qualification that it was noted that Michelangelo's estimate of the total cost had risen from 25,000 ducats to 35,000. Had Michelangelo changed his mind and now envisioned a richer design, Buoninsegni drily enquired, or had he made a mistake with his original figures? Their other concern was that the whole scheme had advanced so far on the basis of a drawing. Michelangelo had explained rather airily that 'I have been unable to attend to the making of the model, as I wrote and told you I would. It would take a long time to explain the why and the wherefore.' He had, however, made 'a little one in clay, for my own use here, which, although it is crinkled like a fritter, I want in any event to send you so that this thing may not seem to be a figment of the imagination'. Understandably,

the Pope and cardinal felt they simply must see a proper model of such a colossally expensive project.

By this time, all potential collaborators on the façade had been elbowed aside. Baccio d'Agnolo took this well enough. At Florence during the Easter celebrations, which fell on 22 April, he had buttonholed Buonarroto Buonarroti and launched into a long, self-justifying speech. Clearly, he wanted to retain good relations. The same could not be said of Jacopo Sansovino, who thought he had been commissioned to carve the reliefs on the façade. He had heard he was cut out of the work, perhaps to be replaced by Baccio Bandinelli. Younger and hence more pliant, Bandinelli might have been prepared simply to execute Michelangelo's designs.

On 30 June Sansovino sent Michelangelo a furious letter: 'Not having been able to talk to you before your departure, I have decided to let you know my opinion of you.' With Michelangelo, he alleged, 'there are neither contracts nor good faith, and all the time you say no or yes as it suits and profits you.' Expecting Michelangelo to do anyone else any good 'would be like wishing water would not make anyone wet'.

*

Papal finances had in any case been stretched, partly by the continuing war over Urbino. Francesco Maria della Rovere had not accepted his ejection meekly. In January he had retaken much of the territory. In time, Urbino was recovered, largely by the traditional Florentine recourse of buying off Francesco Maria's soldiers.

However, there had been a near-fatal reverse to Medici dynastic hopes. On 29 March the 24-year-old Duke Lorenzo de' Medici, counter-attacking at the head of 10,000 troops paid for by his uncle the Pope, was wounded in the head by a ball from a predecessor of the musket known as an arquebus. He was trepanned and slowly recovered, but was probably also suffering from syphilis.

In April Leo discovered, or – according to his opponents – pretended to discover a plot against his life. The previous year he had ejected Borghese Petrucci, ruler of Siena, thus annoying his brother Cardinal Alfonso Petrucci, who was suspected of being in cahoots

with Francesco Maria della Rovere. On 15 April 1517 Cardinal Petrucci's major-domo, Marcantonio Nini, was arrested. After interrogation under torture, Nini eventually confessed – or was forced to declare – that there had been a conspiracy to murder Leo involving his master, Cardinal Petrucci, and a doctor named Battista da Vercelli.

Cardinal Petrucci was arrested, along with his friend Cardinal Sauli. Leo announced that there had been a plot to poison him and appointed three cardinals to judge the case. Next, Cardinal Raffaele Riario was arrested, interrogated by Cardinal de' Medici and sent to prison in the Castel Sant' Angelo in such a state of terror that he could not walk and had to be carried. (Aretino had bequeathed Riario the elephant Hanno's tusks, 'so that his hunger for the papacy, as intense as that of Tantalus, may be moderated').

Leo then announced that two other cardinals were implicated and proclaimed that he would be merciful if they confessed. Under this pressure, cardinals Soderini and Castellesi admitted their guilt. Riario, Soderini and Castellesi all paid huge fines (150,000 ducats, in Riario's case). Cardinal Petrucci was strangled in his cell; the bit-players Nini and the doctor Vercelli had their flesh ripped from their bodies with red-hot pincers before being hanged from Ponte Sant' Angelo. Cardinal Soderini fled into exile. So, from Leo's point of view, it ended most satisfactorily: his enemies the della Rovere and Soderini were weakened and humiliated while the papal finances gained an extremely useful boost. There would be more cash for projects such as the San Lorenzo façade.

Not surprisingly, there were suspicions that this had all been engineered by the Medici, or at least exaggerated. It was noted that Cardinal Riario was implicated in the Pazzi plot, in which Cardinal de' Medici, Cardinal Giulio de' Medici's father, had been murdered and the Pope's father wounded. However, there is not enough evidence to be sure where the truth lay in this nasty affair.

*

At first Michelangelo did little to supply the wooden model the Pope had wished to see. During the summer of 1517 he remained at Carrara – where he had now spent a year, almost uninterruptedly.

Meanwhile, the foundations for the structure were constructed, 'little by little', because of the difficulties of removing the old underground walls and making strong new arches. June and July went by; Michelangelo intended to return to Florence in August, but both he and his assistant Pietro Urbano fell seriously ill; the artist did not recover until early autumn.

On 31 October 1517 in distant Saxony a monk named Martin Luther fastened ninety-five theses for debate to the door of Wittenberg church. Thesis 86 asked: 'Why does the pope, whose wealth today is

Wooden Model for the Façade of San Lorenzo, autumn 1517.

greater than the wealth of the richest Crassus, build the Basilica of Saint Peter's with the money of poor believers rather than with his own money?' Had Luther known that the Pope was instead spending his own money on a vastly extravagant marble frontage for his family's favoured church, he would scarcely have been less critical.

It was not until the end of the year that Pietro Urbano finally arrived in Rome with the model. He showed it to the Pope and cardinal on 29 December, and it pleased them wonderfully, except that someone remarked – Buoninsegni did not reveal who – that the façade had grown so much that Michelangelo would never finish it in his lifetime:

a prescient remark that applied, as it happened, to almost every one of Michelangelo's large architectural and sculptural ensembles.

It must have been quite a task to transport the model to Rome by mule, if it was the same as the one that is now in the Casa Buonarroti. This is over 9 feet wide and 7 feet tall: an imposing object, handsome and elegantly classical. However, it has caused disappointment even to some passionate admirers of Michelangelo's architecture.

The model is grand but lacking the tension of his later designs. Of course, it is impossible to be definite about a structure that was never built, but this suggests that Michelangelo's design for San Lorenzo was a little dull. The lack of architectural excitement might have been offset by the ten statues of saints that would have gestured commandingly from every storey (there was once another model with wax figures, but this has disappeared). Nevertheless, the model suggests that Michelangelo was still feeling his way as an architect; and that perhaps he was uncharacteristically affected by Leo X's taste for the harmonious and well-mannered.

After seeing the model the Pope and cardinal wanted Michelangelo to come to Rome to discuss it, and this time he came. Over a year after the first oral agreement with the Pope, Michelangelo and he agreed a contract, on 19 January 1518. The total price for the San Lorenzo project had inflated once again, and was now 40,000 ducats, with Michelangelo bearing all expenses and undertaking to complete the whole in eight years. In eighteen months, he had transformed a straightforward, more or less manageable scheme into a feat requiring Herculean effort, enormous expenditure and verging on the utterly unfeasible.

The most daunting aspect of the whole enterprise was that, according to the contract, the façade of San Lorenzo was to be made entirely of the finest marble, from either Carrara or Pietrasanta. This was, of course, the material Michelangelo loved: stone that was, as his faithful assistant mason Michele di Piero di Pippo wrote, 'like the moon reflected in a well'. But making buildings from solid marble was unusual, even in antiquity, except in places such as Athens, where it was the local building stone. And marble was not by any means a conveniently handy material in Florence.

To obtain it, it was necessary first to extract the stone from barely accessible veins high in the mountains, then to slide these pieces of stone weighing tons down the upper slopes on a sledge, or *lizza*. Next the stone had to be transported to the sea by ox-cart, manoeuvred into a ship and sailed to Pisa. After that it was transferred to a barge which carried it up to the highest navigable point of the Arno at Signa, then into another ox-cart for the final journey into Florence. The entire journey was around 93 miles, and often took many months to accomplish.

All this was needed for ordinary-sized slabs of marble, but Michelangelo's design also called for something yet more difficult to quarry and transport. On the lower level of the façade there were to be twelve solid marble columns, each of around 11 *braccia* – or 21 feet – high.

This was hair-raisingly ambitious. It would be hugely demanding even to find unflawed pieces of stone this big, let alone to slide them down the mountain and on and off two boats. The quarrying of monumental columns for grand Roman buildings such as the Pantheon was one of the great achievements of antiquity: a feat that was accomplished by employing the almost unlimited manpower of the Roman Empire. Michelangelo proposed to quarry his materials using an ad hoc labour force of local quarrymen supervised by masons largely recruited from Settignano – and used to dealing with sandstone, not marble.

On 13 March 1518 Buoninsegni sent Michelangelo a letter – somewhat vaguely addressed to Michelangelo 'in Pietrasanta or in Carrara' – relaying the great pleasure with which the cardinal and the Pope had received the news that he was finally going to begin quarrying in the mountains above Pietrasanta, as they had been imploring him to do for a year. This was followed up by another from Cardinal de' Medici himself, expressing his and his cousin the Pope's delight – and their additional pleasure that they would no longer have to exhort him to do this. However, achieving this involved yet a further burden on Michelangelo. He would have to supervise the completion of a road leading up to the quarries, which were sited in the mountains near a little town named Seravezza, north of Pietrasanta.

Michelangelo's life in these years was peripatetic: he moved constantly between Florence, the docks at Pisa and Pietrasanta, Seravezza and Carrara. Between 1516 and 1520, William Wallace has calculated, he made thirty journeys outside Florence and nineteen trips to the quarries. His correspondents sometimes had little idea where to address letters to him (one is headed 'To Michelangelo at Pisa or wherever he may be'). We can picture him on horseback riding across the north Tuscan plain to the coast, up to Pietrasanta and Carrara, down to Pisa.

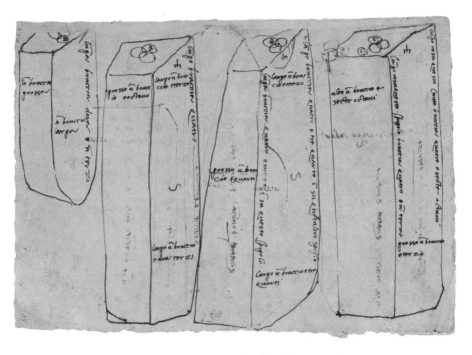

Drawing of Marble Blocks for the Façade of San Lorenzo, 1516–20.

For the next two years Michelangelo was running a far-flung enterprise involving quarrying in two different places and complex transportation by sea, river and land, all of this under conditions in which communication was slow and unreliable. To make his wishes clear to his teams at the various quarries and docks, Michelangelo used highly idiosyncratic drawings.

These are rough representations of the shape of the piece of stone Michelangelo wanted, in shallow perspective with the dimensions

carefully noted. Sometimes Michelangelo's mark of ownership – three intersecting circles – is inscribed on the base. The effect is almost surreal. You get from them a sense of a bulge here, a curve there, of latent possibility: the figure or architectural member that Michelangelo sensed *inside* this block.

Michelangelo's daily life went on as he moved from quarry to port, from Florence to the sea, to the mountains and back. On the reverse of a dry business communication he got from Bernardo Niccolini, Cardinal Medici's agent in Florence, he compiled a whimsical illustrated menu. Two bread rolls, it begins, a pitcher of wine, a herring, tortegli (a variety of ravioli). Beside each description he doodled a drawing: a bulging jug for the wine, a slightly woebegone smoked fish, and so on down the list, so that by the time he had finished Michelangelo had conjured up two different salads, seen from varying angles, two bowls of fennel soup and a small plate of spinach.

It is impossible to say why Michelangelo amused himself in this way, but the menus, if that is what they are, seem to be for two. The other bowl of fennel soup would have been for his assistant Pietro Urbano, to whom he was growing increasingly close.

*

As well as the ambition to create a façade that would be 'a mirror for all Italy', Michelangelo had a business scheme in mind. No sooner had he decided to quarry near Pietrasanta than he began to campaign for a special concession from the Arte della Lana, the wool guild, which in turn controlled the Opera del Duomo. The cathedral works always required supplies of marble. In return for opening up the quarries around Seravezza and supplying marble to the Duomo workmen when required, Michelangelo wanted a lifetime's concession to quarry for his own use.

Hardly had he arrived in Pietrasanta than he began to bombard his brother Buonarroto, who was acting as his representative in Florence, with enquiries about this concession. By 2 April he was already in a state of impatience. He wanted Buonarroto to find out if Jacopo Salviati – banker, brother-in-law of the Pope and a major political figure in Florence – was minded to have it granted. If not, Michelangelo

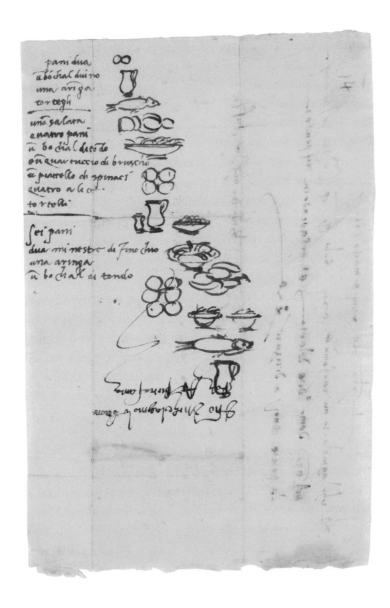

List of Foods with Sketches of Food and Drink, 1517–18.

intimated he might change his mind about quarrying near Pietrasanta. As usual, he was beset by difficulties and saw himself as a victim: 'If the promise made to me is kept I'm prepared to carry on with the enterprise, with its enormous expense and trouble, though as yet without any certainty of success.'

In addition, he wanted control over the route of the extension of the road over a marsh and into the mountains that would have to be constructed so as to move the blocks of marble. And he wanted all this granted, he instructed Buonarroto to explain to Jacopo Salviati, solely out of public-spiritedness: 'In matters of this kind I do not seek my own advantage, but the advantage of my patrons and of my country.' It was simply that he, and he alone, knew where the finest stone was to be found.

A fortnight later he was so agitated that he sent an assistant to wait in Florence until the evening of Thursday 22 April, as Buonarroto had promised it would be ready then. If the concession was not granted by that point, Michelangelo would give up on the quarries near Pietrasanta: 'I shall immediately take horse and go in search of the Cardinal de' Medici and the Pope and shall tell them how I'm placed. And I shall abandon the enterprise here and go back to Carrara, for they implore me to do so, as they would implore Christ.'

Meanwhile, there were constant frustrations. The Carraresi, annoyed by the opening of rival quarries, were bribing the bargemen not to accept Michelangelo's stone. The second lot of barges he had ordered never arrived – more bribery – the masons from Florence whom he had imported knew nothing about marble and hadn't quarried a usable chip of it so far, while costing hundreds of ducats. Understandably, Michelangelo was working himself into a state.

On 18 April he wrote a frantic lament to his brother from Pietrasanta: 'In trying to tame these mountains and to introduce the industry into these parts, I've undertaken to raise the dead . . . Oh cursed a thousand times be the day I left Carrara! It's the cause of my undoing. But I shall soon return there. To-day it is a crime to do right.' In the event, the concession was granted on 22 April.

*

One of the reasons for the delay in granting Michelangelo his wish was that Lorenzo de' Medici could not be consulted, as he was absent from Florence. The young Duke was wedding a French princess, Madeleine de la Tour d'Auvergne. This marriage, a great coup for Medici diplomacy, took place in the Château of Amboise in the Loire Valley – which happened to be where Leonardo da Vinci, who had accepted an offer to join the French court, was now living.

View of the Apuan Alps near Seravezza.

As a gift to the French King, Francis I, on behalf of Lorenzo the Pope, commissioned two paintings from Raphael, one of *St Michael Vanquishing Satan* and the other of *The Holy Family*. Michelangelo heard about these from Sebastiano, who was sorry Michelangelo was not in Rome to deplore them in person: 'I shall not tell you anything else but that they appear to be figures who have been in smoke, or figures of iron that shine, all light and all black.' In other words, they were executed in *sfumato*, the deep shadows and soft shading originated by Leonardo da Vinci and loathed by Michelangelo. 'Think how things are going,' Sebastiano snorted: 'two fine ornaments received by the French!

By mid-May 1518 Michelangelo was high in the mountains at Seravezza and had calmed down a little; he informed Buoninsegni that the quality of marble there had turned out to be excellent, and ended his letter with an apology: 'If in writing to you I haven't written as grammatically as one should, or if I've sometimes missed out the main verb, please forgive me, because I'm troubled with a ringing in my ears, which prevents my thinking as clearly as I'd like.'

It wasn't surprising that his head was buzzing. From being a sculptor-cum-painter Michelangelo had manoeuvred himself into the position of being – in addition – a civil engineer, contractor, transport manager, paymaster and supplier of building materials. In May the first of the giant columns began to be quarried, a lengthy and labour-intensive business that took four months in all. Michelangelo had spent most of August supervising the procedure of moving this massive object from the high slopes. Berto da Filicaia, the overseer of the Opera del Duomo, had helped by lending 200 *braccia* (or 383 feet) of rope, and two large pulleys previously used in building the dome of the cathedral. Michelangelo had had capstans manufactured locally of walnut and a specially large *lizza* to carry the marble. Eleven local men were recruited to help. Some idea of the intractability of what he was undertaking can be gauged from a splendidly understated letter he sent in September from Seravezza to Berto da Filicaia in Florence, who was helping with practical details.

Michelangelo began by announcing, 'things here are going tolerably well.' The extra road was almost finished; little remained to be done: 'That is to say, there are a few boulders, or rather outcrops, to be cut away.' The men who were filling in the marsh were doing so, albeit 'to the worst of their ability'.

With that whisk of sarcasm Michelangelo introduced his major piece of news: 'As to the marbles, I've got the quarried column safely down into the river-bed, fifty *braccia* from the road. It has been a bigger job than I anticipated to sling it down.' Casually, he explained that this operation had not gone smoothly: 'One man had his neck broken and died instantly, and it nearly cost me my life.'

However, Michelangelo ended on a triumphant note: 'The site here

is very rough to quarry and the men very inexperienced in an operation of this kind. A great deal of patience will therefore be needed for some months, until the mountains are tamed and the men trained; then we shall get on faster. It is sufficient that what I have promised I shall perform without fail and shall produce the finest work that has ever been produced in Italy – with God's help.'

That optimism was ill-founded. The marble from which the second column was being excavated turned out to be flawed, so the whole thing had to be re-cut from deeper in the mountain. When this was taken out, it seems it broke. Either Michelangelo's nerves were badly affected by the fatal accident or his health was damaged by the huge effort and disappointments. News soon reached Florence that he had fallen ill, either emotionally or physically.

Jacopo Salviati wrote a letter exhorting Michelangelo to redouble his efforts to create this monument and so bring honour to Florence, himself and his family. Buonarroto's reaction to his brother almost getting killed by a 20-foot cylinder of falling marble was less stoical: 'It seems to me that you must value your person more than a column, the Pope and all the world.' Perhaps Michelangelo took that advice: by early October he was back in Florence.

Meanwhile, Michelangelo had been trying to set up a workshop capable of handling all this marble in Florence. In July 1518 he bought a piece of land on Via Mozza to the north-west of San Lorenzo from the Cathedral Chapter for 300 ducats. However, characteristically, he was unhappy about the price and, equally typically, he raised it immediately with Cardinal de' Medici. He claimed he had been charged 60 ducats more than it was worth, which the chapter said they regretted but they had to stick to the terms for the sale that had been sent by the Pope.

Michelangelo's reaction to that was sharp: 'If the Pope is issuing Bulls granting licence to rob, I beg Your Most Reverend Lordship to get one issued to me too, because I have more need of it than they.' He suggested they should give him an extra bit of land to make up the difference. The plot he had already bought was around an acre, on which he soon erected utilitarian buildings, ready to carve marble on

a massive scale. The cardinal replied to the letter at once, saying that Michelangelo should be charged a fair price, the papal bull notwithstanding. He pointed out that the Pope was ready to accommodate him in everything, and only wanted the work to move forward without pause.

While Michelangelo was giving his full attention to quarrying, engineering works, shipping, barges, mules and all his other practical problems, naturally his other commissions were neglected. A stream of plaintive letters arrived from Metello Vari, wondering what had happened about the statue of the naked *Risen Christ* he had commissioned for Santa Maria sopra Minerva, and also why Michelangelo never wrote back. According to the contract, it was due to be delivered in mid-1518. Hurt, puzzled, persistent, Vari continued to press his case: 'I have I think written you very many letters and have never had a reply to any of them, which surprises me very much.'

Less easy to ignore was the ex-*Gonfaloniere* for life, Piero Soderini. Soderini had commissioned a reliquary and altar for the church of San Silvestro in Rome, to hold the head of St John the Baptist. He had asked Piero Rosselli – the man who had made the scaffolding for the Sistine Chapel ceiling – to construct it.

Michelangelo ended up supplying a design for this, but it was too large for the space, which he hadn't seen. Soderini was disappointed that he couldn't come to Rome to supervise the entire project and add tombs for himself and his wife. Perhaps it was just as well Michelangelo's design was unsuitable, since his warm relations with the Soderini clan were perilous to him. Goro Gheri, a devoted Medici adherent who administered Florence in the absence of Duke Lorenzo, described them as dangerous beasts, 'those accursed Soderini'.

By now, understandably, Cardinal della Rovere was becoming concerned about the tomb of Julius II. The faithful Leonardo Sellaio, looking after Michelangelo's affairs in Rome, had a series of uncomfortable interviews with the cardinal, in which he swore that Michelangelo would soon deliver two new figures.

Sellaio wrote repeatedly, imploring Michelangelo to come up with at least one sculpture and thus confound his enemies. It seemed 'uno gran' maestro' was pouring this poison into the cardinal's ears. Even-

tually, he discovered who this important person was: Jacopo Sansovino. Evidently, he was still furiously vengeful, and seemed to be sowing similar doubts in the mind of the Pope.

Nor was he the only enemy causing trouble. In November Cardinal della Rovere showed Sellaio two letters complaining about Michelangelo from Alberico Malaspina, Marquis of Massa. As lord of the quarries at Carrara, the marquis was infuriated by Michelangelo's opening up a rival operation at Pietrasanta. He insisted he had always tried to help Michelangelo, but that the artist 'always wanted to fight with men and do strange things' (an accusation that had some truth). One of these letters was addressed to the cardinal; the other, more ominously, to the Pope.

Towards the end of December, Michelangelo replied to Leonardo Sellaio, venting a great quantity of pent-up frustration. He appreciated that Sellaio was exhorting him to work for his own good: 'But I must make it clear to you that such exhortations are, nevertheless, so many knife-thrusts, because I'm dying of vexation through my inability to do what I want to do, owing to my ill-luck.' The marble was in boats at Pisa, but couldn't be transported to Florence, because it hadn't rained and the Arno had dried up: 'On this account I am more disgruntled than any man on earth.'

The marble for Metello Vari's *Risen Christ* was sitting in one of the first boats in Pisa. Although he was being pressed, Michelangelo didn't feel like writing back. Even the weather was conspiring against him, preventing the completion of his new premises, almost a small sculpture factory: 'I have an excellent workshop in preparation here, where I shall be able to erect twenty figures at a time. I cannot roof it because there is no wood here in Florence, nor likely to be any until it rains, and I don't believe it will ever rain again from now on, unless to do me some mischief.' Though he didn't say so in the letter, he had been ill again, which added to (and was possibly caused by) his frustrations.

By April 1519 Michelangelo was back in the quarries of Seravezza, supervising the agonizing business of sliding another 20-foot column down the mountain. There was, as he wrote to his favourite assistant, Pietro Urbano, a catastrophe: 'Things have gone very badly. That is to

say, on Saturday morning, having made great preparations, I set about having a column lowered and nothing whatsoever was lacking; but after I had lowered it about fifty *braccia* one of the rings of the tackle attached to the column broke and the column fell into the river in a hundred pieces.'

The fault lay with this ring, which had been forged by one Lazaro, a friend of Michelangelo's foreman, Donato Benti. It had looked strong enough to hold up four columns but, after it broke, it became clear that Lazaro had swindled them by providing a link that was not made of solid iron but a hollow roll of metal 'no thicker than the back of a knife'. Every one of those standing around had been in danger of death, Michelangelo concluded; worse, 'a splendid block was ruined.'

A fortnight later, on 4 May, a larger political disaster occurred. Lorenzo de' Medici, Duke of Urbino, ruler of Florence and main hope of the dynasty, died, aged twenty-six, probably of syphilis[3] complicated by the effects of his old head wound. The timing, from the point of view of the San Lorenzo project, could not have been worse. Without a legitimate Medici heir, the rationale for a triumphant dynastic monument was lacking.

A little after Lorenzo's death the first loads of marble began arriving at Michelangelo's new workshop on Via Mozza. The immense foundations of the façade were ready. After years of deliberation and effort, the actual construction could soon begin. However, it was not to be. Cardinal de' Medici came to Florence after the death of his nephew; before departing on 27 September, he ordered Michelangelo to stop quarrying. As Michelangelo noted in a dry summary of his expenses on the project, written at the end of the following February or in early March: 'The Cardinal, by order of the Pope, told me not to proceed further with the work ... because they said they wished to relieve me of the trouble of transporting the marbles.' The formal ending of his role as a marble magnate came in the spring of 1520. In a *ricordo* written on 10 March Michelangelo noted, 'Now, Pope Leo, perhaps to

3 This terrifying disease was first described in Naples in the aftermath of the French invasion of 1494. It was given its name in a poem written by an Italian doctor in 1530. Sexual promiscuity now carried a more immediate danger than the risk of hell fire.

achieve more quickly the façade of San Lorenzo . . . by agreement liberates me.'

For years, the beautiful pieces of stone, quarried, paid for and slowly transported, continued to pile up in Florence. The façade project was never actually cancelled; it just faded away. Hope lingered for a long while that the works might be restarted. But the mood of the Medici had darkened after the death of Lorenzo, Duke of Urbino. There were doubts, it was rumoured, that Michelangelo could ever finish it without working with other artists, which he resolutely refused to do. And, more fundamentally, the Pope was running out of money. Around the same time, another costly luxury – the weaving of Raphael's tapestries for the Sistine Chapel – was also halted.

In setting out his expenses on the project, as the cardinal asked him to, Michelangelo added a note of pure bitterness to his recitation of costs: 'I am not charging to his account, over and above, the space of three years I have lost over this; I am not charging to his account the fact that I have been ruined over the said work for San Lorenzo; I am not charging to his account the enormous insult [*vitupero grandissimo*] of having been brought here to execute the said work and then of having it taken away from me; and I still do not know why.'

This draft of a letter[4] was written around the time of Michelangelo's forty-fifth birthday. If not yet old by modern standards, Michelangelo was now certainly middle-aged: despite heroic exertions, in the four years since he had left Rome, he had achieved almost nothing. As he later wrote in a poem: 'There's no hurt that's equal to time lost.'

4 One wonders if such an angry missive was ever actually sent.

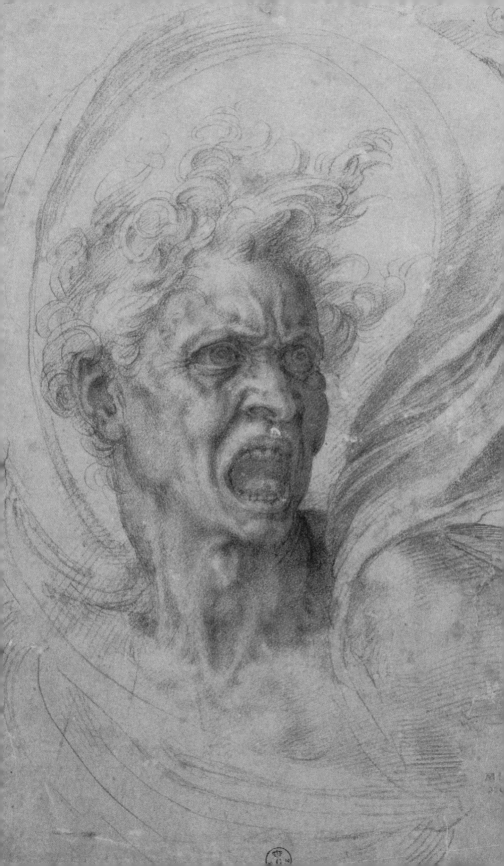

TOMBS

'In such great slavery, such weariness,
and with false concepts, and a soul in danger,
to be where I am, carving things divine'

– Michelangelo, fragment of poem, 1552

'One day in the church of Santa Maria sopra Minerva, one
of the pupils of the painter Annibale Carracci [1560–1609]
asked him what he thought of Michelangelo's sculpture of the
Risen Christ. Carracci answered: "Look well at its beauty,
but to understand it thoroughly you must realize how bodies
were constructed at that time," in this way making fun of
Michelangelo whose style did not imitate nature.'

– Anecdote told by Gianlorenzo Bernini to Paul Fréart
de Chantelou, 1665

There was another death in spring 1520, more unexpected than
that of Lorenzo de' Medici, Duke of Urbino. The agent of
Alfonso d'Este, Duke of Ferrara, visited Raphael's house on
21 March and found him working on paintings that were 'most beau-
tiful'. A fortnight later, on 6 April, Good Friday, the painter was dead
from a sudden fever, aged thirty-seven. It brought the artistic duel
between him and – on the other side – Sebastiano and Michelangelo
to an abrupt conclusion.

*

Throughout 1517 and 1518, Michelangelo had received a stream of
reports from Leonardo Sellaio on the painting Sebastiano was doing

(facing page)
Head Known
as the Damned
Soul (Il
Dannato),
c. 1522–3 (?).

in competition with Raphael: *The Raising of Lazarus*. It was 'a miraculous thing, so that I do not believe it will go to France because there has never been anything like it.' Simultaneously, he and Sebastiano ran down Raphael's work at every opportunity. When the frescoes in the loggia of the Villa Farnesina, commissioned by Agostino Chigi, were unveiled, Leonardo Sellaio thought them a disgrace: 'an offensive thing to a great patron, rather worse than the last Stanza of the Vatican Palace'.

Sebastiano, Michelangelo and Sellaio were in a small minority. As far as most observers were concerned, Raphael went on from one brilliant success to another. Patrons scrambled to acquire his works. Alfonso d'Este, who had been so impressed by the Sistine Chapel ceiling in 1512 that he had not bothered to look at Raphael's frescoes in the Stanza della Segnatura, now sent his agent incessantly to importune the painter from Urbino. Already, he had a work by Giovanni Bellini, doyen of Venetian painters (and Sebastiano's master, according to Vasari); another, by the rising star of art in Venice, Tiziano Vecellio, was on its way. A picture by Raphael would make a splendid addition.

Alfonso never got it, although eventually Raphael offered him the cartoon of the *St Michael* which had been sent to France. *Faute de mieux*, Alfonso accepted it. Raphael simply had too many other commissions from more important clients – unless he was punishing Alfonso for the snub in 1512 when the latter had lingered over the Sistine Chapel ceiling and not bothered to look at Raphael's *Stanze* at all. On one occasion, when he called at Raphael's house, Alfonso's envoy was told he could not see the master as he was busy upstairs, painting Castiglione's portrait. Raphael's projects were endless: besides St Peter's, there were a vast and sumptuous villa in the classical manner intended as the Roman residence of the Medici family, palaces to be designed for the Pope's physician, Jacopo da Brescia, and Giovan Battista Branconio d'Aquila, and another apartment in the Vatican to be frescoed.

It was not surprising that, when Sebastiano exhibited his finished picture of *The Raising of Lazarus* at the Vatican in December 1518, Raphael had not yet even begun his rival altarpiece, *The Transfiguration*. Michelangelo had supplied designs for Sebastiano's painting, too, helping his friend with the almost naked figure of Lazarus, the people gathered around him and – almost certainly – Christ summoning

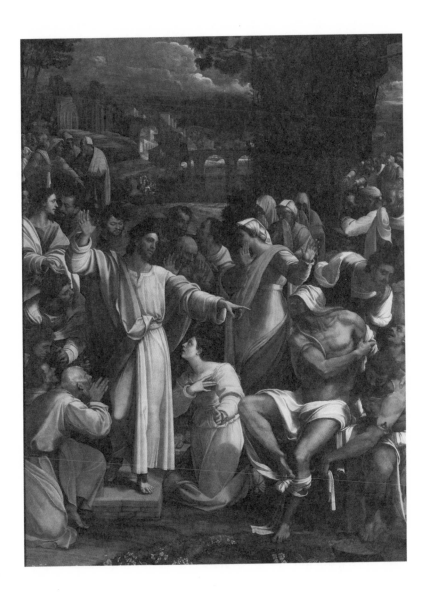

Sebastiano del Piombo, *The Raising of Lazarus*, 1517–19.

Lazarus from the dead with a commanding gesture. The Venetian patrician Marcantonio Michiel saw it and noted in his diary that it was praised by all, including the Pope.

The assistance that Michelangelo gave to Sebastiano was not unprecedented. For example, Leonardo da Vinci had apparently helped Giovanni Francesco Rustici a great deal with his bronze sculptures for the Baptistery in Florence during 1506–11, perhaps as a way of bolstering the prospects of a sculptural rival to Michelangelo. The amount of assistance that Sebastiano had from Michelangelo for a series of major works was, however, unparalleled, and potentially fraught. The Venetian painter, with his meddling, his elaborate compliments, and his schemes, was a complicating factor in Michelangelo's life, one of which he was perhaps beginning to tire.

Possibly, Raphael had shrewdly waited to see what Sebastiano had come up with before starting his own altarpiece. An early study shows that at one point he planned to depict only the Transfiguration itself, but then he added a scene showing the disciples left at the bottom of Mount Tabor who were unable, in the absence of the Messiah, to cure a boy possessed by demons. This gave him more opportunities to demonstrate his painterly brilliance. In the final painting he presented both light – Christ in radiance on the mountain-top – and the confusion and shadows of the drama below. A comparison of Raphael's picture with Sebastiano's suggests that – for one last time – he had done what he did so well: learned from the work of others, assimilated it and transformed it into something of his own.

The composition of the lower part of his *Transfiguration* is much like *The Raising of Lazarus*: an interlocking mesh of extended arms and vehemently pointing fingers. But Raphael's composition was more smoothly integrated and tightly organized: partly because it was all conceived by one mind, rather than a cut-and-paste of a group of figures by Michelangelo into a crowd and landscape invented by Sebastiano.

Raphael gave close attention to *The Transfiguration*, and he was working on it up to the point of his final, sudden illness. Vasari described how he was laid out on a bier in the room where he had been working, the panel hanging above: 'the sight of this living work

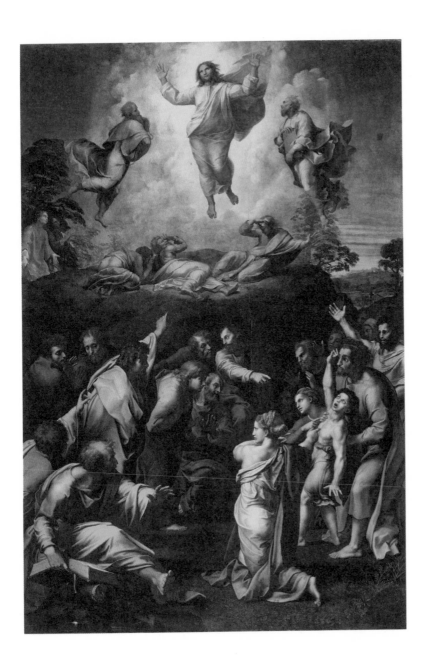

Raphael, *The Transfiguration*, 1518–20.

of art along with his dead body made the hearts of everyone who saw it burst with sorrow.'

Pandolfo Pico della Mirandola wrote to Isabella d'Este, relating how the papal court was 'plunged in the most profound and universal grief for the ruin of those hopes of the greatest things which were expected' from Raphael. Almost blasphemously, he noted that 'The heavens have proclaimed this death by one of those signs which marked the death of Christ, when the rocks were opened.' Walls in the Vatican Palace had cracked, and Leo, weeping bitterly for his favourite artist, had fled.

Raphael's body was carried in procession to the Pantheon – one of the greatest buildings to survive from antiquity had been transformed into the church of Santa Maria Rotonda. According to a contemporary report, one hundred painters accompanied the procession, carrying torches. Raphael's tomb was of unparalleled prominence and splendour for an artist.

Sebastiano was less grief-stricken. Six days after the death of Raphael, he reported baldly to Michelangelo, 'I think you have heard how that poor Raphael of Urbino has died, which I believe may have rather displeased you; and God forgive him.' Then he quickly moved on to announce that he had just hung his *Raising of Lazarus* beside Raphael's *Transfiguration* at the Vatican: 'Today I brought my panel again to the palace where Raphael's can be seen, and I was not ashamed.' Clearly, Sebastiano thought that he had scored a victory, or at least a draw. Others did not agree. The cardinal kept Raphael's picture in Rome as the high altarpiece of San Pietro in Montorio. The *Raising of Lazarus* was sent to Narbonne, where nobody saw it but provincial Frenchmen.

Scarcely was Raphael buried than Sebastiano began a campaign to replace him. The big prize was the last, and largest, of the suite of rooms in the Vatican, the hall that came to be known as the Sala di Costantino. This had been begun by Raphael in 1519, and Sebastiano was desperately keen to grab it from Raphael's leading assistants and heirs, Giulio Romano and Gianfrancesco Penni. To that end he asked Michelangelo to intercede for him with Cardinal Bibbiena, who was apparently in charge of the commission.

The result can scarcely have been what Sebastiano expected. Michelangelo was unwell himself; Pandolfo Pico della Mirandola had

ended his letter by announcing gloomily, 'Yesterday we heard from Florence that Michelangelo was ill.' It was only a few weeks after he had written that bleak and bitter accounting of the San Lorenzo façade and the 'enormous insult' he had received. He was in a black mood, and not about to ask for favours. After a two-month pause he dispatched an elaborately ironic exercise in comic entreaty to Cardinal Bibbiena: 'Monsignor – I beg Your Reverend Lordship not as a friend or servant, since I do not deserve to be either the one or the other, but as a contemptible man, poor and crazy, that you arrange for Sebastiano Veneziano the painter to have some part of the work in the Vatican Palace, now that Raphael is dead.' To indulge the madman in this way might be, he added, a pleasant change, like eating onions instead of capon.

When this strange missive arrived, it did not have the effect that Sebastiano had hoped for. He took it to the cardinal, who told him that the Pope had already given the commission for the great Sala to Raphael's ex-assistants. The cardinal then asked Sebastiano whether he had read Michelangelo's letter; the painter said he hadn't, after which Cardinal Bibbiena laughed a great deal. Subsequently, Sebastiano discovered that Bibbiena had shown the letter to the Pope, and hardly anything else was talked about in the papal palace. Everyone thought it was very funny.

Sebastiano then came up with another idea: Michelangelo should paint the great room himself. Recklessly, he proposed to a papal attendant that his celebrated friend should be given the job, and was told that would indeed be a marvellous idea. Sebastiano then sent a letter to Michelangelo asking what he thought. Michelangelo, as was his habit with unwelcome enquiries, did not reply for a long time.

Undiscouraged, Sebastiano persisted with the project, becoming obsessed, if not slightly unhinged, on the subject (at one point, he suspected that Raphael's pupils were intercepting his mail). His adoration of Michelangelo, together with his determination to find his friend painting commissions he clearly did not want, is one of the most curious episodes in art history. Sebastiano was an example of a great painter who fell – artistically speaking – for an even greater artist, who, as Proust's character Swann remarked of the love of his life, was not even his type.

Sebastiano took to hanging around the Vatican Palace in hope of an audience with Leo X – his access plainly not as good as the late Raphael's. Eventually, after a month, he got one. The resulting conversation – which was quickly relayed to Florence – gave a glimpse of what Leo X really thought of Michelangelo: 'The pope values you,' Sebastiano concluded, 'and when he speaks of you, he seems to discuss one of his brothers, almost with tears in his eyes; because he has told me you were nurtured together, and he shows that he knows you and loves you, but that you frighten everyone, including popes.'

Leo was well aware of Michelangelo's originality and influence as an artist. 'Look at the works of Raphael,' he remarked to Sebastiano, 'who when he saw the works of Michelangelo, immediately abandoned Perugino's style, and as much as he was able, moved closer to that of Michelangelo.' However, there was a qualification: 'He is terrible, as you see; one cannot deal with him.' When Leo said this, Sebastiano defended Michelangelo (or so he told his friend): 'I answered His Holiness that your terribleness never poisoned anyone and that you seem terrible for the love of the importance of the great works you have.'[1]

*

The deaths of Giuliano and Lorenzo de' Medici had blasted the hopes of the family. By the summer of 1519, apart from the Pope and the cardinal, the senior branch of the Medici boasted just one legitimate child: an infant girl named Caterina, born on 13 April; her mother, Madeleine de la Tour d'Auvergne, followed her husband Lorenzo to the grave a fortnight later. No one at that time could have imagined that this female orphan would eventually become one of the most powerful rulers in Europe.

Lorenzo and Giuliano died so young and had such a negligible impact on history that it is easy to forget how much was once expected

1 When Michelangelo heard this, he protested: naturally he did not think of himself as terrible at all, but an innocent victim of ill fortune and bad treatment. Sebastiano was forced to backtrack on the defence he had made. 'I, for my part,' he explained in his next letter, 'do not consider you terrible . . . except in art, that is, the greatest master who ever was. So it seems to me: if I am in error, mine the injury.' This explanation seems to have been accepted.

of them. Machiavelli – who dedicated *The Prince* first to Giuliano, then, after his death, to Lorenzo – had seen in them the best chance for Italy to escape from being a chaotic battleground of foreign armies, as had been its fate since Charles VIII first invaded in 1494.

The minds of the Pope and cardinal began to turn from the triumphant façade of San Lorenzo towards the building of a family mausoleum. One day in June 1519, the month after Lorenzo's death, Cardinal de' Medici outlined the idea to a canon of San Lorenzo named Giovan Battista Figiovanni. He wanted to build a new funerary chapel to contain 'our fathers, and our nephew and brother'. That is, his own father, Giuliano de' Medici, murdered in the Pazzi plot of 1478, and Leo's father, Lorenzo the Magnificent, plus the two princes who had more recently died (also, confusingly, named Lorenzo and Giuliano). He also outlined a second scheme at San Lorenzo: a library to house the family's superb book collection. Nothing was done about this for another five years, but work on the funerary chapel – or New Sacristy – began almost immediately, in November 1519.

Michelangelo was appointed *capomaestro*, for which he was first paid the following June. Initially, however, his role may not have been very exacting nor his ideas particularly daring. The ground plan and exterior walls would have been agreed early on – probably before the cardinal left Florence at the end of September 1519. However, these would not have required a huge amount of thought, because the plan was to build a near-duplicate of Brunelleschi's Old Sacristy on the other side of the church. This contained the tombs of four earlier Medici, including Giovanni, father of Cosimo the Elder.

The outside walls of the new building blended seamlessly with those of the church. Inside, the initial designs by Michelangelo for the architectural members in *pietra serena* – the beautiful grey-green sandstone quarried around Settignano and Fiesole – were different to those of Brunelleschi, but they were still quite conventionally in the idiom of Giuliano da Sangallo and Cronaca.

*

Michelangelo was now settling into his new headquarters in Florence, a big, bare place whose appearance can be imagined from the building

accounts. It had earth floors and windows covered with cheap cloth, but also a touch of refinement in its carved stone window and door frames. Michelangelo bought pulleys to help in the lifting of heavy blocks and paid for a well to be dug. There was probably an outside area, roofed, but open for the storage of marble; in the yard vines were trained up canes – a mark of domesticity. Inside were workbenches on which small models could be made and drawings laid. In the cold months, the interior was heated by a coal fire.

The San Lorenzo façade project was suspended and the New Sacristy was in its early stages, but there was still plenty for Michelangelo to get on with. The marble for the attempt to carve the second version of Metello Vari's *Risen Christ* was in one of the first boats to arrive from Pisa. This tiresome commission was also, evidently, among the first tasks that Michelangelo tackled, because in January 1520 Vari was told the good news that it was almost finished.

There followed, however, a lengthy stand-off. In April Michelangelo wanted the remainder of his fee: 50 ducats. Vari replied that first the *Christ* should be sent to Rome, then the money would immediately be paid. As a result, the *Risen Christ* stayed in Florence. At the end of October Vari agreed to pay the ducats in advance, and the money finally arrived in Florence the following January, a year after the statue was more or less completed. Only after that did the sculpture begin a very slow progress by sea towards Rome. In March Pietro Urbano was sent to Rome to supervise its installation and add the finishing touches. This proved to be a big mistake.

Pietro Urbano from Pistoia – 'who lives with me' – functioned as a secretary and was trusted to carry out business transactions; but he was more than that, and it was obvious that Michelangelo cared about this young man. 'Treat my assistant, Pietro,' he wrote to his brother Buonarroto, 'as you would treat me.' Vasari wrote that Pietro was talented but would 'never exert himself'. The evidence bears this out. Michelangelo was constantly urging him to practise his draughtsmanship; Pietro was full of reasons why he couldn't at that particular moment get on with it.

Michelangelo's concern for him was revealed by the degree of his worry when Pietro was unwell. Between 29 August and 5 September

1519 he spent money on medicine, marzipan and cordial for Pietro, who had fallen ill at Carrara, apparently with dysentery. From Florence he wrote a worried letter, asking him to send a message with some masons: 'I'm anxious, as you were not as well as I should have liked when I left. That's all. Take care of yourself.'

There were, however, doubts in Michelangelo's mind about Pietro's character. While staying with the Buonarroti family, the young man got up to some unspecified kind of mischief. Early in 1521 Michelangelo banished him to his native Pistoia (a place of which he developed a low opinion, writing in a later sonnet that the Pistoiese were 'envious, arrogant and enemies of heaven').

Pietro's final temptation and downfall came a little later, when he was delegated to install the sculpture of *The Risen Christ* in the church of Santa Maria sopra Minerva in Rome. He arrived at the end of March 1521, but the statue itself was delayed. It had reached Santa Severa, on the coast near the mouth of the Tiber, but could not be sent on the final stretch up the river because of bad weather. The wait went on for weeks. At first, Pietro was full of good intentions. He was going to work, either in marble or terracotta, and, as he had promised Michelangelo, he was going to stick to the company of Florentines.

It was two months before the sculpture finally arrived at the port of Rome, the Ripa. Even then Pietro had great trouble in unloading it, 'because they wanted Christ to pay duty to enter Rome'. Michelangelo had left certain fine details – the hair, toes and fingers – to be carved *in situ* (perhaps to avoid damage in transit). When Pietro got the marble to the church, he began work on these, and announced he would finish on 15 August, the Feast of the Assumption. However, on 14 August the tiresome Metello Vari sent Michelangelo bad news. Pietro had suddenly disappeared, and with him had vanished a ring worth 40 ducats, plus a cape and hat.

Sebastiano and another friend of Michelangelo, Giovanni da Reggio, went to inspect *The Risen Christ*. They consulted the sculptor Federigo Frizzi, a pupil of Michelangelo's, who had made the tabernacle for the statue. The consensus was damning: 'I must let you know that all he has worked on is completely disfigured,' wrote Sebastiano, 'and especially he has shortened the right foot, where it's manifest, the

toes have been mutilated; and he has cut short the fingers of the hands.' Frizzi thought the hands now 'look as if they have been made by a confectioner: they do not look made of marble, but as if they had been fashioned by pastry-cooks, they are so clumsy'. Sebastiano thought his infant son would have made a better job of the beard. Frizzi took over the job and repaired the damage.

It was a sad mess. The first few years of the 1520s were a low point for Michelangelo. Not only did the San Lorenzo project founder, but *The Risen Christ*, the only sculpture he had completed in more than half a decade, was not a true success. Even the loyal Leonardo Sellaio plainly had his doubts. The figure, he assured Michelangelo, 'is most successful . . . nevertheless, I have spread it around, where it seemed suitable, that it is not from your hand'.

Perhaps it was because it was a second version, carved with gritted teeth after the first was abandoned because of the flaw in the marble; or, possibly, Michelangelo's creative energies were flagging. But, for whatever reason, *The Risen Christ* is among Michelangelo's least engaging works. It is not exactly a failure, but it lacks the emotional force of his best creations. It is, for a triumphant resurrected saviour, oddly static and a little chilly.

Michelangelo himself seems to have felt guilty about the statue, as he offered to carve a new – third – version for Vari. But, instead, Vari asked for a gift of the first, unfinished sculpture with the black vein across its face. And, against Sellaio's advice, Michelangelo presented this to him. The commission, undertaken out of friendship, was exasperating until the end.

Meanwhile, Pietro Urbano – dismissed by Michelangelo – proceeded to go right off the rails, as Sebastiano detailed: 'Pietro shows a very ugly and malignant spirit after finding himself cast off by you. He does not seem to care for you or anyone alive, but thinks he is a great master. He will soon find out his mistake, for the poor young man will never be able to make statues. He has forgotten all he knew of art.'

He disappeared for 'many days' because he was being pursued by the law: Sebastiano had heard he gambled, chased prostitutes, minced around Rome in velvet shoes and threw money around. The phrase Sebastiano used for Pietro's expeditions in those shoes – '*fa la ninpha*'

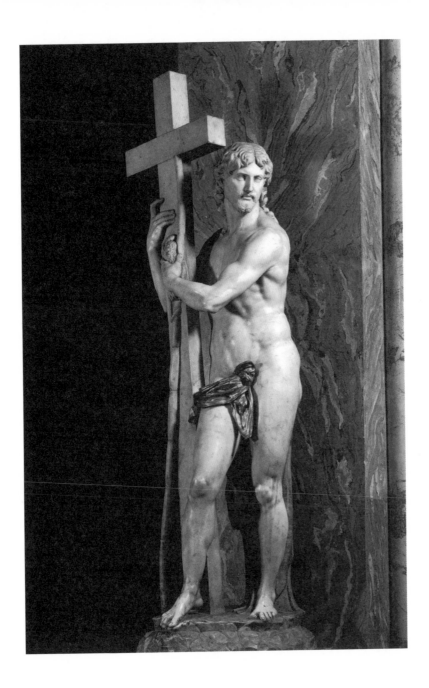

The Risen Christ, 1520–30.

('play the nymph') – suggests effeminacy as well as dissipation. Sebastiano felt sorry for him, as he was still young, even if he had done things that were shocking to recount. Pietro departed for Naples, intending to head on to Spain.

*

After *The Risen Christ* was more or less finished at the beginning of 1520, or even before, Michelangelo presumably turned his attention once more to the question of Pope Julius's tomb. He had been promising to complete some more figures, and the ones most likely to have been undertaken at this time are the four unfinished *Slaves* or *Captives* now in the Accademia in Florence.

Like *The Risen Christ*, these are disappointing, at least by Michelangelo's own, stratospheric standards. It is telling that scholars have been unable to agree on whether they were carved by the artist himself, by assistants, or a mixture of the two. These lumbering, half-formed giants – compared by John Pope-Hennessy to the Wagnerian duo Fafner and Fasolt – belong to a different world from the wonderful *Rebellious* and *Dying Slave* of a few years before. Subsequently, they were placed in the grotto at the Boboli gardens; nowadays, the tour groups mainly march straight past them on the way to *David*. The most finished of these figures, the so-called *Bearded Slave*, appears, as Michelangelo sometimes seemed himself, middle-aged and weary.

If his interest in Julius's tomb was dwindling, as well it might over a decade and a half after the initial idea had filled him with excitement, his interest in the new scheme for a Medici mausoleum was beginning to kindle. The reason why Michelangelo did not go to Rome to install *The Risen Christ* himself – with such disastrous results – was that he was making yet another journey to Carrara to select yet another consignment of marble. This time it was for the tombs of Lorenzo and Giuliano de' Medici.

On 1 December 1521, after a few days' illness, Pope Leo X unexpectedly died of a fever. This development transformed Italian politics. Cardinal Soderini hurried back from exile to Rome, where on 6 December he delivered a speech to his fellow cardinals, thanking God for the death of Pope Leo, attacking the Medici and urging his colleagues to

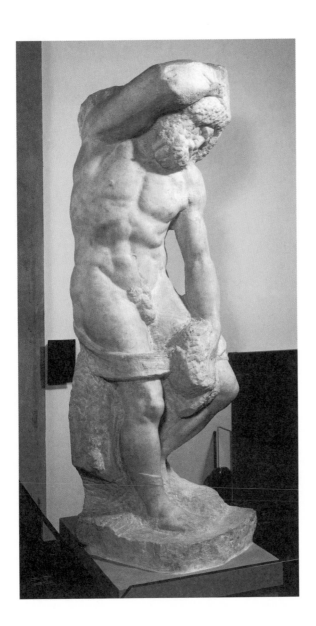

Bearded Slave, 1525–30.

choose a better man as Leo's successor. Obviously, Soderini was still outraged at being accused – unjustly, as he maintained – of involvement in the Petrucci plot to poison Leo four years previously. His outburst, however, was considered to have damaged his own chances of becoming Pope, which otherwise might have been good.

As it was, the conclave that opened on 27 December was one of the most open for centuries. Roman bookmakers made Cardinal Giulio de' Medici the favourite, but narrowly. After the voting began in the Sistine Chapel, it emerged that pro- and anti-Medicean parties were evenly balanced. On 30 December Giulio de' Medici conceded that he could not win and threw his support behind his ally, Cardinal Farnese (who had been one of the three judges appointed to try their fellow cardinals over the Petrucci plot). But neither could Farnese win the necessary two thirds of the votes. After the eighth ballot, he dropped out. Cardinal Wolsey had some support, too, but not enough, as he was considered too young at forty-eight and, furthermore, was English.

The New Year came, and still the cardinals could not agree. On 9 January Cardinal de' Medici made a speech in which he admitted that his own preferred candidates could not win and suggested as a compromise a Dutch cardinal, Adriaan Boeyens from Utrecht. He was sufficiently old at sixty-three, and favoured by the young Holy Roman Emperor Charles V, whose tutor he had been. Perhaps out of exhaustion, the cardinals elected him, the first non-Italian Pope for over a century. The Roman crowd, waiting outside the Vatican, was appalled when the news was announced. That a 'barbarian Dutchman', or, alternatively, 'mad German', should become Pope was regarded as a catastrophe by educated Roman opinion. One satirist even put a 'to rent' sign on the Vatican.

It was weeks before the new Pope, who was acting as imperial viceroy in Spain, heard the news of his election. He took the name Adrian VI, but it was almost eight months before he arrived in Rome to take up his post. He was the first Pope for almost twenty years not to require Michelangelo's services.

*

Although there is plenty of evidence about Michelangelo's emotional life, there is nothing in the record about his sexual activities, if any.

Condivi described Michelangelo's physical constitution as being 'healthy above all by nature and from physical exercise as well as his continence regarding sexual intercourse, as well as food'. Probably, he was being reasonably honest. The kind of sexual pleasure he was attracted to was considered a serious sin, and he was a pious man. It is striking that he avoided investing his money at interest – though probably tempted by this – presumably on the grounds that he disapproved of usury. However, his advice to Calcagni allowed a tiny bit of wriggle room: indulge in sex 'at least as little as you can'. There is a hint that, at the end of 1521, his conscience wavered.

On 14 December Sellaio ended a letter of news with an unexpected warning 'not to go about at night and to abandon practices noxious to the mind and body – so that they may not harm the soul'. (Michelangelo had apparently taken up this habit.) There is no certainty, but it is not hard to guess what Leonardo was talking about. 'Night' was a code word for sodomy in Tuscan comic literature – as is suggested by the title of the magistrates specifically detailed to deal with the problem, the Officers of the Night. According to court records, most encounters between casual male partners took place between sunset, when work ended, and the third or fourth hour after nightfall, the time of curfew, when the taverns closed.

In 1514 Machiavelli wrote a letter to a friend, Francesco Vettori, which contained a light-hearted description of such a nocturnal quest by a friend they had in common, Giuliano Brancacci. In *Forbidden Friends*, his study of same-sex relationships in Renaissance Florence, Michael Rocke paraphrased the letter like this:

> He mapped Brancacci's search through the alleyways around the Borgo Santi Apostoli, past the palace of the Parte Guelfa, across the New Market and into the Piazza della Signoria, the government square, where he came upon a 'little thrush' agreeable to being kissed and having its 'tail-feathers ruffled'. After his successful find, he sealed his conquest, as Machiavelli put it, by thrusting his *uccello* (bird, or penis) into the *carnaiuolo* (game bag, or anus).

If this was the kind of prowling Michelangelo had taken up after dark, he soon found the self-control to stop. On 4 January Sellaio

expressed relief at Michelangelo 'being cured of a malady from which few recover; and yet I am not surprised because few are like you. This is pleasing news. Persevere.' This left little doubt that the 'malady' was a moral one, which could be cured by Michelangelo's remarkable will-power (perhaps assisted by guilt and shame).

Benvenuto Cellini recalled a memory of more decorous nocturnal pursuits of Michelangelo's either in 1517–19 or 1521–3 (Cellini himself having been in Rome during the intervening years). There was a cer-tain youth called Luigi Pulci, who was 'very graceful and extraordinarily handsome' and gifted both as a poet and a musician: 'In Florence it used to be the custom on summer evenings to gather together in the streets; and on those occasions, he used to sing, improvising all the time, among the very best voices. His singing was so lovely that Michelangelo Buonarroti, that superb sculptor and painter, used to rush along for the pleasure of hearing him whenever he knew where he was performing.' This handsome singer was accompanied by Cellini himself, and the goldsmith nicknamed Piloto, who was a close friend of Michelangelo's.[2]

According to Cellini, there was a louche side to Luigi Pulci (whose father had been beheaded for incest). Some while after these Floren-tine musical soirées took place, Luigi turned up in Rome, having 'just left some bishop or other, and . . . riddled with the French pox'. Cellini nursed him back to health, after which he had an affair with the nephew of a cardinal and another with Cellini's mistress, a courtesan named Pantasilea. Cellini attacked him with a sword and, after he had recovered from his wounds, Pulci was killed in a riding accident while showing off on his horse in front of Pantasilea's house.

2 Cellini's father was a renowned performer on the fife, as well as being an engineer and instrument-maker, and Cellini himself performed on the flute and cornet. Piloto, or Giovanni da Baldassare was a close associate of Michelangelo's in the 1520s; among other jobs, Piloto made a ball with seventy-two facets to Michelangelo's design to crown the cupola of the New Sacristy. As we shall see, when Michelangelo fled Flor-ence a second time, Piloto was one of his chosen companions. According to Vasari, the goldsmith was a member of a group of idlers who 'paid more attention to playing jokes and enjoyment' than to working. He was finally killed by a young man he had attacked with 'his slanderous tongue'.

With his good looks and beautiful voice, Pulci was perhaps an example of the kind of person the character Michelangelo refers to so strikingly, as we have seen, in Giannotti's *Dialogues*. Whenever he saw someone with talent or a lively mind, 'I am bound to fall in love with him, and I fall prey to him in such a manner that I am no longer my own.' Pulci, and for that matter Cellini and Piloto, were characters who belonged to an intriguingly bohemian side of Michelangelo's life.

*

The sudden departure of Leo from life altered the political balance of power. From controlling much of central Italy, the Medici were soon reduced to a rather shaky grip on Florence, where Cardinal Giulio de' Medici, now head of the family, withdrew after the papal election. Ominously for Michelangelo, by the late spring of 1522 Francesco Maria della Rovere was back in firm control of Urbino.

Among Florentine republicans, there were hopes that the government of the city might turn more their way. Advocates of a *governo largo* (a broad government) wanted offices opened to a wider range of candidates. At first the cardinal was sympathetic, then – characteristically, since he was a man whose strength and weakness was that he could always see both sides of a question – he changed his mind.

This in turn infuriated some hotheads among the republican idealists who met in the gardens of the Palazzo Rucellai, known as the Orti Oricellari. A few of these devised a plot to assassinate the cardinal on St Zenobius's Day, 25 May, in the Duomo: the very place where his father, Giuliano, had been murdered forty-four years before.

Unfortunately for the conspirators, a French courier was caught carrying messages between exiled dissidents, tortured and – apparently – revealed the details. Several of the Soderini were implicated. Two younger members of the family fled into exile. The ex-*Gonfaloniere*, friend and supporter of Michelangelo's, Piero Soderini – already deposed when the Medici returned to Florence in 1512 – had his property confiscated and his memory damned. He died shortly afterwards, in early June. Cardinal Soderini, whose ecclesiastical post gave him immunity, was also accused of involvement. Two young intellectuals from the Orti Oricellari, Jacopo da Diacceto and Luigi Alamanni, were executed.

What Machiavelli thought of this is not recorded. He had been a regular at the soirées in the gardens; indeed, his greatest work, *The Discourses on Livy*, was inspired by those meetings. Machiavelli, however, took a dim view of conspiracies. He agreed with Tacitus that men 'have to respect the past but submit to the present, and while they should be desirous of having good princes, should put up with them of whatever sort they may turn out to be'. Those who acted otherwise generally brought 'disaster both upon themselves and upon their country'.

Michelangelo must also have had complicated feelings about these events. Both Piero Soderini and his brother the cardinal had treated him with kindness.[3]

For the time being, however, he was obliged to put up with the prince he had. And, as a patron, there was much to be said for Cardinal Giulio de' Medici. Michelangelo's greatest achievements in late middle age – above all, his blossoming into a great architect – were the direct result of an association so close that the cardinal almost counted as a collaborator.

His initial idea for the tomb in the new Medici chapel was a reprise in miniature of his first idea for the tomb of Julius II: a freestanding monument in the centre of the chapel. However, the cardinal objected that it was hard to see how such a tomb could be large enough to provide a monument for four separate, important individuals and also leave sufficient space in what was to be only a moderate-sized room. So, after one more attempt at a freestanding tomb, Michelangelo started thinking about wall monuments.

The basic design of at least the two tombs of the younger Medici – Lorenzo, Duke of Urbino, and Giuliano, Duke of Nemours, who were known as the *Capitani* – must have been, however approximately, decided by April 1521, because Michelangelo then went again to Carrara to supervise the quarrying of still more stone.

The real design problem, however, lay in the third tomb, which, thanks to more deaths, wars and political revolutions that were to

3 The plotters' agent in Rome, Battista della Porta, was a close associate of Michelangelo's half a decade later; so, too, possibly, was the poet Luigi Alamanni, cousin and namesake of the one who was executed, who fled to France.

come, was never to be built. One of the chapel's four walls was occupied by the altar; if two of the other walls contained tombs for the *Capitani*, then the earlier Lorenzo and Giuliano – known as the *Magnifici* – would have to share one monument. Michelangelo, however, had set a division of the other two tombs into three sections, or bays. This suited individual tombs well: a single sarcophagus in the centre, with effigy above, other elements arranged symmetrically around – as can be seen in the tombs that were actually completed (or, at least, as we shall see, semi-completed).

However, three into two won't go. Two sarcophagi and two funerary sculptures were extremely tricky to integrate into a tripartite design. Yet a flurry of studies shows Michelangelo attempting to do just that. As you look from one to another, the elements – pilasters, sarcophagi, columns, volutes – morph and recombine. The sheer fecundity of Michelangelo's ideas is astonishing: not just one or two solutions but a shape-shifting shower of them.

This was just the kind of design problem the cardinal relished. Benvenuto Cellini described an occasion, years later, after he had become Pope and wanted a morse (or clasp) for his cape about the size of a small plate. This was to have a figure of God the Father on it and, in the centre, a huge and beautiful diamond. Many other artists produced designs, all of them doing the obvious thing and putting this jewel in the middle of God the Father's chest.

'The Pope, whose judgement was very sound, saw what had happened', and after looking at some sketches, threw the others aside and asked to look at Cellini's model: 'So I can see if you've made the same mistake as they have.' But Cellini had come up with a brilliantly unorthodox solution. He had made the diamond into a throne, held aloft by cherubs, on which God sat, twisting so his legs were to one side but with his face and upper body facing outwards. When the Pope saw it, his eyes seemed to light up and he cried out, 'You wouldn't have done it any other way, even if you were my very self.'

Those were revealing words. Giulio de' Medici thought like an artist. While his cousin, Leo X, preferred elegantly good-mannered classical architecture, he relished novelty and originality. There are numerous descriptions in letters of the delight he found in Michelangelo's

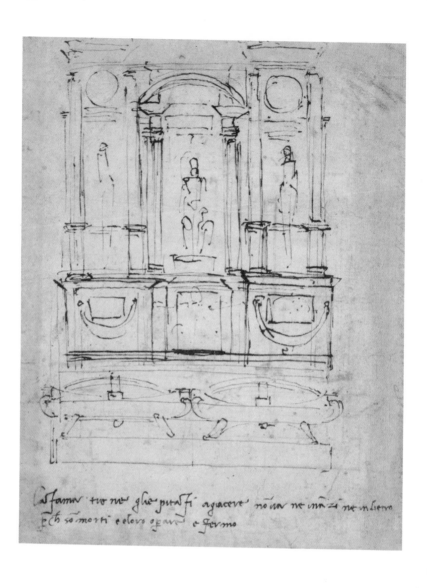

Study for Double Tomb for the Medici Tombs in the New
Sacristy, c. 1521. This is one of a number of ideas
Michelangelo sketched for the never executed tomb
of Lorenzo the Magnificent and his assassinated
brother, Giuliano.

architectural inventions over the coming years and the astonishingly close interest he took in the details of such things as window frames and ceilings. There is no record of what passed between him and Michelangelo during the long months in 1522 that he spent in Florence, awaiting the arrival of the new Pope, but it is hard to believe that there were not many audiences such as Cellini described, in which he inspected and discussed Michelangelo's designs, spurring the artist on to greater boldness.

As Michelangelo struggled with the conundrum of the third tomb, he began to change into an architect of extraordinary audacity. He started to treat the architectural vocabulary of cornices, capitals and triglyphs with the same familiarity as the human body: as something he could recompose and reinvent according to his imagination.

*

In the summer of 1522 the nine years allotted to Michelangelo to complete Julius's tomb were up. The agents of the della Rovere lost little time in preparing a legal arquebus to put to Michelangelo's head.

The new Pope, Adrian VI, reached Rome in the late summer. Evidently, he was persuaded that it was scandalous that one of his predecessor's tombs was still uncompleted almost a decade after his death. The following spring a *motu proprio* – that is, a document expressing the Pope's wishes, 'on his own impulse' – was drawn up. Michelangelo was either to produce the tomb or repay the money. The sum that the executors named the following year was 8,000 ducats. This was, as it happened, a little more than the total value of Michelangelo's property portfolio. If Michelangelo had to make a refund, he would lose all the wealth he had so carefully built up.

The power of the della Rovere was ascendant, and their head was Duke Francesco Maria, now back in control of Urbino, and a man who had – like Michelangelo – suffered an enormous insult at the hands of Leo X and the Medici. Cardinal della Rovere, with whom Michelangelo had mainly dealt over the tomb, had died in September 1520. The other executor of Julius's will was Lorenzo Pucci, now Cardinal Santi Quattro – who had been, previously, the papal treasurer with whom Michelangelo had had dealings over the payments for the Sistine Chapel ceiling.

Aretino had bequeathed Cardinal Santi Quattro, an ecclesiastical accountant and canon lawyer, the jaws of the elephant Hanno, 'so that he can devour more readily all of Christ's revenues'. According to the Florentine politician and historian Francesco Guicciardini, it was Santi Quattro who had suggested to Leo X that the building of St Peter's could be conveniently funded by the sale of indulgences (thus inadvertently triggering the Reformation).[4] Pope Adrian accused Santi Quattro of embezzling money from the very same indulgences, but Cardinal Giulio de' Medici intervened to save him.

Cardinal de' Medici could be a powerful protector for Michelangelo too; indeed, before long he was effective in reining Santi Quattro in. However, there was a catch: the cardinal would preserve him from the consequences of not completing the monument to Pope Julius, but only if Michelangelo worked on his own projects. And, of course, it was these projects – the Medici tombs, the façade of San Lorenzo, the library of San Lorenzo – that had stopped Michelangelo concentrating on Julius's tomb in the first place.

*

After Michelangelo made Florence his base, and especially after the San Lorenzo façade project was suspended and his most intensive phases of quarrying came to an end, friction between him and the other Buonarroti increased.

At the end of February or early March 1521 there was a fraught dispute. Michelangelo angrily summoned his father from Settignano, infuriated by the fact that Lodovico had been complaining his son had turned him out of the house. As usual, Michelangelo protested that he was the victim: 'Never to this day, since the day I was born, has it ever occurred to me to do anything, either great or small, opposed to your interest; and all the toils and troubles I've continually endured, I've endured for your sake.' How could Lodovico say that Michelangelo had turned him out?'This is the last straw, added to the worries I have about other things, all of which I endure for your sake.' He begged his father 'for the love of God, and not

4 Santi Quattro also later handled the question of the divorce of King Henry VIII of England. Leo X owed him 150,000 ducats when he died.

for my sake' to come down to Florence from Settignano and have the matter out. It seems that meeting did not go well. Ludovico added a resentful note at the end of Michelangelo's letter: Michelangelo had made him come to Florence, then – presumably after more argument – had driven him away and hit him several times. This was not at all the way that Florentine fathers were supposed to be treated by their sons.

In the summer of 1523 another almighty Buonarroti family row came to a head. Perhaps because Lodovico Buonarroti was now nearly eighty and, as he often observed, approaching death (in fact, he lived for another eight years), Michelangelo decided to get the question of the family finances sorted out. This question was arbitrated by two rela-tions, who proposed that in exchange for waiving debts and guaranteeing the inheritance of Gismondo, his youngest brother, Michelangelo should become the legal owner of the family villa at Settignano, with Lodovico retaining use of house and property while he was alive. It was a reasonably fair arrangement, but the Buonarroti hated it. Lodovico, never particularly rational, and now highly cantankerous, concluded that he was being deprived of all his property and thrown on to the street. He threatened to sue Michelangelo, who responded with fury.

For the first time in a correspondence of twenty-seven years, he began his reply not with 'Dearest Father' but, baldly, 'Lodovico'. His father's accusations, he protested, were killing him: 'If my existence is a cause of annoyance to you, you have found the way to remedy it . . . say what you like about me; but don't write to me any more, because you prevent me from working.'

He ended on an ominous note: 'Take care of yourself, and beware of those of whom you must beware. For man only dies once, and does not return to put right what he has done amiss. Even in a matter like this you have delayed until the hour of death. May God help you.'

In the aftermath of this falling-out, all the rest of the family moved out of the houses Michelangelo had bought on Via Ghibellina. At the beginning of August Lodovico's brother-in-law, Raffaello Ubal-dino, reported two encounters he had had with Michelangelo. The artist expressed great displeasure at being alone in this way; Ubaldino summarized his feeling in one statement: 'I don't count myself as having a father or brothers or anyone else in the world for me.'

Michelangelo's mood was melancholy. A strange letter to a new friend, Giovanni Battista Fattucci, a Florentine priest attached to the Duomo, complained about a tailor Fattucci had recommended. 'He never let me try on the doublet, which he could perhaps have altered and made to fit me' (as it was, it was tight across the chest). Michelangelo dated the letter, 'At the eleventh hour, each one of which seems to me a year'. At the bottom, he wrote, 'Your most faithful sculptor in Via Mozza near the Canto all' – and he put a little sketch of a millstone, a *macina*.

The place in question – 'Millstone Corner' – was indeed nearby. But Michelangelo must have been referring to an idiom: to be at the millstones – meaning to be in distress. In July 1523 he wrote that although he had a great task to perform – whether he meant the tomb of Julius or the Medici tombs is not clear – he doubted his ability to do it: 'I'm old and unfit; because if I work one day I have to rest for four in consequence.' He was forty-eight.

In reality, he was not utterly solitary. He had added a new member to his household, a seventeen-year-old youth named Antonio Mini, who more or less replaced Pietro Urbano. And by the beginning of 1522 another young man had entered his life, a nineteen-year-old named Gherardo Perini, who was more socially elevated than Michelangelo's assistants. Perini was, as Vasari put it, 'a Florentine gentleman', who was Michelangelo's great friend. He was no assistant, nor a louche singer such as Luigi Pulci, but a youthful gentleman: a type of person for whom Michelangelo would fall again, and more heavily, in the years ahead.

On 31 January 1522 Perini sent a breathlessly enthusiastic message to Michelangelo, suggesting they had not known each other long. He was and always would be ready to offer any service and hoped soon to see him again and know him better. To this, Michelangelo sent a reply to 'the Prudent Young Man, Gherardo Perini, in Pesaro'.

All the young Gherardo's friends, Michelangelo wrote, were delighted to hear that the young man was well, but, he continued coyly, particularly 'those who you know are especially fond of you'. He hoped soon to satisfy himself about every detail of Gherardo's well-being by seeing him in person, 'because it is a matter of concern to me'. He ended, sounding a little distrait, 'On the I know not what day – of February, according to my servant, Your poor and ever faithful friend, Michelangelo.'

The terms were different from those in which he had addressed Pietro Urbano – flowery, even courtly – and instead of presenting Gherardo with a somewhat prosaic gift of stockings, as he had Pietro, he gave him works of art and – almost certainly – poems.

Vasari related how Michelangelo gave him drawings, among them 'some heads in black chalk, which are divine'. Three of these survive,[5] one of which bears a short personal message: 'Gherardo, today I have not been able to come.' This suggests that the drawing might have been a graceful apology for a missed appointment, the words jotted at the bottom before an assistant took it to Perini.

Michelangelo was not the first artist to give drawings as presents, although it was quite a new practice, as the notion of a drawing as an independent work of art, rather than a utilitarian part of a painter's working process, was itself novel. However, Michelangelo's were unusual in their intimate, personal quality. He made a present of a fragment of his imagination.

Another sheet, with Perini's name written at the top, is of a male head shouting in some violent emotion, the sinews of the neck standing out, the mouth wide open, the hair wildly waving in the wind like the waves in a stormy sea, a cloak swirling around the figure's head. He has something of the look of the warriors in Leonardo's *Battle of Anghiari*, possessed by homicidal rage, but he does not seem to be a soldier. The names this image has acquired, 'Fury', or '*Il dannato*' ('the Damned Soul'), make sense. It is hard not to see it as a symbolic, presumably unconscious, self-portrait: Michelangelo in a mood of passionate vehemence.

On the back of a letter from a fellow painter – Giovanni da Udine, an ex-associate of Raphael – dated Easter 1522, Michelangelo jotted down a poem. It is perhaps written with Gherardo in mind: 'The soul tries a thousand remedies in vain;/Since I was captured, it's been struggling/In vain to get back on its earlier road.' Another poem, written on a sketch for the Medici tombs, imagines the writer as a fish on a line, pulled heavenwards by the sight of the beloved: 'I see I'm yours, and from afar I'm called to draw nearer to that heaven whence I come, and with your beauties as bait.'

5 In the view of some scholars, these are copies of the originals.

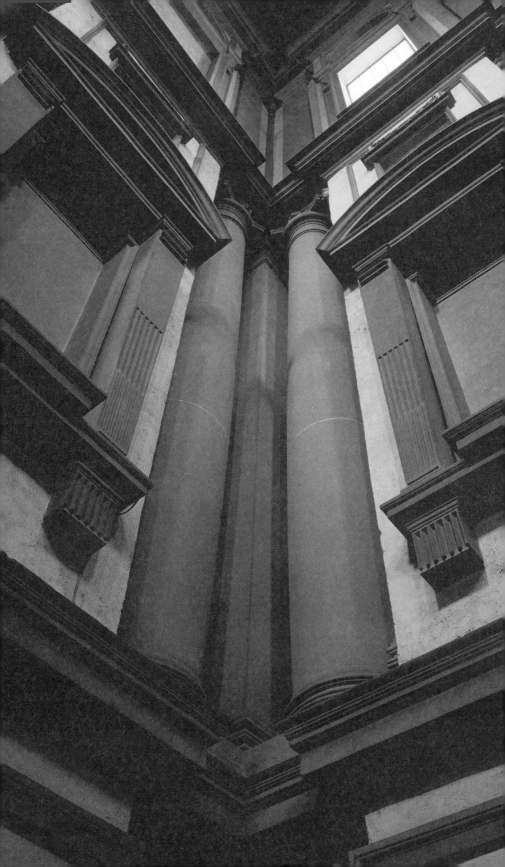

NEW FANTASIES

*'All artists are under a great and permanent obligation
to Michelangelo, seeing that he broke the bonds and
chains that had previously confined them to the
creation of traditional forms.'*

– Giorgio Vasari, 1568

P ope Adrian VI's reign was short – blessedly so, as far as many
Romans were concerned. He arrived in Rome only at the end
of August 1522, and died after a brief illness on 14 September
1523. As was commonly the case with deaths of prominent people in
Italy at that time, poison was suspected. The Dutch Pope was certainly
unpopular in literary and artistic circles. He was reported to have
described the *Laocoön* as 'the idols of the ancients' and there were fears
that he would have the great antique sculptures of the city burnt to
make lime to build St Peter's.

According to Vasari, the Pope intended to remove Michelangelo's
frescoes from the Sistine Chapel ceiling, calling them 'a bath house of
nudes'. If so, he was by no means the last to compare Michelangelo's
work to a *stufa*, or bathhouse – which was a place of public nakedness
but also of sexual assignation and casual encounter.

The conclave to choose his successor opened on 1 October. Like the
previous papal election, it was sharply divided not only, as conclaves
usually were, between adherents of powerful European monarchs but
also between supporters and opponents of the Medici. Voting began
on 6 October, and went on and on. Roman bookmakers gave odds of
six to one against a Pope being elected in October; but those who took

(facing page)
The vestibule of
the Laurentian
Library,
c. 1526–34.

bets at eight to ten that the conclave would not even end in November lost badly.

The impasse was finally broken in the third week of the month when the French faction put forward Cardinal Orsini as their candidate. Cardinal Colonna, who commanded four votes, violently hated Cardinal Giulio de' Medici, but he hated the Orsini, traditional foes of his family, even more. After that, Medici quickly pulled ahead, and became Pope on 18 November. He took the name Clement VII. It was an almost direct succession from his cousin Leo, with only a short interregnum between two Medici popes.

Clement was another youthful pope, at only forty-five, and considered the handsomest man ever to sit on the throne of St Peter (not a hard contest to win). However, he became Pope with an almost empty treasury, a Church in the process of splitting and the political situation that had faced his predecessors – namely that Italy was the battlefield in a conflict between rival superpowers – more daunting than ever. A fortnight later, Michelangelo, writing to a stone-cutter who was supervising quarrying for him in Carrara, expressed uncharacteristically open satisfaction with this result: 'You will have heard that Medici is made Pope, which I think will delight everyone. I expect, for this reason, that as far as art is concerned many things will be executed here. Therefore work well and faithfully, so as to gain honour.'

He was right. The election of a second Medici Pope unblocked the financing of the funerary chapel at San Lorenzo. Work had been partially suspended – though quarrying had continued – but soon after he became Pope, Clement began to drive on the project from Rome with urgency. Early in 1524 intensive work started in the interior of the chapel. In April Michelangelo listed twenty-three *scarpellini* on site. The numbers fluctuated, dropping in the winter months; but even so this was stone-carving on a light-industrial scale.

For the first time, Michelangelo was presiding over a huge team of stone-cutters, some of them sculptors in their own right, and many of them old friends and neighbours. William Wallace has calculated that, of the stone-carvers at San Lorenzo whose homes can be discovered, 94 per cent were from Fiesole or Settignano – overwhelmingly

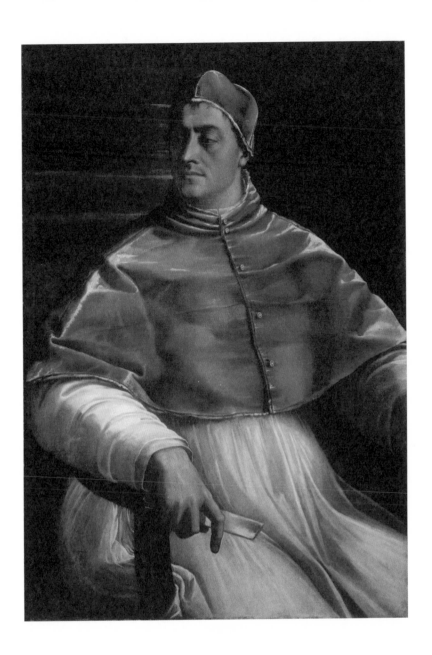

Sebastiano del Piombo, *Pope Clement VII
without Beard*, before 1527.

from the latter – and many from a handful of families: five Ferrucci from Fiesole, seven Cioli, eight Fancelli, five Lucchesino. One of the masons who worked at San Lorenzo was Bernardo Basso, son of Piero Basso, the handyman and farm-worker on the ancestral Buonarroti farm at Settignano,whose mother was perhaps Michelangelo's wet nurse. He had obviously been returned to favour after being dismissed from the Roman workshop.

At Settignano, Michelangelo was by now something approaching lord of the manor. By this stage he owned property in the area worth 3,313 florins – more than the Medici lands at Poggio a Caiano were valued at in 1510 (and he had bought as much again elsewhere).

Moreover, there was an overlap between Michelangelo's role as architect and country landowner. He handed out (and sold) grain to his assistants and rented out houses to them. Thus, as always, Michelangelo's position was paradoxical. He was a landed gentleman, related, as he now believed, to the Count of Canossa, while simultaneously being in charge of large building projects and working with mallet and chisels with his own hands.

The masons and assistants were often identified by nicknames: the Friar, the Godfather, Lefty, the Chicken, Anti-Christ, the Porcupine. They sound like the jokey, cheery bunch you would be likely to find on any building site. What Michelangelo did not do, and it seems resolutely resisted doing, was to take on anyone who even approached equal status with him: another master sculptor. Andrea Sansovino, his old rival at the time of the commission for *David*, wrote a very cordial letter at the beginning of March, offering his services as a 'most faithful brother'. He had talked to the Pope at Christmas, and Clement had said that he would be very happy for Sansovino to help at San Lorenzo if Michelangelo liked the idea – but it seemed he didn't. Sansovino wrote again, but nothing came of the suggestion.

Michelangelo was working with a small army of collaborators, not as Raphael had – orchestrating a repertory company of brilliant, individual talents – but finding ways to ensure the workforce carried out his ideas almost as precisely as if he had been holding the tools himself. At the beginning of 1524 Michelangelo made a full-scale

wooden model of the architectural framework of one ducal tomb to provide a detailed guide for the marble-cutters who would carve it. He also made templates in tin and cut profiles of mouldings out of paper to make sure that the *scarpellini* followed his designs to the millimetre.

Michelangelo's obsessiveness can be seen in his voluminous *ricordi* for this period in which each nail, piece of wood and pound of plaster was carefully noted, with its cost, and – until the job was finally re-allocated to someone more suitable – each workman, what work they had done and what they were paid for it (he had listed 104 names by June 1525).

In 1524, Michelangelo moved into a new house, rented for him by Clement's agents. It was in Via dell' Ariento, just behind the church of San Lorenzo. He was now effectively living on the job, and with him a little household consisting of Antonio Mini (the replacement for Pietro Urbano), also Niccolò da Pescia – another member of the household whose role was unclear: he 'lives with me as part of my household' – and a housekeeper, Mona Agniola.

We can imagine his movements during a typical day in July with the help of a note he sent to his capable *capomaestro*, Meo delle Chorte – another mason from Settignano. Around the middle of the month he wrote to him to make an appointment for the next day to inspect a batch of marble stacked outside the church. He asked Meo to meet him in the Piazza San Lorenzo early so they could examine two pieces of marble for flaws, 'before we are bothered by the sun, so that we can move them inside and you can leave'.

Michelangelo himself would not have left, but perhaps gone inside to inspect the work being done inside the sacristy[1] – and then

1 In the 1970s an extraordinary series of working drawings was discovered on the walls of the altar chapel in the New Sacristy at San Lorenzo, including two full-scale ones of windows for the Laurentian Library obviously intended for the craftsmen who would make wooden models of the mouldings. The ninety-seven architectural sketches show him, in the words of Caroline Elam, 'obsessively pursuing' the perfect profile of such things as balusters, tomb lids and cornices. Over a hundred more figurative images, many in a crypt, are not generally attributed to Michelangelo.

continued, probably back in his workshop on Via Mozza, drawing, carving and modelling in wax and clay until late at night. His habit, always, was to sleep little and work much.

As usual, he had a huge amount to do. Michelangelo spent seven months of 1524 making full-size clay models of the sculptures for the Medici tombs. These were to test the figures' poses and relations to each other and to the architecture.

He had devised a design as complex as the one for his other, earlier tomb, the one for Pope Julius. It was to have included not only the figures that we see today, but also river gods reclining on the ground below the tombs of the two younger Medici dead: Lorenzo II, so briefly Duke of Urbino, and Giuliano, Duke of Nemours. Other figures would have represented heaven and earth and the message would have been, presumably, that the whole world mourned these princes – including air, water, and even time itself.

Of all this elaborate conception, only the main parts of the tombs of the two younger Medici – including their own effigies, plus the times of day – were eventually carved: though enough to secure lasting attention for these otherwise historically insignificant individuals. The four rivers were not even started, although part of a clay model for one survives. In addition, three statues were made for the third tomb, that of the older Lorenzo and his brother Giuliano, but none of the architectural framework. The inexorable march of time, bringing with it more deaths and deadly events, stopped the project well before completion.

Not surprisingly, given his character, there were strains between Michelangelo and his subordinates. In a long grumble written on 26 January 1524, just as the work in the chapel went into top gear, Michelangelo described his problems with underlings:

'It is characteristic of the poor ingrate that if you assist him in his time of need, he says you can well afford it, whatever you give him. If you put him into some job in order to do him a kindness, he always says that you were forced to do so, and that you put him into it because you did not know how to do it yourself.'

The ungrateful underling then:

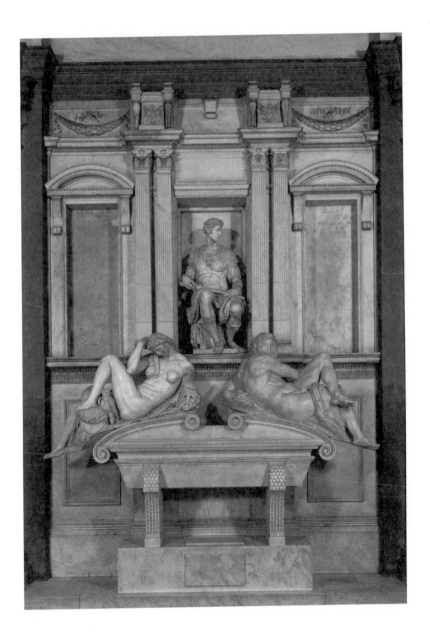

Tomb of Giuliano de' Medici, Duke of Nemours, 1524–34.

waits until his benefactor happens to make some mistake publicly, and then takes this opportunity of speaking ill of him and being believed. This is what has always happened in my case. For no-one has ever had dealings with me, I mean workmen, for whom I have not wholeheartedly done my best. Yet because they say they find me in some way strange and obsessed [having some 'bizarria o pazzia'], which harms no-one but myself, they presume to speak ill of me and to abuse me.

Clement was concerned by Michelangelo's determination to micro-manage every detail. With Christendom falling apart, the papacy in crisis and the political landscape of Italy in violent turmoil, he devoted a surprising amount of time to fretting about his favourite artist. 'Beg Michelangelo to take on help,' he instructed one of the artist's friends, the priest Fattucci, 'for two reasons: first because one person cannot do everything, second because we ourselves shall only live for a little time.'

However, Michelangelo's tight grasp of details brought trium-phantly successful results: it can be seen in the superb clarity, precision and elegance of the carving in both chapel and library. Only a genius who was also a control freak could get such results.

The tombs are effectively a sculptural whole, both the architectural parts and the sculpted figures. Michelangelo's architectural imagin-ation had taken wing. A transformation occurred between the two phases of building the New Sacristy (or Medici Chapel). When he started the project in 1520/21, he was a follower of the Florentine idiom of Brunelleschi and Giuliano da Sangallo; by the time work began at a feverish pace in early 1524, he was a revolutionary.

The architectural forms Michelangelo invented in the second part of the design – the tombs and surrounding elements, which were carved out of marble, not *pietra serena* – were so radical that Vasari, writing a quarter of a century later, still didn't know quite what to make of them. On the one hand he found them seductively attractive, on the other disturbingly disrespectful of the venerable rules of clas-sical architecture. He praised Michelangelo's own designs, while accusing those who imitated them of 'fantastic ornamentation con-taining more of the grotesque than of rule or reason'.

The breakthrough has been pinpointed by the architectural historian Caroline Elam: it occurred in the windows in the third storey of the interior of the sacristy. These were the last part of the *pietra serena* architectural framework to be put in place, because they were the highest. Of the visitors to the chapel today – a fraction of the tens of millions streaming into the Sistine Chapel – perhaps few are likely to glance up at these openings. Yet these windows contain, in embryo, the potential of not just one future style, but two. In their wilful, witty breaking of the classical rules is the essence of Mannerist architecture. Beyond that, they lead towards the Baroque of a century later. Michelangelo's later architecture was a point of departure for Borromini, most gifted and audacious architect of the mid-seventeenth century, whose style influenced further generations of architects in northern Italy, Austria and southern Germany.

The most radical thing about these windows is that their sides are not four-square but converge at an oblique angle. In other words, they are *dynamic*: they strain to link the lower part of the chapel with the coffering of the dome, the segments of which shrink as they get closer to the centre. The whole upper part of the interior seems to flex and contract like a muscle.

*

After he became Pope, Clement never returned to Florence, but his interest in the projects at San Lorenzo remained intense. For the most part, his comments and instructions were relayed either by the priest Fattucci, or by Jacopo Salviati, married to one of Lorenzo the Magnificent's daughters and, apart from Clement, the last adult male in the main branch of the family. It was acceptable for a cardinal to communicate directly with an artist, but not for the Pope, spiritual ruler of the world. On occasions, however, artist and pontiff broke through that convention.

At the beginning of 1525 Michelangelo wrote a letter directly to Clement. It began apologetically. However, quickly, Michelangelo lapsed into sarcasm. He was prompted to write by yet more frustrations in the supply of stone and – typically – would have liked to take charge of it himself: 'I am certain, idle and unreasonable though I am,

that had I been left to carry on as I began, all the marbles for the said work would be in Florence today.' That 'idle and unreasonable though I am' hinted at the intimacy of two middle-aged men, each of whom knew the other very well.

On 23 December 1525 Clement took the extraordinary step of penning a direct message to Michelangelo himself. It was a post-script to a letter written on his behalf by a secretary (who added a startled confirmation that His Holiness had personally written this passage):

> You know that popes do not live long, and we could not wish more than we do to see or at least to know that the chapel with the tombs of our family and also the library are finished. Therefore, we commend the one and the other to you: meanwhile we will bring ourselves (as you once said) to a decent patience, praying God to give you the courage to carry everything forward. Never doubt that you will lack either work or reward while we live.

It was signed with a capital 'I' for Iulius, or Giulio, and written in the intimate 'tu' form. Even more of a hint at the shared history that existed between the two men, under all the layers of protocol, is that 'as you once said', and after it a mild rebuke that the Pope had remembered and taken to heart: that he must be patient. The other feeling that comes poignantly across is Clement's sense that the time he had to accomplish these works, so dear to his heart, was short.

*

In the view of several shrewd observers who saw him at close quarters, Clement's character was unsuited to supreme power. The Florentine diplomat and friend of Machiavelli, Francesco Vettori, noted that Clement 'endured an enormous labour to become, from a great and respected cardinal, a small and little esteemed pope'. The doctor and man of letters Paolo Giovio thought the Pope had 'the Medici talent for knowledge and singular judgement in almost everything, including the fine arts'. That subtle discrimination, however, he thought almost a vice, leading him to spend his time 'investigating the secrets of craftsmen and their works

with almost depraved shrewdness'.[2] In Giovio's opinion, Clement was 'never deceived in small matters, whereas, not surprisingly, in great matters touching the welfare of everyone, he was very often deceived'.

Francesco Guicciardini, who served Clement as an advisor, then as commander of the papal army, found him a hopeless ditherer. 'Any small impediment,' Guicciardini thought, 'was sufficient to make him fall back into that confusion wherein he had languished before he came to a decision, since it always seemed to him, once he had decided, that the counsel he had rejected was the better one.'

Perhaps Clement had difficulty in coming to a decision because he was presented with a state of affairs in which there were no good options. He did in fact from time to time make a bold strategic choice, but the result was apt to be disastrous.

Since the first French invasion of 1494 the essential problem for Italian politicians had been that their peninsula was dominated by the armies of competing European powers: France, Spain and – to an extent – the Holy Roman Empire. Partly by good luck, Julius II had preserved papal independence by sudden lurches from an alliance with France to a pact with Spain. Leo, too, had just about got away with a similar policy. But the game was becoming steadily harder to play.

One impediment was the result of a dynastic throw of the dice in a previous generation. The Holy Roman Emperor Maximilian I (1459–1519), had arranged the marriage of his son Philip to the daughter of the Queen of Castile. The consequence was that his grandson Charles became first King of Spain, then, after Maximilian's death, Holy Roman Emperor, controlling Flanders, the Netherlands, Austria and – more loosely – Germany. Suddenly, instead of a balance of power, there was a threat that there would be just one European superpower.

2 Nor was Clement's erudite connoisseurship confined to the visual arts; Cellini described how he played the cornetto in a wind ensemble before Clement on 1 August 1524. They rehearsed for eight days, and were commended by the Pope, who said he had never heard music played 'so sweetly and with such good ensemble' – a comment on which the musical historian Richard Sherr in turn commented, 'to like music is one thing, but to notice the effectiveness of the "ensemble" is another, the kind of thing that music critics do.'

On 24 February 1525 the armies of the Emperor won a crushing victory over the French at Pavia, south of Milan. The French suffered enormous casualties and the French King, Francis I, was captured and taken to Madrid.

At this point the feelings of many Italians were probably similar to those attributed to Henry Kissinger about the Iran–Iraq war: a shame they can't both lose.[3] A few months before this great conflict, Clement had written to Francesco Sforza, the ousted Duke of Milan over whose erstwhile territory France and the Empire were fighting. He lamented the ferocity and duration of the wars devastating Christendom and excused himself for not being able to put it right, as sometimes happens 'to those put in great apprehension and danger' – that is, himself.

Clement had been elected Pope with the backing of the young Emperor Charles, but after this he decided to change tack – much as Julius had before him – and put together an anti-imperial alliance of Venice, the papacy and – once Francis was released, France. This was the League of Cognac, formed in May 1526. It was a decision that brought catastrophic consequences for Clement himself, and for his Church.

However, because Clement did not have enough money to pay for a large army, the Venetian forces made up the bulk of the army, with Francesco Maria della Rovere in command. Like his great predecessor as Duke of Urbino, Federigo da Montefeltro, he supplemented his income by fighting as a *condottiere*, a mercenary commander. In 1523, before Clement became Pope, he had become a commander of the Venetian armed forces, and Captain General the following year.

When in September 1526 Francesco Guicciardini, now Lieutenant General of the papal forces, suggested that he should take precedence over della Rovere, the Duke's reaction was to punch Guicciardini to the ground and order him out of his presence before worse befell him. Guicciardini joked that he took to carrying with him an astrolabe – normally used by astronomers and astrologers to determine the

3 A secretary in the forces of the Duke of Urbino summed up this point of view. Italy, he wrote, was currently afflicted by three varieties of barbarian: the French, the Spanish and the Germans. Eventually, he predicted, they would all calm down, but in the interim Italy would have been turned into a wasteland.

positions of the stars and planets – to discover how bad Francesco Maria's temper was each day. The Duke's unforgiving, choleric temperament did not bode well either for the Pope or for Michelangelo.

*

Despite the Pope's esteem for Michelangelo's ideas, there were stresses in their relationship. One point of conflict was the statue of *Hercules*, planned long ago to be the pendant to Michelangelo's *David*. This commission also brought Michelangelo into frustrating conflict with a younger sculptor: Baccio Bandinelli (1493–1560). Bandinelli wanted to challenge and outdo Michelangelo, but he also wanted to *be* Michelangelo.

Bandinelli's career up to this point had shown conscious or unconscious emulation of the great man. Right from the start, he had conceived a desire to create colossi. According to Vasari, while still a boy he made a snow sculpture in a Florentine square of Maforio, a classical river god over 15 feet long.

In 1521 Bandinelli had proposed a funerary monument of impractically vast proportions, vaster than Michelangelo's schemes for Julius II. This was intended to be the tomb of Henry VIII of England, a megalomaniac folly containing 142 lifesize bronze statues, reliefs, and an equestrian sculpture of the king commissioned via Giovanni Cavalcanti, a Florentine merchant trading with London.

However, Bandinelli had one big handicap: his modest talent. For that reason, perhaps, Michelangelo did not at first appear to regard him as a danger. Yet Bandinelli also had two assets that Michelangelo lacked. He was, like his father before him, a diehard Medici loyalist. In addition, he was adept at currying favour at the papal court. Sebastiano called him 'Bacino' or 'little kiss'.

In 1525 a colossal block of marble arrived in Florence. It was, like the block for *David*, 9½ *braccia* high (that is, over 18 feet); but unlike the marble from which *David* was carved, it was also wide enough to make a two-figure group. No doubt as soon as he saw it in the cliff face at Carrara – as he surely would have – Michelangelo began to dream of the masterpiece he could make from this beautiful piece of stone. Bandinelli, too, went to the quarry to inspect it.

Even by the standards of transport from Carrara, however, this monster block was extremely slow to arrive. The last delay came as it was being transferred from barge to ox-cart at Signa for the last lap of the journey to Florence, when it fell into the Arno and sank into the sand. Michelangelo's old friend Pietro Rosselli was given the job of salvaging it. When it reached Florence in July 1525, it was trundled on rollers to the Opera del Duomo – where the marble for *David* had lain for so long. Bandinelli, who had long coveted the opportunity to

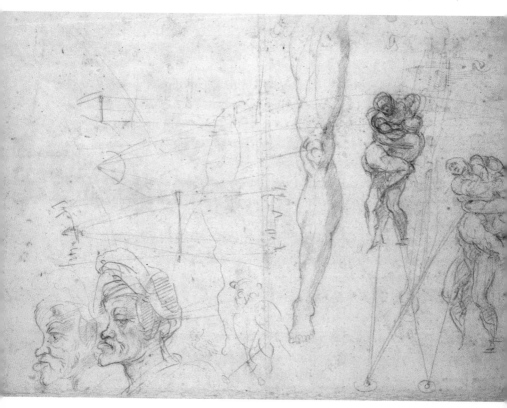

Hercules and Antaeus and Other Studies (recto) plus *Miscellaneous Sketches and a Poe*

rival Michelangelo's early masterpiece, set about making models of a Hercules vanquishing the fire-breathing giant Cacus.

Around the same time Michelangelo was at least toying with a slightly different idea. On another of the sheets that were partly given

over to practice drawings by his young apprentices and protégés, he sketched a group of Hercules wrestling with Antaeus, the hero's legs bowed with effort, clutching the naked body of his foe[4] in a deadly but ferociously close embrace. It was a subject of subjects for Michelangelo, and an addition to a page also covered with perspective exercises, owls, caricature heads – some probably by Michelangelo's assistant, Antonio Mini, or Niccolò da Pescia.

This was a period in which Michelangelo seems to have passed a good deal of time – perhaps in the evening in the Via Mozza workshop – with various young men he was attempting to instruct in drawing. A second sheet with what look like practice exercises on it – eyes and hanks of hair – has, written on the lower right, the name of another associate of the artist: Andrea Quaratesi (1512–84). Or rather, partially written several times: 'Andrea Quar', 'Andra Quar –', 'Andrea qu –', plus another of those injunctions of Michelangelo's: 'Andrea be patient' ('*Andrea abbi patientia*'); and, in another hand: 'It gives me great consolation.' The impression is of two people chatting on paper, one much older than the other. Andrea Quaratesi was probably in his early teens when these drawings were done in the mid-1520s (which explains the schoolboy incompetence of some). He was a youth from a noble banking family from the same *quartiere* as the Buonarroti, Santa Croce.

Andrea was still on friendly terms with Michelangelo half a decade later: in 1531 and 1532 he wrote amiable, if not lengthy, letters to Michelangelo from Pisa (the second asking advice about a house Andrea intended to buy). Probably before this, Michelangelo had paid Quaratesi an unusual compliment: he drew his portrait. According to Vasari, Michelangelo 'hated drawing any living subject unless it were of exceptional beauty'. Certainly, his portraits were rare. It can't be said that, to a modern eye, Andrea seems extraordinarily good-looking, but the drawing is of a delicate, almost Flemish naturalism. The sitter seems wary and ill at ease. His age is hard to gauge precisely, but he is perhaps in his late teens. This drawing demonstrates that, if Michelangelo

4 Like Bandinelli's choice, Cacus, Antaeus was a giant who was slain by the hero, in his case by being held aloft and crushed to death.

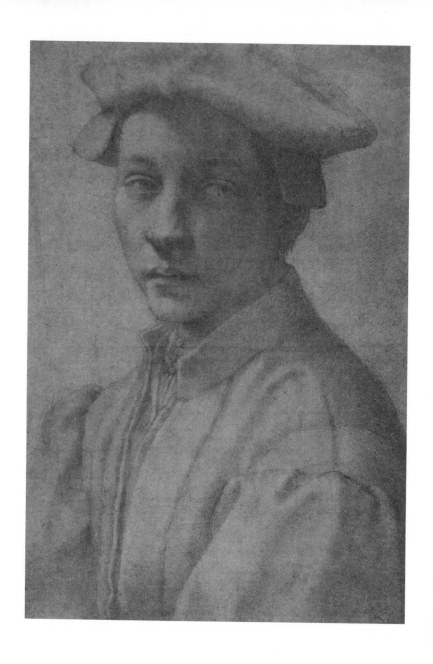

Portrait of Andrea Quaratesi, 1528–31.

seldom drew portraits, it was not because he could not but because he did not want to.

On the sheet with doodles of owls, plus Hercules and Antaeus, there is also a poem: a *canzone*. This does not read like an exercise in the manner of Petrarch but as a bitter reflection on ageing and wasted time:

> Alas, alas, for I have been betrayed
> By my fleeting days and by the mirror
> That speaks the truth to all who look hard at it!
> That's what happens when one delays too long at the end,
> As I have done, while time has fled from me:
> He finds himself in one day, as I have, old.

In this poem, he fears he is damned: 'I can neither repent, nor prepare myself,/Nor ask for guidance, with death so near to me.' For the first time, there occurs a strange metaphor that recurs in Michelangelo's work: shedding his skin, like a snake, or a flayed martyr: 'Now that time is changing and sloughing off my hide,/Death and my soul are still battling,/One against the other, for my final state.'

There was a tinge of pessimistic melancholy to the tombs he was working on. Such a feeling is natural to funerary monuments, but it was much more marked in the Medici tombs than in the earlier vainglorious project for Julius's tomb. One of the themes of the New Sacristy was the inexorable, destructive passage of days and years.

Michelangelo left a clue to part of his meaning on a sheet of architectural sketches – a dialogue between his marble figures:

> Day and Night speak and say: 'We, in our swift course, have led Duke Giuliano to his death; it is only fair that he should take revenge on us as he does. And his revenge is this: Having been killed by us, he, being dead, has deprived us of light, and by closing his eyes has shut ours, which no longer shine upon the earth. What might he have done with us, then, if he had lived?'

He told Condivi about a detail that he intended to include, but finally did not: 'In order to denote Time, he left on the work a piece of the marble for the mouse he wished to make (but never did, as he

was prevented) since this little creature is continually gnawing and consuming, just as time is continually devouring everything.'

This story is too improbable for Condivi to have made up. It smacks of a private joke, since Topolino, or Little Mouse, was the nickname of one of Michelangelo's principal assistants at this time, Domenico di Giovanni di Bertino Fancelli (b. 1464) from Settignano. Topolino spent long periods of time at Carrara in the 1520s, supervising the quarrying and dispatching of marble to Florence and sending frequent charming, gossipy letters to his boss. He also worked on the roughing out of sculptures in 1519 – presumably *The Risen Christ* and four *Slaves* – and later the figures in the chapel.

According to Vasari, however, Michelangelo was amused by his pretentions as a sculptor in his own right: 'He never sent a shipment without including three or four figures which he had roughed out himself and which made Michelangelo nearly die of laughter.' Once he showed Michelangelo a figure of Mercury he had begun, asking his opinion: '"You're a fool, Topolino," Michelangelo said, "to want to make statues. Don't you see that from his knee to his foot this Mercury is lacking about eight inches, and that you've made him both a dwarf and a cripple?"' Topolino then sawed 'the Mercury in two below the knees and added the length required' and 'gave the figure a pair of buskins to hide the joins'. This fits the notion of a little mouse, always gnawing away at things.

*

When Michelangelo discovered in early autumn that Bandinelli was to be given the marvellous piece of marble that had been hewn from the cliff face in Carrara, he was outraged and so, too, were many Florentines. One wit wrote a poem suggesting that the block of marble, 'learning that it was to be mangled by the hands of Bandinelli, had thrown itself in the river out of despair'.

Michelangelo expressed his own feelings in a letter to Rome at the beginning of October. One of the Pope's favourite tactics in diplomacy was postponing the evil day of confrontation and, accordingly, he replied via Fattucci that Bandinelli had not definitely been given the commission; he was merely making models. Meanwhile, Clement wished that Michelangelo would pay a bit more attention to the jobs

he, the Pope, was giving to him: namely, in addition to the tombs already under way in the library, another tomb for himself and Leo X, and a ciborium to go on the altar of San Lorenzo to contain the collection of relics amassed by Lorenzo the Magnificent.

Then, he suddenly proposed what sounds like a consolation prize to mollify Michelangelo: a colossal statue to go in the corner of the piazza in front of San Lorenzo. Michelangelo responded by indicating that the chagrin and depression of being deprived of the *Hercules* was preventing him from doing anything else:

> I'll always go on working for Pope Clement with such powers as I have, which are slight, as I'm an old man – with this proviso, that the taunts, to which I see I am being subjected, cease, because they very much upset me and have prevented me from doing the work I want to do for several months now. For one cannot work at one thing with the hands and at another with the head, particularly in the case of marble. Here it is said that they are meant to spur me on, but I assure you they are poor spurs which drive one back.

Again there was that self-pitying stress on his age – he was now fifty – together with fury at being deprived of the stone. Both Fattucci and Jacopo Salviati tried to calm him down. Salviati, the Pope's close relation by marriage and one of the most senior members of the papal entourage, wrote as a firm friend of Michelangelo's – but also as someone who knew how to handle him.

'It grieves me most greatly,' he began, 'to have learned the fantasies that have been put into your head.' However, Salviati went on, if Michelangelo downed tools in this way it would simply confirm what his enemies had always said about him: that he never completed anything while monopolizing huge projects for himself and refusing to help anyone else, either by teaching them or giving them part of the work.

In Salviati's view it was ridiculous to suggest that a competition was being set up between Baccio Bandinelli and Michelangelo: 'On no account can Baccio be put on the same level as you, or make the least *paragone* with your works, and I rather marvel that you wish to give this credit.'

There were good reasons not to give yet another huge commission to Michelangelo. Obviously, he had more than he could manage to do

already – even without taking the tomb of Julius II into account. Another gigantic statue as large as the *David* but more complex because it comprised two figures, would be at least two or three years' work, if he were to carve it himself. He already had numerous sculptures to carve in the Medici Chapel alone. When could he do it?

Nonetheless, other Florentine citizens could see that a splendid artistic opportunity would be missed if Michelangelo did not sculpt the companion to *David*. A pair of Michelangelo masterpieces outside the Palazzo Vecchio would have been a sensational sight. Five hundred years later, we can share their disappointment.

Michelangelo wrote to Rome again, saying that he had been approached by several Florentine citizens imploring him to sculpt the *Hercules*, and adding that they could wait a few years for him to begin it. 'I replied that, although I recognized their kindness and that of the whole people, I couldn't repay them, except by doing it and doing it as a gift, if the Pope were agreeable; as I was already committed, since, being committed to him, I could not work on anything else without his permission.'

The answer was still no and, furthermore, there were repeated expressions of wonderment that Michelangelo had still not responded to the Pope's project for a colossus in the piazza outside San Lorenzo. Eventually, he did, but by that time his rage and depression had turned to sardonic humour.

As to the colossus, which was to be 40 *braccia* – that is, over 76 feet – high, Michelangelo started to discuss the idea. He thought it would not look so good in the corner of the piazza near the Palazzo Medici (where Clement had proposed), but in the opposite corner, where there was currently a barber's shop.

Then he commenced an elaborate fantasia. Since, he began, there might be objections to the removal of this hairdresser's, perhaps the colossus could be seated, with its buttocks 'at such a height that the barber's shop could go underneath and the rent would not be lost. And as at present the said shop has an outlet for the smoke, I thought of putting a cornucopia, which would be hollow inside, into the hand of the said statue to serve as a chimney.'

Thus Michelangelo had transformed the Pope's heroic statue into

a figure with a hairdresser's under its buttocks and a chimney running up its arm. Nor did he stop there. The head, being hollow, could be put to some practical use. A street trader who hung around in the piazza, a friend of Michelangelo's, had suggested it would be suitable for a pigeon loft. However, Michelangelo himself thought it would be better to increase the size of the figure even more and transform it into a campanile for San Lorenzo: 'And with the bells clanging inside and the sound issuing from the mouth the said colossus would seem to be crying aloud for mercy, especially on feast days when there is more ringing and with larger bells.' He ends with, as William Wallace puts it, 'some almost Shakespearean gibberish': 'To do or not to do the things that are to be done, which you say are not now to be done, it is better to let them be done by whoever will do them, for I will have so much to do that I cannot do more.'

The Pope, his suggestion transformed into a grotesque parody, replied – a little hurt – that it had been intended seriously, not as a joke. But the idea was dropped.

*

In the 1520s Michelangelo was under pressure of every possible kind: political, financial, familial, artistic, emotional, sexual – but, above all, from the endlessly protracted question of the other tomb: the one for Julius II.

Negotiations about this continued to drag on, year after year. Acting for Michelangelo, Fattucci discussed it time and time again with Cardinal Santi Quattro. This man, who had previously been a great enemy of Michelangelo's, became extremely pliable after a word with the new Pope.

In March 1524 Cardinal Santi Quattro suggested that the work he had already done – including *Moses*, and the various *Slaves*, could be valued at 9,500 ducats. All that Michelangelo would need to do in addition was one further sculpture – the Madonna – and, if he wished, the rest could be done by Sansovino or someone else under his supervision. Furthermore, he could wait until his work for the Pope was completed before doing anything else.

This was an excellent opportunity but, somehow, it slipped by.

Possibly, when it came to it, Michelangelo could not give up, or perhaps it was vetoed by Duke Francesco Maria. No doubt it went against the grain with that irritable man to see a famous artist diverted from making a della Rovere monument into constructing a masterpiece in honour of his enemies, the Medici.

At times, Michelangelo seemed inclined to give up the struggle. In April 1525 he wrote, 'I don't want to go to law. They can't go to law if I admit that I'm in the wrong. I'll assume that I've been to law and have lost and must pay up. This I'm prepared to do, if I can.' He hoped that the Pope would help him secure as good terms as possible.

The following year Michelangelo suggested that the project could be reduced to a wall tomb, like the fifteenth-century sepulchre of Pope Pius II – a footling affair in comparison with the majestic structure Michelangelo had first imagined. He would do it, he said, 'little by little, sometimes one piece and sometimes another, and I'll pay for it myself'.

He would sell his property, make restitution to the heirs of Julius and get on with his work for Clement, 'since as it is I do not live life at all . . . There is no course that could be taken that would be safer for me, nor more acceptable to me, nor a greater relief to my mind, and it could be done amicably and without going to law.' He even drew a sketch of this idea for a small wall-tomb, but Julius's executors, not surprisingly, turned it down.

Michelangelo was trapped in a struggle between two powerful men – Clement and Francesco Maria – but the dilemma was also the product of his own temperament. Another artist, a Jacopo Sansovino or a Raphael, would have handled it with ease. But for Michelangelo to do so he would have had to let go: of money, of control, of his original grand conception. In moments of depression, he seemed willing to do this, but when it came to it he changed his mind.

*

At the very beginning of 1524, on 2 January, Fattucci had written from Rome, telling Michelangelo that the Pope wanted him to make designs for the library – which up to that time had been only the vaguest of proposals. In reply, the artist was characteristically curt, verging on

curmudgeonly: 'I have no information about it nor do I know where he wants to build it.' However, he would 'do what I can, although it's not my profession'.

This project had been in the air for decades. Lorenzo the Magnificent had himself begun to build a library but had not got far before his death. It was with a spare piece of marble begged from the builders working on this that Michelangelo carved his first sculpture, the head of the faun, in 1490. This building was, as much as the tombs, a monument to the Medici, to their learning and high culture.

The Laurentian Library was to be Michelangelo's first purely architectural work and, unenthusiastic though he seemed when he

Staircase of the Laurentian Library, c. 1526–34.

embarked on it, the result was a work of extraordinary originality and almost surreal imagination. It was a project, to judge from the attention he gave it, even dearer to Clement's heart than the tombs.

He was concerned, for example, about the type of wood used to make the readers' benches for the library, urging Michelangelo to consider walnut, because he wanted the furniture to last well (as, in fact,

it has). Clement relished the details of building: the exact forms of mouldings, mortar, the construction of vaults and foundations. On being shown Michelangelo's design for the door from the vestibule of the library to the reading room, he said, 'he had never seen a more beautiful door, either ancient or modern.'

This is indeed one of Michelangelo's most extraordinary architectural creations; the triangular pediment above it sticks out over the columns on either side like a pair of sharp elbows struggling to emerge from the structure. As that reaction implies, Clement wanted novelty, not the faithful reproduction of antiquity. When discussing the ceiling of the Laurentian Library, he asked Michelangelo to come with 'qualche fantasia nuova'. He also prized, indeed delighted in, Michelangelo's idiosyncrasy, the personal character of his ideas. Time and again he instructed Michelangelo to do something, 'a vostro modo': in your own way.

There was a constant flow of drawings from Florence to Rome – fifteen batches in the first six months of 1524 – and when they arrived, the Pope pored over them. For his part, the artist took account of the Pope's suggestions – which were frequently very much to the point; when Michelangelo made the extremely innovative suggestion that the library should be lit by skylights, Clement replied that at least two friars would have to be given the full-time job of keeping them clear of dust.

The Pope gave an enormous amount of attention to Michelangelo's letters. Sebastiano thought he had perused one so frequently that he knew it by heart. When Fattucci showed him the letter accompanying the design for that beautiful door in the library in April 1526, Clement read it to himself 'at least five or six times', then aloud to his household, saying that what Michelangelo had written was of such quality 'that he didn't suppose there could be a man in Rome who could think of it'.

With the vestibule of the library, Michelangelo developed his concept of architecture as a drama of conflict and tension. The interior is like a building turned inside out. The mighty columns and window frames one might expect to find on a façade are displayed instead on the interior walls. And those columns, instead of standing,

conventionally, in front of the wall, are pushed *into* it. They stand, like giant statues, in niches too narrow for them. Everywhere there is a sense of tension and struggle: the staircase flows out into the entire

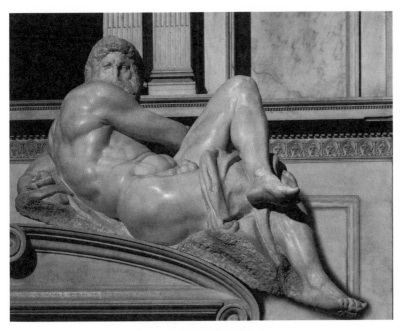

Day, 1524–34, Medici Chapel.

space, pushing out towards the walls. This is heroically muscular architecture.

It is in fact much like the anatomy of *Day*, one of the marble figures on which Michelangelo was at work for the Medici tombs. This is, as Kenneth Clark put it, Michelangelo's grandest piece of 'muscle architecture'. *Day* is a nude, but a mature, middle-aged, bearded one, like the unfinished *Slaves*. The forms of his back and shoulders swell, the veins of his arms bulge: but he seems to wrestle with himself. One arm is folded behind his spine, the other in front of his chest, his legs are energetically crossed. He is an emblem of energy, but also of frustration.

The Herculean *Day* was paired with *Night* – one of Michelangelo's most celebrated, and weirdest, creations. She, too, is twisting against herself, one arm behind her back, her head resting on the other. To a

modern eye, however, one of the oddest things about her is the limited extent to which she seems female at all: her breasts are stuck-on appendages, spaced strangely far apart, and her thighs those of an athletic man.

Michelangelo's feelings about the female body, perhaps, were revealed in a burlesque love poem he wrote around this time. 'You have a face sweeter than boiled grape juice', it begins, 'it looks as if a snail had walked across it/It shines so much – and prettier than a turnip . . . When I look down upon each of your breasts they look like two watermelons in a bag.'

Unlike the other three times of day, *Night* was accompanied by attributes: a nest of symbols on which she lies. Condivi passed on Michelangelo's terse explanation of these: 'In order that his purposes should be better understood, he put with *Night*, who is made in the form of a woman of marvellous beauty, the owl and some other appropriate signs.' As so often, however, he didn't make his meaning entirely clear. Around the naked figure he carved a wonderful and disturbing sculptural fantasia which hints at much more than a simple identification: 'this woman stands for night.'

On her headdress is a crescent moon. A jaunty but disturbingly empty-eyed mask lies under her beefy arm. Altogether, this is an image that suggests disguise, subterfuge, sexuality, dreaming. Her left foot rests on a hefty bundle of poppies, standing for sleep and oblivion. Beneath the arch of her thigh, seeming to emerge from between her legs is a magnificent owl, its tail feathers brushing her body in the most intimate way. A few years later Michelangelo adapted her figure for a highly erotic painting of *Leda and the Swan*, in which similarly placed feathers play a part in energetic avian–human intercourse. An intriguing footnote was that 'owl' – '*gufo*' – was a slang term for 'sodomite' in Florence, though that would have been an astonishingly indecent meaning for Michelangelo to have intended consciously in such a sacred place.

When he came to describe this figure, Vasari was almost – but of course not quite – lost for words: 'What can I say of the *Night*, a statue not only rare but unique? Who has ever seen a work of sculpture of any period, ancient or modern, to compare with this? For in

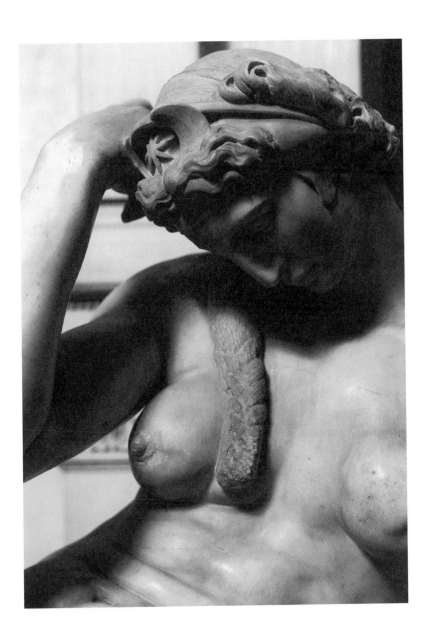

Night, 1524–30, Medici Chapel.

her may be seen not only the stillness of one who is sleeping but also the grief and melancholy of one who has lost something great and noble.'

Across the room, on the sarcophagus of Lorenzo, Duke of Urbino, were *Dawn* and *Evening*. The first, a somewhat more believably female nude than *Night*, seems to awake to start the day in a mood of desolate sadness. The face of *Dawn* indeed resembles a classical tragic mask. Her companion *Evening* was, like *Day*, a middle-aged male nude, but weary rather than dynamic, lost in a gloomy reverie.

Among the most bizarrely imaginative or – in the Shakespearean sense – fantastical aspects of the chapel are the sculptures representing dukes Lorenzo and Giuliano. They are wearing extravagantly improbable versions of Roman armour. Lorenzo wears an ornate helmet, Giuliano a cuirass so tightly moulded to his muscular chest that it is almost as if he were nude. The sculptures abound in weird details: below Lorenzo's elbow is a little box from which protrudes the beautifully finished carving of a bat's head. Giuliano's cuirass bears in its centre a grotesque mask, a more elaborate version of the ones that form a frieze along the wall beneath his feet. The whole effect is mysterious, and slightly sinister.

Here were monuments to two men who must have been well-known to Michelangelo: he had sat beside Giuliano at the table of Lorenzo the Magnificent and lived in Florence under the rule of Lorenzo II, Duke of Urbino. Yet there is little – if any – attempt at portraiture. Some details, such as Giuliano's long neck, may be derived from the actual appearance of the Duke, but the overall effect is of figures of fantasy, belonging to the same world of imagination as the fantastic heads Michelangelo drew for Gherardo Perini.

A decade after work on the tombs was abandoned, as a consequence of war, revolution, Michelangelo's gradual loss of interest and the death of his patron, a Florentine merchant and poet, Niccolò Martelli (1498–1555), revealed a little of Michelangelo's thinking about these sculptures: 'He did not use as his models Duke Lorenzo and Lord Giuliano as Nature had composed and portrayed them, but rather gave them a size, proportion and beauty . . . which he thought would bring them

more praise; for, he said, in a thousand years nobody would know they had been different.'

This solution got over the problem presented by the real, far from heroic – indeed rather scraggy and undistinguished – appearance of Lorenzo and Giuliano (as can be seen in their portraits by Raphael). It also hinted at an underlying ambiguity. In thus ignoring the truth of how the two Medici looked, Michelangelo transformed them, in effect, into works by him. He was forced by circumstance to create memorials to the glory of powerful men. Yet he must have known that, in the eyes of posterity, and even of many contemporaries, he was making a great monument to his own genius.

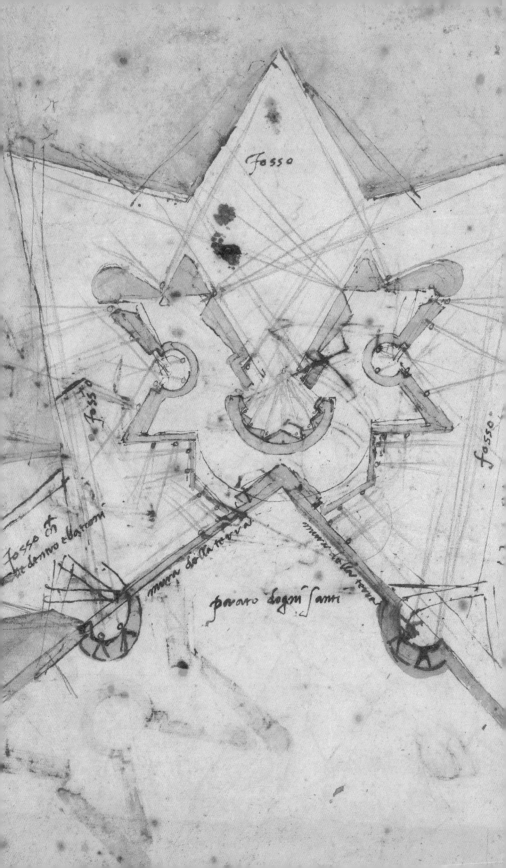

Fosso

fosso

Fosi

Fosso con
le dame e bastioni

muro della terra

muro della terra

fosso

porto d ogni santi

REVOLT

*'A people accustomed to live under a prince . . . [should it
regain its liberty] . . . differs in no wise from a wild animal
which, though by nature fierce and accustomed to the woods,
has been brought up in captivity and servitude and is
then loosed to rove the countryside at will, where being
unaccustomed to seeking its own food and finding no place
in which to find refuge, it becomes the prey of the first
comer who seeks to chain it up again.'*

– Niccolò Machiavelli, *Discourses on Livy*, 1515

The comic poet Francesco Berni, a friend and admirer of
Michelangelo, described the papacy of Clement VII as 'com-
pounded of compliment, debate, consideration, complaisance,
of "furthermore", "then", "but", "yet", "well", "perchance", "haply" and
such terms'. Clement was inclined to temporize and wait until the
situation became clearer. Unfortunately, it never did.

The big picture was, however, that the Emperor Charles V was
becoming more and more powerful, and furthermore was incensed
by Clement's disloyalty in joining the League of Cognac against him:
'I shall go into Italy and revenge myself on those who have injured me,
especially on that poltroon the pope.'

Internally, the politics of Italy were an immensely complicated maze
of disputes, factional quarrels and ancient grudges. Four months after
the league was proclaimed in May 1526, Clement's true weakness
became obvious when he was almost deposed and murdered by one
of his cardinals.

In September of that year Cardinal Pompeo Colonna, an ally of

(facing page)
Design for
Fortifications
(detail),
c. 1528–9.

the Emperor, saw his chance. On the 26th, taking advantage of the tension between the Pope and the Emperor, the Colonna rode into Rome with an army of imperial troops from Naples and other follow-ers. Clement could do nothing about it; his government was so unpopular because of high taxes and corruption that the citizens of Rome watched the invaders pass like a parade going by. At first he was determined to meet this outrageous attack courageously seated on his papal throne. However, he was persuaded to reconsider, and escaped to the Castel Sant' Angelo along a raised corridor that had been wisely constructed by medieval popes for just such emergencies.

He stayed there while the Vatican and surrounding area were thor-oughly sacked, then was obliged to agree to terms of surrender dictated by the Emperor's envoy, Ugo de Moncada. Cardinal Colonna was rumoured to be sadly disappointed that Clement had not been killed, or at least dethroned, and he himself made Pope instead. As soon as he got a chance, Clement – decisive for once – reneged on the agree-ment, raised an army, sacked the lands of the Colonna and deprived the cardinal of all his ecclesiastical positions. This probably relieved his feelings, but made the situation worse.

By the end of the year a large imperial army was massing in Lom-bardy. It was made up of Landsknechts – Swiss and German men at arms, many of them Lutherans who had come to believe that the Pope was the Antichrist and Rome Babylon. So began 1527, described by Francesco Guicciardini as 'a year full of atrocities and events unheard of for centuries'.

The following months formed a punctuation point in history. It was a crisis in which many complex struggles were fought out simul-taneously: Pope against Emperor, Florentine republicans against Medici; international power politics, local disputes; families against families. For Italian political liberty the result was a disaster, as many felt at the time. Culturally, too, 1527 marked a boundary. Like 1914 or 1789 or 1815, it was a year in which the cultural mood seemed to change, becoming darker, more earnest and more intensely devout.

We catch only glimpses of Michelangelo over the months that followed. In November 1526 he was agitated, as always, about the tomb of Julius II. As Clement's power ebbed, that of Francesco Maria della

Rovere increased; Michelangelo expressed fear of the'ill-will' the della Rovere seemed to feel towards him and the punitive payments they would try to extract from him – more than 'a hundred Michelangelos' could afford. He was in 'a great turmoil', wondering what would happen to him without Clement's protection, 'since I would be unable to exist in the world'.

As the Pope's finances dwindled, the work at San Lorenzo began to slow. However, while papal authority collapsed around his ears, Clement still found a moment to worry that Michelangelo was overworking.

*

The huge imperial force camped near Ferrara was unpaid, semi-starved and known to swear by 'the glorious sack' of Florence, the Pope's own temptingly wealthy city (one of the prime problems of the day was that no state, not even Charles V's, could afford armies of the size that were now fighting in Italy). At the end of March 1527 the imperial troops finally began to move south-westwards across the Apennines, towards the Papal States, Rome – and Florence.

Clement had appointed Cardinal Passerini to rule the city on behalf of the two remaining Medici heirs, both illegitimate: the seventeen-year-old Alessandro, and Ippolito, who was sixteen. Passerini's regime was opposed by virtually the entire population of the city. However, revolution was prevented by fear of the approaching army.

There are signs that Michelangelo was tempted to flee before catastrophe struck, just as he had been in 1494. The Mantuan agent in Florence tried to persuade him to move north to safety and serve his master, Federico Gonzaga. Mantua, though a small state, was a rich and cultivated one; a few months later Benvenuto Cellini found refuge there. Michelangelo seemed to consider the idea, and even offered to sell his youthful masterpiece *The Battle of the Centaurs* to the Gonzagas. But in the end he decided to stay put. He was, the ambassador bluntly pointed out, 'rich'. His houses and farms were clustered in and around Florence; his family and most of his friends were there.

On 16 April the ravening imperial army arrived in Florentine territory. For a few days it looked as if the city would indeed be sacked

but, at the last moment, troops loyal to the League of Cognac arrived, led by none other than Julius's nephew and heir, Francesco Maria della Rovere, Duke of Urbino, and the imperial army moved away southwards. That same day, 26 April, there was an insurrection in Florence. The republic was restored, but only for a few hours.

Cardinal Passerini had ridden out of the city to greet the army of the Duke of Urbino, which had just reached the outskirts. In the confusion, the insurgents forgot to lock one of the nine gates in the walls behind him. So Passerini rode back in again, accompanied by a thousand troops, and rapidly retook the city. As so often, the Florentines – so brilliant at finance and the arts – turned out to be incompetent at the brutal business of power politics.

In the final stage of the skirmish, defenders of the Palazzo Vecchio threw heavy stones down from the roof at the pro-Medici soldiers. One of these hit *David*, breaking one marble arm in two places. The young Giorgio Vasari, together with his friend and fellow painter Francesco Salviati, gathered up the fragments, then saved them until there was an opportunity to restore the sculpture.

Michelangelo had other things to worry about. The Duke of Urbino was in Florence and in a position to ask him in person about Pope Julius's tomb. He might even – an alarming possibility – have gone to Via Mozza to take a look for himself. If so, it was probably a sticky moment.

Some still believed that the imperial army would return. Three days later, on 29 April, Michelangelo noted that his friend Piero Gondi had asked a few days before if he could hide certain things in the New Sacristy at San Lorenzo, because of the dangerous times. Michelangelo, not wanting to intrude into his business or to see where he concealed these things, just gave him the key.

However, the imperial army continued towards Rome. On the morning of 6 May it attacked the city, overpowered the hastily assembled defending troops and broke through the walls. Early in the engagement, the imperial commander, the Duke of Bourbon, was shot dead,[1] which had the effect of removing the last restraints of discipline

1 Benvenuto Cellini claimed that he might personally have fired the fatal arquebus ball.

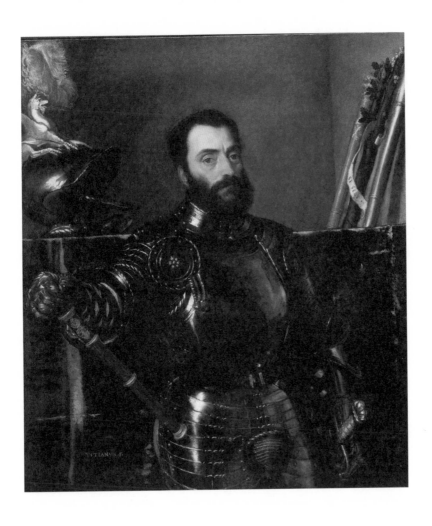

Titian, *Portrait of Francesco Maria della Rovere,*
Duke of Urbino, 1536–7.

from his soldiers. Pope Clement, unable to believe what was happening, fled once more along the corridor from the Vatican to the Castel Sant' Angelo, in company with many cardinals and members of his court. Paolo Giovio covered the Pope with his own violet cap and cloak as he dashed over the final bridge to the castle in case the soldiers below should spot Clement's white vestments and take a shot at him.

Once inside the impregnable Castel Sant' Angelo, the Pope was besieged, while the rest of Rome was sacked with extreme brutality. As one of the imperial army briskly put it, the besiegers 'killed 6,000 men, plundered the houses, carried off what we found in churches and elsewhere and finally set fire to a good portion of the town'.

The soldiers of the Emperor set about systematically removing all the portable wealth in the city. Every church was robbed, and ransom demanded from every person the invaders could get their hands on. The rich were forced to pay huge sums, and even the humble had to pay something. The fate of the painter Perino del Vaga was typical. Vasari described how, caught in the turmoil, 'and having a wife and baby girl, [he] ran from place to place in Rome with the child in his arms, seeking to save her'. Eventually, he was caught and forced to pay such an enormous ransom that he became completely distraught.

Rosso Fiorentino, a younger painter influenced by Michelangelo, suffered a slightly farcical ordeal: 'Taken prisoner by the Germans and used very ill, for, besides stripping him of his clothes, they made him carry weights on his back barefooted and with nothing on his head,' and humiliatingly – if slightly comically – remove 'almost the whole stock from a cheesemonger's shop'. Both of these artists were fortunate to survive. Many did not.

Torture of prisoners was routine, frequently used to extract information about hidden – often non-existent – treasures. The Archbishop of Corfu, unable to pay the huge sum his kidnappers demanded, was tied to a tree and had one of his fingernails removed each day, until he died from pain, shock and hunger. Almost every building in the city was damaged. From the Castel Sant' Angelo, Clement watched the smoke rising from the villa Raphael had designed for the Medici. He understood it was revenge for the damage he had inflicted on

Colonna property a few months before. Hell, an eyewitness told the Venetian diarist Sanuto, was less horrible.

It seemed to many that Savonarola's prophecies were coming true: the corruption of Rome was being punished like that of Sodom and Gomorrah. The news reached Florence on 11 May, and on the seventeenth the Medici regime in Florence fell for the second time in a month. The republic was restored once more.

War and famine had already struck. Next came plague. In June there was a terrible outbreak in central Italy. In Rome, it killed thousands of the besieging troops; in Florence, it caused the worst epidemic for a century: in 1527 over 10 per cent of the population died.

Many of the middle classes moved to their farms and villas in the countryside. Yet, for the most part, Michelangelo seems to have stayed in Florence. In September he wrote to Buonarroto, who was in Settignano, advising him not to come to Florence, where the epidemic seemed to be getting worse and worse. In a postscript, Michelangelo told his brother – presumably far too late – not to touch the letter in case of infection.

However, Michelangelo's *ricordi* give the impression of everyday life continuing normally. He notes down rents collected for his properties in Via Ghibellina and the countryside. On 4 June he lost his maid, Chiara, 'who has gone with God and left me without a servant, without telling me in advance'. It sounds as if there had been a row; on 14 June another servant, Caterina, was employed.

It must have been an eerie time: the death carts rumbling through the streets, church bells tolling for funerals, a lot of the wealthier citizens away. 'All the houses and shops were shut,' the Venetian ambassador reported. 'No persons were to be met with who had the form of human beings; one saw only ministers of the church and spectacles of horror.'

Throughout the summer and autumn of 1527 Clement was under virtual imprisonment in the upper floors of Castel Sant' Angelo, facing demands for a vast sum to pay off the occupying army. Two artists, the sculptor Raffaello da Montelupo and goldsmith Benvenuto Cellini helped man the artillery.

Finally, Clement was obliged to hand over seven hostages, including

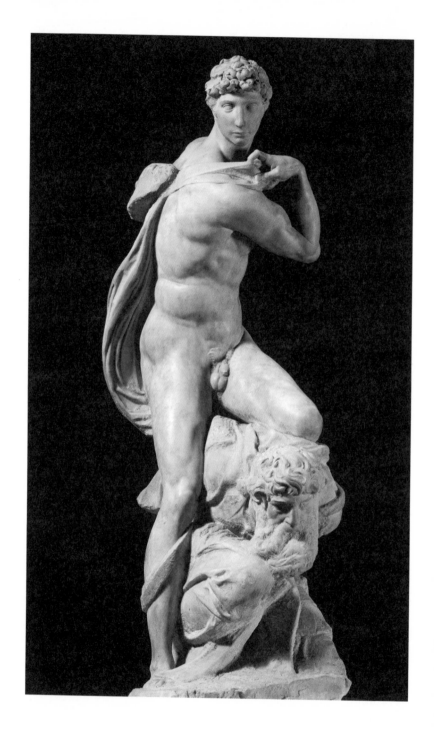

Victory, c. 1528 (?), Palazzo Vecchio, Florence.

two archbishops and Michelangelo's ally and supporter Jacopo Salviati. The hostages were subject to a mock execution, led to a gallows with chains round their necks, to put further pressure on the Pope.[2]

On 6 December – helped at last by his deadly enemy of the year before, Cardinal Colonna, who was appalled by what had happened to his native city – Clement managed to slip away to Orvieto, where he set up a threadbare court. The English envoy, on a mission to discuss Henry VIII's divorce, found Clement 'miserable and alone, few of his household remaining'. Even so, in March 1528 Clement had a letter sent to Michelangelo, wondering whether he had done any work at San Lorenzo. The Pope, though oppressed by expenses, offered to send 500 ducats if he were prepared to start again.

On the whole, it seems unlikely that he did. Michelangelo may, on the other hand, have got on with the tomb of Julius II. This might be the moment he carved the two-figure sculpture known as *Victory*. Such groups had always been part of the design of the Julius tomb. This, however, is the only example actually carved – and almost, if not quite, completed.

The subject is a curly-headed young man, muscular but extraordinarily – indeed, unnaturally – lithe. His body and limbs swivel like a spring, with an impossible degree of torsion, so that his shoulders are parallel with one extended thigh. The other leg rests, knee foremost, on a conquered older man, bearded and bound: a brother of the four unfinished lumbering *Slaves*. But the victorious youth is an amazing creation: a human corkscrew, twirling in space. He was also, perhaps, a token of what Michelangelo hoped for: victory for the republic.

*

In Florence, conditions returned to those of three decades before, when Savonarola was the dominating voice. On Sunday 9 February 1528 the *Gonfaloniere*, Niccolò Capponi, made a speech to the Great Council that echoed the sermons of the friar in the 1490s: throwing himself to

2 According to Cellini, Salviati was responsible for the Sack of Rome, having unwisely advised the Pope to pay off his mercenary army shortly before the besieging troops arrived, so perhaps he deserved this ordeal.

his knees and shouting 'Mercy!', he then proposed that Jesus Christ should be elected King of Florence. The motion passed with only 18 against out of 1,100. Officially, at least, illegitimate members of the Medici family were replaced as rulers of the city by the Son of God.

The only glimpse we have of Michelangelo at this time suggests, paradoxically, that under these conditions of plague and revolution he was leading a more relaxed life. Instead of working from dawn to dusk, he seems, according to Cellini, to have had time to wander and pay attention to good-looking young men.

After manning the artillery at Castel Sant' Angelo, Cellini had returned to Florence to find that his father and everyone else in the house had died of the plague. Not over-distressed by this bereavement, he had set up business as a jeweller in the Mercato Nuovo, a little north of Santa Croce. At that time he was often visited by Michelangelo, who was interested in a medal of Hercules prising open the lion's mouth that Cellini was making.

With no false modesty, Cellini described how 'the divine Michelangelo was quite unfamiliar with my method of working. As a result of this he praised my work so highly that I began to burn with ambition to do really well.' At that time, 'a certain Federico Ginori appeared on the scene. He was a young man of very fine spirit who had lived for some years in Naples, where, because of his noble, handsome looks, a princess had taken him for her lover.'

Ginori wanted a model of Atlas holding the world on his shoulder. He therefore 'begged' Michelangelo to make a design for him. According to Cellini, Michelangelo agreed but suggested that 'the young goldsmith called Benvenuto' should make one too; then Ginori could have the best carried out. Cellini set about this commission; by and by Michelangelo's old friend Bugiardini came along with the great man's design. On comparing Michelangelo's drawing with the model Cellini had made, everyone thought Cellini's was better. And when Michelangelo saw it himself, he had nothing (according to Cellini) but 'tremendous praise'.

This anecdote places Michelangelo close to a circle of passionately dedicated republicans. The Ginori family was connected with these, as was the poet Luigi Alamanni, one of the instigators of the plot to assassinate Cardinal Giulio de' Medici – as he then was – in 1522.

Another prime mover in that plot was Battista della Palla (1489–1532), who was especially close to Michelangelo at this time.

Della Palla had started out, like several other leading opponents of Clement VII, as an ambitious young man in the Medici inner circle. Under Leo X he went so far as to hope for a cardinal's hat, then veered abruptly into the anti-Medici camp. He spent the years after the failure of the conspiracy in France, where his interest in religious reform attracted the attention of Marguerite of Navarre, sister of the French King, Francis I, and protector of humanist and Lutheran intellectuals in France.[3]

The new Florentine Republic dispatched della Palla on a diplomatic mission to France in March 1528. One of the ways he tried to cultivate favour with Francis I was by adding to the King's collection of Italian art.[4] Ten years before, in 1519, Francis I had professed himself an admirer of Michelangelo's art and expressed a desire to have some small thing by his hand. Now, at last, he got an important piece. Among the most significant Florentine works that della Palla succeeded in sending to Francis I was the 8-foot statue of *Hercules* that Michelangelo had carved in the time of Piero de' Medici.[5]

*

3 He presented her with a portrait of Savonarola, and all his sermons and writings, which she said provided 'all my spiritual consolation'. Under his influence she became such a devotee of Savonarola and such a believer in the destiny of Florence that she was known as 'La Florentine'.

4 The Ginori family enthusiastically assisted in this effort, among them Michelangelo's young friend Federico Ginori. Cellini's cap badge with the figure of Atlas therefore ended up in the collection of the King of France.

5 The artist had probably given it to the Strozzi in return for their taking his brothers into their wool business. As a public-spirited act, Filippo Strozzi, the head of the family, ordered it to be presented to the King of France – the greatest ally of the Florentine republic, in whom much hope was placed. His brother Lorenzo confirmed the gift: 'We have handed over to Battista della Palla the *gigante* or rather the Hercules, although many people – and especially Michelangelo – are unhappy that we are depriving ourselves of it, but I had sooner that everyone else criticized me than that you [Filippo Strozzi] did.' Michelangelo's misgivings were well grounded: the statue ended up outdoors in the grounds of Fontainebleau, apparently became badly eroded and was last seen in the late seventeenth century. It would have been safer, and also probably looked magnificent, in the courtyard of the Palazzo Strozzi.

During the summer of 1528 Michelangelo suffered the loss of his favourite brother, Buonarroto. The plague was diminishing at that point, but still claiming victims. Buonarroto's decline and death on 2 July can be traced in Michelangelo's notes of his expenses: so much for medicines, so much to pay the fees of the three doctors who attended him. New cloths for his window, as the old ones were tainted by infection (and presumably burnt), the sacristan of Santa Croce's fee for the burial. Then there were the wax candles for his laying out, the money for the certificate paid to the officials of the plague, the tax paid for the body to enter the Gate of Santa Croce, since Buonarroto had died at Settignano. And so on, through a neatly itemized inventory of loss.

Even though his relationship with his brother seems to have cooled after the big row about Buonarroti finances in 1523, Buonarroto's death must have hit Michelangelo hard. A later family tradition claimed that Buonarroto died in Michelangelo's arms, which might be hagiographic embroidery but, alternatively, might be true. As we have seen, he reacted with intense anxiety to illness amongst those he loved.

His sorrow was expressed in poetry, in paradoxes and intellectual convolutions in the manner of Petrarch, and as formalized in their way as book-keeping, but not necessarily any less heartfelt for that. In one poem, probably dating from 1528, he lamented his own survival: 'Excess of pain still makes me survive and live,/Like one who, going faster than all others,/Sees himself reaching the end of his days after them.'

With the death of his brother, Michelangelo inherited a little family. His accounts document his responsibility for Buonarroto's children: his niece Francesca, eleven; and nephews Lionardo, who was nine, and Simone, seven. The last and youngest did not long survive, but Lionardo came to live with Michelangelo in his house in Florence and Francesca was sent to live with the nuns of the Convent of Boldrone until she was ready to marry. Thus Michelangelo ended the year with a novel responsibility as a family man.

*

If, for reasons of state, Michelangelo's early marble *Hercules* was sent to France, he had, albeit tantalizingly briefly, an opportunity to carve a companion to his *David*. Baccio Bandinelli, a Medici loyalist, had absented himself from Florence after the fall of the regime and was living in Lucca, leaving the beautiful piece of marble he had been given by Clement VII merely blocked out with his group of *Hercules and Cacus*. On 22 August the republican authorities allocated Michelangelo the marble, which he had been so upset to lose. Or, at least, he got his hands on what remained of it. It was, in effect, a repetition of the situation with the *David*. He was presented with a piece of marble already blocked out by another artist.

According to Vasari, Michelangelo now had a look at the stone and proposed that he could get a different subject out of it – and one more suited to an ardently religious city faced with the imminent prospect of war: 'Abandoning the *Hercules and Cacus*, he chose the subject of Samson holding beneath him two Philistines whom he had cast down, one being already dead, the other still alive, against whom he was aiming a blow with the jaw-bone of an ass.' Here was a perfect emblem of the republic in its current struggle: a heroic judge smiting the ungodly heathen (and of course, his struggle with Bandinelli mirrored that of followers of the Medici with their opponents).[6] Unfortunately, Michelangelo did not have much opportunity to work on it, as he was diverted to real struggles against the enemies of Florence.

Apart from advancing the Florentine cause through art, one of della Palla's obsessions was improving the fortifications of the city. This was an area in which Michelangelo could contribute. He had a reputation, as yet untested, as a military engineer, perhaps because it was felt that,

6 It was a tussle that Michelangelo was ultimately to lose. After the fall of Florence, Bandinelli returned, reclaimed the block and continued with his project for *Hercules and Cacus*. This was finally installed in 1534, to widespread execration from the Florentines, partly from political motives, but justified on artistic ones. Cellini claimed later to have told Bandinelli to his face that if Hercules' hair was shaved off there would not be enough space for his brains, that the statue's shoulders resembled the pommels of a donkey's saddle, his muscles looked like a 'great sack of melons' set up against a wall, and it was impossible to tell which leg he was standing on – all spot on, from the critical point of view.

in the area of design, there was nothing he could not do.[7] Indeed, ironically and poignantly, while powerless and cooped up in the Castel Sant' Angelo in September 1527, Clement VII had issued a papal brief appointing him superintendent of the fortifications of Bologna. If Michelangelo knew of this, he ignored it, but a year later he offered his services to the Florentine Republic *'gratis et amorevolmente'* – freely and lovingly – like a good patriot.

On 3 October the *Gonfaloniere* summoned him to a meeting about the defences of an important strongpoint to the south of Florence: the hill of San Miniato. Thus, at fifty-three, Michelangelo began to practise a profession of which he had had before at best a theoretical grasp.

A series of his designs for the defences of the city survive. They are, to a modern eye, powerful abstract images. Art historians have compared the outlines of his bastions, ramparts and ravelins – the last being the aggressive triangular fortifications that jut out in front of the walls like spikes – to the claws of crabs and lobsters. They do indeed resemble the limbs of some predatory, armoured creature, their forms bristling with lines representing the trajectory of cannon balls. Their intention was, however, largely defence rather than attack.

The game changer in early-sixteenth-century warfare was artillery, which could shatter old-fashioned fortifications. The race, therefore, was to find a way to strengthen vulnerable parts of medieval town walls, such as those of Florence, particularly gates and corners. This put architects in the vanguard of military innovation.

The most successful response to artillery was the bastion: a platform projecting from the walls on which defensive cannon could be mounted. These could fire outwards at a variety of angles, or parallel with the walls in case the attackers came close in. This system was developed by the Sangallo family, among them Michelangelo's old mentor Giuliano da Sangallo. The siege of Florence was in part a

7 In the Renaissance, military engineering tended to be practised by artists, such as Leonardo and the Sangallo dynasty, who were also active in other fields, such as civil architecture, or even painting.

Design for Fortifications, c. 1528–9.

battle between two architects: Michelangelo for the defence and Antonio da Sangallo, Giuliano's nephew, chief engineer of the attacking forces.

The surviving designs probably come from the late summer and autumn of 1528, around the time of that meeting to which Michelangelo was summoned on the hill of San Miniato on 3 October.

These drawings were perhaps done partly as demonstration pieces, to convince the government of what he could do. If so, they were successful. In January Michelangelo was elected to the Nove della Milizia (or Nine of the Militia), an old republican committee initiated to supervise Machiavelli's militia under the government of Piero Soderini. It had been revived as soon as the republic itself was re-established. Michelangelo had risen to a high level in the Florentine government, and this elevation caused resentment. 'Envy,' an eyewitness to the politics of the republic recalled, 'must always be reckoned with in republics especially when the nobles form a considerable element, as in ours, for they were very angry, among other matters ... to see Michelangelo made a member of the Nine.' To some Michelangelo was the greatest artist who had ever lived, to others, obviously, he was just an upwardly mobile artisan.

On 6 April 1529 Michelangelo moved a further step up the ladder of command. He was appointed to a new post apparently created with him in mind: Governor and Procurator General of the city's fortifications. He was to receive one golden florin a day: a good income, which always mattered to Michelangelo.

He later complained that it took him a long time to convince the government of the vital necessity of fortifying the hill of San Miniato, the commanding high point to the south of Florence just outside the city walls, but he could never persuade the *Gonfaloniere*, Niccolò Capponi, who was more interested in diplomacy than war. Capponi's policy was to try to come to an agreement with Clement VII. This – perhaps the wisest course – was opposed by strong believers in the republic, such as Battista della Palla.[8]

8 It is hard to be sure what Michelangelo – favourite artist of Clement's, friend and ally of della Palla's – felt about it. However, he never expressed any regret for the part he played in the siege, only for the fact that the Florentine republic eventually lost.

It is likely that della Palla and his allies were behind Michelangelo's new appointment. At the beginning of April a new Signoria came into office, containing hard-line opponents of the *Gonfaloniere*; within a few days Michelangelo was made director of fortifications. A week later Capponi was discovered to have been in secret diplomatic communication with the Pope; he was forced to resign, and narrowly escaped torture and execution. His successor was Francesco Carducci, another of the men of low social rank whose rise, like Michelangelo's, infuriated the aristocrats.[9]

No sooner was he appointed than Michelangelo was dispatched in April and May to inspect the fortifications of important dependent towns, including Pisa and Livorno. In July he went on a journey to Ferrara, a mission Michelangelo suspected of being a plot to divert him from doing his new job of strengthening the defences of Florence.

In reality, there was good reason to take a look at the fortifications of Ferrara, since these were among the most up-to-date in Italy. Duke Alfonso d'Este, the ruler of the city, was a noted expert on the subject. But Michelangelo's task involved more than simply inspecting bastions; it was an excuse for negotiation. Senior Florentine diplomats accompanied him.

Immediately before Michelangelo's journey to Ferrara, the outlook for Florence had darkened. Clement, after nearly a year in Orvieto, had returned to Rome wearing the beard he had grown as a sign of mourning after the Sack of Rome. The Pope was saddened, humiliated, but not completely defeated. He still had one very high card in his hand: he was, after all, the head of the Western Christian Church.

Now Clement realized through harsh experience that Spain, with the Empire, had become the European superpower. He could only survive with Charles's approval; conversely, Charles needed to cooperate with the Pope. Only then would there be any hope of settling the

9 Carducci's kinsman Baldassare Carducci was the leader of the *Arrabbiati*, or Angry Party; he had been imprisoned by the Venetians for, among other offences, describing Pope Clement as a *bastardaccio*, or nasty, big bastard (which made him popular with some Florentines).

religious divisions in Germany and the Low Countries, including the heartlands of the Empire. Negotiations began.

On 29 June a treaty between Pope and Emperor was proclaimed at the high altar of Barcelona Cathedral. Among its terms were that Modena should be returned to the Empire, Alfonso deprived of Ferrara, and that the government of Florence should be arranged as the Pope pleased.

When the news of the treaty arrived in Florence in mid-July, there was consternation. Two parties emerged. One, including the new *Gonfaloniere* and – it seems – Michelangelo, argued that there was nothing now left to do except make immediate preparations for war. The other argued that it was best to try and reach some accommodation with the Emperor, which would probably now entail a compromise with the Pope.

As a member of the League of Cognac and an independent northern Italian state, Ferrara was a crucial pivot in the military and political game. Venice, Ferrara and France were the three allies that more optimistic Florentines hoped would support them in a struggle with the Pope and/or the Emperor. Alfonso d'Este's own interest was in hanging on to Modena, of which he had obtained control. His true intention was probably to make a separate peace with the Emperor, and abandon Florence. However, he was playing a long game, waiting to see how events would turn out. To please him, the Florentine Republic had appointed his 21-year-old son Ercole a commander of their forces, but he procrastinated about raising the troop of two hundred soldiers he was supposed to, pleading the difficulty of finding horses or a suitable lieutenant.

The diplomatic mission to Ferrara, organized immediately after this alarming development, may have been prompted by the pro-peace faction, as Michelangelo irritably recalled. Another senior Florentine ambassador, Galeotto Giugni, was dispatched to Ferrara just before Michelangelo. He was instructed that Michelangelo had various errands, and would report to him orally (*'a bocca'*), suggesting some confidential mission.

Alfonso d'Este (1476–1534) was an eccentric man, noted for strolling around Ferrara on hot days stark naked, but also a wily political

operator who had maintained the independence of his small state despite turbulent conditions and multiple threats (not least from Julius II). He was also one of the great artistic patrons of the Renaissance. In his *camerino d'alabastro*[10] he had already assembled three great masterpieces of mythological painting by Titian, plus another by Giovanni Bellini, altered by Titian to fit with the ensemble.

The Duke would also have dearly loved a work by Michelangelo; this may well have been one reason why Michelangelo was loth to visit Ferrara. D'Este was, as his paintings filled with sensuous nudes suggested, a great lover of women. He had married Lucrezia Borgia, the notorious daughter of Pope Alexander VI, by whom he had eight children (and was so upset by her death, of puerperal fever, that he fainted at her funeral). Then, unusually for a sixteenth-century ruler, he married his mistress Laura Dianti, a beautiful low-born woman whom he obviously valued for reasons that were neither financial nor dynastic.

When he arrived, Condivi related, 'the Duke received Michelangelo with a joyful countenance.' The artist was given a tour of the military and artistic sights of the city. 'He rode in person with Michelangelo, he showed him all the relevant items and more, from bastions to artillery; and he also opened up all his collection for him, showing him everything with his own hands, notably some works of painting.' This would have been the first time Michelangelo had seen some of the supreme works by one of his greatest contemporaries: Titian.

According to Vasari, when admiring the collection Michelangelo singled out for special praise Titian's portrait of d'Este, a selection that must have carried a bitter, sarcastic undercurrent, because in this work the Duke's hand rests on the cannon named La Giulia, fashioned from the metal of Michelangelo's destroyed bronze statue of Julius II.

Michelangelo told Condivi that, as he was leaving, d'Este said to him jokingly, 'Michelangelo, you are my prisoner. If you want me to

10 This was located in a two-storey corridor linking the Castello Estense to the Palazzo Ducale, in which Alfonso had a series of small private apartments. By 1529 it would have contained the richest array of Venetian mythological painting to be seen in any one place.

let you go free, I want you to promise me to make me something by your own hand, as suits you, just as you wish, sculpture or painting.'

This light remark had a sinister undertone. Being Alfonso d'Este's prisoner was not entirely a joking matter. He had locked up two of his brothers, Giulio and Ferrante, for conspiring against him in 1506. They were still imprisoned in the castle at Ferrara when Michelangelo paid his visit almost a quarter of a century later. D'Este later reminded Michelangelo by letter that he had long wished to own something by his hand. It is significant that Michelangelo remembered the slightly sinister remark 'You are my prisoner.' That was exactly how the artist felt in relation to his patrons: bound, his freedom curtailed. Willingly or unwillingly, however, he agreed to make a painting for the Duke.

After leaving Ferrara, Michelangelo returned to Florence and continued to supervise the fortifications.[11] By this stage the strengthening of the walls of the city was a huge operation. In July the Chancellor of the Nove della Milizia, Marcantonio Cartolaio, noted that two hundred were labouring there 'night and day'.

Michelangelo covered the hill of San Miniato, above the city, with an innovative system of bastions and curtain walls, all placed, according to descriptions of those who saw them, 'marvellously' in relation to the convolutions of the land.

These emergency constructions were made from earth mixed with straw held by linings of unbaked bricks. And the fortifications at San Miniato were only the most important of Michelangelo's defences; there were also bastions at the Porta alla Giustizia and Porta San Giorgio.

Altogether, it was a colossal coordinated operation, in which Michelangelo's experience of running a large workforce at San Lorenzo must have been most useful. Some members of his team of workers and foremen from those projects worked on the fortifications. In a sour irony, some of the beautiful marble quarried with such expense and difficulty for the projects of the Medici popes was carved into cannon balls (one mason made 664).

11 If the diplomatic activity of which he was a part was intended to persuade d'Este to support the Florentine republic more directly, it failed. He never did.

During August and early September 1529 it became clear that Florence was without allies and would have to undergo a war or make some agreement with Clement. When on 12 August Charles V arrived at Genoa, the Florentine ambassadors were told that the Emperor could have nothing to do with them until they came to terms with his friend the Pope. Charles suggested that Florence should do this if the city wanted to avoid the fate of Rome. Almost simultaneously, news reached Florence that France had made a separate treaty with the Emperor. The League of Cognac had fallen apart.

In accordance with his new agreement with the Pope, Charles set about suppressing the Florentine republic, returning the city to Medici rule – but also, ultimately, to his own. His intention was that, instead of being an unpredictable, unstable and independent state, Florence would become a loyal and reliable part of his empire.

On 14 September the imperial army entered Florentine territory and set about besieging Cortona. The political and military trap was closing; it was obvious that Florence was going to be attacked and might well suffer the terrible fate of Rome. Simultaneously, the fortification building was reaching a crescendo. On 20 September 1529 the Signoria decreed that every male between eighteen and fifty years of age was required to work on it.

Meanwhile, Michelangelo became suspicious of treachery. The Captain General of the forces of Florence, a Bolognese *condottiere* named Malatesta Baglione, had left some cannon outside the bastions that Michelangelo had designed at San Miniato without guards. Michelangelo asked an officer named Mario Orsini why this had been done, and Orsini replied, 'You must know that all the men of his house are traitors, and he too will betray the city.'

Michelangelo, appalled, then went to the Signoria and revealed what he had heard and seen. He showed them the danger threatening the city and said there was time to take precautions, if they wished. However, instead of giving him thanks, they abused him for being too 'suspicious and timid'. So Michelangelo had denounced the general in command – who might well want to take revenge – with no result.

At this point, as he described afterwards in a letter to his friend Battista della Palla, Michelangelo's nerve abruptly snapped. On the

morning of Tuesday 21 September Michelangelo was on the bastions at San Miniato when 'someone' came out of the Gate of San Niccolò below (the hill of San Miniato being outside the walls). This mysterious person 'whispered' in Michelangelo's ear that it was dangerous to stay a moment longer and that he should leave Florence without delay. The man went home with him, where he had dinner and stayed at his side until he was on his way. He ended on a note of enigmatic doubt: 'Whether he were god or devil I know not.'

The one detail his cryptic letter left out was the identity of the man who had come out of the Gate of San Niccolò. It seems likely, however, that it was in fact Rinaldo Corsini who accompanied Michelangelo on the first part of his journey. This Corsini, according to Benedetto Varchi, the Florentine poet, intellectual and historian, 'did not cease urging him that he must take flight affirming that the city, within a few hours not to say days, would be in the hands of the Medici'.

Michelangelo probably referred to him in such an enigmatic manner for reasons of security. After all, Corsini – if he was indeed the unnamed man who came out of the San Niccolò gate – had incited the Governor General of the city's fortifications to defect at a moment of intense danger.

The artist left Florence at such speed that he did not have time to say goodbye to any of his friends, which would have been, in any case, a risk. He and his party tried first to leave by one of the gates to the east of the city, the Porta alla Giustizia, but the guards did not want to let them out. At the Gate of Prato to the north-west they awoke the soldiers from a stupor. At this point someone shouted out, 'Let him go, he's one of the *Nine*, it's Michelangelo.' So the riders slipped away into the countryside beyond. With Michelangelo went his assistant Antonio Mini, the goldsmith Piloto, and Rinaldo Corsini.

The four men rode north. According to Vasari, 'each of them carried a number of crowns, sewn into his quilted doublet.' The Prior of San Lorenzo, Figiovanni, later wrote that it was to save his money that Michelangelo took flight, which perhaps was a consideration.

Eventually they reached Ferrara, where they stayed at an inn.

Alfonso d'Este kept a careful check on new arrivals in his city, and rapidly found out that Michelangelo had arrived. The Duke immediately sent courtiers to the inn with instructions to conduct the artist, his horses and his baggage to the d'Este ducal residence.[12]

Michelangelo's sense of dread is conveyed by Vasari's account: 'Finding himself in the power of another, Michelangelo had no other course but to submit with a good grace; and so he went with them to see the duke, although he left his belongings at the inn.'

D'Este was a little put out by the visitors' baggage remaining in the hostelry, but once again treated Michelangelo to a tour of his collection and pressed him to enter his service. This Michelangelo declined, having – as we shall soon see – a different plan. The Duke then offered to give him 'anything in his power'.

'Not wanting to be outdone in courtesy, Michelangelo thanked him warmly', then turned to his companions and explained that they had carried with them a large sum of money, all of which was at the Duke's service. The message was clear: Michelangelo was not a servant but an equal. The game of competitive courtesy continued when Michelangelo returned to his inn, where d'Este sent many gifts, and instructions to the innkeeper not to accept any payment for the bill.

At this point, Rinaldo Corsini left the group and shortly afterwards returned to Florence, while Michelangelo, Antonio Mini and Piloto the goldsmith went on to Venice (an Italian state beyond the reach of Pope, Emperor or Florentine republic, which is doubtless why they headed there).[13]

Michelangelo had planned to go straight on to France, where of

12 It is possible that Vasari confused this visit to Ferrara with the better documented one in the previous summer, which was described by Condivi. On the other hand, Michelangelo certainly did pass by the city at this time, and Vasari could have had a separate source for these events in the goldsmith, Piloto.

13 The journey can be traced in a series of accounts jotted down by Michelangelo on 10 October. He was covering his companions' expenses – so 10 ducats had gone to Rinaldo Corsini, and 4 on Piloto's horse. From Ferrara, Michelangelo, Antonio and Piloto had gone via boat to Venice from Bondeno, just up river. Once he had arrived, he rented accommodation and set about some emergency shopping: stockings for Antonio, boots for Piloto, two shirts, a little hat and a cap. He was still so on edge that he got the month wrong, writing 'September' at the top, rather than 'October'.

course he would have been welcomed with enthusiasm by Francis I, one of the great rulers of Europe. Indeed, the French ambassador to Venice, Lazare de Baïf, was greatly excited by his arrival. But Michelangelo, he reported, 'is never seen but remains hidden for he does not want to make this city his home'. According to Vasari, Michelangelo evaded the Venetians' invitations because he had a low opinion of their 'understanding of his art'. The truth perhaps was the reverse: Michelangelo did not think highly of Venetian painting, nor of the kind of patron who collected it. When he heard that Michelangelo was in his native city, Sebastiano was mortified at not being able to show him around and introduce him to the right people: 'If I had been in Venice everything would have been different.'

If Michelangelo had continued on to France, his life and the history of art would have been altered. However, as he explained in his letter to Battista della Palla, 'when I reached Venice and made enquiries about the route I was told that going from here one has to pass through German territory which is difficult and dangerous.' The whole of northern Italy was controlled by imperial forces, and the Emperor himself was waiting to move on from Piacenza to Bologna, where he was to meet the Pope.

Apparently, della Palla had been planning to go to France himself. If he was still making the journey, Michelangelo asked, could della Palla tell him where they could meet? 'And we'll go together.' But instead of travel arrangements, in reply he got an extraordinary outpouring of patriotic eloquence.

Della Palla was in a state of religious-cum-chauvinistic exultation. He had complete faith that the enemy force camped in front of the walls of Florence would be 'broken in the hands' of the Florentines. He foresaw the fortifications of the city – obviously an obsession with him – not in their present temporary state, but perfected with permanent walls and bastions defending the holy city in years to come.

Everywhere in the city, della Palla saw 'a universal and admirable fervour to preserve freedom: a unique fear of God; a reliance on Him and on the justice of our cause'. He looked forward to 'the renewal of

the world and the golden age' which he confidently expected Florentines to enjoy in the future.

On 30 September, in common with a number of others who had fled the city, Michelangelo had been declared an outlaw unless he returned by 6 October. But della Palla had obtained a safe-conduct for him back to Florence for the whole month of November. He enclosed ten letters from other friends exhorting Michelangelo to save himself, his friends, his honour and his property, by returning – and, what was more, to enjoy the glorious victory that was to come. Michelangelo was won over, but against his better judgement, as he later told Condivi. He was swayed by 'great entreaties' and appeals to his patriotism.

On 16 November Lazare de Baïf irritably reported that the Florentines had pardoned Michelangelo's 'timidity and cowardice and that he had therefore returned'. His chagrin was understandable. Subsequently, an offer of a salary and house in France arrived, which de Baïf forwarded on to Florence. But it was too late; Michelangelo's moment of wavering was over. Soon he was back in Florence, where the enemy bombardment had begun.

The first artillery ball was fired against the city on 29 October, most of the fire being sent – just as Michelangelo expected – against San Miniato. On that first day fifty cannon balls were discharged at the Romanesque campanile of the church. After Michelangelo's return, his first priority, as he explained to Condivi, was to protect this tower, 'which was all shattered from the continuous poundings of the enemy artillery'. Michelangelo's solution was to fight the flying missiles with absorbent elasticity, hardness with softness.

At first, 1,800 bales of wool from the Arte della Lana were used as padding; later, mattresses stuffed with wool, hemp and jute. Condivi described how, 'using stout ropes he slung them at night down from the summit to the base, so that they covered the parts that could be hit.' On 16 December a chance shot caused a building at San Miniato to collapse, killing thirteen people who had been inspecting the fortifications at that moment: three citizens, five soldiers and five captains, including Mario Orsini, the officer who had warned Michelangelo of treachery.

However, on the whole, it worked well. Because the top of the tower stuck out, the mattresses hung some distance from the lower walls. 'And so when the cannonballs were fired, partly from the distance they had to travel, and partly from the presence of the mattresses, they did little or no harm, not even damaging the mattresses themselves, since they were yielding.'

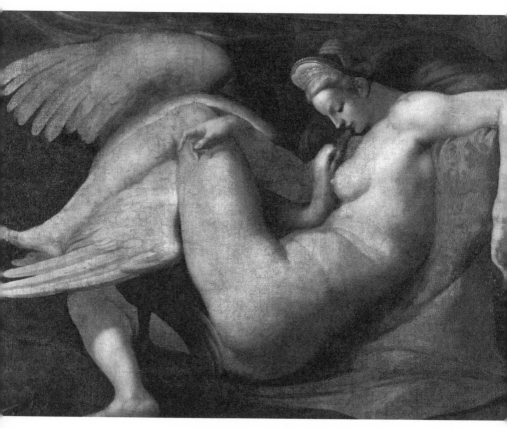

After Michelangelo, *Leda and the Swan*, c. 1540–60.

This was not a work of art, but it was a sculptor's solution to the problem: a layer of resilient flesh and skin over the bones of the structure. The detailed description in Condivi's Life indicates that this was an achievement of which Michelangelo was proud. He rejoiced greatly, 'in saving the town and inflicting harm on the enemy'.

In due course, it was not bombardment that broke Florentine resist-

ance, but starvation. After failing to break through the walls, the Prince of Orange, who had succeeded the Duke of Bourbon in the command of the imperial army, decided on a strategy of blockade. While the food supply lines were slowly eliminated and communication with the outside world cut off, Michelangelo got down to his painting for Alfonso d'Este. The subject, perhaps selected by the artist rather than the Duke, was Leda and the swan.[14] Two early sketches can be found on a sheet of paper dated 6 January, which suggests that the painting was begun in the days that followed.

According to the myth, Leda, the wife of the King of Sparta, was raped by the god Zeus in the form of a swan. She subsequently bore four children, Helen, Clytemnestra, Castor and Pollux, laid in the form of eggs. The story was bizarre to begin with, and Michelangelo's visualization of it – as far as can be seen from surviving copies – was thoroughly weird. The painting was apparently destroyed in France in the seventeenth century because it was considered indecent. French collectors of that time seem to have been particularly troubled by depictions of this theme. Correggio's picture of the same subject was cut to pieces by its much later owner, Louis Orleans, son of the Duke of Orleans, and only put back together again with some difficulty.

Possibly, *Leda* represented an attempt by Michelangelo to cater to the tastes of the louche Duke of Ferrara. In Alfonso d'Este's *camerino* Michelangelo had recently seen Titian's mythological painting *The Andrians*. He would have noted one of the most sensuously beguiling female nudes in Western art.

Michelangelo now painted one of the strangest. Leda's body is at once burly and elongated. She wraps herself around the huge, fluttering bird in a serpentine fashion, while it stretches out its snaky neck to kiss her on the mouth. Meanwhile, it caresses her bottom with its feathers in a startlingly amorous manner.

Judging from the surviving copies, for all its weirdness, the *Leda* was a deeply sensual and mysteriously poetic image. As so often in

14 The loves of Jupiter were a subject favoured by northern Italian connoisseurs. A year or two afterwards, Correggio painted a series, including a Leda, for Duke Federico II Gonzaga at Mantua, which was then presented to Charles V.

Michelangelo's works, the body speaks its own language. Leda's fingers are relaxed, but curling with pleasure. The impression of avian–human intercourse is at once graphic and surreal: the woman seeming to sleep, perhaps dream, the swan heroically virile. (It was a creature worthy to take a place beside Jonah's magnificent fish on the Sistine Chapel ceiling in Michelangelo's bestiary.)

*

In the early months of 1530 Florentine Republicans still clung to the idea that Ferrara – and, more importantly, France – might intervene to save them. But from March, when the blockade began to tighten, hopes faded. D'Este withdrew his envoy, made peace with the Pope and supplied the besiegers with artillery and troops. There was no longer any patriotic point in sending him his picture, nor was it possible, since communications were cut. Letter carriers were hanged if captured.

Within the city, life became more and more difficult. Even earlier in the year, meat had been scarce. At Easter the commander of Florentine forces, Malatesta Baglione, slaughtered a donkey instead of the traditional lamb to set an example. By summer even horse meat was a luxury; rat and cat meat were costly. Most of the population was reduced to eating bread made from bran and drinking only water (wine, like oil, having run out). Deaths from disease increased.

By July the Florentine position was clearly unwinnable from the point of view of Baglione and the other mercenary commander, Stefano Colonna. They therefore began secret negotiations with the besieging army. However, among the more fervent followers of Savonarola, such as Battista della Palla, there still existed the 'universal and admirable fervour to preserve freedom' of which he had written to Michelangelo. They did not believe that God would let them down. Coming to terms which stipulated that the Medici should return to their full power and rights was treachery to them.

Eventually, however, faced with the threat by their commanders simply to open the gates and march out with the regular troops, they had no choice. Michelangelo's description to Condivi of what

happened – 'the enemy were let in by consent' – suggests that he agreed with the ardent republicans. On Friday 12 August, the surrender was signed. The siege of Florence had lasted about ten months. As Cecil Roth wrote, 'overwhelmed by numbers from without and sapped by betrayal from within, the wonder is that she bore up for half the time.' Some of the credit for the fact she did must go to Michelangelo.

LOVE AND EXILE

'Let time suspend its days and hours that moment,
The sun stop short upon its ancient way;
That I may have, and not for my own merit,
My sweet and longed-for lord forever stay,
Folded in these unworthy ready arms.'

– Michelangelo, sonnet to Tommaso de' Cavalieri, 1533

In October 1529, a few days after Michelangelo fled from Florence, Clement VII began to travel north towards Bologna to negotiate with Charles V. He was a sadly diminished figure from the handsome, youthful-looking man who had become Pope six years before: his skin yellow from liver disease; almost blind in one eye.

Clement had finally learned his lesson: he could only function as an ally of the Emperor. One of many questions settled between the two of them that winter in Bologna was the fate of Florence. It was, as the Pope wanted, to be ruled by the Medici; and, as the Emperor wished, it was to be a loyal and reliable part of his empire, governed by hereditary princes who would owe allegiance to him. There would be no more idiosyncratic constitutions, nor lurches from one foreign policy to another.

While Florence was under siege, on 24 February 1530 Charles V was crowned Holy Roman Emperor[1] in the church of San Petronio, Bologna. Cardinal Alessandro Farnese anointed him with holy oil, and

(facing page)
The Fall of Phaeton (detail), 1533.

1 Charles was the last Holy Roman Emperor to be crowned by the Pope. Previously, over the 730 years since Pope Leo III had crowned Charlemagne on Christmas Day AD 800, it had been acknowledged that the only way to acquire the title of Emperor, as opposed to Emperor Elect, was through a papal coronation. Later emperors simply

then Pope Clement gave him the orb and sceptre, sword and crown of Empire.

Afterwards, the Duke of Urbino held that sword aloft in the grand procession that moved from San Petronio to the other great Bolognese church, San Domenico. In his heart, Clement blamed the Duke of Urbino for not intervening to halt the Sack of Rome. He had arrived[2] outside the city with troops loyal to the League of Cognac, but instead of coming to the rescue of the Pope and the city – either for good military reasons or possibly to take revenge for past injuries he had suffered from the Medici – he had just ridden away.

When Florence finally surrendered in August 1530, Clement, who knew the Florentines well, thought it best to introduce them gently to their fate. The terms merely referred to a new form of government 'to be arranged and instituted by his Imperial Majesty within the next four months, always providing that the city's liberty be maintained'.

On 20 August a new government was installed by acclamation (only Medici supporters were allowed into the piazza to shout 'Yes' and 'Palle, palle!'). No one was allowed to leave the city, and the leaders of the Republican party were arrested. Some, including the ex-*Gonfaloniere* Francesco Carducci, were beheaded; others, such as Battista della Palla, were tortured and imprisoned. Della Palla was found dead in his cell in the Tuscan town of Volterra in 1532, presumed to have been poisoned.

It was a time of settling scores. The effective head of the Florentine

proclaimed themselves 'Elected Emperor of the Romans'. The ceremony at Bologna thus marked the end of a long era.

2 The army commanded by the Duke of Urbino and the Marquis of Saluzzo was visible from Castel Sant' Angelo on 1 June, raising hopes among the besieged which were not fulfilled. Opinion at the time was divided about the reason for Urbino's consistent failure to attack the enemy. Francesco Guicciardini attributed it to cowardice, his brother Luigi put it down to the Duke's hatred of the Medici. In a dialogue by Paolo Giovio, the Marquis del Vasto, another military commander, took the view that Urbino's forces were too weak and badly trained to retake the city, so his decision was a reasonable one. Many agreed that it was most unwise of Clement to put his faith in a man he and his cousin Leo X had so mistreated. But then, as we shall see in the case of Michelangelo, Clement was not a man to hold a grudge and may not have expected others to do so against him.

Sebastiano del Piombo, *Clement VII
and the Emperor Charles V in
Bologna*, c. 1530.

government was Baccio Valori, who had been the Pope's representative with the besieging army. Michelangelo was on his list of traitors to be punished. According to Condivi, 'The court sent to Michelangelo's house to have him seized as well; and all the rooms and chests were searched, including even the chimney and the privy.' Michelangelo's caution and timidity saved him. He could not escape, but he succeeded in hiding. 'Fearing what was to happen, Michelangelo had fled to the house of a great friend of his where he stayed hidden for many days, without anyone except his friend knowing he was there.'

Figiovanni, the prior of San Lorenzo, stated that he was the one who had sheltered the artist during the purge. He added that a man named Alessandro Corsini had been given the job of tracking down and killing Michelangelo. This man was a kinsman of Baccio Valori, a long-term Medici supporter who had departed the city at almost the same time as Michelangelo the previous October and joined the papal forces. (As part of his punishment for this treachery, a lifelike portrait of him dangling from a rope by one leg had been painted by Andrea del Sarto on the wall of the Bargello.) There might have been an element of grudge involved, since Alessandro Corsini was also a kinsman of the Corsini family member Michelangelo had apparently cut up as an anatomical specimen.

For Michelangelo, the 'many days' he spent hiding in the house of Prior Figiovanni must have been terrible: listening to stories of the arrests, tortures and execution of his friends and colleagues, waiting for the knock on the door. However, Figiovanni, having dealt for many years with Clement, probably sensed the Pope would not want Michelangelo killed or ill-treated. Indeed, Clement's over-riding anxiety was to avoid damage to the city, which was, after all, his family's prime possession; that concern included the safety of its great artist.

Immediately after the surrender, there remained a serious danger that Florence would be sacked, as Rome had been. The imperial army, their pay many months in arrears, stayed camped outside until enough money was raised to persuade them to leave. Food continued to be very scarce. On 25 August 1530 Gismondo Buonarroti wrote to Lodovico, who had taken refuge in Pisa with his grandson Lionardo.

There were some cases of the plague, and a great lack of bread, although some cheese, eggs and preserved meat were beginning to arrive. After some time life began to return to normal, so far as it could with a population reduced by about a third.

When the confusion of the transfer of power was over, Clement sent orders to Florence stating that Michelangelo should be found and, if he proved willing, carry on with the works at San Lorenzo. According to Condivi, instructions were that 'he should be left at liberty and treated courteously.'

It was an act of great forbearance, considering the personal nature of Michelangelo's betrayal and the fact that – rightly or wrongly – it was believed that the artist had insulted Clement and his heirs. Allegedly, Michelangelo proposed that the Palazzo Medici should be demolished and replaced by an open space named the Piazza de' Muli (Piazza of the Mules), 'mule' having the slang meaning of 'bastard'. Though the story was related by Varchi long afterwards, the harsh joke could have been authentic.

Michelangelo returned to working on the Medici Chapel but, he told Condivi – in a bitter phrase – he was now 'driven more by fear than by love'. Quite when his pardon was issued is unclear, but in November Clement was communicating with Michelangelo about the projects in San Lorenzo. By the twenty-fifth Michelangelo was 'well disposed to work there', and in December was again to be given his monthly salary.

*

Clement may have wanted Michelangelo alive and well treated, but Clement was in Rome. Florence was now controlled by political opponents and – in some cases – personal enemies. The city was run by the Pope's commissary, Baccio Valori, who was living in the Palazzo Medici almost as a dictator. According to Vasari, 'to win Baccio Valori's goodwill Michelangelo then started work on a marble figure showing Apollo drawing an arrow from his quiver, and he carried it almost to completion.' This, then, was a sculpture Michelangelo made as an insurance policy against persecution by the new regime.

It is a strange work. Art historians have found it impossible to decide whether it is supposed to be a David or an Apollo (or perhaps the first in the process of turning into the second). It is an elegant, slightly listless little figure: Michelangelo working at less than full power. Valori also asked Michelangelo to make designs for his house.

Over a year later he wrote to Michelangelo, mentioning the figure, which he still hadn't received, but he didn't press Michelangelo about the sculpture, 'as I know for certain, from the affection that you bear me, that I do not need to demand it.' In fact, Valori never got it; the moment when he had the power to extract a work from Michelangelo had passed. It is likely that he stopped carving *David/Apollo* in late 1530, when Valori was replaced as the Pope's representative by Nikolaus von Schönberg, Archbishop of Capua (1472–1537).

Baccio Valori wasn't the only one waiting in vain for something by Michelangelo. Alfonso d'Este was keenly looking forward to getting his *Leda and the Swan*; as he wrote, 'Every hour seems to me a year waiting to see this work.' He sent an emissary – Jacopo Laschi, a courtier known as Il Pisanello – to take delivery of the painting and arrange for payment. In the extremely courteous way d'Este approached this subject there was a hint that he knew the situation had changed. When *Leda* had first been promised, he had been a valuable ally of the Florentine Republic. Under those circumstances, the picture had probably been planned as a gift. Subsequently, he had been of no help to the republic, and had actually assisted its enemies.

In the letter, he intimated that Michelangelo could name his price, asking him to write, saying, because I shall be much more certain of your judgement than of my own in evaluating it'. Moreover, he would be a useful friend for the artist if he got his picture, always 'desirous of pleasing you and being of help to you'.

It was not a bad offer. D'Este obviously still very much wanted his picture. However, Michelangelo was no longer d'Este's prisoner. As Condivi related, Michelangelo showed the Duke's emissary Il Pisanello the painting, which somehow failed to make the impression it should have: 'The duke's go-between, mindful of what he knew about Michelangelo's great reputation and being unable to perceive

the excellence and artistry of the picture, said to him: "Oh, but this is just a trifle."'

Michelangelo then asked him what he did, and he replied he was a merchant or dealer (*mercante*). The artist immediately presumed that this was an insult: the courtier's claim to be a merchant was a sarcastic reference to the fact that all Florentines were known to be money-grubbing traders. Infuriated, Michelangelo replied: 'You have just made a bad deal for your master; get out of my sight.'

It may be that Il Pisanello made an unwise remark, but that was probably only an excuse. Michelangelo must have blamed d'Este for the city's defeat; what was more, as he must have known, the Duke was viewed with great suspicion by the Pope. Michelangelo didn't want his money or his friendship. Instead, he made a free gift of this valuable work of art to his assistant, Antonio Mini, who needed to raise funds for his sister's dowry.

In autumn 1531 Mini took it with him to France. The young man sent a series of letters to Michelangelo, at first excited by his journey though north Italy and over the Alps, then disillusioned by the difficulties he encountered when he arrived. Eventually, poor Mini died; *Leda* entered the French royal collection, where, as we have seen, it seems to have been destroyed a century or more later, presumably because some puritanically minded person found it indecent.

*

Slowly, Florence was nudged towards rule by Alessandro de' Medici. In February 1531 Alessandro, still only twenty and hence under age, was given the right to a seat on all government bodies. His parentage was, and remains, unclear. His mother was almost certainly a North African slave named Simonetta, making Alessandro of mixed race and explaining his nickname of *Moro*, or Moor. But his father was either Lorenzo II de' Medici (the official version) or, it was rumoured, the young Giulio de' Medici in the days before he had become a cardinal, let alone Pope Clement VII, though this was never publicly acknowledged.[3]

3 After having been freed from slavery, Simonetta lived as a peasant at Colle Vecchio near Rome. In 1529 she wrote to Alessandro asking him to assist her in her poverty,

While he was being made head of state, Alessandro himself was in Brussels, where the Emperor Charles V made him a Duke and betrothed him to his own illegitimate daughter, Margaret of Austria. He arrived back in Florence on 5 July 1531 and the next day the proclamation from the Emperor was read out, pardoning the city but explicitly recognizing Alessandro de' Medici as ruler. Florence was now governed by a man who was inexperienced, still extremely young, and had some habits – such as an enthusiasm for seducing nuns and/ or wives and daughters of citizens – guaranteed to make him unpopular in a city that had recently been a Savonarolan republic with Christ as its head.[4]

Clement favoured Alessandro over Ippolito (illegitimate son of his cousin Giuliano de' Medici) – although the youth seemed badly suited to high ecclesiastical rank. Ippolito, perhaps as a consolation prize, was made a cardinal. The historian J. R. Hale described him rioting 'incognito with a gang of like-minded teenagers through the streets of Bologna' at the time of Charles V's coronation there in 1530.

The rise of Alessandro was an ominous development for Michelangelo. 'He knew,' as he told Condivi, that 'Duke Alessandro hated him deeply and was a wild and vindictive youth.' The original cause for this hostility is unknown – perhaps it was simply temperamental, perhaps Alessandro resented Michelangelo being forgiven so easily for his treachery (and being so venerated by Clement, who was perhaps, as we have seen, Alessandro's own father).[5] In any case, Michelangelo

and shortly afterwards died. He was accused of having had her poisoned to remove an embarrassment.

4 J. R. Hale describes Alessandro as 'sexually the most voracious of his family', with a taste for going about incognito, but also 'in an informal and eccentric way, a skilled politician'.

5 It may be relevant to Alessandro's hatred of Michelangelo that the artist was apparently close to Alessandro's cousin and rival, Cardinal Ippolito de' Medici. According to Vasari, the cardinal 'loved Michelangelo dearly', and once gave him a beautiful Arabian horse which Michelangelo admired, plus ten mule-loads of fodder to feed it. There was certainly no love lost between the two younger Medici. In 1534, Ippolito wrote to Charles V asking to replace Alessandro, whom he subsequently plotted to blow up with a bomb under his bed.

was in no doubt that Alessandro 'would have got rid of him, were it not from consideration of the Pope'.

Other would-be patrons were not as easy to escape as Alfonso d'Este. One of Charles V's senior commanders, the Marchese del Vasto, soon asked for a picture. In April 1531 Figiovanni forwarded this request for a painting 'at your convenience', which could, it seemed, be anything 'on canvas or on panel, in your own way, and with the choice of subject at your discretion'. By this stage, collectors just wanted a Michelangelo, no matter what it depicted. Exhausted and busy though he was, Michelangelo immediately produced a cartoon of Christ and Mary Magdalene in the garden, *Noli me Tangere*.[6]

When the Marchese visited Florence in mid-May he wanted to inspect the sculptures in the Medici Chapel and the cartoon for his own painting. Figiovanni noted that Michelangelo had worked a miracle in producing it so quickly and that it was a 'divine thing'.

This was not the only design he produced under pressure. There was also a cartoon for Valori's successor as acting governor of Florence, the Archbishop of Capua. This was made, according to Antonio Mini, 'in a fury to satisfy the Archbishop'. Michelangelo was in no position to refuse either of these patrons, but succeeded in evading the task of actually painting the pictures. Vasari described how Michelangelo recommended to the Marchese that the artist Pontormo should do this job: 'no one could serve him better than that master'. The collaboration worked so well that Pontormo also painted the picture for the Archbishop from Michelangelo's design.

Probably around this time – exactly when it is impossible to be sure – Lodovico Buonarroti died. Michelangelo's reaction was recorded in two quite different ways. One was a lengthy, unfinished poem in which he compared his grief for his father with his feelings about his brother Buonarroto's death a couple of years earlier: 'He was my

6 It has been suggested that this might have been intended as a gift for the Marquis's relation by marriage, Vittoria Colonna, the Marchioness of Pescara. It would certainly have fitted with the themes of a couple of works Michelangelo later made for her, which depicted Christ with female figures. If this theory is true, this was a first contact between Michelangelo and a person who was to become extremely important in his life (as we shall see in the next chapter).

brother, you were father to me/To him by love to you by duty bound.' He contrasted the sense of loss he felt for each by using the metaphor of art: 'My brother's painted by my memory's hand,/But you it sculpts alive within my heart.' By this, Michelangelo – with his profound belief in the significance of sculpture – meant that he felt Lodovico's absence more deeply.

He then went on to imagine his father in heaven: 'you have become divine . . . not without envy can I write that line.' Lodovico's death, he reflected, teaches him how to die. Michelangelo looked forward to joining him: 'perfect love of father and son finds/Increase in heaven, as all virtues do.' At that point the poem breaks off; no doubt Michelangelo was aware that his love for his father had in reality been far from perfect.

The other record of Lodovico's death was a list of expenses incurred for the old man, both during his illness and for his funeral. Judging from these payments, it looks as if Lodovico died some time in the winter of 1530, or in the first part of 1531: Lodovico was, then, eighty-six years old at the time of his death; he bequeathed Michelangelo good genes for longevity, if not much else.

The Buonarroti family was shrinking. It now consisted of Michelangelo, two younger brothers he did not much like – Gismondo and Giovansimone – plus his surviving nephew and niece, the last of whom was living in a convent. There was less than there had been to tie him to Florence.

*

Both physically and mentally, Michelangelo was in a bad state. He had survived three years of plague, warfare, malnutrition, heavy responsibility, feverish work and constant anxiety, ending with crushing disappointment and a narrow escape from execution as a traitor.

By June 1531 Pope Clement, whose agents had quite recently been attempting to put Michelangelo to death, was becoming worried about the artist's health. Via his secretary, Pier Polo Marzi, he instructed Michelangelo to take things steadily, not to drive himself to extreme exhaustion, but in such a way as to keep himself healthy and vigorous, alive and not dead. Disturbing reports must have been reaching Rome.

It doesn't seem Michelangelo took that advice to heart. On the contrary, he apparently reacted by furiously overworking and treating himself with almost masochistic harshness. In September Giovan Battista Mini, the uncle of Michelangelo's assistant Antonio Mini, sent precisely such a warning to Baccio Valori. He had not seen Michelangelo for some months, the sculptor having been staying at home to avoid the plague, but had seen him a couple of times recently. They had talked a great deal about art with Antonio and the painter Bugiardini.

Together, they went to look at the sculptures for the Medici Chapel, the elder Mini being particularly struck – as was Vasari – by the figure of *Night*, 'a most miraculous thing'. Michelangelo was just completing work on one of the 'old men', probably *Evening*, the more finished of the two.

Mini remarked to his nephew Antonio and Bugiardini that Michelangelo seemed to have become terribly thin, and they responded that they didn't think the artist could live much longer if something didn't change. He worked a lot, ate badly and slept little. As a result he seemed extremely tired and 'diminished in the flesh'; he was suffering from catarrh, headaches and dizziness. The reason, Antonio and Bugiardini thought, was that he had two problems: one in the head and the other in the heart.

They believed the first ailment was caused by his working in the sacristy during winter. It would be better for the Pope to command him to work on the sculptures of the *Madonna and Child* and *Duke Lorenzo* in his studio (where there was a stove). Meanwhile, others could get on with working on the architectural framework of the chapel. The other problem ailing Michelangelo's heart was his dispute with the Duke of Urbino: that is, the tomb of Julius II.

*

Michelangelo was back in correspondence with his old friend Sebastiano, who marvelled that he was still there at all, having suffered so much danger, worry and exhaustion. Sebastiano himself could never be again the man he had been before the Sack. Now that they had gone through fire and water, he said to Michelangelo, let them try to live the rest of the life remaining to them in as much peace as possible.

Sebastiano was now what he had never been under Leo X: a favoured artist with the ear of the Pope. In 1531 he was appointed to the sinecure of sealer of papal documents with the lead seal, or Piombo (hence he became known as Sebastiano del Piombo). This post required him to take holy orders. Sebastiano sent a slightly embarrassed letter, mentioning that he had also consequently been made a friar, and that Michelangelo would laugh if he saw him in his habit.

During 1531 and the early months of 1532 the interminable question of Julius II's tomb was once more renegotiated. The question was mooted by Sebastiano, who had run into Girolamo Genga (1476–1551), a painter and architect at the court. Genga passed on the information that the Duke was still keen for the tomb to be completed but was angered by Michelangelo's insistence that in order to complete the project he required another 8,000 ducats. No doubt he took the view that enough time and money had already been expended, with little apparent result.

In June 1531 the Pope, touchingly delighted to receive a letter from Michelangelo, offered to mediate between the artist and the Duke. Clement's purpose in trying to settle the dispute was partly to lift the burden of stress from the artist: 'We shall make him twenty-five years younger,' he announced to Sebastiano: a reminder that the wretched business had now been dragging on for a quarter of a century.

Essentially, as Michelangelo wrote to Sebastiano in August 1531, there were only two possibilities:

> One is to do it; the other is to give them the money to have it done themselves. Of these two courses, only the one agreeable to the Pope can be taken. To do it myself will not, in my opinion, be agreeable to the Pope, because I should not be able to devote myself to his things. Therefore they'll have to be persuaded – I mean whoever is acting for Julius – to take the money and get it done themselves.

A new agreement was eventually reached, but not without a great deal of discussion, and many of Sebastiano's garrulous exhortations to his old friend. The points that Sebastiano wanted to get across were how much the Pope favoured Michelangelo, how good an opportunity

this was to get free of the whole wretched business, and how little Michelangelo's reputation would suffer from having some other, inferior sculptor finish off the tomb. Sebastiano was still stressing the last point on 5 April 1532 when Michelangelo was finally about to set out for Rome: 'You are resplendent like the sun. Neither honour nor glory can be taken from you; just consider who you are, and think that no one is making war on you except yourself.'

Meanwhile, Clement was moving cautiously to transform Florence into a hereditary possession of his family. There was much canvassing of influential political figures behind the scenes before, at the end of April, another new constitution was agreed. At its head would be Alessandro, 'who henceforth is to be called the Duke of the Florentine Republic'. His son would succeed him, or, failing that, the next of kin. Alessandro de' Medici – dissolute, very young, but shrewd in his way – was now in a position that Cosimo the Elder and Lorenzo the Magnificent had hesitated to take.

When he returned to Rome for the first time in many years, Michelangelo did not stay in his own house on Macel de' Corvi, which after the Sack and fifteen years of neglect was in a dilapidated state. Even the slabs of marble for Julius's tomb were tumbled over in the workshop. Instead he lodged in the Belvedere at the far end of the Vatican courtyard, where he stayed in the apartments of a friend, Benvenuto della Volpaia (a member of the same enterprising family as the draughtsman of the architectural drawings he had copied in 1516).[7]

When Michelangelo met with Clement – probably immediately after his arrival – it was the first time the two men had encountered each other face to face in a decade. Michelangelo had good reason to be nervous about the meeting.

The new contract for the tomb, the fourth to date, was signed in the Pope's own apartments on 29 April in the presence of Clement himself, Sebastiano and the ambassador to the Duke of Urbino,

7 Benvenuto promised to look out from the top of Bramante's spiral staircase when he heard Michelangelo was approaching. His room was prepared by Benvenuto's wife, Mona Lisabetta. (She sent a message after Michelangelo returned to Florence, saying he should stay in the same room next time.)

Giovan Maria della Porta. On the surface, it was a reasonable com-
promise. Michelangelo would finish six of the statues he had already
made (which six is unclear, perhaps the four slaves done in Florence,
plus *Victory* and *Moses*). Others would make five more, paid with
2,000 ducats from Michelangelo, who would keep the house in Rome.
Everything was to be done within three years. Michelangelo was to
spend two months of the year in Rome, the remainder in Florence.
He would work only on the tomb of Julius and the projects at San
Lorenzo.

There was to be a new location for the tomb too. Placing it in
St Peter's was obviously impractical, as construction there had more
or less ceased; grasses and wildflowers sprouted from the now deceased
architect Bramante's new crossing piers, as if from a Roman ruin. The
Duke of Urbino favoured Santa Maria del Popolo, which was associ-
ated with the della Rovere family. Michelangelo countered that there
wasn't a good site for it there and the light would be wrong (which
revealed how carefully he thought about the placing of his works).
Instead he proposed San Pietro in Vincoli, the church with which
Julius was associated when he was a cardinal.

The contract was finalized two days after the new constitution of
Florence was agreed. Clement must have felt satisfaction at solving
two such long-running disputes: the government of the city and the
completion of the tomb of his predecessor. He ordered Michelangelo
to return that very day to continue work on the Medici tombs at San
Lorenzo.

Subsequently, Michelangelo came to believe – whether through
paranoia or not, it is hard to say – that the ambassador to the Duke
of Urbino had 'got together with the notary' and altered some clauses.
Clement, Michelangelo insisted, would never have allowed these add-
itions. He claimed that Sebastiano had wanted to inform the Pope,
and 'get the notary hanged'.

Meanwhile, the ambassador was working hard to persuade Duke
Francesco Maria della Rovere to accept these terms. He reported that
everyone in Rome thought the agreement was marvellous and the
result would be splendid, and advised the Duke to write a personal,
polite letter to Michelangelo, praising and encouraging him, 'as it has

been said to me that this man will shift to being much more tractable when he recognizes your good disposition towards him, and that he will be set to perform miracles.' Nonetheless it took over a month for the Duke – whose instinct probably was not to offer Michelangelo soft words – to ratify the contract.

Soon after the ratification came through, Michelangelo announced that he would like to return to Rome. There followed a concerted campaign to dissuade him from doing so, partly, presumably, because the Pope's priority was for him to push on with the projects in Florence. But Clement and his circle were also concerned about the possible effects of Michelangelo suddenly exchanging the climate of Florence for the steamy atmosphere of Rome.[8] Even the ambassador to the Duke of Urbino was persuaded by Clement that for Michelangelo to come to Rome in the hot season would be dangerous. September would be a safer month. Sebastiano implored him at least to ride when it was cool. Michelangelo seems to have responded that working with clay – presumably on models for Julius's tomb, which is what he proposed to do – was easier in the heat. However, he delayed his arrival until September. He was to stay for a long time.

Michelangelo's initial purpose in Rome was probably to get on with the tomb as rapidly as possible. However, before the end of the year something happened on a much deeper level than the practical. It was an event that overwhelmed Michelangelo's emotions and transformed the creative rhythm of his life. He encountered a young Roman aristocrat named Tommaso de' Cavalieri (known to his intimates as Tommao).

Exactly how and where they met is unknown, but it would not have been difficult. Cavalieri's house was on the Capitoline Hill, which made him and Michelangelo almost neighbours: Macel de' Corvi, to which he had now returned, was at the foot of the hill. In addition, they had friends and acquaintances in common. Tommaso's maternal grandfather was a Florentine banker, and Michelangelo knew many in this community.

8 Perhaps Benvenuto della Volpaia's sudden death from fever at the end of June renewed worries about Michelangelo. Having lost one valued master from his circle, Clement did not want to take risks with the well-being of another.

One of them, the faithful Leonardo Sellaio, had disappeared, possibly in the Sack. Bartolomeo Angelini, a customs official, now looked after Michelangelo's affairs. He may also have helped to introduce them; he would come to be an intermediary. Alternatively, perhaps the introduction was made by Pierantonio Cecchini, a Florentine sculptor. Cavalieri was already interested in the arts – and, what is more, practising them.

How old Cavalieri was when he and Michelangelo met is a much debated point. The register of his birth has not been found, but circumstantial evidence suggests he was born between 1512 and 1520, and was thus between twelve and twenty-one when he met Michelangelo (who was fifty-seven in the winter of 1532/3).

No certain portrait survives but, to his contemporaries, Tommaso was good-looking and cultivated. The Florentine intellectual Benedetto Varchi, writing fifteen years later, described Cavalieri as of 'incomparable beauty', with 'graceful manners, so excellent an endowment and so charming a demeanour that he indeed deserved, and still deserves, the more to be loved the better he is known'. Vasari noted that 'infinitely more' than any other friend, 'Michelangelo loved the young Tommaso de' Cavalieri, a well-born Roman who was intensely interested in the arts.'

For the artist it seems to have been a *coup de foudre*. With his combustible flesh, bones as dry and brittle as kindling and 'sulphur heart', he wrote in a sonnet to Tommaso, it was no marvel that 'in a flash, one should be caught in the first fire and set alight.' His initial approach, it seems, was to send a written message via the sculptor Pierantonio Cecchini and, with it, a gift of two drawings.

The letter itself is lost, but a draft of a follow-up survives, marked by Michelangelo's feeling of alarm at having sent the first: 'Inadvisedly, Messer Tommao, my dearest lord, I was prompted to write to your lordship, not in answer to any letter I had received from you, but being the first to move.'

Michelangelo had thought of this approach as like crossing a little stream. Instead, he found himself floundering in the ocean; then, continuing with his aquatic metaphor, he apologized, for not having 'the skill to steer a course through the surging sea of your brilliant

endowments'. Nothing anybody else could do was worthy of the 'matchless and unequalled' Tommaso. If he were ever to believe that anything he could do might please the young man, he would devote the present and his remaining life to serving him, Michelangelo's only regret being that he had not spent the past doing so too. This convoluted expression of self-abasement – so different from the manner in which Michelangelo dealt with popes and dukes – was never sent. Rather, a reply arrived from Tommaso, not so extravagantly grovelling as Michelangelo's, but still warmly courteous: 'I promise you truly that the love I bear you in exchange is equal or perhaps greater than I ever bore any man, neither have I ever desired any friendship more than I do yours.'

Tommaso had been ill – presumably the reason for his delay in replying – and felt that Fortune was opposing him in thus depriving him of the company of 'a man supreme in art'. However, now that he was recovering, he would spend his time looking at the two drawings Michelangelo had sent ('the more I study them the more do they delight me').

On receiving this Michelangelo sent – for him – a positively euphoric reply. He would have counted himself disgraced, before heaven and earth, if he had not learned that Tommaso 'would willingly accept some of my drawings'. The news had caused him 'much surprise and pleasure no less'. He dated it, 'on the, for me, happy first day of January'. At the start of 1533 a new phase in Michelangelo's life and work had begun.

*

Whatever the strength of his feelings, Michelangelo's relationship with Tommaso de' Cavalieri is unlikely to have been a physical, sexual affair. For one thing, it was acted out through poems and images that were far from secret. Even if we do not choose to believe Michelangelo's protestations of the chastity of his behaviour, Tommaso's high social position and the relatively public nature of their relationship make it improbable that it was not platonic.

The philosophical justification for it Michelangelo advanced was the same as the claim made by the Neoplatonists at the court of

Michelangelo (?), *Ganymede,* c. 1533.

Lorenzo the Magnificent, in particular by Marsilio Ficino: love of beauty was an experience of the good, which meant, in Christian terms, of the divine. Therefore the contemplation of Tommaso's good looks was virtually a foretaste of heaven. In looking at his 'lovely face', Michelangelo claimed, his soul had 'often already risen up to God'. This reasoning was emotionally and intellectually precarious. However, on this shaky equivalence, a great deal of Michelangelo's life's work rested. This was why it seemed right to him and his contemporaries to cover the ceiling of the Sistine Chapel with beautiful male nudes.

In a letter he received from his old friend Bugiardini about an ominous comet he had seen, Michelangelo wrote out sonnets to Tommaso. The first began: 'If one chaste love, one pity pure, sublime, should link two lovers in a single fate . . .' It continued through a sequence of conditional clauses to list the possibilities of such a union: 'If one soul into two bodies can become eternal, so that both are raised in flight to heaven on like wings'. The conclusion was that only one thing can break that bond: scorn or disdain. His greatest worry, at this point, seems to have been that Tommaso's mind would be poisoned against him.[9]

A second poem emphasized the chastity of Michelangelo's love: 'Alas, how therefore shall the chaste desire/That burns within my heart ever be heard/By those who in others only see themselves?' Evidently, not everyone believed the purity of Michelangelo's devotion to this young man. Some were warning Tommaso not to become too closely involved with this famous artist, old enough to be his grandfather. For a while Michelangelo thought Tommaso was listening to this 'foolish, fell, malevolent crowd', who accused others of sharing their own evil suspicions.

The unusual aspect of Michelangelo's love for Tommaso – apart from its intensity – was that it immediately gave rise to great art. With

9 Humorous accusations of same-sex relationships were common among Roman humanists, such as the circle of Paolo Giovio, and were often couched in scatological Latin verse. These were just the sort of people who might have made amusingly defamatory remarks about Michelangelo's feelings for Tommaso. Being laughed at might well have discouraged a teenager from having anything more to do with this ardent artist.

that first letter Cecchini had brought Tommaso two drawings. They may have been of Ganymede and Tityus; certainly Tommaso was given elaborately finished drawings of those subjects early on. In some respects the two were a pair; in imagery they mirrored one another, as in each scene the most active participant was a gigantic, powerful bird. However, the images held opposite meanings.

In classical mythology, Ganymede, son of the ruler of Troy, was the most beautiful of men (rather as Tommaso de' Cavalieri was said to be by his admirers). One day, when he was tending sheep on Mount Ida, he was snatched by the god Jupiter in the form of an eagle and carried up to Olympus, where he became cup-bearer to the gods. From Plato onwards, this story was frequently given a moral, almost mystical, interpretation, in which Ganymede was the human soul, beloved by the divine power and carried up to heaven.

Ostensibly, then, this image was of just the moral, elevating variety of love that Michelangelo proclaimed in his poems to Tommaso, the kind traduced by the vulgar liars who misunderstood the purity of the artist's behaviour. However, there was another interpretation of the relationship of Jupiter and Ganymede current in antiquity and common in sixteenth-century Italy: that this was the archetype of a sexual partnership between an older man and a youth. Ganymede was another name for catamite.

Michelangelo's conception managed to suggest both of these possibilities. His divine eagle does not look like a virtuous bird. On the contrary, it is a ferocious creature, head and neck thrust forward, beak gaping in a predatory leer, its eye fierce and beady. Ganymede's calves are gripped tightly in its powerful talons, the great bird's groin pushed against his buttocks. A psychological complication is that, in his poetry it is Michelangelo who is carried up on Tommaso's wings, the artist who is the passive captive, as he memorably announced in a sonnet punning on Tommaso's surname: 'To be happy I must be conquered and chained . . . naked and alone', by 'an armed Cavalier'.

The drawing of Tityus depicted, in contrast, the suffering that comes from physical desire. The giant Tityus had attempted to rape Latona, mother of Apollo and Diana. His punishment in Hades

was to have his ever-renewing liver – traditionally, the seat of lust – eternally devoured by a vulture.

In Michelangelo's drawing Tityus is a noble nude, brother of Adam on the Sistine Chapel ceiling. He is manacled to a rock, turning his

Tityus, c. 1533.

head towards the huge bird – a close relation of the eagle that captured Ganymede – that is perched above him, extending its neck to peck at his midriff. The sense of suffering is conveyed not so much by the main figure as through an almost surreal detail: to the right a tree is growing, its roots clutching the rock below like a skinny hand, and from the side of its trunk the severed stump of a branch has metamorphosed into a human face with a single staring eye and screaming mouth. Below, at the edge of the stone ledge, scuttles a crab. These last two strange items allude to Dante's *Inferno*.

In Canto XIII the poet comes across a macabre living wood of

souls, forever wailing, transformed into knotted trees with warped trunks and dark leaves. There, suicides are punished. The crab hints at the zone below, which, as Dante's companion, Virgil, points out, is a desert of horrible, burning sands. There, the sodomites were punished.

The drawing of Tityus's torture is not a study for something else but just as much a considered, completed work as a section of the Sistine Chapel ceiling. The scale was small, but this and the other drawings given to Tommaso – though finished in themselves – would have provided the designs for a sequence of mythological paintings comparable to the Titians in Alfonso d'Este's *camerino d'alabastro*.

If Michelangelo felt himself held captive by Tommaso, he was demonstrating a remarkable degree of freedom towards his patrons. Instead of serving anyone, he was giving the finest fruit of his imagination *gratis* to someone he loved.

These drawings were what numerous wealthy and powerful collectors craved: the inventions of Michelangelo's mind – and he was presenting them, humbly, to a teenager. More: the drawings show how hard he was striving to make images that would appeal to a young person. They are full of birds and animals – the eagle and vulture, the crab in *Tityus* – and bizarrely imaginative detail. The drawings were designed to beguile an adolescent, just as he, Michelangelo, had been captivated as a boy by the fish-demons of Schongauer's *Temptation of St Anthony*.

*

Michelangelo stayed on and on in Rome, for much longer than the two months stipulated in his new contract for the tomb of Julius II. One of the things he did during that time was to re-establish his household at Macel de' Corvi.

The street was on the fringe of the *abitato*, the built-up area of Rome, and descriptions of the courtyard and kitchen garden behind the main building suggest an almost rustic setting, with vines, fig trees, peaches and pomegranates, plus a population of chickens, a cockerel and a number of cats.

Michelangelo now had a new servant/assistant, a young man named Francesco d'Amadore, from Castel Durante in the Marche, and

invariably known as 'Urbino', presumably because the famous city was close to his hometown. According to Vasari, he joined Michelangelo in 1530. For the next two decades, Urbino was to be a mainstay of Michelangelo's life. He came to love him as much perhaps as Michelangelo did Tommaso but in a quite different, much less metaphysical manner.

For some reason, conceivably his near-death experiences during and after the siege of Florence, Michelangelo's amorous emotions seem to have become even stronger in his late middle age. The next decade and a half saw the strongest relationships of his life and – not coincidentally – was the period in which he composed the bulk of his 302 poems.

Michelangelo may have made some progress on Julius's tomb at this time, but he also had other things on his mind. Tommaso was one; another was the Resurrection. A series of beautiful drawings from this time – approximately, at least – represent Christ climbing, or flying, triumphantly from his tomb. Some of these may have been done to help Sebastiano, who frequently implored Michelangelo in letters to help him out by providing drawings – something, anything, 'figures, or legs or bodies or arms'. On one occasion, begging for some help, 'a bit of clarification', he slightly blasphemously referred to the Latin hymn '*Veni Spiritus Sanctus*': his point was that without Michelangelo's illumination there was no light in him. It was not to be much longer, however, before Michelangelo's patience with Sebastiano snapped.

Some of the Resurrection drawings may have been for one of Sebastiano's commissions, never actually fulfilled, for an altarpiece in the Roman church of Santa Maria della Pace. Others look like independent works in their own right, or studies for a picture Michelangelo was planning himself. Whatever the reason, he had variations on the theme of the Risen Christ running through his mind.

The most astonishing example is on the reverse of the drawing of Tityus. At some point, apparently after the composition was finished, Michelangelo turned the sheet over and traced the figure of the prone, tortured giant – with the meaning transformed. Tityus's right arm, shackled to the rocky floor of Hades, becomes the left arm of Jesus

The Risen Christ, c. 1532–3.

extended upwards in triumph; instead of reclining, the naked figure now leaps agilely from the open tomb. This transformation reveals how Michelangelo's mind was filled with forms, the meaning of which was in flux. Flip the page, change the angle, and everything was completely different.[10]

*

It was more than nine months before Michelangelo reluctantly went back to Florence, at the end of June 1533. From then on, a stream of letters from Sebastiano and Bartolomeo Angelini kept him up to date with life in Rome.

'Your house is watched over constantly,' Angelini wrote on 12 July. 'I go there often during the day – the hens and their master the cock are flourishing, and the cats miss you dreadfully, though not enough to put them off their food.' Tommaso sent his warm regards, and was hoping, as they all were, for a letter from Michelangelo. A week later the heat was increasing and the crop of figs looked promising. By the beginning of August the Muscat grapes were ripening, 'and Tommaso will have his share, if they survive the magpies.'

There is a charming, gossipy quality to Angelini's letters. This must have been the texture of his friendship with Michelangelo, not only on paper but also face to face. Here was proof that the reclusive artist, for all his angst, could take a relaxed interest in cats and figs.

A torn and damaged sheet of paper with a draft of a letter to Angelini gives a sense of Michelangelo's state of mind (its fragmentary

10 In a masterly exposition of the poems and drafts of poems to be found in one manuscript (Vat.Lat.3211), Leonard Barkan demonstrated how the same flux and metamorphoses that can be found in Michelangelo's drawings also occurred in his poems. These go through multiple versions: Barkan counts twenty different incarnations of some or all of the sonnets. There was a psychological aspect to this. One poem, Barkan points out, though it began as a 'passionate expression of feelings towards Tommaso Cavalieri, ended up in its final form directed to a less specified object, possibly identifiable with Vittoria Colonna'. In the process, a phrase, 'o signor mio' ('o my lord'), turns up in various contexts before vanishing altogether, so that in the end 'it isn't only a male beloved or Tommaso Cavalieri who is cancelled out but the hopes associated with desire itself.'

condition providing an accidental but touching impression of breathless passion). Michelangelo began, apparently, with some discussion of his household at Macel de' Corvi and the political situation, then moved on to the condition of his emotions. A stray phrase connected Michelangelo's 'soul to Messer Tommao'. Then a longer preserved section explained that connection in a piece of poetically metaphysical deduction. If Michelangelo longed, night and day, ceaselessly to return to Rome, that was easy to understand. His heart was in the possession of Tommaso de' Cavalieri, the heart was the dwelling place of the soul. So the 'natural impulse' was for his soul to yearn 'to return to its own abode'.

On 28 July, in reply to some gentle teasing from Tommaso about his failure to write, Michelangelo answered that it was quite impossible for him to have forgotten the young man. He made a comparison between bodily nourishment and the superior, spiritual kind that came from his feelings for Tommaso: 'I realize now that I could [as soon] forget your name as forget the food on which I live – nay, I could sooner forget the food on which I live, which unhappily nourishes only the body, than your name, which nourishes body and soul, filling both with such delight that I am insensible to sorrow or fear of death.' A sequence of drafts exists of this passage, in which he toys with variations on the food/name of beloved comparison as if he were writing a poem.

Michelangelo's mind was full of Tommaso. He implored Sebastiano to send him news of the young man 'because if he were to fade from my memory I think I should instantly fall dead'.

It is hard to disentangle the truth of the relationship between Michelangelo and Tommaso from the curlicues of philosophy, poetic convention and courtly flattery that overlay it. However, it is impossible to doubt that genuine emotions existed on both sides, and that for a while at least Michelangelo channelled all his deepest feelings into adoration of this young Roman gentleman.

The love of Michelangelo for Tommaso was *sui generis*, because it mirrored the uniqueness of Michelangelo himself. He was at once an aristocrat – at least in his own mind – and an artisan, a poet, a carver of stone. Similarly, he and Tommaso were lovers – albeit platonic

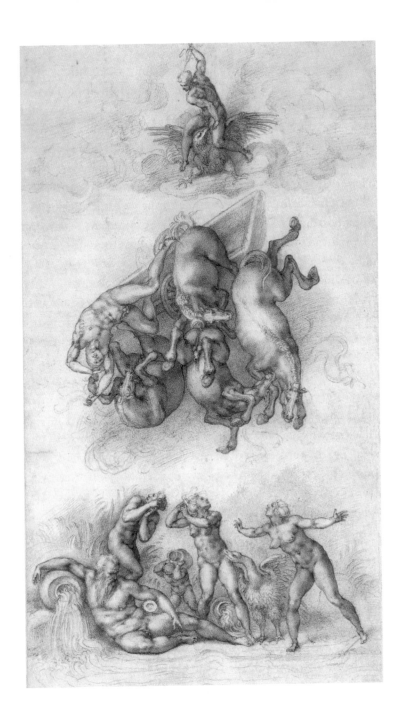

The Fall of Phaeton, 1533.

ones – but also at another level patron and artist. Michelangelo submitted his ideas to the young man for comment or approval almost as he did to Pope Clement – except with more intimacy and feeling.

A drawing of Phaeton riding the sun god's chariot that was finally given to Tommaso was impeccably finished, with a more elegantly pyramidal composition than earlier attempts at the same subject. Presumably it incorporated some of Tommaso's ideas. Indeed, the discussion of nuances of image and meaning between the artist and his beloved was part of the point. Michelangelo treated the young man as if he were a great patron, while simultaneously Tommaso was being taught to understand the subtleties of art.

According to the myth, Phaeton borrowed the sun god's chariot but lost control of its team of horses, so that the earth was in danger of being seared by heat. It was a warning against over-reaching; but who was in danger of flying too recklessly and generating excessive heat – Tommaso or Michelangelo – was not made clear.

*

It did not pass unnoticed that Michelangelo was creating a series of brilliant new works for a young Roman gentleman who lived on the Capitoline Hill. Sebastiano, who had long been hopeful that Michelangelo would return to painting, saw unexpected opportunities in the drawing of Ganymede. In July 1533 he suggested that this pagan and erotic image would be a good basis for a fresco for the interior of the cupola above the New Sacristy. The naked Ganymede, Sebastiano proposed, could be transformed into St John the Evangelist being carried up to heaven.

Perhaps he was joking, but, even if he was, the idea reveals that Sebastiano had seen the potential in Michelangelo's drawings. These might have been on a small scale, but they suggested much larger possibilities. In the same letter, Sebastiano revealed that the Pope had conceived an exciting new commission for Michelangelo, 'something beyond your dreams'. He did not say what this was, but it was almost certainly the very first reference to the enormous painting on the altar wall of the Sistine Chapel that was to take up years of Michelangelo's

life. The subject of this, *The Last Judgement*, had something in common with *Ganymede* and *Phaeton*:[11] it, too, involved naked figures ascending and falling through the air.

On 6 September Tommaso apologized to his 'one and only lord' for not having replied sooner to a letter from Michelangelo, but he had a good excuse, as he had been ill. He added a piece of news: 'perhaps three days ago I received my *Phaeton*, very well done, and it was seen by the Pope, Cardinal de' Medici and everyone.'

Perhaps this was the final, finished drawing of Phaeton sent by Michelangelo from Florence, but it has recently been suggested that in fact Tommaso was talking about a luxurious *objet d'art* he had commissioned: an engraving of Michelangelo's design in rock crystal by a specialist craftsman called Giovanni Bernardi.

Certainly, he goes on to say that his cousin's son, Cardinal Ippolito de' Medici, had insisted on seeing all Michelangelo's drawings and wanted to have both the *Tityus* and the *Ganymede* 'made in crystal'. Tommaso clearly resented this appropriation of these private gifts and thought Michelangelo would too, but he was only partially successful in saving them: 'I couldn't see how to prevent him from having the *Tityus* made, and master Giovanni is doing it now. I worked very hard to save the *Ganymede*.' It sounds as if the *Ganymede* was a particularly private image.

*

On 22 September Michelangelo rode from Florence – perhaps a day's ride away – to meet Pope Clement at San Miniato, where the ancient road north-west from Rome met that from Florence to Pisa. The Pope was en route to France to officiate at the greatest triumph of his last years.

He had presided over the widening split in Western Christendom;

11 Clement had received a briefing in the Vatican gardens, possibly towards the end of June, about Copernicus's new theory that the earth revolved around the sun. He presented the lecturer, Albert Widmanstadt, with a manuscript to mark the event. This exposition had obviously interested and excited him – unlike his successor Urban VIII, in the seventeenth century, who put Galileo on trial for asserting the same idea. Perhaps it set him thinking about a sky-based subject for Michelangelo.

the Church in England was now separating from Rome, as Henry VIII had not been granted his divorce. Here, as so often, poor Clement had no room for manoeuvre: Catherine of Aragon, the queen whom Henry wished to divorce, was the aunt of the Emperor Charles V, who was affronted by this insult to the honour of his kinswoman. Clement might well have been more pliable had he not been, effectively, Charles's prisoner at the moment the question of divorce was raised.[12] On the other hand, Clement was extremely successful in enhancing the power of the Medici. By 1533 his illegitimate son (or cousin's grandson) Alessandro was ruler of Florence, the illegitimate Ippolito was a cardinal and his cousin's grand-daughter Caterina was betrothed to Henri, second son of Francis I, King of France.

Despite his failing health, Clement decided to oversee the wedding in person. The journey was postponed at one point because Clement was shouting out in pain from gout, but he and his entourage finally left Rome on 9 September. When he and Michelangelo met, it is hard to believe that Clement's magnificent new commission for the artist was not on the agenda.

Michelangelo was increasingly ill at ease in Florence, which was in a state of seething resistance to the regime of Duke Alessandro. Francesco Guicciardini stated baldly, 'We have a whole people opposed to us, and the young more than the old.' It was therefore necessary to take steps to hold the city down.

The bastion Michelangelo had built at the Porta alla Giustizia had been strengthened and Duke Alessandro had had his own coat of arms placed on it. To Michelangelo's friend Donato Giannotti this was visible evidence that the republic was being replaced by tyranny; it must have infuriated Michelangelo. Alessandro also disarmed the citizens and installed a garrison of Spanish troops to protect

12 Henry first began to have serious doubts about the legality of his marriage to Catherine in 1527, because she had previously been married to his now deceased older brother Arthur and, according to Leviticus, if a man weds his brother's wife they shall be childless. Henry and Catherine were without a male heir. At the moment when Henry demanded a separation from her, on 22 June, Clement was under siege by imperial forces in the Castel Sant' Angelo. If Clement had had more freedom of action, very probably there would not have been an English Reformation.

him under the command of Alessandro Vitelli (who ordered a second version of Michelangelo's *Noli me Tangere* to be painted by Pontormo).

By April 1533 a project to build a vast new stronghold for this army of occupation was in the air. A debate began about where it should be sited and, naturally, one of those on the list to be consulted was Michelangelo, ex-Captain General of Florentine fortifications. However, according to Condivi, when Vitelli asked Michelangelo to ride over and give his opinion, the artist said he would not unless directly ordered by the Pope. This 'greatly enraged the Duke'; from that point, even more than he had before, 'Michelangelo went in fear.'

It is not clear when this tense exchange occurred, but early autumn 1533 is a likely moment. The final decision about the site of the fortress had been postponed until after the Pope's return from France (and while he was away Michelangelo's excuse that he would do nothing without Clement's order would have been particularly effective).

Clement officiated at Caterina's wedding in Marseilles on 28 October, and was not back in Rome until December. In the meantime, Michelangelo left Florence. On 29 October he was still settling accounts with the nuns who were looking after his niece Francesca. Soon afterwards he was probably back in Rome, where, according to Angelini, his share of the Muscat grapes and pomegranates from his garden was being saved and everyone – including Tommaso – was eagerly anticipating his return.

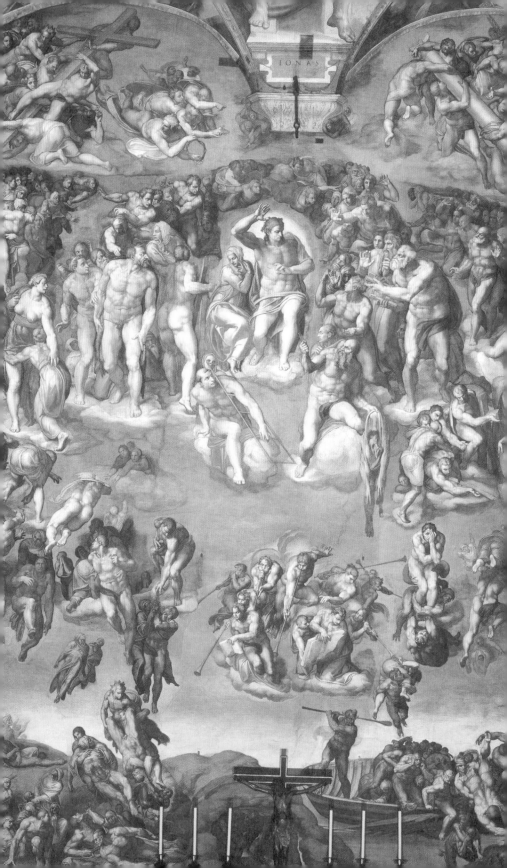

JUDGEMENT

*'The exchange of kisses that [Michelangelo] has
portrayed among some of the saints in heaven greatly
annoys the rigid censors of painting. They say that he
certainly fell into impropriety with this gesture, since it is
not plausible that the blessed should kiss in this
manner when they have been restored to their bodies,
no matter how much they may love one another and
rejoice in one another's glory.'*

– Gregorio Comanini, *Il Figino*, 1591

Sebastiano's first mention of the Pope's new project for
Michelangelo in the summer of 1533 was tantalizingly vague:
'something beyond your dreams'. This may have been because,
beyond deciding that he wanted Michelangelo to paint once more in
the Sistine Chapel, Clement had not yet settled precisely what the
commission would be.

According to Condivi, the Pope, 'being a person of great discern-
ment . . . brooded on this project time and time again'. Eventually, he
elected to have Michelangelo paint 'the day of the Last Judgement'.
Vasari described an even more ambitious enterprise: that Michelangelo
would paint *The Last Judgement* on the altar wall; but that he would
also paint the opposite, end wall of the chapel with 'a scene showing
Lucifer driven from heaven as a punishment for his pride and hurled
with all the angels who had sinned with him into the depths of hell'.
This second subject, if it was really ever considered, was quickly
shelved. The idea is plausible, however, because it would have looked
so good: two mighty frescoes by Michelangelo depicting airborne

*(facing page)
The Last
Judgement,
1536–41.*

figures and the topography of hell (which were, of course, the common factors in three of the drawings for Tommaso that had been attracting so much attention: *Phaeton*, *Tityus* and *Ganymede*).

When Clement got back from France in mid-December 1533, he got down to the task of persuading Michelangelo to paint a huge new mural – indeed, possibly two of them. The artist's resistance did not take long to break. On 2 March 1534 a Mantuan agent in Venice, who had obtained the information from the imperial ambassador – who in turn must have heard the morsel of gossip from someone in Rome – reported that Clement had so worked on Michelangelo that he had persuaded him to paint a mural above the altar of the chapel. He added, wrongly, that the scaffolding had already been erected.[1] By the summer of 1534, however, Michelangelo had returned to Florence for another stint of supervising the works at San Lorenzo.

At that point, Clement entered his final, lingering illness. On 24 August he was given extreme unction, then hung on for another month. In mid-September Michelangelo left Florence for Pescia, west of the city, where he met Cardinal Cesis (1481–1537) – who, knowing the Pope's illness, was probably en route to take part in the next con-clave – and Baldassare Turini da Pescia, the papal secretary. He went on with them via boat from Pisa to Rome. This looks like a pre-arranged escape: another flight.

Two days after he arrived, on 25 September, Clement VII died. It was providential, Michelangelo told Condivi, that he was not in Flor-ence at this moment, for he believed – rightly or wrongly – that Duke Alessandro, freed from the restraint of the Pope, would have had him killed. Michelangelo never set foot in his native city again.

He left the projects at San Lorenzo in a semi-completed state. The reading room of the library was finished, and the vestibule partly so, but,

1 What else Michelangelo did that winter is unknown. Presumably, he did some work on the tomb of Julius, which was due to be completed in April 1535, although it is not clear what it was. Perhaps he made models for some of the new figures in the reduced project, such as the effigy of the reclining Pope. At the instigation of the ambassador to the Duke of Urbino, the site for the structure in San Pietro in Vincoli was prepared. It seems likely that some of the sonnets Michelangelo wrote to Tom-maso date from these months.

inconveniently, there was no staircase – only 'signs on the floor', sketches, and 'many stones' lying around with no clear indication of how they should be put together. In the New Sacristy, the two effigies of dukes Lorenzo and Giuliano had been installed in their niches, but *Night, Day, Evening* and *Dawn* were still lying on the floor. The sculptures of the river gods had never even been begun in stone; Tribolo had been prevented by illness from carving Heaven and Earth, as had been planned, and after Michelangelo's departure, never did so. The saints Comas and Damian who were to flank the Virgin and Child on the tomb of the Magnifici were carved by Raffaello da Montelupo and Giovanni Angelo da Montorsoli. The latter had been sent from Rome by Clement, to avoid further delay. However, sadly, the architectural framework of this third, joint tomb – on which Michelangelo had spent so much thought – was never made.[2]

Michelangelo had no intention of returning to complete the projects at San Lorenzo. When he left Florence in September 1534, it was in the knowledge that he was going for good. He said as much in a farewell note to a young man named Febo di Poggio: 'I shall not return here any more.'

The remainder of the short letter to Febo suggests that there had been an unexpected development in Michelangelo's private life. The way he wrote to Febo was strikingly, almost shockingly, different in tone from the convoluted, courtly tone of his exchanges with Tommaso. This letter is intimate, informal and – since some *froideur* seems to have developed between them – a little plaintive. Michelangelo began: 'Although you have conceived for me a great hatred – I do not know why – I certainly do not believe that it is owing to my affection for you, but owing to what other people say, which you ought not to believe.'

He ended with a pledge, not of the kind of transcendent, almost mystical, passion he expressed for Tommaso, but certainly with powerful feeling: 'I want you to understand that as long as I live and wherever

2 The tombs and the library remained in this condition, more or less as building sites, for many years. But such was Michelangelo's prestige that, even in that condition, they were regarded as masterworks. On 5 April 1536 the Emperor Charles V made a triumphal entry into Florence, which was now acknowledged to be his possession. He stayed at the Palazzo Medici and was shown the sights of the city, among them the unfinished tombs, which he greatly admired.

I may be I shall always be ready to serve you with loyalty and with affection'; he wanted good for Febo more than his own welfare; he prayed God would open the young man's eyes so he would love Michelangelo rather than hate him.

Febo, like Tommaso, was presented with sonnets – which Michelangelo was producing abundantly in these years. The poems apparently dedicated to him play on his names 'Febo' or 'Phoebus', or Apollo the sun god, and 'Poggio', or hill. The sole letter from him to survive, however, is disingenuous and mercenary, utterly unlike the elegant but affectionate writings from Tommaso.

It is dated 14 January 1535. Febo stated that he had not been able to get away to say goodbye to Michelangelo on the day he left Florence, but was not at all angry with him, since he thought of him as a father. However, he had not bothered to get in touch during the next three and a half months, which he had spent in Pisa. Now, finding himself back in Florence and short of money, Febo would like to take up Michelangelo's offer of help and asked him to send an order to his banker to hand over some cash. It was most unlikely that Michelangelo's love for Tommaso de' Cavalieri had any physical expression; one does not feel so sure about his relations with Febo.

The temptations of sin were the theme of a drawing Michelangelo made, dubbed *The Dream* (*Il Sogno*). Vasari listed it with *Ganymede*, *Tityus* and the others made for Tommaso, though exactly when it was executed is unknown. It depicted a splendidly muscular young man leaning on a globe, presumably symbolizing the world. Beneath him is a box containing grinning masks: representing most probably vain earthly pleasures and pretences. They look very much like the sinister mask beneath *Night* in the Medici Chapel.

Behind the young man the vices are represented in a ring, among them anger and avarice and, most prominently, lust, symbolized by two naked, embracing figures. Floating in the clouds above them, half erased by some prudish owner in the past, is the most forthright piece of sexual imagery Michelangelo ever invented: a massive, erect penis pointing upwards like a cannon.

The young man in the allegory, however, is being distracted from the temptations around him by a naked winged figure flying down

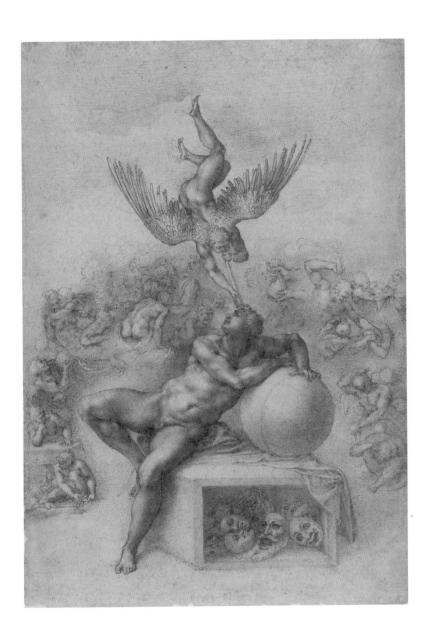

The Dream, c. 1533–4.

from heaven who blows through a trumpet pointed directly at his forehead. He is being awakened from sin to virtue. For Michelangelo himself in late middle age, as we have seen, the call of erotic passion was perhaps more urgent than it had ever been. These were the years in which, as the translator and scholar of his verse, James Saslow, has emphasized, he wrote, 'the first large body of love poetry in any modern European vernacular directed by one man to another'. A few of his sonnets of this time were to Febo, but the great bulk, it seems, were to Tommaso.

Clement's death deprived Michelangelo of a dedicated patron, a firm supporter, and – in so far as the difference in rank between them allowed such a relationship – a friend. However, his reaction may well have been relief. He was, for the moment, free – both of the projects at San Lorenzo, which had now taken up most of his time for two decades, and also of this new obligation to paint an enormous mural in the Sistine Chapel. But this interval of liberty was extremely brief. On 13 October 1534, the second day of the conclave, Cardinal Alessandro Farnese was almost unanimously elected (he received every vote except his own), and took the name of Paul III.

Farnese was a veteran of Roman ecclesiastical politics. He had been a strong candidate at every papal election since 1513 and, though he was an ally of Clement's, Farnese complained that Giulio de' Medici, by winning in 1523, had robbed him of ten years on the throne of St Peter. Perhaps in recompense, Clement frequently expressed his wish that Cardinal Farnese should succeed him, and made his cousin's son Cardinal Ippolito de' Medici promise to vote for him.

Although it was during his pontificate that the Counter-Reformation began to gain momentum, in many ways Paul III was the last of the popes of the Renaissance. He had been a cardinal for four decades, since 1493. The Venetian ambassador noted that Alexander VI Borgia had elevated the youthful Farnese for an obscene reason: Farnese's sister Giulia was the Pope's mistress. For that reason, the Romans disrespectfully called Farnese 'Cardinal Fregnese' – the pussy Cardinal, or Cardinal Cunt.

Before he took holy orders (which were not obligatory for a cardinal) in 1513, Farnese himself had four illegitimate children: two sons,

subsequently legitimized by Julius II, a daughter and another son. He favoured these in as outrageously nepotistic a fashion as any of the Borgia, della Rovere or Medici popes had promoted their own relations.

Alessandro Farnese was close to the Medici in education and tastes. In his youth he had been a protégé of Lorenzo the Magnificent – who wrote a warm letter recommending him for an office in the papal Curia in Rome. This was a man from exactly the circle that had formed and most appreciated the art of Michelangelo, and he had been observing the artist's progress for decades. When the *Pietà* was unveiled in 1500, Farnese was already a cardinal. As a lieutenant to Julius II, he had had an insider's view of the evolution of the Sistine Chapel ceiling.

Just as he had been poised for two decades to become Pope, Paul had been waiting many years to get control of Michelangelo. Therefore it was not surprising he immediately confirmed Clement's commission for *The Last Judgement*. 'After the elevation of Pope Paul III,' Condivi related, 'the latter sent for Michelangelo to ask him to stay in his service.' Michelangelo replied that, unfortunately, he was under contract to the Duke of Urbino to finish the tomb of Julius II. Then, infuriated, the Pope exclaimed that he had wanted to have Michelangelo work for him for thirty years. Was he to be denied this wish now that he was at last Pope? 'Where is this contract? I will tear it up.'

According to Condivi, Michelangelo was horrified at the prospect of being diverted yet again from completing this thirty-year-old commission. He even thought of leaving the Papal States and living either at an abbey near Genoa, one of the benefices of his friend the Bishop of Aléria, or, alternatively, in the territory of the Duke of Urbino: both of these were places where he might be able to get on with the tomb of Julius II unmolested by Paul III. 'But, fearing the greatness of the Pope, and rightly so, he stayed put, hoping to satisfy the Pope with soothing words.'

This information might have been intended precisely to excuse Michelangelo from responsibility for yet another delay. Condivi's Life was written, it seems, from internal evidence, partly to explain that he was not to blame for the decades of procrastination over the tomb.

Titian, *Pope Paul III*, 1545–6.

However, Michelangelo did appear truly reluctant to get down to painting *The Last Judgement*.

Probably, he really was eager to get the tomb over and done with.[3] And perhaps he also dreaded embarking on a vast fresco at the age of sixty. Painting was, after all, not his profession. By now, Michelangelo had seen many popes come and go, almost all dying younger than the age at which Paul III was elected. So, like everyone else in Rome, he did not expect Pope Paul to last long.

Indeed, one of the reasons why it was so easy for all the various competing interests to agree to elect Cardinal Farnese Pope was that he was so elderly. Born in 1468, he was now sixty-seven – seven years older than Michelangelo and eleven years more than Clement had been at his death. There was a reasonable chance that his would be a short pontificate.

In 1534 no one would have predicted that Paul III would last fifteen years: the longest papal reign of the sixteenth century. So, as Vasari put it, Michelangelo decided to 'spin matters out (seeing the Pope was an old man) until circumstances changed'.

*

It was not until six months after Paul III's coronation that preparatory work in the chapel began, on 16 April 1535, with the construction of scaffolding on the altar wall. The plan for the new painting entailed the destruction of a large section of the existing decoration: three frescoes by Perugino, several portraits of early popes, and – saddest of all for posterity and perhaps for the artist himself – two lunettes

3 Although a letter written seven years later, in 1542, puts the matter in an intriguingly different light. The ambassador to the Duke of Urbino, Michelangelo claimed, had advised him confidentially that it would actually please the Duke if he were to give up working on the tomb and let others finish it off. As Michelangelo put it, 'I should go with God, as he couldn't be bothered about the Tomb, though he took it very ill that I should serve Pope Pagolo [Paul III]'. Michelangelo's characteristically suspicious deduction was that the Duke of Urbino wanted him to turn the tomb over to another sculptor so as to get the house on Macel de' Corvi back from him. So, possibly, Michelangelo's overriding motivation was a determination not to lose his dwelling.

of *Ancestors of Christ* by Michelangelo. These were among the last parts of the ceiling Michelangelo had painted, and probably among the most beautiful. Known only from engravings, they depicted on the left 'Abraham, Isaac, Jacob and Judas', and on the other side 'Phares, Esron and Aram'. All of this had to be hacked off, and two windows filled in. However, Michelangelo went much further in his demands for alterations to the wall on which he was going to paint.

The original wall tilted slightly backwards, so that the top of the wall was around 5½ inches further back than the bottom. This slant was now reversed, so that the highest point of the painting was now almost a foot further forward than the lowest. To achieve this required major – and extremely dusty and noisy – building works. Some 81 cubic yards of masonry had to be removed and replaced by a new, smooth surface of brick. This was described by Vasari: 'a projection [*scarpa*] of bricks, well laid, selected and well made'.

Quite why Michelangelo insisted on this extraordinarily elaborate procedure is mysterious. Vasari believed it was to 'prevent any dust or dirt from settling on the painting'. However, this was a very costly, time-consuming and probably ineffective method of keeping the mural clean (greasy candle smoke from the altar would surely be more likely to settle on a wall that jutted forwards; in any case, shortly after *The Last Judgement* was completed the Pope appointed a full-time cleaner to keep it and the ceiling free of dirt). More plausibly, he was concerned with the visual effect of the painting – perhaps wanting the upper parts containing Christ and the most significant figures to catch the light and make an impact from a distance.

Whatever the purpose, the re-angling of the wall suggests that Michelangelo was thinking seriously about the effect of his huge painting. The next stage in preparation, however, was conducted in a curious, not to say highly eccentric, manner – a slow-motion tussle between two elderly artists over a point of technique. Vasari described what happened: 'Fra Sebastiano had persuaded the Pope that he should make Michelangelo paint it in oils, whereas the latter would only do it in fresco.'

Sebastiano had perfected a technique for painting murals in oil and used it for *The Flagellation of Christ* he had painted, with help from

Michelangelo's drawings, and finally completed, after much delay, in 1524. Naturally, he was proud of this achievement: a method of painting on walls satisfactorily in oils was the Holy Grail sought by several early-sixteenth-century painters, Leonardo among them. It would allow the slow, ruminative methods, deep shadows and rich colours that suited Sebastiano (and Leonardo). He had been praised for the invention; in 1530 the Venetian poet, scholar (and lover of Lucrezia Borgia) Pietro Bembo (1470–1547) wrote that Sebastiano 'has discovered the secret of painting in oils on marble that is very beautiful, and will make painting nearly eternal'.

Understandably, Sebastiano wanted his friend to make use of this discovery. However, the crepuscular chiaroscuro of Leonardo's art and Raphael's *Transfiguration* with 'figures who have been in smoke, or figures of iron that shine, all light and all black' – as Sebastiano himself had described it – was the opposite of the clean sculptural clarity Michelangelo sought in painting.

Sebastiano hero-worshipped his great friend but was also capable of being unwisely bossy with him. Despite Michelangelo's reluctance he persisted with his idea. So, with 'Michelangelo saying neither yea nor nay', Sebastiano's formula was applied to the wall of the chapel. Only when that was done, 'after being pressed', did Michelangelo announce that he would only paint *The Last Judgement* in true fresco, adding 'that painting in oils was a technique for women and for leisurely and idle people like Fra Sebastiano'.

This arcane dispute about plaster wrecked a friendship that had lasted for over two decades; the closest bond Michelangelo had ever had with an artist even approaching his own level. Afterwards, Michelangelo never forget the affront and held it against Sebastiano until the end of Sebastiano's life. After a quarter of a century of alliance with Michelangelo against patrons and rival artists alike, it was Sebastiano's turn to encounter the closed door.

The new Pope, however, showed his strong approval of the new project – and desire to bind Michelangelo closer to him – while the wall was still being prepared. On 1 September 1535 Paul issued two papal briefs, making Michelangelo 'supreme architect, sculptor and painter of our Apostolic Palace . . . and a member of our household

with all the favours, prerogatives, honours, duties and preferences that are enjoyed and can be or are accustomed to be enjoyed by our familiars'. In other words, like his erstwhile friend Sebastiano, a permanent member of the papal court. There was no question of a fee for *The Last Judgement*; Paul granted Michelangelo an income of 1,200 *scudi* a year for the rest of his life. Half of this was to come from the tolls on a crossing over the river Po, the rest from the papal treasury. He was to be given these payments for life because Paul envisaged him working for the papacy in perpetuity, as the brief explained. The money was for 'the picture of the story of the Last Judgement which you are painting on the altar wall of our chapel' and also 'for other works in our palace if this work will have been done'. Michelangelo was more secure than ever before but, also, more than ever a prisoner.

Michelangelo told Condivi how one day Paul III appeared in his house at Macel de' Corvi accompanied by an entourage of 'eight or ten Cardinals', plus no doubt guards and attendants. The Pope demanded to see the cartoon made under Clement for the wall of the Sistine Chapel, the statues that he had already made for the tomb and everything else – at which the Cardinal of Mantua (Cardinal Ercole Gonzaga), 'seeing the *Moses* said: "This statue alone is enough to honour the tomb of Julius."'

Cardinal Gonzaga (1505–63) was an interesting person to have made this remark, so satisfactory to Michelangelo (and the Pope) that one wonders whether one of them might have prompted the cardinal to make it. Although his position as a cardinal was the result of outrageous nepotism, Ercole Gonzaga was extremely pious and a member of a group of younger, reform-minded clergy with whom Michelangelo became close in the later 1530s and '40s.

Ercole Gonzaga was an ally of three enthusiastic reformers made cardinals in 1535 by Paul III: Gasparo Contarini, Jacopo Sadoleto and an Englishman named Reginald Pole, who was to play an important part in Michelangelo's life over the years to come. Paul III appointed this earnestly pious trio to a commission to look into the reform of the Church. The report they produced, *De emendanda ecclesia*, turned out to be as forthright in condemning corruption as the northern Protestants could have wished. In a neat demonstration of how he was

simultaneously the last Pope of the Renaissance and the first of the Counter-Reformation, Pope Paul made two of his teenage grandsons cardinals at the same time as the reformers.

Cardinal Gonzaga might well already have been on friendly terms with Michelangelo on the day of the pontifical descent on Macel de' Corvi.[4] And, of course, he was absolutely correct. *Moses* was such a tremendous masterpiece that nothing else was needed, really, as a monument to Julius. That, however, was not what the contract stipulated. Yet by a *motu proprio* of 17 November 1536, the Pope released his 'beloved son', Michelangelo Buonarroti, that 'singular and unique painter and sculptor', from his obligation to work on the tomb of Julius II. For the time being, work on the tomb was once again postponed.

*

On 25 January 1536 work commenced to scrape Sebastiano's ill-fated preparation off the chapel wall and a layer of plaster suitable for true, traditional fresco was put on instead. On 18 May some payments for pigments were recorded. Soon afterwards, more than eighteen months after Paul had become Pope and nearly three years since Clement had originally contemplated the commission, Michelangelo finally climbed the scaffolding, picked up his brushes and began to paint.

His task was a formidable one: a surface of 46 by 43 feet, or around 1,800 square feet, to be covered with frescoes. The scaffolding alone must have been some seven storeys high; when, after Michelangelo's death, it was decided to cover the nakedness of the figures with scraps of cloth and saintly underpants, a structure on four levels had to be put up with curtains and parapets across the front of each floor and ladders at the side: this extended only a little over halfway up the wall. Michelangelo must have worked on something similar, but higher, and perhaps – as we shall see – lacking an effective parapet.

4 Also, Cardinal Gonzaga had long-standing knowledge and understanding of Michelangelo's work. As the son of Isabella d'Este, he had grown up with a sculpture by Michelangelo – the early *Sleeping Cupid* rejected by Cardinal Riario – in the family collection. Indeed, the Gonzaga family collection was one of the finest in Renaissance Italy. Gonzaga's elder brother, Federico II, was the Marquis of Mantua whose agent had tried to recruit Michelangelo into the service of the Gonzagas in 1527.

On the first day he painted, Michelangelo climbed to the very top, where he began on the left-hand side in the lunette that depicted the angels carrying the cross and the crown of thorns, with, as was his habit, a group of angelic bystanders who are floating effortlessly in the azure air, peering over the naked side of a spirit who is apparently directing the others, who are holding the cross aloft. In the right-hand lunette, he painted the angels carrying the column, reed, sponge and ladder: more magnificent blonde beings with superb physiques rotating the Doric column clockwise in space.

Then he proceeded methodically downwards until he had finished. And, as on the ceiling, he seems to have worked without much assistance; the main exception being his servant Urbino – who was beside him on the scaffolding and probably did some of the actual painting, as well as other jobs.

<p style="text-align:center">*</p>

In March of 1536 a widowed aristocratic woman named Vittoria Colonna moved back to Rome after a long period of living away from her native soil. She stayed in the city for most of the rest of that year and this – it seems close to certain, though there is no direct evidence – must have been when she first encountered Michelangelo.

Vittoria Colonna was to be, with the possible exception of his mother, Francesca, the most important woman in the artist's life. However, the relationship between the two of them – a pious blue-stocking in her mid-forties and the now immensely celebrated 61-year-old Michelangelo – is hard to get into focus. Their correspondence, which Condivi tells us was voluminous, has almost entirely disappeared: the probable reason for this is that many of Vittoria's other letters were seized by the Inquisition after her death and trawled for evidence to prove not only that she had been a dangerous heretic holding unsound doctrines about salvation but also that her relationships with prominent Catholic reformers were scandalously amorous. It seems likely either Michelangelo, or someone acting on his behalf, thought it best to ditch the evidence of their friendship and thus keep well clear of this investigation (which eventually led to one of their circle being first beheaded, then his body burnt).

In the absence of letters, we are left with a wealth of poetry which, on his side, was often composed within the conventions of Petrarchan verse: the distant, unattainable lady hopelessly admired by a trapped and suffering lover. Taken literally, this could scarcely have applied to the feelings of an elderly sculptor so ardently interested in young men for a middle-aged female intellectual with a passion for theology. The basis of their love – if that is the correct word – cannot have been conventionally romantic. The truth was more likely to be that theirs was a genuine meeting of minds.

After Vittoria's death, Michelangelo described her in a letter to his old helper and advisor Giovan Francesco Fattucci simply as 'a very great friend'. Revealingly, he used not the feminine form of the word, '*amica*', but the masculine one, '*amico*'. His true feeling was perhaps that Vittoria was a woman so intelligent and a spirit so elect that – in Michelangelo's mind – she transcended her sex. A madrigal of 1544/5 begins with just that thought: 'A man within a woman, or rather a god/Speaks through her mouth.'

Vittoria came closest perhaps of all the people Michelangelo had encountered in his already long life to being a mental match. She was clever and subtle, an important artist – in words – in her own right and seemed to have had the knack of handling him to a greater degree than Pope Clement, Sebastiano or any of the others who had attempted that tricky task. She was one person on whom Michelangelo never tried to close the door.

Poetry, in all probability, played a part in bringing them together. Vittoria's life had been superficially most unlike Michelangelo's – but there was a deep resemblance. They were both trapped in the world of brutal sixteenth-century power politics, and they had each – without entirely escaping that predicament – used remarkable talents to reach a novel kind of fame.

Vittoria had been born in 1490 or 1492 into the Colonna, one of the most powerful feudal clans of Rome. She was married in 1509 to Ferrante Francesco d'Avalos, the Marchese di Pescara, a member of a military dynasty of Spanish extraction. As far as he and the Colonna family were concerned, this was simply a bit of hard-nosed dynastic deal-making. She, however, seems to have fallen in love with her

philandering general of a husband; certainly she turned her adoration of him into the theme of her poetry, firstly during his lifetime and then after his death – from wounds suffered at the Battle of Pavia in 1525.[5]

By the late 1520s and early '30s Vittoria Colonna had become an almost unique figure in early-sixteenth-century Europe: a famous female author. After her husband's death her first impulse was to withdraw into a convent in Rome. Clement VII forbade this, perhaps out of a desire to thwart members of the Colonna family whatever they wanted to do, so instead she lived at the d'Avalos court on the island of Ischia in the Bay of Naples. There, in the period after the Sack of Rome in 1527, several ecclesiastical intellectuals took refuge, with Vittoria presiding over them in what sounds like a weird mixture of a nunnery, a nineteenth-century Parisian *salon*, and one of the castles of love described by medieval troubadours.[6]

When Vittoria appeared in Rome in 1536 it was almost inevitable she would meet Michelangelo, given the fame they both enjoyed as poets and the intersecting circles they inhabited (Tommaso, who as a Roman aristocrat would have known the Colonna well, is one person who might have introduced them). There is however no evidence of where or when it happened. But it is tempting – though nothing more

5 During the interval in the battle, in which the ailing d'Avalos was tempted to accept the throne of Naples in exchange for betraying his master, the Emperor Charles V, Vittoria dissuaded him, declaring that being Queen of Naples was nothing to her in comparison with 'the loftiness of perfect virtue' – a sentiment of which one suspects the increasingly pious and puritanical Michelangelo would have approved.

6 Paolo Giovio, whom we have already met in several guises as Clement's doctor and as a hostile biographer of Michelangelo, was one of these. He wrote a dialogue, *Concerning Men and Women Flourishing in Our Times*, based on conversations held there. The speakers included Giovio himself and Vittoria's late husband's cousin, Alfonso d'Avalos, the Marquis del Vasto, who discussed such topics as why Italy had fallen under the domination of foreign powers and what had led a man as intelligent as Clement VII to employ such enemies as the Duke of Urbino. The work ends with a cascade of praise for Vittoria: she was a philosopher and a poet, her writings illuminating all her other virtues, 'like fires lit for festivals on the tops of pyramids'. From the point of view of mundane accuracy, this eulogy is probably misleading, as, for example, when he described her breasts 'swelling and subsiding with her breathing like a pair of nesting doves'.

than a guess – to associate the impact she had on him with the appear-
ance in *The Last Judgement* for the first time in Michelangelo's art of
a throng of heroic, virtuous women. These female saints – some naked,
some more or less clothed – form a large group to the left of Christ.
This was, iconographically speaking, highly unorthodox: 'an unpre-
cedented privileging of women', in the words of an art historian who
has studied the picture.

*

Otherwise, Michelangelo was becoming more and more deeply – and
perhaps contentedly – established in the life of an exile. The following
year, on 10 December 1537, he was one of a number of foreigners
awarded Roman citizenship in a ceremony on the Campidoglio. Mean-
while, back in Florence a violent political drama had unfolded.
Supported by the new Pope, Paul III, Duke Alessandro's opponents
plotted busily, even forming a government in exile. Among them were
several people who were to be, or already were, very close to
Michelangelo, including Donato Giannotti and the leader of the
anti-Medicean exiles Cardinal Niccolò Ridolfi (1501–50). The artist
must have known about the plans and hopes of the exiles. Indeed, the
possibility of a change in government at Florence was another reason
for him to procrastinate over beginning *The Last Judgement*. A new
regime would have opened the prospect of a return home.

It was yet another member of the Medici clan who brought a sud-
den end to Alessandro's reign: Lorenzo (1514–48) – nicknamed
Lorenzino; or, by those who hated him, Lorenzaccio, or Lorenzo the
bad – was the grandson of Michelangelo's old protector Lorenzo di
Pierfrancesco de' Medici. This Lorenzino was thus a member of an
impoverished and junior branch of the Medici family; he resented the
fact that his illegitimate cousin had been given privilege and power.
Like earlier Florentine plotters, he brooded on the actions of
Brutus, assassin of Julius Caesar and – to republicans – a heroic
tyrant-slayer.

Lorenzino attached himself to Alessandro's court and made himself
useful, among other services assisting the Duke in his philandering
love affairs. Lorenzino also put on a performance of a play, *Aridosa*,

which he had written to celebrate Alessandro's marriage to Margaret of Austria. According to Vasari, Lorenzino planned to wipe out the Duke and his court by arranging for a collapse of the stage.

In the first week of 1537 Alessandro's amorous target was allegedly Caterina, the virtuous wife of Leonardo Ginori, head of one of the branches of this wealthy family, and brother-in-law of Federigo, the beautiful young man for whom Michelangelo had designed a cap badge. Lorenzino told the Duke that she would sleep with him, but he must wait alone and unguarded. This he did, taking off his sword and falling asleep, only to be awakened by Lorenzino and a hired assassin, who stabbed him to death.

The surviving members of the regime, led by Cardinal Cibo, decided to make yet another junior member of the Medici family 'head and leader of the government of the city of Florence'. He was Cosimo, a member of the same branch of the family as Lorenzino,[7] just eighteen years old and son of the celebrated warrior Giovanni dalle Bande Nere.

This was the moment for the exiles to strike, but they made a hash of it. The city did not rise in their favour, and a series of missions, including one by Donato Giannotti, failed to bring about a settlement. In July an exile army under Filippo Strozzi and his son Piero advanced into Tuscany, but it was crushingly defeated by forces from Florence at the village of Montemurlo, between Prato and Pistoia. The exiled leaders were taken back to Florence and executed at a rate of four a day. Filippo Strozzi was imprisoned for seventeen months and the next year committed suicide, still in captivity.

The Florentine exiles, Michelangelo among them, still did not give up hope. However, the possibility of returning to Florence receded, and so too did the prospect of him working for anyone except Paul III.[8] At some unknown date after this, Michelangelo made a bust of

7 Cosimo's grandfather was Giovanni, brother of Lorenzo di Pierfrancesco de' Medici.
8 A strange and bitter irony was that Michelangelo's design of Ganymede and the eagle for Tommaso was copied in a celebratory painting by Battista Franco to represent the apotheosis of the teenaged Duke Cosimo de' Medici after his victory at the Battle of Montemurlo, the bird and naked youth hovering implausibly about the field of victory.

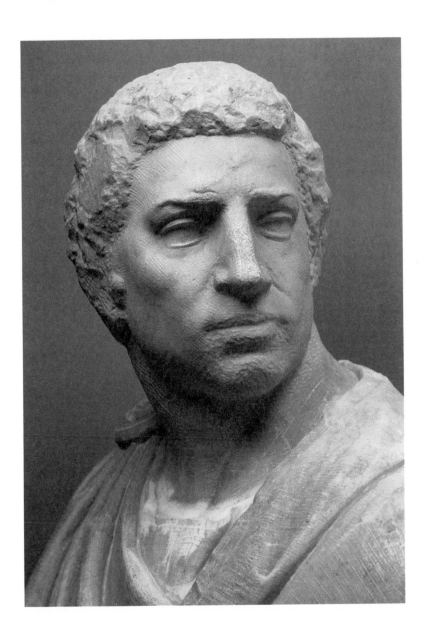

Brutus, c. 1537–55.

Brutus, the classical slayer of the tyrant Julius Caesar, for Cardinal Niccolò Ridolfi, at the urging of Giannotti, who was Ridolfi's secretary. It was a classical image, based, according to Vasari, on a Roman gem, 'cut on a cornelian of great antiquity'. This was an image of the assassin as hero. However, after chiselling the noble and determined face, he put it aside. A later inscription on the base claimed that Michelangelo, while carving it, had reflected on the crime of murder and then stopped work. [9]

*

Painting *The Last Judgement* was a huge effort, which took Michelangelo from his sixty-second year to his sixty-seventh. In all, the actual painting comprised 449 *giornate*, or days spent executing true fresco, but this was of course only part of the work involved. All the main figures were drawn in advance on cartoons, which were then transferred to the fresh plaster on the wall before the frescoing began (some of the subsidiary parts were done freehand, without a guide).

The work in true fresco was only a part of the painting process. On *The Last Judgement*, more than he had on the ceiling, Michelangelo also painted over the surface *a secco* – that is, with additional pigment over the dried fresco – applying such details as the trumpets with which the angels are awakening the dead and covering up the seams between *giornate*. Because of the complex interrelation of the numerous figures, in some places Michelangelo made alterations after he had

9 In the *Dialogues* he wrote about the interpretation of the *Divine Comedy* in the mid-1540s, Donato Giannotti, speaking in his own person, asked a question: 'Don't you think that Dante made a mistake by placing Brutus and Cassius in Lucifer's mouth?' Dante thus gives those two assassins, with Judas, the most ignominious position in Hell. To Giannotti, this seems quite wrong, 'the universal consensus' of mankind, he argues, 'celebrates, honours and extols those who, to free their country, kill tyrants'.

To this the character 'Michelangelo' replies that it is 'a great presumption' to kill a ruler, whether he is just or unjust, without knowing what the consequences will be. There follows a statement that might reflect the true feeling of the ageing artist: he had become weary, he explains, 'of those who say no good can come if one does not begin with an evil' – that is, murder –'they do not understand that times change, men get tired.'

begun to paint. And, despite his dismissive attitude to Sebastiano's idea that he should work in oil, he did use a little oil to add lustrous shades of reptilian green and blue to the skin of the demons in the zone of hell. Previously, of course, the cartoons had to be prepared, and before that studies made – perhaps from life – for each figure, although some of this work was probably done while the wall was being rebuilt, plastered and re-plastered.

The painting took Michelangelo longer than the entire, much larger area of the ceiling. But then not only was Michelangelo a quarter of a century older than he had been when previously at work in the chapel, but the work itself was more complex. The ceiling included substantial areas of architectural framing, which was essentially repetitive. In contrast, *The Last Judgement* had no frame at all.

This was one of the most radical aspects of Michelangelo's scheme. By removing the earlier frescoes by Perugino, himself and others, he had punched a hole in the orderly decorative patterning around the walls of the chapel which, on the other three sides, still took the form of bands of painting and decoration rising from the floor to the lower sections of the great ceiling.

Above the altar level, the entire wall on which Michelangelo was painting was presented as one imaginary space, with no painted architrave or masonry surrounding it to say, 'This is a picture.' Instead it was as if one side of the chapel had fallen away to reveal the tremendous sight of Christ judging the just and unjust in the realm beyond. To make that point, on the right-hand side a heroically muscular nude representing either Simon of Cyrene or the Good Thief, Dismas, appears to rest a cross on the real cornice that runs around the room beneath the paintings of early popes.

What Michelangelo was doing was at once traditional and unprecedented. As a subject, the Last Judgement was familiar, indeed time-honoured. There were several examples in Florence that he would have known from childhood, including a mosaic on the vault of the Baptistery in Florence. The subject was more popular in the fourteenth century than it was during the Renaissance, but there was an important precedent in a series of paintings by Luca Signorelli in Orvieto Cathedral.

Just as Signorelli had, Michelangelo depicted many of his figures naked. Some nudity was justified in paintings of *The Last Judgement*, particularly among the damned, about whose dignity no one need worry. But the sheer scale of Michelangelo's huge painting, and therefore the quantity of the naked flesh on show, was unparalelled, as was the fact that almost every figure in it – damned, saved, canonized and martyred – was more or less undressed.

The innocently devout Fra Angelico had shown the blessed embracing the ecstasy of their salvation. So did Michelangelo, but the effect was very different. In the mass of the saved on the right-hand side of his mighty fresco – opposite the heroic female martyrs – nude, curly-haired young men with the bodies of Olympic shot-putters passionately kiss and caress. Some of them hug grey-haired elders.

Similarly, the torments of the damned often revealed their sins – but Michelangelo did so with startlingly graphic earthiness. Amid a cascade of horror-struck nudes tumbling towards the inferno, there is a man, bulging with muscles and seated in space as if on a privy. He turns towards the viewer, one eye staring out in almost comic consternation. He gnaws the fingers of his left hand, while with his right he tries unavailingly to bat away an athletic demon who is grasping his testicles as if they were a pair of ripe red fruit while dragging his victim inexorably downwards.

In his First Letter to the Corinthians St Paul posed a question: 'But some will ask, "How are the dead raised? With what kind of body do they come?"' The essence of the answer, in the view of Cardinal Tommaso Cajetan (1469–1534), a prominent theologian, lay in Paul's words later in the same epistle: 'What is sown is perishable, what is raised is imperishable. It is sown in dishonour, it is raised in glory. It is sown a physical body, it is raised a spiritual body.'

Michelangelo had, then, to decide how to represent spiritual bodies. From the point of view of someone educated – as Michelangelo, Clement and Paul had all been – at the courts of Lorenzo de' Medici and Julius II – this question could have only one answer. A spiritual body would be a more beautiful body, and that must mean one more closely resembling the ideal forms of ancient sculpture. Therefore Michelangelo set about designing a scene made up, essentially, of dozens of

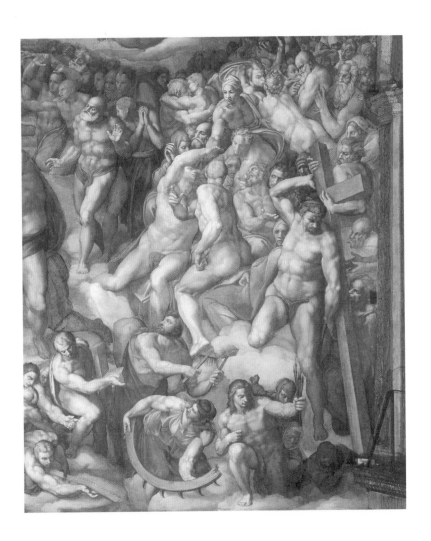

The Last Judgement, 1536–41, detail of group saved on right.

perfect, muscular naked figures, the successors of *David*, the two earlier *Slaves* and the *ignudi* on the ceiling above.

There needed, however, to be a distinction between the elect and the damned. So while Michelangelo gave almost every figure the physique of an athlete, the damned had faces that reflected their corruption and the misery and despair they experienced.

Not all the saints and saved are youthful. St Peter has white hair and a partially bald head, and grey beards and balding pates are scattered elsewhere, but almost all the bodies are athleticelly brawny. Christ himself is beardless, young, with only a loose piece of cloth hanging from his shoulders and covering his groin. Most of the major saints grouped around him – Bartholomew, John the Baptist, Lawrence, Blaise, Catherine – were, originally at least, completely unclothed and, like all the figures in *The Last Judgement*, heavily muscled. All of this was justifiable in terms of St Paul's epistle. But the result was that a large number of groins, penises, breasts, testicles and buttocks appeared to float above the altar of the Pope's chapel. St Bartholomew, who was martyred by being flayed, holds the skin that had been so violently removed from him (while being miraculously covered in a new one). On the old skin was painted the most astonishing image in the whole fresco: a self-portrait, almost a self-caricature, of Michelangelo – black, sour, unworthy, but nonetheless being held aloft in hope of salvation.

*

Towards the end of September 1537 Michelangelo received an unexpected letter. Its writer was Pietro Aretino, author of the last will and testament of Hanno the elephant. Since writing that, Aretino had become notorious as a poet, satirist, playwright and pornographer. The racy fluency of his writing had made him a success at the court of Pope Leo X, where he was particularly favoured by Cardinal Giulio de' Medici (later Clement VII). But even the Pope's protection was not enough to save him from the consequences of publishing sixteen sonnets describing the extremely explicit *modi*, or sexual positions, drawn by the painter Giulio Romano and engraved by Marcantonio Raimondi. Subsequently, Aretino had returned to Rome but fled again after attacking a prominent bishop in verse and surviving an attempted

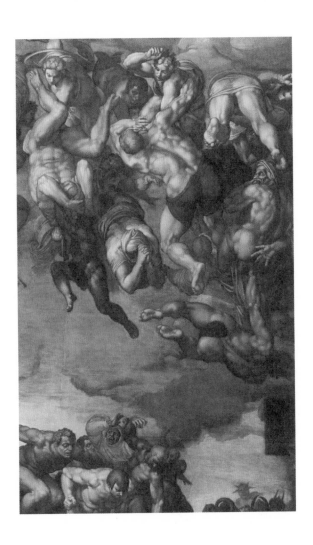

The Last Judgement, 1536–41, Sistine Chapel;
detail: *Lustful Soul being Dragged Down.*

stabbing. He took refuge in Mantua, where he published other attacks on the papal court. After the Marquis of Mantua offered to have him assassinated to placate ruffled feelings in Rome, in 1527 Aretino had left for Venice, where he had become a close friend of Michelangelo's great contemporary Titian.

In 1537 Aretino was in the process of inventing an entirely novel genre. In retrospect, although newspapers did not yet exist, it is obvious that he was practising something akin to journalism – more specifically, Aretino was an embryonic columnist, turning out topical essays: intimate, gossipy, controversial and flattering. These came in the form of letters to the famous, in which he touched on all manner of subjects, for example addressing young Duke Cosimo of Florence on the art of government, Pope Clement on withstanding adversity, Titian on the art of painting and, as we shall see, Michelangelo on his current majestic project, *The Last Judgement*.

The idea of publishing such letters had emerged when a Venetian printer and several of Aretino's younger collaborators had suggested that some of his actual correspondence – which was already renowned – should be printed. Unfortunately, it was not possible to retrieve enough to make a book, so Aretino set about producing more at speed.

Michelangelo was an obvious person for Aretino to address, although it is unlikely that they knew each other well. The two men had scarcely coincided in Rome in 1516, if at all, and Aretino had in any case been in the opposite camp, a friend of Raphael's. However, Aretino was not one to let a small consideration such as that stand in his way. The letter that arrived at Macel de' Corvi was part art criticism – a genre that was just emerging into being – but also an offer of an alliance. Aretino was not only the first journalist and critic, but also the grandfather of public relations. Implicitly, he was offering his services, and he began a marvellous demonstration of what he could do. In a few words Aretino encapsulated the dizzy rise in prestige of the artist: 'The world has many kings but only one Michelangelo.'

Thus, far from being a mere craftsman, Michelangelo was a rarer being than any prince. Indeed, his powers rivalled those of God: 'hidden in your hands lives the idea of a new kind of creation'. Next, Aretino, not a man for false modesty, added some praise of himself, pointing

out that his name was 'now acceptable to all our rulers and so it has shed a great deal of its ill-repute'. He then got to the point. Aretino had heard that Michelangelo was at work on a new painting in which the artist intended to outdo even his own Sistine Chapel ceiling, thus triumphing over himself. After that, Aretino described how he imagined Michelangelo would tackle this awesome subject. The results were more rhetorical than visual: 'I see Nature standing there to one side, full of terror, shrunken and barren in the decrepitude of old age. I see Time, withered and trembling, who is near to his end . . .' And so on, in a manner naturally much more literary than pictorial. Aretino ended by exclaiming that, although he had vowed never to enter Rome again (having fled for his life on more than one occasion), he would have to do so to see this new masterpiece Michelangelo was painting: 'I would rather make a liar of myself than slight your genius.'

There was perhaps a light dusting of irony in Michelangelo's cordial but brief reply. 'Magnificent Messer Pietro, my lord and brother,' he began. 'The receipt of your letter has caused me at once both pleasure and regret. I was exceedingly pleased because it came from you, who are uniquely gifted among men.' But, sadly – since he had 'completed a large part of the composition' – it was too late to follow Aretino's rather vague suggestions. He ended by imploring him not to break his resolution never again to come to Rome simply to see *The Last Judgement*: 'that would be too much.' Michelangelo understood that the writer wanted something in return, a drawing perhaps, if he had anything to Aretino's taste.

Aretino wrote back again, explaining that his ideas were not intended as advice on the painting, but merely to show that it was not possible to imagine anything as marvellous as Michelangelo would actually produce. Then he suggested that a portion of the cartoons, which Michelangelo might surely otherwise burn, would be a gift he would treasure and take with him to his grave.

Either because he did not get around to it, or because he resented the direct request, however, for the time being Michelangelo sent no gift to Aretino. The omission was noted.

*

We have an intriguing glimpse of Michelangelo and Vittoria Colonna in conversation in 1538. It occurs in a set of dialogues on painting written by a young Portuguese artist named Francisco de Holanda (1517–84). Holanda was in Rome between 1538 and 1540, sent by the King of Portugal to learn about the science of fortifications, but he was also keen to study ancient and contemporary sculpture, architecture and painting. At the beginning of the *Dialogues*, Holanda explained how he had sought out the acquaintance of notable artists and connoisseurs, rather than cardinals and aristocrats, 'because from them . . . I obtained some fruit and knowledge'. In particular, Holanda admired Michelangelo and, by his account, the feeling was reciprocated: 'So much that if I met him either in the palace of the Pope or in the street, we could not part until the stars sent us to rest.'

One might wonder whether Michelangelo, under pressure to complete an enormous fresco, could really have found all this time to talk to a rather modestly talented foreign artist. On the other hand, there are things we do not know about Holanda – how handsome he looked, how charming his manner was – and Michelangelo had a habit of expending his time, energy and talent on not particularly brilliant young men. There are aspects of these *Dialogues* that have to be treated with caution. Some, at least, of the views on art attributed to Michelangelo seem to have been Holanda's own. However, the location and the interaction between the artist and Vittoria Colonna both seem absolutely convincing.

The first dialogue is set on Sunday 20 October 1538 at the church of San Silvestro di Monte Cavallo, where Holanda found Vittoria and his great friend and mentor, a Sienese diplomat named Lattanzio Tolomei (1487–1543). They had been listening to a sermon on the Epistles of St Paul by a fashionable preacher, Fra Ambrogio Catarino Politi. After the preaching, Vittoria arranges to send for Michelangelo, without letting him know that Holanda is there, so that he may be inveigled into discoursing about art, saying that no doubt the young Portuguese would rather hear 'Michelangelo talk about painting, than Brother Ambrogio expound this lesson'.

She dispatches a servant with a message to Michelangelo: 'tell him that I and Master Lattanzio are here in this quiet chapel, and that the church is closed and very pleasant, if he cares to come and lose a little

of the day with us, so that we may gain it with him.' This done, her servant finds Michelangelo walking with his assistant Urbino in the street nearby, and he joins them in the empty church, where she, with tact and cunning, goes about luring him into doing this thing he does not want to do. Of course, in the end, she gets her way.

All this rings completely true. Michelangelo's reluctance to get drawn into social gatherings is confirmed elsewhere (for example, in the other, slightly later, dialogues by his friend Donato Giannotti). The picture drawn of a Vittoria who is a great aristocrat but also a graceful and humorous conversationalist helps explain her success with senior ecclesiastics and with such a tricky social proposition as Michelangelo himself. The other participant in the gathering is also just right for a companion of Vittoria Colonna and Michelangelo in 1538.

At just this time, in 1538/9, Lattanzio Tolomei performed the Spiritual Exercises under the direction of their author and the founder of the Jesuits, Ignatius Loyola (1491–1556), a programme of intense spiritual rigour that constituted a manual for improvement of the soul by prayer, self-examination and submission. However, in 1538, the Jesuits were not the powerful and established order they were to become. Loyola and his followers had just arrived in Rome, were under suspicion of being unorthodox or heretical and were years away from receiving papal approval. A few years later, Tolomei was in correspondence with Cardinal Contarini, one of the leaders of the reform movement in the Church.

In other words, the apparently innocent dialogue on painting places Michelangelo among Roman intellectuals operating on the dangerous edge of religious innovation. This was where Vittoria already was, and where Michelangelo – veteran of the revolutionary Savonarolan republic of Florence – also found himself.

While Michelangelo was at work on the scaffolding in the Sistine Chapel, the religious mood of Europe was becoming more puritanical. Many, looking at this new painting through the eyes of pious Christians untrained in Renaissance humanism and classical art just saw paganism and gross indecency – Christ as Apollo, Charon, Minos, stark-naked saints and sinners. Before *The Last Judgement* was even finished, it was controversial.

Vasari told a story about a visit the Pope paid to Michelangelo when he had already finished more than three quarters of the work. Biagio da Cesena, the master of ceremonies and very high-minded, happened to be with the Pope in the chapel and was asked what he thought of the painting. He answered that it was most disgraceful that in so sacred a place there should have been depicted all those nude figures, so shamefully exposing themselves, and that it was less a work for a papal chapel and more for the public baths and taverns.

If this anecdote is true, Biagio followed Pope Adrian VI in comparing Michelangelo's work to a *stufa*, or steam bath. These public baths, which had spread to Italy from Germany, were places where sixteenth-century Romans could see their fellow citizens naked. Naturally, they had a reputation as places for sexual assignation: brothels with hot water. It may be that Michelangelo went to these baths; even used them as an ideal spot to study nude figures in all manner of postures. Certainly the connection was made more than once by his contemporaries.

Biagio's verdict had an immediate sequel. 'Angered by this comment, Michelangelo determined he would have his revenge; and as soon as Biagio had left he drew his portrait from memory in the figure of Minos, shown with a great serpent curled round his legs' (and, as Vasari doesn't say, the huge snake's jaws are clamped around the satanic ruler's penis).[10]

<p style="text-align:center">*</p>

Before he finished *The Last Judgement*, Michelangelo had a serious accident. According to Vasari, the artist 'fell no small distance from the scaffolding in the chapel and hurt his leg; and in his pain and anger

10 This story sounds too good to be true. Could Michelangelo really have lampooned an important papal official in this way? But if it was merely *ben trovato*, the anecdote was invented very close to the time of the painting itself. The painting was unveiled in 1541 and, in 1544, the year of Biagio da Cesena's death, a satirical sonnet suggested he was standing among the dead as a punishment for his 'bad government'. This suggests that, at least, there must have been a figure in the picture that looked like Biagio; it has recently been suggested that it might in fact have been not Minos, but a less conspicuous member of the flock of damned souls, fluttering above in a clerical cowl.

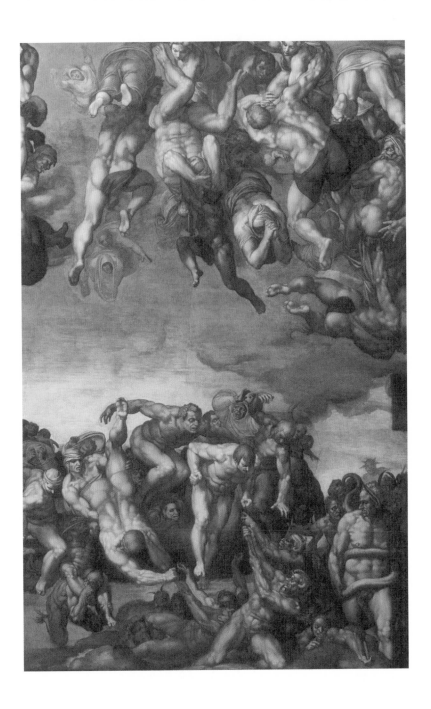

The Last Judgement, 1536–41, Sistine Chapel; detail:
Minos being Gnawed by a Serpent.

he refused to be treated by anyone'. It sounds like a recurrence of the angry depression which afflicted him, especially when he was exhausted and suffering from anxiety. This time his behaviour verged on the suicidal. In the insanitary conditions of sixteenth-century Rome, an untreated injury was extremely dangerous. Michelangelo was rescued by a Florentine doctor and friend of his named Baccio Rontini. Vasari described how the doctor went to see how Michelangelo was and, getting no answer when he knocked on the door, managed to enter the house and found the artist in 'a desperate condition'. The doctor refused to leave his side until he was better.[11]

*

On 31 October 1541 *The Last Judgement* was finally revealed to the world – eight years after Pope Clement had talked Michelangelo into accepting the commission, and five and a half since he had begun to paint. This was, with the exception of *The Risen Christ*, the first major work of his revealed in public since the Sistine Chapel ceiling twenty-nine years before to the day. The unveiling created an enormous stir. Vasari recalled how it had caused 'the wonder and astonishment of the whole of Rome, or rather the whole world'. He made a journey to Rome himself just to see this painting, 'and I along with the rest was stupefied by what I saw'.

Nino Sertini, the envoy from Mantua, wrote a report about the sensational new mural two and a half weeks after the unveiling. This was sent to Cardinal Ercole Gonzaga – the man who had exclaimed that *Moses* alone was enough to honour Julius's tomb – who had taken over the government of Mantua after the death of his brother Federigo the previous year.

Sertini reported that 'Even though the work is of such beauty as Your Illustrious Excellency can imagine, there is nonetheless no lack

11 It is not clear exactly when this happened, but that it really did is supported by the fact that Rontini was congratulated in 1546 by Niccolò Martelli (1498–1555), a Florentine merchant and poet, for saving Michelangelo's life not once but twice: when he fell from the scaffolding and also when he suffered an acute bout of fever. Rontini was a good friend of Vasari's, and so he is likely to have heard the story at first hand.

of those who condemn it.' Among the first to criticize were the Theatines, an austere order devoted to returning clergy and laity to a virtuous life.

The Theatine view – perhaps stated by Cardinal Carafa, one of the founders of the order and a man with whom Michelangelo was to clash in times to come – was that *The Last Judgement* was indecent: 'the nudes displaying themselves [literally, 'displaying their goods'] in such a place is not right.' Others, Sertini went on, complained that the beardless Christ was too youthful-looking, and 'does not possess the majesty that should become him'.

So, the painting was highly controversial: 'in a word, there is no lack of talk.' However, there was little dispute that this was a great triumph of art; among the princes of the Church it had its ardent defenders. Cardinal Cornaro, who had spent a long time in the chapel contemplating the picture, declared that 'if Michelangelo would give him a painting of only one of those figures he would pay him whatever he asked.' Sertini felt that this put the matter well. He would try to have a copy made to send to Mantua, although he feared that it would not give a full idea of a work so large and complex.

Altogether, the whole affair anticipated a modern exhibition opening. There was intense interest beforehand, even – in the case of Aretino's published letter – pre-publicity. Even in advance, many expected this work to be a great masterpiece. In the event, it divided opinion. It provoked moral outrage, and an argument – also contemporary in its echoes – between the values of art and religion. Eventually, there were to be determined efforts to censor this shocking picture.

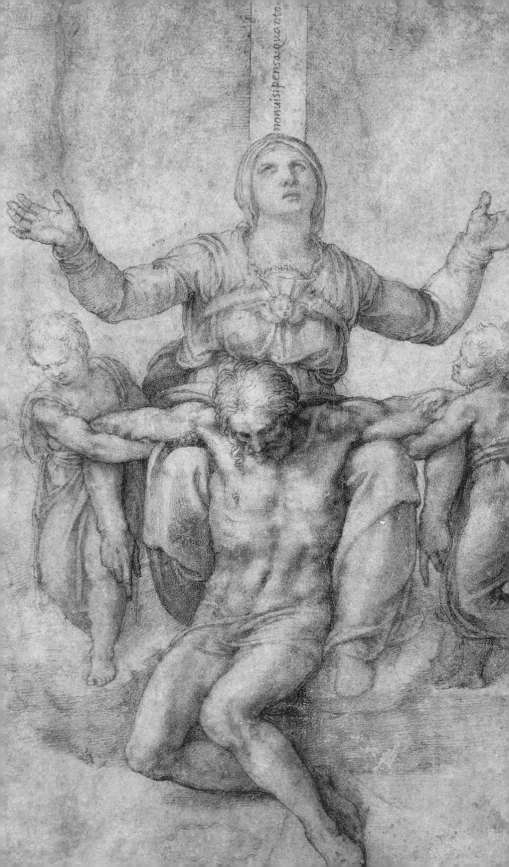

CHAPTER TWENTY

REFORM

*'The Marchesa of Pescara, the spiritual daughter of the
heretic Pole, his accomplice and the accomplice of other
heretics, was defiled by the Cardinal with false doctrines.'*

– From the Compendium of evidence posthumously assembled
against Vittoria Colonna by the Inquisition, 1567

With *The Last Judgement* finished, the question of the tomb
of Julius II came back to haunt Michelangelo yet again.
The old Duke of Urbino, Francesco Maria della Rovere,
had died in 1538. Like virtually all unexpected deaths in Renaissance
Italy, his was attributed to poison.[1] Francesco Maria was succeeded
by his son, Guidobaldo, who sent Michelangelo a courteous letter the
following year, expressing willingness to wait until after Michelangelo
had finished work on *The Last Judgement*, but also remarking that he
was as keen as Michelangelo must be to see his ancestor Julius II's
tomb finished after all these years.

However, no sooner was *The Last Judgement* unveiled than Paul III
commissioned Michelangelo to paint yet more frescoes. These were
in a newly built chapel in the Vatican which became known, because
Paul III had built it, as the Capella Paolina or Pauline Chapel. This
had recently been finished, and was awaiting decoration.

On 23 November 1541 Cardinal Ascanio Parisani – a senior member

1 It was allegedly administered in the manner Hamlet's father was assassinated, by
dropping venom in the ear; in della Rovere's case, by the Duke's barber. Francesco
Maria della Rovere was also, however, suffering from dropsy and venereal disease,
neither of which can have improved his famously violent temper. It is equally possible
that one of those, or perhaps a viral infection, caused his death.

(facing page)
*Pietà for Vittoria
Colonna* (detail),
c. 1538–40.

487

of the Vatican bureaucracy – wrote to the Duke of Urbino breaking the bad news. He explained that Michelangelo had to paint the chapel for the Pope and so would be unable to move on the tomb, adding that, as Michelangelo was now so old – almost sixty-seven – if he managed to paint this chapel before he died, he doubted he would ever be able to do anything else afterwards. The cardinal proposed that other sculptors finish off the work and – after haggling – it was finally agreed that this would happen, with Michelangelo contributing three sculptures from his own hand. One of these, the Duke insisted, should be *Moses*. It was clear to everyone who saw it that this sculpture was a masterpiece.

That should have been the end of it, since Michelangelo had already at least semi-finished far more marble figures than three. However, as usual, the negotiations about the tomb had made Michelangelo hysterical, and he found a new way of complicating the matter.

The obvious choice of three statues to adorn the tomb were *Moses* plus the *Dying* and *Rebellious Slaves* (or, as he called them, *Prisoners*). Michelangelo decided, however, not to include the latter two masterpieces, since, as the petition explains, they were made for an earlier and much larger scheme. In this petition, drafted by his new man of business, Luigi del Riccio, it was explained that these 'are unsuited to the present design, nor would they by any means be appropriate for it'. But why were these magnificent works no longer suitable for the tomb? After all – artistically speaking – the sight of *Moses* flanked by the two *Slaves*, or *Prisoners*, would have been sensational. It would also have been badly out of tune with the new mood in Rome.[2]

2 Alternatively, perhaps he had already another home in mind for them. The statues were later presented to Roberto Strozzi around 1546, in whose palace Michelangelo had been nursed by Luigi del Riccio (who perhaps brokered this gift), and given by Strozzi to Francis I of France. The whole episode echoes the gift of Michelangelo's early *Hercules* to Francis during the Siege of Florence, also from the Strozzi family. One wonders whether Michelangelo was not himself making this handsome present to Francis himself, via an indirect route. In the spring of 1546, the King had taken the unusual step of writing in person to Michelangelo, who replied on 26 April, expressing his regret at not being able to serve the king immediately. If, he went on, a little life remained to him after he finished his current work for the Pope (that is, the frescoes in the Pauline Chapel), he very much desired to make a work in marble, bronze or painting for Francis. It was not to be, but Michelangelo may well have felt

After the denunciations of the nudes in *The Last Judgement* for 'displaying their goods', perhaps Michelangelo thought it unwise to ornament the monument to a dead Pope with two over-lifesize naked young men. To do so would be to invite further attacks and – perhaps – he no longer thought it fitting either.

Therefore, Michelangelo had begun two other statues to go beside *Moses*: Leah and Rachel, standing for the *Contemplative Life* and the *Active Life* (which he now wanted to pass on to another sculptor so he could concentrate on the Pauline frescoes). These two statues were in every way opposite to the two naked prisoners carved thirty years before. They were clothed, devout and female.

These figures had long been an intended part of the scheme for the tomb, but they now became more prominent. A perfect balance between the active and contemplative was at the heart of Cardinal Pole's conception of the ideal ruler, explained in detail in his work on the papacy, *De summo pontifice*, but already hinted at in a letter to Cardinal Contarini. From a monument like a Roman triumph, in which Julius's effigy would have been surrounded by the naked figures of mourning arts and conquered cities, Michelangelo had moved to a much more sober conception, more in accordance with the taste of the new, reforming age.

*

It was almost certainly through Vittoria Colonna that Michelangelo grew close to the expatriate Englishman Reginald Pole, who was becoming increasingly prominent in Rome. Condivi – hence Michelangelo himself – singled Pole out for those friends of the artist 'from whose virtuous and learned conversation he could gather some fruit'. He was described as 'the most reverend and illustrious Monsignor Pole for his rare talents and singular goodness'.

Pole was an extraordinary, unique figure: the only man who came within a whisker of becoming Pope and simultaneously had a good claim to the throne of England (arguably better than Henry VIII's).

that the two *Slaves* were a suitable substitute, and left open – if necessary – the possibility of a move from Italy to France.

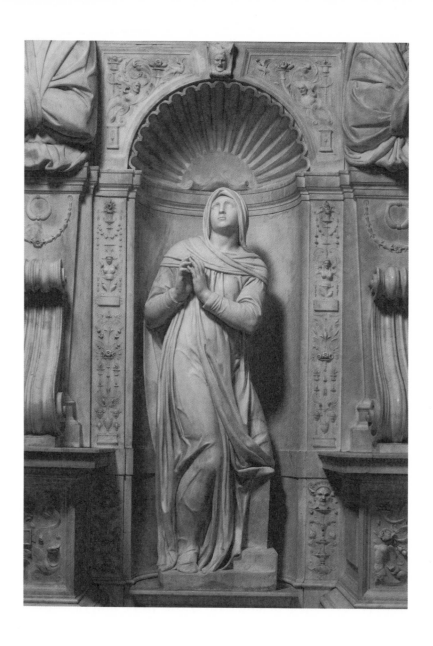

Rachel, or the Contemplative Life, from the Tomb of Julius II, c. 1541–5.

Pole was the grandson of George, Duke of Clarence – notoriously murdered in a butt of Malmsey wine, at least according to Shakespeare. He was thus the great-nephew of two kings, Edward IV and Richard III.

Pole began as a protégé of Henry VIII, who part paid for his expensive education at the University of Padua. In 1536, however, Pole broke with Henry, bravely and bitterly. He sent the King a copy of a book, *Pro ecclesiasticae unitatis defensione*, defending the unity of the Church and attacking Henry's position on the two great matters of English politics: the King's divorce and his assumption of supreme authority over the Church within his kingdom. This stand naturally enhanced Pole's reputation in Rome; later in the year, he was made a cardinal.

In consequence, Henry VIII took revenge on his family, back in England, arresting and interrogating several of them, including Pole's mother, Margaret, Countess of Salisbury (1473–1541). She was imprisoned in the Tower of London, stripped of her titles, and finally executed on 27 May 1541, a few months before the completion of *The Last Judgement* on 27 May 1541, with dreadful incompetence.[3] Clearly, Pole believed deeply in the unity of the Church, and paid the price – or, rather, his relations did – for doing so.

In retrospect, we tend to see the beliefs of the past as neatly sorted, in this case, into a Catholic package, a Lutheran, a Calvinist, and so forth. At the time, however, things were not necessarily so orderly. Pole may have believed in the unity of the Church, but he also held – or came very close to holding – one of the crucial tenets of Lutheranism: that salvation, or 'justification', was obtained through faith alone (or, in Latin, *sola fide*). This was in distinction to the traditional Roman doctrine that the way to heaven lay, at least partly, through charity. It might seem strange to us today that sixteenth-century Europe was divided into armed and mutually murderous camps by a theological point. But it was, just as in many parts of the world today

3 The executioner's first blow with his axe struck her shoulder, and ten more were reportedly required to kill this lady of nearly seventy. She is revered in the Catholic Church as the Blessed Margaret Pole.

people kill each other over similarly fine distinctions in political or religious belief.

In 1541, however, the two camps were still in the process of sorting themselves out, doctrinally speaking. There were those who were loyal to the unified Western Church and accepted the authority of the Pope yet were attracted by beliefs that – in hindsight – seem Protestant. Pole was one of these; Vittoria Colonna came into contact with others in Naples in the 1530s. Among these was Juan de Valdés (c. 1500–1541), a Spanish theologian who had fled to Italy to escape the attentions of the Inquisition, and a Capuchin friar named Bernardino Ochino, who became a favourite preacher of Vittoria's.

Collectively, this group was known as the Spirituali. They were a literary, intellectual and aristocratic circle, amongst whom writing sonnets was as common an occupation as penning religious tracts. Marcantonio Flaminio, Pole's secretary, was a poet and also part-author of the book that was the best-known statement of Spirituali faith: the *Beneficio di Cristo*, or Benefit of Christ; the writing of sonnets and theological thought blurred into one in this world.

The Spirituali were a great deal less populist and truculent than the northern reformers. Their emphasis was on finding a personal relationship with Christ, a connection as close as that with the beloved in a poem in the manner of Petrarch. The interface between romance and piety was of enormous interest, two decades later, to the inquisitors examining the case of Vittoria Colonna. Again and again they questioned a surviving member of the Spirituali who had fallen into their hands not only about her doctrinal beliefs but also about her relationship with Pole and another leading reformer, Cardinal Giovanni Morone. Were they, as hinted repeatedly by these questioners, not only heretics but also lovers? The answer seemed to be no, although Vittoria's latest biographer notes that her feelings for Pole bordered on infatuation.[4]

The way in which poetry, doctrine and a sense of closeness to the

4 She was so devoted to the English cardinal that after 1541, when he was appointed governor of the Patrimonium Petri, largest of the Papal States, which was administered from Viterbo, she spent much of her time in Viterbo too.

Redeemer were intertwined amongst the Spirituali was perfectly illustrated by one of the surviving interchanges between Michelangelo and Vittoria. Vittoria did not welcome her literary celebrity. On the contrary, she protested at her work being pirated and published. However, out of love for Michelangelo she made an anthology. In a letter to his nephew Lionardo, Michelangelo described it: 'a little book made of parchment that she gave me . . . in which are one hundred and three sonnets'.[5]

This was a graceful present – Vittoria's personal choice of her own art, made just for him – but at first Michelangelo, who was decidedly cranky about being put under an obligation in any way, tried to decline the gift. Almost certainly her poems were the 'cose', to which Michelangelo was referring in an undated letter. He began by explaining why he had not previously accepted the 'things' which she had 'several times' wished to give him. The reason was that he had wanted to make a gift in return.

Then he made a sudden leap into theology. 'Recognizing,' he wrote, 'that the grace of God cannot be bought,' he now realized it was 'a grave sin to receive it with a sense of discomfort'. This was a light, witty reference to a subject of intense importance to Vittoria, Pole and their associates. Whether the grace of God could be 'bought' – that is, earned through virtuous acts – was precisely the question that came to divide Counter-Reformation Catholicism from the northern Reformation. Many Christians were to die for their beliefs on this question over the decades that followed. Michelangelo's own inner convictions were – perhaps wisely – veiled, but he must have been affected by what Vittoria believed.

'I admit,' he concluded the letter, 'that the fault is mine and willingly accept these things.' Once he has them he will feel as if he has been saved: 'that I dwell in paradise'. Naturally, he did also give gifts to Vittoria; it was just that – in the spirit of a virtuous, reformist Christian doing good deeds, he gave her things not so as to get something in return but because that was what his heart told him to do. Like his

5 This still exists, in the Vatican Library, a simply bound and plain little volume, with on its title page the inscription: '*Sonetti spirituali della Sig.ra Vittoria*'. The handwriting has been identified as belonging to a calligrapher Vittoria Colonna employed.

presents to Tommaso, these took two forms: poems and drawings. And these were similarly adapted to the recipient. As we have seen, the drawings for Tommaso were calculated to please a clever teenager. They were full of diverting and extraordinary detail: horses tumbling through the air, gigantic birds, carousing cupids. For Vittoria, in contrast, he made images suited to a poet whose inner life was taken up by her relationship with Christ.

According to Condivi, he made three drawings for her: a *Crucifixion*, a *Pietà* and a *Christ and the Woman of Samaria*.[6] The second two dealt with a subject that was naturally of intense interest to Vittoria: a woman, one to one, so to speak, with Christ (just as she herself often was, in her poetry). Jesus fell into conversation with the woman of Samaria. In the conventional images of the Pietà, the Madonna passively mourns; in the drawing for Vittoria, however, she is much more active, holding her arms up to heaven. On the cross was inscribed a quotation from Dante's *Paradiso*, making a theological point about that subject of burning controversy: redemption. 'They do not realize how great the cost in blood!'

Christ himself had earned salvation for those who had faith. In the final drawing of the trio, he is in the act of doing so, on the cross but not passively suffering or dead – as so often represented – but leaning out and looking up with a serpentine twist: an active redeemer in the act of winning that grace for which Vittoria, Michelangelo and their circle so hoped.

In the early 1540s for a moment it seemed possible that the unity of the Church might be saved with a theological compromise. Another leading Italian reformer was Gasparo Contarini (1483–1542), a Venetian nobleman who after a spiritual crisis and in despair at his worthlessness in the eyes of God had found his own way to belief, which was very close to Martin Luther's doctrine of salvation by faith alone – but before Luther, in 1511. Contarini had been made a cardinal by Paul III. In 1541 he was the Imperial Legate at an Imperial Diet in Regensburg (or Rattisbon) in Bavaria, which attempted to bridge the religious chasm that was splitting Christendom. The negotiations

6 The last no longer survives, but studies for it do, and prints and paintings copying it.

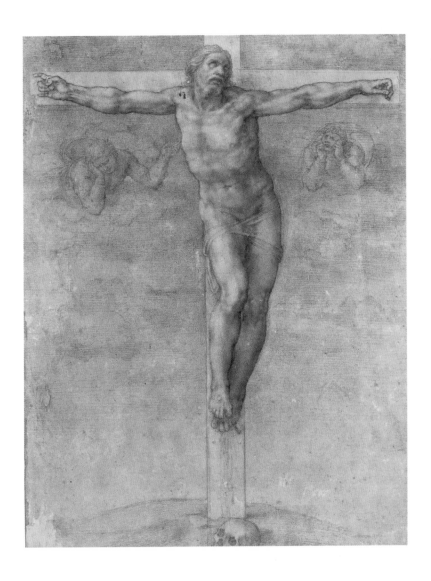

The Crucifixion, c. 1538–41.

came up with a fudged compromise on the question of justification by faith alone. However, the agreement fell apart, as it turned out that none of the more intransigent theologians on each side really wanted it. Contarini returned to Italy and died the next year, 1542, a defeated man.

In the aftermath of the failure at Regensburg, the hard-liner Cardinal Carafa persuaded Paul III to form a Roman Inquisition on the lines of the Spanish Inquisition to enforce religious orthodoxy, with Carafa himself as one of the Inquisitors General. Determined to crush heresy, Carafa personally paid for the locks and chains for the Inquisition's new prison. 'Even if my own father were a heretic,' he announced, 'I would gather the wood to burn him.' The crackdown was not yet complete, but the shadows of suspicion were beginning to fall on any theological unorthodoxy.

The Spirituali were an early target. Bernardo Ochino, Vicar General of the Capuchins and Vittoria Colonna's favourite preacher, was summoned to Rome in August 1542; instead, he fled Italy over the Alps for Geneva – now a Calvinist state. He was followed by another leading member of the group, Peter Martyr Vermigli. These were defections as shocking as those of Burgess and Maclean in the Cold War and, like them, they cast a shadow over the friends the defectors had left behind. When Marcantonio Flaminio died in 1550, Cardinal Carafa was hovering near his bedside, watching out for signs of heresy.

*

In the meantime, yet another contract for Julius's monument had been signed, on 20 August 1542, in which it was agreed – as Michelangelo had petitioned – that all the statues, including the *Active* and *Contemplative Lifes*, should be completed by Raffaello da Montelupo. However, the Duke of Urbino did not send his ratification of the agreement, and the anxiety caused by this prevented Michelangelo 'not only from painting, but from living life at all'.

An unnamed Monsignor, perhaps Cardinal Alessandro Farnese, the Pope's nephew, told him to paint and not worry. Michelangelo memorably replied that 'one paints with the head and not with the hands, and if one cannot concentrate, one brings disgrace upon oneself.'

Therefore, until my affair is settled, I can do no good work.' Then he launched into an extensive self-justification, going into the whole history of the tomb, back to 1505.

The tone suggests that Michelangelo was cracking up; in defending himself against such attacks, he remarked, he was bound to become *pazzo*: mad, or obsessed. There is a hint of persecution mania about this letter. He protested his innocence of any sharp practice: 'I'm not a thieving usurer but a Florentine citizen of noble family, the son of an honest man.' It is tempting to speculate as to whether the defection of Ochino played any part in Michelangelo's own anxiety attack; as he must have known, it caused alarm and consternation to Vittoria Colonna.

In the end, he gave in and decided to finish the *Active* and *Contemplative Lifes* after all. He resigned himself, as he told Luigi del Riccio, to staying at home and completing the sculptures, since the ratification of the contract by the Duke was not going to come otherwise. It would suit him better than 'dragging himself to the Vatican every day to paint'. So, finally, after so many years, so much anguish, fury and interminable negotiation, the matter was settled.

In November 1542 Michelangelo began once more to paint. In the three and a half decades since he had conceived the heroic physical beauty of the Sistine Chapel ceiling, Michelangelo's vision of humanity had been utterly transformed. In *The Conversion of St Paul*, the first of the two frescoes in the Pauline Chapel – probably begun at the end of 1542 and finished in 1545 – mankind is depicted as huddled, crushed and awestruck. Christ zooms down from above like a spiritual missile, emitting a ray of golden light from his right arm, and the little group on the road to Damascus scatter as if from the force of an explosion. A great horse rears up – the last of Michelangelo's heroic depictions of animals – Paul's entourage flees, covering their ears, shielding their faces, or are blown on to the ground. The saint-to-be himself has been hurled from his mount by the force of the holy onslaught. He lies vainly trying to protect his blinded eyes from the light of revelation. The angels surrounding Christ are in some cases beautiful and discreetly naked, suggesting that Michelangelo had still not quite given up the belief that a bodily beauty could reflect spiritual grace.

The mortals however, are lumpen, their faces mostly coarse. They inhabit a featureless upland[7] with, in the distance, a toy-fort Damascus. Nothing could be further from the confidence that underpinned the paintings of the Sistine Chapel ceiling.

It has been suggested that the face of Paul, blinded and felled by the power of Christ, has Michelangelo's own features. Is this an intentional portrait, or perhaps a half-conscious or unconscious one? That he was aware of the possibility that a self-portrait might creep almost unintentionally into an artist's work is indicated by a madrigal written around this time. It begins, 'Since it's true that, in hardstone, one will at times/ Make the image of someone else look like one's self.'

*

After Angelini died in 1540, Luigi del Riccio took over his role in helping Michelangelo with practical affairs. Like many of Michelangelo's Roman circle, he was a banker by profession – he was manager of the Strozzi and Ulivieri bank in Rome – and a Florentine. Yet del Riccio was more than simply an able man of business. For almost a decade he was Michelangelo's closest advisor, and something like an editor, helping the artist with his poetry and planning a published collection of the artist's writings (a project that lapsed after del Riccio's death).[8]

7 A passage in Holanda's *Dialogues on Painting* probably expressed Michelangelo's true view of landscape, because it is so trenchant and unconventional. He began by attacking northern, Flemish painting: 'They paint in Flanders, only to deceive the external eye.' Flemish art, he complained, was all about trivialities, depictions of 'bricks and mortar, the grass of the fields, the shadows of trees, and bridges and rivers, which they call landscapes, and little figures here and there; and all this, although it may appear good to some eyes, is in truth done without reasonableness or art, without symmetry or proportion, without care in selecting or rejecting.'
8 Michelangelo had misgivings about his poetry, revealed by the regularity with which he asked his literary friends to revise what he had written. On the other hand, in his later middle age he was a prolific poet. In the decade and a half following his meeting with Tommaso de' Cavalieri at the end of 1533, he wrote over two hundred poems, or about three quarters of his output. That same year a comic poet, Francesco Berni (1497/8–1535), sent Michelangelo a poem from Venice remarking that, whereas the mellifluous followers of Petrarch wrote mere words, 'he says things.' This was an

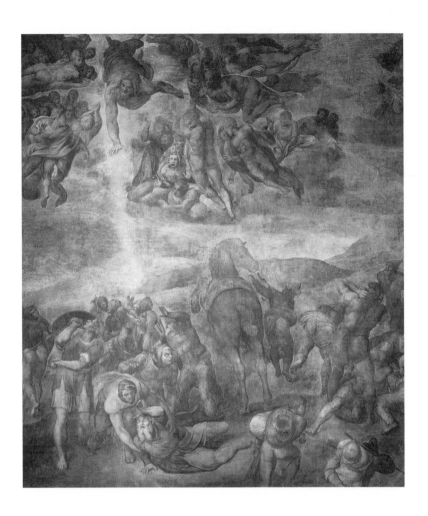

The Conversion of St Paul, 1542–5, Pauline Chapel, Vatican.

Michelangelo's social life seemed to centre on del Riccio and Donato Giannotti. Del Riccio, for example, invited him to dinner on 29 August 1542, the feast of the beheading of St John the Baptist: 'If you want to give everyone pleasure come to supper at the bank this evening.' Unfortunately, Michelangelo was unable to go, as he had given his household servants the day off, and had neither a servant to reply to the letter, nor one to accompany him through Rome at night: 'A poor man with no one to serve him is guilty of these lapses.'

Perhaps he was simply making excuses. Michelangelo apparently remained averse to company. In the first of two dialogues written by Giannotti in the mid-1540s, *Dialogues on the Days that Dante Spent Looking through the Inferno and Purgatory*, there is a scene demonstrating exactly how difficult it could be to lure the artist into coming out. After detailed discussion of the chronology of *The Divine Comedy*, the talkers in the dialogue adjourn about noon, with the quartet of friends agreeing to meet in the evening. Del Riccio, in addition, presses them all to come to dinner with him, but Michelangelo refuses, on the grounds that he wants to stay on his own because if he mixes with the company at dinner he will be too cheered by it.

Naturally, del Riccio thinks this ridiculous. There will be a delightful group of talented and engaging people who greatly admire Michelangelo and long to see him, there will be music and dancing, which will drive away all melancholy (it is true the notion of Michelangelo dancing strains the imagination). Even the morning they had spent strolling through the vineyards and flocks of the Roman *disabitato* had infringed on Michelangelo's sense of self; a dinner party would do yet more damage. The best theme for our thoughts, he insisted, in gloomily medieval fashion, was death.

Despite the artist's curmudgeonliness, the friendship between Michelangelo and del Riccio revolved around poetry, food and the cult of a young man, del Riccio's nephew, named Francesco, or Cecchino del Braccio. A beautiful and charming youth, Cecchino was effectively del Riccio's adopted son and was made a sort of mascot by Michelangelo,

acute way of underlining the tough, difficult texture of Michelangelo's language and his thought. It was as if pieces of roughly carved stone were coming out of his mouth.

del Riccio, Giannotti and their circle of Florentine exiles in Rome. Del Riccio and Michelangelo both referred to him as their 'idol'. In a letter asking del Riccio a favour, Michelangelo jokingly described a dream in which 'our idol', like some divine apparition, 'seemed both to smile and to threaten me'.

Cecchino's death, aged only fifteen, on 8 January 1544, left del Riccio distraught. 'Alas, Alas!' he wrote to Giannotti, 'our Cecchino is dead,' adding that Michelangelo was making a design for a simple marble tomb. Eventually, Cecchino's tomb in Santa Maria in Aracoeli was delegated to Michelangelo's assistant Urbino, but over the following months the artist himself produced instead a verbal monument of fifty poems, forty-eight short epitaphs, one madrigal and one sonnet.

Strangely, considering del Riccio's grief, accompanying these variations on the theme of mourning, death and beauty were little jokey notes explaining that the poems were in thanks for gastronomic presents: 'For the fig bread'; 'For the duck last night'; 'For the salted mushrooms, since you don't want anything else'; 'this clumsy one . . . for the fennel'; 'I didn't mean to send you this, as it is very stupid, but the trout and the truffles would prevail even with heaven.' Some had a slightly ungrateful tone: 'The trout says this, not I, so if you don't like it, don't marinade any more of them without pepper.'[9] Apart from summoning up an evocative list of dishes on the table of mid-sixteenth-century Rome, these notes present an image of poetry being extracted from the artist against his will, because he cannot bear to be in del Riccio's debt, even for fennel or fig bread.

*

In the summer of 1544, Michelangelo – burdened with work in the Pauline Chapel and the completion of the tomb – fell dangerously ill

9 Appended to one epitaph, no. 197, beginning, 'My flesh, now earth, and my bones here, deprived of their beautiful eyes', were two more lines, which Michelangelo describes as 'a moral thing', referring to 'being in bed with Cecchino,' who embraced me and in whom my soul lives on'. Whether the person who was in bed with Cecchino was del Riccio or Michelangelo, and whether the lines were intended to have a sexual meaning, is a matter of scholarly debate.

with a high fever. Del Riccio took him to his own apartments in the Strozzi-Ulivieri Palace, where he was nursed and treated once again by the doctor who had saved his life before, Baccio Rontini. Michelangelo's nephew Lionardo, hearing of his illness, set off from Florence. He was concerned, Michelangelo clearly suspected, more about the safety of his inheritance than about his uncle's state of health. When he arrived in Rome, Michelangelo refused to see him. Instead, he was handed a furious letter from the bedridden, possibly still delirious artist.

Michelangelo accused Lionardo of being like his late father, Buonarroto, 'who turned me out of my own house in Florence'.[10] Lionardo was to stop bothering him about his will. 'So go with God, and don't come near me anymore and never write to me again.'

On 21 July the artist, recovering from his high temperature, sent a message to Roberto Strozzi, who was in Lyon, asking if Francis I had made any response to a desperate offer he had made, perhaps the product of a rambling mind: if the King of France would liberate Florence from the regime of the Medici, he would erect a bronze equestrian statue of the monarch at his own expense in the Piazza della Signoria. (There is no record of any reply.)

The correspondence between Michelangelo and Lionardo was not resumed until December, when the artist – having got over the worst of his irritation – sent a short message, beginning: 'I do not want, however, to fail you.' He was reluctant to break completely with this young man – the only hope of continuing the direct Buonarroti line – but Michelangelo frequently seemed determined to behave in the manner of an old-fashioned Florentine paterfamilias. The tone of his first surviving letter to Lionardo, who was by then twenty-one, is almost shockingly different from the swooning adoration with which Tommaso de' Cavalieri was addressed, or the Mannerist complexity of the courtesies to Vittoria Colonna: 'I have received three shirts together with your letter, and am very surprised that you should have sent them to me, as they're so coarse that there's not a peasant in Rome

10 An accusation that does not seem to be strictly true: Michelangelo had left the house on Via Ghibellina after a furious family quarrel.

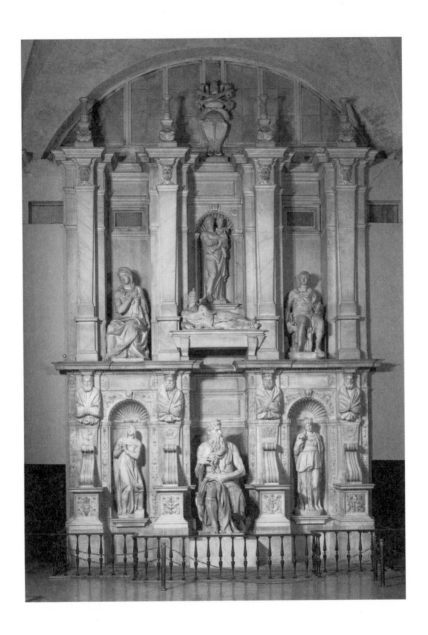

Tomb of Julius II, 1505–45, San Pietro in Vincoli, Rome.

who wouldn't be ashamed to wear them.' This was characteristic of the manner he adopted to Lionardo, when he suspected – probably rightly – that his nephew was mainly interested in his rich uncle's money.[11]

*

At the beginning of 1545, after forty years, the tomb was finally completed. On 25 January Raffaello da Montelupo's sculptures were installed, and Michelangelo's in February. So there it was – but how it should be judged was another matter. In Condivi there was an appraisal at once proud and apologetic: 'It is true that the tomb, just as it is, botched and rebuilt, is yet the most impressive to be found in Rome and perhaps anywhere else.' This was just. After all, as Cardinal Gonzaga had quite truly remarked, *Moses* alone was enough. Here was one of Michelangelo's greatest works, and indeed one of the most remarkable statues in the history of art.

This carving was sufficient to make the Tomb of Julius II the finest papal tomb of the sixteenth century, perhaps of all time. Its rivals are those of Pollaiuolo in the late fifteenth century, and Bernini in the seventeenth. But the tomb as a whole was not the great masterpiece it might have been. The conception had been altered too often; work from very different periods of Michelangelo's life fitted awkwardly together; the sculptures carved by other hands – as he had always feared – were weak and lumpen in comparison with his own. It looks like what it is: a compromise dragged painfully out of the artist by legal threats.

*

11 Francesca – Michelangelo's niece and Lionardo's sister – received less abrasive messages, but also less attention. She was by now no longer truly a Buonarroti, as she had married Michele Guicciardini in 1537, with her uncle's farm at Pazzolatica as dowry. She had four children, but seems to have been an even lower priority for her uncle than Lionardo. In a letter to the latter from 1541, when, admittedly, Michelangelo was fully occupied in completing *The Last Judgement*, he added a message for her: 'Although Francesca isn't very well, as she writes me, tell her from me that in this world one can't be wholly fortunate, and that she must be patient.'

At the end of 1545, for the second time in little over a year, Michelangelo fell dangerously ill. Once more, Luigi del Riccio took him into his own apartments in the Strozzi-Ulivieri Palace and nursed him there. By mid-January 1546 del Riccio was able to write to the artist's nephew in Florence, announcing that Michelangelo had almost recovered. Nonetheless, rumours of his illness – and death – were circulating. As had happened eighteen months before, Lionardo rode south at high speed to make sure his inheritance was safe and, when he arrived, Michelangelo refused to see him. Eventually, on 6 February, he sent Lionardo another stinging letter: 'You say that you were under an obligation to come because of the love you bear me. Cupboard love!'

It was possibly at this moment that Michelangelo had his one recorded quarrel with del Riccio. In an undated letter, Michelangelo observed angrily that it was within the rights of someone who has saved him from death to insult him, but that he does not know which is harder to bear – dying or this insult. The injury, whatever it was, concerned an engraving, the plate of which the artist pleaded to have destroyed. After his signature, he described himself as 'not a painter, nor a sculptor, nor an architect' – whatever del Riccio wanted to call him, but not a drunkard either, as he had told del Riccio when he was with him.

Michelangelo did not describe the engraving that upset him so much, but one suspects it was his own portrait by Giulio Bonasone, dated 1546, and showing the artist as emaciated, heavily lined in the face, with hair swirling as if with nervous agitation. This might indeed have been enough to wound a man sensitive about his appearance.

As it happened, his tender care of Michelangelo through sickness was almost the last service del Riccio performed for the artist. Towards the end of 1546, probably in October, del Riccio died; he had been Michelangelo's closest friend and advisor for the previous half a decade. The artist was poleaxed with grief. 'Now that Luigi del Riccio is dead,' a papal official wrote in November to the Pope's wicked son, Pier Luigi Farnese, Duke of Parma and Piacenza, Michelangelo was so stunned 'that he can do nothing but give himself up to despair'.

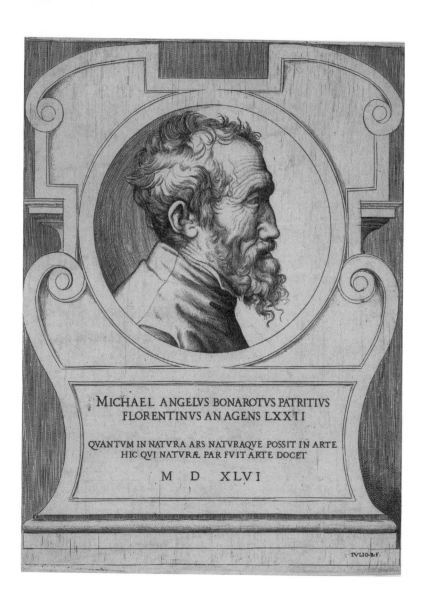

Giulio Bonasone, *Portrait of Michelangelo Buonarroti*, 1546.
This image of an agitated and aged man is perhaps the most
accurate we have of Michelangelo in later life.

This was awkward, because of another demise. On 3 August Antonio da Sangallo the Younger, chief architect of the Basilica of St Peter's, had died. At first, the Pope and his advisors thought that Giulio Romano – pupil of Raphael, who had been Antonio's predecessor – would make a suitable replacement. However, Romano declined, and died later in the year. That left Michelangelo, who, understandably, felt he had enough to do. In the spring of 1546, wearily, the 71-year-old artist had begun to paint the second fresco in the Pauline Chapel: *The Crucifixion of St Peter*.

An agent sent another message to Pier Luigi Farnese a few days later. If ever the Pope had need of Michelangelo, he reported, it was now, especially for the building of St Peter's and the Vatican Palace, but it was even more difficult to control the artist 'now that Messer Luigi is dead, who used to manage him' and persuade him 'to comply with the wishes of his Beatitude'.

Plainly, a simple order from the Pope was not sufficient to persuade Michelangelo to do what was required, even though Paul III could be a formidable man to cross. He had no compunction about having Benvenuto Cellini thrown into a cell in the Castel Sant' Angelo in 1538, where the goldsmith almost perished. For that matter, the Farnese altogether could be as dangerously violent and unpredictable as the della Rovere. In 1538 Pier Luigi had violently raped the young Cosimo Gheri, Bishop of Fano – a friend of Reginald Pole's – who later died, possibly as a result.

Michelangelo, however, seems to have treated Paul III with no more, or even less, respect than he had Clement VII. In the first dialogue on painting by Francisco de Holanda, Michelangelo is made to explain his lack of courtly ceremony:'Sometimes, I may tell you, my important duties have given me so much licence that as I am talking to the Pope, I put this old felt hat nonchalantly on my head, and talk to him very frankly.'

Michelangelo vigorously defended his bearish behaviour.'Do you not know,' he asked,'that there are sciences that require the whole man without ever leaving him free for your idle trivialities?' It was unreasonable to expect a busy man to waste his time on courtly flimflam, he insisted. 'Painters are not in any way unsociable through pride,' but because nothing else is as interesting to them as painting, or because they do not wish to be distracted from their thoughts by 'useless conversations'.

Indeed, in his view, being difficult – 'singular and reserved, or what-ever you may be pleased to call it' – was actually a necessity for those who wanted to achieve remarkable things. 'Even his Holiness annoys and wearies me when at times he talks to me and asks me somewhat roughly why I do not come to see him.' Michelangelo's response was that he was better occupied working for the Pope in his own house, than 'by standing before him all day, as others do'.

Paul III took no offence at this lèse-majesté; not even for addressing him while wearing the old felt hat: 'on the contrary, he has given me a livelihood.'

Paul III and Michelangelo were two elderly men who had spent much of their lives in the same environment. They might well have encountered each other first over fifty years before, in the mid-1490s. They shared many values and attitudes, had lived through the same turbulent times. The Pope evidently agreed with Aretino that the world had many kings but only one Michelangelo. However, that, naturally, only made him all the more determined that the artist should take charge of designing the greatest church in Christendom.

By the end of December he had got his way, partly by offering to intervene in the matter of the ferry across the Po. In 1535 the Pope had given Michelangelo a right to the profits from this ferry near Piacenza as an income. But it had taken some time for the artist to start getting the money and, almost as soon as he did so, trouble started. A rival ferry was established, which finally had to be stopped on the orders of the Pope. Next, the municipality of Piacenza tried to divert the flow of cash in its direction; when the fearsome Pier Luigi Farnese became Duke of Parma and Piacenza in 1545, he grabbed it for himself.

By this time, Michelangelo had had enough of earnings 'based on water', but there were further complications before the Pope, and under pressure from the Duke, confirmed Michelangelo's right to all the money. Shortly afterwards, Michelangelo gave in to the Pope's desire. On 2 January 1547 a *motu propio* was signed, making Michel-angelo the architect in charge of the Basilica of St Peter's.

*

Within two months, Michelangelo was struck by an even greater grief than the loss of Luigi del Riccio. For a decade, he had maintained his friendship with Vittoria Colonna, in which she was at once muse, spiritual guide and fellow-spirit. They had not always been living in close proximity. She had been forced to leave Rome in 1541 because her brother, Ascanio, was at war with the Pope. For the next three years she spent most of her time in Viterbo, keeping close to her own spiritual mentor, Reginald Pole. But, according to Condivi, 'she would come to Rome for no other reason than to see Michelangelo.'

Some of Michelangelo's most accomplished and memorable poems were addressed to Vittoria, including two in which he mingled the imagery from his own art of sculpting with the theological questions that obsessed them. His sonnet no. 152 uses the metaphor of sculpture for salvation:'By what we take away, lady, we give to a rugged mountain stone/A figure that can live? And which grows greater when the stone grows less.' Here was the fascination with sculpture as an act of discovery within a piece of marble: by chipping away, the figure was slowly revealed.

Then, in the sonnet, he moved to matters spiritual: 'So, hidden under that excess/Which is the flesh/The trembling soul/Still contains some good works/That lie beneath its coarse and savage bark.' Then he jumps again, almost blasphemously: only she can free these from the outer shell: 'For in myself I find no strength or will.' The conventions of love poetry and devotional verse are completely interfused; the sense might be that Michelangelo's salvation lay not so much with Christ as with Vittoria; or rather, perhaps, she was his only route to the Redeemer.

As he aged, Michelangelo was increasingly preoccupied by guilt,'so near to death and so far from God'. In a short poem he lamented that 'My soul, troubled and perplexed, finds within itself . . . some grave sin.' The interesting question this raises is exactly what the sin that weighed on Michelangelo's conscience was.

In 1544 Vittoria came back to live in Rome and took up residence in the monastery of Sant' Anna dei Funari. She fell ill at the beginning

of 1547, made her will on 15 February and died on 25 February, in her mid- to late fifties. In one of the most poignant touches in Condivi's Life, the writer noted how Michelangelo would 'say that what grieved him above all else was that when he went to see her as she was passing from this life, he did not kiss her brow or her face but simply her hand'. Even at the moment of death, he could not quite break through the barriers of rank, gender and convention that held them apart. The moving thing is that he wanted, at least in retrospect, to escape these inhibitions. He was not only, like all of us, a product of his times, but also someone struggling against the age in which he lived, and sometimes also against himself.

Again according to Condivi (who was by this time not just a scribe and amanuensis but also an eyewitness to Michelangelo's life), Vittoria's death drove Michelangelo almost mad with despair.

We have Michelangelo's own account of how he felt, scattered through his letters. To his old friend the priest Fattucci he wrote that he had been very unhappy of late, staying in his house and going through his things, when he had found a few poems which he was sending to Fattucci in Florence, although he could not be sure he had not sent them before. 'You'll rightly say that I am old and distracted, but I assure you that only distractions prevent one from being beside oneself with grief.'

Around the same time, perhaps in March or early April 1547, he added a bitter reflection to a letter of thanks for a grateful literary compliment he had been paid: 'I am an old man, and death has robbed me of the dreams of youth – may those who do not know what old age is bear it with what patience they may when they reach it, because it cannot be imagined beforehand.'

Benedetto Varchi, the scholar and critic, had elected to give his lectures based on Michelangelo's poem to the Florentine Academy, a society founded in 1540 to encourage the study of Italian literature. Varchi's discourse, which was published in book form, was a splendid tribute to a writer who had not completed his education in Latin grammar and consequently never felt himself to be a true member of the world of letters. However, for Michelangelo, there was sorrow in

this too. The sonnet to which the lecture was devoted was addressed to Vittoria Colonna.[12]

For the artist, the sequence of bereavements continued. On 21 June 1547 Sebastiano del Piombo died; even though they were not on such friendly terms as before the disagreement about the correct plaster on which to paint *The Last Judgement*, this must still have been a blow to Michelangelo. In January of 1548, the death of his least favourite sibling, Giovansimone, followed, which at least gave Michelangelo an occasion to scold his nephew Lionardo. He accused the young man of treating the matter too lightly: 'I would remind you that he was my brother, no matter what he was like.'

It was in this gloomy period, it seems likely, that Michelangelo wrote one of his most astonishing poems. It is not above love, or God, or Neoplatonic metaphysics. It is a darkly comic and scatological reflection on old age that takes his house as a metaphor for his ageing self, beginning with its location in the – probably thoroughly insanitary – sixteenth-century street market, the Macel de' Corvi:

> Around my door are such mounds of dung as must have come from giants who either ate grapes or took laxatives, and found nowhere else to shit . . . dead cats, carrion, filth and sewage are my constant companions, I never seem to get away from them.

As it continues, there is an echo of *The Tempest* and the trapped spirit of Ariel: 'I am shut up here like pith in the bark of a tree / Alone and miserable like a soul imprisoned in a vial.' His almost grand house was reduced, in this atrabilious mood, to 'a wretched cave', where a thousand spiders wove their webs.

The verse lists his ailments and diminishing faculties, including

12 This was no. 151. This plays, like no. 152, quoted above, on the theme of sculpture and salvation. It begins with his most famous lines: 'The best of artists can no concept find / That is not in a single block of stone / Confined by the excess.' Then Michelangelo leaps to an emotional conclusion: 'Noble and gracious lady, most divine, / The evil that I flee and the good I crave / Both reside in you.' If she is merciful, he will live; if not, he dies. The sonnet reads like a Petrarchan love poem, but with a dark weight of guilt and anxiety behind it.

constipation, deafness, fading sight, tinnitus and kidney stones: 'Within the body [my] soul enjoys such ease/That if the plug were pulled to free a fart,/It would not stay behind for bread and cheese/ That blocked back door stops death from flying out.'

Michelangelo was, he insisted with Rabelaisian hyperbole, a tired, sick old man: 'can't sleep for my catarrh, and yet I snore'; he felt 'a cobweb forming in one ear', a cricket singing in the other; his face would frighten crows; 'lumbagoed, ruptured, knackered – that's the way/My toil has left me.' He ended with a truly staggering description of his art: *tanti bambocci* ('so many toys'), that is, *David, Moses* and the *Pietà*: or, as the scholar and translator Anthony Mortimer nicely turns the phrase,'those big dolls'.

Was all that effort worth it? 'I wonder what/The point was, if my end is still like one/Who swims across the sea and dies in snot.' The result of the art for which 'in bygone days I won such golden opinions', had been that here he was, 'poor, old and servant to another's will'.

The complaints in the poem were paralleled in Michelangelo's grouchy letters to his nephew Lionardo. His feeling of poverty was perhaps the result of the fact that, less than a year after he had taken on the task of designing St Peter's, he lost the earnings from the ferry across the Po after all. This was hardly the Pope's fault, because it followed from the fact that his son – the violent, rapacious and dangerously out of control Pier Luigi – had been (understandably) murdered by some of his subjects. He was stabbed and hung out of a window in his palace at Piacenza on 10 September 1547; consequently, the Duchy, and with it Michelangelo's ferry revenues, passed out of the power of the Farnese family. Paul III eventually found him another suitable sinecure, as Civil Notary to the Chancellery of Rimini.

In the poem, Michelangelo bleakly listed that, in his bladder, there were 'three black stones'; in 1548 and again in the spring of 1549 he sent Lionardo graphic accounts of his troubles. As regards being unable to urinate, he reported in March of the latter year, he had been very ill with it,'groaning night and day, and unable to get

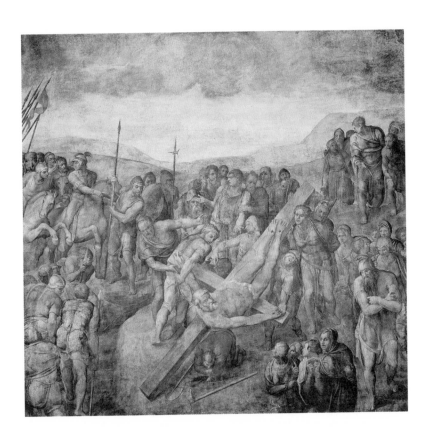

The Crucifixion of St Peter, 1545–9, Pauline Chapel, Vatican.

any sleep whatever'. His doctors prescribed 'a certain kind of water to drink', which – oddly enough – seems to have worked. In a medically detailed account, Michelangelo explained that this solution caused him 'to discharge so much thick white matter in the urine, together with some fragments of the stone' that he felt much better.[13]

Michelangelo lamented being 'poor, old and servant to another's will' in the poem. In a letter to Lionardo from May 1548 he glumly noted that he had served a series of popes 'under compulsion'. There is a sense of a titanic being, trapped and coerced, about Michelangelo's last painting, too, which he was slowly executing during these years: *The Crucifixion of St Peter*. It is, if anything, even bleaker than its predecessor. Once more the setting is a landscape without a single tree. There are no naked angels, no heavenly beings swooping down. The only nude is an old man, the white-haired but still heroically muscular figure of Peter, who has asked to be crucified upside down but with a mighty effort raises himself from the wood of the cross – itself in the process of being lifted to the vertical – and fixes the viewer with a stare of tremendous intensity.

To the left, a Roman soldier directs operations; all around are soldiers, and a crowd of onlookers, trudging over the bare hill. Among these, on the right, is a gigantic bearded figure in a hood, his arms folded, lumbering heavily onwards. Both this gloomy giant and the martyred saint seem like psychological self-portraits of the ageing artist.

This, however, was far from being a phase of weary decline. On the contrary, it was one of dynamic originality. This was the paradox, as so often with Michelangelo: the more he complained, the more creative he was. Frequently, of course, it had been tasks he was forced to under-

13 The most vivid testimony to the aged artist's urinary problems is in the remark attributed to him by Bernini expressing the sheer effort his art required: 'Nelle mie opera caco sangue!' ('I shit blood in my works'). The source, dating from around a century after Michelangelo's death, is very late, but it is hard to imagine that he did not say those very words. The bodily metaphor of painful straining fits so well with his actual physical problems; and it is hardly a remark any worshipful admirer would have invented.

take against his will that turned out most triumphantly (the Sistine Chapel ceiling being the most outstanding case in point). In his seventies, 'lumbagoed, ruptured, knackered' though Michelangelo may have been, he set about inventing new forms for a new age that was only just coming into being: an era of revived and renewed Catholic Christianity.

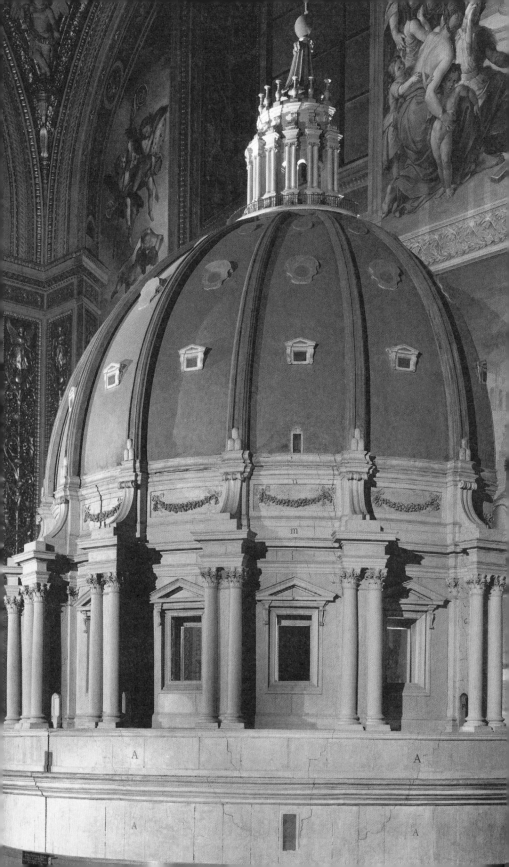

DOME

'From 1547 until the present day, during which time we deputies of the Fabbrica have counted for absolutely nothing and have been kept by Michelangelo in absolute ignorance of his plans and doings . . . the expense has reached the total of 136,881 ducats. As regarding the progress and the designs and the prospects of the basilica, the deputies know nothing whatsoever, Michelangelo despising them worse than if they had been outsiders.'

– From a letter to Pope Julius III from the Deputies in charge of the fabric of St Peter's, c. 1551

A t the point when Michelangelo took over the architecture of St Peter's, the great church had already been under reconstruction for forty-one years. The foundation stone had been laid on 18 April 1506, the day that Michelangelo had ridden north on a post horse to Florence. In those four decades, disappointingly little progress had been made. Initially, under Julius II and Leo X, the works had moved forward briskly enough, but papal finances ran low, and – especially during and after the Sack of Rome – building had slowed to a standstill. As a result, after four decades, parts of the fourth-century basilica of the Emperor Constantine still stood, while sections of the new structure looked like an ancient Roman ruin, from which weeds could be seen growing.

Michelangelo's erstwhile enemy and rival, the great architect of the High Renaissance, Donato Bramante, had made one crucial and irrevocable decision: the new church would culminate in a huge, classical dome. While he was still alive, Bramante began the construction of

(facing page) Wooden Model of the Dome of St Peter's, 1558–61, later altered by Giacomo della Porta.

the four immense crossing piers which would support this massive hemisphere of masonry. After his death in 1514 a succession of architects took over work on the project – Giuliano da Sangallo, Fra Giocondo, Raphael, Peruzzi. Many of these wanted to put their own stamp on the project, as architects are apt to do. So, too, did generations of popes and senior ecclesiastics. The history of the evolving plans for St Peter's is complex, and much debated. However, it is clear from even a glance at the plans associated with various designers that the conception of the great building metamorphosed over the years like some sea creature: shrinking, growing, moving around on its site.

Antonio da Sangallo the Younger was the longest serving of all the architects who supervised the basilica. He had first been appointed as Raphael's number two after the death of his uncle Giuliano in 1516, and continued, for the most part as a junior member of the team, for thirty years.

When Peruzzi died in 1537, Paul III appointed Antonio the principal architect. Over the following years he elaborated a new plan that departed in several ways from Bramante's original conception. This was even bigger than the structure envisaged under Julius II (and even larger than the one eventually completed), and had an element that Bramante's church had lacked: a nave.

The ideal of a centrally planned church – essentially a round dome above a square building – greatly appealed to Renaissance humanists and architects, but not to some ecclesiastics, because it was less traditional and unsuited to certain rites, such as processions. For that reason, at times the basilica had sprouted a nave, transforming the building into the shape of a Latin cross. Antonio da Sangallo bolted on a large one, but he also expanded the walls in every direction so that parts of the Vatican – including, in Michelangelo's opinion, the Sistine Chapel – would have had to be demolished to accommodate it.

We can get a very good idea of what the Sangallo St Peter's would have looked like had it been constructed, because he spent eight years and a huge amount of money on constructing a wooden model of it, which is itself on a vast scale. This still exists, a masterpiece of sixteenth-century woodwork, and it shows very clearly the effect Sangallo's church would have had: grandiose and finicky, fussy and dull.

Recently, attempts have been made to defend Sangallo's design, and it is true that some aspects – the beautifully detailed interior, for example – are more harmonious than the basilica that we see today. But the essential weakness of the exterior is undeniable: it is a wedding-cake construction of tier upon tier of columns and pilasters which, however big they were in reality, would have seemed feeble in relation to the whole. This was what Michelangelo saw at a glance, and corrected.

Many an architect, coming fresh to a project on which a predecessor had laboured for so long and at such cost, might have let things be. Before he died, Sangallo had not only seen the model completed by his assistant, Antonio Labacco, he had made a substantial start on the actual construction of the outer walls at either side of the crossing. Any major change would mean this work would have to be knocked down.

Nothing is more characteristic of Michelangelo than the energy, confidence and determination with which he set about nullifying everything Sangallo had intended. Once again he had been forced to take on a project against his own deep inner resistance. Then, no sooner was he committed to it, than he was energized and his imagination began to soar. Soon he conceived far more radical ideas than his patron had expected. And this despite the fact that he was now over seventy, saddened by bereavement, and had almost died himself twice in the previous two years. The inner volcano of ideas was undiminished and apparently inexhaustible. It was indeed, one suspects, the galvanizing effect of new projects that kept him going on and on, despite all the sorrows of his life and the difficulties he encountered.

The problem with Sangallo's design for St Peter's was, as Michelangelo saw, that it was inorganic. That is, there was no inevitable and convincing relationship of parts to whole such as one sees in a living creature, as in a human body. And that, as Michelangelo explained in a draft of a letter to a cardinal whose name was (tantalizingly) omitted, was precisely what architecture required. It was indisputable, Michelangelo wrote, 'that the limbs of architecture are derived from the limbs of man. No one who has not been or is not a good master of the human figure, particularly of anatomy, can comprehend this.'

He did not, of course, mean that elements of a building should crudely look like arms, legs or torso but that the whole should work like a living body, each part balanced or tensed against another. Only if you had studied and deeply internalized the interrelations of muscles, bones and sinews, as Michelangelo himself had, could you conceive an architectural design that had true life and power. This was his credo as an architect, and he immediately set about acting on it.

In a letter to Bartolomeo Ferratino, canon of St Peter's and one of the deputies in charge of the structure, he detailed his objections to Sangallo's scheme. He began with a surprising declaration of admiration for Bramante – the very man whose intrigues against him, in league with Raphael, he blamed for his troubles with Julius II. That, however, was personal rivalry. When it came to the serious matter of design, he admitted, 'One cannot deny that Bramante was as skilled in architecture as anyone since the times of the ancients.'

He continued with a passage that came close to something Michelangelo tended to avoid: direct commentary on art. Bramante's plan, he insisted, 'was not full of confusion, but clear, simple, luminous and detached in such a way that it in no way impinged on the palace'. Michelangelo meant that unexpected word 'luminous', which he used to describe Bramante's conception in a practical sense as well as a metaphorical one. Light and illumination were always of crucial importance to him. Then he zeroed in on his target: 'Anyone who has departed from Bramante's arrangement, as Sangallo has done, has departed from the true course; and that can be seen by anyone who looks at his model with unprejudiced eyes.'

Sangallo's church, he believed, would be dark, as too few windows illuminated its enormous internal spaces. That literal darkness conveyed to him a moral failing – perhaps, indeed, it was one and the same, a dark place leading to black sin. He enumerated various improbable crimes that might be committed in the shadows in the interior of Sangallo's gloomy basilica: 'such as the hiding of exiles, the coining of money and the raping of nuns'.

Furthermore, if the walls of Sangallo's ambulatory were to come down, it would not be all loss, as his old assistants and associates were angrily protesting: the stones could be reused. Michelangelo urged

Ferratino to try to convince the Pope of all this. Understandably, Paul III was dubious about axing the work of many years by a distinguished architect whom he had employed for much of his career. Inevitably, though, Michelangelo prevailed.[1]

The new scheme Michelangelo proposed was radically different from Bramante's – despite his praise – except in two essentials. It was centrally planned and crowned by a dome, but rather than inflating the original design, Michelangelo contracted it. Like a clenched muscle, it was both smaller and stronger. As had happened before on other occasions – for example, when he carved *David* from an awkwardly shaped and damaged block – he seemed inspired by the constraints of the situation he faced. Michelangelo accepted as given the four great crossing piers, but he excavated – one is tempted to say 'sculpted' – a dynamic shape from within the outlines of the earlier plans.

Bramante's church had been a calmly classical square, with projections in the centre of each side; Sangallo's was essentially similar, but with a nave tacked on. The exterior of Michelangelo's was a series of constantly varied curved and angular surfaces, punctuated by mighty pilasters. These are not puny ones, like Sangallo's, rising in rows one above the other, but gigantic bastions of stone scaling most of the height of the walls and seeming to jostle one another as if squeezed by the effort of supporting and restraining the undulating volume of the building. In the intervals between these compressed masses of masonry, windows seem to force their way through.

This is classical architecture reinvented as dynamic visual drama.

1 Michelangelo's redesigning of the basilica caused fury to, among others, an architect named Nanni di Baccio Bigio, the son of Baccio Bigio, who had tried to muscle in on the San Lorenzo scene in 1516. On 14 May 1547 Michelangelo received a letter from Florence warning him of what was being said about him, views that were being spread about by a painter named Jacopino del Conte. Nanni was saying that he was himself making a model of St Peter's which would knock Michelangelo's into nothing. He declared, Michelangelo was told, 'that what you are doing is mad and foolish ... that [you] throw quantities of money away and that you work at night so that no one may see what you are doing; that you are following in the footsteps of a certain Spaniard, having no knowledge of your own of architecture, and he less than nothing'. Who this Spaniard could have been was unclear, but this was far from being the last attack Michelangelo suffered from Nanni.

The crowning feature, which Michelangelo spent a great deal of time thinking and rethinking, was, of course, the dome. Bramante's dome, to judge from surviving drawings and representations, would have rested on the building as a geometrical and logical conclusion. Michelangelo's, in its various incarnations, and – though somewhat altered by later architects – as actually completed, is quite different. It seems to surge upwards from the heaving walls below, encircled by a ring of outlying columns propelling it aloft.

This was, effectively, the first baroque dome, and St Peter's – as Michelangelo re-imagined it – was the prototypical baroque church. Elderly, grief-stricken, constipated, Michelangelo made himself a great master of architecture: an art that, of course, was not even his profession.

*

The dome and outer walls of St Peter's were not the only designs with which Michelangelo invented the architecture of the future; nor was the basilica the only building he undertook for Pope Paul III. For twenty-seven years, as cardinal then as pontiff, Paul had been constructing an enormous family headquarters, the Palazzo Farnese, in the centre of Rome, close to the Cancelleria. In 1546, when Michelangelo took over the half-built edifice, it remained a vast, inchoate mass. (Vasari wrote that year that it seemed unlikely it would ever be finished.)[2]

Antonio da Sangallo had also been in charge of the Palazzo Farnese and had got further in putting his mark on the design than he had with St Peter's. Already over two storeys of the façade had been built, following a scheme of exceptional tedium: serried rows of windows evenly spaced across a flat, cliff-like wall. Michelangelo gave this animation, as he had once corrected a fellow apprentice's drawing in the workshop of Ghirlandaio, with a few strokes of his pen.

One element that had not yet been set was the cornice at the top. Michelangelo raised the height of the wall and greatly increased the

2 Michelangelo's work at the Palazzo Farnese was also a target of furious criticism by Nanni di Baccio Bigio.

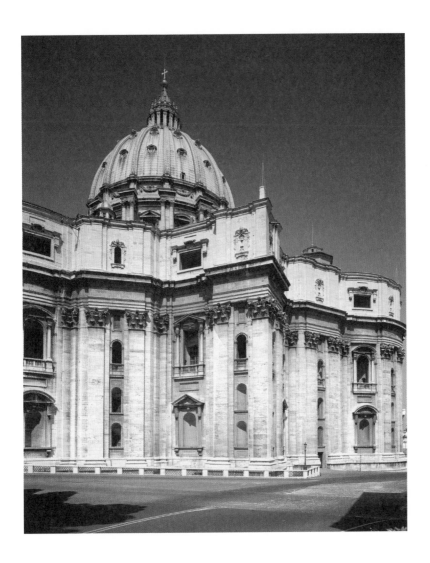

St Peter's, view of the walls of the chancel and transept.

size of the cornice, creating a dramatic mass of masonry that jutted out at the top of the building like a shoulder. An anonymous admirer of Sangallo protested that this was horribly incorrect. According to the rules of the classical authority on architecture, Vitruvius: the cornice was too big, its ornamentation all wrong, and it had all, in any case, been made up whimsically by Michelangelo.

What the critic failed to see, and Michelangelo knew intuitively by the 'judgement of the eye', was that it all worked visually. The cornice gave the façade gravitas; its ornament under the Roman sun produced – in the words of the architectural historian James Ackerman – 'a flickering arpeggio of highlights within the bold shadows of the overhang'. Michelangelo made one other change: he squeezed the height of the central window and placed above it an enormous coat of Farnese arms, carved in stone. Thus, with two modifications, the whole composition in stone was punctuated and animated.

Another extraordinary scheme was for the remodelling of the top of the Capitoline Hill, or Campidoglio. This was the headquarters of the civic government of Rome but was now on the outskirts of the inhabited part of the city. Mid-sixteenth-century drawings show it to have had a neglected, rural air – with mounds of earth and muddy tracks covering a space on which two medieval buildings were haphazardly grouped.

Michelangelo's involvement with this place probably began as early as the mid-1530s. It would have been close to his heart, as his own house was nearby and Tommaso lived on the slopes of the hill. At that time, he designed a pedestal for the magnificent bronze equestrian statue of the Emperor Marcus Aurelius, which Pope Paul III decided to move from its previous position in front of the Lateran Basilica.[3] This was done in preparation for a visit to the city by Charles V in 1538. Michelangelo also designed – or at least began to work out – an entire new piazza to crown the hill.

Audaciously, he turned the major problem of the commission into its most striking feature. The two existing structures – the Palace of

3 Michelangelo, true to form, objected to this move. He seems to have preferred to leave antiquities as they were, rather than move them around.

the Conservators, or magistrates, and the Palace of the Senators, were in diverse styles and set at an awkward angle of 80 degrees to each other. Michelangelo proposed to erect a third palace, at the same angle, to create a novel kind of piazza shaped like a trapezium. He also

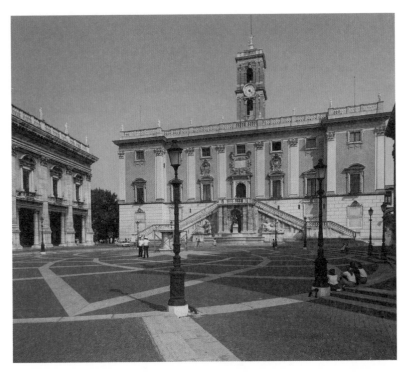

The Campidoglio, Rome.

devised façades of heroic grandeur punctuated by gigantic piers two storeys high and, as at the Palazzo Farnese, with a massive cornice at the top.

In the centre of the piazza, he placed an astonishing piece of pavement, oval like an egg, gently rising in a curve towards the statue of Marcus Aurelius. This was embellished with a design of intersecting arcs radiating from the centre, perhaps intended to symbolize the belief that Rome was the *caput mundi* (literally, the world's head). Earlier Renaissance urban design had been lucidly geometric, based on right angles and circles. Once again, Michelangelo here took a form that had been static and made it dynamic: the whole area seems to

open and swell like some stone organism as you ascend the steps from below.[4]

Such boldness suggested enormous confidence, which Michelangelo had always had, but, characteristically it was accompanied by pangs of self-doubt. On a drawing for the dome of St Peter's and an elaborate cornice, perhaps that for the Palazzo Farnese, he revealingly expressed a misgiving: 'I do not have the courage because I am not an architect and it is not my profession.' And, indeed, there were technical aspects of building – the engineering side – in which he was inexperienced. He might have seemed godlike to others, but not (understandably) to himself.

A late-sixteenth-century work on the obelisks of Rome – *De gli obelischi di Roma* (1589), by the supervisor of the Vatican Gardens, Michele Mercati – recounted a similar failure of nerve. In 1547 Pope Paul III asked Michelangelo to raise the great Egyptian obelisk that was then lying on the ground near St Peter's. Michelangelo refused. Mercati added that 'some who had been his intimate friends told me that they had asked him many times why, being a man of such admirable genius and having invented such convenient instruments for moving heavy weights, did he not consent to the will of the Pontiff?' Michelangelo's only reply was: 'What if it should break?'

*

The last years of Pope Paul III were darkened by the murder of Pier Luigi, fears of a repeat of the Spanish attack on Rome of two decades before and political intrigue concerning the Duchy of Piacenza and Parma. When in November 1549 his grandson Ottavio, son of Pier Luigi, decided to go over to the imperial side, the Pope was enraged. This may have contributed to a fever, from which he died on 10 November, lamenting that he had given way to his besetting sin of nepotism: 'otherwise I would have been without great offence.'

4 Little of this was realized during Michelangelo's lifetime, but works began shortly before his death and were continued afterwards (Tommaso de' Cavalieri being one of those supervising them). The third palace, however, was not put up until the seventeenth century, and the façade of the Palazzo Senatorio was never built to his design.

Many expected, and in Michelangelo's case probably also hoped, that his successor would be Reginald Pole, friend of Michelangelo and Vittoria Colonna. During the 1540s the cause of the Spirituali and those who still hoped for compromise with the northern Protestants had not prospered, but they had not lost all hope that a theological *via media* might be found and Christendom reunited. The Council of the Church, so long postponed, had finally convened in 1545 at Trento, a town in the extreme north of the Italian peninsula but – politically – a free city of the Holy Roman Empire. Most of the delegates were Italian. The Council of Trent's decree on Justification by Faith, issued in 1547, was disappointing to the Spirituali. Pole himself left the council on grounds of illness, which perhaps masked a mental crisis.

Slowly, the two reform movements of north and south were separating into ideological foes. It was a division caused by theological divergence, but also by cultural and psychological differences. The historian Diarmaid MacCulloch has pinpointed the distinction. Martin Luther suffered a spiritual crisis out of which he emerged with a conviction that his salvation was a private matter between him and God,'empowering him to defy what he saw as the worldly powers of bondage in the Western Church'. In 1522 a Basque knight called Iñigo (later Latinized to Ignatius) de Loyola also had a 'solitary struggle with God' but came out of it with a spiritualized version of a knightly code. In 1537 he and his companions dedicated themselves as the Society of Jesus or, as they were soon known, the Jesuits, and put themselves at the service of the Pope.

Michelangelo was probably close to the Jesuits during the 1540s. Certainly, Vittoria Colonna asked him to preach in the Convent of St Anna when she was living there and to intercede in the case of her favoured preacher Bernardino Ochino, the defector to Protestantism. Loyola also gave some marriage counselling to her brother Ascanio and his wife. As we have seen, Michelangelo's friend Lattanzio Tolomei followed Loyola's *Spiritual Exercises*, as did Cardinal Contarini.

Typically, the artist's own contribution to Loyola's movement was architectural. On 6 October 1554 he climbed down into a deep hole excavated in the centre of Rome and laid the foundation stone of the

Jesuits' new church, the Gesù. Loyola reported that: 'Taking charge of the work is the most celebrated man known here, Michelangelo.' He added that Michelangelo was working 'for devotion alone', without any fee. It is not clear whether he actually made a design for the building – all that survives is some notes of his on another architect's plan, but if he did, it was, like many of his schemes, unrealized.

Michelangelo, the Spirituali and Reginald Pole were attempting to bridge a widening chasm. On the one hand, they had considerable theological sympathy with the more moderate reformers. On the other hand, like Loyola, they felt instinctive loyalty to the Church and the Pope. Few people alive had been in a better position than Michelangelo to observe the failings and foibles of a succession of pontiffs over almost half a century. Yet still he served the Pope and had dedicated himself to creating the greatest visible symbol of papal authority: St Peter's.

*

The conclave to choose the new Pope began on 29 November, with so many cardinals attending that their accommodation overflowed the Sistine Chapel and the balloting took place in the Pauline Chapel, beneath Michelangelo's austere and very newly completed murals.

The late Pope had made his last inspection of *The Crucifixion of St Peter* in the second week of October. On the thirteenth the Florentine ambassador reported that the 82-year-old pontiff was fit enough to climb a ladder of 'ten or twelve rungs' to see the painting from the scaffolding. Less than a month later he was dead, and within six weeks the scaffolding must have been removed. In the interim, Michelangelo's last fresco was, presumably, finished. On the final day, very rapidly Michelangelo brushed in a group of four women, huddling together on the lower right, shaken, fearful, their eyes flickering nervously sideways. In their way, they are an extraordinary creation, but it is hard to imagine anything more remote from the confident masculine beauty of *David* or *Adam*.

Once more, as had happened in 1523, the conclave was sharply divided between parties adhering to Charles V and those adhering to Henri II, the new King of France (Francis I having died in 1547).

Pole was one of Charles V's candidates of choice, partly because the Emperor still wanted a compromise with the northern Lutherans, and Pole was likely to attempt to deliver that. Early in December he came within one vote of being elected; indeed his papal vestments were ordered and news of his election was sent to Paris, where Henri II was downcast. However, Pole slipped back partly because Cardinal Carafa opposed him as a heretic (and read out a dossier of evidence he had compiled on the case), partly because others thought him too young or too English. The conclave dragged on and on: one cardinal died during the proceedings – leading to the usual accusations of poisoning. Eventually, on 8 February 1550, Cardinal Giovanni Maria Ciocchi del Monte was elected and took the name Julius III.

Privately, del Monte (1487–1555) had believed he would become Pope all along. On his way to the conclave he had met with the artist Giorgio Vasari and told him, 'I go to Rome and without a doubt I shall be Pope.' He told Vasari to finish any other jobs he had quickly, and to set out for Rome as soon as he heard the news, as there would be plenty for him to do under the new papacy. This Vasari did, getting on his horse as soon as the news of Julius III's election reached Florence. On arriving in Rome he went straight to kiss the new Pope's feet, and Julius – after reminding him that his prediction had not proved wrong – set him to work.

One of the tasks Vasari left behind was the printing of the first edition of his *Lives of the Artists*, which was just going through the press. The project had been maturing for several years, and in circles close to Michelangelo. One evening in Rome during the mid-1540s Vasari had been at dinner in the house of Cardinal Farnese, with several literary men around the table, including Annibale Caro, Paolo Giovio and the raffish poet Francesco Maria Molza. (In a sonnet addressed to the artists, the last attributed his spiritual reformation to the sight of Michelangelo's *Last Judgement*.) Giovio remarked that he would like to add a series of biographies of artists to the volume of short lives of great men he had already written.

When he had finished speaking, the cardinal turned to Vasari and asked, 'What do you say, Giorgio? Will it not be a fine work and a noble labour?' However, Vasari, though praising Giovio's prose,

observed that in the lives of artists he had already penned – Michelangelo's among them – Giovio had made a lot of mistakes. Then everyone in the company suggested that Vasari himself should prepare a summary of the main facts from which Giovio could work. He undertook to do this, going through the notes on art and artists he had kept as a sort of hobby and using them as a basis. When he showed his work to Giovio, the latter urged him to write the book himself. He took up this suggestion with dedication and enthusiasm.

On 29 March, three weeks after Michelangelo's seventy-fifth birthday, the great work was ready. A few days later Vasari jotted down a list of important people to whom he intended to give copies. Naturally, in addition to a series of cardinals and the Duke of Urbino, it included Michelangelo. Vasari presented his work to him in person, and the artist 'received it with great pleasure'. As Michael Hirst has noted, there are signs that the artist read this slightly late birthday present with careful attention.

He responded, elegantly, to the cascade of praise it contained of him and his works by dedicating a sonnet to Vasari, extolling his achievements as a painter and, even more, his new ones as an author. By setting his 'learned hand to the worthier task of putting pen to paper', Vasari had rekindled memories of artists long dead, and so made both them and himself 'live for eternity'.

In a letter written to Vasari – who had returned to Florence for some months – on 1 August, Michelangelo hinted that the biographer had become one of those intimate friends (like the recently lost Luigi del Riccio and Vittoria Colonna) on whom he relied for emotional and psychological support: 'Since you revive the dead' – that is, by writing their biographies – 'I am not surprised that should prolong the life of the living or rather the half living, long since hastening to the grave. In short, I am wholly yours, such as I am.'

Vasari had known Michelangelo for many years before this. As we have seen, when only a teenager he had gathered up the fragments of *David*'s arm, smashed in the political tumult of April 1527, thus helping to save one of the great man's most important works. He claimed to have been, briefly, Michelangelo's pupil. Vasari's own biographer, Patricia Rubin, suggests this was more probably wish fulfilment than reality,

but Vasari's hero worship was real enough. When he found himself in Rome in the mid-1540s, he made it his business to cultivate Michelangelo's friendship, ask his advice on all his works, 'and he in his goodness conceived much more affection for me'.

Vasari related an anecdote from those years in his *Life of Titian*. The supreme Venetian painter was Michelangelo's closest living rival in artistic fame and prowess, but also his opposite. Titian's strengths – in portraiture, landscape, the female nude, the naturalistic depiction of textures and surfaces, and the sensuous manipulation of oil painting – were all in areas Michelangelo neglected or actively disdained (and oil, as we have seen, he considered a suitable medium only for lazy characters, such as Sebastiano).

In 1546, Titian was summoned to Rome by Cardinal Farnese, where he produced a series of magnificent paintings, including a portrait of Paul III with two of his grandsons (the cardinal and Duke Ottavio). One day, Vasari – who knew Titian well – went along to visit the Venetian at his studio in the Vatican Belvedere accompanied by Michelangelo. At that time, Titian was at work on one of his mythological masterpieces, a startlingly – even outrageously – sensual depiction of Danaë reclining languidly, legs apart, while Jupiter makes love to her in the form of a shower of gold.

What followed was a classic account of a studio visit. At the Belvedere, Vasari recalled, 'naturally, as one would do with the artist present', they praised the picture warmly. Afterwards, however, they discussed Titian's art more candidly, and Michelangelo performed an adroit critical manoeuvre: while continuing to extol Titian's work, he managed to point out exactly where it fell short. Speaking of the Venetian's method, 'Buonarroti commended it highly, saying that his colour and his style pleased him very much but that it was a shame that in Venice they did not learn to draw well.' If Titian had been properly taught, and followed up that training, what might he not have achieved, for 'he had a fine spirit and a lively and entrancing style.' Unfortunately, as Michelangelo would have registered in a fraction of a second, Danaë's left leg was in completely the wrong place.

Vasari had known Michelangelo quite well before the publication of his *Lives*, but clearly the friendship deepened after 1550. He told

several stories about their relations during the following few years, while Vasari was once again living in Rome. In 1550, a Jubilee year, the Pope gave them a special dispensation to carry out the traditional pilgrimage to each of the seven ancient basilicas of the city on horseback rather than on foot, perhaps in view of Michelangelo's age. 'While they were going from one church to another they discussed the arts very eagerly and fruitfully.'[5]

There was no doubt that Michelangelo valued Vasari's company, loyalty and unstinting admiration. In another letter, written in October 1550, Michelangelo urged Vasari, who was in Carrara quarrying marble for the tombs the Pope had commissioned, to 'come back soon'. Yet there are hints, even in the anecdotes that Vasari related in his second edition, that Michelangelo resented Vasari's attentions, even while he needed them. His relationships with the people close to him were seldom uncomplicated by his simultaneous yearning for friendship and company, and his urge to cut himself off.

This combination of contradictory feelings perhaps explained the artist's perverse reaction to gifts. Either his gratitude was extreme, or he resisted accepting the present at all. Vasari told a strange, if comic, story about this quirk. When he carved in the hours of darkness, Michelangelo wore a home-made cap to illuminate his work: 'a hat made of thick paper with a candle burning over the middle of his head so that he could see what he was doing and have his hands free'.

Vasari, noting this, decided to send a gift of candles, four huge bundles of them, weighing 40 pounds. His servant carried this load across town and delivered them at Macel de' Corvi in the late evening, two hours after sunset, 'with all courtesy'. However, Michelangelo flatly refused to accept the gift. Whereupon the servant, infuriated,

5 On another occasion when they went riding together, they were crossing the Pons Aemilius, a Roman bridge across the Tiber of which the repair had first been allocated to Michelangelo, then in 1552 to Nanni di Baccio Bigio, so as to save the great man's time and energy. Michelangelo took the view that Nanni had skimped on materials and failed to reinforce the ancient structure. As they passed over it, he remarked, 'Giorgio, this bridge is shaking. Let's ride faster in case it crashes down while we're on it.' Sure enough, in the floods of 1557 it partly collapsed, and has been known ever since as the Ponte Rotto, or Broken Bridge.

told him that they'd been breaking his arms all the way from the bridge over the Tiber, and he wasn't going to take them back again. He pointed out that there was a large pile of muck outside Michelangelo's door in which he could conveniently set all 40 pounds of candles and light them simultaneously, which is exactly what he was going to do. 'At this Michelangelo said: "Just put them down here then. I'm not having you play tricks at my door."'

Then, having grudgingly accepted these candles – and other items, including a mule, some sugar and a flagon of Malmsey wine – he drafted a bizarre poem of thanks, mingling inordinate gratitude with irrelevant despondency. Compared to Vasari's kindness, Michelangelo wrote, 'I should count as nothing, even if I were to give you all that I am: for it is no present to repay a debt.' In the middle of the poem, there was an odd complaint of powerlessness: 'Too much calm weather has taken the wind from my sails/So completely that my fragile boat lies lost on a windless sea, or/Seems like a wisp of straw on a rough and cruel sea.'

Much of Michelangelo's later correspondence concerns presents sent from Florence by his nephew and heir, Lionardo, and Michelangelo's response is sometimes grateful, sometimes curmudgeonly. Frequent offerings included white wine from *trebbiano* grapes – acid, fresh and fruity but now considered most fitted for distillation into cognac. Lionardo also dispatched ravioli, pears and *marzolino*, a delicate type of sheep's milk cheese, since Michelangelo remained fond of the Tuscan diet of his youth.

On occasion Michelangelo was gracious in his praise of the quality of the wine and the deliciousness of the food, but if these failed to please, he certainly said so. On 20 December 1550 he wrote, 'I got the *marzolini*, that is to say twelve cheeses. They are excellent, but as I've said to you on other occasions – do not send me anything else unless I ask for it, particularly not things that cost money.' On 21 June 1553: 'I've received the pack load of *trebbiano*, which you sent to me, that is to say forty-four flasks; it is very good, but it's too much, because I no longer have anyone to give it to, as I used to have. So if I'm alive next year I don't want you to send me any more.'

Michelangelo was not only unwilling to be placed in anybody's

debt, he was also – as he had always been – secretive about his work. One evening Vasari went to the house in the Macel de' Corvi just after nightfall to fetch a drawing. Recognizing Vasari's knock, Michelangelo stopped working and let him in with a lamp in his hand. Vasari told him what he wanted, and Michelangelo sent his servant Urbino upstairs to fetch it. In the meantime, Vasari noticed the leg of Christ in the *Pietà* that Michelangelo was at that moment carving, and peered closer to examine it: 'To stop Vasari seeing it, Michelangelo let the lamp fall from his hand, and they were left in darkness. Then he called Urbino to fetch a light, and meanwhile coming out from the enclosure where he had been working he said: "I am so old that death often tugs my cloak for me to go with him. One day my body will fall just like that lamp, and my light will be put out."'

*

In these years, venerable and immensely famous though he was, Michelangelo still had need of allies – because he had numerous enemies. The architectural heirs of Antonio da Sangallo had by no means given in. They watched with fury and consternation as an eld-erly – and in their view, architecturally inexperienced – artist took over the greatest building project of the age and proceeded to demolish the design of a man they revered. That there was a great deal of irate criticism from early on was obvious from an extraordinary step taken by Paul III. On 11 October 1549, two days before he mounted the scaffold in the Pauline Chapel and just under a month before he died, the Pope issued a *motu proprio* giving Michelangelo powers over the structure such as most architects can only dream of.

This remarkable document proclaimed that Michelangelo – 'our beloved son', member of the papal household and 'our regular dining companion' – had redesigned 'in a better shape' the scheme for St Peter's. It went on to approve not only the new design – of which Michelangelo had produced, in his workshop at Macel de' Corvi, a wooden model – but also to endorse in advance any demolition of the fabric ordered by Michelangelo, even at considerable expense. All these points, and the exact form of the design, were to be observed in per-petuity and never changed.

Naturally, with the election of a new Pope four months later, Michelangelo's detractors took fresh heart. According to papal records, they claimed that the noble structure designed by Bramante and 'most beautifully embellished' by Antonio da Sangallo had been 'completely destroyed' by Michelangelo, who had knocked down the stones they had erected at the expense of vast amounts of gold, thus obscuring their reputations and diminishing the honour of St Peter by building a smaller church to mark his tomb. In short, 'everything had been thrown into confusion by the decisions of a single man.' The supporters of the late Antonio da Sangallo were angry, and what is more they had on their side the Deputies – that is, the committee charged with supervising the building.

A meeting was held to discuss these grievances at the beginning of 1551, the dramatic climax of which was described by Vasari. The Deputies, whose spokesmen were the cardinals Giovanni Salviati and Marcello Cervini, complained that one of the semicircular bays of the church would be too dark as Michelangelo had planned it (this area was known as the Chapel of the King of France because it was the successor to the ancient chapel of Santa Petronilla, for which Michelangelo had carved the *Pietà* half a century before). Michelangelo replied that there would be three additional windows in the vault above. At that, Cardinal Cervini exploded, 'But you never told us that!'

Michelangelo then made a reply that was sublime in its arrogant assurance: 'I'm not and I don't intend to be obliged to discuss with Your Eminence or anyone else what I ought or intend to do. Your duty is to collect the money and guard it against thieves, and you must leave the task of designing the building to me.'

There was an extra edge to this exchange, since Cardinal Cervini was an austere reformer of the intransigently orthodox variety, and also an inquisitor at a time when the Roman Inquisition increasingly had Michelangelo's friends the Spirituali in their sights. Furthermore, another accusation made by the Deputies implied that Michelangelo's conception of the church was unseemly, even unchristian. It was alleged he was 'constructing a temple in the image of the sun's rays': the essentially circular design, bristling with radiating buttresses, evidently looked strange and pagan to some.

To Michelangelo, as always, what mattered was that he should retain absolute control. He turned to the Pope and exclaimed, 'unless my labours bring me spiritual satisfaction, I am wasting all my time and work.' That in turn implied that if the basilica were not executed according to how he conceived it, it would not bring him peace. It was his gift to God. At this meeting Julius III decisively sided with Michelangelo, putting his hand on the artist's shoulder with the words, 'Both your soul and your body will profit, never fear.'

Julius's pontificate was in many ways a continuation of Paul III's, not least in its resolute support of Michelangelo. A long-term church careerist, diplomat and canon lawyer, he had been close to the papal court for years. During the Sack of Rome he had been one of the hostages taken by the imperial troops, who had hung him up by his hair and subjected him to fake executions. He had seen the reverence paid to Michelangelo by his two predecessors, and he entirely shared their admiration for the artist. Indeed, the intensity of his feeling for Michelangelo verged on the peculiar. According to Condivi, the Pope not only declared that he would happily give years of his own life, and his own blood, if that enabled the artist to live longer, he also announced that if Michelangelo were to die he would have him embalmed and keep the great man's corpse ever near him.

Julius was eccentric in other ways. Like Paul III, and Clement VII, he was nepotistic. He made five of his relations cardinals, which was excessive. There was scandal at one of these appointments, that of Innocenzio del Monte (1532–77), partly because he was only seventeen and the adopted son of the Pope's brother, but also because it was widely believed that Innocenzio was Julius's lover. According to rumour, Julius had fallen in love with Innocenzio, then called Santino, when he was only thirteen and the son of one of his servants. According to other versions, he was a beggar Julius had met on the streets of Parma, or the Pope's illegitimate son. None of these stories was creditable to the papacy.

The new Pope was a lover of pleasure and a connoisseur of the arts. He spent a great deal of money on a magnificent residence in the fields outside the Porta del Popolo. This, the Villa Giulia, was designed by the

architect Giacomo Barozzi da Vignola (1507–73) under the supervision of Vasari. No aspect of the structure was built without Michelangelo's 'advice and judgement'. (It may well have been a drawing for the Villa Giulia that Vasari had come to fetch on the evening when Michelangelo dropped the lamp.)

While Julius was alive Michelangelo's command of St Peter's was secure, although his opponents did not give up. The Deputies wrote Julius a memorandum, expressing their disapproval of Michelangelo's behaviour, especially his 'mania' for pulling down his predecessor's work. 'However,' they added tersely, 'if the Pope is pleased with it we have nothing to say.'

Michelangelo had other detractors. In 1550 a further volume of Aretino's letters appeared, including a very different one about *The Last Judgement*. In the interim, Aretino's mood had been soured by Michelangelo's failure to reward him for his flattery with a cartoon for a section of *The Last Judgement* (which the writer had proposed as a suitable gift to himself). Eventually, he fired off an eloquent summary of all that was said against the picture. Michelangelo had dared 'not merely to paint martyrs and virgins in improper attitudes, but to show men dragged off by their genitals', and he had done so, not in a brothel – literally, a *bagnio*, or bathhouse – but 'in the most sacred chapel in the world'.

Aretino went on to attack Michelangelo's notorious reclusiveness: '*since* you are divine, [you] do not deign even to associate with your fellow human beings.' He pointed out that if he had been given the drawing he had asked for – and never, to his obvious fury, received – it would have proved wrong those who claimed that only favoured young men were given such presents: 'certain Gherardos and Tommasos'.

Although Aretino's malice was personal – and his hypocrisy, as a famous pornographer, was shameless – the attacks on *The Last Judgement* had not died away. In 1549 an anonymous Florentine expressed his revulsion at the carnal worldliness of much contemporary religious imagery, for which he blamed Michelangelo personally, but also Paul III for having allowed a painting so 'dirty and obscene' to be placed in the chapel, where divine services were sung. The view

that something would have to be done about *The Last Judgement* was growing stronger.

The passage in Aretino's letter that stung Michelangelo most, however, was probably one about his failure to keep his word over the tomb of Julius II, despite the vast fortune paid out by the Pope and his heirs. The tomb continued to trouble Michelangelo even after it had been completed. In 1553 his literary friend and helper Annibale Caro wrote to the secretary of the Duke of Urbino, noting that Michelangelo was still so upset 'at being in disgrace with the Duke that this alone might be the cause of bringing him to his grave before his time'.

The desire to put his own case in the matter of the tomb was, above all, the motive for Michelangelo to encourage – probably, to instigate – a second biography of himself, written by his assistant Condivi,[6] almost certainly in collaboration with Caro. There were probably other impulses involved. Vasari, despite his strictures on Giovio's mistakes and muddles, had made errors and omissions of his own. Furthermore, he had moulded Michelangelo's life into his own literary shape. The relation between biographer and subject – if that subject is alive – must always be tense. This refashioning of his own experiences caused unease to Michelangelo, who so powerfully wanted to control the shape of his works.

There was a precedent in a brief autobiography – only a few pages long – by the fifteenth-century Florentine sculptor Lorenzo Ghiberti. However, effectively, Condivi's biography was a new form, invented like so many others in stone, paint and words by Michelangelo. His life was pared down to a series of dramatic vignettes – the boy sculptor

6 Not much is known of Ascanio Condivi (1525–74). He came, like several of Michelangelo's close associates in later life, from the Marche. Like many of his assistants over the years, he does not seem to have been particularly talented. His hometown was Ripatransone, near the Adriatic coast. He arrived in Rome around 1545, and left again for his native town in 1554, the year after the publication of the book that bears his name. His abilities as a writer seem to have been as limited as they were as a painter, but – again like several young men who became close to Michelangelo – he must have had other qualities: perhaps charm and good looks, certainly deep affection for and loyalty to the great man. He wrote of how he had hardly dared to hope to be worthy of 'the love, the conversation and the close familiarity' he gained with the master.

meeting Lorenzo de' Medici in the sculpture garden, the young master fleeing on horseback from Rome, the confrontation with Julius II at Bologna – that has powerfully affected the way the world has thought about him from that day to this. Like many of Michelangelo's late works, however, the Life gives the impression of a project from which his attention was diverted before it was complete, and which was left to others to finish (hence its strange mistakes).

When Condivi's book was published, on 16 July 1553, Michelangelo had once more found stability, supported to an extravagant degree by the Pope, surrounded by new friends and reverent helpers. But his epic struggles were not yet over. Within two years, just after his eightieth birthday, he was to encounter a new and hostile pontiff and, shortly afterwards, a fresh and bitter bereavement.

CHAPTER TWENTY-TWO

DEFEAT AND VICTORY

'In his meditation on death, Michelangelo attained his ultimate perfection, his ultimate felicity and his ultimate beatitude.'

– Benedetto Varchi, funeral oration on Michelangelo in the church of San Lorenzo, Florence, 14 July 1564

'The effect of the capital works of Michael Angelo perfectly corresponds to what Bouchardon said he felt from reading Homer; his whole frame appeared to be enlarged, and all nature which surrounded him, diminished into atoms.'

– Joshua Reynolds, *Discourses on Art*, 1778

Duke Cosimo of Florence had long hoped to lure Michelangelo back to his native city. In 1550 or 1551 the Duke had used Benvenuto Cellini as an emissary, with unsatisfactory – but revealing –results. Cellini had made a beautiful bronze portrait bust of the banker Bindo Altoviti (1491–1557), a friend of Vasari and Michelangelo and one of the Florentine opponents of the Medici living in Rome. Seeing this bust one day, Michelangelo sent Cellini a spontaneous letter of praise. This survives only in Cellini's autobiography, but it seems genuine, partly because of a characteristic touch: Michelangelo, always intensely conscious of lighting, complained about the poor illumination of the bust in the position in which Altoviti had put it.

Cellini showed the letter to his master, Duke Cosimo, who urged him to write to Michelangelo promising him great favour if he came back to Florence. Michelangelo did not reply. When Cellini next went

(facing page)
Study for the
Porta Pia,
1561.

541

to Rome, after talking money with Altoviti and kissing the Pope's feet, he went to visit Michelangelo and repeated what he had written in the letter. To this Michelangelo answered that he had to continue with his work on St Peter's and could not leave Rome. Cellini pressed him further, at which Michelangelo gave him a hard look and asked, 'with a sly smile', how satisfactory Cellini himself found the Duke as a patron. Clearly, Michelangelo knew that Cosimo was inclined to be both penny-pinching and dictatorial, and had no intention of entering his service.

On 23 March 1555, a fortnight after Michelangelo's eightieth birthday, Julius III died, apparently as the result of a drastic diet his doctors had prescribed as a cure for gout. This time the election of the new Pope was not a protracted affair, mired in conflict between French and imperial candidates. The French cardinals were still boarding their ship at Marseilles to travel to the conclave when the others rapidly and unanimously agreed on a new Pope. He was Cardinal Marcello Cervini: the deputy at St Peter's with whom Michelangelo had clashed so sharply and come close to insulting in public.

Like his predecessor, the austere Dutchman Adrian VI, the new Pope decided to keep his own baptismal name and reign as Pope Marcellus II. It was an indication that his, too, was to be a sternly reforming papacy. Naturally, on his accession, the opponents of Michelangelo's design for St Peter's believed their moment had come. After all, the new pontiff had been their vehement spokesman. Michelangelo wrote to Vasari, detailing how hostile architects and ecclesiastics were manoeuvring against him; Vasari reported what was happening to Duke Cosimo, who ordered him to urge the artist to leave for Florence – adding that he would be expected to do nothing there, except provide 'occasional advice and plans for his buildings'. Perhaps Michelangelo would have done so, since Pope Marcellus would surely have sacked him as architect of St Peter's. However, Marcellus reigned for only twenty-two days before dying of a stroke on 1 May.

A week later, Michelangelo wrote to Vasari, declaring that he had a duty to continue with the work on St Peter's and asking the Duke's permission to carry on so he could leave 'with a good reputation,

with honour and without sin'. Obviously, he now believed he would be allowed to do so, whoever became Pope.

He may have hoped it would be Reginald Pole, who indeed came close once more to election – only two votes short – but Pole was no longer in Rome. In July 1553 – the month that Condivi's *Life of Michelangelo* was published – King Edward VI had died. Mary, his sister and successor, was a committed Catholic and, as a result, the following year Pole was sent back to England as Papal Legate. Another friend and supporter was lost to Michelangelo.

In the conclave of May 1555 Cardinal Carafa once more undercut Pole's support and adroitly prevented Cardinal d'Este – son of Duke Alfonso – from being elected. Eventually, on 23 May, Carafa himself became Pope, taking the name Paul IV. He was, like Marcello Cervini, an implacably orthodox reformer. He had been prime mover of the Roman Inquisition and had suspected several of Michelangelo's closest associates, including Pole and the now deceased Vittoria Colonna, of heresy. Carafa was also a bitter foe of the Jesuits; when Loyola heard of his election, he went pale and shook.

It may have been in the years of Paul IV's pontificate that Michelangelo's correspondence with Vittoria Colonna disappeared.[1] Condivi had related a couple of years before that Michelangelo still had 'many' of her letters. Today, only seven remain. Almost certainly, had she still been alive, Vittoria would have been put on trial; proceedings were also underway against Pole when he died, in England on 17 November 1558.

Pole passed away only a few hours after his cousin, Queen Mary, to whom he had been, effectively, chief minister. Since 1556 he had been Archbishop of Canterbury. During those two years, around

1 Her correspondence with Pole ended up in the files of the Holy Office, used as evidence in the trials of one of her associates, Pietro Carnesecchi (1508–67), a Florentine merchant and theologian who had also been a favourite of Clement VII (and was hence almost certainly well known to Michelangelo). In 1557 Carnesecchi was summoned before the Inquisition, but refused to leave the relative safety of Venice, where he had taken refuge. It was a decade before he was captured (with the connivance of Duke Cosimo de' Medici), tried and interrogated 119 times – including three days being specifically questioned about Vittoria Colonna's beliefs.

280 Protestants were executed for heresy; ironically, as Pole himself had been suspected of the same offence.

The new Pope did not sack Michelangelo from his position at St Peter's. However, his income was abruptly cut off. Michelangelo repeatedly stated that he worked on St Peter's for nothing. He had had inserted into Paul III's *motu proprio* of 1549 the fact that he had made his design for the basilica 'without accepting the reward or fee' that the Pope had repeatedly offered him but instead offered his labours out of 'the unfeigned affection and single-minded devotion he has for that church'.

There were two ways of looking at this. It was true that he received no income specifically for his supervision of the construction of St Peter's. On the other hand, since 1535 he had received a handsome income as painter, sculptor and architect to the papal court. This was set at 100 gold *scudi* a month. Admittedly, the payment of this was somewhat irregular, and only half appeared in cash, the other portion coming from the ferry on the Po and the sinecure at Rimini. But still, as the authority on Michelangelo's finances Rab Hatfield points out, his salary was enormous, more than Piero Soderini had received as *Gonfaloniere* of Florence, twelve times the stipend that Titian had from Charles V. Furthermore, Michelangelo's expenses were low, his habits frugal, his house long ago extracted from the della Rovere. Most of his money went into property or the chest in his bedroom.

Perhaps, in 1555, someone simply decided to take him at his word. Or, possibly, the two new popes crowned that spring simply omitted to renew the arrangements. In his *ricordi* Michelangelo grimly noted that 'Pope Caraffa' had withdrawn his annual 1,200 gold coins, 'previously given to me by Pope Farnese'. In September he also lost the income from his sinecure. For the next five years, apart from a one-off payment of 200 *scudi*, he really was working for nothing.

It was no consolation that there was less work actually taking place on St Peter's. Construction had pushed ahead during the last years of Paul III and the first of Julius III. In December 1550 and February 1552 Michelangelo ordered feasts to celebrate progress on the basilica. The accounts for the first of these festivities, attended by the masons, bricklayers and labourers on the project, give some idea of the size

of the workforce under his command: '100 pounds of sausages bought from the butcher Nanno'; '90 pounds of flank of pork'; 'two barrels of wine'; 'two and a half dozen caps' – the latter presumably a party gift for everyone to wear while they ate and drank.

Thereafter, however, work slowed for the usual reason: papal involvement in Italian wars and the consequent drain on finances. In June 1555 yet another representative of Duke Cosimo, a chamberlain named Lionardo da Ancona, visited the artist to try to lure him back to Florence, but Michelangelo – as he explained to Vasari – was determined to stay at least until the fabric of St Peter's had reached a stage at which his design could not be altered. If he were to go before, 'it would be the cause of great ruin, of great loss and great sin.'

One of the reasons why his presence was so much desired in Florence was that Duke Cosimo wanted to complete the magnificent Medici family projects at San Lorenzo. As already noted, the library there still lacked that vital element, a staircase. All that could be seen in Florence were a large number of dressed stones, some marks on the floor and a rough clay model. No precise design could be found. Obviously, the only place from which it might be retrieved was Michelangelo's head.

The sculptor Tribolo had been sent to Rome during the reign of Paul III in an attempt to persuade Michelangelo to return to Florence and finish the schemes at San Lorenzo, but the great man was uncooperative, refusing to leave the city and claiming to have forgotten the shape of the staircase. Finally, the Duke asked Vasari, as a close friend of the artist, to write and plead with him to help. In reply, still somewhat grudgingly, Michelangelo finally wrote back saying that if he had been able to remember it well, 'no entreaties would have been necessary.' He did indeed recall a 'certain staircase, as if in a dream', but was not sure it was correct, as it seemed a clumsy thing. There followed a detailed description from which, with some adjustments, Vasari and the sculptor and architect Bartolomeo Ammannati managed to complete the project. The originality of its conception, the stairs flowing down like lava and almost filling the vestibule, as Vasari wrote, astonished everyone. Michelangelo there re-imagined stairs as thoroughly as he did walls, windows and every other architectural component he needed.

Quite why Michelangelo was so uncooperative about the matter of the staircase is a matter of conjecture. Perhaps he really could not remember a design that he had, after all, conceived some thirty years before; possibly, he had originally intended to decide the final dimensions on the spot. On the other hand, perhaps – no matter how politely he replied to his letters and his courtier – Michelangelo disliked and distrusted Duke Cosimo, and was not disposed to be helpful.

*

That autumn, Michelangelo suffered two losses. First, on 13 November 1555, came the death of his youngest and last surviving brother, Gismondo Buonarroti. Michelangelo heard this, he told his nephew Lionardo, with 'great sorrow'. But he was about to suffer a much more severe blow. On the day he wrote to Lionardo, his servant Francesco d'Amadore – Urbino – was already gravely ill. Michelangelo was as distressed as he would have been if Urbino had been his own son; he was nursing Urbino himself, sleeping dressed in his clothes so that he could more easily get up and tend his servant – or rather, as Vasari puts it, 'since this was what he had become, his companion'.

The bond between them was certainly close. On his visit a few years previously, Cellini, while attempting to persuade Michelangelo to move back to Florence, made the fatuous suggestion that Urbino could remain in Rome and supervise the construction of St Peter's, receiving his instructions on what to do from Michelangelo by letter (even although, by Cellini's own account, Urbino was only 'a general helpmate', who had evidently learned nothing about art in his quarter of a century at Michelangelo's side). In the end, pestered by this and other arguments posed by Cellini, Michelangelo turned to Urbino 'as if to ask his opinion'. At this, Urbino, 'in his uncouth way', shouted, 'I shall never part from my Michelangelo until either he or I is under the ground.'

On 3 December Urbino died, and Michelangelo's grief was overwhelming. He was 'so stricken and troubled that it would have been more easeful to die with him . . . I now seem to be lifeless myself and can find no peace'. Nearly three months later Michelangelo was still prostrate with sorrow; on 23 February 1556 he wrote to Vasari, 'the greater part of me has gone with him, and nothing but unending

wretchedness remains to me.' His feeling of loss and loneliness was so powerful that he actually implored Lionardo to travel to Rome to keep him company. At the end of April he still felt so shattered that he expected to die himself.

Altogether, Michelangelo's reaction was more like what might be expected on the death of a parent, child or sexual partner, although there is no evidence that Urbino was the last of those. At this point in Michelangelo's life the idea seems unlikely, especially as Urbino had married in 1551, bringing a bride from his native region of the Marche, who lived with him in Michelangelo's house and by whom he had children (the oldest a boy named Michelangelo d'Amadore). However, if Urbino was not his lover, Michelangelo grieved for him as if he had been. Their relationship revealed the intensity of his need for some-one – sex or no sex – who was truly close to him. This seemed, if anything, to grow stronger with age.

Michelangelo treated Urbino's widow, Cornelia, and her children almost like a surrogate family. She wrote frequently, asking for his advice; he at one point seriously thought about taking her son, little Michelangelo, into his household to bring him up. His attitude to his own family softened after Lionardo's marriage – after intermin-able discussion of various possible brides – in 1554, to Cassandra di Donato Ridolfi. Subsequently, they had a stream of children, many of whom died (including another boy baby christened Michelangelo); but some lived, among them an heir named Buonarroto and a second Michelangelo.

The re-establishment of the Buonarroti family as a wealthy and respected Florentine dynasty had been Michelangelo's longest-lasting project; it dated back to an era even before Julius's tomb had been proposed. Now, it was achieved. He had earned a fortune, which would keep the Buonarroti for generations; through Lionardo's offspring the line was assured.

Nonetheless, Michelangelo remained capable of a gruff response when one of Lionardo's gifts did not please, as on 25 June 1558: 'I've had the *trebbiano*, but not without shame and consternation, because I gave some of it away without tasting it, believing it to be good. After-wards I was disgusted with it.' For his part, Lionardo took a close

interest in safeguarding his inheritance, just as Michelangelo had always suspected.

This came to a head almost at the end of Michelangelo's life, when he made an enormous gift to Urbino's successor as his servant, a man named Antonio del Francese, who was from the same town in the Marche, Castel Durante. Vasari told the story (while getting the names of the servants confused). One day he asked Antonio what he would do after he – Michelangelo – died. Antonio replied that he would have to find another master. 'Oh, you poor creature,' Michelangelo replied. 'I'll save you from such misery.'

He then presented him with 2,000 *scudi*, an immense sum, roughly equivalent to two thirds of his own fee for painting the Sistine Chapel ceiling, or twenty times the annual income of a Florentine university professor. Michelangelo stated in a legal document on 14 April 1563 that this gift was Antonio's rightful property. A few months later he furiously rebutted Lionardo's suggestion that he was being robbed. He could not be better treated; furthermore, he was not an infant and knew how to look after himself. Those who told Lionardo otherwise were scoundrels and liars.

Michelangelo was, unquestionably, peculiar about money. He hoarded it, prevaricated about it, demanded it out of – one guesses – a complicated mixture of financial insecurity dating back to his childhood and determination to receive fitting respect from his patrons. Nonetheless, he was capable of acting, as on this occasion, with almost embarrassing generosity. The common element in both responses was, perhaps, control. He would decide how much he deserved to earn, and also on whom he would choose to lavish his money.

The question of his lost income continued to upset Michelangelo through the years of Paul IV's pontificate. Donato Giannotti tried to intervene on his behalf, but unsuccessfully. So did Sebastiano Malenotti, who was working with Michelangelo as an overseer of the works on St Peter's, and living in his house. Malenotti persuaded the Deputies to take it up with the Pope, but to no avail. In March 1556 Malenotti confided to Lionardo Buonarroti that Michelangelo was beginning to get over the loss of Urbino, but would do so faster if he got his salary back. There were reasons, including the hostility

of the Pope, why he did not. Paul IV was a sternly reforming defender of theological orthodoxy. He rapidly made himself extremely unpopular in Rome by trying to stamp out prostitution, gambling and blasphemy. He forced the Jews of Rome to wear distinctive clothing and restricted them to a ghetto. He instituted censorship in the form of an index of forbidden books, and toyed with the idea of tearing down the altar wall of the Sistine Chapel, which would have involved destroying *The Last Judgement*. Probably that was the intention, since, according to Vasari, he had already asked Michelangelo to 'tidy up' the fresco, since he found its nudity indecent. To this, Michelangelo made another magnificent reply: 'Tell the Pope that this is a trivial matter and can easily be arranged; let him set about putting the world to rights, for pictures are soon put right.' (He did not, however, say this to Paul's face, and it seems unlikely anyone would have repeated it to him.)[2]

Paul IV was a harbinger of a new and intolerant age, but in some ways he resembled predecessors such as Julius II and Paul III. He was an irascible Neapolitan nobleman, unable to resist promoting his Carafa relations, and with a furious hatred of the Spanish (perhaps caused by the domination by Spain of his native territory). Like Julius II, he was determined to drive the barbarians from Italy, but he had much less success.

By mid-1556 a Spanish army under the Duke of Alba was poised to attack Rome; the citizens began to fear a repeat of the cataclysmic Sack of 1527. The city was fortified and its defences bolstered at a cost estimated by the Venetian ambassador to be 80,000 *scudi* a month. This vast expenditure did not do much good. On 1 September Alba invaded the Papal States and sacked the town of Anagani on the fifteenth. Ten days later, Michelangelo, accompanied by Malenotti and his new servant, Antonio, departed for the north.

In a rather disingenuous letter to Lionardo, Michelangelo claimed this departure was for a pilgrimage to Loreto. It is true that when his

2 Later in the sixteenth century, the painter and writer on art Gian Paolo Lomazzo (1538–92) reported that Paul IV wanted to have *The Last Judgement* destroyed because of its 'wicked exhibition of nakedness and buffooneries'.

income stream flagged, Michelangelo's thoughts sometimes turned to improving his soul by pilgrimage. During one of the interruptions of the Po ferry money in the 1540s, he had considered travelling as far as Santiago de Compostela. On this occasion, however, he was clearly putting a brave face on a panicky flight, the last in his long history of hasty departures.

The little party arrived at Spoleto in the Umbrian hills, and stayed there. And, it seems, Michelangelo enjoyed his holiday in the country. Later in the year, he wrote to Vasari that, recently, 'at great expense and inconvenience', he had travelled to the mountains, 'so that less than half of me has returned to Rome, because peace is not really to be found except in the woods.' It is a surprise to discover Michelangelo, so disdainful of landscape painting, taking pleasure in the bosky slopes of Umbria. But he was a child of a hill community: Settignano. He experienced some of his happiest days, as well as anxious ones, in the Apuan Alps. Michelangelo was a true lover of high, solitary places.

At the end of October he was summoned back to Rome. Work continued on St Peter's; it is not surprising, however, that with the papal treasury a million *scudi* in debt, Michelangelo's stipend was still not restored. At this point, he was on the verge of coming back to Florence. He just needed to stay long enough to complete a wooden model that he was having made of the dome and lantern of the basilica – the crowning culmination of the building – so that his design would be set unalterably. Then he could leave Rome. In a letter to Urbino's widow, Cornelia, he announced he would go back to Tuscany at the end of the summer.

Then a catastrophic mistake was discovered – one that was partly, at least, Michelangelo's fault. One of his drawings had been misinterpreted by Malenotti; as a result, the centring of the vault over the apse known as the Chapel of the King of France was wrongly constructed and so, too, was some of the actual masonry, which would now have to be demolished. It was a hard blow to Michelangelo's reputation and self-esteem. 'If one could die of shame and grief,' he wrote to Vasari, 'I would be dead.'

Malenotti was blamed for the error and dismissed, after which he told a lot of lies about it, according to Michelangelo. The affair was a

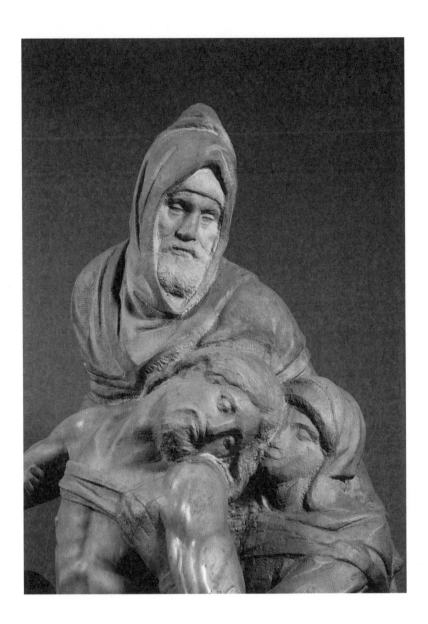

The Head of Nicodemus, from Pietà (detail), c. 1547–55.

little peculiar. It had arisen, according to Michelangelo, because his age and ill health had prevented him from supervising the works properly. However, if the confusion went on long enough for part of the vault to have been built, he can scarcely have been visiting the site at all. Alternatively, he bore more responsibility for the mistake than he admitted. Either way, here was more ammunition for his architectural enemies: the work – already slow – was put back yet further. Stubborn pride made it impossible now for Michelangelo to retire from Rome.

*

The Pope's favourite architect, Pirro Ligorio (c. 1510–83) would naturally have liked to take over St Peter's, but Paul IV, though he did not pay Michelangelo, found – as his predecessor had – that his advice was indispensable. In September 1558 the Florentine ambassador sent a dispatch concerning the amount of Michelangelo's time the Pope took up. The artist reported that the Pope required his attendance every day, and they had long conversations – most of which Michelangelo spent listening (since Paul IV was notoriously talkative).

Michelangelo was amazed at the number of schemes the Pope had in mind. Asked what these were, he replied that they were 'cose grande, grandissime'. Pressed further, he started to say that the Pope's grandiose notions were 'cose da –' Then he stopped himself, and added, 'It is not seemly that I should discuss a Pope.' So, sadly, we shall never know how Michelangelo was going to complete that thought. The conversation, in any case, suggested a degree of weariness with Paul IV.

The Florentine ambassador was informed of all this by Francesco Bandini (c. 1496–1562), who had met the artist at morning Mass in the church of Santa Maria sopra Minerva. He was yet another of the Florentine banking community in Rome from which Michelangelo drew so much of his social circle (and hailed, furthermore, from just the same neighbourhood as the Buonarroti: the quartiere of Santa Croce). Once more, a praetorian guard of friends and supporters formed around the artist, including his new servant, Antonio, and Bandini.

It was Bandini, in turn, who found Michelangelo an invaluable helper in Tiberio Calcagni, who functioned as not so much an assistant but as a visual amanuensis. He was born in 1532 and came from one of the many Florentine merchant families living in Rome. His father, Roberto, had a successful business making ecclesiastical vestments. He was well educated, to judge from the penmanship of his letters, and ambitious to become a painter and sculptor.

It fell to him to complete a couple of works Michelangelo had set aside. One was *Brutus*, another was a *Pietà* Michelangelo had intended to present to a church; he wanted to be buried below the altar on which it was placed. This *Pietà* had been regarded as a great masterpiece in the making, partly because what Michelangelo was trying to do – carve four separate interlinked figures out of one block – was immensely difficult. It was described in the most enthusiastic terms by Condivi. Then, perhaps in 1554 or '55, Michelangelo smashed it to pieces.

One day when Calcagni was at the house in Macel de' Corvi, he asked Michelangelo why he had broken the *Pietà* and had thus 'wasted all his marvellous efforts'. Michelangelo replied that one reason was that he had lost his temper because his beloved, now deceased, servant Urbino had nagged him to finish the sculpture.

However, there was another reason why he took a mallet to the half-finished sculpture, reminiscent of his gruelling and infuriating experience with *The Risen Christ*: a piece broke off the Madonna's arm and he found a crack elsewhere, mishaps that made him 'so hate the work that he had lost patience and broken it'.

He would have smashed it into rubble, if Antonio had not persuaded him to give it to Francesco Bandini. Bandini, who like so many people yearned to own a Michelangelo, gave Antonio 200 ducats to persuade the artist to allow Calcagni to put the fragments together and finish it.

This he did, except poor Calcagni never quite completed the sculpture before he died himself, in 1566. Many parts awaited final cutting and polishing, and Christ still lacked a left leg – perhaps because that part, possibly the section containing the fatal crack, had been too pulverized for reconstruction to be feasible. Christ's left knee was years later in the possession of another artist close to Michelangelo in his last years, Daniele da Volterra.

As it exists today, the *Pietà* is a mixture of parts, some finely finished, some obviously not carved by Michelangelo, others still rough or a mosaic of shards, plus one tremendous, looming figure: Nicodemus, who towers like a giant above the dead Christ and tiny figures of the two Marys, the Virgin and Magdalene, encircling them with his arms. Rather than looking down on the group beneath, he seems to gaze out, brooding, so this amounts not so much to a sculpture of the dead saviour mourned by the holy women as a carving of someone meditating on that subject. This hooded and bearded figure was, as Vasari explained to Lionardo Buonarroti, a self-portrait.

If Vasari was correct in identifying this gentle troll as Nicodemus, the choice was interesting, especially in a sculpture intended for Michelangelo's own tomb. Nicodemus was a Pharisee, who in the Gospel of St John 'came to Jesus by night, and said unto him, "Rabbi, we know thou art a teacher come from God"'. The association between Nicodemus and night was twice repeated. He was a secret, nocturnal worshipper. For that reason, in the mid-sixteenth century, those who wanted to keep their true faith hidden – Calvinists in France, for example – were referred to either proudly or critically as 'Nicodemites'.

It is just possible that Michelangelo's choice of Nicodemus was a hint at his own hidden beliefs, those he shared with Pole and Vittoria Colonna. What is certain is that there was a connection between Michelangelo and night. It was made by his enemies – who complained that he worked by night so no one could see what he was doing – by his biographers, and by the artist himself. According to four sonnets he wrote on the subject, Michelangelo believed that he had a temperamental affinity for the dark, '*il tempo bruno*'. Night was the time of shadows, melancholy and thoughts of death – but also of soothing oblivion and dreams.

'Oh night, O sweetest time, though black of hue,' he wrote in sonnet no. 102, 'you cut the thread of tired thoughts, for so/You offer calm in your tired shade.' In sonnet no. 104 he described how 'he who created time from nothingness' gave one half to the sun, the other to the moon: 'I was assigned the dark time for my own,/As what my birth and cradle suited best.'

This was an intriguing and – for the time – startling series of

reflections. The year of the poems is unknown, but they seem to date from later than the period of the Medici Chapel, in which the most imaginatively extraordinary figure was that of *Night*. It was literally true, as recorded by his father, that Michelangelo was a child born in the night: 'at the 4th or 5th hour before daybreak'; this is around 1.30 to 2.30 a.m. But also at a deep level he came to identify himself with the hours of darkness, and secrecy.

*

In August 1559, after a brief illness, Pope Paul IV died, perhaps because he was shaken by a family upheaval in which he had exiled two of his rapacious nephews – one a cardinal – or possibly just of one of the summer fevers that killed so many in Rome. In celebration, while he was dying the Roman populace smashed a statue of him, wrecked his house and also demolished the office of the Inquisition, destroying its records and releasing its prisoners (among them Cardinal Morone, a close ally of Reginald Pole and hence, probably, of Michelangelo).

The conclave that followed was again deeply split. It began in September and lasted for over three months. Finally, on the day after Christmas 1559, a new Pope was elected: Giovanni Angelo Medici (1499–1565), who took the name Pius IV. He was not related to the Florentine Medici – he came from a humble family in Milan – but nonetheless was closely allied with them. His election was strongly supported by Duke Cosimo and also by Caterina, now Catherine de' Medici, Queen Mother of France.[3] So Michelangelo approached a new decade, and his own eighty-fifth birthday, with yet another papal master, his seventh and last.

Pius IV was a determinedly new broom. One of his first acts was

3 Ruling on behalf of her sons, she was the last French monarch and almost the last of the Medici family to attempt to employ Michelangelo. In November 1559 she wrote to the artist, asking him to make a bronze sculpture of her late husband King Henri II, who had been killed in an accident that July, on horseback. The artist passed on the commission to his friend, the painter Daniele da Volterra, who – according to Vasari – completed only the horse from Michelangelo's drawings. This was taken to France, where later the figure of Louis XIII was put on it, and the whole monument melted down at the time of the French Revolution.

to arrest and put on trial the Carafa nephews (they were both subsequently executed). Another was to reinstitute Michelangelo's salary, which was paid again from June 1560. The artist once more had an enthusiastic patron, and soon embarked on a series of fresh projects.

While the conclave was still in secession, the Florentines of Rome asked Michelangelo to make designs for their church, San Giovanni de' Fiorentini, which was situated on the bank of the Tiber opposite St Peter's and the Vatican, where so many of the community – like Tiberio Calcagni's family – lived and worked. It must have helped that Francesco Bandini was one of the Deputies in charge of the scheme. 'For his architectural work,' Vasari explained, 'since his old age meant that he could no longer draw clear lines, Michelangelo made use of Tiberio, who was a modest and well-mannered young man.' So it was Calcagni who prepared measured drawings for five different schemes for the church; the Florentine colony finally chose one of these, for which Calcagni also made a clay model and then a wooden one.

'After the choice had been made,' Vasari went on, without a trace of irony, 'Michelangelo told them that if they put the design into execution they would produce a work superior to anything done by either the Greeks or the Romans: words unlike any ever used by him, before or after, for he was a very modest man.'

And, indeed, no false modesty was required. Had it been built to this plan – which, sadly, it was not – San Giovanni dei Fiorentini would have been unprecedented and extraordinary. The design was basically circular, with a series of elliptical chapels clustering around the circumference like fruits on a stem. These alternated with more chunky squared-off sections containing the three entrance porches and, on the remaining side, the main altar. Over half a century before the baroque style appeared, this again was something very like a baroque building.

Another, less ambitious, scheme, for the Sforza chapel attached to the church of Santa Maria Maggiore, was actually completed. Its two side walls are not flat, nor curved, nor in any standard geometric shape, but flexed like two shallow springs, trapped between giant columns and buttressing walls so the whole structure seems to be held in a state

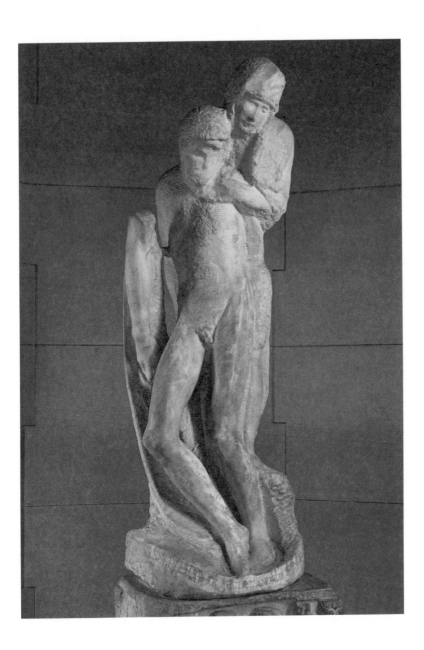

The Rondanini Pietà, c. 1552/3–1564, Castello Sforzesco, Milan.

of tension. In this project, too, Tiberio Calcagni acted as Michelangelo's deputy and lieutenant.

After the moment of frustrated fury in which he took his mallet to the *Pietà* with his self-portrait as Nicodemus, Michelangelo began yet another sculpture of the same subject. He needed to keep practising his primary art. Or, as Vasari put it, it was necessary 'for him to find another block of marble, so that he could continue using his chisel every day'.

This last *Pietà*, as we see it today, is not so much unfinished as semi-smashed by its own creator. It is not clear whether we, four and a half centuries later, ought to think of this as a work of art – say, a piece of fractured, pre-modernist expressionism – or as evidence of a process that was interrupted.

The two figures, the mother holding up her dead son, seem from some angles to be clinging together. It can even look as though the son is holding the mother up. Her pinched face and his feeble, whittled limbs bring to mind Shakespeare's phrase 'a poor, bare, forked animal'. Perhaps accidentally, it looks like a meditation on the weakness of old age.

Today, this marble, known as the *Pietà Rondanini*, is in the museum of the Castello Sforzesco, Milan, where it is enshrined in a stark ring of concrete panels designed in the brutalist style. It is perhaps more accurately described as a piece of excavation than a work of art: the result of the artist's effort to discover a satisfactory group of figures within a partially completed work which he had abandoned (which is why, almost surreally, the sculpture as it exists sprouts an additional, severed, arm of Christ). What is undeniable is that this last, poignant sculpture is evidence that Michelangelo's urge to find a better, truer form deeper within the block had not weakened.

The same is true of a sequence of drawings of the crucifixion with two attendant figures from his last few years. These drawings seem to fade into a haze of ectoplasm. This was partly the result of his quavering hand and fading sight, but, if you look closely at these sheets, it becomes evident that the spider's web of fine lines is not an attempt to obscure the contour, it is the result of a series of efforts to clarify it.

Condivi praised two mental faculties that the artist had to an extra-

ordinary degree. The first was memory, which in Michelangelo's case was so retentive 'that for all the many thousand figures he is seen to have painted he has never made two alike or with the same attitude; indeed I have heard him say that he never draws a line without remembering if he has ever drawn it before, and then cancelling it if it is to be seen in public'.

The second capacity in which Michelangelo was almost preternaturally gifted, according to Condivi, was imagination, so much so that it was one of the reasons for his chronic dissatisfaction with his own work: 'He is also endowed with a most powerful imaginative faculty, the basic reason why he has been little content with what he has done, and has denigrated it: for it has not seemed to him that his hand has realized the idea that he formed within.'

Against this passage, Tiberio Calcagni noted not a correction, but a confirmation. Michelangelo, hearing or looking again at that passage, had evidently been struck by a lesson it held for a younger artist such as Calcagni. 'He said to me that it is true: if you want to do well, always vary what you do, as it is better to make a mistake than to repeat yourself.'

The obverse of this was, for Michelangelo, an almost cruel dismissal of his own work, resulting in the shattered stone of his last two sculptures, and also, as we have seen, in recurrent bonfires of his drawings. The surviving works on paper – perhaps around five hundred – are the remnants of many thousands, most of them destroyed by Michelangelo himself, or at his orders. These conflagrations continued.

To borrow Vasari's words once more: 'I know for a fact that shortly before he died he burned a large number of his own drawings, sketches, and cartoons so that no one should see the labours he endured and the ways he tested his genius, and lest he should appear less than perfect.'

*

For over forty years Michelangelo had been lamenting that he was an elderly man and death could not now be far away. But now he was truly old, and there were clear anticipations of mortality. Early one morning in August 1561 Michelangelo collapsed. It occurred as he was working, barefoot, in the room where he carved and stored his marble. After he had been there for around three hours, his servant Antonio

heard him fall and discovered Michelangelo lying unconscious, his face and limbs distorted and twisted. Not surprisingly, Antonio concluded that his master was dying. Francesco Bandini and Tommaso de' Cavalieri hurried to be by his side.

With them came Tiberio Calcagni, who described what happened in a letter to Lionardo Buonarroti: 'When we arrived we found that he had come to his senses and that he was much better. Moreover he urged us to leave and not to bother him that he might sleep.' Over the next few days, he recovered, although he was clearly shaken by whatever had happened to him – perhaps a minor stroke – and for a while, as Calcagni put it, 'he seemed to live in an imaginary world.'

However, he still had more works to invent and more battles to fight. On 29 August Michelangelo mounted his horse and, again according to Calcagni, 'rode to work on his designs for the Porta Pia', the festive and fanciful gate in the eastern walls of Rome which he was designing for his new patron, Pope Pius IV.

This was one of his last and most extraordinary creations: a fantasia of a gate, wilfully breaking all architectural rules and looking, in one of the drawings he made for it – the outlines blurred and shifting as in his late crucifixion studies – like the portal through which he was soon to pass: the entrance to another world.

This, however, was only a part of a larger conception: a vista. It provided a focus at the far end of the Via Pia, a long avenue shooting out of the city. Long streets of baroque Rome are often regarded as the invention of a later Pope, Sixtus V (reigned 1585–90) and his architect Domenico Fontana, but, as James Ackerman has argued, the prototype was the Via Pia, and therefore the credit should go to Pius IV and Michelangelo.

*

In many ways, though he grew older and weaker, more pious and more gloomy, Michelangelo never changed. The incredible vitality of his ideas was still there; so, too, were fundamental emotional patterns, among them – as we have seen before – the impulse to close the door even on his dearest friends. Tommaso de' Cavalieri, the greatest love of his life, was eventually to receive this treatment.

What the reason was it is now impossible to say, but a dignified, affectionate letter of 15 November 1561 exists from Tommaso – no longer the beautiful adolescent of thirty years before, but a middle-aged husband and father. Someone, he suspected, had been telling the artist lies about him: 'I tell you frankly that if you do not want me as a friend, you can do as you like, but you cannot compel me not to be a friend to you. I shall always be at your service.' Whatever the tiff was about, it was forgotten.

Right to the end, Michelangelo retained his *terribilità*; at eighty-eight he was still formidable. His final foe was the Florentine sculptor and architect named Nanni di Baccio Bigio (c. 1513–68). Bigio had long been among Michelangelo's detractors, telling anyone who would listen that the old man's designs were mad, childish and ruinously expensive. In April 1562 he asked Duke Cosimo to use his influence with Pope Pius IV to have him replace Michelangelo at St Peter's. The Duke replied that he would never do such a thing while Michelangelo was alive, but would do what he could to help Bigio at a later time. A year later, however, Bigio seized an opportunity.

In August 1563 Casare Bettini, the overseer of works at the basilica, was murdered by the Bishop of Forlì's cook (who found him *in flagrante delicto* with his wife). This left a vacancy, which was filled against Michelangelo's wishes by Bigio, who had – as always – been telling the Deputies that disastrous mistakes were being made in the building. Michelangelo's reaction was to demand an audience with the Pope, then offer his resignation, saying that if the Deputies and the Pope no longer thought him able to do the job he would retire forthwith to Florence and end his days there.

The result was a decisive victory. Bigio's accusations were investigated, found baseless and, in Vasari's words, he 'was contemptuously dismissed in the presence of many noblemen' (though that did not prevent the resilient fellow starting a new campaign for the post the night on which, as he put it, 'it has pleased God to terminate Michelangelo's days').

For a few more months Michelangelo remained in charge, but his hold on life was slackening. On 28 December he wrote a last letter to

Lionardo Buonarroti, thanking him – for once, graciously – for 'twelve most excellent and delicious *marzolini* cheeses', and apologizing for not having replied to several of his nephew's letters, as he could no longer use his hand to write. Just over six weeks later he was dead.

*

A few weeks before Michelangelo died, on 21 January, the Council of Trent had issued a decree calling for the parts of *The Last Judgement* regarded as obscene to be covered up. Work began in August of that year, undertaken by Michelangelo's friend Daniele da Volterra, who added *braghe*, or underwear, to several figures. The process of covering the nakedness of Michelangelo's creations with jockstraps and wisps of flying cloth went on for centuries – at least until the 1760s.

Despite all the efforts of Michelangelo and his admirers, in the long run his intentions for the design of St Peter's were ignored. The dome was completed in 1580–85 by Giacomo della Porta, who raised its height and curvature, and made other changes. Half a century after Michelangelo's death a much more drastic alteration was made: a nave was added, as many clergymen had wanted all along. As a result, the whole effect was transformed internally and externally. The church that Michelangelo built can only be seen from behind, in the Vatican gardens, where very few visitors are able to go.

Like the tomb of Julius II, St Peter's thus ended up at least partially a failure. In other respects, however, Michelangelo's death was followed by triumph. In Florence, four months after the arrival of his body and its interment in March, magnificent funeral rites were held. A cata-falque 56 feet high was built in the church of San Lorenzo, adorned with reclining figures of the Tiber and Arno to symbolize the two centres of his activities, hangings, other statues and a cycle of paintings illustrating scenes from his life, almost as if he were a saint: his meeting with Lorenzo de' Medici in the sculpture garden; his construction of the fortifications of San Miniato; painting *The Last Judgement*; writing poetry; presenting his model of the dome of St Peter's to Pius IV. An inscription described him as 'the greatest painter, sculptor, and architect that ever lived'.

Four and a half centuries later some might quarrel with one or other of those claims, but one thing is indisputable. Michelangelo transformed all the arts in which he worked, but, more fundamentally – through his example and limitless ambition – he transformed the notion of what an artist could be. That may be his greatest achievement of all.

ACKNOWLEDGEMENTS

It is normally the case, I suspect, that biographers react in one of two ways to the experience of spending years in the company of their subjects. They either end up loathing or loving them. Certainly there are grounds for disliking Michelangelo Buonarroti. It is easy to understand Giovan Battista Figiovanni's remark that the patience of Job would not suffice for one day of dealing with this man. However, I am sure that my family, friends and editors had plenty of reason for saying the same of me as I wrestled with this project. Conversely, I myself had plenty of opportunity for understanding Michelangelo's problems as he worked year after year on enormous enterprises which he had undertaken in a moment of heady optimism.

For me, all that notwithstanding, it has been an enthralling experience to spend so much time getting close to this hugely talented, neurotic, complicated, curmudgeonly but ultimately engaging man. I hope the reader will agree.

My excuse for adding to the Apuan Alp of writing already in existence about Michelangelo was the very scale of the literature. The volume of the contemporary documentation of his life and affairs, the sheer mass of academic books and essays, the enormous length of his life and the tumultuous historical events he experienced, often at very close quarters: all these combine to make it difficult to see man and work together as a coherent whole.

This, nonetheless, was my aim. I have also tried to balance his life so as to give due weight to his youth, for which the evidence is relatively sparse, in relation to his middle and old age – from which by far the bulk of the five volumes of his letters, most of his poems and all the contemporary memoirs date.

In attempting this book I am indebted to generations of scholars. Among those whose insights and discoveries about Michelangelo I have found especially useful I should like to mention Caroline Elam,

Acknowledgements

Rona Goffen, Rab Hatfield, Michael Hirst, Alexander Nagel, James Saslow and William Wallace. For the wider historical background I have drawn deeply on the works of Cecil Clough, J. R. Hale, F. W. Kent, Lauro Martines, Diarmaid MacCulloch, Michael Rocke, and T. Price Zimmermann. My thanks and gratitude go to Michael Hall and David Ekserdjian, who heroically undertook the task of reading the manuscript and made many invaluable suggestions.

I have benefited from conversations with Patrick Boyde and Carol Plazzotta. George Shackelford and Claire Barry shared insights into *The Temptation of St Anthony* at the Kimbell Art Museum. Martin Clayton not only assisted me on the question of Renaissance dissection but arranged for me to spend a truly memorable afternoon leafing through boxes of Michelangelo's drawings. Richard Rex gave me the benefit of his wide knowledge about early-sixteenth-century history and theology in the period of the Reformation and Counter-Reformation. Both of these kindly read and commented on sections of the text. Alessandra Masolini and Erika Favoro both provided invaluable help with translations from sixteenth-century Tuscan.

I am indebted to Lida Cardozo-Kindersley for giving me instruction in elementary stone-carving, and also to Mark Evans of the V&A and Arnold Nesselrath of the Vatican Museums for giving me the opportunity not only to see Raphael's tapestries hung in their original positions, but also to spend an afternoon in the Sistine Chapel empty of visitors and illuminated only by the Roman August sun.

As always, my first reader and counsellor has been my wife, Josephine, and also for a series of draft chapters my son, Tom, who helped compile the bibliography and assisted at various stages in the evolution of the text. My editor at Fig Tree, Juliet Annan, has been as instrumental in encouraging this book at different stages of its gestation as any pope was in Michelangelo's schemes. She made numerous invaluable suggestions about the structuring of the text, as did Courtney Hodell and – again – Michael Hall. My thanks also go to my wise text editor Sarah Day, my agent David Godwin, the designer Claire Mason, editorial assistant Sophie Missing and – once more – to my picture researcher, Sally Nichols.

NOTES AND REFERENCES

ABBREVIATIONS

British Museum, 2005: *Michelangelo Drawings: Closer to the Master*, exhibition catalogue, British Museum, 2005.

British Museum, 2010: *Fra Angelico to Leonardo: Italian Renaissance Drawings*, exhibition catalogue, British Museum, London, 2010.

Calcagni/Elam: Elam, Caroline, "'Ché ultima mano!": Tiberio Calcagni's Marginal Annotations to Condivi's *Life of Michelangelo*", *Renaissance Quarterly*, vol. 51, no. 2, pp. 475–97, Chicago, 1998.

Cart. I, Cart. II, Cart. III, Cart. IV, Cart. V: Michelangelo, *Il Carteggio di Michelangelo*, vols. I–V, Poggi, Giovanni, Barocchi, Paola, and Ristori, Renzo (eds.), Florence, 1973.

Cart. In. I, Cart. In. II: Michelangelo, *Il Carteggio Indiretto di Michelangelo*, vols. I–II, Barocchi, Paola, Bramanti, Kathleen Loach, and Ristori, Renzo (eds.), Florence, 1988–95.

Casa Buonarroti, 1992: *Il Giardino di San Marco: Maestri e Compagni del Giovane Michelangelo*, exhibition catalogue, Casa Buonarroti, Florence, 1992.

Condivi/Bull: Condivi, Ascanio, 'Life of Michelangelo Buonarroti', in Michelangelo, *Life, Letters and Poetry*, translated by George Bull, Oxford, 1999, pp. 3–73.

Detroit Institute of Arts, 2002: *The Medici, Michelangelo and the Art of Late Renaissance Florence*, exhibition catalogue, Detroit Institute of Arts, Detroit, 2002.

Gemäldegalerie, 2008: *Sebastiano del Piombo*, exhibition catalogue, Gemäldegalerie, Berlin, 2008.

Michelangelo/Mortimer: Michelangelo, *Poems and Letters*, translated by Anthony Mortimer, London, 2007.

Michelangelo/Saslow: Michelangelo, *The Poetry of Michelangelo: An Annotated Translation*, translated by James M. Saslow, New Haven, 1991.

National Gallery, 2004: *Raphael: From Urbino to Rome*, exhibition catalogue, National Gallery, 2004.

Palazzo di Venezia, 2008: *Sebastiano del Piombo 1485–1547*, exhibition catalogue, Palazzo di Venezia, Rome, 2008.

Palazzo Vecchio, 1999: *Giovinezza di Michelangelo*, exhibition catalogue, Palazzo Vecchio, Florence, 1999.

Notes and References

Ramsden I, Ramsden II: Michelangelo, *The Letters of Michelangelo*, vols. I–II, translated by E. H. Ramsden, London, 1963.

Ricordi: Michelangelo, *I Ricordi di Michelangelo*, Ciulich, Lucilla Bardeschi, and Barocchi, Paola (eds.), Florence, 1970.

Vasari/Bull: Vasari, Giorgio, *Lives of the Artists*, translated by George Bull, vol. I, London, 1987.

Vasari/de Vere: Vasari, Giorgio, *Lives of the Painters, Sculptors and Architects*, vols. I–II, translated by Gaston de Vere, London, 1912.

I. THE DEATH AND LIFE OF MICHELANGELO

3 'The Academy and confraternity of painters . . .': Vasari/Bull, p. 433.

3 On 14 February 1564 . . .: The account of Michelangelo's last illness is based on letters from Tiberio Calcagni, Daniele da Volterra and Diomede Leoni: in Cart. In. II, pp. 171–4, nos. 357–9.

3 'The uncertainty of his speech . . .': Quoted in Papini, p. 512.

5 In 1506, when he was only thirty-one years old . . .: Vasari, 1962, vol. II, p. 385.

7 an inventory was made of his goods: See Corbo, pp. 128–30. On Michelangelo's wealth at death, see Hatfield, pp. 183–5.

8 a confusing multitude of currencies . . .: On the money Michelangelo used, see ibid. pp. xxi–xxiv.

9 The first was in Rome, in the church of Santi Apostoli . . .: Vasari/Bull, p. 431.

11 When the corpse arrived . . .: Ibid. p. 432.

11 Next Michelangelo was carried in procession . . .: Ibid. pp. 436–8.

2. BUONARROTI

13 'I do not wish to expatiate further . . .': Ramsden II, p. 133, no. 363.

13 Michelangelo may be the first individual . . .: On the biographies by Vasari and Condivi, see Hirst, 1997.

15 We know this because . . .: On the annotations by Tiberio Calcagni, see Calcagni/Elam, and Procacci, pp. 279–94.

15 Calcagni often began a note with 'He told me' . . .: Calcagni/Elam, p. 476.

15 'Pietra. Errore . . .': Ibid.

16 'So I think,' he concluded, 'that . . .': Ramsden II, p. 84, no. 295.

16 Eighteen months later . . .: Ibid. pp. 91–2, no. 306.

16 'I was never a painter or a sculptor . . .': Ibid. p. 92.

17 'I have always striven to resuscitate our house . . .': Ibid. p. 64, no. 272.

17 Although, like a lot of people . . .: For the early history of the Buonarroti family, see Ristori, Renzo, 'Introduzione', Cart. In. I, pp. x–xvi.

17n. His faith was strengthened . . .: For the letter from Count Alessandro da Canossa, see Cart. II, no. CDLXXIII, p. 245. He came to visit Michelangelo later in Rome, 'as a relative', according to Ramsden II, p. 86, no. 298.

18 On 1 November 1420 one Antonio . . .: Brucker, pp. 119–20.

18–19 Among the poor of Florence, there was a special category . . .: For the *poveri vergognosi* and the frescoes in San Martino dei Buonomini, see Cadogan, 2000, pp. 208–13.

19 At one point he mused that . . .: Ramsden II, p. 130, no. 359.

19 On another, he asked Lionardo . . .: Ibid. p. 129, no. 357.

19 The finances of the Buonarroti . . .: For a survey of the financial and political position of the Buonarroti family in Michelangelo's early years, see Hatfield, pp. 204–10.

19 Between 1477 and 1480 there are records . . .: Ristori, Renzo, 'Introduzione', Cart. In. I, p. xix.

19 Citizens in this position . . .: For the condition of being a 'specchio', see Napier, vol. III, p. 132.

20 The very first account of Michelangelo's career . . .: See Bull, pp. 169–71.

20 'In contradiction . . .': Ibid. p. 171.

20 Michelangelo ate little: Vasari/Bull, p. 423.

20–21 Michelangelo's birthplace . . .: See Hatfield, p. 205.

21 for a Florentine, the selection of godparents . . . : For the role of godparents in Florentine life, see Haas, pp. 66–83.

21 'I record that today . . .': Ramsden II, p. 272, Appendix 35.

21 The day on which Michelangelo . . .: On the date of Michelangelo's birth, see Lippincott.

23 When, after endless deliberation . . .: Ramsden II, p. 145, no. 386.

23 'All you need to have . . .': Ibid. p. 129, no. 357.

23–4 'A priest, a friend of his . . .': Vasari/Bull, p. 428.

24 'if you want to prolong your life . . .': Quoted in Calcagni/Elam, p. 494.

24 In the social world . . .: For a discussion of homosexual relationships in Renaissance Italy, see Rocke, and, for Michelangelo in particular, Michelangelo/Saslow, pp. 16–17 and 26–7.

25 Margherita he missed 'more . . .': Ramsden II, p. 7, no. 206.

25 'treat her kindly in word and deed . . .': Ibid. p. 5, no. 203.

25–6 'The family's declaration for the *catasto* . . .': Frey and Grimm, 1885, p. 194.

26 it was divided into four large subdivisions . . .: On the importance of the *quartiere* and *gonfaloni*, see Kent and Kent, and Eckstein.

27 The Buonarroti brothers . . .: Frey, 1909.

28 His father jotted down . . .: Hirst, 2011, pp. 6–7.

28 to the north, off Via Ghibellina . . .: On the *Stinche*, see Brackett, 1992, pp. 44ff.

29 'Spit hard! . . .': Quoted in Rocke, p. 44.

29 The *quartiere* of Santa Croce . . .: For the social geography of Santa Croce in the fifteenth century, see Jacks and Caferro, *passim*.

29 lower-middle-class dyers and their *tiratoi* . . .: See Girouard, pp. 34–6.

29 A prominent silk merchant named Tommaso Spinelli . . .: Jacks and Caferro, p. 84.

31 In September 1519 . . .: Ricordi, pp. 88–9, nos. LXXXIV–LXXXV.

31 'There was no need': Cart. II, p. 202, no. CDXLIV.

31 Touchingly, Michelangelo's niece, Francesca . . .: Ricordi, p. 274.

31 Although Lodovico Buonarroti . . .: Wallace, 'Miscellanae', 1994, p. 346.

31–2 It was probably no accident . . .: Ramsden I, p. 123, no. 137.

32 No sooner had the Buonarroti . . .: For Florentine wet nurses, see Haas, pp. 89–132.

33 'to my great shame . . .': Ramsden II, p. 64, no. 272.

33 'a major landowner . . .': On Michelangelo's property portfolio, see Hatfield, pp. 61–86 and 104–14.

33 In the 1520s he planted vines . . .: Ramsden I, p. 124, no. 138. The Roman garden is described in letters from Bartolomeo Angelini, Cart. IV, pp. 13, 20, 32, nos. CMVII, CMXI, CMXXI.

33 The ancestral Buonarroti farm was moderately substantial: Frey and Grimm, 1885, pp. 190–91.

34 Settignano was a village of masons . . .: On quarrying in Settignano and the social interconnections between Michelangelo and Settignanese masons, see Wallace, *Michelangelo*, 1994, pp. 32–8 and 100–102.

34 Michelangelo's wet nurse, Condivi wrote . . .: Condivi/Bull, p. 9; Vasari/Bull, p. 326.

34 'Though he be your own child . . .': Quoted in Haas, p. 90.

35 Her husband, Piero Basso . . .: Wallace, 'Michelangelo at work', 1989 (2), *passim*, Basso family tree on p. 239.

35 The Florentines, being interested in this stone . . .: on *macigno*, see Wallace, *Michelangelo*, 1994, pp. 147–50.

37 'colour and flavour . . .': Quoted in ibid. p. 149.

37 Even this sculptor's marble . . .: Cellini, 1898, p. 134.

37 The art historian William Wallace has established . . .: Wallace, *Michelangelo*, 1994, p. 37.

3. UNRULY APPRENTICESHIP

39 'What does the pupil look for . . .': Quoted in Ames-Lewis, p. 36.

39 'As a trustworthy model . . .': Michelangelo/Saslow, p. 322, no. 164.

39 Michelangelo, like many of his contemporaries . . .: On Michelangelo's horoscope and contemporary astrology, see Riggs, *passim*.

39 One poem was written in beautifully elegant . . .: Barkan, 2011, pp. 93–4.

40 'I have to cook, sweep the floor . . .': Cart. I, pp. 7–8, no. V (letter dated 14 February 1500). Translation by Alessandra Masolini.

41 Perhaps with a view to his joining his uncle Francesco . . .: On Lionardo Buonarroti's primary education, see Black, p. 337, no. 25.

41 This well-intentioned educational enterprise . . .: Ibid. pp. 371–2.

41 In 1497 he turned up . . .: Ramsden I, p. 4, no. 2.

42 Analysis of the *catasto* tax returns . . .: Black, p. 41.

42 Condivi explained: 'both heaven . . .': Condivi/Bull, p. 9.

42 Granacci lived around the corner from Via de' Bentaccordi . . .: Grasso, Monica, in *Dizionario Biografico degli Italiani*, vol. 58 (2002), accessed online at http://www.treccani.it/enciclopedia/francesco-granacci_(Dizionario-Biografico)/

42n. Francesco da Urbino . . . a family named Morelli: See Black, p. 141.

43 Francesco Granacci already had . . .: Vasari/de Vere, vol. I, p. 564.

44 At around this time . . .: Condivi/Bull, loc. cit.

44 Writing to his great friend. . . : Ramsden II, p. 35, no. 234.

44 In a dialogue written by another close friend . . .: Giannotti, p. 30.

44–5 A document at Carrara. . . : Hirst, 1985, p. 157.

45 This appalled his father and uncle: Condivi/Bull, loc. cit.

45 A pharmacist named Luca Landucci . . .: See Landucci, 1883, and (in English) Landucci, 1927.

45 Though being thrashed 'was extremely disagreeable . . .: Condivi/Bull, loc. cit.

46 'I am very pleased that you are receiving . . .': Cart. I, pp. 7–8, no. V. Translation by Alessandra Masolini.

46 This is clear from one of the few documented facts . . .: Cadogan, 2000, p. 162.

47 Condivi, he complained, 'says that . . .': Vasari/Bull, pp. 327–8.

48 He insisted in old age that . . .: Ramsden II, p. 92, no. 306.

48 Furthermore, the passage in Condivi implies . . .: Condivi/Bull, p. li.

48 It was there that he acquired his knowledge . . .: On Michelangelo and the Ghirlandaio workshop, see Hirst and Dunkerton, pp. 83–8. On the connections in drawing technique, see Hirst, 1988, p. 4.

48 Condivi states – no doubt echoing Michelangelo . . .: Condivi/Bull, p. 10.

50 he studied the techniques which the great Florentine masters . . .: On Ghirlandaio, Masaccio and Giotto, see Cadogan, 2000, pp. 93–101.

50 In 1487 Ghirlandaio was . . .: On Ghirlandaio's background, see ibid. pp. 13–21.

51 a contract . . . to paint the main chapel of Santa Maria Novella: For the Tornabuoni Chapel, see Ibid. pp. 236–43.

51–2 Vasari described an incident . . .: Vasari/Bull, p. 328.

52 'life on paper': The subtitle of Barkan, 2011.

52–3 This was a novel way of working . . .: On Leonardo as draughtsman, see Chapman, Hugo, in British Museum, 2010, pp. 67–9.

54 A plentiful supply of paper . . .: On the making and supply of paper in the Renaissance, see ibid. pp. 35–8.

54 The price list of a Florentine stationer's . . .: Ibid. p. 35.

54 after Ghirlandaio had used a piece of paper . . .: Ibid. p. 224.

55 A sheet with studies of the *Madonna and Child* . . .: British Museum, 2005, p. 289, no. 289.

55 'Work hard and don't . . .': Ramsden I, p. 110, no. 121.

55 He also instructed his brother . . .: Ibid. p. 120, no. 132.

55 A sheet of sketches in the Ashmolean . . .: For a discussion of this drawing, see Barkan, 2011, pp. 177–81.

58 Ghirlandaio, though he made no engravings . . .: British Museum, 2005, p. 222.

58 Michelangelo did a 'perfect pen-and-ink copy'. . .: Vasari/Bull, p. 329.

58 Condivi says that it was Granacci . . .: Condivi/Bull, p. 10.

58 'he now wished to try to make use of colour': Ibid.

59 a *Star Wars* picture: The Christiansen quotation is from an audio interview accessible at http://www.metmuseum.org/metmedia/audio/exhibitions/041-special-exhibition-michelangelos-first-painting

59 Michelangelo paid particular attention . . .: Condivi/Bull, loc. cit.

59 Technical examination . . .: Christiansen, loc. cit., https://www.kimbellart.org/conservation/michelangelo, and conversation between author and Claire Barry, Fort Worth, 2012.

61 Another story in Condivi reveals a pushy desire . . .: Condivi/Bull, p. 11.

61 'This was because as well as the perfection . . .': Ibid.

4. MEDICI

63 'No one, even among his adversaries . . .': Guicciardini, *Storie Fiorentine*, in Ross and McLaughlin, p. 270.

63 'The beginning of love . . .': Lorenzo de' Medici, p. 37.

63 On Sunday 26 April 1478 . . .: For a compelling account of the Pazzi plot, see Martines, 2003, pp. 111–32.

65 Eighty-five years later . . .: Hirst, 2011, p. 7.

65 The 'chief cause that led the Pazzi to conspire' . . .: Machiavelli, 2003, p. 400.

65–6 'This will not only contribute . . .': Quoted in Roscoe, 1822, p. 149.

66 Michelangelo probably first . . .: Condivi says he was fifteen to sixteen years old when he joined the Medici household (Condivi/Bull, p. 14), and that he stayed two years until Lorenzo's death. Lorenzo died in April 1492.

66 Niccolò Valori . . .: Martines, 2003, p. 89.

66 It was made up of crossbow men with nicknames . . .: Ibid., p. 233.

66n. Early 1490 fits the chronology . . .: For Lorenzo's illness in March 1490, see Hook, 1984, p. 178. For his departure in April, see Tribaldo de' Rossi, p. 251.

67 Officially, the most powerful posts in the administration . . .: Hale, 1977, pp. 16–19.

67 in observing Lorenzo you saw two different people . . .: Kent, 2007, p. 4.

67 As the historian Lauro Martines put it . . .: Martines, 2003, p. 248.

67 'No one, even among his adversaries . . .': Guicciardini, *Storie Fiorentine*, in Ross and McLaughlin, p. 271.

68 One of his most vehement . . .: Martines, 2003, p. 226.

68 Lorenzo 'desired glory . . .': Guicciardini, *Storie Fiorentine*, in Ross and McLaughlin, p. 271.

68 a form of rheumatoid arthritis . . .: See Strauss and Marzo-Ortega, pp. 212–13.

68 Lorenzo's sculpture garden at San Marco . . .: See Elam, 1992.

68 This was just one of several locations . . .: Fusco and Corti, p. 106, and passim.

69 Two ancient sculptures of the flayed Marsyas . . .: Ibid. p. 110.

69 It was a fashion of the time to display . . .: Ibid. p. 114.

69 There is an example of his doing just this . . .: Bullard, p. 31.

70 The consequence was that in 1489 . . .: Kent, 2007, p. 23.

70 they found a young sculptor . . .: Vasari/Bull, p. 330.

70 Bertoldo di Giovanni (d. 1491) . . .: For Bertoldo's career, see Draper.

71 A strange letter survives . . .: Ibid. pp. 7–9.

71 'homoerotic double-talk . . .': Kent, 2007, p. 58.

71 Seeing Torrigiano at work . . .: Vasari/Bull, loc. cit.

72 Benvenuto Cellini, who encountered him . . .: Cellini, 1956, pp. 30–31.

72 Vasari, probably repeating Granacci's memories . . .: Vasari/de Vere, vol. I, p. 694.

72 Michelangelo's opinion of Torrigiano . . .: Condivi/Bull, p. 72.

72 Cellini heard Torrigiano's side of the story . . .: Cellini, 1956, pp. 30–31.

74 The lengthy description of his appearance . . .: Condivi/Bull, pp. 72–3.

74 Benedetto da Maiano . . . is one plausible master . . .: This suggestion was made in Lisner, 1958.

76 This procedure was defined . . .: For Michelangelo's carving technique, see Wittkower, pp. 99–126.

76 The process of subtraction went . . .: Ibid. p 127.

77 The only eyewitness account . . .: Quoted in Wallace, 2010, p. 145.

79 like seeing a figure lying in a basin of water . . .: Vasari, 1960, p. 151.

79 Michelangelo began one of his most celebrated sonnets . . .: Michelangelo/ Saslow, p. 302, no. 151.

79 an ancient head of an elderly faun . . .: For the story of the faun, see Condivi/ Bull, pp. 11–13.

5. ANTIQUITIES

83 'When Lorenzo had shown him . . .': Quoted in Fusco and Corti, p. 147.

83 'a good room in the house . . .': Condivi/Bull, p. 13.

83 Bertoldo's room and furniture . . .: For the inventory of Bertoldo's room, see Draper, p. 16.

83 a tax declaration from the mid-1490s . . .: Elam, 1992, p. 46.

83 Michelangelo was provided with a violet cloak . . .: Vasari/Bull, p. 331.

83 'He loved exceedingly all . . .': Machiavelli, 1909, p. 360.

84 'very learned and shrewd': Condivi/Bull, p. 14.

85 It was explained to him that, with the Medici . . .: Unger, 2008, p. 397.

86 'The appearance of a man which because . . .': Ficino, p. 183.

86 Pico della Mirandola's celebrated *Oration on the Dignity of Man* of 1486 proposed . . .: Quoted in Ross and McLaughlin, p. 477.

87 'He never left his studies for the lyre . . .': Calcagni/Elam, p. 491.

87 There was a profound sense of artistic style . . .: Baxandall, p. 26.

88 Most would have read Cristoforo Landino's *Commentary* . . .: Ibid. p. 117–18.

88 Michelangelo's *Madonna* was carved . . .: For a discussion of the *Madonna of the Stairs*, see Hirst, M., in Casa Buonarroti, 1992, pp. 86–9.

90 The aged Michelangelo commented pithily . . .: Calcagni/Elam, p. 492.

90 'more grace and design' . . .: Vasari/Bull, p. 331.

90 Literary detectives such as the Florentine Poggio Bracciolini . . .: For Bracciolini and Lucretius, see Greenblatt.

91 'many times a day [Lorenzo] had him summoned . . .': Condivi/Bull, p. 14.

91 'rare and lordly things': Francesco Malatesta to Isabella d'Este, quoted in Fusco and Corti, p. 149.

91 Indeed, he had many of them inscribed . . .: Kent, 2007, pp. 146–7.

93 In February 1489 Nofri Tornabuoni . . .: Fusco and Corti, p. 52.

93 The collection was part . . .: Kent, 2007, p. 148.

93 the great Venetian humanist scholar Ermoleo Barbaro . . .: Bullard, loc. cit.

94 Nofri Tornabuoni wrote . . .: Quoted in Fusco and Corti, p. 120.

94 The first time this little work was mentioned . . .: Hirst, in Casa Buonarroti, 1992, p. 52.

94 'We seem to be looking into the boiling cauldron . . .': Clark, 1956, p. 193.

95 Michelangelo seems to have thought . . .: Condivi/Bull, pp. 14–15; Calcagni/Elam, p. 482.

95 This was placed over a fireplace . . .: Draper, p. 16.

95 Michelangelo's subject of the Centaurs . . .: Condivi/Bull, pp. 14–15.

96 'an antique goblet': Ovid, pp. 273–82.

6. PIERO DE' MEDICI AND FLIGHT TO BOLOGNA

99 'Michelangelo has similarly with great diligence . . .': Condivi/Bull, p. 68.

99 A contemporary letter noted . . .: Draper, p. 17.

99 The day after Bertoldo's death . . .: On Lorenzo's last illness and the consecration of Giovanni de' Medici as a cardinal, see Hook, 1984, pp. 183–5.

100 'Michelangelo returned to his father's house . . .': Condivi/Bull, p. 15.

100 A letter written on 7 April 1492 . . .: Rocke, p. 201.

101 The historian Michael Rocke . . .: Ibid. p. 115.

101 Civic anxiety about it culminated . . .: Ibid. pp. 27–8.

102 In 1492, '94 and '96 . . .: Ibid. p. 176.

102 In 1502 the painter Botticelli . . .: Ibid. p. 298, note 121.

102 In Condivi, the assessment of Piero . . .: Condivi/Bull, p. 16.

102 'He told me he had never said such a thing': Calcagni/Elam, p. 490.

102 Piero treated Michelangelo 'most affectionately': Condivi/Bull, pp. 16–17.

103 After he recovered from his grief . . .: Ibid. p. 15.

104 'there was a heavy snowfall in Florence . . .': Caglioti, pp. 262–4.

104 Landucci reports that . . .: Landucci, 1927, p. 243.

104 Sadly, Michelangelo's marble *Hercules* . . .: For the fate of Michelangelo's *Hercules*, see Joannides, 1977.

104–5 Michelangelo took the place of his dead teacher . . .: Vasari/Bull, p. 332.

104n. On 11 August 1495 . . .: Caglioti, pp. 262–4.

104n. 'There was the severest snowstorm . . .': Landucci, 1927, pp. 55–6.

105 this work came about almost as a favour . . .: Condivi/Bull, p. 16.

105 Santo Spirito, south of the river . . .: For Lorenzo's oversight of the Sacristy scheme, see Kent, 2007, p. 101.

105 Piero de' Medici followed in his father's footsteps . . .: Hirst, 2011, p. 20.

107 Vasari, who would have known it well . . .: Vasari/Bull p. 333.

107 Michelangelo's figure corresponds . . .: Pini, p. 17.

107 'his precious body . . .': Quoted in Henderson, p. 162.

107 Such detailed visualization . . .: Ibid.

107n. Perhaps the advent of modernism made it possible . . .: The attribution was first made in Lisner, 1964, and took some time to gain acceptance.

108 His outline notes for his Lenten sermons of 1491 . . .: Martines, 2006, p. 96.

108 In his sermon of Sunday 20 March 1491 . . .: Ibid. p. 27.

108 Savonarola conducted a public dialogue with Christ . . .: Ibid. pp. 71–2.

108 Michelangelo had 'always had a strong affection' . . .: Condivi/Bull, p. 68.

109 Savonarola was preaching in the convent of San Marco . . .: Parks, Tim, p. 241.

109 Pico felt the hair on his head rising . . .: Martines, 2006, p. 94.

109 Lorenzo allegedly complained . . .: Ibid. p. 23.

111 On 23 June 1489 . . .: Kaye, pp. 151–66.

111 many of these men were doubtful about Piero . . .: Martines, 2006, p. 30.

112 The trigger for cataclysm . . .: On the invasion of 1494, see Setton, pp. 448–82.

112 On 2 September 1494 . . .: Ibid. p. 461.

112 On that very day the little city of Rapallo . . .: Leathes, p. 112.

113 This concerned a virtuoso lyre player . . .: Condivi/Bull, pp. 16–17. For the identification of Cardiere, see Cummings, pp. 37–8, cited in Hirst, 2011, p. 21.

114 a series of letters from . . . Cardinal Bibbiena: For Bibbiena's letters, see Moncallero.

114 'He told me he had heard this from others . . .': Calcagni/Elam, p. 491, note 45.

114–15 On 14 October a Florentine sculptor named Adriano . . .: Elam, 1992, p. 58.

115 Michelangelo fled to Venice . . .: Condivi/Bull, p. 17.

115 When foreigners first arrived . . .: Ibid.

115 in an awkward predicament . . .: Ibid. For Gian Francesco Aldrovandi, see Ciammitti, Luisa, in Palazzo Vecchio, 1999, pp. 139–41.

116 Aldrovandi, seeing Michelangelo . . .: Condivi/Bull, pp. 17–18.

117 The first works Michelangelo made in Bologna . . .: Ibid.

117 Finishing the shrine . . .: For the Arca di San Domenico, see Dodsworth.

117 Aldrovandi asked Michelangelo . . .: Condivi/Bull, loc. cit.

119 The little statuettes Michelangelo made . . .: For the sculptures of the Arca di San Domenico, see Emiliani, Andrea, in Palazzo Vecchio, 1999, pp. 127–37, and also catalogue entry, ibid. pp. 292–6.

7. ROME: CUPID, BACCHUS AND THE PIETÀ

121 'The church itself . . .': Lucian Freud in conversation with author, 2004, quoted in Gayford, p. 169.

121 'The countenance of this figure . . .': Shelley, p. 188.

121 In the fraught days of November 1494 . . .: For the events of November 1494 and their aftermath, see Martines, 2006, pp. 34–111, and Hale, 1977, pp. 77–8.

122 Next, Michelangelo, 'applied himself . . .': Condivi/Bull, p. 19. On the *Sleeping Cupid* and its fate, see Hirst and Dunkerton, pp. 20–28.

123 Condivi, presumably following . . .: Condivi/Bull, pp. 19–20.

123 He was 'indignant at being tricked . . .': Ibid. p. 19. For the bank deposit, see Hirst and Dunkerton, p. 22.

123 When he saw the young Michelangelo . . .: Condivi/Bull, p. 19.

124 The first letter in Michelangelo's huge correspondence . . .: Ramsden I, p. 3, no. 1.

124 Rome was . . . another country: A magisterial survey of medieval Rome is to be found in Krautheimer, pp. 231–326. Stinger, and Partner, deal with many diverse aspects of the Renaissance city, passim.

126 Michelangelo's first act . . .: Ramsden, loc. cit.

126 By the 1490s the cardinal had . . .: On Cardinal Riario and the Cancelleria, and the statues displayed there, see Frommel, Christoph Luitpold, in Palazzo Vecchio, 1999, pp. 143–8. For the *Juno*, see Hirst and Dunkerton, p. 31.

127 The Gallis lived in the area of Rome . . .: See Baldini, Nicoletta, Lodico, Donatella, and Piras, Anna, in Palazzo Vecchio, 1999, pp. 149–62.

127 This last – a Cupid holding a quiver . . .: For the case in favour of this carving, see Weil-Garris Brandt, 1996, pp. 644–59.

128 At their second meeting, he had evidently . . .: The evidence is in payments made to Michelangelo's account: see Hirst and Dunkerton, loc. cit., and Hatfield, p. 3.

128 the first printed edition of *De architectura* . . .: Campbell, Lilly.

128 'merry face, and the squinting, lascivious eyes . . .': Condivi/Bull, p. 21.

130 Vasari wrote about *Bacchus*'s androgyny . . .: Vasari/Bull, p. 335.

130 There was a passage in Pliny . . .: Summers, 1981, pp. 265–8.

130 'Ciasun segue, o Bacco, tè . . .': See Fantazzi, p. 134.

130 Michelangelo's day of excited exploration . . .: On the statues at the Palazzo dei Conservatori, see Stinger, p. 256. For the *spinario*, see Haskell and Penny, p. 308. For the *Apollo Belvedere*, see Brown.

132 'I've not yet been able to settle up my affairs . . .': Ramsden I, p. 4, no. 2.

132 'Christians ate grass . . .': Quoted in Kent, 2002, p. 25.

132 Landucci noted that many were dying . . .: Landucci, 1927, p. 123.

132 That day, Lodovico Buonarroti's second wife . . .: Casa Buonarroti, 1992, p. 44; de Tolnay, vol. I, 1947, p. 7.

133 Eventually, his younger brother Buonarroto . . .: Ramsden I, p. 5, no. 3.

133 'Don't be surprised that I have at times . . .': Ibid.

133 He had been commissioned to make 'a figure' for Piero . . .: Ibid.

134 He had plotted return to power . . .: Martines, 2006, pp. 182–97, and Landucci, 1927, pp. 118 and 125.

134 Landucci, though a supporter of Savonarola's . . .: Landucci, 1927, p. 126.

134 Like its date, the patron of the *Manchester Madonna* . . .: For a discussion of the *Manchester Madonna*, see Hirst and Dunkerton, pp. 37–46. For a convincing account of its rise, fall and resurrection in scholarly favour, see Penny, Nicholas, in Palazzo Vecchio, 1999, pp. 115–26, and catalogue entry, pp. 334–40.

134 On 26 March the following year, he drew 30 ducats . . .: Casa Buonarroti, 1992, p. 444; Hatfield, p. 7.

137 Savonarola's youthful moral enforcers . . .: Martines, 2006, p. 118.

137 a letter written on 18 November to the Elders of Lucca . . .: Milanesi, p. 630.

138 the eloquent advocacy of Jacopo Galli . . .: For the contract, see ibid. pp. 613–14.

138 Bilhères was an eminent Gascon clergyman . . .: For his biography, see Samaran.

138 One of the greatest of late-fifteenth-century French *Entombments*. . . : Forsyth, pp. 88 and 200.

138 By the third week in November . . .: Hirst, 1985, p. 155.

138 Over a quarter of a century later . . .: Cart. III, p.98, no. DCLVIII.

139 By 13 January Michelangelo's friends . . .: For Piero d'Argenta, see Hirst and Dunkerton, pp. 40–42.

139 'the cardinal's barber . . .': Vasari/Bull, p. 335. On the identification of Piero with the cardinal's barber, and the altarpiece for San Pietro in Montorio, see Agosti and Hirst.

139 At the time of the siege of Florence . . .: Cart. III, p. 269, no. DCCLXXXVIII, p. 399, no. DCCCLXIV.

139 Another sixteenth-century text . . .: Vasari/Bull, p. 335.

140 His letter to Buonarroto in January 1498 . . .: Cart. In. I, p. 1, no. 1.

140 On 17 February Landucci noted . . .: Landucci, 1927, p. 130.

140 It was 9 Feburary before Michelangelo . . .: Hirst, 1985, p. 155.

140 On 27 February in the Piazza de' Signori . . .: Landucci, 1927, p. 130.

141 On 10 March Piero d'Argenta wrote again . . .: Milanesi, p. 59.

141 'the Seraphic Brother Girolamo . . .': Ibid. Translation by Alessandra Masolini.

141 On 7 April 1498, for example . . .: Masson, p. 9.

141–2 A madrigal by Michelangelo . . .: Michelangelo/Saslow, p. 394, no. 232.

142 Girolamo Savonarola was very soon to be walking towards death: For his end, see Martines, 2006, pp. 219–82.

142 On 7 April, the same day that Spanish Barbara burnt . . .: Hirst, 1985, p. 154.

144 Condivi explains that he put this question to the great man . . .: Condivi/Bull, p. 22.

145 Santa Petronilla – demolished when Bramante began . . .: On Santa Petronilla and the position of the *Pietà*, see Weil-Garris Brandt, 1987, and Wallace, 1992, passim.

145 Yet, as William Wallace has pointed out . . .: Wallace, 1992.

146 Vasari has a vivid story about why he did this . . .: Vasari/Bull, p. 36.

146 Michelangelo's signature was in the imperfect tense . . .: For a discussion of the signature and its significance, see Goffen, pp. 113–18.

146 Michelangelo had probably heard . . .: Ibid. p. 114.

146 It was installed, by July 1500 . . .: The date of the *Pietà*'s completion is unclear. See Hirst and Dunkerton, p. 55.

146n. Another bitter rival, Pietro Torrigiano . . .: Benedettucci, Fabio, in Casa Buonarroti, 1992, p. 116.

8. DAVID AND OTHER BODIES

149 '[Michelangelo's] plastic problem . . .': Newman, p. 573.

149 'With Michelangelo anatomical science . . .': Boccioni, quoted in Coen, p. 238.

149 On 2 September 1500 Michelangelo was credited with 60 ducats . . .: Hirst, 1981, p. 581. For *The Entombment*, see Hirst and Dunkerton, pp. 57–71 and 107–27, and Nagel, 1994.

151 *The Entombment* is the first of Michelangelo's works . . .: Hirst and Dunkerton, pp. 68–9. The drawing is in the Louvre, Paris.

152 Condivi described how he was on very good terms . . .: Condivi/Bull, p. 16.

152 Lorenzo Ghiberti, creator of the bronze doors . . .: Quoted in Clayton and Philo, p. 8.

152 The historian of medieval science James Hannam . . .: Hannam, p. 252.

153 Pollaiuolo 'understood about painting nudes . . .': Vasari/de Vere, vol. I, p. 533.

153 Even a celebrated anatomist such as Andreas Vesalius . . .: Hannam, p. 259.

153 Leonardo da Vinci (1452–1519) was . . . definitely studying anatomy . . .: On Leonardo as anatomist in Milan, see Clayton and Philo, pp. 9–14.

154 In the spring of 1501, apparently leaving *The Entombment* unfinished . . .: Hatfield, pp. 14–15.

154 Probably the overriding reason for his journey . . .: Vasari/Bull, p. 337.

154 The block had been quarried at Carrara . . .: For the history of the block, see Seymour, pp. 21–39.

154 Michelangelo told Tiberio Calcagni . . .: Procacci, Ugo, 'Postille contemporanee in un esemplare della vita di Michelangelo del Condivi' in Atti del Convegno di Studi Michelangioleschi, Rome, 166, p. 287.

154–5 According to a document, one of them . . .: Seymour, p. 133.

155 Simone had earned his name . . .: Vasari/de Vere, vol. I, p. 758.

155 Condivi pointed to one in particular . . .: Condivi/Bull, p. 23.

155 Andrea Sansovino (c. 1467–1529) . . .: For Sansovino (otherwise, Andrea Contucci), see Vasari/de Vere, vol. I, pp. 782–91. On his work in Genoa and Baptism of Christ, see Pope-Hennessy, 1970, p. 345.

156 the history of that piece of stone: See Seymour, pp. 21–39.

156 Agostino had 'hacked a hole' between its legs . . .: Vasari/Bull, p. 337.

157 Donatello's *David* of 1408 . . .: But see Pope-Hennessy, John, *Donatello*, London, 1993, pp. 40–46, who argues that the sculpture in the Bargello is not the one commissioned for the Duomo in 1408. It does, in any case, give an idea of what Agostino di Duccio's *David* might have looked like.

157 Vasari claimed that Leonardo da Vinci . . .: Vasari/Bull, loc. cit.

157 Now, Leonardo was back in Florence . . .: On Leonardo's return to Florence in 1500–1502, see Nicholl, pp. 331–42.

159 Vasari wrote that, for the two days it was on show . . .: Ibid. p. 332.

160 It was only at the time that *David* was nearing completion . . .: See, for example, Clayton and Philo, pp. 7 and 8–9, no. 23.

160 Four days after knocking the *nodum* from David's chest . . .: Seymour, p. 137.

160 A month later, on 14 October . . .: Frey, 1909, p. 107.

160 Vasari attributed the building . . .: Vasari/Bull, p. 338.

160 It had been stipulated that Michelangelo . . .: Seymour, p. 137.

160 However, on 25 February 1502 . . .: Gaye, vol. II, p. 107.

162 in July 1501 it was still the idea . . .: Seymour, p. 135.

162 Clearly, *David* was carved to be seen from behind . . .: See Goffen, p. 123.

162 In the autumn of 1502, a year after Michelangelo . . .: Landucci, 1927, p. 200. On Soderini, see Hale, 1977, p. 200.

163 Michelangelo told Condivi that he carried the statue out . . .: Condivi/Bull, p. 23.

163 On 16 June 1503 . . .: Hirst, 2000, pp. 487–8.

163 including Donatello's bronze *David* and *Judith and Holofernes* . . .: Pope-Hennessy, 1993, pp. 149–50.

163 on 25 January 1504, the Operai of the Duomo brought together . . .: For the minutes of this riveting meeting, see Seymour, pp. 141–55.

165 He declared that Donatello's *Judith and Holofernes* . . .: Ibid. pp. 143–5.

165 The news had arrived that Piero de' Medici . . .: Landucci, 1927, p. 211.

166 Giuliano da Sangallo, Michelangelo's friend and mentor . . .: Seymour, p. 147.

166 Leonardo da Vinci, for his part, was discreetly negative: Ibid. p. 151. On Leonardo's drawing of *Neptune*, after *David*, see Goffen, pp. 128–9.

166 This decision was taken on Michelangelo's advice . . . : Hirst, 2011, p. 46.

166 On 1 April La Cronaca and Michelangelo were instructed . . .: Hirst, 2011, p. 46.

166, 168 To do so was in itself a feat of engineering . . .: Vasari/Bull, p. 338.

168 On 14 May at around eight in the evening . . .: Landucci, 1927, p. 214.

168 No sooner was he seen in public . . .: Hirst, 2000, p. 490 and note 30.

168 The fact that *David* was dubbed 'the Giant' . . .: For the role of the *giganti* on St John's day, see Landucci, 1927, p. 20 and note 2.

168–9 According to Piero Parenti, David was not universally praised . . .: Hirst, 2011, loc. cit.

169 The Florentine authorities agreed that *David*'s nakedness . . .: Caglioti, pp. 334ff.

169 Already in 1550 Vasari was unable . . .: Michelangelo/Mortimer, p. 158.

9. MICHELANGELO VERSUS LEONARDO

171 'On another occasion Michel Agnolo . . .': Frey, 1969, p. 115.

171 at the time he was beginning *David* . . .: Hirst and Dunkerton, pp. 58–9; Hatfield, pp. 11–12.

171 Six months before Galli had found yet another . . .: Mancusi-Ungaro, pp. 9–24.

171–2 The Piccolomini family . . .: Ibid. pp. 10–11.

172 On 22 May 1501 Michelangelo . . .: Ibid. p. 13.

172 By 11 October 1504 . . .: Ibid. p. 16.

172 On 20 September 1561 he wrote to his nephew . . .: Ramsden II, p. 202, no. 469.

172–3 There was some more correspondence . . .: Mancusi-Ungaro, p. 21.

172n. The architecture of this Piccolomini altar . . .: Ibid. pp. 11–12.

173 His bronze *David* was last recorded . . .: Flick, pp. 59–61.

173 It was for a man the Florentine government wanted . . .: For the documents concerning this commission, see Gatti.

174 On 12 August 1502 Michelangelo was commissioned . . .: Ibid. p. 441.

174 On 30 April 1503 the reply came back . . .: Ibid. p. 442.

174 He agreed to make twelve over-lifesize statues of the Apostles . . .: Frey, 1909, pp. 110–11.

175 In July 1503, after Michelangelo had missed his target . . .: Gatti, pp. 443–4.

175 As described by Benvenuto Cellini, casting in bronze . . .: Leoni, pp. 171–7; Cellini, 1898; pp. 111–26.

175 Next a layer of wax the thickness . . .: This account of bronze casting is based on Leoni, op. cit.

175 Cellini's heart-stopping account of casting his *Perseus* . . . : Cellini, 1956, pp 343–9.

177 Michelangelo seems finally to have cast the bronze *David* . . .: Gatti, p. 444.

177 By April 1504 the Maréchal . . .: Ibid. pp. 444–5.

177 Robertet told the ambassador . . .: Ibid. p. 445.

177 Michelangelo . . . received a letter asking him to come back . . .: Cart. I, p. 83, no. LIX.

178 That Michelangelo was thinking about the bronze *David* . . .: For discussions of this drawing, see Goffen, pp. 131–4; Seymour, pp. 4–9.

179 'David with the Sling . . .': Seymour, p. 7.

179 This mystery was solved convincingly . . .: Ibid. pp. 7–8.

179 The line quoted from Petrarch . . .: Goffen, loc. cit.

180 The gifted painter, Leonardo noted . . .: Kemp and Walker, p. 197.

180 Michelangelo's fascination with Leonardo's *Madonna and Child with St Anne* . . . : British Museum, 2005, pp. 93–4, Wilde, 1953, p. 66.

180–81 Michelangelo's pen-strokes provide a further intriguing clue . . .: Wilde, 1953, p. 66.

182 In April 1501 Leonardo was visited . . .': Nicholl, pp. 336–7.

182n. A hint of close contact . . .: Reti, Ladislao, 'The Two Unpublished Manuscripts of Leonardo da Vinci in the Biblioteca Nacional of Madrid – II', *Burlington Magazine*, vol. 110, no. 779 (Feb. 1968), p. 81.

184 To Leonardo, painting was the supreme art . . .: Richter, Irma, p. 195.

184 in Leonardo's cool, rational understanding of religion . . .: Ibid.

184 As an artist who practised both painting and sculpture . . .: Ibid. p. 207.

184 'The sculptor in creating his work . . .': Ibid. p. 330.

185 'The painter' – for whom, read Leonardo himself . . .: Ibid.

185 'burning in the shadows': Michelangelo/Saslow, p. 67, no. 2.

185 Varchi had paid Michelangelo the high compliment . . . : Varchi, Benedetto, *Due lezzioni di M. Benedetto Varchi*, Florence, 1549.

185 He asked Michelangelo to write down his views . . .: The following quotations are all from Ramsden II, p. 75, no. 280.

185n. Leonardo was a man to whom clothes . . . : Jones, pp. 9–10.

186 Its marble contained a nasty crack . . .: See Hirst, 2005.

186 Many of Leonardo's own activities during these years . . .: See Nicholl, pp. 394–5; Richter, Jean Paul, vol. 2, p. 371.

187 a Florentine humanist civil servant named Agostino Vespucci . . .: http://www. academia.edu/384690/AgostinoVespucci's Marginal Note about Leonardo da Vinci in Heidelberg.

187 a friend of Machiavelli's, Luca Ugolino . . . : Strathern, Paul, *The Artist, the Philosopher and the Warrior*, London, 2009, p. 307.

187 Bartholomeo Pitti, who joined the Opera del Duomo committee . . .: Hirst, 2000, p. 489.

189 The third Madonna and child of these years was fully sculptural . . .: Mancusi-Ungaro, pp. 35–42.

190 The last of these Madonnas was a painting . . .: Hirst, 2011, pp. 78–9. For a recent consideration of Doni Tondo as a marriage painting, see Hupe.

190 There was, Vasari wrote, 'the greatest disdain'. . .: Goffen, p. 148.

190 Paolo Giovio, who knew both men . . .: Ibid. p. 145; Bull, pp. 170–71.

191 with Michelangelo, as the art historian Rudolf Wittkower wrote . . .: Quoted in Goffen, p. 149.

191 Michelangelo was made to make an extraordinary confession . . .: Giannotti, pp. 32–3; Bull, loc. cit.

191 He is, he said, 'of all men, the most inclined to love persons': Quoted in Bull, p. 311.

192 When invited to accompany them to dinner . . .: Giannotti, loc. cit.; Bull, loc. cit.

192 Leonardo da Vinci was passing through the Piazza Santa Trinita . . .: *Il Codice Magliabechiano*, ed. Frey, Carl, loc. cit.

193 In the early 1490s Leonardo had devised . . .: See Nicholl, pp. 280–5.

193 Michelangelo's mentor, Giuliano da Sangallo . . .: Ibid. p. 282.

193n. The evidence we have is just a glimpse . . .: Ibid. p. 379, Frey, loc. cit.

194 after completing *David*, Michelangelo neglected sculpture . . .: Condivi/Bull, p. 24.

194 It was, in his view, inferior to painting: Richter, Irma, pp. 198–9.

195 In March 1503 Leonardo was back in Florence . . .: Nicholl, p. 356.

195 'the most brutal madness there is': Richter, Jean Paul, vol. 1, p. 353.

195 Borgia . . . gave him a 'cape à la française' . . .: Jones, p. 9.

195 Leonardo was to paint a huge picture . . . : Wilde, 1953, pp. 70–77; Nicholl, pp. 371–6, 389–94. Attempts to find the remains of Leonardo's work beneath the wall of the Palazzo Vecchio have recently been made.

195 According to the building contracts, the painting . . .: Wilde, 1944, p. 80.

196 Leonardo moved into a new workshop . . .: Nicholl, p. 371.

196 Vasari related that Pope Leo X . . .: Vasari/Bull, p. 269.

196 At the end of the summer, Michelangelo . . .: Casa Buonarroti, 1992, p. 450.

196 'to stage a competition': Quoted in Goffen, p. 143.

196 Perhaps, as Leonardo's biographer Charles Nicholl mused . . .: Nicholl, p. 380.

196 Leonardo had written about battles . . . : da Vinci, vol. I, pp. 115–17.

197 Machiavelli . . . first mentioned the subject on 24 May 1504 . . .: Hörnquist, p. 151.

197 Intriguingly, in *The Prince* Machiavelli used the story of David . . .: Machiavelli, 1975, p. 85.

197 As the art critic and historian Jonathan Jones drily noted . . .: Jones, p. 187.

198 One person who did see and describe it was Benvenuto Cellini . . .: Cellini, 1956, pp. 30–31.

198 They help explain why, according to Vasari . . .: Vasari/Bull, p. 342.

200 'the reinvention of the human body': Hall, James, *The Reinvention of the Human Body*, London, 2005, title.

200 So Michelangelo constructed a cartoon of his main scene . . .: See Bambach, 1999, passim.

200 If 'you have to invent a scene' . . .: Richter, Irma, pp. 181–2.

201 Michelangelo adopted this freewheeling way . . .: British Museum, 2005, pp. 290–1, no. 92.

202 A sheet from around 1503/4 . . .: Ibid. pp. 292–3, no. 93.

202 On the other side of the sheet . . .: Ibid. p. 294, no. 15.

202 'You should not make all the muscles of the body . . .': Nicholl, p. 382.

202 'Oh anatomical painter!' . . .: Richter, Jean Paul, vol. I, p. 190.

202 A drawing from 1504–6 . . .: Clayton and Philo, pp. 78–9, no. 23.

202 The text, in Leonardo's mirror-writing . . .: Ibid. p. 78.

203 He slowly painted the middle section . . .: Nicholl, pp. 389–92, 403.

203 Leonardo ignored the time limit . . .: Ibid. p. 407.

10. GIANTS AND SLAVES

205 'Françoise . . . knowing she would have to compose . . .': Proust, p. 480.

205 Julius . . . had been elected Pope . . .: Shaw, p. 122; Baumgartner, pp. 89–90.

205 a fresco by Melozzo da Forli painted in 1477 . . .: Clark, 1969, p. 119.

205 On that occasion he was outmanoeuvred . . .: Shaw, p. 82.

206 First he tricked Cesare Borgia . . .: Ibid. pp. 120–22, 131–3.

206 Julius was also a connoisseur . . .: See Brown; Fusco and Corti, pp. 52–3.

206 In a whirlwind of activity, Michelangelo . . .: Hirst, 1991, p. 762–3; Hatfield, pp. 17, 37–8.

208 For comparison, Leonardo da Vinci left . . .: Hatfield, p. 38.

208 The tomb of his uncle Sixtus IV . . .: See Wright, pp. 359–88.

208 Condivi described it, undoubtedly quoting from Michelangelo's words . . .: Condivi/Bull, pp. 26–7.

208 Moses, St Paul and the Active and Contemplative Life . . .: Vasari/Bull, p. 345.

208 Higher still there would have been 'two angels . . .': Condivi/Bull, loc. cit.

208 more than forty statues in all . . .: Ibid.

209 'there will be nothing to equal it the world over': Ramsden I, pp. 13–14, no. 8.

209 The scheme was all agreed by the end of April . . .: As shown by the payment and letter from Alamanno Salviati, quoted in Hirst, p. 1991, pp. 762–3.

209n. the Mausoleum of Halicarnassus . . .: Pliny, p. 347.

210 According to the version in Condivi, Michelangelo's solution . . .: Condivi/Bull, pp. 27–8.

210 This story was probably not much exaggerated . . .: See Hirst, 1991, loc. cit.

210n. The role of Alamanno Salviati . . .: Hirst, 1991, loc. cit.

211 One day when he was high up in the mountains . . .: Condivi/Bull, pp. 24–5.

211 Another decade later, now verging on ninety . . .: Elam 1998, pp. 492–3.

212 the character of Julius II was less than saintly . . .: See Shaw, passim.

214 Servants who displeased him . . .: Ibid. p. 171.

214 St Peter's was nearly 1,200 years old and in danger of falling down . . .: See Frommel, in Millon and Lampagnani, pp. 399–423.

214 the Pope sent his architects . . .: Condivi/Bull, p. 28.

215 On 14 January 1506, on a vineyard . . .: Haskell and Penny, p. 243.

215 What followed was described many years later . . .: Casa Buonarroti, 1992, p. 21; Barkan, 1999, pp. 3–4.

215, 217 On 31 January 1506 Michelangelo wrote to his father . . .: Ramsden I, pp. 11–12, no. 6.

217 Michelangelo began to arrange a house and sculpture workshop . . .: Ibid. pp. 148–9, no. 157.

217 Frequently, Julius went to Michelangelo's house . . .: Condivi/Bull, p. 25.

217 there is a record of a payment . . .: Hirst, 1991, p. 766, Appendix B.

217 He had been paid an additional 500 ducats in January . . .: Hatfield, p. 19.

218 On 11 April, Holy Saturday, Michelangelo overheard . . .: Ramsden I, p. 13, no. 8.

218 'Most Blessed Father, I was turned out of the Palace . . .': Ramsden II, p. 230, no. 227.

218 'feeling he was in a safe place, he rested': Condivi/Bull, p. 29.

218 Tiberio Calcagni noted down a further detail . . .: Procacci, p. 289.

218 Condivi described what happened next . . .: Condivi/Bull, p. 29.

220 The Pope, Sangallo told him, was willing . . .: Ramsden I, pp. 13–14, no. 8.

220 Michelangelo's Roman banker Giovanni Balducci . . .: Cart. I, p. 15, no. IX.

221 Another, extraordinary, account arrived from a master mason . . .: Ibid. p. 16, no. X.

221n. He added a dark postscript . . .: Ramsden I, pp. 13–14, no. 8.

222 Julius put pressure on the Florentine government . . .: Vasari, 1962, vol. II, pp. 380–81.

222 A few years previously, Leonardo had produced working drawings . . .: Nicholl, pp. 353–5.

222 A Florentine merchant named Tommaso da Tolfo . . .: Cart. II, pp. 176–7, no. CDXXIV.

222 There is a hint that Michelangelo was in a highly wrought state . . .: *Anonimo magliabechiano*, ed. Frey, loc. cit.

223 'You've tried and tested the Pope . . .': Condivi/Bull, p. 30.

223 The first time Michelangelo set out to meet the Pope . . .: The incident is related in the correspondence of Machiavelli, *Machiavelli and His Friends: Their Personal Correspondence*, eds. Atkinson, James B. and Sices, David, DeKalb, 1996, pp. 129–32.

223 On 11 November Julius was carried in triumph . . .: Shaw, pp. 161–2.

223 Ten days afterwards Cardinal Alidosi . . .: Vasari, 1962, p. 385.

223 'His disposition is such that, if spoken to kindly . . .': Ibid.

224 'I was forced to go there with a rope round my neck . . .': Ramsden I, pp. 148–9, no. 157.

224 Michelangelo still seems to have fallen short . . .: Condivi/Bull, pp. 31–2.

225 In the very first letter, sent on 19 December . . .: Ramsden I, p. 19, no. 9.

225 At the end of April 1507 . . .: Ibid. p. 33, no. 23.

225 At the end of June it was finally cast . . .: Ibid. p. 35, no. 27.

225 Unfortunately, only the bottom half of the figure . . .: Ibid. p. 36, no. 28.

225 On 10 November he was still labouring . . .: Ibid. p. 40, no. 37.

225 the statue was not installed . . . until February 1508 . . .: Ibid. p. 42, no. 40, note 1.

226 'Well, I owe as much to Pope Julius . . .': Vasari/Bull, p. 348.

226 He told Buonarroto how the Pope had come . . .: Ramsden I, pp. 21–2, no. 11.

226 This was probably the occasion when, as Michelangelo told Condivi . . .: Condivi/Bull, p. 32.

227 Shortly after the Bolognese got rid of their papal garrison . . .: Hirst, 2011, p. 83.

227 a house and workshop of his own: Palazzo Vecchio, 1990, p. 445.

227 a marvellously Polonius-like letter of advice . . .: Cart. I, pp. 9–10, no. VI. Translation by Alessandra Masolini.

228 Condivi reported some thoroughly insanitary habits . . .: Condivi/Bull, p. 70.

228 Vasari added a little more information . . .: Vasari/Bull, p. 340.

228 a drawing on the wall of the kitchen at Settignano . . .: Casa Buonarroti, 1992, pp. 220–21, cat. 12.

228 He wrote on 19 December 1506 . . .: Ramsden I, p. 19, no. 9.

228 he had found another reason for Giovansimone to stay . . .: Ibid. pp. 24–5, no. 13.

229 Then, in March, the plague broke out . . .: Ibid. pp. 28–9, no. 17.

229 'You write me that a friend of yours . . .': Ibid. pp. 32–3, no. 22.

229 On Friday 30 January he parted company . . .: Ibid. p. 21, no. 11.

229 'I have to-day received a letter of yours . . .': Ibid. pp. 24–5, no. 13.

11. VAULT

231 'On 28 November we visited the Sistine Chapel again . . .': Goethe, p. 146.

231 'When I went to the Sistine Chapel . . .': Lucian Freud in conversation with author, 2004, quoted in Gayford, p. 169.

231 Once back in Florence, in March 1508 . . .: Hatfield, pp. 65–6.

231 Then another urgent summons arrived from Rome . . .: See Shearman, pp. 24–5.

232 In the spring of 1504 the fabric of the chapel . . .: For the early history of the Sistine Chapel, see Sherman, pp. 22–91; on the oracle in the ceiling, ibid. p. 32.

232 Johann Burchard, Papal Master of Ceremonies . . .: Ibid. and note 5.

232 This was the place where – with the exception of the Basilica of St Peter's . . .: See Shearman, pp. 24–50.

232 As Michelangelo later recollected, it called for 'twelve Apostles . . .': Ramsden I, pp. 148–9, no. 157.

233 'I, Michelangelo, sculptor, have received an account . . .': Ricordi, pp. 1–2, no. III.

233 'I told the Pope that if the Apostles alone were put there . . .': Ramsden I, loc. cit.

233 On 11 May, the day after the contract was signed . . .: Ricordi, p. 2, no. III.

233 '*Buon fresco*' – good, or true, fresco – was, in Vasari's opinion . . .: Vasari, 1960, p. 221.

234 By Saturday 10 June the senior Papal Master of Ceremonies . . .: Seymour, 1972, p. 104, no. 5.

234 The workmen were probably making a lot of dust . . .: Mancinelli, 1986, pp. 221–3; Seymour, 1972, loc. cit.

235 He paid for more marble on 6 July . . .: Hatfield, pp. 22–3.

236 There were in fact two potential themes . . .: See Evans et al., pp. 21–5.

236n. These have been many . . .: For interpretations of the ceiling, see O'Malley; for Paul III's appointment of a cleaner, see Mancinelli, 1997, p. 172.

238 Julius agreed, though naturally he and other theologians . . .: On the theological aspects of the ceiling, see O'Malley.

238 The question of Michelangelo's assistants . . .: See Mancinelli, 1999; and Wallace, 'Michelangelo's Assistants', 1987, pp. 203–16.

239 As Michelangelo told Condivi: 'after he had started . . .': Condivi/Bull, p. 37.

239 Vasari told much the same story . . .: Vasari/Bull, p. 352.

239 At the beginning of October, there were signs of strain . . .: His complaint can be deduced from his father's reply, Cart. I, pp. 85–6, no. LX.

239 By the end of January 1509 Michelangelo . . .: Ramsden I, pp. 48–9, no. 45.

239 'Thinking that this excuse . . .': Condivi/Bull, loc. cit.

239n. Raphael also had difficulties with his plaster . . .: See Nesselrath, Arnold, in National Gallery, 2004, p. 285.

240 The restorers in 1980–89 discovered . . .: See Mancinelli, 1999, pp. 52–4.

240 This fits well with a story Vasari related . . .: Vasari/Bull, p. 351.

240 Technical evidence from *The Flood* . . .: Mancinelli, 1999, pp. 52–4.

240–41 The only problem – as Rab Hatfield...has pointed out...: Hatfield, pp. 23–30.

241 By June or July 1509 Michelangelo's mood...: Ramsden I, p. 49, no. 46.

241 At this time Lodovico Buonarroti was in a state of panic: Cart. I, p. 87, no. LXI.

241 From Rome, Michelangelo reassured him...: Ramsden I, pp. 48–9, no. 45; p. 50, no. 47.

241–2 In July 1508 he had been in contact with one junior assistant...: See Cart. I, p. 73, no. LI.

242 A glimpse of the household was given in a letter sent by Michi...: Ibid. p. 110, no. LXXVIII.

242 The amount left in Michelangelo's Roman bank account...: Hatfield, pp. 25, 28.

242 The response was exasperation...: Ramsden I, p. 54, no. 51.

242–3 Michelangelo wrote a caudate sonnet...: It is No. 5. See Michelangelo/ Saslow, pp. 70–72, for commentary.

243 'I've got a goitre from this job...': Michelangelo/Mortimer, pp. 3–4.

243n. '*Giovanni, a quell propio [sic] da Pistoia*'...: On Giovanni da Pistoia, see Reggioli, Cristina, in *Dizionario Biografico degli Italiani*, accessed online at http://www.treccani.it/enciclopedia/giovanni-da-pistoia_(Dizionario-Biografico)/

245 Michelangelo's letters were 'disappointing': Pope-Hennessy, 1968, p. 110.

245 The most extraordinary missive from these years...: Ramsden I, p. 52, no. 49.

245 Alone among the other Buonarroti...: On Giovansimone, see Ristori, Renzo, '*Introduzione*', Cart. In. I, pp. xxxviii–xliii.

246 There was a further explosion...: For an account of this dispute, see Hatfield, pp. 41–3.

246 Buonarroto wrote to tell him what had happened...: Cart. In. I, pp. 25–7, nos. 13 and 14.

246 Theoretically, a Florentine family was bound together...: On Florentine male familial bonding, see Kent, 1977, pp. 44–8.

246 According to a proverb, 'the pear...': Ibid. p. 46.

247 As the Florentine philosopher Marsilio Ficino put it...: Ibid.

247 In the spring of 1508, in the brief interval...: Ramsden I, p. lx, the date was 13 March 1508.

247 Otherwise, under Florentine law derived from Roman practice...: For the significance of emancipation, see Kuehn, pp. 10–12 and 42.

247 A few days before his emancipation he withdrew 750 florins...: Hatfield, p. 41.

247 Ideally, according to treatises such as Alberti's...: Kent, 1977, p. 44.

248 The Pope took a close interest in the work...: Condivi/Bull, p. 37.

248 He made up his mind on 1 September 1510...: Shaw, p. 261.

249 In his efforts to make the papacy a stable and dominant power...: On Julius's political manoeuvres, see ibid. pp. 245–78

249 'Those French have taken away my appetite and I don't sleep . . .': Quoted in ibid. p. 259.

249 The Pope, he wrote to his father, 'has gone away . . .': Ramsden I, p. 55, no. 53.

12. INCARNATION

251 'Of course, as most of my figures . . .': Sylvester, p. 114.

251 By the time Michelangelo caught up with Julius . . .: Shaw, p. 262.

251 On 25 October it was paid to him in Rome: Ramsden I, pp. 57–8, nos. 55 and 56.

251 He must have a second tranche of his fee . . .: Ibid.

251 He had taken to his bed with fever: Shaw, pp. 267–8.

252 On 2 January 1511, barely recovered, Julius departed . . .: Ibid. pp. 269–70.

252 The Florentine historian and statesman Francesco Guicciardini . . .: Quoted in ibid. p. 270.

252n. Ferrara was typical of the cat's cradle . . .: Shaw, pp. 259–61, and passim.

253 Writing a decade later, he considered these months as lost: Ramsden I, pp. 148–9, no. 157.

253 'It's God's will that the Duke of Ferrara should be punished . . .: Shaw, p. 259.

253 in a dispute over who was responsible for this disaster . . .: On the loss of Bologna and murder of Cardinal Alidosi, see ibid. pp. 271–7.

253 In his diary for 14 August . . . Paris de Grassis . . .: Quoted in Seymour, 1972, p. 108, no. 15.

253 Four days later, the Pope fell ill again with fever . . .: Shaw, pp. 286–7.

253 During this time, Michelangelo later wrote . . .: Ramsden I, pp. 148–9, no. 157.

254 an attack on the martial policies of his patron: Michelangelo/Saslow, pp. 78–9, no. 10.

254 Even Lorenzo de' Medici . . .: Roscoe, loc. cit.

255 Another poem by Michelangelo . . .: Michelangelo/Saslow, pp. 73–4, no. 6.

255 In October 1511 Julius appointed him . . .: National Gallery, 2004, p. 305.

255–6 'One day the Pope asked . . .': Condivi/Bull, p. 38.

256 On 16 August 1511, just after the first part of the Sistine Chapel . . .: Shearman, 2003, p. 148.

256 He was a lover of the good life . . .: Vasari/de Vere, vol. I, p. 737.

256 On 21 April 1508 . . . Raphael had written to his uncle . . .: National Gallery, 2004, p. 305.

257 The first frescoes he finished . . .: See Nesselrath, Arnold, in National Gallery, 2004, pp. 281–92.

257 In a desperate, angry moment . . .: Ramsden II, p. 31, no. 227.

258 Raphael painted gentlemen . . .: Lodovico Dolce gave the opinion to Aretino, Dolce, p. 258.

258 According to Vasari, he told Perugino in public . . .: Vasari/de Vere, vol. I, p. 593.

259 Taddei liked always to have Raphael 'in his house . . .': Vasari/Bull, p. 287.

259 When he was in Rome early in 1506 . . .: Ramsden I, pp. 11–12, no. 6.

259–60 when Raphael saw the 'new and marvellous style' of the ceiling . . .: Condivi/Bull, p. 37.

259n. Raphael certainly used the Christ Child in the *Bruges Madonna* . . .: See National Gallery, 2004, pp. 182, 186, 188, 196 and 214.

261 While Michelangelo was absent from Rome, Vasari related . . .: Vasari/Bull, p. 297.

261 One figure in Raphael's fresco of *School of Athens* . . .: Nesselrath, Arnold, in National Gallery, 2004, p. 284.

261 The scholar James Elkins has established . . .: Elkins, pp. 176–86.

262 There are perhaps five hundred drawings by Michelangelo . . .: On the history of the connoisseurship of Michelangelo drawings, see Bambach, 2010, pp. 42–8, 100–108.

262 Long before that, in 1518, Michelangelo had ordered . . .: The bonfire was reported by Leonardo Sellaio, Cart. I, p. 318, no. CCLV.

264 On 1 October he paid Michelangelo 400 ducats . . .: Ramsden I, pp. 62–3, no. 63.

267 'captives of ancient ignorance . . .': Joost-Gaugier, p. 21.

267 In the minds of Julius and those around him . . .: See Stinger, pp. 235–91.

267 In these decades, from the 1490s to the 1520s, preachers . . .: See O'Malley.

267n. 'to show the vast scope of his art. . .': Condivi/Bull, p. 63.

268 Michelangelo felt he was acting like God . . .: Michelangelo/Saslow, p. 77, no 9.

268 On the same sheet of paper as the little poem about God's creation . . .: Ibid. pp. 75–6, nos. 7 and 8.

268n. Only a decade later, the Dutch pope, Adrian VI . . .: Vasari/Bull, p. 355.

270 Jonah, Vasari felt, felled everyone . . .: Ibid. p. 360.

270 one female figure: the soul . . . of the still uncreated Eve: See Steinberg, 1992, passim.

270n. It is not surprising that this composition fixed itself . . .: Michelangelo/Saslow, loc. cit.

272 The panel of *The Separation of Light from Darkness* . . .: Hall, p. 114.

272 In April 1512 the army of the French King . . .: Shaw, pp. 294–6.

272n. Not long afterwards, in mid-July, Alfonso d'Este . . .: On Alfonso d'Este's visit to the Sistine ceiling, see Luzio, pp. 540–41.

273 Early in August the Holy League . . .: Cartwright, vol. II, pp. 64ff.

273 His advice was to get away as quickly as possible . . .: Ramsden I, p. 71, no. 80.

273 Prato fell after twenty-four hours . . .: On the victims of Prato, see Stephens, p. 58, note 3.

274 On 1 September Giuliano de' Medici entered the city . . .: Villari, vol. II p. 19.

274 As soon as he heard, Michelangelo wrote to Buonarroto . . .: Ramsden I, p. 74, no. 81.

274 Lodovico Buonarroto wrote back with chilling news: His letter does not survive. For Michelangelo's reply, see Ramsden I, pp. 81–2, no. 85, and Cart. I, p. 139, no. CVI.

274 'I work harder than anyone who has ever lived . . .': Ramsden I, p. 70, no. 77.

274n. Estimates of the casualties varied . . .: Roth, p. 2; Hale, 1977, p. 94.

275 On 21 August he thought – as usual, optimistically . . .: Ibid. p. 71, no. 79.

275 'I shall soon be home . . .': Ibid. p. 74, no. 81.

275 'I lead a miserable existence . . .': Ibid. p. 74, no. 82.

275 In early October he told his father . . .: Ibid. p. 75, no. 83.

275 'other things have not turned out for me . . .': Ibid.

275 'Today is the first day our Chapel was opened . . .': Ramsden I, p. 76, note 2.

275 Julius lived just long enough to see the completed ceiling: Shaw, pp. 311–13.

13. ROMAN RIVALRY

277 'No piece of statuary has ever . . .': Freud, p. 124.

277 From his sickbed, on 4 February 1513 . . .: Hirst, 2011, pp. 111 and 304, note 2.

277 Over two weeks before, on 18 January, The balance of 2,000 ducats . . .: Hatfield, p. 30.

278 the design finally agreed by Michelangelo and the Pope's heirs . . .: For the second tomb contract, see Hatfield, p. 31, Pope-Hennessy, 1970, p. 315, and Hirst, 2011, pp. 112–15.

278 Michelangelo moved to larger premises . . .: Hatfield, pp. 98–100, and Ricordi, pp. 59–61.

279 'a house of several storeys . . .': Described in the tomb contract of 1516, quoted in Ramsden II, p. xxiv.

279 Cardinal della Rovere had called him a 'swindler': Cart. III, p. 7, no. DXCIV. The word is 'ciurmadore': rascal, scoundrel, trickster.

279 'Within three weeks of signing the contract for the tomb . . .': See Hatfield, p. 35, for the payment on 22 May and Vari's relations with the bank.

280 On 18 February, just before Julius died . . .: Unger, pp. 203–5.

280 they were consoled by another friend, Luca della Robbia . . .: Trexler, 1980, pp. 198ff.

281 Three weeks later the political hierarchy of Italy was transformed . . .: Baumgartner, pp. 92–3.

281 When the news of Leo's election was heard in Florence . . .: Landucci, 1927, p. 267.

281 On II April Leo X processed through Rome . . .: Roscoe, 1846, Vol. I, pp. 355–8.

283 Machiavelli, hoping in vain to be forgiven . . .: Machiavelli, 1975, pp. 134–5.

283 The new Pope's favourite arts . . .: See Adalbert Roth, 'Leo X and Music' in Evans et al., 2010, pp. 15–18.

283 his old bête noire, Leonardo da Vinci . . .: Nicholl, p. 460 ff.

284 In the summer of 1513, it was reported . . .: Luschino, pp. lxxxix–xciii, translated in Papini, pp. 176–7.

284 a fanatical adherent of Savonarola's, Fra Benedetto Luschino . . .: On Luschino, see Ragagi, Simone, in *Dizionario Biografico degli Italiani*, vol. 66(2007), accessed online at http://www.treccani.it/enciclopedia/benedetto-luschino_(Dizionario_ Biografico)/

285 'running after friars and fictions . . .': Ramsden I, pp. 96–7, no. 107.

285 Such prophesying was a recurrent problem for the Medici . . .: On the Medici regime's crackdown on prophesying, see Polizzotto, p. 284, and passim.

285 We get a snapshot of Michelangelo's daily life . . .: Ramsden I, p. 113, no. 124. On the dating of the encounter, see Henry, p. 265.

286 'Doubt not but that Angels . . .': Quoted in ibid. p. 264.

287 Over the next three years, work proceeded quietly . . .: Hirst, 2011, pp. 111–15, Pope-Hennessy, 1970, pp. 315–17.

288 In November Michelangelo asked his father . . .: Ramsden I, p. 82, no. 86, dated 1513 in Cart. I, p. 145, no. CX.

288 'I should not have been more annoyed . . .': Ibid. p. 85, no. 90, dated 1514 in Cart. I, p. 151, no. CXV.

288 'his life was in the balance . . .': Ibid.

289 The same year, 1514, Michelangelo sent for . . .: Ibid. p. 84, no. 89, dated 5 January 1515 in Cart. I, p. 154, no. CXVII.

289 'That scoundrel Bernardino' . . .: Ibid. p.103, no. 101.

289 Michelangelo broke with Jacopo Torni . . .: Vasari/de Vere, vol. I, p. 608.

289 As the art historian Fabrizio Mancinelli . . .: Mancinelli, 1999, p. 50.

291 As an example of what Michelangelo 'would have achieved' . . .: Condivi/Bull, p. 26.

291 In the fifteenth and early sixteenth centuries Moses . . .: For the contemporary Roman view of Moses, see Stinger, pp. 209–18.

293 Around the time that he sent for the apprentice . . .: Ramsden I, p. 85, no. 90.

293 He continued with this demand for two decades . . .: Hatfield, p. 100.

293 In a letter to his uncle in Urbino dated 1 July 1514 . . .: Quoted in Talvacchia, p. 142.

294 In contrast, Raphael was an inspired collaborator: Ibid. pp. 186–204.

294 In 1519, at the height of Raphael's power . . .: Ibid. p. 194.

295 Michelangelo was now approaching forty . . .: On the point at which sixteenth-century people considered themselves old, see Gilbert, 1967.

295 Gellesi touchingly declared that . . .: Cart. I, p. 162, no. CXXIV.

295–6 'I wish to see you emperor of the world' . . .: Quoted in Goffen, p. 259.

296 Sebastiano had arrived in Rome on 21 August 1511 . . .: Gemäldegalerie, 2008, p. 120.

296 Sebastiano had been invited to come to Rome . . .: Ibid.

296 It was a *Pietà* ordered by a cleric named Giovanni Botonti . . .: Ibid. pp. 162–4.

296 Vasari succinctly described its rationale . . .: Vasari/de Vere, pp. 140–43.

298 He took Sebastiano 'under his protection . . .': Ibid. p. 142.

298–9 Leo decided to make his own, characteristic contribution . . .: Evans et al., p. 18.

299 On 16 June 1515 he wrote to Buonarroto . . .: Ramsden I, p. 90, no. 97.

299 Now he told Buonarroto, in the three months since his visit . . .: Ibid. 94, no. 103.

299n. This was done to test a theory . . .: Goffen, p. 228.

299 he intended to 'make one great effort . . .':Ramsden I, p. 94, n. 103.

300 he had 'incurred heavy expenses . . .': Ibid.

300 the façade for a private chapel that was being built in the Castel Sant' Angelo . . .: Zöllner et al., p. 470.

301 In the middle of 1515 Leo was pondering a dramatic demonstration . . .: See Clough, pp. 81–2.

301 Instead, on 29 June in St Peter's . . .: Ibid. p. 81.

301 On 30 November Leo X made a triumphant entry into Florence . . .: For Leo's *entrata*, see Boucher, vol. I, pp. 22–3, and Shearman, 1975.

301n. Michelangelo was sent a long account of the entry . . .: Cart. I, pp. 184–5, no. CXLIV.

302 According to Vasari, when Leo saw the temporary façade . . .: Vasari/de Vere, vol. II, p. 809.

302 Leo was en route to an appointment in Bologna: Clough, pp. 83–4.

303 On 13 October Cardinal Giulio de' Medici wrote . . .: Ibid.

14. MARBLE MOUNTAINS

305 'I shit blood in my works!': Quoted in Clements, p. 301.

305 In March the Dowager Duchess of Urbino . . .: Clough, p. 86.

306 Events moved on quickly: Ibid. pp. 86–9.

306 Cardinal della Rovere wrote a letter . . .: Cart. I, p. 186, no. CXLV.

306 According to the new contract . . .: Pope-Hennessy, 1968, p. 317.

306–7 A week later, on 15 July, Argentina . . .: Cart. In., p. 51., no. 33. Soderini's letter is Cart. I, p. 188, no. CXLVII.

307 The first, dated 9 August, was from Leonardo Sellaio . . .: Cart. I, p. 190, no. CXLVIII.

307 Giovanni Gellesi, wrote that he was pleased . . .: Ibid. p. 191, no. CXLIX.

307 One explanation for this nervous crisis . . .: Baldriga, p. 740, and Pope-Hennessy, 1968, p. 325.

307 His assistant Silvio Falcone . . .: Cart. I, p. 311, no. CCL.

308 After excommunicating him, Leo and his nephew Lorenzo . . .: Clough, pp. 90–91.

308 San Lorenzo had been left without a grand frontage . . .: On the San Lorenzo project, see Ackerman, pp. 53–70, Wallace, *Michelangelo*, 1994, pp. 9–74, and Millon and Lampugnani, pp. 565–72.

309 'one sees someone rising from the lowest depth . . .': Vasari/de Vere, vol. II, pp. 54–5.

309 the first section had been unveiled on St John's Day . . .: Millon and Lampugnani, p. 593.

309 On 7 October Domenico Buoninsegni wrote to Baccio . . .: Cart. In., p. 54., no. 35.

309 Buoninsegni summoned Baccio and Michelangelo . . .: Cart. I, pp. 204–5, no. CLXII.

310 By 21 November Buoninsegni was furious . . .: Ibid. pp. 219–21, no. CLXXIII.

310 Leonardo Sellaio sent a warning . . .: Ibid. p. 222, no. CLXXIV.

310 Finally, in mid-December, Michelangelo rode to Rome . . .: Ricordi, p. 102, no. XCIX.

311 'I came to Florence to see the model . . .': Ramsden I, p.104, no. 114.

311 Like a large number of the stone-workers . . .: Condivi/Bull, p. 173.

311 Cardinal de' Medici wanted an altarpiece . . .: On the commission, see Gemälde-galerie, 2008, pp. 178–80.

312 Raphael 'was turning the world upside down': Ibid. p. 178, and Cart. I, p. 243, no. CXCIII.

312 a matter that was close to his heart and the Pope's: Cart. I, p. 244, no. CXCIV.

312 Cardinal de' Medici also sent a list . . .: Ibid. pp. 245–7, no. CXCV.

312 Illegitimate and orphaned . . .: On Giulio de' Medici's character, see Price Zim-mermann, 2005, pp. 19–27, especially note 25 for a summary of contemporary opinion.

313 When Leo's beloved pet elephant, Hanno . . .: Lowe, 1993, p. 96.

313 'whenever Buonarroti comes to see me . . .': Ramsden I, p. xliv.

313 what one scholar has called a 'crash-course' . . .: Christof Thoenes, quoted in Zöllner, p. 220.

313 incisive analyses in Michelangelo's hand . . .: See Chapman, Hugo, in British Museum, 2005, pp. 155–6.

315 On 2 May he wrote to Buoninsegni with buoyant assurance . . .: Ramsden I, p. 105, no. 116.

315 These terms, high-handed as they were . . .: Cart. I, pp. 280–81, no. CCXXIII.

315 Michelangelo had explained rather airily . . .: Ramsden I, p. 105, no. 116.

316 At Florence during the Easter celebrations . . .: Cart. I, pp. 274–5, no. CCXIX.

316 On 30 June Sansovino sent Michelangelo a furious letter . . .: Ibid. p. 291, no. CCXXXI (translation in Bull, p. 138).

316 della Rovere had not taken his ejection meekly . . .: Clough, pp. 90–91.

316–17 In April Leo discovered . . .: For the Petrucci conspiracy, see Lowe, 1993, pp. 104ff.

317 the bit-players Nini and the doctor Vercelli . . .: Lowe, 1994, p. 196.

318 the foundations for the structure were constructed . . .: Cart. I, p. 292, no. CCXXII.

318 Michelangelo intended to return to Florence in August . . .: Ramsden I, p. 107, no. 114, and Ricordi, pp. 100–101, no. XCVII.

318 On 31 October 1517 in distant Saxony: Aland, p. 62.

318 He showed it to the Pope and cardinal on 29 December . . .: Cart. I, p. 315, no. CCLIII.

319 Over a year after the first oral agreement . . .: Milanesi, pp. 671–2.

319 The most daunting aspect of the whole enterprise . . .: On the difficulties of marble quarrying and transportation on this scale, see Wallace, *Michelangelo*, 1994, pp. 43–4.

319 'like the moon reflected in a well': Wallace, *Michelangelo*, 1994, p. 20, and Cart. II, p. 6, no. CCLXXXIV.

319 To obtain it, it was necessary . . .: Ibid. pp. 38–61.

320 On 13 March 1518 Buoninsegni sent Michelangelo . . .: Cart. I, p. 324, no. CCLX.

320 This was followed up by another from Cardinal de' Medici . . .: Ibid. p. 332, no. CCLXVI.

321 William Wallace has calculated . . .: Wallace, *Michelangelo*, 1994, p. 26.

322 On the back of a dry business communication . . .': For a lively discussion of this strange sheet, see Barkan, 2011, pp. 81–5.

322 By 2 April he was already in a state of impatience: Ramsden I, p. 109, no. 120.

324 A fortnight later he was so agitated . . .: Ibid. p. 112, no. 123.

325 The young Duke was wedding a French princess . . .: Pedretti, p. 174.

325 As a gift to the French King, Francis I . . .: Talvacchia, p. 134.

325 'I shall not tell you anything else . . .': Cart. II, p. 32, no. CCCIV (translation in Goffen, p. 250).

326 By mid-May 1518 Michelangelo was . . . at Seravezza . . .: Ramsden I, p. 108, no. 119.

326–7 Some idea of the intractability of what he was undertaking . . .: Cart. II, p. 82, no. CCCXLIII, and Ramsden I, pp. 117–18, no. 129.

327 Jacopo Salviati wrote a letter exhorting . . .: Cart. II, p. 84, no. CCCXLIV.

327 'It seems to me that you must value your person . . .': Ibid. p. 85, no. CCCXLV.

327 In July 1518 he bought a piece of land . . .: Wallace, *Michelangelo*, 1994, pp. 64–5.

327 'If the Pope is issuing Bulls . . .': Ramsden I, p. 114, no. 125.

328 The cardinal replied to the letter at once . . .: Cart. II, p. 37, no. CCCVIII.

328 'I have I think written you very many letters . . .': Ibid. p. 178, no. CDXXV (translation in Pope-Hennessy, 1968, p. 326).

328 Soderini had commissioned a reliquary . . .: Ibid. p. 20, no. CCXCIV.

328 Goro Gheri, a devoted Medici adherent . . .: Lowe, 1993, p. 99.

328 The faithful Leonardo Sellaio . . . : Cart. II, p. 106, no. CCCLXIII, p. 111, no. CCCLXVII, p. 115, no. CCCLXX.

328 It seemed 'uno gran' maestro' . . .': Cart. II, p. 127, no. CCCLXXX. For the unmasking of Sansovino, see ibid. p. 146, no. CCCXCVI.

329 In November Cardinal della Rovere showed Sellaio two letters . . .: Ibid. p. 106, no. CCCLXIII.

329 Towards the end of December . . .: Ramsden I, p. 121, no. 134.

330 'Things have gone very badly . . .': ibid. p. 124, no. 139.

330 A fortnight later, on 4 May . . .: See Clough, p. 91.

330 A little after Lorenzo's death the first loads of marble . . .': See Wallace, Michelangelo, 1994, p. 57.

330 As Michelangelo noted in a dry summary of his expenses . . .: Ramsden I, pp. 128–31, no. 144.

331 'There's no hurt that's equal to time lost': Michelangelo/Saslow, pp. 155–7, no. 51.

15. TOMBS

333 'In such great slavery . . .': Michelangelo/Mortimer, p. 61, no. 282.

333 'One day in the church of Santa Maria sopra Minerva . . .': Delbeke, p. 126.

333 The agent of Alfonso d'Este visited Raphael's house on 21 March . . .: Talvacchia, p. 222. On the death of Raphael, see Vasari/Bull, p. 321.

333 'a miraculous thing . . .': Cart. II, p. 100, no. CCCLVIII (translation in Goffen, p. 251).

334 'an offensive thing to a great patron . . .': Ibid. p. 138, no. CCCLXXXIX (translation in Goffen, p. 251).

334 now sent his agent incessantly to importune the painter . . .: See Shearman, 2003, passim.

334 Raphael offered him the cartoon of the St Michael . . .: Talvacchia, p. 134.

334 On one occasion, when he called at Raphael's house . . .: See Shearman, 2003, pp. 478–9.

334 The Venetian patrician Marcantonio Michiel . . .: Gemäldegalerie, 2008, p. 178.

336 Leonardo da Vinci had apparently helped Giovanni Francesco Rustici . . .: Vasari/de Vere, vol. II, p. 519.

336 he planned to depict only the Transfiguration itself . . .: Talvacchia, p. 222.

336 'the sight of this living work of art . . .': Vasari/Bull, p. 321.

338 'plunged in the most profound and universal grief . . .': Cartwright, vol. II, p. 169.

338 According to a contemporary report, one hundred painters . . .: Talvacchia, p. 222.

338 'I think you have heard how that poor Raphael . . .': Cart. II, p. 227, no. CDLXII (translation in Goffen, p. 255).

338 This had been commissioned from Raphael in 1519 . . .: Talvacchia, p. 208.

339 'Yesterday we heard from Florence . . .': Cartwright, vol. II, p. 169.

339 'Monsignor – I beg Your Reverend Lordship . . .': Ramsden I, p. 135, no. 145.

339 When this strange missive arrived . . .: Cart. II, p. 233, no. CDLXVII (translation in Goffen, p. 258).

339 Sebastiano then came up with another idea . . .: Ibid. pp. 239–41, no. CDLXX.

340 a glimpse of what Leo X really thought . . .: Ibid. pp. 246–7, no. CDLXXIV (translation in Goffen, pp. 259–60).

340 When Michelangelo heard this . . .: Ibid. pp. 255–6, no. CDLXXIX (translation in Goffen, p. 261).

341 One day in June 1519, the month after Lorenzo's death . . .: For Figiovanni's interview with Cardinal de'Medici, see Corti.

341 Michelangelo was appointed *capomaestro* . . .: Wallace, *Michelangelo*, 1994, p. 22.

341 Michelangelo was now settling into his new headquarters . . .: Ibid. pp. 66–7.

342 The marble for the second attempt . . .: See Ramsden I, p. 121, no. 134.

342 in January 1520 Vari was told the good news . . .: Cart. II, p. 208, no. CDXLIX.

342 There followed, however, a lengthy stand-off . . .: For a summary of this process, see Pope-Hennessy, p. 326.

342 'Treat my assistant, Pietro . . .': Ramsden I, pp. 109–10, no. 120.

342 Vasari wrote that Pietro was talented . . .: Vasari/Bull, p. 421.

342–3 Between 29 August and 5 September 1519 . . .: Ricordi, pp. 88–9, and Ramsden I, p. 127, no. 142.

343 Early in 1521 Michelangelo banished him . . .: Ramsden I, pp. 139–40, no. 149, dated second half of February or early March in Cart. II, pp. 274–5, no. CDXCIV.

343 He arrived at the end of March 1521 . . .: Pope-Hennessy, loc. cit.

343 Even then Pietro had great trouble in unloading . . .: Cart. II, p. 305, no. DXXI (translation in Pope-Hennessy, loc. cit.).

343 announced he would finish on 15 August . . .: Ibid. p. 309, no. DXXV.

343 on 14 August the tiresome Metello Vari . . .: Ibid. p. 310–11, no. DXXVI.

343–4 'I must let you know that all he has worked on . . .': Ibid. pp. 313–15, no. DXXVIII (translation in Bull, 1995, p. 153).

344 The figure, he assured Michelangelo . . .: Ibid. pp. 310–11, no. DXLVIII (translation in Pope-Hennessy, 1970, p. 327).

344 Michelangelo himself seems to have felt guilty . . .: Cart. II, pp. 336–7, no. DXLV.

344 'Pietro shows a very ugly and malignant spirit . . .': Ibid. pp. 313–15 (translation in Symonds, p. 232).

346 compared by John Pope-Hennessy to the Wagnerian duo . . .: Quoted in Hibbard, p. 171.

346 Cardinal Soderini hurried back from exile . . .: Lowe, 1993, pp. 121ff.

348 the conclave that opened on 27 December . . .: Baumgartner, pp. 95ff.

348 a 'to rent' sign on the Vatican . . .: Reiss, p. 344.

348 It was weeks before the new Pope . . .: Ibid. p. 345.

349 Condivi described Michelangelo's physical constitution . . .: Condivi/Bull, p. 72.

349 'at least as little as you can': Calcagni/Elam, p. 494.

349 On 14 December Sellaio ended a letter of news . . .: Cart. II, pp. 336–7, no. DXLV (translation in Bull, p. 156).

349 Rocke paraphrased the letter . . .: Rocke, pp. 151–2.

349–50 On 4 January Sellaio expressed relief at Michelangelo . . .: Cart. II, p. 338, no. DXLVI (translation in Bull, p. 156).

350 Benvenuto Cellini recalled a memory . . .: Cellini, p. 64.

350 Piloto made a ball with seventy-two facets . . .: Vasari/Bull, p. 365. On Piloto's end, see Vasari/de Vere, p. 443.

351 the kind of person the character Michelangelo refers to so strikingly . . .: Giannotti, loc. cit.

351 Ominously for Michelangelo, by the late spring of 1522 . . .: Clough, p. 99.

351 This in turn infuriated some hotheads . . .: On the plot of 1522, see Villari, pp. 332–3.

352 He agreed with Tacitus that men 'have to respect the past . . .': Machiavelli, 2003, p. 399.

352 His initial idea for the tomb in the new Medici chapel . . .: Chapman, Hugo, in British Museum, 2005, p. 168.

352 The basic design of at least the two tombs of the younger Medici . . .: Wallace, 1994, p. 83.

352–3 The real design problem, however, lay in the third tomb . . .: On the problem of the third tomb, see Morrogh.

353 Benvenuto Cellini described an occasion, years later . . .: Cellini, 1956, p. 89.

355 The following spring a *motu proprio* . . .: Ramsden I, pp. 142–3, no. 152, and p. 255.

355 a little more than the total value of Michelangelo's property portfolio: Hatfield, p. 92.

355–6 Aretino had bequeathed Cardinal Santi Quattro . . .: Lach, vol. II, p. 139.

356 it was Santi Quattro who had suggested to Leo X . . .: Stinger, p. 136.

356 'Never to this day, since the day . . .': Ramsden I, pp. 137–40, no. 149, dated second half of February or early March in Cart. II, pp. 274–5, no. CDXCIV.

357 Perhaps because Lodovico Buonarroti . . .: For Michelangelo's appropriation of the property at Settignano, see Hatfield, pp. 87–96.

357 'If my existence is a cause of annoyance to you . . .': Ramsden I, pp. 144–5, no. 154.

357 In the aftermath of this falling-out . . .: Hatfield, pp. 67–8.

357 At the beginning of August Lodovico's brother-in-law . . .: Cart. In. I, p. 200, no. 117, and p. 201, no. 118.

358 'He never let me try on the doublet . . .': Ramsden I, pp. 140–41, no. 150.

358 to be at the millstones . . .: Ibid. p. 141, note 4.

358 'I'm old and unfit . . .': Ibid. pp. 145–6, no. 155.

358 He added a new member to his household . . .: Wallace, *Michelangelo*, 1994, p. 87.

358 Perini was, as Vasari put it, 'a Florentine gentleman' . . .: Vasari/Bull, p. 424.

358 On 31 January 1522 Perini sent . . .: Cart. II, p. 342, no. DL.

358 To this, Michelangelo sent a reply . . .: Ramsden I, p. 141, no. 151.

358 Vasari related how Michelangelo gave him drawings . . .: Vasari/Bull, loc. cit.

359 'The soul tries a thousand remedies in vain . . .': Michelangelo/Saslow, p. 88, no. 18.

16. NEW FANTASIES

361 'All artists are under a great and permanent obligation . . .': Vasari/Bull, p. 366.

361 He was reported to have described the *Laocoön* . . .: Reiss, p. 347.

361 the Pope intended to remove Michelangelo's frescoes . . .: Ibid. p. 340.

361 The conclave to choose his successor . . .: Baumgartner, pp. 101ff.

362 Michelangelo, writing to a stone-cutter . . .: Ramsden I, p. 146, no. 156.

362 Early in 1524 intensive work started . . .: Wallace, *Michelangelo*, 1994, pp. 87–93.

362 William Wallace has calculated . . .: Ibid. pp. 98–9.

364 At Settignano, Michelangelo was by now . . .: Hatfield, pp. 61–96.

364 The masons and assistants were often identified . . .: Wallace, *Michelangelo*, 1994, pp. 101–2.

364 Andrea Sansovino, his old rival . . .: Cart. III, p. 38, no. DCXVI.

365 Michelangelo made a full-scale wooden model . . .: Wallace, *Michelangelo*, 1994, p. 88.

365 Michelangelo's obsessiveness can be seen in his voluminous *ricordi* . . .: Ibid. pp. 88–90.

365 he had listed 104 names by June 1525: Ibid. p. 106.

365 We can imagine his movements . . .: Ramsden I, p. 155, no. 164.

365n. In the 1970s an extraordinary series . . .: See Elam, 1981.

366 Michelangelo spent seven months of 1524 . . .: Wallace, 1994, p. 92.

366 He had devised a design as complex . . .: For a recent discussion of the tomb designs, see Chapman, Hugo, in British Museum, 2010, pp. 168–85.

366 In a long grumble written on 26 January 1524 . . .: Ramsden I, pp. 153–4, no. 161.

368 Vasari . . . didn't know quite what to make of them: Vasari/Bull, p. 366.

369 The breakthrough has been pinpointed . . .: Elam, 2005, pp. 207–11.

369–70 At the beginning of 1525 Michelangelo wrote a letter directly to Clement: Ramsden I, p. 151, no. 160, dated January or early February 1525 in Cart. III, p. 131, no. DCLXXXVII.

370 On 23 December 1525 Clement . . .: Cart. III, p. 194, no. DCCXXXII (translation in Wallace, 2005, p. 196).

370 Francesco Vettori, noted that . . .: Price Zimmerman, 2005, p. 22.

370 'investigating the secrets of craftsmen . . .': Ibid. p. 21.

371 Francesco Guicciardini, who served Clement . . .: Ibid. p. 19.

371 Nor was Clement's erudite connoisseurship confined . . .: See Sherr, p. 233.

372 Clement had written to Francesco Sforza . . .: Setton, p. 226.

372 a commander of the Venetian armed forces . . .: Clough, p. 99.

372 When in September 1526 Francesco Guicciardini . . .: Ibid. pp. 75 and 79.

372n. Italy, he wrote, was currently afflicted . . .: Setton p. 228.

373 while still a boy he made a snow sculpture . . .: Vasari/de Vere, vol. II, pp. 265–6.

373 In 1521 Bandinelli had proposed a funerary monument . . .: Goffen, p. 353.

373 In 1525 a colossal block of marble arrived in Florence . . .: Ibid. pp. 354–8.

374 Michelangelo's old friend Pietro Rosselli . . .: Wallace, *Michelangelo*, 1994, p. 55.

374 he sketched a group of Hercules wrestling with Antaeus . . .: British Museum, 2005, pp. 198–9.

375 A second sheet with what look like practice exercises . . .: Barkan, 2011, pp. 177–8. On the writing, see Ibid. pp. 197–9.

375 Andrea was still on friendly terms . . .: Cart. III, p. 400, no. DCCCLXV, and p. 431, no. DCCCLXXXIX.

375 Michelangelo 'hated drawing any living subject . . .': Vasari/Bull, p. 390.

377 On the sheet with doodles of owls . . .: Chapman, Hugo, in British Museum, 2010, p. 198.

377 'Alas, alas, for I have been betrayed . . .': Michelangelo/Saslow, pp. 135–6, no. 51.

377 Michelangelo left a clue: Ibid. no. 14.

377 'We, in our swift course, have led . . .': Ibid.

377 'In order to denote Time . . .': Condivi/Bull, p. 46.

378 Topolino spent long periods of time at Carrara . . .: See Wallace, *Michelangelo*, 1994, pp. 69–70.

378 Michelangelo was amused by his pretensions . . .: Vasari/Bull, pp. 429–30.

378 One wit wrote a poem suggesting that the block of marble . . .: Vasari/de Vere, vol. II, p. 276.

379 'I'll always go on working for Pope Clement . . .': Ramsden I, p. 162, no. 173.

379 'It grieves me most greatly,' he began . . .: Quoted in Goffen, p. 358.

379 In Salviati's view it was ridiculous . . .: Ibid.

380 'I replied that, although I recognized their kindness . . .: Ramsden I, pp. 162–3, no. 174.

380–81 his rage and depression had turned to sardonic humour: Ibid. pp. 164–5, no. 176.

381 'some almost Shakespearean gibberish': Wallace, 2005, p. 195.

381 'To do or not to do the things that are to be done . . .': Translated in ibid.

381 The Pope, his suggestion transformed . . .: Cart. III, p. 194, no. DCCXXXII.

381 In March 1524 Cardinal Santi Quattro . . .: For a summary of these negotiations, see Pope-Hennessy, 1968, p. 318.

382 'I don't want to go to law . . .': Ramsden I, p. 159, no. 168.

382 'little by little, sometimes one piece . . .': Ibid. pp. 162–3, no. 174.

382 'since as it is I do not live life at all . . .': Ibid. p. 159, no. 168.

382 on 2 January, Fattucci had written from Rome . . .': Cart. III, p. 17, no. DC.

383 'I have no information about it . . .': Ramsden I, p. 150, no. 159.

384 'he had never seen a more beautiful door . . .': Cart. III, p. 220, no. DCCXLVII.

384 When discussing the ceiling of the Laurentian Library . . .: Elam, 2005, p. 221.

384 Time and again he instructed Michelangelo . . .: Wallace, 2005, p. 194.

384 There was a constant flow of drawings from Florence . . .: Wallace, in eds. Gouwers and Reiss, 2005, p. 193.

384 Sebastiano thought he had perused one so frequently . . .: Cart IV, p. 17, no. CMX.

384 When Fattucci showed him the letter accompanying the design . . .: Cart III, p. 220, no. DCCXLVII.

385 Michelangelo's grandest piece of 'muscle architecture': Clark, 1956., p. 241.

386 'You have a face sweeter than boiled grape juice . . .': Michelangelo/Saslow, p. 90, no. 20.

386 Condivi passed on Michelangelo's terse explanation . . .: Condivi/Bull, ibid.

386 'gufo' – was a slang term for 'sodomite' . . .: Rocke, p. 109.

386, 388 'What can I say of the *Night* . . .': Vasari/Bull, p. 69.

388 Michelangelo's gradual loss of interest . . .: Vasari:, 1962, vol. III, p. 993.

17. REVOLT

391 'A people accustomed to live under a prince . . .': Machiavelli, 2003, p. 153.

391 The comic poet Francesco Berni . . .: Quoted by Hook, 1972, p. 19.

391 'I shall go into Italy and revenge myself . . .': Ibid. p. 36.

391–2 In September of that year Cardinal Pompeo Colonna . . .: On the Colonna raid, see ibid. pp. 93–102.

392 By the end of the year a large imperial army . . .': Ibid. pp. 116–30.

392 'a year full of atrocities . . .': Price Zimmerman, 1995, p. 80.

392–3 In November 1526 he was agitated . . .: Ramsden I, p. 166, no. 178.

393 Clement still found a moment to worry . . .: A frequent concern of Clement, for example, Cart III, p. 248, no. DCCLVVII.

393 known to swear by 'the glorious sack' of Florence . . .: Roth, p. 17.

393 Clement had appointed Cardinal Passerini to rule Florence . . .: Ibid. pp. 14–17.

393 The Mantuan agent in Florence tried . . .: Hirst, 2011, pp. 223–4, and notes 1–4, pp. 353–4.

393 On 16 April the ravening imperial army . . .: Roth, p. 19.

394 there was an insurrection in Florence . . .: Ibid. pp. 23–9.

394 One of these hit *David* . . .: Ibid. p. 29, and Vasari/de Vere, vol. II, p. 557.

394 The Duke of Urbino was in Florence . . .: Roth, p. 39.

394 Michelangelo noted that his friend Piero Gondi . . .: Ricordi, p. 228.

394 On the morning of 6 May it attacked the city . . .: Hook, 1972, p. 162.

396 Paolo Giovio covered the Pope . . .: Price Zimmermann, 1995, p. 83.

396 As one of the imperial army briskly put it . . .: Chastel, p. 91.

396 The fate of the painter Perino del Vaga . . .: Vasari/de Vere, vol. II, p.170.

396 Rosso Fiorentino, a younger painter . . .: Ibid. p. 904.

396 The Archbishop of Corfu . . .: Hook, 1972, pp. 175–6.

397 Hell, an eyewitness told the Venetian diarist Sanuto . . .: Gouwens, Kenneth, *Remembering the Renaissance: Humanist Naratives of the Sack of Rome*, Leiden, 1998, p. xvii and note 2.

397 The news reached Florence on 11 May . . .: Roth, p. 40.

397 the worst epidemic for a century . . .: For the plague of 1527, see Morrison et al.

397 In September he wrote to Buonarroto . . .: Ramsden I, p. 171, no. 182.

397 Michelangelo's *ricordi* give the impression . . .: Ricordi, loc. cit.

397 'All the houses and shops were shut . . .': Roth, p. 75.

397 Throughout the summer and early autumn of 1527 . . .: Hook, 1972, pp. 211–20.

399 The English envoy, on a mission to discuss . . .: Reynolds, 2005, p. 156.

399–400 the *Gonfaloniere*, Niccolò Capponi . . .: Roth, pp. 76–7.

400 With no false modesty, Cellini described . . .: Cellini, pp. 83–4.

401 Della Palla had started out . . .: For a summary of the career of della Palla, see Elam, 1993.

401 Francis I had professed himself an admirer . . .: See the letter from Gabriello Paccagli to Michelangelo, speaking of the King's admiration, Cart. II, pp. 151–2, no. CDI.

401n. He presented her with a portrait of Savonarola . . .: On della Palla and Marguerite of Navarre, see Elam, 1993, p. 44.

401n. The Ginori family enthusiastically assisted . . .: See ibid. pp. 58–60.

402 Buonarroto's decline and death . . .: Ricordi, pp. 239–40.

402 'Excess of pain still makes me survive . . .': Michelangelo/Saslow, pp. 126–7, no. 45.

403 On 22 August the republican authorities . . .: Hirst, 2011, p. 229.

403 According to Vasari, Michelangelo now had a look . . .: Vasari/de Vere, vol. II, pp. 279–80.

403n. It was a tussle that Michelangelo . . .: For Bandinelli's *Hercules and Cacus*, see Goffen, pp. 358–65.

404 appointing him superintendent of the fortifications . . .': Hirst, 2011, p. 226.

404 '*gratis et amorevolmente*': Wallace, '*Dal disegno allo spazio*', Michelangelo's 'Drawings for the fortifications of Florence', *Journal of the Society of Architectural Historians*, vol. 46, no. 2, 1987, p. 119.

404 On 3 October the *Gonfaloniere* . . .: Ibid.

404 The game changer in early-sixteenth-century warfare . . .: See Ackermann, pp. 124–6.

406 The surviving designs probably come from . . .: See Wallace, 1987, passim.

406 elected to the Nove della Milizia . . .: Roth, pp. 74 and 193.

406 'Envy,' an eyewitness to the politics of the republic . . .: Giambattista Busini to Vasari, quoted in Papini, p. 245.

406 On 6 April 1529 Michelangelo moved . . .: Wallace, 1987, p. 19, and Roth, pp. 186–7.

407 Capponi was discovered to have been . . .: Roth, pp. 124–9.

407 No sooner was he appointed than Michelangelo . . .: Wallace, 2001, p. 478.

408 a treaty between Pope and Emperor . . .: Hallman, p. 38.

408 When the news of the treaty arrived in Florence . . .: Roth, pp. 142ff.

408 Another senior Florentine ambassador . . .: Wallace, 2001, p. 487.

409 Alfonso d'Este (1476–1534) was an eccentric man . . .: Hollingsworth, p. 8.

409 He had married Lucrezia Borgia . . .: Ibid. pp. 1 and 11ff.

409 'the Duke received Michelangelo . . .': Condivi/Bull, p. 47.

409–410 when admiring the collection Michelangelo . . .: Vasari/Bull, p. 371.

410 'Michelangelo, you are my prisoner . . .': Condivi/Bull, p. 48.

410 He had locked up two of his brothers . . .: Hollingsworth, pp. 12, 17 and 26.

410 In July the Chancellor of the Nove della Milizia . . .: Wallace, p. 133.

410 He covered the hill of San Miniato . . .: Ackerman, p. 318.

411 In a sour irony, some of the beautiful marble . . .: Wallace, William E., 'Michelangelo's Leda: The Diplomatic Context', *Renaissance Studies*, vol. 15, no. 4, 2001, p. 490.

411 When on 12 August Charles V arrived at Genoa . . .: Roth, pp. 147–50.

411 On 14 September the imperial army . . .: Roth, pp. 166ff.

411 Michelangelo asked an officer named Mario Orsini . . .: Giambattista Busini, quoted in Papini, p. 247.

411 Michelangelo, appalled, then went to the Signoria . . .: Condivi/Bull, pp. 43–4.

412 Michelangelo's nerve abruptly snapped . . .: Ramsden I, pp. 175–6, no. 184.

412 This Corsini, according to Benedetto Varchi . . .: Quoted in Papini, p. 248.

412 He and his party tried first to leave . . .: Busini, pp. 103ff.

412 'each of them carried a number of crowns . . .': Vasari/Bull, p. 370.

412–13 The Prior of San Lorenzo, Figiovanni . . .: Corti.

413 Michelangelo's sense of dread . . .: Vasari/Bull, p. 370.

413 Michelangelo, Antonio Mini and Piloto . . .: Ricordi, pp. 262–3.

413n. The journey can be traced . . .: Ibid.

414 Michelangelo had planned to go straight on to France . . .: Ramsden, loc. cit.

414 the French ambassador to Venice, Lazare de Baïf . . .: Dorez, L., *Nouvelles recherches sur Michel-Ange et son entaurage*, Paris, 1918, pp. 211–12 (translation in Papini, p. 250).

414 Michelangelo evaded the Venetians' invitations . . .: Vasari/Bull, p. 371.

414 'when I reached Venice . . .': Ramsden, loc. cit.

414 a state of religious-cum-patriotic exultation: Cart. III, pp. 282–3 (translation in Polizzotto, p. 374).

415 On 30 September, in common with . . .: Hirst, 2011, pp. 238–9.

415 The first artillery ball was fired . . .: Roth, p. 225.

415 After Michelangelo's return, his first priority . . .: Condivi/Bull, pp. 44–5.

415 On 16 December a chance shot . . .: Roth, p. 226.

416 'And so, when the cannonballs were fired . . .': Condivi/Bull, pp. 44–5.

416 He rejoiced greatly . . .: Ibid.

416–17 Eventually, it was not bombardment that broke . . .: Roth, pp. 263–5.

417 Two early sketches can be found . . .: Wallace, p. 497, note 94.

418 At Easter the commander of Florentine forces . . .: Roth, p. 266.

418 the Florentine position was clearly unwinnable . . .: Ibid. pp. 294–321.

419 'the enemy were let in by consent': Condivi/Bull, pp. 44–5.

419 As Cecil Roth wrote, 'overwhelmed . . .': Roth, p. 321.

18. LOVE AND EXILE

421 'Let time suspend its days . . .': Michelangelo/Mortimer, p. 19, no. 72.

421 on 24 February 1530 Charles V was crowned . . .: Hallman, p. 39. For the ceremony in Bologna, see Eisenbichler.

422 Some, including the ex-*Gonfaloniere* . . .: Roth, p. 335.

422n. Marquis del Vasto, another military commander . . .: The view of d'Avalos is quoted in Price Zimmerman, 1995, p. 91.

424 'The court sent to Michelangelo's house . . .': Condivi/Bull, p. 45.

424 he was the one who had sheltered the artist . . .: Corti, p. 29.

424 On 25 August 1530 Gismondo Buonarroti . . .: Cart. In. I, p. 330, no. 219, and p. 331, no. 220.

425 'he should be left at liberty . . .': Condivi/Bull, p. 45.

425 Allegedly, Michelangelo proposed . . .: Roth, p. 97.

425 'driven more by fear than by love': Condivi/Bull, p. 45.

425 Quite when his pardon was issued is unclear . . .: Gaye, Vol. II, p. 21.

425 'to win Baccio Valori's goodwill . . .': Vasari/Bull, p. 372.

426 Art historians have found it impossible . . .: For a recent discussion, see Detroit Institute of Arts, 2002, pp. 216–17.

426 Over a year later he wrote to Michelangelo . . .: Cart. III, pp. 386–7, no. DCCCLVI (translation in Detroit Institute of Arts, 2002, pp. 216–17).

426 'Every hour seems to me a year. . .': Ibid. p. 290, no. DCCCLIII.

426 the picture had probably been planned as a gift: See Wallace, 2001.

426 Michelangelo could name his price . . .: Cart. III, p. 290, no. DCCCIII.

426–7 Michelangelo showed the Duke's emissary . . .: Condivi/Bull, p. 48.

427 In autumn 1531 Mini took it with him to France . . .: Vasari/Bull, p. 371. Mini's letters in Cart. III, pp. 350–80, passim. He reported to Michelangelo that he had arrived in Lyon on 23 December 1531, Cart. III, p. 361, no. DCCCXLI.

427 In February 1531 Alessandro, still only twenty . . .: Hale, 1977, p. 119.

427 His parentage was, and remains, unclear: See Brackett, 2010, pp. 303–25.

427n. After having been freed from slavery . . .: See Ibid. and Brackett, John, in Boyce Davies, p. 670.

428 He arrived back in Florence on 5 July 1531 . . .: Hallman, p. 39.

428 'Duke Alessandro hated him deeply . . .': Condivi/Bull, p. 46.

428n. 'sexually the most voracious of his family': Hale, 1972, p. 122.

429 In April 1531 Figiovanni forwarded . . .: Cart. III, p. 301, no. DCCCXII.

429 Exhausted and busy though he was, Michelangelo . . .: Goffen, p. 317.

429 This was made, according to Antonio Mini . . .: See a letter from Antonio Mini in Lyon to Antonio Gondi, Cart. III, pp. 340–41.

429 'no one could serve him better than that master': Vasari/de Vere, vol. II, p. 362.

429–30 'He was my brother, you were father to me . . .': Michelangelo/Mortimer, pp. 25–7, no. 86.

429n. 'a gift for the Marquis's relation by marriage . . .': Goffen, pp. 316–17.

430 The other record of Lodovico's death . . .: Ramsden, I, pp. 295–7.

430 Via his secretary, Pier Polo Marzi . . . : Cart. III, pp. 312–13, no. DCCCXVII.

431 In September Giovan Battista Mini . . .: Ibid. pp. 319–20.

431 Michelangelo was back in correspondence . . . : Ibid. pp. 299–300, no. DCCCXI.

432 Sebastiano sent a slightly embarrassed letter . . . : Ibid. p. 342, no. DCCCXXXIII.

432 The question was mooted by Sebastiano . . .: Cart. III, pp. 303–6, no. DCCCXIII.

432 In June 1531 the Pope offered to mediate . . .: Ibid. pp. 312–3, no. DCCCXVII.

432 Essentially, as Michelangelo wrote to Sebastiano . . .: Ramsden I, p. 177, no. 186.

433 Sebastiano was still stressing the last point . . .: Cart. III, p. 388, no. DCCCLVII (trans, lation in Bull, pp. 228–30).

433 Michelangelo did not stay in his own house . . .: On the condition of the house, Sebastiano's letter of 16 July 1531, see Ibid. pp. 308–10, no. DCCCXV.

433 The new contract for the tomb, the fourth to date . . .: For the new contract, see Milanesi, pp. 702–6, and Pope-Hennessy, 1970, pp. 319–20. On the fact that Clement was present, see Ramsden II, pp. 26–7, no. 227.

434 There was to be a new location for the tomb . . . : Pope-Hennessy, 1970, p. 320.

434 He ordered Michelangelo to return that very day . . . : Ramsden II, pp. 26–7, no. 227.

434 Meanwhile, the ambassador was working hard . . . : Bull, 1995, pp. 231–2.

435 Soon after the ratification came through . . . : Cart. III, pp. 419–20, no. DCCCLXXXI, and pp. 421–2, no. DCCCLXXXII. The ambassador's letter, Ibid. pp. 417–18, no. DCCCLXXX.

435 Exactly how and where they met is unknown . . . : For a recent discussion of this relationship, see Buck, pp. 76–91.

435n. renewed worries about Michelangelo . . . : Cart. III, p. 373, no. DCCCXLVIII, pp. 403–4, no. DCCCLXVIII.

436 How old Cavalieri was . . .: Buck, p. 76.

436 of 'incomparable beauty' . . .: Ibid.

436 'infinitely more' than any other friend . . . : Vasari/Bull, p. 420.

436 he wrote in a sonnet to Tommaso . . .: Michelangelo/Saslow, p. 224, no. 97.

436–7 'Inadvisedly, Messer Tommao . . .' : Ramsden I, p. 193, draft 4.

437 Instead, a reply arrived from Tommaso . . .: Cart. III, p. 445, no. DCCXCVIII.

437 a positively euphoric reply: Ramsden I, pp. 180–81, no. 191.

437n. Humorous accusations of same-sex relationships . . . : Gouwers, 1998, op. cit., p. 17.

439 In looking at his 'lovely face' . . .: Michelangelo/Mortimer, p. 23, no. 83.

439 In a letter he received from his old friend Bugiardini . . .: Cart. III, p. 433, no. DCCCXCI.

439 'If one chaste love, one pity pure . . .': Michelangelo/Mortimer, p. 15, no. 59.

439 A second poem emphasized . . .: Ibid. p. 14, no. 58.

439 'foolish, fell, malevolent crowd': Ibid. p. 23, no. 83.

440 there was another interpretation of the relationship . . .: See Barkan, 1991, passim.

440 'To be happy I must be conquered . . .': Saslow, p. 226, no. 98.

443 According to Vasari, he joined Michelangelo in 1530 . . .: Vasari/Bull, p. 402.

443 A series of beautiful drawings from this time . . .: See Chapman, Hugo, in British Museum, 2005, pp. 417–21.

443 On one occasion, begging for some help . . . : Cart. III, pp. 405–6, no. DCCCLXIX.

443 The most astonishing example . . .: See Buck, pp. 110–17.

445 'Your house is watched over constantly . . .' : Cart. IV, p. 12, no. CMVI.

445–6 A torn and damaged sheet of paper . . .: Ramsden I, pp. 194–5, draft 6.

445n. In a masterly exposition . . .: Barkan, 2011, pp. 235–86.

446 On 28 July, in reply to some gentle teasing . . .: Ramsden I, p. 184, no. 193.

446 He implored Sebastiano to send him news . . .: Ibid. p. 185, no. 194.

448 A drawing of Phaeton riding the sun god's chariot . . .: Buck, pp. 123–35.

448 he suggested that this pagan and erotic image . . .: Cart. IV, pp. 17–19, no. CMX.

449 On 6 September Tommaso apologized . . .: Cart. IV, p. 49, no. CMXXXII. On the question of whether the letter refers to the arrival of a drawing or the completion of a crystal engraving, see Plazzotta, C., in Buck, pp. 85–6.

449 On 22 September Michelangelo rode from Florence . . .: Ricordi, p. 278, no. CCLIII.

449n. Copernicus's new theory . . .: See Shrimplin, pp. 266–70.

450 Despite his failing health, Clement decided . . .: Setton, p. 270.

450 'We have a whole people opposed to us . . .': Quoted in Hale, 1983, p. 40.

450 The bastion Michelangelo had built . . .: Ibid. p. 32.

451 when Vitelli asked Michelangelo to ride over . . .: Condivi/Bull, pp. 46–7.

451 Clement presided over his niece's wedding . . .: Setton, p. 270.

451 On 29 October he was still settling accounts . . .: Ricordi, p. 277.

19. JUDGEMENT

453 'The exchange of kisses . . .': Comanini, Gregorio, *Il Figino*, 1591, quoted in Campbell, Stephen, p. 620, note 102.

453 the Pope 'being a person of great discernment . . .': Condivi/Bull, p. 51.

453 an even more ambitious enterprise . . .: Vasari/Bull, p. 374.

454 On 2 March 1534 a Mantuan agent in Venice . . .: De Vecchi, 1986, p. 178.

454 Clement entered his final, lingering illness . . .: Pastor, vol. X, pp. 322–3.

454 In mid-September Michelangelo left Florence . . .: Ramsden I, pp. 187–8, no. 198.

454–5 The reading room of the library was finished . . .: Ackermann, pp. 310 and 314; Vasari/Bull, pp. 375, 399–400.

455–6 He said as much in a farewell note . . .': Ramsden I, pp. 187–8, no. 198.

455n. The tombs and the library remained . . .: See Detroit Institute of Arts, 2002, pp. 21, note 34.

456 Febo, like Tommaso, was presented . . .: For example, Michelangelo/Saslow, pp. 228–30, nos. 99 and 100.

456 The sole letter from him to survive . . .: Cart. IV, p. 67, no. CMXLI.

456 The temptations of sin were the theme of a drawing . . .: See Buck, pp. 100–109.

458 'The first large body of love poetry . . .': Michelangelo/Saslow, p. 15.

458 On 13 October 1534, the second day of the conclave . . .: Setton, p. 394; Baumgartner, pp. 102–3.

458 Farnese was a veteran of Roman ecclesiastical politics . . .: On his career, see Pastor, vol. XI, pp. 17–20.

458 The Venetian ambassador noted that Alexander VI . . .: Gregorovius, book XIII, p. 351, note 2.

459 'After the elevation of Pope Paul III . . .: Condivi/Bull, p. 51.

461 Michelangelo decided to 'spin matters out . . .': Vasari/Bull, p. 376.

461 six months after Paul III's coronation . . .: Mancinelli, 1997, p. 160.

461n. a letter written seven years later . . .: See Ramsden II, p. 27, no. 227.

462 'a projection (*scarpa*) of bricks, well laid . . .': Vasari/Bull, p. 178.

462 the Pope appointed a full-time cleaner . . .: De Vecchi, 1986, p. 172.

462 'Fra Sebastiano had persuaded the Pope . . .': Vasari/de Vere, vol. II, p. 151.

463 in 1530 the Venetian poet, scholar (and lover . . .: Palazzo di Venezia, 2008, p. 172.

463 with 'Michelangelo saying neither yea nor nay' . . .: Vasari/de Vere, loc. cit.

463–4 On 1 September 1535 Paul issued two papal briefs . . .: Mancinelli, 1997, p. 158.

464 one day Paul III appeared in his house . . .: Condivi/Bull, p. 52.

464 Ercole Gonzaga was an ally of three enthusiastic reformers . . .: See Mayer, *Reginald Pole: Prince and Prophet*, 2000, p. 117.

465 by a *motu proprio* of 17 November 1536 . . .: Vasari, 1962, vol. III, p. 1193.

465 On 25 January 1536 work commenced . . .: Mancinelli, 1997, p. 160.

466 On the first day he painted, Michelangelo climbed . . .: Ibid. p. 166.

466 In March of 1536 a widowed . . .: Ramsden II, p. 237.

467 After Vittoria's death, Michelangelo . . .: Ibid. p. 120, no. 347; Condivi/Bull, p. 67.

467 'A man within a woman . . .': Michelangelo/Saslow, pp. 398–9, no. 235.

467 Vittoria's life had been superficially most unlike Michelangelo's . . .: For Vittoria Colonna's life, see Brundin, pp. 15–36.

468n. During the interval in the battle . . .: Price Zimmermann, 1995, p. 77.

468n. a dialogue, *Concerning Men and Women* . . .: Ibid. pp. 100–101.

469 These female saints – some naked . . .: See Partridge, pp. 116–22.

469 The following year, on 10 December 1537 . . .: Ackerman, p. 145.

469 It was yet another member of the Medici . . .: Hale, 1977, pp. 125–6.

469–70 Lorenzino also put on a performance of a play, *Aridosa* . . .: Piccolomini, p. 85.

470 Alessandro's amorous target was allegedly Caterina . . .: Hale, 1977, p. 125.

470 The surviving members of the regime . . .: Ibid. pp. 127–8.

470 This was the moment for the exiles to strike . . .: Najemy, pp. 466–8.

472 'cut on a cornelian of great antiquity': Vasari/Bull, p. 413.

472 the actual painting comprised 449*giornate* . . .: Mancinelli, 1997, p. 163.

472n. 'Don't you think that Dante made a mistake . . .': Piccolomini, pp. 90–93.

473 he did use a little oil to add lustrous shades . . .: Mancinelli, 1997, p. 163.

474 In the mass of the saved on the right-hand side . . .: See Partridge, pp. 126–34.

474 The essence of the answer . . .: See Hall, Marcia B., in Hall, *Artistic Centres*, 2005, pp. 95–112.

474 Michelangelo had, then, to represent a spiritual body . . .: Ibid. p. 97.

476 Towards the end of September 1537 . . .: Cart. I V, pp. 82–3, no. CMLII (translation in Aretino, 1976, pp. 109–11, no. 31).

478 In 1537 Aretino was in the process . . .: for Aretino's career, see Aretino, 1976, pp. 13–43.

479 There was perhaps a light dusting of irony . . .: Cart. I V, pp. 87–8, no. CMLV, and Ramsden II, p. 3, no 199.

479 Aretino wrote back again . . .: Cart. I V, pp. 90–91, no. CMLVII.

479–80 We have an intriguing glimpse . . .: On Holanda, see Bury.

480 At the beginning of the *Dialogues* . . .: Holanda, p. 31.

480 The first dialogue is set on Sunday 20 October 1538 . . .: See Shearman, 2003, p. 961.

481 he performed the Spiritual Exercises . . .: Conwell, pp. 52–3.

481 Tolomei was in correspondence with Cardinal Contarini . . .: See Delph et al., p. 15, note 19.

481–2 Vasari told a story about a visit the Pope made . . .: Vasari/Bull, p. 379.

483 These public baths, which had spread to Italy . . .: See Girouard, pp. 82–4.

483 the connection was made more than once . . .: On this connection, see Lazzarini, pp. 115–21.

483 Before he finished *The Last Judgement* . . .: Vasari/Bull, p. 379–80.

483n. a satirical sonnet suggested he was standing . . .: See Schlitt, p. 118.

484 *The Last Judgement* was finally revealed . . .: Partridge, op. cit., p. 10.

484 Nino Sertini, the envoy from Mantua . . .: de Vecchi, 1986, p. 190.

484n. It is not clear exactly when this happened . . .: See Barocchi, vol. III, p. 1301.

20. REFORM

487 'The Marchesa of Pescara . . .': Quoted in Musiol, p. 211.

487 Francesco Maria was succeeded by his son, Guidobaldo . . .: Cart. I V, pp. 106–7, no. CMLXX.

487–8 On 23 November 1541 Cardinal Ascanio Parisani . . .: Pope-Hennessy, p. 320.

487n. in the manner Hamlet's father was assassinated . . .: For the Duke's death, see Clough, p. 79 and note 19.

488 In this petition, drafted by his new man of business . . .: Ramsden II, pp. 19–22, no. 219.

488 perhaps he had already another home in mind . . .: Cart. IV, p. 229, no. MLIV; Ransden, p. 61, nos. 246 and 266.

489 Condivi – hence Michelangelo himself – singled Pole out . . .: Condivi/Bull, p. 66.

489 Pole was an extraordinary and unique figure . . .: For his character and career, see Mayer, *Reginald Pole: Price and Prophet*, 2000, pp. 1–12 and passim.

492 Among these was Juan de Valdés . . .: On Valdés, Ochino and the Spirituali, see MacCulloch, pp. 213–18.

492 The interface between romance and piety . . .: Musiol, pp. 215–32.

492 The answer seemed to be no . . .: Ibid. p. 10.

493 out of love for Michelangelo she made an anthology . . .: Brundin, p. 81.

493 Almost certainly her poems were the 'cose' . . .: Ramsden II, p. 4, no. 201; Cart. IV, pp. 120–21, no. CMLXXXIII.

493 Naturally, he did also give gifts to Vittoria . . .: On the subject of Michelangelo, Vittoria Colonna and gifts, see Nagel, 1997.

493n. This still exists, in the Vatican Library . . .: Brundin, p. 81.

494 According to Condivi, he made three drawings . . .: Condivi/Bull, pp. 67–8.

494 In the early 1540s for a moment . . .: MacCulloch, pp. 226–33.

496 'Even if my own father were a heretic . . .': Quoted in Ibid. p. 231.

496 In the meantime, yet another contract . . .: Pope-Hennessy, 1970, pp. 320–22.

496 'not only from painting, but from living life at all': Ramsden II, pp. 24–5, no. 226.

496–7 'one paints with the head and not with the hands . . .': Ibid. p. 26, no. 227.

497 it caused alarm and consternation . . .: Musiol, p. 205.

497 'dragging himself to the Vatican every day to paint': Ramsden II, pp. 32–3, no. 229.

497 In *The Conversion of St Paul* . . .: Steinberg, 1975, pp. 22–41.

498 It has been suggested that the face of Paul . . .: Ibid. p. 39.

498 'Since it's true that, in hardstone . . .': Michelangelo/Saslow, p. 409, no. 242.

498 Like many of Michelangelo's Roman circle . . .: On Luigi del Riccio, see Ramsden II, pp. 244–50.

498n. Michelangelo's true view of landscape . . .: Holanda, pp. 46–7.

500 Del Riccio, for example, invited him to dinner . . .: Cart. IV, p. 142, no. CMXCVI.

500 'A poor man with no one to serve him . . .': Ramsden II, p. 23, no. 222.

500 In the first of two dialogues . . .: Giannotti, pp. 31–3.

500 The best theme for our thoughts . . .: Ibid. p. 33.

500–501 A beautiful and charming youth, Cecchino . . .: For Cecchino, see Ramsden II, pp. 256–8.

501 'seemed both to smile and to threaten me': Ibid. pp. 16–17, no. 215.

501 'Alas' he wrote to Giannotti . . .: Ibid. p. 257.

501 a verbal monument of fifty poems . . .: Michelangelo/Saslow, pp. 329–90, nos. 179–228.

501 'For the fig bread' . . .: Ibid. pp. 356, 360, 363, 380.

50In. Appended to one epitaph, no. 197 . . .: Ibid. p. 359, no. 197.

502 In the summer of 1544, Michelangelo . . .: Ramsden II, pp. 37–8, no. 238, note 1, p. 245.

502 Michelangelo accused Lionardo . . .: Ibid. pp. 37–8, no. 238.

502 On 21 July the artist, recovering from . . .: Gaye, vol. II, p. 296.

502 'I do not want, however, to fail you': Ramsden II, p. 39, no. 241.

502–3 'I have received three shirts . . .': Ibid. p. 3, no. 203.

504 On 25 January Raffaello da Montelupo's sculptures . . .: Pope-Hennessy, 1970, pp. 321–2.

504 In Condivi there was an appraisal . . .: Condivi/Bull, pp. 53–4.

504n. 'In a letter to the latter from 1541 . . .': Ramsden II, p. 9, no. 209.

505 At the end of 1545, for the second time . . .: Ibid. pp. 269–71.

505 'You say that you were under an obligation . . .': Ibid. p. 57, no. 262.

505 In an undated letter . . .: Ibid. p. 41, no. 244, dated Feb–March 1546 in Cart. IV, p. 232, no. MLVI.

505 'Now that Luigi del Riccio is dead' . . .: Ramsden II, p. 250.

507 In the spring of 1546, wearily . . .: Steinberg, 1975, p. 55.

507 An agent sent another message to Pier Luigi Farnese . . .: Ramsden II, pp. 267–8.

507 In 1538 Duke Pier Luigi had violently raped . . .: Mayer, pp. 71–2.

507 'Sometimes, I may tell you . . .': Holanda, pp. 41–2.

507 'Painters are not in any way unsociable . . .': Ibid. p. 41.

508 'Even his Holiness annoys and wearies me . . .': Ibid.

508 By the end of December he had got his way . . .: For the complicated history of the Po ferry, see Ramsden II, pp. 266–8.

508 On 2 January 1547 a *motu propio* was signed . . .: Ibid. p. 306.

509 She had been forced to leave Rome in 1541 . . .: Ramsden II, p. 241.

509 'she would come to Rome for no other reason . . .': Condivi/Bull, p. 67.

509 'By what we take away, lady . . .': Michelangelo/Mortimer, p. 40, no. 152.

509 'so near to death and so far from God': Ibid. pp. 17–18, no. 66.

509 'My soul, troubled and perplexed . . .': Michelangelo/Saslow, p. 471, no. 280.

510 She fell ill at the beginning of 1547 . . .: Ramsden II, pp. 242–3.

510 In one of the most poignant touches . . .: Condivi/Bull, p. 67.

510 Vittoria's death drove Michelangelo almost mad . . .: Ibid.

510 'You'll rightly say that I am old and distracted . . .': Ramsden II, p. 76, no. 281.

510 'I am an old man, and death . . .': Ibid. p. 72, no. 279.

510 Benedetto Varchi, the scholar and critic . . .: Varchi. See Ramsden II, pp. 257–9.

511 'I would remind you . . .': Ramsden II, p. 87, no. 300.

511 'Around my door are such mounds of dung . . .': Michelangelo/Mortimer, pp. 56–7, no. 267.

511n. It begins with his most famous lines . . .: Ibid. p. 39, no. 151.

512 The verse lists his ailments . . .: Ibid. pp. 56–7, no. 267.

512 he insisted with Rabelaisian hyperbole . . .: Ibid.

512–13 he sent Lionardo graphic accounts of his troubles . . .: Ramsden II, p. 91, no. 306, and pp. 102–3, nos. 323–4.

514 In a letter to Lionardo from May 1548 . . . : Ibid. p. 91, no. 306.

514 'Nelle mie opera caco sangue!': Chantelou, p. 174, quoted in Clements, p. 301.

21. DOME

517 'From 1547 until the present day . . .': Ramsden II, p. 310.

517 Michelangelo's erstwhile enemy and rival . . .: On the building history of St Peter's, see Millon and Lampugnani, pp. 598–672, and Ackerman, pp. 199–227.

519 'that the limbs of architecture . . .': Ramsden II, p. 129, no. 358.

520 In a letter to Bartolomeo Ferratino . . .: Ibid. p. 69, no. 274.

521n. Michelangelo's redesigning of the basilica . . .: Cart IV, pp. 267–8, no. MLXXXIII.

522 In 1546, when Michelangelo took over . . .: Ackerman, p. 179.

524 An anonymous admirer of Sangallo . . .: Ibid. p. 184.

524 'a flickering arpeggio of highlights . . .': Ibid.

524 the remodelling of the top of the Capitoline Hill . . .: Ibid. pp. 139–73.

526 'I do not have the courage . . .': Barkan, 2011, p. 218, and Cart. IV, p. 247, no. MLXVIII.

526 'some who had been his intimate friends . . .': Mercati, quoted in Papini, pp. 394–6.

527 The Council of the Church, so long postponed . . .: MacCulloch, pp. 234–7.

527 The historian Diarmaid MacCulloch has pinpointed . . .: Ibid. p. 221.

527 Michelangelo was probably close to the Jesuits . . .: On Colonna and Loyola, see Astell, p. 191, note 4.

527–8 Typically, the artist's own contribution . . .: Ibid. p. 190.

528 The conclave to choose the new Pope . . .: Baumgartner, pp. 82–100.

528 The late Pope had made his last inspection . . .: Steinberg, p. 55.

529 Privately, del Monte . . . had believed . . .: Vasari/de Vere, vol. II, p. 1051.

529 One of the tasks Vasari left behind . . .: Rubin, 1995, pp. 110–14.

529 One evening in Rome during the mid-1540s . . .: Vasari/de Vere, vol. II, pp. 1042–3.

530 three weeks after Michelangelo's seventy-fifth birthday . . .: Rubin, 1995, p. 114.

530 As Michael Hirst has noted, there are signs . . .: Hirst, 1997, p. 68.

530 He responded, elegantly . . .: Michelangelo/Saslow, pp. 467–8, no. 277.

530 In a letter written to Vasari . . . on 1 August . . .: Ramsden II, pp. 121–2, no. 348.

530 Vasari's own biographer, Patricia Rubin . . .: Rubin, 1995, p. 80.

531 Vasari related an anecdote from those years . . .: Vasari/Bull p. 455.

532 the Pope gave them a special dispensation . . .: Ibid. p. 393.

532 In another letter, written in October 1550 . . .: Ibid. p. 396.

532–3 Vasari told a strange, if comic, anecdote . . .: Ibid. p. 423.

532n. On another occasion when they went riding . . .: Ibid. pp. 398–9.

533 Compared to Vasari's kindness, Michelangelo wrote . . .: Michelangelo/ Mortimer, pp. 67–8, no. 299.

533 'I got the *marzolini* . . .': Ramsden II, pp. 127–8, no. 357.

533 'I've received the pack load of *trebbiano* . . .': Ibid. p. 143, no. 382.

534 One evening Vasari went to the house . . .: Vasari/Bull, pp. 328–9.

534 a *motu proprio* giving Michelangelo powers . . .: Ramsden II, p. 308–9.

535 According to papal records, they claimed . . .: Ibid. p. 310.

535 A meeting was held to discuss these complaints . . .: Vasari/Bull, pp. 396–7.

535–6 It was alleged he was 'constructing a temple . . .': Ramsden II, p. 310.

536 During the Sack of Rome he had been one of the hostages . . .: Partner, p. 38.

536 According to Condivi, the Pope not only declared . . .: Condivi/Bull, p. 62.

536 There was scandal at one of these appointments . . .: For Julius III and Inno- cenzo del Monte, see Dall'Orto, Govanni, in Aldrich and Wotherspoon, vol. I, pp. 233–4.

537 This, the Villa Giulia . . .: Vasari/Bull, p. 397.

537 The Deputies wrote Julius a memorandum . . .: Ramsden II, p. 292.

537 In 1550 a further volume of Aretino's letters appeared . . .: See Cart. IV, pp. 215–17, no. MXLV, and Aretino, 1967, pp. 223–5, for the original of November 1545.

537 In 1549 an anonymous Florentine . . .: De Vecchi, 1986, pp. 191–2 and 269.

538 In 1553 his literary friend and helper Annibale Caro . . .: Ramsden II, p. 253.

538 The desire to put his own case . . .: See Hirst, 1997, pp. 70–72.

538n. Not much is known of Ascanio Condivi . . .: On Condivi, see ibid. and Papini, pp. 409–12.

22. DEFEAT AND VICTORY

541 'In his meditation on death . . .': Ramsden II, p. liii.

541 'The effect of the capital works . . .': Reynolds, 1778, p. 83

541 In 1550 or 1551 the Duke had used Benvenuto Cellini . . .: Cellini, pp. 350–52.

542 This time the election of the new Pope . . .: Baumgartner, pp. 111–12.

542 Michelangelo wrote to Vasari, detailing . . .: Vasari/Bull, p. 401.

543 'with a good reputation, with honour . . .': Ramsden II, pp. 153–4, no. 398.

543 the following year Pole was sent back to England . . .: MacCulloch, p. 281.

543 Michelangelo still had 'many' of her letters: Condivi/Bull, p. 67.

543n. Her correspondence with Pole . . .: Musiol, pp. 4–5.

544 around 280 Protestants were executed for heresy . . .: MacCulloch, pp. 285–6.

544 However, his income was abruptly cut off: Hatfield, p. 165.

544 He had had inserted into Paul III's *motu proprio* . . .: Ramsden II, p. 308.

544 his salary was enormous . . .: Hatfield, pp. 167–8.

544 In his *ricordi* Michelangelo grimly noted . . .: Ricordi, p. 346, no. CCXCVII.

544 Michelangelo ordered feasts to celebrate progress . . .: Ramsden II, pp. 311–12.

545 'it would be the cause of great ruin . . .': Ibid. p. 155, no. 402.

545 The sculptor Tribolo had been sent to Rome . . .: Vasari/Bull, pp. 399–401.

546 on 13 November 1555, came the death . . .: Ramsden II, p. 159, no. 407.

546 On the day he wrote to Lionardo . . .: Ibid. p. 160, no. 408.

546 his servant – or rather . . . his companion': Vasari/Bull, p. 402.

546 On his visit a few years previously, Cellini . . .: Cellini, 1956, p. 352.

546 'so stricken and troubled . . .': Ramsden II, p. 160, no. 408.

546–7 'the greater part of me has gone with him . . .': Ibid. p. 161, no. 410.

547 At this point in Michelangelo's life . . .: On Urbino, see Papini, pp. 436–40.

547 Michelangelo treated Urbino's widow . . .: Ramsden II, pp. 172–3, no. 431; Cart. V, pp. 79–280, passim.

547 'I've had the *trebbiano* . . .': Ramsden II, p. 183, no. 443.

548 Vasari told the story . . .: Vasari/Bull, pp. 424–5. For the gift to Antonio del Francese, see Hatfield, pp. 181–2.

548 He then presented him with 2,000 *scudi* . . .: Hatfield, pp. 181–3.

548 The question of his lost income . . .: Ibid. p. 166.

549 Paul IV was a sternly reforming defender . . .: On Paul IV, see Baumgartner, pp. 114–16.

549 Probably that was the intention . . .: Vasari/Bull, p. 402.

549 By mid-1556 a Spanish army . . .: Ramsden II, p. 300.

549–50 In a rather disingenuous letter to Lionardo . . .: Ibid. p. 168, no. 245.

549n. Paul IV wanted to have *The Last Judgement* destroyed . . .: See Campbell, Stephen.

550 'at great expense and inconvenience' . . .: Ramsden II, p. 169, no. 426.

550 In a letter to Urbino's widow, Cornelia . . .: Ibid. pp. 172–3, no. 431.

550 'If one could die of shame and grief' . . .: Ibid. p. 178, no. 437.

552 In September 1558 the Florentine ambassador . . .: Ibid. p. xlix.

552 He was yet another of the Florentine banking community . . .: Wallace, 2000, p. 88.

553 It was Bandini, in turn, who found . . .: Vasari/Bull, pp. 404–5.

553 'Tiberio asked Michelangelo why he had broken . . .': Ibid. p. 405.

554 This hooded and bearded figure . . .: Pope- Hennessy, p. 339.

554 those who wanted to keep their true faith hidden . . .: See Koslofsky, pp. 48–9.

554 'Oh night, O sweetest time . . .': Michelangelo/Mortimer pp. 32–3, no. 102.

555 while he was dying the Roman populace smashed . . .: Baumgartner, p. 116.

555 Finally on Christmas Day 1559 . . .: Ibid. pp. 115–20.

555n. In November 1559 she wrote to the artist . . .: Cart V, p. 185, no. MCCCVI. She followed this up with a further letter the following year, Ibid. p. 263, no. MCCCXLI.

556 Another was to reinstitute Michelangelo's salary . . .: Hatfield, p. 166.

556 'For his architectural work,' Vasari explained . . .: Vasari/Bull, p. 413

556 Had it been built to this plan. . .: See Ackerman, pp. 227–40.

556 Another, less ambitious, scheme . . .: Ibid. pp. 240–48.

557 Or, as Vasari put it, it was necessary 'for him . . .': Vasari/Bull, p. 405.

559 'the many thousand figures he is seen . . .': Condivi/Bull, p. 71.

559 'He is also endowed with a most powerful . . .': Ibid.

559 Against this passage, Tiberio Calcagni . . .: Calcagni/Elam, p. 492; Procacci, p. 293.

559 'I know for a fact that shortly before he died . . .': Vasari/Bull, p. 419.

559 Early one morning in August 1561 Michelangelo . . .: Papini, pp. 505–7.

560 one of his last and most extraordinary creations . . .: See Ackerman, pp. 251–67.

560 as James Ackerman has argued . . .: Ibid. p. 257.

561 a dignified, affectionate letter . . .: Cart. V, pp. 273–4, no. MCCCLXVIII.

561 His final foe was the Florentine sculptor . . .: Ramsden II, pp. 313–14.

562 a last letter to Lionardo Buonarroti . . .: Ibid. p. 208, no. 480.

562 on 21 January, the Council of Trent . . .: De Vecchi, 1986, p. 269, note 35.

562 A catafalque 56 feet high . . .: Vasari/Bull, p. 439.

BIBLIOGRAPHY

ACKERMAN, James S., *The Architecture of Michelangelo*, London, 1970

Adhémar, J., 'Arentino: Artistic Advisor to Francis I', *Journal of the Warburg and Courtauld Institutes*, vol. 17, no. 3, pp. 311–18, London, 1954

Agosti, Giovanni, and Hirst, Michael, 'Michelangelo, Piero d'Argenta and the "Stigmatization of St Francis"', *Burlington Magazine*, vol. 138, no. 1123, pp. 683–4, London, 1996

Aland, Kurt (ed.), 'Martin Luther's 95 Theses', electronic resource, 2004

Aldrich, Robert, and Wotherspoon, Garry (eds.), *Who's Who in Gay and Lesbian History*, London, 2001

Ames-Lewis, Francis, *The Intellectual Life of the Early Renaissance Artist*, London, 2000

Amy, Michaël J., 'The Dating of Michelangelo's *St Matthew*', *Burlington Magazine*, vol. X, no. 1169, pp. 493–6, London, 2000

Aretino, Pietro, *The Letters of Pietro Aretino*, translated by Thomas Caldecot Chubb, Connecticut, 1967

—, *Selected Letters*, translated by George Bull, London, 1976

Arkin, Moshe, '"One of the Marys ...": An Interdisciplinary Analysis of Michelangelo's Florentine *Pietà*', *The Art Bulletin*, vol. 79, no. 3, pp. 493–517, London, 1997

Astell, Ann W., *Eating Beauty: The Eucharist and the Spiritual Arts of the Middle Ages*, New York, 2006

Atkinson, James B., and Sices, David (eds.), *Machiavelli and His Friends: Their Personal Correspondence*, Dekalb, 1996

BALDRIGA, Irene, 'The First Version of Michelangelo's Christ for S. Maria Sopra Minerva', *Burlington Magazine*, vol. X, no. 1173, pp. 740–45, London, 2000

Bambach, Carmen, 'Berenson's Michelangelo', *Apollo* (Feb. & Mar. 2010)

—, 'Michelangelo's Cartoon for the "Crucifixion of St Peter" Reconsidered', *Master Drawings*, vol. 26, no. 2, New York, 1987

—, 'The Purchases of Cartoon Paper for Leonardo's "Battle of Anghiari" and Michelangelo's "Battle of Cascina"', *I Tatti Studies*, vol. 8, pp. 105–33, Chicago, 1999

Barkan, Leonard, *Michelangelo: A Life on Paper*, Princeton, 2011

—, *Transuming Passion: Ganymede and the Erotics of Humanism*, Stanford, 1991

—, *Unearthing the Past: Archaeology and Aesthetics in the Making of Renaissance Culture*, New Haven, 1999

Barnes, Bernadine, 'A Lost Modello for Michelangelo's "Last Judgement"', *Master Drawings*, vol. 26, no. 3, pp. 239–48, New York, 1988

Bibliography

—, 'Metaphorical Painting: Michelangelo, Dante, and the Last Judgement', *Art Bulletin*, vol. 77, no. 1, pp. 64–81, London, 1995

Barolosky, Paul, *Michelangelo's Nose: A Myth and Its Maker*, Pennsylvania, 1990

Baumgartner, Frederick J., *Behind Locked Doors: A History of the Papal Elections*, London, 2005

Baxandall, Michael, *Painting and Experience in Fifteenth Century Italy*, Oxford, 1972

Beck, James, 'Cardinal Alidosi, Michelangelo, and the Sistine Ceiling', *Artibus et Historiae*, vol. 11, no. 22, pp. 63–77, Krakow, 1990

Becker, Marvin, 'Changing Patterns of Violence and Justice in Fourteenth- and Fifteenth-Century Florence', *Comparative Studies in Society and History*, vol. 18, no. 3, pp. 281–96, Cambridge, 1976

Black, Robert, *Education and Society in Florentine Tuscany*, Boston, 2007

Boström, Antonia, 'Daniele da Volterra and the Equestrian Monument to Henry II of France, *Burlington Magazine*, vol. 137, no. 1113, pp. 809–20, London, 1995

Boucher, Bruce, *The Sculpture of Jacopo Sansovino*, 2 vols., New Haven and London, 1991

Boyce Davies, Carole (ed.), *Encyclopedia of the African Diaspora*, Santa Barbara, 2008

Brackett, John, *Criminal Justice and Crime in Late-Renaissance Florence 1537–1609*, Cambridge, 1992

—, 'Race and Rulership: Alessandro de' Medici, First Medici Duke of Florence, 1529–37', in Earle, T. F., and Lowe, K. J. P. (eds.), *Black Africans in Renaissance Europe*, Cambridge, 2010, pp. 303–25

Branca, Mirella, and Pini, Serena, *Michelangelo: The Wooden Crucifix*, Rome, 2010

Brown Deborah, 'The *Apollo Belvedere* and the Garden of Giuliano della Rovere at SS. Apostoli', *Journal of the Warburg and Courtauld Institutes*, vol. 49, pp. 235–8, London, 1986

Brucker, Gene A. (ed.), *The Society of Renaissance Florence: A Documentary Study*, New York, 1971

Brundin, Abigail, *Vittoria Colonna and the Spiritual Poetics of the Italian Reformation*, Aldershot, 2008

Buck, Stephanie (ed.), *Michelangelo's Dream*, London, 2010

Bull, George, *Michelangelo: A Biography*, London, 1995

Bullard, Melissa, *Lorenzo il Magnifico: Image and Anxiety, Politics and Finance*, Florence, 1994

Burroughs, Charles, 'The "Last Judgement" of Michelangelo: Pictorial Space, Sacred Topography, and the Social World', *Artibus et Historiae*, vol. 16, no. 32, pp. 55–89, Krakow, 1995

—, 'Michelangelo at the Campidoglio: Artistic Identity, Patronage and Manufacture', *Artibus et Historiae*, vol. 14, no. 28, pp. 85–111, Krakow, 1993

Bury, J. B., *Two Notes on Francisco de Holanda*, London, 1981

Busini, Giovambattista, *Lettere di Giovambattista Busini a Benedetto Varchi sopra l'assedio di Firenze*, Florence, 1861

Bibliography

Butler, Kim E., 'The Immaculate Body in the Sistine Ceiling', *Art History*, vol. 32, no. 2, pp. 250–89, Oxford, 2009

CADOGAN, Jean K., *Domenico Ghirlandaio: Artist and Artisan*, London, 2000

—, 'Michelangelo in the Workshop of Domenico Ghirlandaio', *Burlington Magazine*, vol. 135, no. 1078, pp. 30–31, London, 1993

Caglioti, Francesco, *Donatello e i Medici*, Florence, 2000

Campbell, Lily B., 'The First Edition of Vitruvius', *Modern Philology*, vol. 29, no. 1, pp. 107–11, Chicago, 1931

Campbell, Stephen J., '"*Fare una Cosa Morta Parer Viva*": Michelangelo, Rosso and the (Un)Divinity of Art', *Art Bulletin*, vol. 84, no. 4, pp. 596–620, New York, 2002

Caravaggi, Roberto (ed.), *Raphael: In the Apartments of Julius II and Leo X*, Milan, 1993

Carlino, Andrea, *Books of the Body: Anatomical Ritual and Renaissance Learning*, Turin, 2004

Cartwright, Julia, *Isabella d'Este, Marchioness of Mantua, 1474–1539: A Study of the Renaissance*, 2 vols., London, 1903

Castiglione, Baldesarre, *The Book of the Courtier*, translated by George Bull, London, 1956

Catterson, Lynn, 'Michelangelo's "Laocoön?"', *Artibus and Historiae*, vol. 26, no. 52, pp. 29–56, Krakow, 2005

—, 'Middeldorf and Bertoldo, Both Again', *Artibus and Historiae*, vol. 26 no. 51, pp. 85–101, Krakow, 2005

Cellini, Benvenuto, *Autobiography*, translated by George Bull, London, 1956

—, *The treatises of Benvenuto Cellini on Goldsmithing and Sculpture*, translated by C. R. Ashbee, London, 1898

'de Chantelou, Paul Fréart, *Journal de Voyage du Cavalier Bernin*, Paris, 1885

Chastel, André, *The Sack of Rome, 1527*, translated by Beth Archer, Princeton, 1983

Clark, Kenneth, *Civilization*, London, 1969

—, *The Nude*, Edinburgh, 1956

Clayton, Martin, and Philo, Ron, *Leonardo da Vinci: Anatomist*, Windsor, 2012

Clements, Robert J., 'Michelangelo on Effort and Rapidity in Art', *Journal of the Warburg and Courtauld Institutes*, vol. 17, no. 3, pp. 301–10, London, 1954

Clough, Cecil, 'Clement VII and Francesco Maria della Rovere', in Gouwens and Reiss, 2005, pp. 75–108

Coen, Ester, *Boccioni*, New York, 1998

Condivi, Ascanio, *Vita di Michelagnolo Buonarroti raccolta per Ascanio Condivi da la Ripa Transone*, Rome, 1553, Davis, Charles (ed.), accessed online at http://archiv.ub.uni-heidelberg.de/artdok/volltexte/2009/714

Conwell, Joseph F., *Impelling Spirit: Revisiting a Founding Experience: 1539, Ignatius of Loyola and His Companions*, Chicago, 1997

Corbo, Anna Maria, 'Documenti Romani su Michelangelo', *Commentari*, vol. XVI (1965)

Corti, G., 'Una ricordanza di Giovan Battista Figiovanni', *Paragone*, 175, pp. 24–31

Cummings, A., *The Politicized Muse*, Princeton, 1992

Bibliography

DELBEKE, Maarten (ed.), *Bernini's Biographies: Critical Essays*, Pennsylvania, 2006

Delph, Ronald K., Fontaine, Michelle M., and Martin, John Jeffries (eds.), *Heresy, Culture and Religion in Early Modern Italy: Contexts and Contestations*, Kirksville, 2006

Dodsworth, Barbara, *The Arca di San Domenico*, New York, 1995

Dolce, Lodovico, *Dialogo della Pittura, di M. Lodovico Dolce, Intitolato l'Aretino*, Florence, 1785

Dorez, L., *Nouvelles Recherches sur Michel-Ange et son entourage*, Paris, 1918

Draper, James, *Bertoldo di Giovanni, Sculptor of the Medici Household*, Columbia, 1992

ECHINGER-MAURACH, Claudia, 'Michelangelo's Monument for Julius II in 1534', *Burlington Magazine*, vol. 145, no. 1202, pp. 336–44, London, 2003

Eckstein, Nicholas A., *The District of the Green Dragon: Neighbourhood Life and Social Change in Renaissance Florence*, Florence, 1995

Eisenbichler, Konrad, 'Charles V in Bologna: the Self-Fashioning of a Man and a City', *Renaissance Studies*, vol. 13, no. 4, pp. 430–39, Oxford, 1999

Elam, Caroline, 'Art in the Service of Liberty: Battista della Palla, Art Agent for Francis I', *I Tatti Studies*, vol. 5, pp. 33–109, Chicago, 1993

—, '"Ché ultima mano!": Tiberio Calcagni's Marginal Annotations to Condivi's *Life of Michelangelo*', *Renaissance Quarterly*, vol. 51, no. 2, pp. 475–97, Chicago, 1998

—, 'Lorenzo de' Medici's Sculpture Garden', *Mitteilungen des Kunsthistorischen Instituts in Florenz*, vol. 1, pp. 40–84, Florence, 1992

—, 'Michelangelo and the Clementine Architectural Style', in Gouwens and Reiss, 2005, pp. 199–226

—, 'The Mural Drawings in Michelangelo's New Sacristy', *Burlington Magazine*, vol. 123, no. 943, pp. 592–602, London, 1981

—, '"Tuscan Dispositions: Michelangelo's Florentine Architectural Vocabulary and Its Reception', *Renaissance Studies*, vol. 19, no. 1, pp. 46–82, Oxford, 2005

Elkins, James, 'Michelangelo and the Human Form: His Knowledge and Use of Anatomy', *Art History*, vol. 7, pp. 176–86, Oxford, 1984

Evans, Mark, Browne, Clare, and Nesselrath Arnold (eds.), *Raphael: Cartoons and Tapestries for the Sistine Chapel*, London, 2010

FANTAZZI, Charles, 'Poliziano's *Fabula di Orfeo*: a *Contaminatio* of Classical and Vernacular Themes', *Revista de Estudios Latinos*, vol. 1, pp. 121–36, Madrid, 2001

Fehl, Philipp, 'Michelangelo's Crucifixion of St Peter: Notes on the Identification of the Locale of the Action', *Art Bulletin*, vol. 53, no. 3, pp. 326–43, London, 1971

—, 'Michelangelo's Tomb in Rome: Observations on the "Pietà" in Florence and the "Rondanini Pietà"', *Artibus et Historiae*, vol. 23, no. 45, pp. 9–27, Krakow, 2002

Ferino-Pagden, Sylvia, 'Raphael's Heliodorus Vault and Michelangelo's Sistine Ceiling: An Old Controversy and a New Drawing', *Burlington Magazine*, vol. 132, no. 1044, pp. 195–204, London, 1990

Bibliography

Ficino, Marsilio, *Marsilio Ficino's Commentary on Plato's Symposium*, translated by Sears Reynolds Jayne, Columbia, 1944

Finlay, Victoria, *Colour*, London, 2002

Flick, Gert-Rudolf, *Missing Masterpieces: Lost Works of Art 1450–1900*, London, 2003

Forsyth, William H., *The Entombment of Christ: French Sculptures of the Fifteenth and Sixteenth Centuries*, Cambridge, Mass., 1970

Foster, Philip, 'Lorenzo de' Medici and the Florence Cathedral Façade', *Art Bulletin*, vol. 63, no. 3, pp. 495–500, London, 1981

Freedman, Luba, 'Michelangelo's Reflections on *Bacchus*', *Artibus et Historiae*, vol. 24, no. 47, pp. 121–35, Krakow, 2003

Freud, Sigmund, 'The Moses of Michelangelo', in *Sigmund Freud: Writings on Art and Literature*, 1997

Frey, Karl, *Il Codice Magliabechiano*, Farnborough, 1969

—, '*Studien zu Michelagniolo Buonarroti und zur Kunst seiner Zeit. III*', *Jahrbuch der Königlich Preussischen Kunstsammlungen*, vol. 30, pp. 103–80, Berlin, 1909

Frey, Karl, and Grimm, H., '*Michelangelo's Mutter und Seine Stiefmutter*', *Jahrbuch der Königlich Preussischen Kunstsammlungen*, vol. 6, pp. 185–201, Berlin, 1885

Frommel, Cristoph L., '"*Capella Iulia*": *Die Grabkapelle Papst Julius II in Neu-St Peter*', *Zeitschrift für Kunstgeschichte*, vol. 40, no. 1, pp. 26–62, Munich, 1977

—, 'The Early History of St Peter's', in Millon and Lampugnani (eds.)

Fusco, Laurie, and Corti, Gino, *Lorenzo de' Medici: Collector and Antiquarian*, Cambridge, 2006

GATTI, Luca, '*Delle cose de' pictori et sculptori si può mal promettere cosa certa: la diplomazia fiorentina presso la corte del re di Francia e il Davide bronzeo di Michelangelo Buonarroti*', *Mélanges de l'École française de Rome. Italie et Méditerranée*, vol. 106, no. 2, pp. 433–72, Rome, 1994

Gaye, *Carteggio inedito d'artisti dei secoli XIV, XV, XVI*, 3 vols., Florence, 1839–40

Gayford, Martin, *Man with a Blue Scarf*, London, 2010

Giacometti, Masscino (ed.), *The Sistine Chapel: Michelangelo Rediscovered*, London, 1986

Giannotti, Donato, *De' Giorni che Dante Consumò nel Cercare l'Inferno e'l Purgatorio*, Florence, 1859

Gilbert, Creighton, 'What is Expressed in Michelangelo's "*Non-Finito*"', *Artibus et Historiae*, vol. 24, no. 48, pp. 57–64, Krakow, 2003

—, 'When Did a Man in the Renaissance Grow Old?', *Studies in the Renaissance*, vol. 14, pp. 7–32, Chicago, 1967

Gilbert, Felix, 'Guicciardini, Machiavelli, Valori on Lorenzo Magnicio', *Renaissance News*, vol. II, no. 2, pp. 107–14, New York, 1958

Giovio, Paolo, *Michaelis Angeli vita*, c. 1527, Davis, Charles (ed.), accessed online at http://archiv.ub.uni-heidelberg.de/artdok/volltexte/2009/714

Girouard, Mark, *Cities and People*, Milan, 1985

Bibliography

Goethe, Johann W., *Italian Journey*, translated by W. H. Auden and Elizabeth Mayer, London, 1970

Goffen, Rona, *Renaissance Rivals: Michelangelo, Leonardo, Raphael, Titian*, London, 2002

Gould, Cecil, 'A New Portrait Attribution to Michelangelo', *Master Drawings*, vol. 27, no. 4, pp. 303–09, New York, 1989

Gouwens, Kenneth, *Remembering the Renaissance: Humanist Narratives of the Sack of Rome*, London, 1998

Gouwens, Kenneth and Reiss, Sheryl E. (eds.), *The Pontificate of Clement VII: History, Politics, Culture*, Aldershot, 2005

Greenblatt, Stephen, *The Swerve: How the World Became Modern*, New York, 2011

Gregorovius, Ferdinand, *History of the City of Rome in the Middle Ages*, translated by Annie Hamilton, 8 vols., London, 1894–1902

HAAS, Louis, *The Renaissance Man and His Children: Childbirth and Early Childhood in Florence, 1300–1600*, Basingstoke, 1998

Hale, J. R., *Florence and the Medici*, Plymouth, 1977

—, *Renaissance War Studies*, London, 1983

Hall, Marcia B. and Steinberg, Leo, '"Who's Who in Michelangelo's Creation of Adam" Continued', *Art Bulletin*, vol. 75, no. 2, pp. 340–44, London, 1993

Hall, Marcia B. (ed.), *Artistic Centres of the Italian Renaissance: Rome*, Cambridge, 2005

—, *Michelangelo's 'Last Judgement'*, Cambridge, 2005

—, 'Michelangelo's *Last Judgement*: Resurrection of the Body and Predestination', *Art Bulletin*, vol. 58, no. 1, pp. 85–92, London, 1976

Hallman, Barbara McClung, 'The "Disastrous" Pontificate of Clement VII: Disastrous for Giulio de' Medici?', in Gouwens and Reiss, 2005, pp. 29–40

Hannam, James, *God's Philosophers: How the Medieval World Laid the Foundations of Modern Science*, London, 2009

Haskell, Francis, and Penny, Nicholas, *Taste and the Antique: The Lure of Classical Sculpture 1500–1900*, London, 1982

Hatfield, Rab, *The Wealth of Michelangelo*, Rome, 2002

Hemsoll, David, 'The Laurentian Library and Michelangelo's Architectural Method', *Journal of the Warburg and Courtauld Institutes*, vol. 66, pp. 29–62, London, 2003

Henderson, George, *Gothic*, Harmondsworth, 1967

Henry, Tom, *The Life and Art of Luca Signorelli*, London and New Haven, 2012

Herlithy, David, 'Tuscan Names, 1200–1530', *Renaissance Quarterly*, vol. 41, no. 4, pp. 561–82, Chicago, 1988

Hibbard, Howard, *Michelangelo*, London, 1978

Hirst, Michael, 'The Marble for Michelangelo's *Taddei Tondo*', *Burlington Magazine*, vol. 147, no. 1229, pp. 548–9, London, 2005

—, *Michelangelo: The Achievement of Fame*, London, 2011

—, 'Michelangelo, Carrara, and the Marble for the Cardinal's *Pietà*', *Burlington Magazine*, vol. 127, no. 984, pp. 152–9, London, 1985

—, *Michelangelo and His Drawings*, New Haven, 1988

—, 'Michelangelo and His First Biographers', *Proceedings of the British Academy*, vol. 94, pp. 63–84, London, 1997

—, 'Michelangelo in 1505', *Burlington Magazine*, vol. 133, no. 1064 (Nov. 1991)

—, 'Michelangelo in Florence: "David" in 1503 and "Hercules" in 1506', *Burlington Magazine*, vol. 142, no. 1169, pp. 487–92, London, 2000

—, 'Michelangelo in Rome: An Altar-Piece and the "Bacchus"', *Burlington Magazine*, vol. 123, no. 943, pp. 581–93, London, 1981

Hirst, Michael, and Dunkerton, Jill, *Making and Meaning: The Young Michelangelo*, London, 1994

de Holanda, Francisco, *Dialogues with Michelangelo*, translated by C. B. Holroyd, London, 1911; reprinted with an introduction by David Hemsoll, London, 2006

Hollingsworth, Mary, *The Cardinal's Hat: Money, Ambition and Everyday Life in the Court of a Borgia Prince*, London, 2005

Hook, Judith, *Lorenzo de' Medici*, London, 1984

—, *The Sack of Rome: 1527*, London, 1972

Hornik, Heidi J. Parsons, and Mikeal, C. (eds.), *Interpreting Christian Art: Reflections on Christian Art*, Macon, 2004

Hörnquist, Mikael, 'Perche non si usa allegare i Romani: Machiavelli and the Florentine Militia of 1506', *Renaissance Quarterly*, vol. 55, no. 1, pp. 148–9, Chicago, 2002

Hupe, Eric, Re-framing the *Doni Tondo*: Patronage, Politics and Family in Michelangelo's Florence', MA Thesis, University of Washington, Missouri, 2011

JACKS, David, and Caferro, William, *The Spinelli of Florence: Fortunes of a Renaissance Merchant Family*, University Park, 2000

Jacobs, Frederika H., 'Aretino and Michelangelo, Dolce and Titian: *Femmina, Masculo, Grazia*', *Art Bulletin*, vol. 82, no. 1 pp. 51–67, London, 2000

Joannides, Paul, 'Michelangelo's "Cupid": A Correction', *Burlington Magazine*, vol. 145, no. 1205, pp. 579–80, London, 2003

—, 'Michelangelo's Lost *Hercules*', *Burlington Magazine*, vol. 119, no. 893, pp. 550–55, London, 1977

—, 'Michelangelo: The Magnifici Tomb and the Brazen Serpent', *Master Drawings*, vol. 34, no. 2, pp. 148–67, New York, 1996

—, 'A Supplement to Michelangelo's Lost *Hercules*', *Burlington Magazine*, vol. 123, no. 934, pp. 20–23, London, 1981

Jones, Jonathan, *The Lost Battles: Leonardo, Michelangelo and the Artistic Duel that Defined the Renaissance*, London, 2010

Joost-Gaugier, Christine L., 'Michelangelo's *Ignudi*, and the Sistine Chapel as a Symbol of Law and Justice', *Artibus et Historiae*, vol. 17, no. 34, pp. 19–43, Krakow, 1996

KANTER, Laurence B., *Luca Signorelli: The Complete Paintings*, London, 2001

Kaye, Jill, 'Lorenzo and the Philosophers', in Mallett and Mann, pp. 151–66

Kemp, Martin, and Walker, Margaret (eds.), *Leonardo on Painting: An Anthology of Writings*, New Haven and London, 1989

Bibliography

Kent, D. V., and Kent, F. W., *Neighbours and Neighbourhood in Renaissance Florence: The District of the Red Lion in the Fifteenth Century*, Locust Valley, 1982

Kent, F. W., 'Bertoldo "*Sculptore*" and Lorenzo de' Medici', *Burlington Magazine*, vol. 134, no. 1069, pp. 24–9, London, 1992

—, 'Bertoldo "*Sculptore*", Again', *Burlington Magazine*, vol. 135, no. 1086, pp. 629–30, London, 1993

—, *Household and Lineage in Renaissance Florence: The Family Life of the Capponi, Ginori and Rucellai*, Princeton, 1977

—, *Lorenzo de' Medici and the Art of Magnificence*, London, 2007

—, '"Rather Be Feared Than Loved": Class Relations in Quattrocento Florence', in *Society and Individual in Renaissance Florence*, Connell, William J. (eds.), Berkeley, 2002

Koslofsky, Craig, *Evening's Empire: A History of the Night in Early Modern Europe*, Cambridge, 2011

Krautheimer, Richard, *Rome: Profile of a City,312–1308*, Princeton, 2000

Kuehn, Thomas, *Emancipation in Late Medieval Florence*, New Brunswick, 1982

Kuntz, Margaret, 'Designed for Ceremony: The *Capella Paolina* at the Vatican Palace', *Journal of the Society of Architectural Historians*, vol. 62, no. 2, pp. 228–55, Berkeley, 2003

LACH, Donald F., *Asia in the Making of Europe*, vol. II, Chicago, 1965

Landucci, Luca, *Diario Fiorentino*, Florence, 1883

—, *A Florentine Diary from 1450 to 1516*, translated by Alice de Rosen Jervis, Dutton, London, 1927

Lavin, Irving, 'Michelangelo's Florence *Pietà*', *Art Bulletin*, vol. 85, no. 4, p. 814, London, 2003

Lazzarini, Elena, *Nudo, Arte e Decoro: Oscillazioni Estetiche Negli Scritti d'Arte del Cinquecento*, Pisa, 2010

Leathes, Stanley, 'Italy and Her Invaders', in Ward, A. W., Prothero, G. W., and Leathes, Stanley (eds.), *The Cambridge Modern History*, vol. I, pp. 104–43, Cambridge, 1903

Leoni, Massimo, 'Techniques of Casting', in *The Horses of San Marco*, Perocco (ed.), London, 1979

Levey, Michael, *Early Renaissance*, Harmondsworth, 1967

Lieberman, Ralph, 'Regarding Michelangelo's "Bacchus"', *Artibus et Historiae*, vol. 22, no. 43, pp. 65–74, Krakow, 2001

Lippincott, Kristen, 'When Was Michelangelo Born?', *Journal of the Warburg and Courtauld Institutes*, vol. 52, pp. 228–32, London, 1989

Lisner, Margit, 'Zu Benedetto da Maiano und Michelangelo', *Zeitschrift für Kunstwissenschaft*, vol. 12, pp. 141–56, Berlin, 1958

—, 'Michelangelos Kruzifix aus S. Spirito in Florenz', *Münchner Jahrbuch für bildende Kunst*, vol. 15, 1964

Lorenzo de' Medici, *The Autobiography of Lorenzo de' Medici the Magnificent*, translated by James Wyatt Cook, Binghamton, 1995

Bibliography

Lowe, K. J. P., *Church and Politics in Renaissance Italy: The Life and Career of Cardinal Francesco Soderini (1453–1524)*, Cambridge, 1993

—'The Political Crime of Conspiracy in Fifteenth and Sixteenth Century Rome', in Lowe, K. J. P., and Dean, T. (eds.), *Crime, Society and the Law in Renaissance Italy*, Cambridge, 1994

Luschino, Benedetto, *Vulnera diligentis*, in Villari, P., *La Storia di Girolamo Savonarola e de' suoi tempi*, Vol. I, Appendix, pp. lxxxix–xciii, Florence, 1898

Luzio, A., 'Federico Gonzaga ostaggio alla corte di Giuliu II', *Archivio della R. Società Romana di storia Patria*, vol. 9, pp. 509–82, Rome, 1886

MACCULLOCH, Diarmaid, *Reformation: Europe's House Divided*, London, 2004

Machiavelli, Niccolò, *The Discourses*, translated by Leslie J. Walker, London, 2003

—, *Florentine History*, translated by W. K. Marriott and F. R. Hirst, London, 1909

—, *The Prince*, translated by George Bull, London, 1975

Mallett, Michael, and Mann, Nicholas, *Lorenzo the Magnificent: Culture and Politics*, London, 1996

Mancinelli, Fabrizio, 'Michelangelo at Work: The Painting of the Ceiling', in Giacometti (ed.), 1986

—, 'The Painting of the Last Judgement: History, Technique and Restoration', in Partridge et al., 1997

—, 'The Problem of Michelangelo's Assistants', in de Vecchi, 1999, pp. 46–79

Mancusi-Ungaro, Harold R., *Michelangelo: The Bruges Madonna and the Piccolomini Altar*, New Haven, 1971

Martines, Lauro, *April Blood: Florence and the Plot against the Medici*, Oxford, 2003

—, *Power and Imagination: City-States in Renaissance Italy*, New York, 1979

—, *Scourge and Fire: Savonarola and Renaissance Florence*, London, 2006

Masson, Georgina, *Courtesans of the Italian Renaissance*, London, 1975

Mayer, Thomas F., *Cardinal Pole in European Context: A Via Media in the Reformation*, Aldershot, 2000

—, *Reginald Pole: Prince and Prophet*, Cambridge, 2000

Meissner, W. W., *Ignatius of Loyola: The Psychology of a Saint*, New Haven, 1997

Mercati, Michele, *De gli obelischi di Roma*, Rome, 1589

Michelangelo, *Il Carteggio di Michelangelo*, vols. I–V, Poggi, Giovanni, Barocchi, Paola and Ristori, Renzo (eds.), Florence, 1973

—, *The Letters of Michelangelo*, vols. I & II, translated by E. H. Ramsden, London, 1963

—, *Life, Letters and Poetry*, translated by George Bull, Oxford, 1999

—, *Poems and Letters*, translated by Anthony Mortimer, London, 2007

Milanesi, Gaetano, *La lettere di Michelangelo Buonarroti*, Florence, 1875

Millon, Henry A., and Lampugnani, Vittorio M. (eds.), *The Renaissance from Brunelleschi to Michelangelo: The Representation of Architecture*, London, 1994

Bibliography

Millon, Henry A., and Smyth, Craig H., 'Michelangelo and St Peter's I: Notes on a Plan of the Attic as Originally Built on the South Hemicycle', *Burlington Magazine*, vol. III, no. 797, pp. 484–501, London, 1969

Moncallero, G. L. (ed.), *Epistolario di Bernardo Dovizi da Bibbiena*, Florence, 1965

Morrison, Alan, Kirshner, Julius, and Molho, Anthony, 'Epidemics in Renaissance Florence', *American Journal of Public Health*, vol. 75, pp. 528–35, Washington, 1985

Morrogh, Andrew, 'The Magnifici Tomb: A Key Project in Michelangelo's Architectural Career', *Art Bulletin*, vol. 74, no. 4, pp. 567–98, London, 1992

Musiol, Maria, *Vittoria Colonna: A Woman's Renaissance*, 2013

NAGEL, Alexander, 'Gifts for Michelangelo and Vittoria Colonna', *Art Bulletin*, vol. 79, no. 4, pp. 647–68, London, 1997

—, Observations on Michelangelo's Late *Pietà* Drawings and Sculptures', *Zeitschrift für Kunstgeschichte*, vol. 59, no. 4, pp. 548–72, Munich, 1996

Najemy, John M., *A History of Florence 1200–1575*, Oxford, 2006

Napier, Henry Edward, *Florentine History: From the Earliest Authentic Records to the Accession of Ferdinand the Third*, 6 vols., London, 1846–7

Newman, Barnett, 'The Sublime is Now', in *Art in Theory 1900–1990*, Harrison, Charles, and Wood, Paul (eds.), London, 1992

Nicholl, Charles, *Leonardo da Vinci: The Flights of the Mind*, London, 2005

Norwich, John J., *The Popes: A History*, London, 2012

OGILVIE, Brian W., *The Science of Describing: Natural History in Renaissance Europe*, Chicago, 2006

O'Malley, John, SJ, 'The Theology behind Michelangelo's Ceiling', in Giacometti (ed.), 1986, pp. 92–148

Ovid, *Metamorphoses*, translated by M. Mary Innes, Harmondsworth, 1955

PAOLETTI, John T., 'The Rondanini "Pietà": Ambiguity Maintained through the Palimpsest', *Artibus et Historiae*, vol. 21, no. 42, pp. 53–80, Krakow, 2000

Papini, Giovanni, *Michelangelo: His Life and His Era*, New York, 1952

Parker, Deborah, 'The Role of Letters in Biographies of Michelangelo', *Renaissance Quarterly*, vol. 58, no. 1, pp. 91–126, Chicago, 2005

Parks, George B., 'The Pier Luigi Farnese Scandal: An English Report', *Renaissance News*, vol. 15, no. 3, pp. 193–200, Chicago, New York 1962

Parks, Tim, *Medici Money: Banking, Metaphysics and Art in Fifteenth-Century Florence*, London, 2006.

Partner, Peter, *Renaissance Rome 1500–1559: A Portrait of a Society*, Los Angeles, 1979

Partridge, Loren, in Partridge et al., 1997, pp. 116–22

Partridge, L., Mancinelli, F., and Colalucci, G., *Michelangelo – 'The Last Judgement': A Glorious Restoration*, New York, 1997

Pastor, Ludwig, Freiherr von, *The History of the Popes from the Close of the Middle Ages*, 40 vols., London, 1891–1953

Bibliography

Pattenden, Miles, *Pius IV and the Fall of the Carafa: Nepotism and Authority in Counter-Reformation Rome*, Oxford, 2013

Pedretti, Carlo, *Leonardo: A Study in Chronology and Style*, Berkeley and Los Angeles, 1973

Penny, Nicholas, *The Materials of Sculpture*, London, 1993

Piccolomini, Manfredi, *The Brutus Revival: Parricide and Tyrannicide during the Renaissance*, Carbondale, 1991

Pini, Serena, *Michelangelo's Wooden Crucifix*, Santo Spirito Complex, Florence, n.d.

Pliny the Elder, *Natural History: A Selection*, translated by John Healy, London, 1991

Polizzotto, Lorenzo, *The Elect Nation: The Savonarolan Movement in Florence, 1494–1545*, Oxford, 1994

Pon, Lisa, 'Michelangelo's Lives: Sixteenth-Century Books by Vasari, Condivi, and Others', *The Sixteenth-Century Journal*, vol. 27, no. 4, pp. 1015–37, Kirksville, 1996

Pope-Hennessy, John, *Cellini*, London, 1985

—, *Donatello: Sculptor*, London, 1993

—, *Italian High Renaissance and Baroque Sculpture*, London, 1970

—, 'Michelangelo in his Letters', in *Essays on Italian Sculpture*, London, 1968

Price Zimmermann, T. C., 'Guicciardini, Giovio, and the Character of Clement VII', in Gouwens and Reiss, 2005, pp. 19–27

—, *Paolo Giovio: The Historian and the Crisis of Sixteenth-Century Italy*, Princeton, 1995

Procacci, Ugo, 'Postille Contemporanee in un Esemplare della Vita di Michelangiolo del Condivi', in *Atti del Convegno di Studi Michelangioleschi*, Florence and Rome, 1964, pp. 279–94

Proust, Marcel, *Remembrance of Things Past, Volume II, Within a Budding Grove*, translated by C. K. Scott Moncrieff and Terence Kilmartin, 3 vols., London, 1981

REISS, Sheryl F., 'Adrian VI, Clement VII, and Art', in Gouwens and Reiss, 2005, pp. 339–62

Reynolds, Anne, 'The Papal Court in Exile: Clement VII in Orvieto, 1527–28', in Gouwens and Reiss, 2005, pp. 143–61

Reynolds, Joshua, *Discourses on Art*, London, 1778

Richter, Irma (ed.), *Selections from the Notebooks of Leonardo da Vinci*, Oxford, 1977

Richter, Jean Paul (ed.), *The Literary Works of Leonardo da Vinci*, Berkeley, 1977

Riggs, Don, 'Was Michelangelo Born under Saturn?', *The Sixteenth-Century Journal*, vol. 26, no. 1, pp. 99–121, Kirksville, 1995

Robertson, Charles, 'Bramante, Michelangelo and the Sistine Ceiling', *Journal of the Warburg and Courtauld Institutes*, vol. 49, pp. 91–105, London, 1986

Rocke, Michael, *Forbidden Friendships: Homosexuality and Male Culture in Renaissance Florence*, Oxford, 1996

Roscoe, William, *Illustrations, Historical and Critical of the Life of Lorenzo de' Medici, Called the Magnificent*, London, 1822

—, *The Life and Pontificate of Leo the Tenth*, Liverpool, 1805

Bibliography

Ross, James Bruce, and McLaughlin, Mary Martin (eds.), *The Portable Renaissance Reader*, London and New York, 1968

Roth, Cecil, *The Last Florentine Republic*, London, 1925

Roush, Sherry, 'Piagnone Exemplarity and the Florentine Literary Canon in the *Vita di Girolamo Benivieni*', *Quaderni d'italianistica*, vol. 27, no. 1, pp. 3–20, 2006

Rubin, Patricia L., '"*Che è di questo czzino!*": Michelangelo and the Motif of the Male Buttocks in Italian Renaissance Art', *Oxford Art Journal*, vol. 32, no. 3, pp. 427–46, Oxford, 2009

—, *Giorgio Vasari: Art and History*, London, 1995

—, 'Vasari, Lorenzo and the Myth of Magnificence', in *Lorenzo de' Medici e il suo mondo*, G. C. Garfagnini (ed.), pp. 427–42, Florence, 1993

Ruvoldt, Maria, 'Michelangelo's Dream', *Art Bulletin*, vol. 85, no. 1, pp. 86–113, London, 2003

SAMARAN, Charles, *Jean de Bilhères-Lagraulas: Cardinal de Saint-Denis*, Paris, 1921

Saslow, James M., *The Poetry of Michelangelo*, New Haven, 1991

Schlitt, Melinda, 'Painting, Criticism, and Michelangelo's *Last Judgement*', in Hall, 2005

Sciglia, Eric, *Michelangelo's Mountain: The Quest for Perfection in the Marble Quarries of Carrara*, New York, 2005

Setton, Kenneth M., *The Papacy and the Levant, 1204–1571*, Philadelphia, 1978

Seymour, Charles Jr, *Michelangelo's David: A Search for Identity*, New York, 1967

—, *Michelangelo: The Sistine Chapel Ceiling*, London, 1972

Shaw, Christine, *Julius II: The Warrior Pope*, Oxford, 1993

Shearman, John, 'The Florentine Entrata of Leo X, 1515', *Journal of the Warburg and Courtauld Institutes*, vol. 38, pp. 136–54, London, 1975

—, *Raphael in Early Modern Sources (1483–1602)*, New Haven, 2003

Shelley, Percy Bysshe, 'Remarks on Some of the Statues in the Gallery of Florence', in *Letters from Abroad, Translations and Fragments*, vol. II, Shelley, Mrs (ed.), Philadelphia, 1840

Sherman, John, 'The Chapel of Sixtus IV', in Giacometti (ed.), 1986, pp. 22–91

Sherr, Richard, 'Clement VII and the Golden Age of the Papal Choir', in Gouwens and Reiss, 2005, pp. 227–50

Shrimplin, Valérie, *Sun Symbolism and Cosmology in Michelangelo's 'Last Judgment'*, Kirksville, 2000

Shrimplin-Evangelidis, Valérie, 'Michelangelo and Nicodemism: The Florentine *Pietà*', *Art Bulletin*, vol. 71, no. 1, pp. 58–66, London, 1989

Squarzina, Silvia D., 'The Bassano "Christ the Redeemer" in the Giustiniani Collection', *Burlington Magazine*, vol. 142, no. 1173, pp. 746–51, London, 2000

Steinberg, Leo, 'Michelangelo's Florentine *Pietà*: The Missing Leg', *Art Bulletin*, vol. 50, no. 4, pp. 343–53, London, 1968

Bibliography

—, 'Michelangelo's Florentine *Pietà*: The Missing Leg Twenty Years After', *Art Bulletin*, vol. 71, no. 3, pp. 480–505, London, 1989

—, *Michelangelo's Last Paintings: The Conversion of St Paul and the Crucifixion of St Peter in the Capella Paolina, Vatican Palace*, London, 1975

—, 'Who's Who in Michelangelo's Creation of *Adam*: A Chronology of the Picture's Reluctant Self-Revelation', *Art Bulletin*, vol. 74, no. 4, pp. 552–66, London, 1992

Stephens, John, *The Fall of the Florentine Republic, 1527–1530*, Oxford, 1983

Stinger, Charles L., *The Renaissance in Rome*, Bloomington, 1998

Strauss, R. M., and Marzo-Ortega H., 'Cosimo Di Medici's Arthritis', *The Journal of the Royal College of Physicians of Edinburgh*, vol. 32, no. 3, pp. 212–13, Edinburgh, 2002

Summers, David, 'Michelangelo on Architecture', *Art Bulletin*, vol. 54, no. 2, pp. 146–157, London, 1972

—, *Michelangelo and the Language of Art*, Princeton, 1981

Sylvester, David, *Interviews with Francis Bacon*, London, 1993

Symonds, J. A., *The Life of Michelangelo Buonarotti*, New York, 1893

TALVACCHIA, Bette, *Raphael*, London, 2007

de Tolnay, Charles, 'Michelangelo Studies', *Art Bulletin*, vol. 22, no. 3, pp. 127–37, London, 1940

Trexler, Richard C., *Public Life in Renaissance Florence*, London, 1980

—, 'True Light Shining vs. Obscurantism in the Study of Michelangelo's New Sacristy', *Artibus et Historiae*, vol. 21, no. 42, pp. 101–17, Krakow, 2000

Tribaldo de' Rossi, 'Ricordanze', in di San Luigi, Ildefonso (ed.), *Delizie degli Eruditi Toscani*, vol. XXIII, Florence, 1786

UNGER, Miles J., *Machiavelli: A Biography*, London, 2011

—, *Magnifico: The Brilliant Life and Violent Times of Lorenzo de' Medici*, London, 2008

VARCHI, Benedetto, *Due Lezzioni*, Florence, 1549

Vasari, Giorgio, *Lives of the Artists*, vols. I & II, translated by George Bull, London, 1987

—, *Lives of the Painters, Sculptors and Architects*, vols. I & II, translated by Gaston de Vere, London, 1912

—, *On Technique*, translated by Louisa S. Maclehose, New York, 1960

—, *La Vita di Michelangelo nelle redazioni del 1550e del 1568*, ed., with commentary, Barocchi, Paola, 3 vols., Milan, 1962

de Vecchi, Pierluigi, 'Michelangelo's Last Judgment', in Giacometti (ed.), 1986

— (ed.), *The Sistine Chapel: A Glorious Restoration*, New York, 1999

Villari, Pasquale, *The Life and Times of Niccolò Machiavelli*, 2 vols., London, 1892

da Vinci, Leonardo, *Treatise on Painting*, McMahon A. Philip (ed.), Princeton, 1956

WALLACE, William E., 'The Bentivoglio Palace Lost and Reconstructed', *The Sixteenth-Century Journal*, vol. 10, no. 3, pp. 97–114, Kirkville, 1979

Bibliography

—, 'Clement VII and Michelangelo: An Anatomy of Patronage', in Gouwens and Reiss, 2005, pp. 189–98

—, '"*Dal disegno allo spazio*": Michelangelo's Drawings for the Fortifications of Florence', *Journal of the Society of Architectural Historians*, vol. 46, no. 2, pp. 119–34, Berkeley, 1987

—, 'Manoeuvring for Patronage: Michelangelo's Dagger', *Renaissance Studies*, vol. 11, no. 1, pp. 22–6, Oxford, 1997

—, *Michelangelo: The Artist, the Man and His Times*, Cambridge, 2010

—, 'Michelangelo's Assistants in the Sistine Chapel', *Gazette des Beaux Arts*, vol. 10, pp. 203–16, Paris, 1987

—, 'Michelangelo's Rome Pietà: Altarpiece or Grave Memorial?', in Bute, Steven et al (eds.), *Verrocchio and Late-Quattrocento Italian Sculpture*, Florence, 1992

—, *Michelangelo at San Lorenzo: The Genius as Entrepreneur*, Cambridge, 1994

—, 'Michelangelo, Tiberio Calcagni, and the Florentine "Pietà"', *Artibus et Historiae*, vol. 21, no. 42, pp. 81–99, Krakow, 2000

—, 'Michelangelo at Work: Bernardino Basso, Friend, Scoundrel and *Capomaestro*', *I Tatti Studies*, vol. 3, pp. 235–77, Chicago, 1989

—, '*Miscellanae Curiositae Michelangelae*: A Steep Tariff, a Half-Dozen Horses, and Yards of Taffeta', *Renaissance Quarterly*, vol. 47, pp. 330–50, Chicago, 1994

—, 'Narrative and Religious Expression in Michelangelo's Pauline Chapel', *Artibus et Historiae*, vol. 10, no. 19, pp. 107–21, Krakow, 1989

—, 'Two Presentation Drawings for Michelangelo's Medici Chapel', *Master Drawings*, vol. 25, no. 3, pp. 242–60, New York, 1987

Wark, Robert R. (ed.), *Sir Joshua Reynolds – Discourses on Art*, Oxford, 1981

Weil-Garris Brandt, Kathleen, 'A Marble in Manhattan: The Case for Michelangelo', *Burlington Magazine*, vol. 138, no. 1123, pp. 644–59, London, 1996

—, 'Michelangelo's Pietà for the Cappella del Re di Francia', in '*Il se rendit en Italie*': *Études offertes à André Chastel*, Rome and Paris, 1987

Weinstein, Donald, *Savonarola and Florence: Prophecy and Patriotism in the Renaissance*, Princeton, 1970

Wilde, Johannes, 'The Hall of the Great Council of Florence', *Journal of the Warburg and Courtauld Institutes*, vol. 7, pp. 65–81, London, 1944

—, 'Michelangelo and Leonardo', *Burlington Magazine*, vol. 95, no. 600 (March 1953), p. 66

—, *Michelangelo: Six Lectures by Johannes Wilde*, Oxford, 1978

'Wittkower, Rudolf, *Sculpture*, London, 1979

Wright, Alison, *The Brother Pollaiuolo: The Arts of Florence and Rome*, New Haven and London, 2005

Bibliography

ZÖLLNER, Frank, Thoenes, Christof, and Pöpper, Thomas, *Michelangelo: Complete Works*, London, 2008

EXHIBITION CATALOGUES

Fra Angelico to Leonardo: Italian Renaissance Drawings, British Museum, London, 2010

Il Giardino di San Marco: Maestri e Compagni del Giovane Michelangelo, Casa Buonarroti, Florence, 1992

Giovinezza di Michelangelo, Palazzo Vecchio, Florence, 1999

The Medici, Michelangelo and the Art of Late Renaissance Florence, Detroit Institute of Arts, Detroit, 2002

Michelangelo e Dante, Casa di Dante in Abruzzo, Milan, 1995

Michelangelo Drawings: Closer to the Master, British Museum, 2005

Michelangelo and His Influence: Drawings from Windsor Castle, Fitzwilliam Museum, Cambridge, 1997

Money and Beauty: Bankers, Botticelli and the Bonfire of the Vanities, Palazzo Vecchio, Florence, 2011

Raphael: From Urbino to Rome, National Gallery, 2004

Sebastiano del Piombo, Gemäldegalerie, Berlin, 2008

INDEX

NOTE: Works by Michelangelo Buonarroti (MB) appear directly under title; works by others under name of artist or author. Page numbers in *italic* refer to captions of illustrations.